THE VINCENT PRICE *Treasury of American Art*

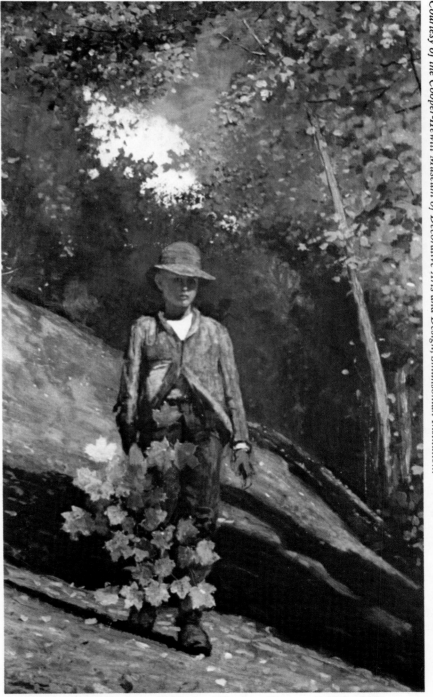

Gathering Autumn Leaves, *1873, by Winslow Homer (1836-1910).*

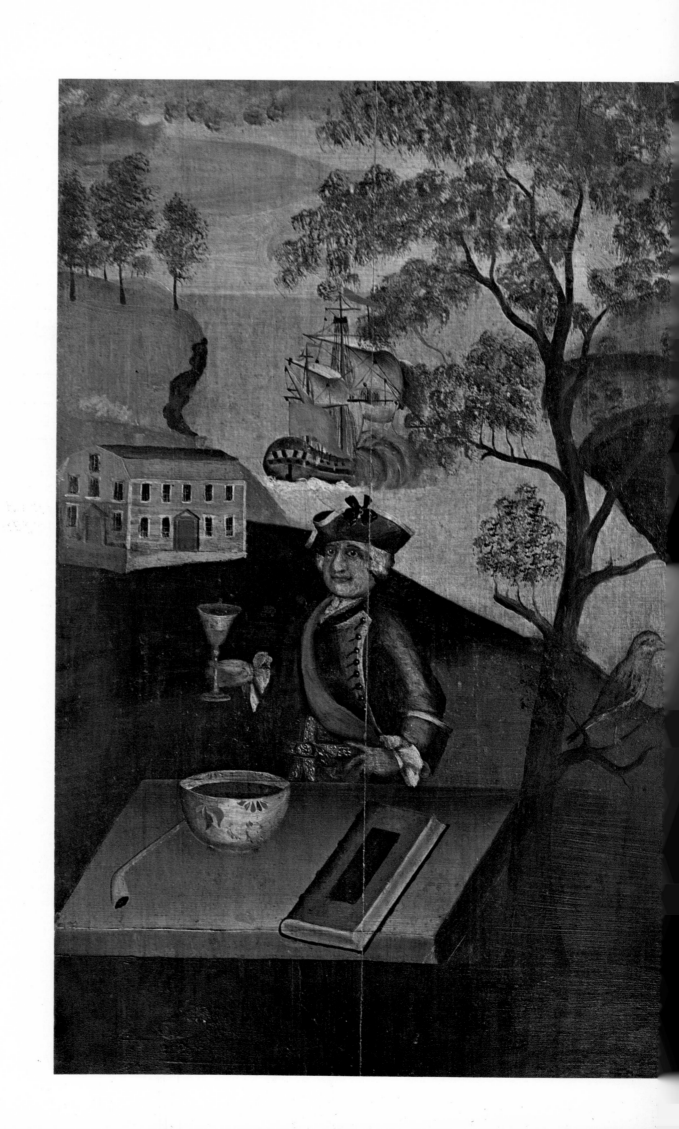

THE VINCENT PRICE
Treasury of American Art

Published by
Country Beautiful Corporation
Waukesha, Wisconsin

To Mary, Barrett and Victoria, gratefully and lovingly.

COUNTRY BEAUTIFUL: *Publisher and Editorial Director:* Michael P. Dineen; *Executive Editor:* Robert L. Polley; *Senior Editors:* Kenneth L. Schmitz, James H. Robb; *Art Director:* Buford Nixon; *Marketing Director:* Gerald Bergman; *Associate Editors:* D'Arlyn M. Marks, John M. Nuhn; *Contributing Editors:* Vincent Barrett Price, Frank Getlein; *Production Manager:* Donna Griesemer; *Circulation Manager:* Trudy Schnittka; *Art Assistant:* Julie Huebsch; *Editorial Secretary:* Karen Hecker.

Country Beautiful Corporation is a wholly owned subsidiary of Flick-Reedy Corporation: *President:* Frank Flick; *Vice President and General Manager:* Michael P. Dineen; *Treasurer and Secretary:* August Caamano.

Acknowledgements

The author and publishers wish to thank the following libraries for their assistance: The Newberry Library, the Ryerson Library of the Art Institute of Chicago, the Chicago Public Library, the Milwaukee Public Library, the Northwestern University Library, the University of Wisconsin-Milwaukee Library, the Archives of American Art and the many museums contributing information.

Frontispiece: *Moses Marcy in a Landscape,* ca. 1760, Unknown artist. Oil. Photo courtesy Old Sturbridge Village, Sturbridge, Massachusetts. In a rare scene of colonial life, a self-satisfied gentleman looks over his possessions from the comfortable prospect of a successful living.

Excerpt from HANS HOFMANN by Frederic Wight originally published by the University of California Press, © 1957, reprinted by permission of The Regents of the University of California.

CONTENTS

FOREWORD

Ralph Waldo Emerson wrote, "There is properly no history, only biography." Certainly the history of American art is biography of a most diverse and fascinating kind. This book is in small part a history of American art, but above all, and most vitally, it is about people. Therefore, I have tried to tell about the artists and their time and what caused them as visual reporters to paint the way they did. Some, caught up in making a living at art, conformed to the prevailing taste of their time, while others dared to peer into a brighter future outside of current modes and moods. Both kinds of artists have their place, for art is one of the few fields of human endeavour where the creative instinct is honestly autonomous. The follower of fashion can be as honest as the leader of the rebellion against it.

This volume is also a biography of America. Each one of these artists represents something of this land, be it the land of their birth or theirs by adoption. It is even evident in those few who chose to leave it and work elsewhere. Some colonial artists, such as the unknown painter of *Moses Marcy* (see frontispiece), were the truest biographers of our early ambitions, our hardships and our successes. Later, others saw the necessity of reporting graphically how we as a nation had failed the great promise of creating a new world out of the need for freedom from the old. Our artists have made note of our natural human heritage, the wealth and health of our environment, and they have been harbingers of its plunder and of its destruction.

There have been those, and many of great talent, who have chosen the Ivory Tower. They have either shut their eyes to ugliness in the search for beauty or turned inward in the effort to find solutions to personal strife. A few have applied themselves to the eternal hope of creating through art a new world, for they had grown tired of searching for it in the real world.

I have also tried to show modern criticism of an artist's work as well as what his contemporaries thought of him. As much as possible I have let the artist speak for himself, or, if he had little to say of his work or his life, his fellow artists often can fill us in. Especially important are the words of artists in others fields, for the painters, poets and philosophers often speak the same language, the one taking inspiration from the other.

The great wealth of American art is by no means concentrated in one museum or city. The pictures here come largely from public galleries all over our country. They are waiting to be viewed and should be seen at firsthand, for the real thing will always come as a surprise. Sometimes a painting may come as a shock because of its size or as a discovery in technique not apparent in the best reproductions. One purpose of this volume then is to invite further study of the works themselves.

It was not so many years ago that research into American Art was like looking for the proverbial needle in the haystack. Now services like the Archives of American Art in the Smithsonian Institution in Washington make it much easier, but there is still a great deal to learn and there are many discoveries and reevaluations to be made.

Perhaps there are those who will say we have not included enough contemporary art, and I feel the same urge to concentrate on the exciting present. But we have set ourselves the task of looking back over three hundred and some odd years of art, and the past fifty years, although overwhelmingly productive and internationally acclaimed,

make up only one-seventh of our art history. And there is no shortage of published material on modern American art.

One of the many things that has made this book such a delight to research is the endless amount of excellent articles, especially those in exhibition catalogues, that have appeared in the last twenty-five years, to complement our rediscovery of our art heritage. It has been stimulating to see forgotten artists emerge from oblivion and others add new brightness to their dim glow. It is still sad, however, to find some hidden beneath bushels of neglect, a few of whom we hope to have illuminated here. To the recognized masters, such as Thomas Eakins and Winslow Homer, I have tried to add a perhaps undisclosed touch of humanity here and there in keeping with the above lines from Emerson. For those unknown heroes of the art fray, I have sifted from fact, or lack of it, and conjectured on their personality as it is revealed by their pictures.

One of the biggest debts I owe is to those brilliant pioneer historians of our art whose patience and perseverance have helped unravel the mystery of whether there is such a thing as American art. Art has always been a matter of maturity, national and personal, and while some mature artists emerged during our national infancy and our adolescent chaos, perhaps it is only now that we are developed enough to compete with older civilizations and present to the world an image uniquely American. I feel we have always faced the world of art with a special "look," an American expression, if you will, that sets us apart and has led to that much appreciated "now" which the world identifies as our own first real art image. To specify this American mood is difficult, but I believe it to be seriousness of purpose. Perhaps this is because we had to struggle so hard for our national identity in a nationally egocentric world before achieving our triumph as a nation and as a culture. To those who say art is international, I must say, yes, in its enjoyment, but it has always been highly nationalistic in its convictions, if not in its inspiration.

Our "seriousness of purpose" in no way denies the element of humor, but our desire for democracy has been something no other nation has even attempted, and it has perhaps taken its toll on our lightness of heart. One has only to look at the parade of American portraits from John Singleton Copley to Thomas Eakins to George Bellows to Ivan Albright to see ourselves as, not heartless, but determined to be heartily aware of our individual and national intent — to be Americans. We tolerate the expatriate, but we do not condone him. We welcome the foreign artist, but he is truly at home only when he becomes American.

I have been struck by the increase in this same seriousness which has survived in our art of recent years: The joy of our landscape painters became the labor of our social realists — the city replaced the country. The heaviness of the nostalgic eye has replaced the virgin viewer's awed wonder — the lyric becomes operatic. The contemplative calm is now instantaneous and often violent action. The report of beauty is no longer obvious, but is usually hidden in the horrible truths of our time, and yet the popularity of Andrew Wyeth's painting reflects a certain longing for the other truth — the more reflective kind. The diversity with which our art expresses our national seriousness is one sure indication of its continuing vitality.

ARTIST UNKNOWN

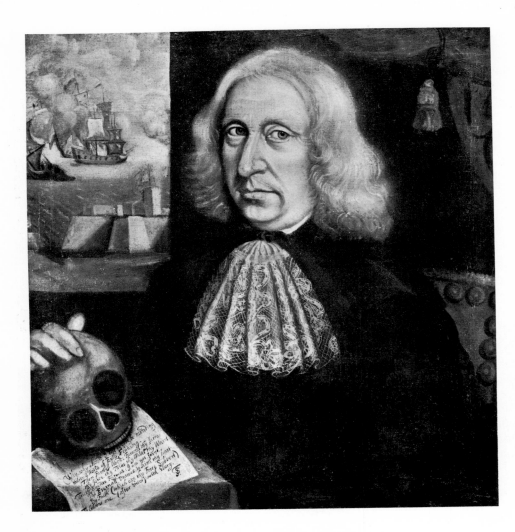

Self-Portrait, *ca. 1690,*
Thomas Smith (active ca. 1675-1700).
24–½ x 23-3/4 in., oil.
Worcester Art Museum,
Worcester, Massachusetts.
The New England mariner Captain Smith,
painting shortly after the Freake limner,
shows considerable ability in modeling
figures and creating three-dimensionality.

One of the earliest masterpieces of American Art is the portrait of *Elizabeth Freake and Baby Mary* in the Worcester Art Museum. Its artist, an unknown Massachusetts limner, painted it about 1674. If you are familiar with other portraits of this period, when you first discover this painting, you are struck, not only by the sweetness of the mother and child, but the strength of its composition and painterliness, making it seem the product of the much more cultured age of Tudor England than Puritan New England. What enchants me is that it contains both art and craft: It is embroidered, sculpted, carved and painted all at once, and, for all its naivety, it is tremendously sophisticated and modern art.

In the case of any painting by an unknown, it is fascinating to find out what the art historians have done to try to know the artist. In this case nothing is really known, but not one writer on art has put himself in any position but complete admiration for the work itself. James T. Flexner, one of the foremost historians of American art, calls the baby "a perfect little doll who never screams or sickens, a girl's imagining of the child she will one day fondle." The mother "looks at us gently from an uncharacterized face that might be the face of all mothers." John McCoubrey says, "It is a style which calls to mind the angular design of lozenge and diamond inlays on New England furniture and the linear surface patterns of New England houses. . . ." All agree it is a masterpiece.

The detective work of modern art identification by X-ray has shown that the artist worked hard to do the job well and to do right by his charming sitters. The baby's pose was altered to make the attachment between mother and child more convincing. The child's left arm was not raised originally, and the mother's was not extended as it is now to keep the stiffly dressed little thing from pitching forward. Through these explorations the Freake portrait artist has been connected with the one who painted the Gibbs children now in a private collection in West Virginia. By comparing brush strokes and design on all these pictures, perhaps we have learned that there was an extremely sensitive painter who "would be noticed as a charming genius in any sophisticated society. . .especially in a society which was suspicious of social pretense," according to art historian Alan Burroughs.

Throughout this book we will come across some artists who have been rescued from obscurity by scholarship and many more who, named or nameless, have emerged from oblivion in the posthumous appreciation of their work. Tastes change and always will, but in America our painters have had to battle foes much greater than that. We have not always been the greatest supporters of our native talent. Each ethnic group that makes up this nation has come to America with preconceived ideas of what art is, and many have been convinced that their way is the only way it should be.

American art has been slow in evolving, though art has been with us from the time of the first settlers. In this book we will trace the beginnings through to the present time and draw some conclusions. We start with this amazing achievement, *Elizabeth Freake and Baby Mary,* and work up and down and back and forth to discover how our art identity has come about. In this masterpiece we can find foreign influences to be sure, but already there is a difference. It is that difference we will be looking for, in each picture, in each personality, to justify the belief that we have : There is such a thing as American Art.

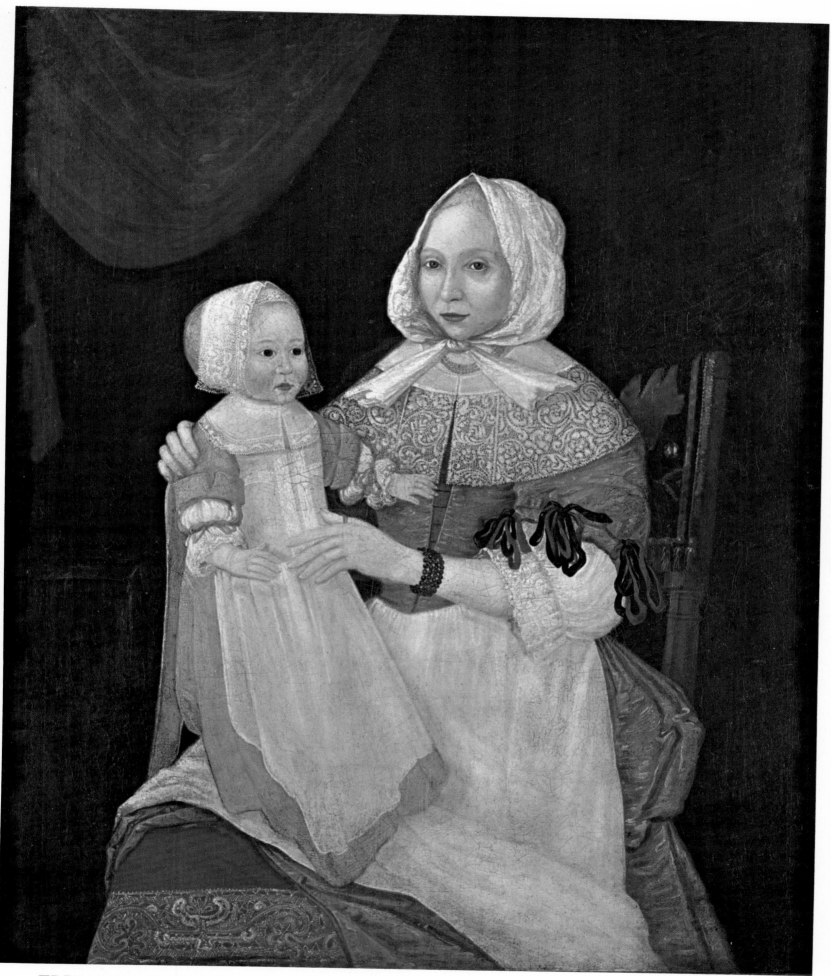

ELIZABETH FREAKE AND BABY MARY, *ca. 1674,*
Artist Unknown (active 1670's). 42½ x 36¾ in., oil.
Worcester Art Museum, gift of Mr. and Mrs. Albert W. Rice.

ROBERT FEKE

MARY McCALL, *n.d.,*
Robert Feke (1705-1750). 50 x 36½ in., oil.
Courtesy, Pennsylvania Academy of the Fine Arts,
Philadelphia, bequest of Helen Ross Schutz.

Isaac Winslow, ca. *1748,*
Robert Feke. 50 x 40 in., oil.
Courtesy, Museum of Fine Arts, Boston.

Robert Feke is recognized as a major early American portraitist during the 1740's, yet we know very little about him before or after this decade. E. P. Richardson in his comprehensive book, *Painting in America,* says, "His fragmentary wandering, adventurous life, his unknown training, show the difficulties and chances awaiting a painter born into a society without an established craft of painting." There is conjecture that the "fragmentary wandering" included a trip to Europe, but if there is something of the English elegance of portraitist Sir Peter Lely's (1618-1680) work in Feke's portraits, it may have been the affectation of his sitters rather than his own. His "adventurous life" refers to the fact that several records state that he was a mariner, but in eighteenth-century New England that was a way of life. There also was a rumor he had once been captured by the Spaniards.

Whatever the circumstances of his life, we do know he worked in Newport in 1745, and there was a demand for his portraits in Philadelphia and Boston about the middle of the eighteenth century, and he had a real and powerful talent. He had access to the studio of Scottish-born John Smibert (1688-1751), perhaps the most accomplished painter to immigrate to the colonies before the Revolutionary War. But Smibert never regarded Feke as his student. Perhaps Feke was that rare bird, the born painter, whose very talent made him a desirable commodity in that "society without an established craft of painting." Craft is just the right word, for, with few exceptions, our early artists went little further than being adequate craftsmen.

Feke rarely penetrated very far into the inner man or woman he was painting, but in this lovely portrait of *Mary McCall* — done at the peak of his artistic development and popularity in the late 1740's — he captured one certain thing, her femininity. She is all woman, as they say, from the corsetted waist to the out-thrust bosom to the suggestively placed flower. Unlike his earlier rather stiff figures, Mary McCall rests more easily within the space she has been placed, and her form and face are softly highlighted. As for her face, Feke painted the features of his women so alike they are difficult to tell apart, but most men would recognize in it a sensuousness which combines his desires and her own awareness of her attraction. The art historian James T. Flexner sees Feke developing a mature style in his female portraits wherein he paints "an unnaturally tiny waist to make the torso a massive jutting triangle. . . .Although our proper critics have ignored the fact," Flexner continues, "any anthropologist up from Africa to study American customs would instantly recognize these images as sexual symbols."

Symbolism is inherent in a great deal of our painting from Feke right down to Willem de Kooning (p. 262). It may be said that, in this land that lacked the facilities for formal training, the untutored artist was forced to devise a style, almost a shorthand of his own invention, to make up his personal language of paint. The ambitious sitters chose one or the other painter because they liked his way of expressing them through his painter's medium. Quite obviously the ladies loved Feke's approach to them, painting each to appear a symbol of femininity. He was a man and, what is more, a sailor man, and he made women look like a sailor's dream during a long hitch at sea.

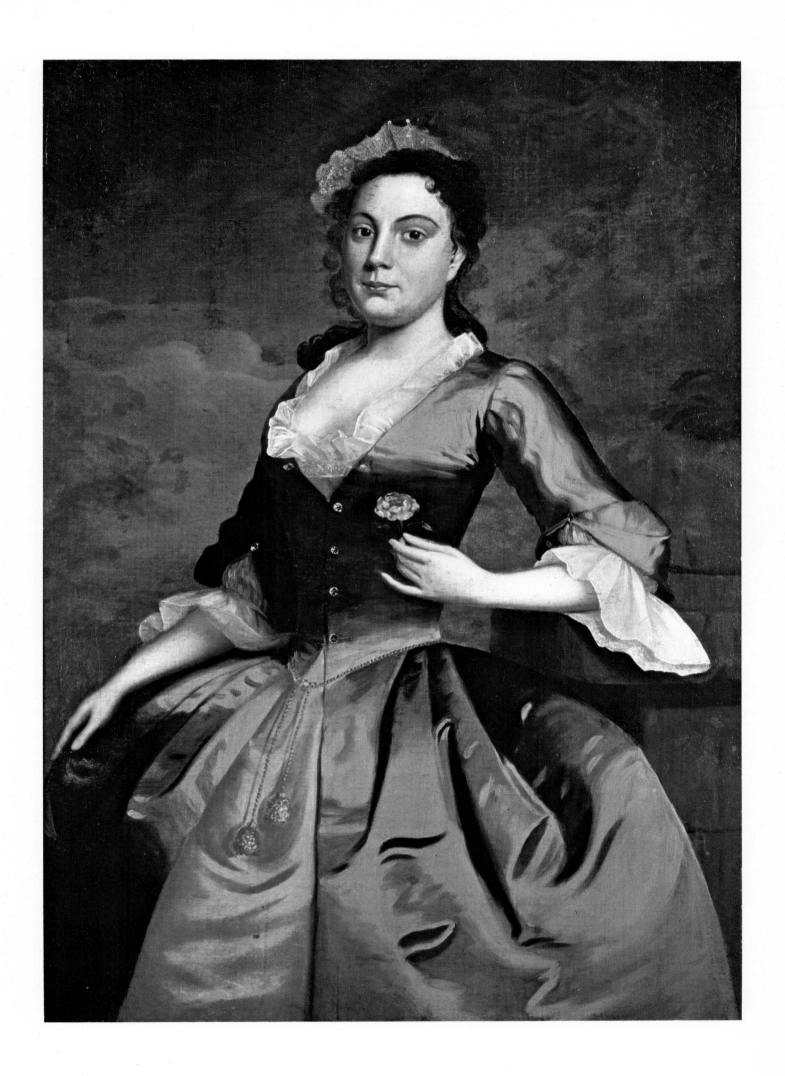

JOHN GREENWOOD

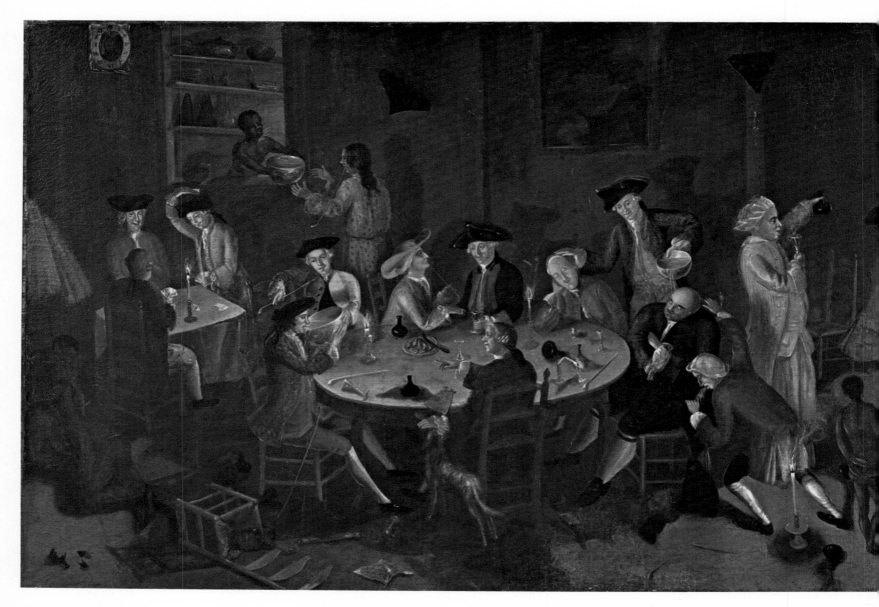

SEA CAPTAINS CAROUSING IN SURINAM, *ca. 1757-58,*
John Greenwood (1727-1792). 37¾ x 75¼ in.,
oil on bed ticking. Courtesy, The Saint Louis Art Museum.

If, after looking at the gallery of early American portraits in this and other volumes, you are tempted to believe that the sitters were all very impressed with themselves, or that they somehow induced their portrait painters to portray them as ideals of respectability, delay judgment until you have explored each detail of John Greenwood's *Sea Captains Carousing in Surinam.* It may come as a surprise that some of these early Americans were very human after all, especially with a few thousand miles separating them from home. You will probably be shocked when you realize who heads the cast in this very early drama of Americans at play.

The gentleman smoking a pipe is Captain Nicholas Cooke, who was to become Governor of Rhode Island. He is talking to Captain Edek Hopkins, later to be Commander of the Continental Navy. Another Hopkins, Stephen, is dousing a Mr. Jonas Wanton with rum. This distinguished carouser was one of the signers of that most sacred of

American documents, the Declaration of Independence. We do not know about all the characters but we can assume they were equally distinguished seafaring men and traders who, having hit the port of Surinam on the north coast of South America, let their hair down, or, probably more accurately, their wigs, and had a real binge.

But there is nothing degrading to these men or snide about this early genre masterpiece. Like the eighteenth-century English satirist, William Hogarth, Greenwood has managed to disguise whatever moral there may be, if there is one at all, with honesty and a certain bitter charm. More than likely the picture was done for the amusement of the patrons of some winehouse. Since Greenwood lived and worked in Surinam for five years and painted 115 portraits there — perhaps even of some of these same men — the pictures, with the sitters presumably the patrons, could hardly have been a threat to their character. Rather these paintings must have been taken simply as a comment on

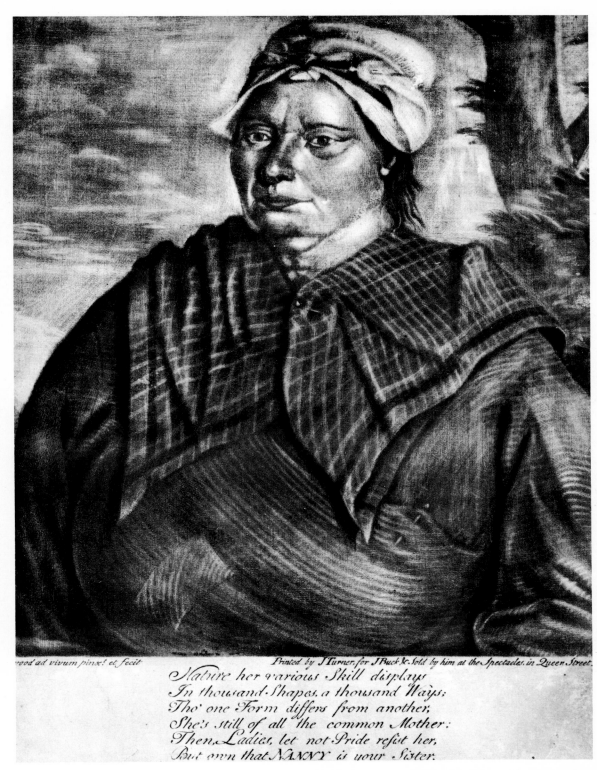

Jersey Nanny, n. d. John Greenwood. mezzotint.
Courtesy Museum of Fine Arts, Boston,
bequest of Henry L. Shattuck.

that part of every man's life he never expects to have recorded, but when it was as harmlessly done as this, even he can enjoy the laugh on himself.

The story of Greenwood himself is rather intriguing, too. The son of a well-to-do society family in Boston, he was apprenticed to the engraver, Thomas Johnson, before he was twenty. He turned to portraiture, and a few years later, at the age of twenty-five, left Boston for Surinam. The reason for his departure is surrounded by conjecture, but he may have been simply looking for work or adventure. Still, he was successful at home and had no serious rivals for commission in Boston, for Robert Feke (p. 10) lived in Philadelphia, John Smibert (1688-1751) was suffering from eye trouble and unable to paint, and John Singleton Copley's (pp. 16-22) promise had not yet become apparent.

Greenwood lived in Surinam until 1758, when he went to Holland and eventually to England. In London he did a few portraits and landscapes but settled down to become one of the most successful antique and old master dealers of his time.

His place in American art is firmly established, however, by his portraits which have a very definite quality of honesty without flattery, almost caricature, and by his genre subjects and engravings. One of them is the famous mezzotint portrait, *Jersey Nanny*, as bawdy a woman as you could imagine. The inscription, believed to have been written by Greenwood, shows us a man very much of his period, a lively one full of robust humor:

Nature her various skills displays
In thousand shapes, a thousand ways;
Tho' one form differs from another
She's still of all the common mother;
Then, ladies, let not pride resist her
But own that Nanny is your sister.

JOHN HESSELIUS

PORTRAIT OF CHARLES CALVERT, *1761,*
John Hesselius (1728-1778). 50¼ x 40¼ in., oil.
The Baltimore Museum of Art.

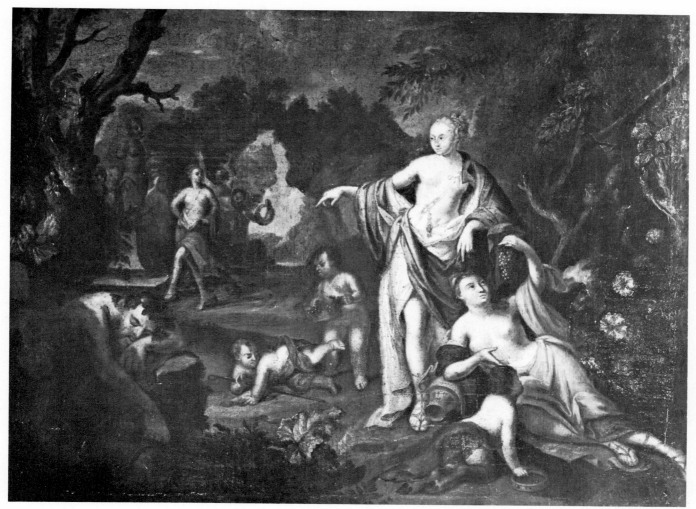

Bacchanalian Revel, *n.d.*
Gustavus Hesselius (1682-1755). 24-½ x 32-½ in., oil.
Courtesy, Pennsylvania Academy of the Fine Arts, Philadelphia.

This is rightfully the story of two men, but since we have only one color reproduction I will use the one as the background for the other. Father and son, Gustavus and John, last name Hesselius, the former born in Sweden, the latter born in America. Between them they span the period of Gustavus's birth in 1682 to John's death in 1778. The father taught the son and the son taught the great Charles Willson Peale (pp. 33-39). Gustavus Hesselius was thirty years old when he came in 1712 to the Swedish colony in Delaware with his minister brother, who was to take a parish there. They were from a strongly religious family and were related to the Protestant leader Emanuel Swedenborg. Hesselius's religious background stayed with him during his early years in Delaware and his later career in Philadelphia.

James T. Flexner, who writes so wittily about our early painters, says of Gustavus, "God was no easy companion for this artistic sport in a long line of ministers; seeking always a truer revelation, he shifted from sect to sect." He was led into the Church of England which was a fashionable one and "must have helped him professionally, but his non-conformist nostrils could not indefinitely suffer the scent of incense." In Philadelphia he "embraced the low German sect of Moravians . . . and . . . during old age he struggled back to the church of his childhood, dying during 1755 in the arms of a Swedish god."

Gustavus's portraits were sincere and penetrating, avoiding the fashionable European style he had brought from Sweden. In contrast, he painted some classical subjects copied from engravings and an original if wholesome *Bacchanalian Revel*. He was also one of the earliest religious painters in America. A *Last Supper* based on an en-

graving was much more to his spirit, and Flexner describes it, "a clumsy picture but an emotional one." Like many artists of his time he was also a craftsman doing coats of arms for coaches, gilding, lettering in gold, and he could also turn his hand to making organs and spinets.

John, the son, did not live as his father had, involved in complicated and frequently changing spiritual motives. He was a country gentleman who became one of the most famous portraitists of Maryland. Although native born and trained, because he came under the influence of John Wollaston (who was born in England but established a reputation as a portraitist in the colonies in the first half of the eighteenth century), Hesselius reflects all the noble affectations of that master's high foreign style and not his father's sincere approach to making forthright portraits.

Despite his artistic shortcomings stemming from Wollaston's influence, there are few American portraits more charming than *Charles Calvert*. It is extremely mannered and the little Calvert gives promise of a certain pomposity, but the endearing devotional look on the black boy's face makes up for it. The whole effect is a treasured memento of our beginnings as a nation with pretensions to elegance.

The boy, Charles Calvert, had every right to this elegance, being the great-great-great-grandson of Maryland's founder, George Calvert, Lord Baltimore. Charles was only five years old when he posed for his portrait, but his stance as a little general has been rehearsed by strict home upbringing, and his fat cheeks and bursting waistcoat give him away as not a little overindulged. But he is a charmer and you cannot help feel an empathy for the picture as a whole. Here is Americana with its faults, perhaps, but Americana nonetheless, and a delight for all of that.

JOHN SINGLETON COPLEY

John Scollay, *1763-64,*
John Singleton Copley, 36 x 28-½ in., oil.
Webb Gallery of American Art,
Shelburne Museum, Shelburne, Vermont.

If any American artist should have been born on the Fourth of July it was John Singleton Copley, but he missed it by one day. He was born in Boston, of course, on July 3, 1738. Just two years before the great year 1776, he left home for London where he lived the rest of his life and he died there in 1815. Copley is unquestionably the greatest and the most American artist of our early history. He was the first to give expression to the particular life that is American and to do it with the full-blown talent of a great artist. The painters who preceded him were competent but altogether less expansive. He had only one advantage — genius. By the time he was sixteen, he had mastered his art. In the next ten years he brought it to the peak of perfection and from then until he left America at the age of thirty-six in 1774 he produced a series of portraits that tell as much about his time and his country as the writings of Benjamin Franklin, Thomas Jefferson and Thomas Paine combined.

Copley's Irish mother had been widowed when he was a child; she remarried, and Copley's stepfather was an engraver, Peter Pelham (ca. 1684-1751), who came from England to become a portrait painter. The Pelham household was one of the few in America dedicated almost wholly to the arts. It was there the boy learned the tools of his trade.

Pelham died when Copley was thirteen, and John became head of the family, his mother and baby half-brother. Serious-minded and determined to put his brief art training to work to make a living, he sought out the only two painters left in Boston, Joseph Badger (1708-1765), and John Greenwood (p. 12). Through the next few formative years he imitated the baroque style of John Smibert (1688-1751) and his school of portraiture, but he soon found himself to be a better painter than any of them.

Copley's first real inspiration in art was Joseph Blackburn, a flashy English portraitist, working in America from 1753 to 1774. Though Blackburn in no way matched the stately standards of London at that time, to young Copley he seemed "a miracle of skill." Copley was an intensely shy and serious young man and he appreciated Blackburn's graceful rococo style, his adeptness with color and his drawing. A greater painter might have put him off. Copley took what he needed from the Englishman and wrote of the experience, "There is a kind of luxury in seeing as well as there is in eating and drinking; the more we indulge, the less we are to be restrained."

After his stirring contact with Blackburn he was on his own. He painted the wonderful portrait of his half-brother, Henry Pelham, *Boy with the Squirrel*, which brought him in an accidental way to European attention. It was purchased by a sea captain who took it to London in 1765 where Sir Joshua Reynolds (1723-1792) was prevailed upon to hang it in the Society of Artists Exhibition. Reynolds wrote to Copley and thus evoked in him the desire to go to England that resulted in Copley's leaving America nine years later. Reynolds complimented him but was deprecating about America. "In any collection of painting it will pass as an excellent picture, but considering the disadvantages you labored under, it is a very wonderful performance."

The "wonderful performance" here is the ability Copley had to paint children who are children. Most early American child portraits are almost comical, the children being cut-down-to-size adults, uneasy in their stiff-legged poses and their Sunday-best clothes. Copley's children may be dressed up Sunday best, too, but they are an entirely different breed. They seem to understand, as did their parents, that the man painting them was not interested in their social position; he was intent only on portraying their young humanity. They have their animal friends to make them at home, but what draws their attention is that silent, hardworking man before the canvas. He seldom says a word and they are fascinated and curious about the results.

Mary and Elizabeth Royall were painted in 1758 when Copley was under Blackburn's spell. It was once attributed to him in fact, but it has that American seriousness of intent that finally identified it as the work of the young Copley. Mary and Elizabeth were the daughters of a well-to-do family from Medford, Massachusetts, and Copley has surrounded them with opulence; but one has the feeling he was making of those drapes an exercise in painting rather than a symbol of their wealth. Later on he would not waste his time on such trivia, concentrating more on the face and the sparce symbols that set off the personality of the sitter. One lovely gesture in this charming picture is the kind of thing only Copley could catch. The sister in blue, obviously the older, seems to be making a gesture with her free hand that brings the little dog's head to attention. These are the humanities with which this giant of American art endows each of his paintings.

MARY AND ELIZABETH ROYALL, *ca. 1758,*
John Singleton Copley (1738-1815). 57½ x 48 in., oil.
Courtesy, Museum of Fine Arts, Boston, Julia Knight Fox Fund.

JOHN SINGLETON COPLEY

Portrait of Paul Revere, *1768-1770,*
John Singleton Copley, 35 x 28-½ in., oil.
Courtesy, Museum of Fine Arts, Boston,
gift of Joseph W., William B. and Edward H. R. Revere.

Copley had none of the felicitousness of the usual portrait painter. He did not have time to charm his sitters; his method would not allow it. Sometimes six-hour sessions and fifteen sittings were needed. He was very businesslike about everything, from the initial meeting with the client to the discussion of cost and the actual time required to do the job. He had none of the traditional training of the Europeans to refer to; each painterly problem had to be solved as it presented itself. He said of his own works that they "are almost always good in proportion to the time I give them, provided I have a subject that is picturesque." One feels he made all his models, if not picturesque, at least pictorially worthy. He prided himself on the truth of his likenesses and, commenting on the report that a child actually mistook one of his portraits for his father, said he was flattered by such criticism because "it is free from all false notions and impertinent conceits that is a result of superficial knowledge of the principles of art."

Essentially Copley's portraits have a literary quality. I read them as I would history or biography, and because of his genius they are poetic, too. His famous portrait of *Paul Revere,* done in 1768, is not of the incipient legendary hero but of the hard-working silversmith. All the heroic trappings are missing, but the hero is there, too, in the character of the man, sleeves rolled up, jaw set, eyes seeing straight into the future. You know here is a man capable of making that historic midnight ride.

Given the portrait of *Mrs. Ezekiel Goldthwait* (Elizabeth Lewis), do you need to know anything more about this wonderful woman than Copley tells us? Can you not guess that she raised the fruit in her own hand-tended garden? She was famous for her gardens which she "always kept in a high stage of preservation." Does she not look like a

motherly type? She had thirteen children. Did she not live in an elaborate house and was she not known for her hospitality? It is all there, but also if you do not care about her life, it is all there in the marvel of Copley's telling of it in paint. Barbara Novak in *American Painting of the Nineteenth Century*, devotes her first chapter to "Copley and the American Tradition." In describing Mrs. Goldthwait she writes: "Predictably...there is the switch of the animate to the inanimate, the inanimate to the animate. The face, painted with relentless responsibility to likeness, tends toward still life, while the brocades, satins, and shining table top are filled with suppressed vitality." But, she adds, "The magic of this illusionism is too easily passed off as *trompe l'oeil*. It is one of the great art historical mysteries...." To understand this mystery, she suggests that we consider Copley's intense empiricism in context of the larger appeal of such realism, especially to Americans who painted the many nineteenth-century still lifes and climaxed by the work of William Michael Harnett (p. 158). The prideful peaches Mrs. Goldthwait lovingly caresses are as much a part of her personality as her lovely skin, her lacey cap, her straightforward look and almost smile.

Copley, fortunately, remained somewhat restrained in subject and style until he reached England. After all, he was a New Englander and a man who had risen from humble beginnings to a very important place in Boston's world of art and, through a fortuitous marriage, even its social world. This gave him access to paint those people of the prosperous class, but not in any way did he lose sight of the fact that he was primarily an artisan. He painted rich and not-so-rich alike, endowing them with their character, not their rank.

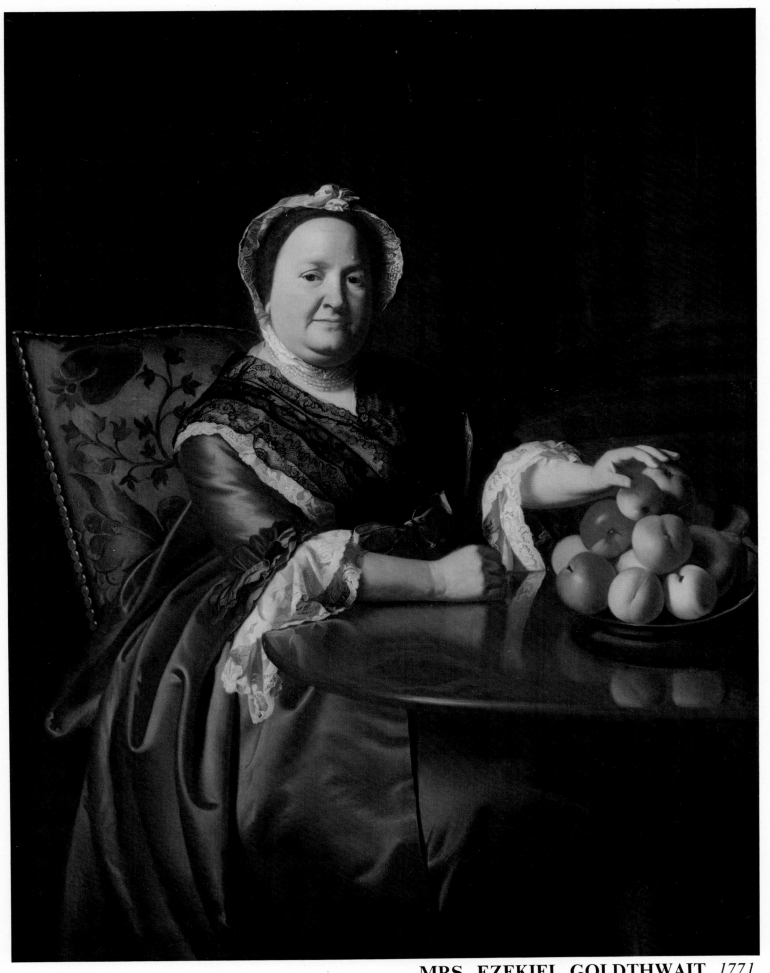

MRS. EZEKIEL GOLDTHWAIT, *1771,*
John Singleton Copley (1738-1815). 50 x 40 in., oil.
Courtesy, Museum of Fine Arts, Boston,
bequest of John T. Bowen in memory of Eliza M. Bowen.

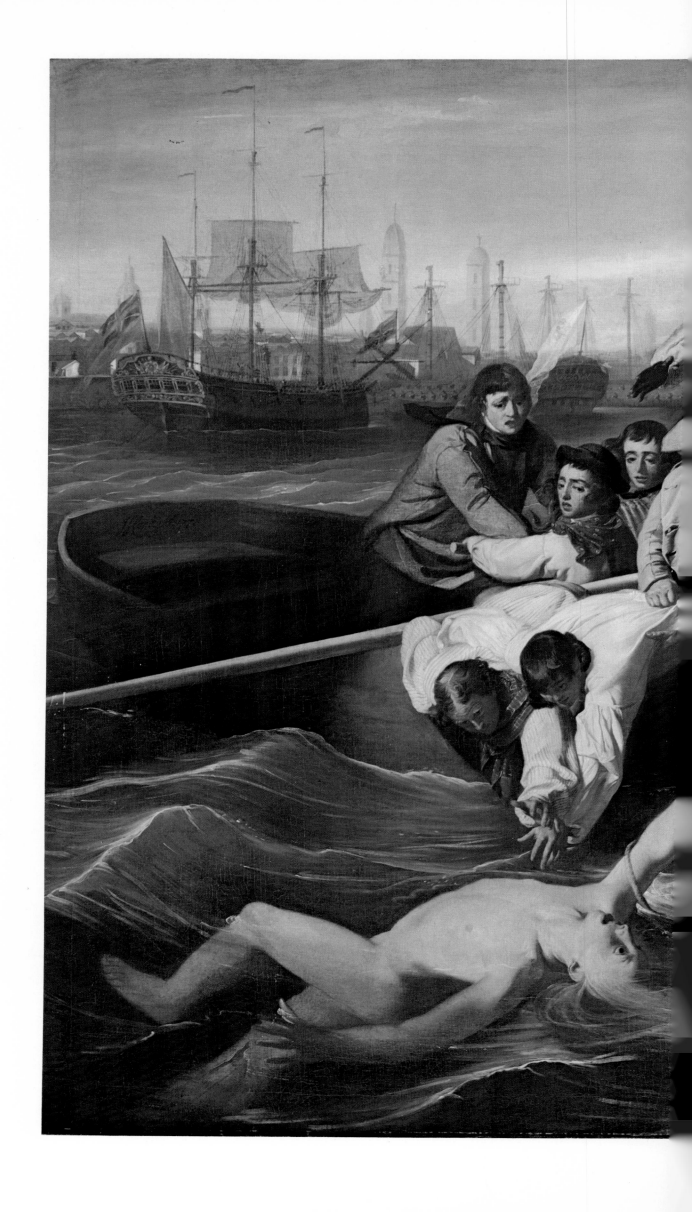

JOHN SINGLETON COPLEY

WATSON AND THE SHARK, *1778,*
John Singleton Copley (1738-1815).
72 x 90¼ in., oil. Courtesy,
Museum of Fine Arts, Boston,
gift of Mrs. George von Lengerke Meyer.
(Backleaf, see pages 20-21.)

Sir Brook Watson, Lord Mayor of London, *1796,*
John Singleton Copley. 50 x 40 in., oil.
Indianapolis Museum of Art, James E. Roberts Fund.

Despite the achievement and popularity of his American portraits, Copley still longed for approbation from those artists and connoisseurs elsewhere who had a background in and appreciation for and from the masters. Benjamin West (pp. 23-27) encouraged him to come expand his skill in England where art was not considered slightly decadent. Copley delayed a long time with true Yankee concern for making a good living at home and competition elsewhere. An extraordinary incident finally convinced him to go. He was a pacifist and single handedly tried to stop the Revolution.

He tried to mediate between the East India Company merchants and the factions led by Samuel Adams and John Hancock in the historic 1773 decision over the tea monopoly imposed on the colonies by Britain — in fact, his own father-in-law, Richard Clarke, was one of the importers of the tea and a Tory. Copley almost succeeded in convincing the patriots that to refuse the tea and order the ships back to England would very possibly lead to civil war. The anger of the mobs, however, and the intransigence of the merchants overwhelmed his pacifism, and the famous Boston Tea Party occurred. After this he was mistreated by the mob who mistrusted his pacifistic beliefs. He then determined to make his living abroad in England and there to improve his art. In 1774 he left his wife and children behind, intending to send for them soon, and sailed for Europe, making the Grand Tour of Paris, Amsterdam, Brussels, Antwerp and Italy before settling in London.

On the trip over, Copley had met a man named Brook Watson. He had a wooden leg, and during the long voyage Copley learned how he had lost it to a shark in Havana Harbor. Copley's aversion to the sea, which, being from Boston, was with him from his youth, and this story whetted his imagination. He determined to tell it in paint. In

London, after he had assimilated from West and others the current academic theories of the grand style of historic painting depicting heroic action, he tackled it and the results are exciting. *Watson and the Shark* is executed in the grand manner, but the story has an unfamiliar dash about it. This kind of contemporary subject matter, factual and specific, was nonacademic, and thus the picture had a startling effect on all who saw it. It still does. Copley's near-photographic realism focuses on the horror and excitement of the event to leave an indelible impression on anyone who has seen the painting.

Much has been written about the dissolution of Copley's talent once he arrived in England. He was still a great painter, but the sitters were a different breed of men. There is still great power in his English portraits, but we miss the seriousness and vigor of the aspiring American faces. Being an honest man he could not very well have superimposed the American attitude on the British. What the critics of his last period are saying is that he could have been a greater painter had he not sought greatness by gravitating toward seeming opportunities for increase in knowledge and skill when he already had them. He had in mind only one thing — great art. His tendency was to inhabit the world of art rather than the world of history. He was a citizen of art, not a citizen of his era. Still, without a question, his American period is his greatest, perhaps because that is where he found himself — not other artists. Art historian James T. Flexner acutely perceived the essential point about the American Copley and his sitters when he stated, "Here is the human race, habitat America 1753-1774. The vision is so intense that despite solecisms in technique which any graduate of a modern art school would despise, we see before us the truth that is beauty."

THE BATTLE OF LA HOGUE, *1778,*
Benjamin West (1738-1820). 60⅛ x 84⅜ in., oil.
National Gallery of Art, Washington, D. C.
(Overleaf, see pages 24-25.)

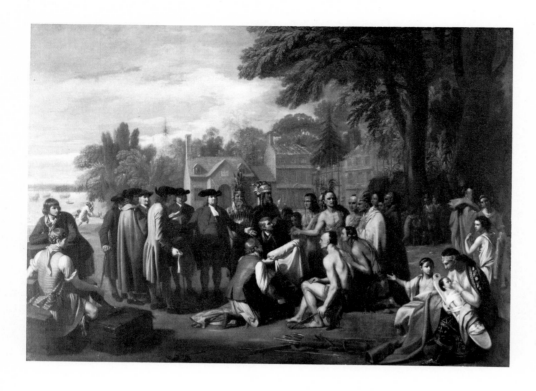

Penn's Treaty with the Indians, *1771,*
Benjamin West. 75-½ x 108-3/4 in., oil.
Courtesy, Pennsylvania Academy
of the Fine Arts,
Joseph and Sarah Harrison Collection.

Benjamin West left America in 1759 at the age of twenty-one to study art in Italy. Although he had had little or no art training during his early years in the Quaker town of Springfield, Pennsylvania, whatever he lacked, he was a born artist. An early contact with the itinerant portraitist William Williams, who gave him several books on academic theories of art, and knowledge of the paintings of Robert Feke (p. 10) gave West the impetus he needed to set himself up, at the age of eighteen, as a Philadelphia portrait painter. He met with little success and two years later moved to New York where he found a patron who financed his trip to Italy. There he studied the masters but took special pride in his American inclination to draw from nature, without which, he wrote, "I should have known nothing but the recipes of the masters."

When West finally established himself in London in 1763, he was apparently so well equipped that it took him only a few years to become one of the front rank of British artists. By 1772 he was so famous that George III appointed him his historical painter, a post he held until the King was officially declared insane in 1811.

West preferred historical painting to portraits or landscapes and he was eminently suited to it. He loved history and went to great lengths to tell it accurately with careful attention to detail. In his famous *Penn's Treaty with the Indians* he borrowed on his own collection of Indian costumes and the knowledge gained from childhood contact with them to bring to Europe the first picture of the true American scene. He never lost his respect for America and, even under the patronage of George III, did not hide his sympathy for the colonial cause. Whimsically enough, the King considered this proof of the painter's sincerity and defended him against Loyalist refugees who tried to undermine the deep friendship between the painter and the monarch. In the Penn painting he flouted his beliefs by explaining that the theme was the conquest of a native people without force or destruction.

West was one of the very first anywhere to paint historical scenes in contemporary costume. Before this mode had been to cast the heroes of even the most immediate past into the Roman or Greek period. *The Battle of La Hogue* would have been rendered as a Roman story even though it took place in 1692. Instead, West studied the period thoroughly and went to great pains to give it every chance of credibility. An admiral of the British Navy helped him by staging a mock battle off Spithead, England, so that the painter might observe ships in action and the effects of canon fire firsthand. It shows us the decisive battle in the effort to restore James II to the English throne. Louis XIV had massed a fleet manned by Irish and French to help the Catholic convert James cross the channel. West captured the final moments of the battle when the British fleet destroyed the French invasion attempt. It has been considered one of the greatest historical paintings ever done and its influence on all historical painting since has been incalculable.

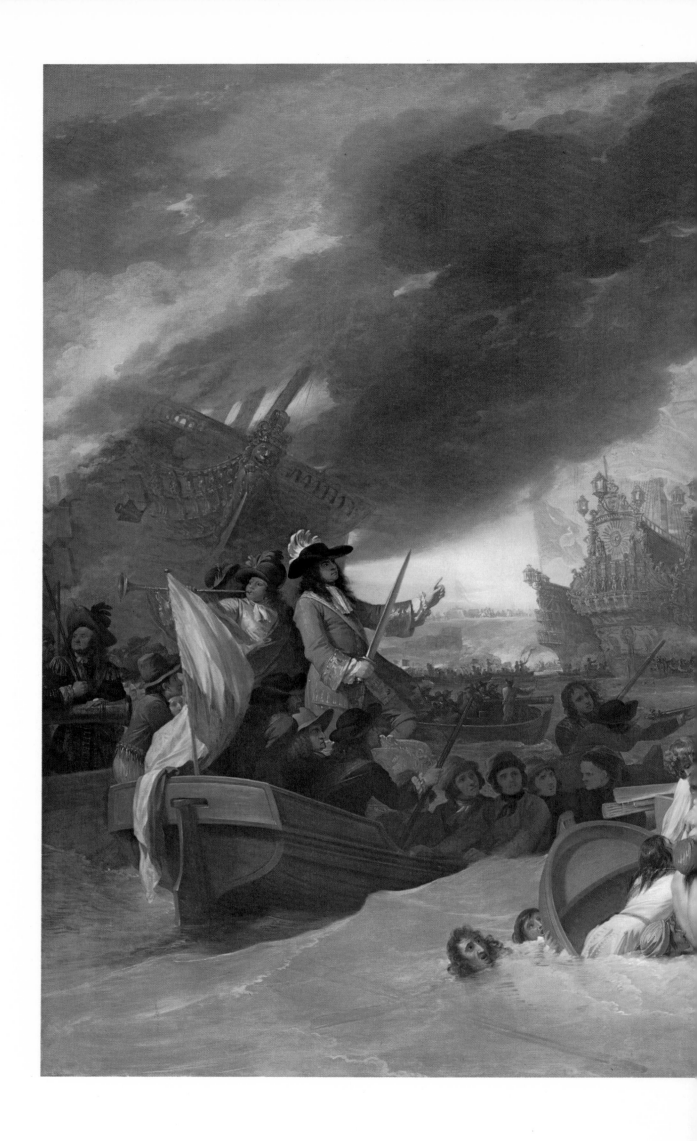

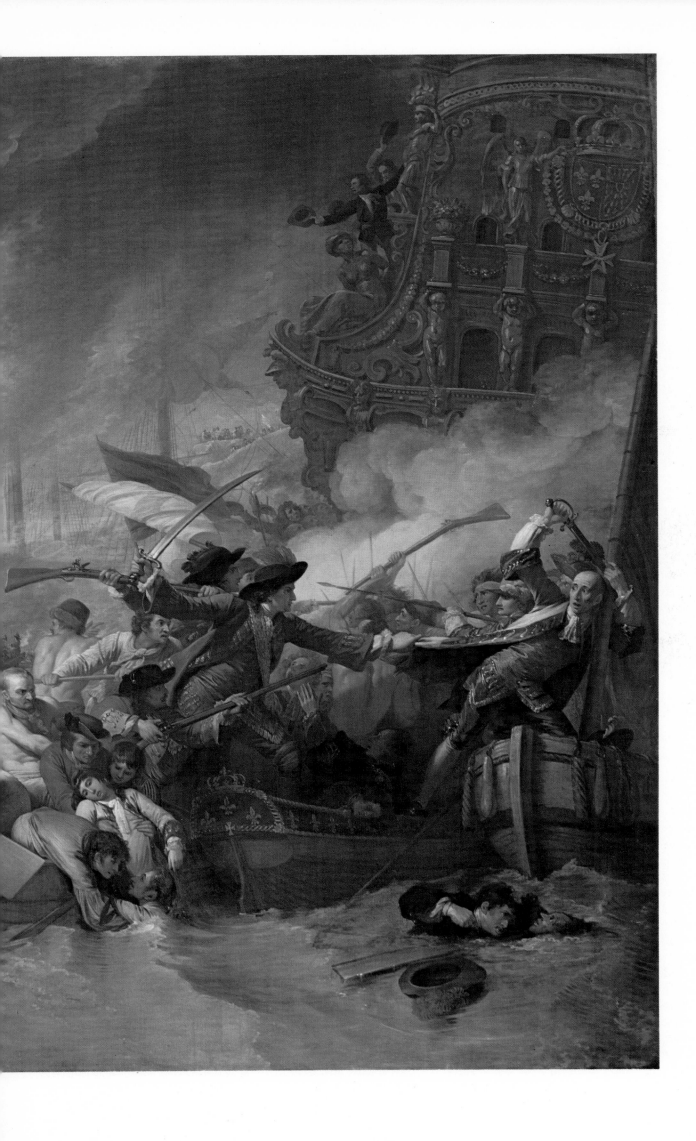

BENJAMIN WEST

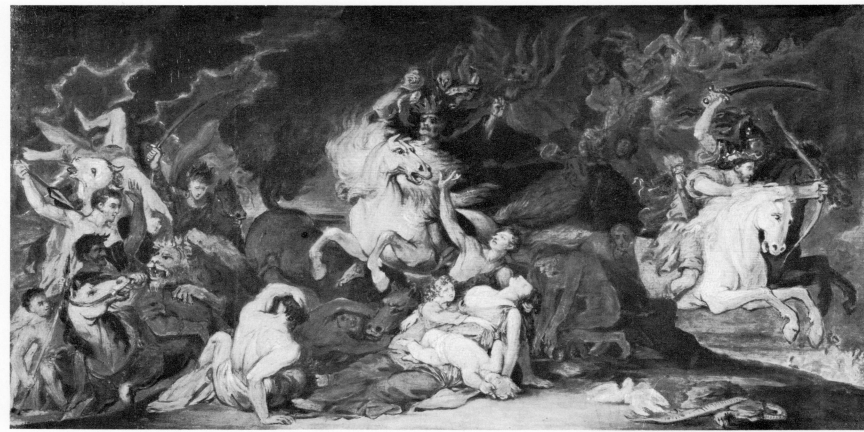

Death on the Pale Horse, No. 1, *ca. 1787,*
Benjamin West. 21 x 36 in., oil.
Philadelphia Museum of Art.

Benjamin West's place in American art could rest on one fact alone: He was the first American to gain an international reputation. But his contribution to our artistic reputation went far beyond that. Although he was a founder of the English Royal Academy of Art and one of its early presidents and was a court painter who associated with the great literati of England — Samuel Johnson, Oliver Goldsmith and Edmund Burke — he retained his identity with his native land in many ways. His wife said that his love of art had precluded all other education, and he remained a simple colonial, never acquiring even a veneer of sophistication in that most sophisticated society in which he moved. But more than that, West used his English fame to make his home and studio a mecca for all the young Americans who, like himself, went to Europe to find their talent. Many of our greatest early painters owe their start to Benjamin West. Charles Willson Peale (pp. 33-39), John Singleton Copley (pp. 16-22), Gilbert Stuart (p. 28), Thomas Sully (p. 56), Rembrandt Peale, Samuel F. B. Morse (p. 68), Washington Allston (p. 54) and John

Trumbull (p. 30) — an impressive list, and all of them were West's pupils. The warmth of his personality and the soundness of his teaching spread over these young men like a security blanket and gave American art one of its brightest periods of accomplishment.

His own long career was divided into three periods besides the brief one of learning at home. The first twenty years of his English career have been called the style of the "stately mode." It harks back to the rediscovery of the antique. The figures have the sedate grandeur found in classic sculpture, and the action in pictures of this time is reserved, lacking in emotion, much in the way Nicholas Poussin (1594-1665) made mythology and history seem inevitably placid. The second style, beginning in the mid-1780's, takes on a greater emotional excitement, if not depth, and is almost baroque in its use of windblown drapery. The conceit of eighteenth-century Europe was for the "terrible sublime," and West's involvement in this made up what was called his "dread manner." The third and last expression of his art is called the "pathetic style"

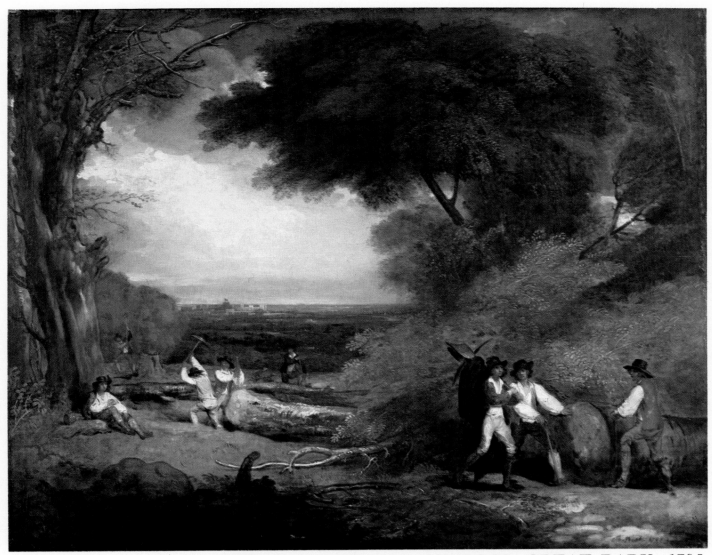

WOODCUTTERS IN WINDSOR GREAT PARK, *1795,*
Benjamin West (1738-1820). 28 x 36 in., oil.
Indianapolis Museum of Art, gift of Mrs. Nicholas H. Noyes.

and was executed during the growth of romanticism in the
early nineteenth century. Here the characters in his story
paintings really show emotional involvement. They no long-
er contain themselves in the pride of their stiff upper lip.
They let us, the spectators, become involved in their trials,
their grief, their humanity.

During the last period when he was allowing his histor-
ical characters to reveal something of their own feelings,
West also gave way to a more human approach to his own
feelings about the simple life. Painted when he was fifty-
seven and still the King's friend and favorite, this land-
scape, *Woodcutters in Windsor Great Park*, shows us his
deep interest in nature and the effects of light in the land-
scape. He does not idealize the scene as you might expect
of a Neoclassicist, nor are the figures exaggerated in their
exertion or rest. It is a pastoral picture in the best sense,
poetic but real. It makes us believe that this artist, who
was capable of imagining the most heroic exploits of great
men, never lost his ability to see men, in whatever activity,
as all of one stripe, human.

GILBERT STUART

One of the great monuments of American art is the work and life of Gilbert Stuart. If he had done nothing else but his great series of portraits of George Washington, he would have been considered the high priest of portraiture. But Stuart's place is secure for other reasons, for he was a very talented and technically daring artist and one who shared his good fortune with others at a time when American artists were not as fortunate as they are now. He was a truly democratic man unimpressed by wealth or position and deeply concerned with the individual character of each person.

Stuart put in his apprenticeship in Europe, especially in the famous studio of his countryman, Benjamin West (pp. 23-27). The two men had much in common, above anything else their loyalty to the land of their birth. Both were born in the United States, but West's success was almost entirely achieved in England, while Stuart had to return home to fully develop his art and to earn any fame at all. He could not have made a wiser decision, for here he found the men and women of character he was so admirably suited to portray. There was just enough of the high European style in his work to please the more sophisticated, and his boast that he "never followed any master but nature herself" was realized for all others in the brilliantly observed portraits that were true to the nature of the sitter with little or no attempt at flattery. James T. Flexner in his book *The Light of Distant Skies* writes that, "The word beauty was not in his vocabulary. He was a practical man creating objects as closely allied to social needs as were medieval cathedrals."

Stuart's technique was different from other painters of his day in that it had greater freedom. He did not go along with West's insistence on draftmanship, but rather he approached the canvas directly with brush and color. He said, "Drawing outlines without the brush is like a man learning the notes without a fiddle." He taught his pupils an almost Pointillist technique of laying dots of color side by side. "Load your pictures with color, but keep your colors as separate as you can." This new approach is responsible for the freshness of his paintings which have stood time's test since the colors were not muddied to begin with. He was a strongly opinionated man on artistic matters of proper subject and style, but however much his contemporaries might disagree with him on various aspects of his art credo, they never questioned his position as the greatest portraitist of his time.

He followed John Singleton Copley (pp. 16-22) in this estimation. Copley had left his brilliant American career to live and work in England. There he too came under the influence of Benjamin West and turned to historical subjects on a grand scale. We today may prefer Copley's severely magnificent and monumental American portraits, not only to his own English period, but to his follower in favor, Stuart's. However, as the country prospered, perhaps some of that sternness we see in Copley's faces was softening with the good life. It was not a weakening of the American character but simply a relaxation from its tough beginnings. Whereas Copley's sitters were the men whose fortunes had been forged from a granite land and the

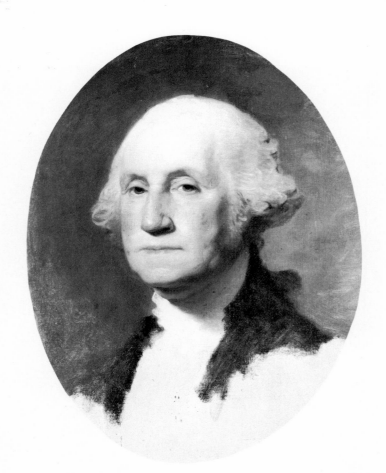

Athenaeum Portrait of George Washington, *1796,*
Gilbert Stuart. 48 x 37 in., oil.
Courtesy, Museum of Fine Arts, Boston,
deposited by the Boston Athenaeum.

women who had stood beside them, Stuart's men had completed the conquest of one part of the land and were looking to the rest of it, so vast and waiting to be farmed and mined to bring America to its greatest economic peak a century later. His women are as unlike Copley's as possible. As Flexner suggests, "He saw women not as mothers but as poised inhabitants of drawing rooms" — drawing rooms they could now afford.

Joseph Brant was the leader of the Iroquois forces in the warfare of the New York frontier and he has been called the most frequently portrayed Indian. Stuart did two portraits; George Catlin (pp. 74-77) copied them; and Charles Willson Peale (pp. 33-39), Ezra Ames (1768-1836) and the Englishman George Romney (1734-1802) all had a go at this fabulous figure. But Stuart's is the most satisfying. It is impossible to imagine anyone capturing more vividly the spirit of the noble savage than in the face and the pose of this portrait.

Stuart does not prettify his sitters as his successor Thomas Sully was apt to do. Sully might be said to have painted people wearing their best faces, while Stuart went above and beyond the call of duty to define their best character traits. Copley, on the other hand, paints the truth, complete and unvarnished and, to modern taste, much more compelling.

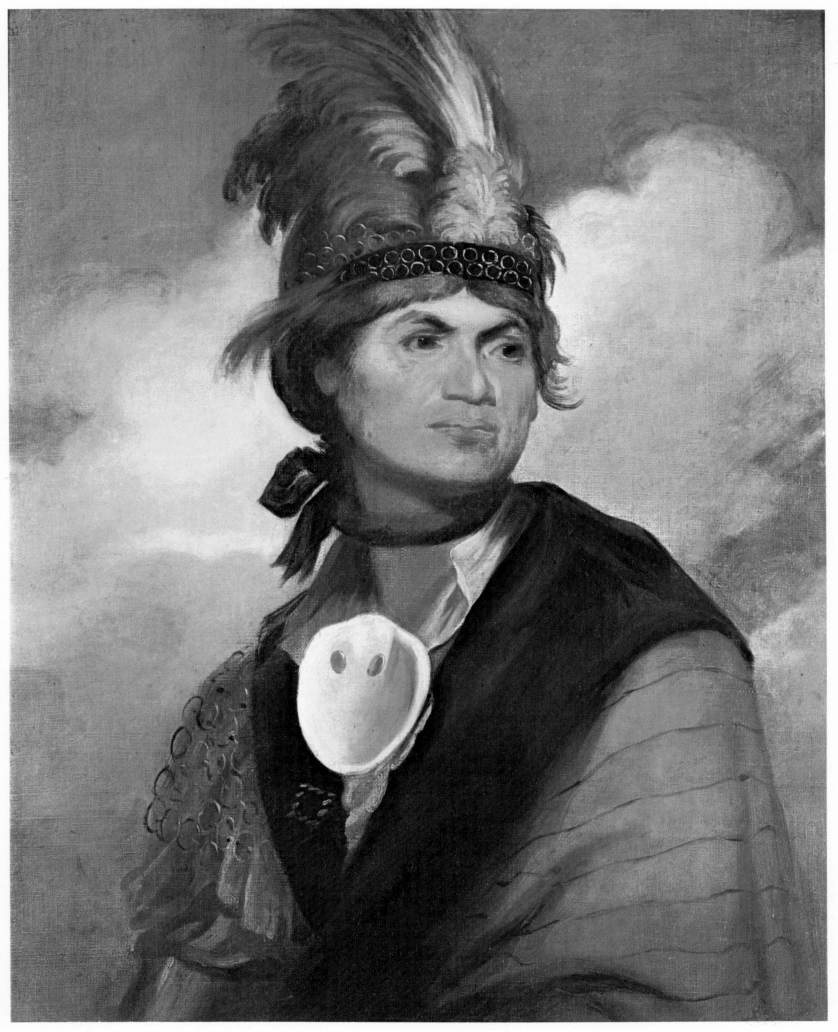

JOSEPH BRANT (THAYENDANEGEA), *1786,*
Gilbert Stuart (1755-1828). 29½ x 24¼ in., oil.
New York State Historical Association, Cooperstown.

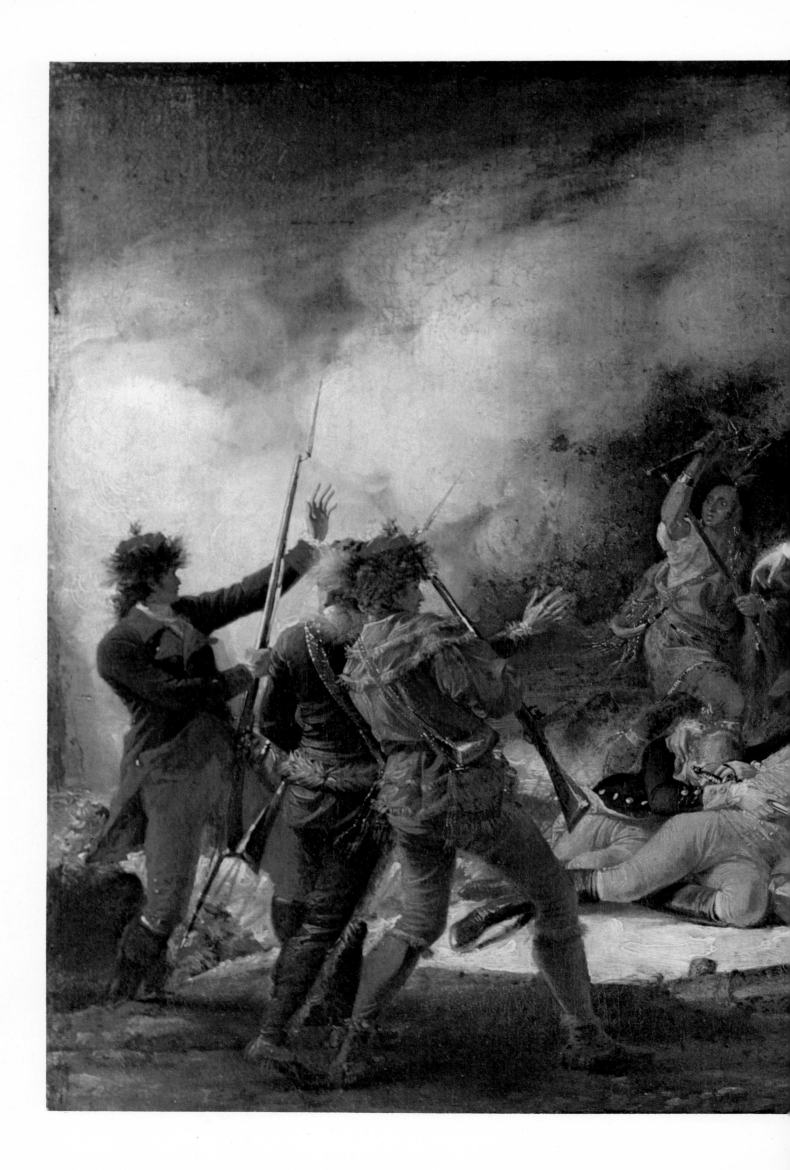

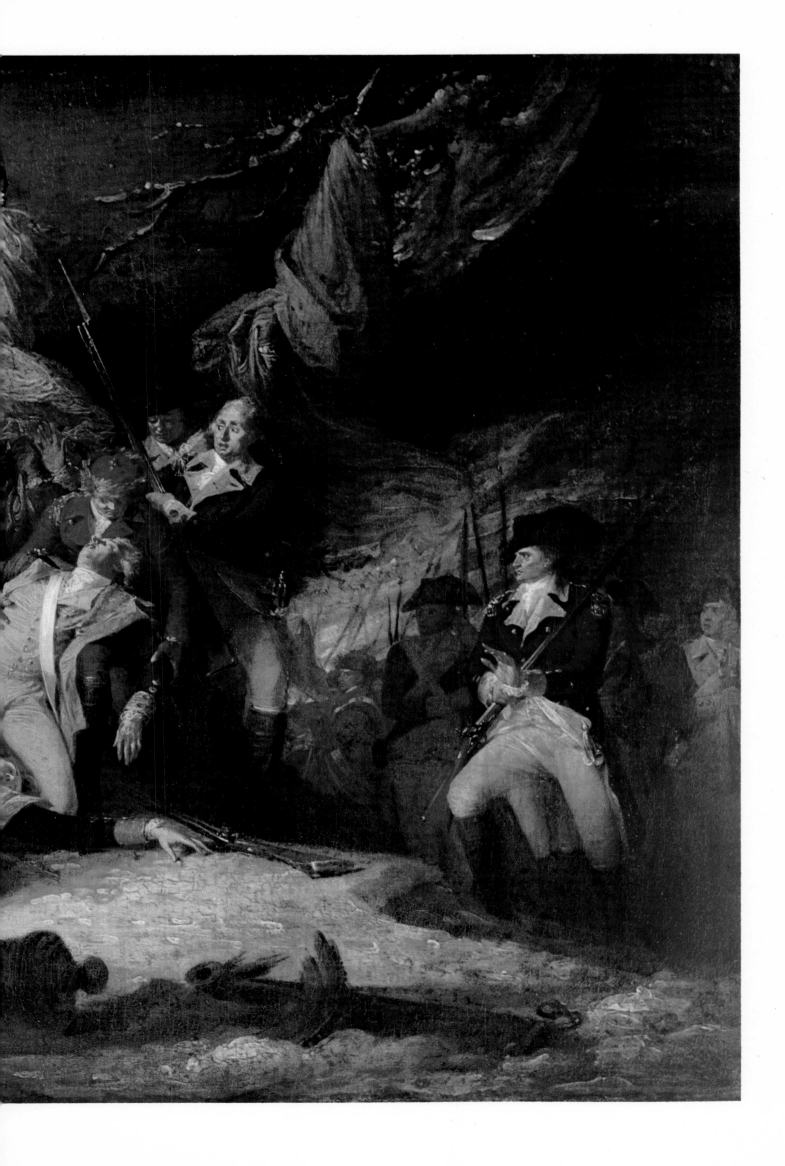

JOHN TRUMBULL

THE DEATH OF GENERAL MONTGOMERY IN THE ATTACK ON QUEBEC, DECEMBER 31, 1775, *1786,*

John Trumbull (1756-1843). 24¾ x 37 in., oil.
Yale University Art Gallery.
(Backleaf, see pages 30-31.)

In 1976 the United States celebrates two hundred years of political and economic liberty. It has been free to govern itself and has grown to become a great and powerful nation. Its humble past is belied by its impressive present, and yet many Americans feel now is the time to review the present with greater humility, for revolution is again in the air, this time the revolution of the human spirit. We look to that war of 1776 with awe at its purpose and promise and wonder how far we have strayed from them. We would do well to cast our thoughts back to the purpose of a young man whose father was governor of Connecticut and "strongly disapproved of the young man's decision to become a painter." Even in those days, in our aggressive young nation, the successful and powerful looked down on the arts as a medium, partially because it was a means of expressing the desire for freedom of the spirit, and it is a viewpoint that can still be found today in our country. John Trumbull, however, intended to have his freedom and he fought for it as he fought for the freedom of his country.

He graduated from Harvard in 1773 at the age of seventeen. As a student with a leaning toward the arts, he saw the work of the satirist William Hogarth (1697-1764), Giovanni Piranesi's (1720-1778) depiction of Imperial Rome, and especially the portraits of the American John Singleton Copley (pp. 16-22). His artistic ambitions were temporarily halted by the Revolution in which he served as a colonel and as aide-de-camp to General George Washington. He resigned his commission before the fighting ended and in 1780 went to London to study under the generous, hospitable American master Benjamin West (pp. 23-27).

Upon debarking in England, he was thrown into jail for eight months in reprisal for the Americans' hanging of Major André. After his release he came back to America only to return to London four years later to fulfill his ambition to work with West. Once established, he dedicated his life to painting the many scenes of the Revolutionary War. He was encouraged and even financed in this by none other than Thomas Jefferson. Trumbull was much influenced by the French artists Jacques Louis David (1748-1825) and Mme. Vigée-LeBrun (1755-1842), during a trip to Paris, but nothing could keep him from home. He returned to collect data for his Revolutionary picture stories, even learning firsthand the terrain of the great battlefields while studying and painting actively.

With this background one would think no one could have been better fitted to complete his ambitious undertaking, and indeed his early pictures helped to promote American nationalism, and even today we know them well through the numerous schoolbook reproductions. Like West, he filled his canvases with real people, people he had seen in action, the Indian, the frontiersman, the common soldier and heroic leaders, but misfortune plagued this eyewitness to a great moment in history.

Young America did not want and could not support great historical paintings. Trumbull's ability to translate his ideas to grandiose scale seemed to grow less with the years, and his commission in 1816 to do murals for the Rotunda of the Capitol ended, not quite a disaster, but disappointingly. One of his biographers, Matthew Baigell, says, "Perhaps Trumbull suffered for his failure more than others since he had tried to confront the problem directly." But Theodore Sizer wrote of him, "Trumbull was a faithful recorder of men and events at the birth of this nation; and therein lies his importance."

Later in life Trumbull's sight became impaired, and Sizer adds, "The tragedy of the one-eyed soldier-turned-painter was that most of his good work was produced before he was forty and he lived to be eighty-five. His last decades were spent less spectacularly painting religious and literary subjects, landscapes and portraits of the Founding Fathers, many of which are in Yale University's collection. He also ventured into architecture, designing the Lebanon, Connecticut, Meetinghouse, a promising example of what he might have done well had he continued in the profession.

The early versions of the painting, *The Death of General Montgomery in the Attack on Quebec*, of which ours is one, were produced when he was thirty-five. It is a masterpiece and not in any sense a dry historical painting. The treatment of the atmosphere of battle is almost Impressionistic. The figures have great movement, and the emotional impact is created by all the elements that go into a great historical painting: skill, honesty and, in this case, firsthand knowledge of the story material, the very important people who made history. His vision of the battle — and the entire war — has become the nation's.

CHARLES WILLSON PEALE

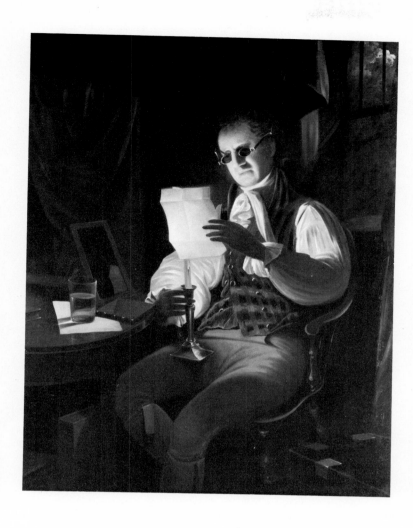

EXHUMING THE FIRST AMERICAN MASTODON, *1806-1808,*
Charles Willson Peale (1741-1827).
The Peale Museum, 50 x 62½ in., oil.
Baltimore, gift of Mrs. Harry White.
(Overleaf, see pages 34-35.)

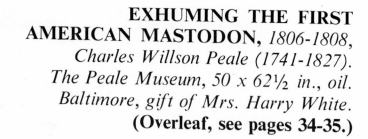

Candlelight Self-Portrait, *ca. 1815,*
Rembrandt Peale (1778-1860). 55 x 45 in., oil.
The Detroit Institute of Arts, gift of the Founders Society,
the Directors Fund. One of Charles's sons, Rembrandt
painted portraits, miniatures and historical works.

Charles Willson Peale was truly a man of his age, the age of reason and the age that first engendered wholly American talents in art and science. Like his contemporaries Thomas Jefferson and Benjamin Franklin, there was little in the realms of natural history, scientific invention and practical crafts to which he did not turn his talented hand. Peale was the epitome of what we proudly call the ingenious American craftsman-artist. In his eighty-six years he was an artist, inventor, saddler, scientist, soldier, writer, naturalist, museum proprietor, and father of an incredibly prolific family (on all counts) of artists.

Exhuming the First American Mastodon narrates an episode from the artist's pursuits as naturalist. As a work of art it is also a great family portrait (at least twenty relatives are included) and a combination of very American styles and subjects for painting: History, genre, landscape and figure painting are all included here. The event is the historic dig in 1801 for the first mastodon fossils in America. Here we see the workers, the equipment for which Thomas Jefferson partly paid, and Peale himself directing the whole operation from a huge sketch.

Upon completion of the excavation, Thomas Jefferson wrote to Peale, "I have to congratulate you on the prospect. . .of obtaining a complete skeleton of the great incognitum, and the world on there being a person at the critical moment of the discovery who has zeal enough to devote himself to the recovery of these great animal monuments."

The painting, hung by Peale in the "mastodon room" of his Philadelphia museum (the nation's first natural history museum, opened in 1786) where the skeleton was displayed, is also a tribute to his family. This family memorial is crowded with portraits, although only the artist, his son Rembrandt and the landowner were present at the actual excavation. By the left diagonal pole is Betsy D. Peale,

second wife of the artist, with their son, Titian II; James Peale (1749-1831), Charles's brother and painter in his own right, stands between two poles in a theatrical stance; young Linnaeus and Franklin (sons) hold a floating cylinder in place. Behind the drawing on the right are Hannah M. Peale, third wife of Charles, and possibly Mrs. Rembrandt Peale, Rembrandt, Rubens (sons), Sybilla and Elizabeth (daughters), Mrs. Raphaelle Peale, Raphaelle (son) and Sophonisba (daughter) and Coleman Sellers under the umbrella.

It is impossible here to list all the family or their achievements, but Charles was one of three artist brothers: Charles Willson, St. George and James. James in turn had five artists in his family, Maria, James, Anna Claypoole, Margaretta Angelica and Sarah Miriam. One of them, James, married the daughter of Raphaelle, and they had two artist children and another who raised an artist daughter, Mary Jane Simes. Four generations, right here, and one could go on and on tracing each artist and his children. James Peale and Charles Willson together had twelve children and seven artist grandchildren.

When the Peales were not painting distinguished patrons, they painted each other, and several group portraits remain. Of these, Charles's *The Peale Family Group*, done before the family was very large, shows the comfortable household of St. George, James, Charles, Rachel (first wife), Mother Peale, several children, in-laws, a servant and dog, Argus.

Self-portraits were another venture in virtuosity. The self-portraits by Charles are numerous and fine, some of the most delightful pictures in his museum. His favorite pupil son, Rembrandt (1778-1860), painted a handsome likeness of himself, particularly in *Candlelight Self-Portrait.* Titian Ramsey Peale II (1799-1885) was another self-portraitist and also the scientific illustrator of the family. Anna Claypoole Peale (1791-1878), James's daughter, was Rembrandt's pupil, turned out a very accomplished portrait of her handsome self and frequently exhibited miniatures and still lifes. Sarah Miriam Peale (1800-1885), another of James's daughters, is claimed to have been the first professional woman painter in America.

And this listing is only bare introduction to the amazing Peales.

34

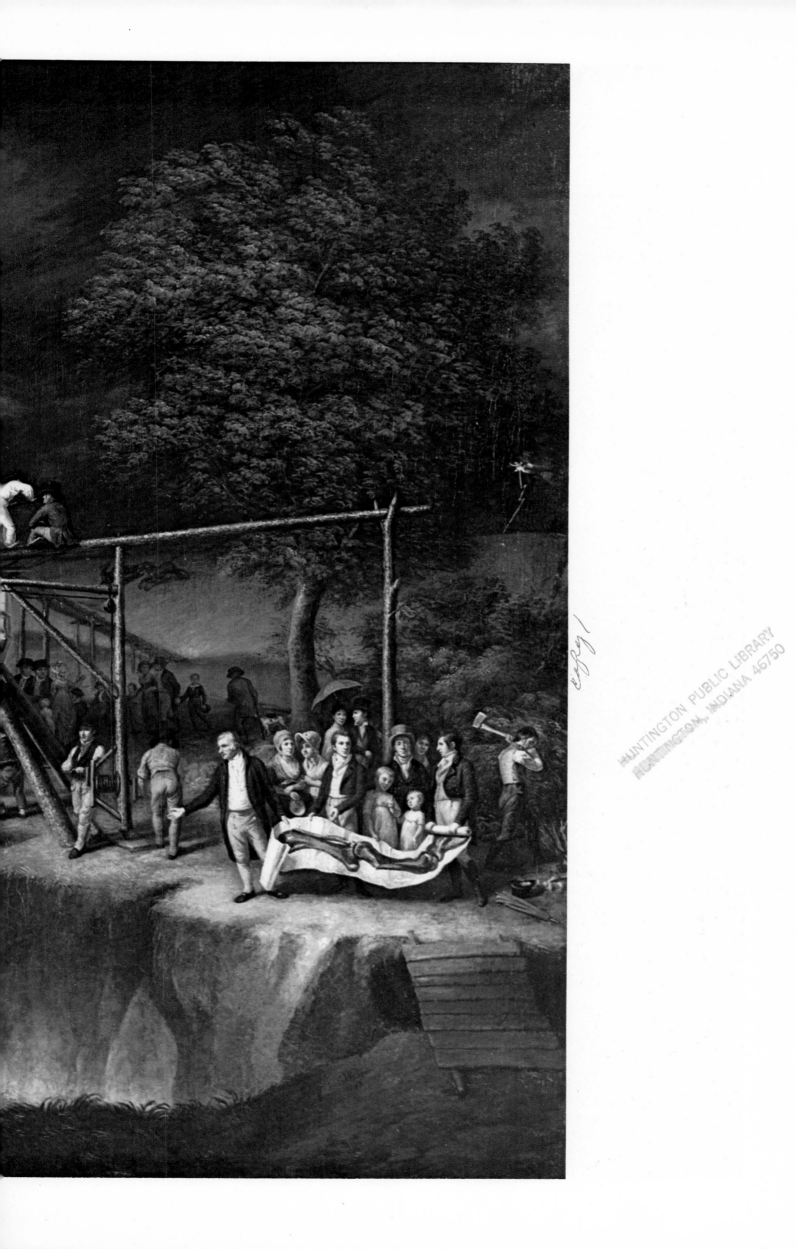

CHARLES WILLSON PEALE

The Lamplight Portrait of James Peale,
the Miniature Painter, *1822,*
Charles Willson Peale. 24-½ x 36 in., oil.
Detroit Institute of Arts.

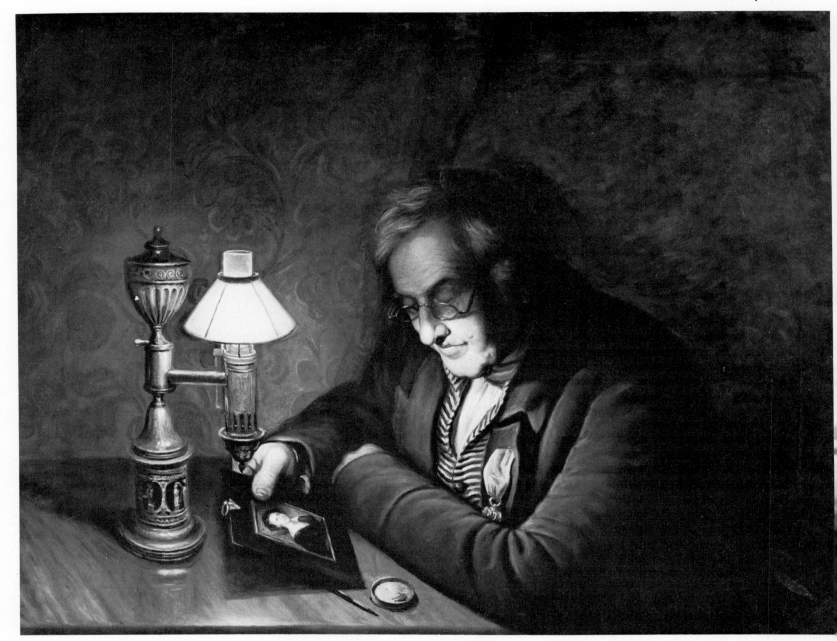

Charles Willson Peale II lived at a time of great men. The American Revolution was part of his life and he believed in it with his whole heart. While a student with Benjamin West (pp. 23-27) in London, he had refused to doff his hat when the King rode by. He did not subscribe to the English theory that "genius for the fine arts is a particular gift and not an acquirement; that poets, painters are born such." He believed in hard work and he taught himself all he knew, gladly coming back home from West's studio.

Peale did not worry that the social status of the artist was hardly a desirable one, nor did he concern himself that his sitters had to be of the highest social group. He did, however, want to memorialize the American heroes, and his sitters include not only his friend Jefferson but John Quincy Adams, Henry Clay, Benjamin Franklin, Robert Fulton, John Paul Jones, Marquis de Lafayette, Meriwether Lewis and, of course, George and Martha Washington. The collection became the basis of his famous Gallery of Distinguished Personages, a main attraction in his mu-

seum in Philadelphia. George Washington sat for him seven times, more than for any other artist, and at one time let Rembrandt, one of Peale's sons, sit in on the session. Gilbert Stuart (p. 28) was quoted as saying he "was in danger of being Pealed all around."

Many of Peale's sitters were not the obvious great men but people who interested him for any reason, especially his family. One of his most famous portraits is the affectionate *Lamplight Portrait* of his younger brother James, the miniaturist. Another is of an old Mohammedan who lived in Georgetown named Mamout Yarrow. Still a third is his rendition of Captain Joseph Brant, or Thayendanegea, Chief of the Mohawks. It is fascinating to compare with the flamboyant version by Gilbert Stuart (p.28).

My favorite is the splendid and impressive *Staircase Group* which was shown at the Columbianum Exhibition in 1795. This was the first artists' exhibition held in America, and it displayed the paintings of Peale in all their virtuosity. *Staircase Group* was the *pièce de resistance,* for

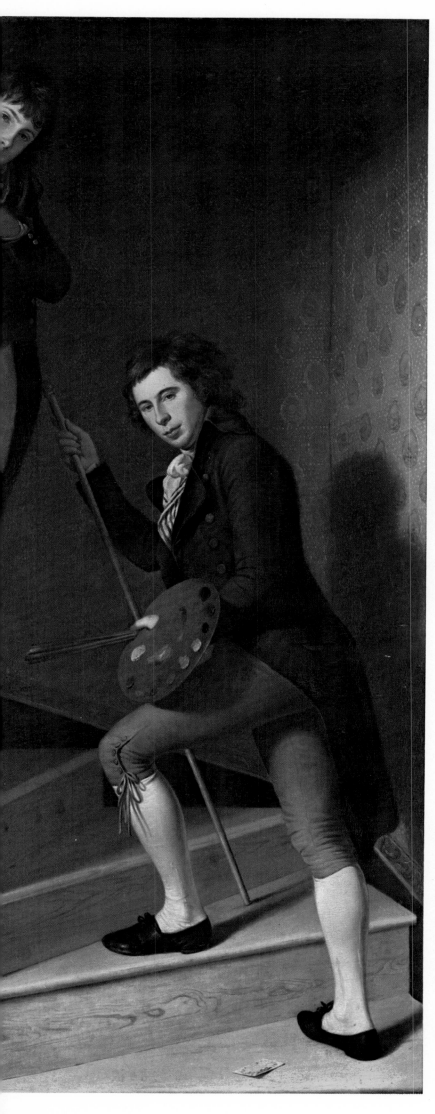

STAIRCASE GROUP, *1795,*
Charles Willson Peale (1741-1827).
89 x 39½ in., oil.
Philadelphia Museum of Art,
George W. Elkins Collection.

it was framed in an actual doorway with wooden steps projecting out below the picture. It was one of the first great examples of *trompe l'oeil* which American art lovers have admired ever since. Peale called his work a "deception" and his son Raphaelle (p. 62) carried on the tradition to its highest degree. The heartwarming fact that George Washington was deceived by this painting and in the dim light bowed sedately to the young men on the stairway must have pleased Peale, who was a man who greatly delighted in the whole human experience, especially the theatrical and lighter side of it.

The models are his artist sons, from top to bottom, Titian Ramsey Peale (the elder, who died shortly thereafter) and Raphaelle Peale (1774-1825), who worked with his father on it. We are fortunate to have this wonderful if tricky picture, for it was Peale's habit to destroy his work after it had served his purpose in his museum. This is one of few "deceptions" which survived.

CHARLES WILLSON PEALE

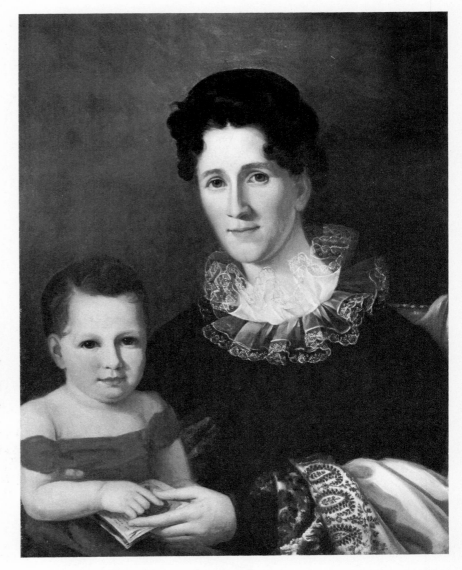

Mrs. Rubens Peale and Son, *1823,*
Sarah Miriam Peale (1800-1885). 30 x 24 in., oil.
The Peale Museum Collection, Baltimore.
Sarah Peale, niece of Charles Willson, set up her
studio in the 1820's and is often considered the first
professional woman artist in the United States.

Charles Willson Peale was not only the father of an enormous family, seventeen in all, many of whom were artists, but he himself can be said to be a true son of the arts. This extraordinary man could and did turn his hand to anything. He was our first natural historian; he developed many of our modern museum techniques; he initiated in America so many aspects of the arts that not only his fellow artists but the general public owe him an everlasting debt. Samuel F. B. Morse (p. 68) has been called the American Leonardo because he was an artist who invented the telegraph, but we have produced only one artist whose curious mind could match the Italian's — Charles Willson Peale. He wrote of himself, "Peale's active mind kept his hands constantly employed," and even here he was underrating himself. And yet he was a man of such sincere humility he never got over the feeling that he was unworthy of such a high calling as the arts.

Peale's Americanism was as deep-rooted as his dear friend Thomas Jefferson's. They had much in common, these two giants, from their interest in the humblest workings of life to the highest dreams for their fellowman. Both were modern men far in advance of their time and yet so necessary to it that, without them, it would not be of such great interest and inspiration to us today. Peale saw no conflict in his varied interests in art, in science, politics and religion. "As this is an age of discovery," he wrote, "every experiment that brings to light the properties of any natural substances helps to expand the mind, and make man better, more virtuous and liberal. And what is of infinite importance in our country, creates a fondness for finding the treasures contained in the bowels of the earth, that might otherwise be lost." With Benjamin Franklin and Jefferson he was one of the great believers in natural law.

Like Leonardo, the whole man is really of greater interest than any one of his special skills, but Peale was a fine painter, considering how poor an art background he had on which to build any greatness. His history is the exact opposite of John Singleton Copley's (pp. 16-22), who triumphed over that background to produce the first great American art expression and whose flight to foreign shores sadly saw the dissipation of it. Peale, too, went to Benjamin West's (pp. 23-27) London studio as a young man, but the grand manner so much desired by Copley was lost on Peale, and he had to come back to our invigorating, if struggling, art climate to breathe freely. In return, he breathed new life into it.

The Artist in His Museum is symbolic of the magnificence of the man himself. Here he portrays himself at eighty-one showing the world one of his proudest achievements. The major paraphernalia of his life are around him: his easel, on which he may have painted natural settings for objects; instruments of research; and his unbounded interests, the little people in the distance. Peale felt an enormous obligation to instruct and inspire the untutored American public. But what catches our eye and holds it is the heroic head of the man himself. What a beautiful face! What concern for us, the viewers, shines out of his eloquent eyes!

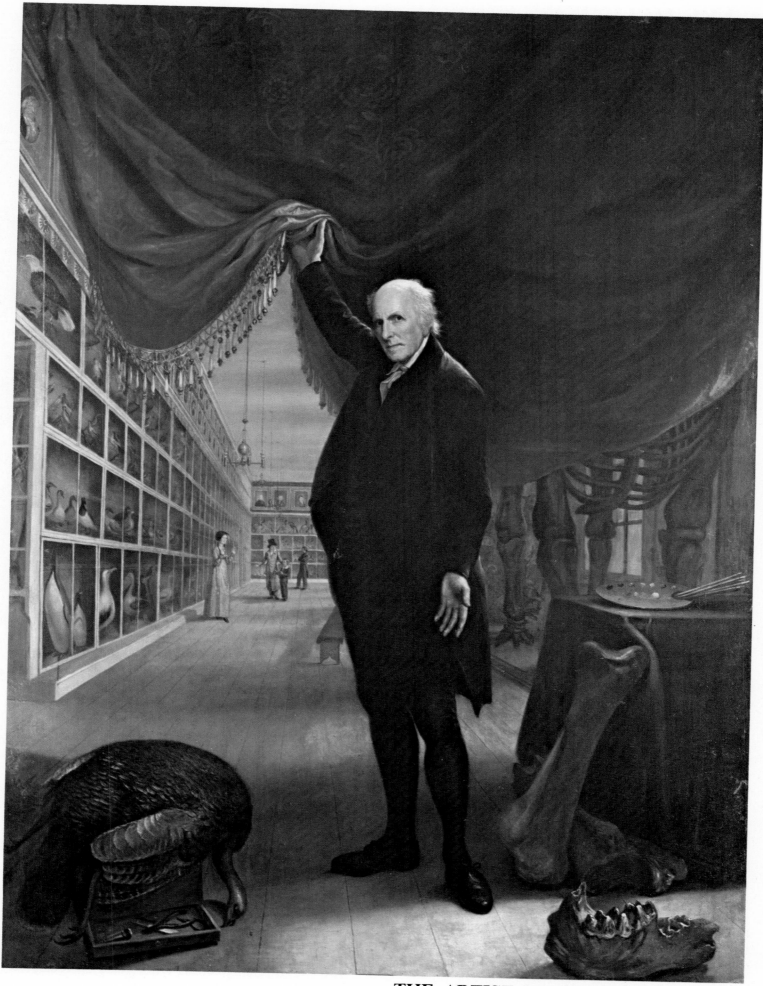

THE ARTIST IN HIS MUSEUM, *1822,*
Charles Willson Peale (1741-1827).
103½ x 80 in., oil. Courtesy,
Pennsylvania Academy of the Fine Arts,
Joseph and Sarah Harrison Collection.

RUFUS HATHAWAY

Reverend Ebenezer Devotion, ca. 1770,
Winthrop Chandler (1747-1790).
55 x 43-3/4 in., oil.
Brookline Historical Society,
Brookline, Massachusetts.
Connecticut-born Chandler's paintings
usually have a hard-lined realism
about them that was popular
in colonial portraits.

The portrait of Molly Whales Leonard, the *Lady With Her Pets*, by Dr. Rufus Hathaway, is a very personal introduction to the lady. The painting could even be considered Molly's personal totem, complete with the animal and vegetable images that express her interests and her "spirit." Thus, Molly's black cat, "Canter," with name inscribed alongside, sits quietly at his mistress's knee, in peace with the birds, one of whom, the parrot, also recalls the seafaring trade so important in Massachusetts when the portrait was painted in 1790. Besides the butterflies as decorative additions, the picture is enhanced by the feathers of other birds in Molly's hair and images of flowers in her bodice and on her fan. Such a painting sometimes would act, as a totem pole does, to signify in an heraldic fashion the nature of its owner.

We know very little about what Molly was really like. She seems to be in her thirties or forties. The complete self-assurance of her face is supported by the billowing curves of her bodice, her skirts and even of the Chippendale chair she sits on. She was probably related to Hathaway. Most of his sitters were, and his family name appears in the Leonard genealogies of Massachusetts.

Hathaway's career, such as it was, is a good example of the way a great deal of painting came into existence in the colonies and the early Republic. He was completely self-taught, as far as can be determined from records and from the work itself. The Chippendale chair, for instance, really only exists as the somewhat exaggerated corners of the back, which, for that matter, are not in the system of perspective that the sitter is. Likewise, the face, the hair, the bodice and the gown are all covered with deep cracks, a clear indication that the painter was less than expert in mixing the pigments for his lighter colors and in laying on one coat after another. Even the general style of the painting seems not so much primitive as archaic. It would seem to be from a time much earlier than 1790, when Hathaway was just over twenty. By this date, for example, John Singleton Copley (pp. 16-22) had completed most of his major works.

Neither his ignorance of the craft nor the difficulties between him and proper training prevented Hathaway from taking up the art and learning by doing. The earliest work from his hand is dated 1790. The year of Molly's portrait, Hathaway traveled to Duxbury, Massachusetts, where he met and married Judith Winsor. Her father, a merchant of that place, persuaded Hathaway to give up his artistic career for a more secure one in medicine. Hathaway studied with a doctor in Marshfield, the home of Molly's family, then became the only doctor in Duxbury, although continuing to paint an occasional portrait for friends and family members.

But as in all the best of our early, somewhat amateurish, portrait art, everything pales in comparison with Molly herself. What a glorious woman she is. One can picture her as a village "character," in a few years the dressy old lady we all know who lives for her pets and preserves the paraphernalia of her life in little glass cases. Everyone in town waits for the big occasion when she gets out and puts on all her finery. The other ladies laugh a little at the wig and the feathers, but Molly is still lovable and commands respect. It is not easy to make her laugh, but when she does, that set little mouth and those shoebutton eyes

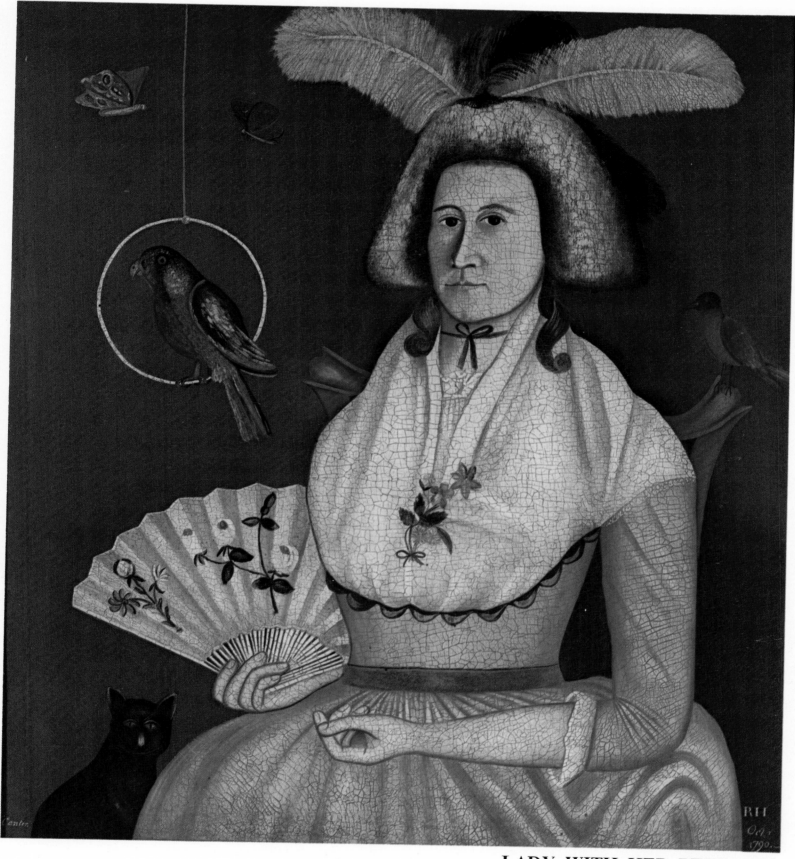

LADY WITH HER PETS, *1790,*
Rufus Hathaway, M.D. (1770-1822). 34½ x 32¼ in., oil.
The Metropolitan Museum of Art, New York,
gift of Edgar William and Bernice Chrysler Garbisch.

crinkle and sparkle. Then suddenly, she folds her fan, gathers her skirts around her and announces that "Canter," the cat, has to be fed.

Hathaway and Molly, the artist and the sitter, together represent one of the most attractive periods of American art, when talented Americans were determined to be artists in spite of the impossibility of adequate training and when an emerging gentry eagerly provided subjects for their half-formed skills. American art has never entirely lost the folk quality here so enchantingly exhibited. It existed before Hathaway and has continued down the years in the work of John Kane (p. 232) and Grandma Moses (1860-1961). It recalls our stern beginnings and a basic American honesty and sturdiness of character that is, we hope, imperishable.

M'KAY

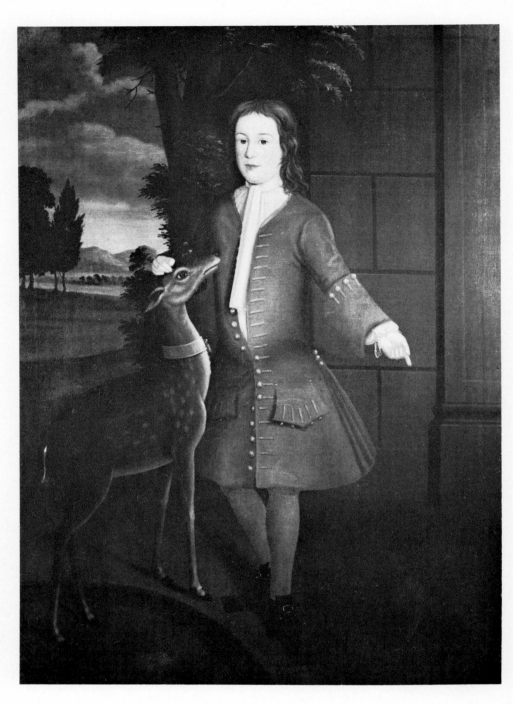

Portrait of John Van Cortlandt, *ca. 1731,
Artist Unknown. 57 x 41 in., oil.
Courtesy of the Brooklyn Museum.
Perhaps done by one of the so-called
Patroon Painters of the Hudson Valley
during the first third of the eighteenth
century, John Van Cortlandt anticipates
M'Kay's Hannah Bush in the pleasant
and straightforward assurance.*

Occasionally we can look at a painting with concern only for its personal appeal to us. Circumstances set us free from consideration of the artist's personality or even his other work. Obviously this can only happen rarely, as in the case of this charming picture, *Hannah Bush*, because we know little or nothing of Hannah or the artist who signed his name twice on her portrait. Two things are obvious: M'Kay was a singularly interesting artist, and Hannah, as he saw her, was a handsome person, and one who was not above decking her person in one sitting with a complete history of the costume of her period. M'Kay's achievement is that he could manage to document her complicated garb and at the same time tell us so much of the character of the lady. There is a whole biography written under that fantastic hat, that fulsome wig: the story of a lady who knew her own mind and would not let anyone forget it.

Modern research has changed her name from Abigail Adams Bush to Hannah. The vital records of Worcester, Massachusetts, reveal that Hannah was John Bush's second wife while Abigail was his third. Hannah died in 1807 at the age of thirty-nine. Our portrait was painted in 1791

when she was twenty-four, but unlike some of these elaborate naive painters, M'Kay manages not to make her look old beyond her years. In spite of the elaborate decor that upholsters every inch of her, she has a pretty young face, slightly amused, one feels, by her own importance. But the look in her dark eyes warns you that she alone is entitled to be amused.

We know John Bush was a successful broker and cattle salesman, not only from the family history and records, but from what his wife could afford to put on her head and bodice, including his miniature hung round her neck and anchored beneath her bosom. The fact he had three wives proves beyond doubt his prosperity, for one can imagine his third, Abigail, was not about to be outdone by Hannah, his second, who in turn had to outdo the first Mrs. Bush. Hannah Bush is the epitome of prospering America in the proud Federalist era.

About M'Kay we know very little, where he got his style or techniques; it does not matter who influenced him or if he left a legacy of talent to a pupil or a son. Artist and painting stand on their own as monuments to a little moment of time that would have been forgotten but for them.

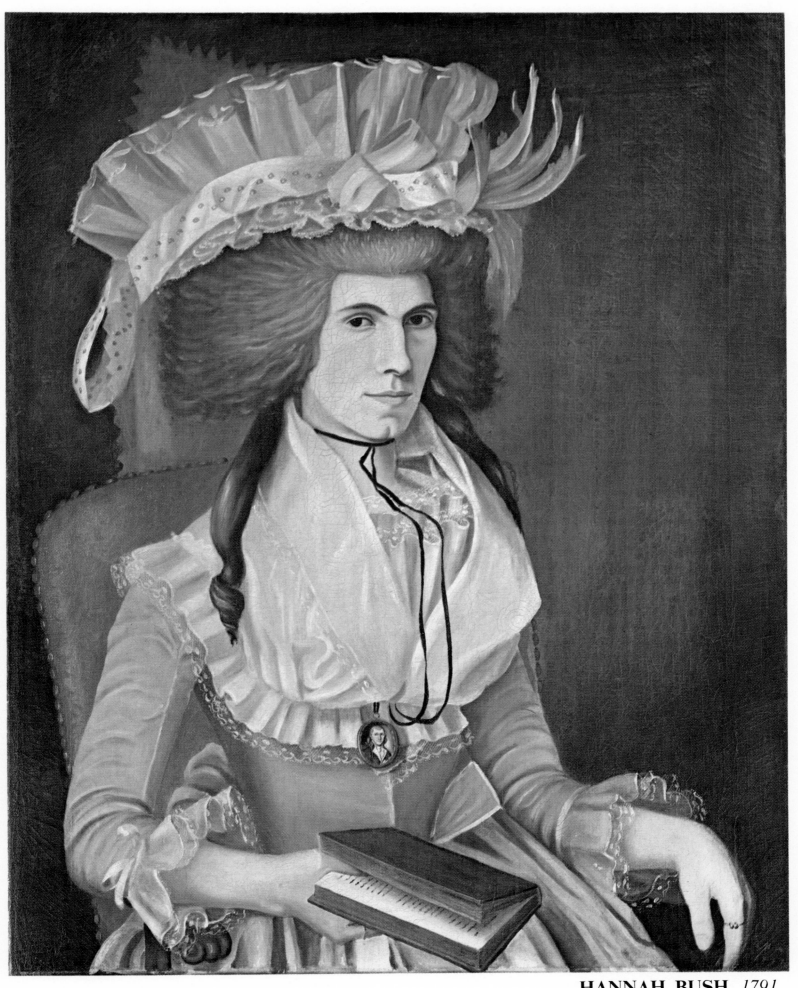

HANNAH BUSH, *1791,*
"M'Kay" (active 1788-1791). 36¼ x 29½ in., oil.
American Antiquarian Society, Worcester, Massachusetts.

RALPH EARL

If you want to understand why we succeeded as a nation, one of the best ways is to look at the portraits of Ralph Earl. The tough, determined faces of his sitters, the sparse luxuries with which they surrounded themselves and the no-nonsense attitudes they assumed for the painter make up an index of how to get started in a rough, new country.

Earl has been described by the historian and critic E. P. Richardson as, "Either the most notable of 'untrained professionals' or the most unskilled of the professional painters." The sketchy details we are able to piece together of his life would indicate an unstable character. It would account for the unevenness of his canvases, too, for he was a vagabond in life and love and habitat. He deserted two wives while married to both, quite understandably never lived long in one place, and drank himself to death.

A New Englander, Earl was forced to move to England in 1778 for seven years because of his Loyalist sympathies. The sojourn took some of the rough edges off his art, and upon his return he proved a more skilled and more productive artist, yet there remained a puritanical streak in all his work. His paintings are not mannered, perhaps because his unsavory character allowed him to paint only a few of those Americans who delighted in seeing themselves more elegant than they were. So thoroughly did Earl fit into the rural American art scene, even after the seven years in England, that for many years he was lumped by critics with primitive artists and, indeed, he deserved to be, except that when he was in complete control of himself and his art, there is a truth in the likenesses he painted that almost matches those of John Singleton Copley (pp. 16-22). James T. Flexner lists him along with Gilbert Stuart (p. 28) and John Trumbull (p. 30) as the colonial painters able to carry on Copley's tradition of greatness.

Chief Justice Oliver Ellsworth and His Wife, Abigail Wolcott is a charming painting and as close as Earl came to doing a fashionable portrait. But even this work is naively pedantic in style, if not primitive. He idealized or anglicized the plain interior with a lush drape at the window, carpets on the floor, an elegant rug, and book-lined walls. The Chief Justice and his lady are in their finery, but the firmly set mouths and the piercing eyes let us know that the real clue to their strength of character is what we see out the window — their home, the same one they are sitting in, set in a clearing. It is unadorned and they have not bothered to landscape; even the fence has been painted just enough to trim the entrance, and the rest of it is there to keep out the cows. Earl has made a very real picture of our forefathers as we like to think of them, down-to-earth and getting on with the business of creating a great democratic nation.

Roger Sherman, *ca. 1775-77,*
Ralph Earl. 64-5/8 x 49-5/8 in., oil.
Yale University Art Gallery,
gift of Roger Sherman White.

44

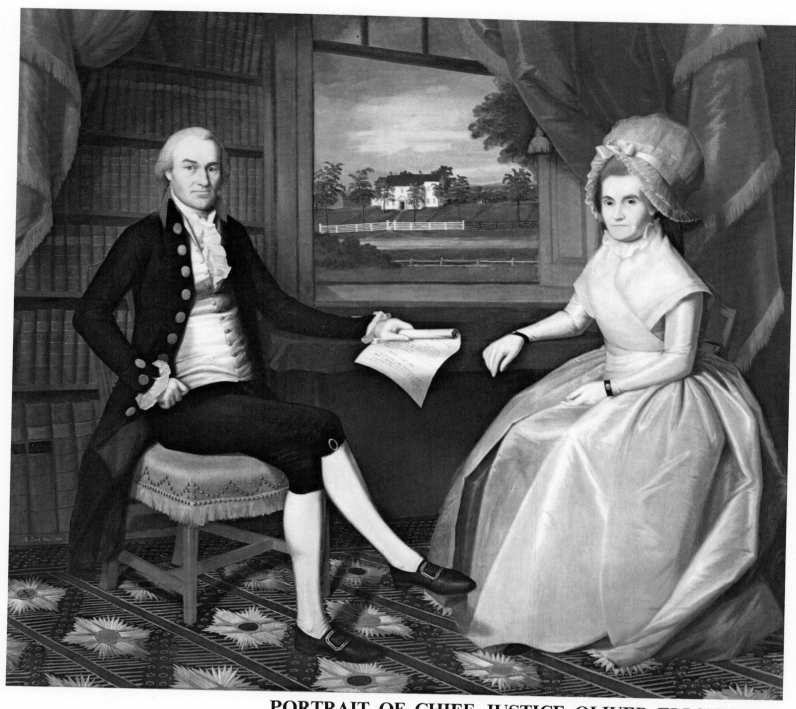

**PORTRAIT OF CHIEF JUSTICE OLIVER ELLSWORTH
AND HIS WIFE, ABIGAIL WOLCOTT,** *1792,
Ralph Earl (1751-1801). 75¹⁵⁄₁₆ x 86¾ in., oil.
Wadsworth Atheneum, Hartford, Connecticut.*

EMMA VAN NAME, *ca. 1795,*
Artist Unknown. 29 x 23 in., oil.
Collection Whitney Museum of American Art, New York,
gift of Edgar William and Bernice Chrysler Garbisch.

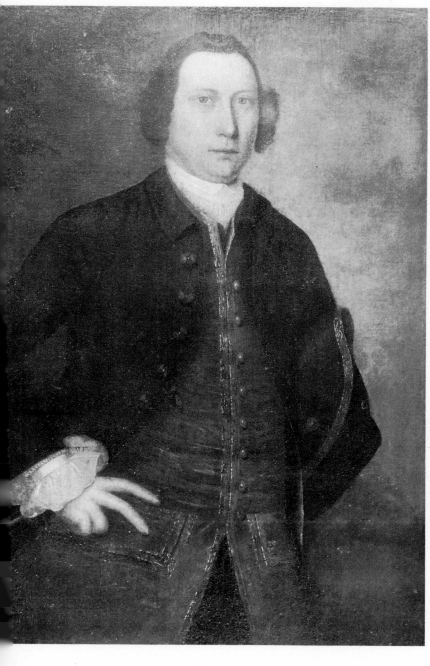

Lawrence Washington, *n. d.*,
Joseph Badger (1708-1765). 40-½ x 29-½ in., oil.
Courtesy, Pennsylvania Academy of the Fine Arts,
Philadelphia, John F. Lewis Collection.
Badger's portraits were fashionable during the
mid-eighteenth century and often typify for us the qualities
of a colonial portrait, with its emphasis on craft.

have worn that dress and certainly that lace cap. She is dipping into strawberries, seemingly eating enough to last a lifetime, but doubtless she lived to eat more.

This enchanting unknown artist has achieved a beguiling portrait of childhood and a ravishing display of his or her painterly skill. To render glass transparent and the diaphanous quality of the peek-a-boo dress requires skill. The strawberries are so succulent that the viewer wishes to join Emma in eating them. Whatever vicissitudes this painting may have suffered due to changing tastes, someone in Emma's family always knew its worth as a work of art, for it has been preserved with love. Its appeal to us is just that, love at first sight.

There were a great many self-taught artists in the colonies and in the young Republic. Americans have always been keen on having someone record family likenesses. Although we may not have been too concerned about who depicted us, we wanted to leave a remembrance for our descendants to honor, not only our countenance, but our possessions and station in life. Sometimes one member of a large and scattered family would take up a self-appointed task to paint their portraits. Sometimes one such artist would conscientiously record the faces of all the farmers or sea captains in the district or the town. Often, too, such a painter, or limner, as a painter was then called, would travel from place to place, painting portraits on order, or tavern signs or coach decorations.

One note frequently found in such primitive portraits is a kind of mistaken equality. Everything is equal, the face, the eyes, the hands, the buttons, the cloth, the lace, whatever. The resulting picture seems to have been put together from independently made parts, and, indeed, that is exactly how many of them were put together, the painter concentrating intently on whatever part he happened to be doing and ignoring the demands of any overall composition within which some parts would necessarily be subordinate to others.

But these technical inadequacies, in the hands of some of the primitive painters, add up to a special charm unattainable through the approved, academic methods of portraiture. Through the intensity of the innocent eye, we see the world and the people in it as if they and we have been newly made and are seeing it all for the first time. Antiquarian interest aside, that is the real charm of *Emma.*

Writing about an unknown painter is great sport. In the first place, you do not have to deal with an artist who, unless he or she recorded personal feelings towards art, lives on the reputation created by the conjectures of biographers and critics. Instead, we are forced, as we should with all art, to appraise it for its own sake, out of context with anything else the artist may have done.

We do not know if *Emma Van Name* was an early work by an artist who died in obscurity or if it was done by an adoring amateur relative. We do not even know if Emma herself survived childhood — a great many children did not in those days — and became an adult of accomplishment with a family of her own. Emma is as lost in time as the artist who painted her. So are the sculptures of the Gothic cathedrals and their unknown sculptors.

Emma Van Name seems to have been painted about 1795, possibly in New York State or City. Though she was probably not over four when she stood for her portrait, you can see in her face how she would look at forty — a serious-minded, plump Dutch matron. That little silver whistle, surely, would have a place in her cabinet of treasures and souvenirs. Her own child would very likely

BASS OTIS

Self-Portrait, *ca. 1840,*
Bass Otis. 30 x 25 in., oil.
National Portrait Gallery,
Smithsonian Institution, lent by
the University of Michigan,
bequest of Henry C. Lewis.

Bass Otis is not a famous name in American art, but the people he painted are many of the greatest in our early history. The fact that we are not overburdened with the painter's fame allows us better to judge his portraits on their own merit — and enjoy them. He was a landmark artist in one respect, however; he produced America's first lithograph, published in 1819 in the *Analectic Magazine.*

Otis was born in Massachusetts in 1784 and was apprenticed to a scythe-maker. He learned painting from a coach-maker, as perhaps many early artists, for coaches were decorated in those days with charming if crude scenes. By 1808 he was painting portraits in New York and later he moved to Philadelphia where he lived from time to time for the remainder of his years.

In 1812 when he exhibited a series of portraits in Philadelphia, the critic of the *Port Folio,* an art magazine, wrote: "We perceive in his works a strength of character, force of effect, and correctness of likeness, that certainly would do credit to artists of more experience; and there is no doubt that, with proper application, Mr. Otis will become a very distinguished portrait painter." It was his debut in that art center, and it brought him to the attention of one of the most energetic and determined art entrepreneurs of his time, Joseph Delaplaine. Much of this extraordinary man's correspondence has been kept, and from it we learn of his plans for his *Repository of The Lives and Portraits of Distinguished Americans.* At first Delaplaine hired a painter, Joseph Wood, but he was apparently undependable. The entrepreneur then pressed Otis into service

in this letter: "You will be pleased to paint for me the original portraits of the Honble. De Witt Clinton — Revd. Dr. John M. Mason — George J. Patten of Hartford — Govr. Strong — Timothy Pickering — Gilbert Stuart — and John Cotton Smith, Govr. of Connecticut, on canvas of the size Giles' portrait you painted for me, or the usual size canvas." This dictatorial request was accompanied by a contract for the sum of twenty dollars per portrait.

In 1816 Otis prepared to go to Virginia where he captured many sitters, including Jefferson, Madison, Monroe and Madison's famous hostess wife, Dolley.

Dolley Madison is still one of the magic names of our early days as a nation. We picture her blending the rather unprepossessing Washington society into genteel gatherings of fun-loving but well-mannered folk. Bass Otis has painted her very much as she probably was: an ample-bosomed matron with a happy if self-satisfied expression. She is the prototype of all future society ladies, even to the hat. One writer called it "a devastating image [with] none of the charm which diarists tell us was possessed by the queen of Washington society." Another thought the popular engraving done from it did not do her justice, but he described the sitter as having "a wish to please, and a willingness to be pleased." The portrait was bought by Rubens Peale for his New York museum and later by P. T. Barnum for his American museum and eventually by Thomas Jefferson Bryon who presented it to the New York Historical Society where it now hangs.

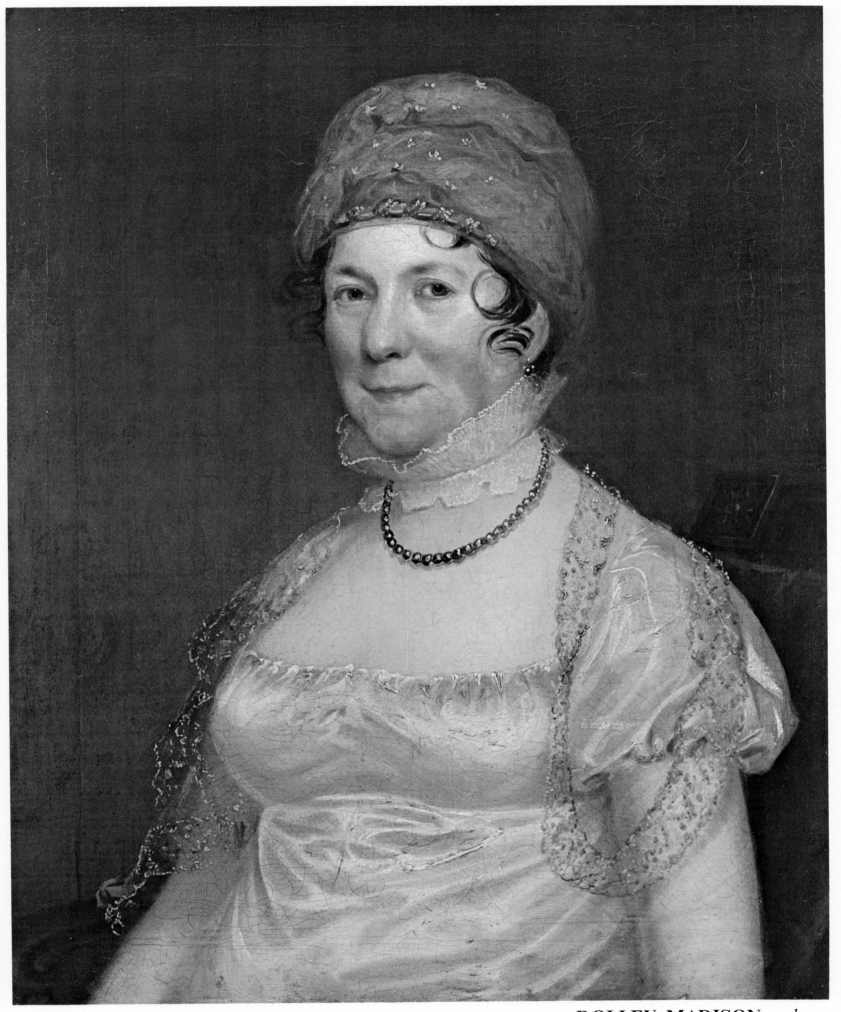

DOLLEY MADISON, *n.d.,*
Bass Otis (1784-1861). 29 x 24 in., oil.
Courtesy, New York Historical Society, New York City.

JACOB MAENTEL

American folk painting has come into its own in recent years, and with good reason. Few countries have produced so much good folk art. Generally, folk traditions remained static in European countries settled in their national ways. They were handed down from generation to generation and did not vary much, either from artist to artist or time to time. But the Eastern Seaboard of America in its formative years was bombarded by one tradition after another from Europe, and something very special evolved, a genuine American folk culture. Unquestionably, parts of the uprooted European traditions showed through, but in the items of American folk art that have been brought together in this century in the great Abby Aldrich Rockefeller and the Garbisch collections and others, one sees an unmistakable originality.

In the great growing metropolitan centers like Boston and Philadelphia, portraiture was a thriving business. The richer and more successful we got, the more we wanted records of our good fortune and good life as recorded in our persons. Everyone who was anyone had his portrait done, and the choice of artists depended on the aforementioned good fortune. As in every age, what went on in the big cities filtered through, somewhat diluted perhaps, to the country. There were many itinerant painters who sized up the farms and their owners, the professional men and their practices, and simply knocked on the door to see if someone wanted to be "done." The prospective sitters were shown samples, even piecemeal samples, of hands and ornamentation. Some painters even carried a few portraits all completed except for the head to suit those who did not know what to wear or did not have the patience to sit for anything but their head. These were professional artists and they have given us some of our most delightful por-

traits of what we looked like in the days before we looked like everyone else.

Jacob Maentel, the creator of this family portrait, was painting outside Philadelphia bout 1810. The Pennsylvania German farmers were prosperous and just as eager to be remembered in art as the city folk. Maentel was an endearing artist who took the trouble not only to let us know who his sitters were but also who he was. Often he told the names of his subjects by having them hold a printed record in their hand. The father and son are Joseph Gardner and Tempest Tucker Gardner. The father was born in 1783 and died in 1866; the son lived from 1811 till 1896. Although their lives span but a century, their likenesses will live forever in Jacob Maentel's watercolor.

Maentel was unusual in his use of this medium, for unlike most folk painters who used house paints or oils, he used watercolor only. The simple pose, usually in profile in his earlier pictures, reminds one of the silhouettes in black and white so popular at this time. But Maentel's color, while subtle, is full in the costumes and faces. The dress is in careful detail, and the faces, one feels, are very good likenesses. Certainly if you met him, you would recognize Joseph Gardner by his long aquiline nose and beetle eyebrows. The son is a small replica of father but perhaps he favors his mother, too. And just in case you could not place them, anyone would know the Gardners by their funny little dog. There cannot have been too many of that breed anywhere.

Elizabeth Fennimore Cooper, ca. 1816,
Artist Unknown. 17-½ x 21-¼ in., watercolor on cardboard.
New York State Historical Association, Cooperstown.
The inscription on the picture's back reads:
"A representation of the hall of the mansion house
of the late William Cooper, Esq., deceased, also
a perfect likeness of his widow Mrs. Elizabeth Cooper,
together with her shrubbery in the south end of the hall,
also the likeness of their old Servant Joseph Stewart,
generally known by the name of 'Governor'."

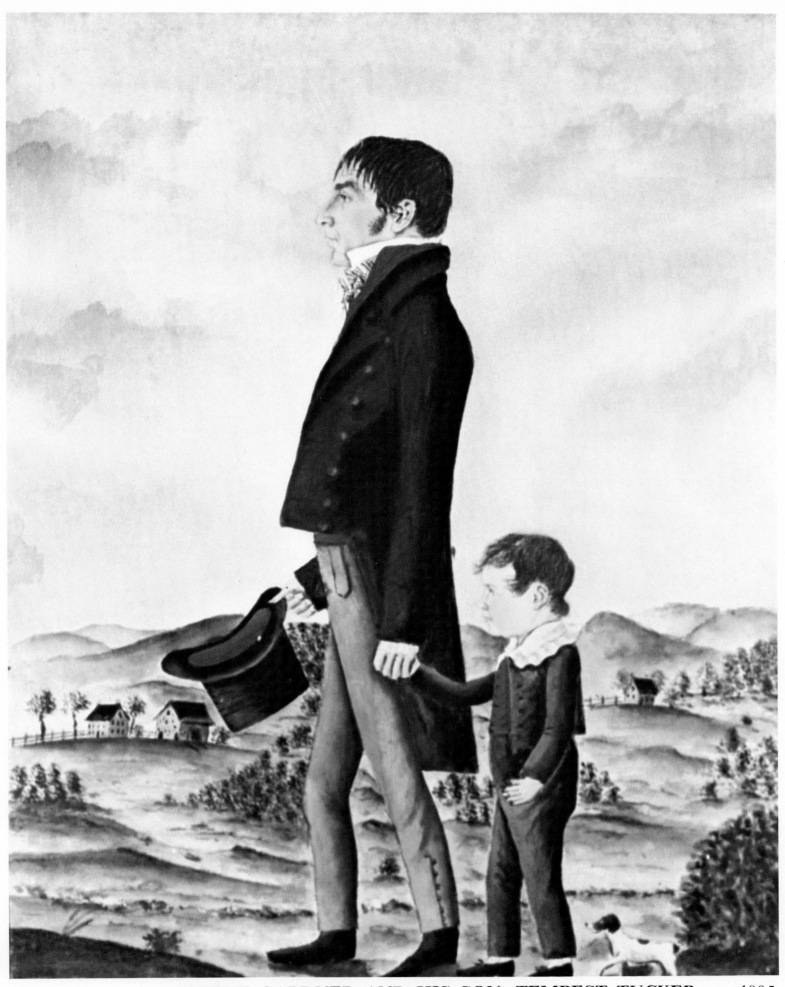

JOSEPH GARDNER AND HIS SON, TEMPEST TUCKER, *ca. 1805,*
attributed to Jacob Maentel (?- ?). 11⅜ x 9⅞ in., watercolor.
Abby Aldrich Rockefeller Folk Art Collection, Williamsburg, Virginia.

JOHN VANDERLYN

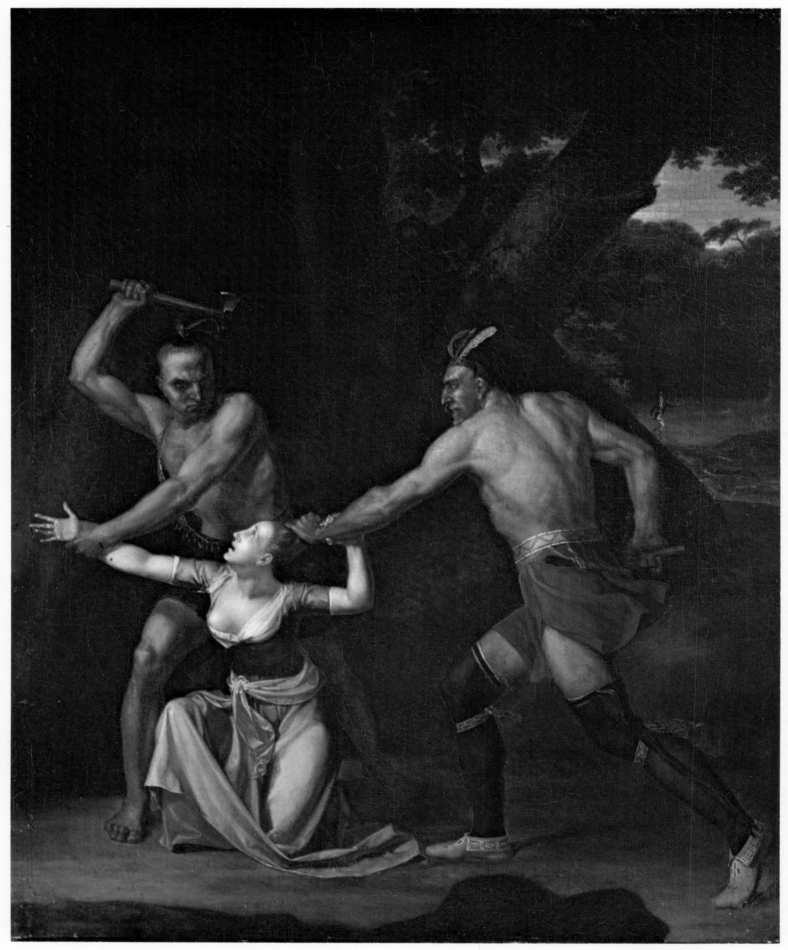

THE DEATH OF JANE McCREA, *1804,*
John Vanderlyn (1775-1852). 32 x 26½ in., oil.
Wadsworth Atheneum, Hartford, Connecticut.

The legend of Jane McCrea was born out of young America's need for a symbol of the hardships accepted in carving a nation out of the wilderness. The actual story is shrouded in mystery, but in her tragic end she served a purpose. At the beginning of the Revolutionary War, Jane lived with her brother near Troy, New York, at Fort Edward. She was away visiting friends when British General John Burgoyne advanced on Saratoga. Trying to get home in the general alarm at the news, she was attacked, scalped and killed by Indians who were Burgoyne's allies. After her body was found, the Indians claimed that a random shot from a pursuing American detachment killed her. Her suitor David Jones, a lieutenant in Burgoyne's army, was said to have sent the Indians to bring her to the enemy camp so they could be married, and it was said that she was killed in a fight with another Indian group. Burgoyne was shocked by her death and gathered his Indian chiefs to reprove them. The Indians resented this and deserted the British cause. Jane's death, however it came about, roused the colonists, and hundreds joined the fight against the British who were subsequently defeated at Saratoga.

John Vanderlyn's famous picture of the incident is full of drama and is brilliantly composed and executed. Still it can hardly be called an American picture. It was painted in Paris in 1804, where Vanderlyn had lived continuously since 1796 and intermittently for eighteen years, and it is suffused by Neoclassicism, a style extremely popular during this period of French art, so that it might as well be a picture of Niobe and two redskinned gladiators. What I find humorous and definitely not stereotyped is the little figure of a man, presumably Jane's suitor, hightailing it across the pastoral background. It helps to illustrate the poem that accompanied the engraving of the painting when it appeared in the magazine *Columbiad* in 1807:

> With calculating pause and demon grin,
> They seize her hands and through her face divine
>
> Drive the descending axe: the shriek she sent
> Attained her lover's ear.

Vanderlyn, when he finally returned to America in 1815, found himself in an unsympathetic art atmosphere. His best works besides *Jane McCrea* were *Ariadne Asleep on the Isle of Naxos* and *Marius Amid the Ruins of Carthage* and had been done in Europe. With Washington Allston (p. 54) and Samuel F. B. Morse (p. 68), he faced the problems often faced by an artist living after a great generation of artists — in this case Benjamin West (pp. 23-27), John Singleton Copley (pp. 16-22) and his own teacher, Gilbert Stuart (p. 28). The European style, and especially his French version of it (he was the first American painter to study in Paris), and the kind of subject matter dictated by it were not what the American public wanted. According to art historian Matthew Baigell, "In personal as well as artistic matters, this was the most tragic generation of American artists. . . .Like some of his contemporaries [Vanderlyn] was unwilling to become merely a good portrait painter. Instead he sought in art an entrance to a world of higher meaning and value." Unfortunately he did not realize what Americans then wanted.

Vanderlyn established a permanent home in New York for his huge panoramic paintings, but this effort, like his commission to do *The Landing of Columbus* for the U.S. Capitol Rotunda, failed to live up to his expectations of art in America. "No one but a professional quack could live in America," he said, and he retired to the town of his birth, Kingston, New York, where he died impoverished at the age of seventy-seven.

*Ariadne Asleep on the Island of Naxos, 1814,
John Vanderlyn. 68 x 87 in., oil. Courtesy,
Pennsylvania Academy of the Fine Arts, Philadelphia,
Joseph and Sarah Harrison Collection.*

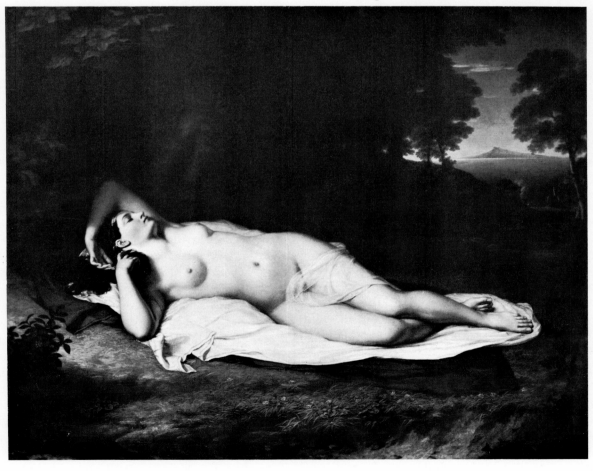

WASHINGTON ALLSTON

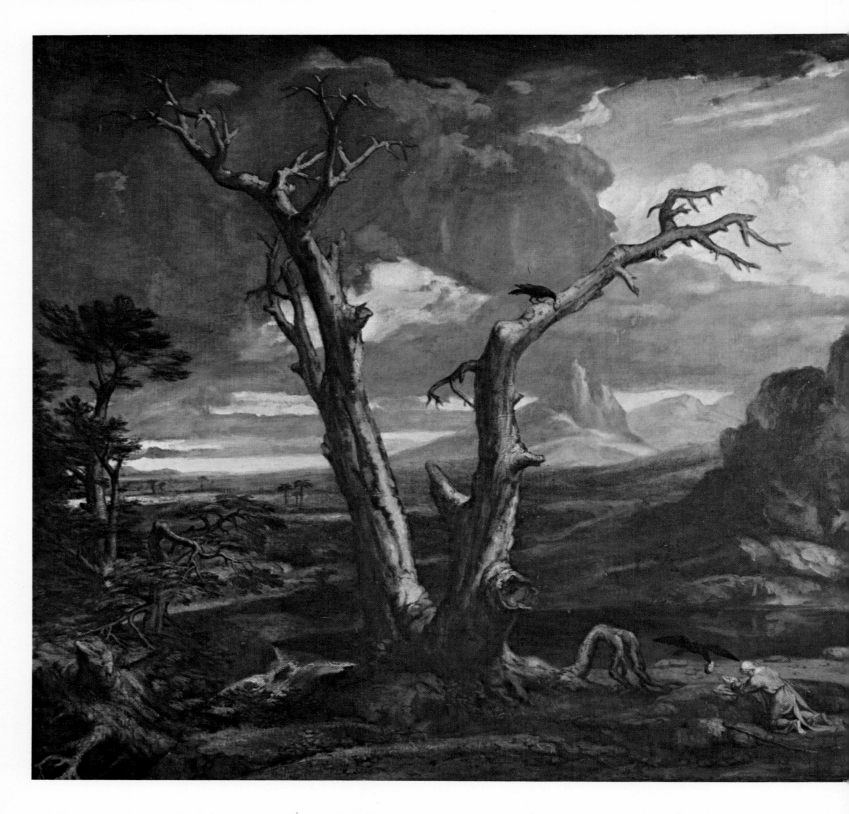

Whenever we come across a painting by Washington Allston, we are moved immediately into another world, another mind. We find ourselves traveling, not by any shortcut to pictorial understanding, but along the bypaths of a curious route on which one may become bewildered, or lost, but never bored. We are given over to the fancy of fright, to the reality of aloneness that makes up the excitement of those rare artists who set out and succeed in exploring their inmost secret selves for the delight and edification of others.

Nathaniel Hawthorne, author of *The Scarlet Letter*, and the English poet Samuel Taylor Coleridge were close and admiring friends of Allston's, and he shared with them a mood of romanticism which was to pervade the world of art in the early nineteenth century and give it some of its most provocative geniuses. Allston's place in this move-

ment in nineteenth-century America was all-important, for he was our first visionary in paint. It was he who opened American painting to the realm of emotion and imagination, a departure from the practical art of the colonies and early republic which was concerned with portraits and recording historical achievements.

As a student, Allston was impressed with the works of the Swiss painter, Heinrich Fuseli (1741-1825), with their elements of horror and fantasy, but Allston went on to draw from his own imagination and reverie, rather than from the two main sources of the early Romantic Movement in painting, the Bible and Shakespeare. *Elijah in the Desert* is a Biblical subject to be sure, but the subject is an excuse to let us into Allston's own thoughts on man's confrontation with his own personality, his soul, alone in the vastness of the world.

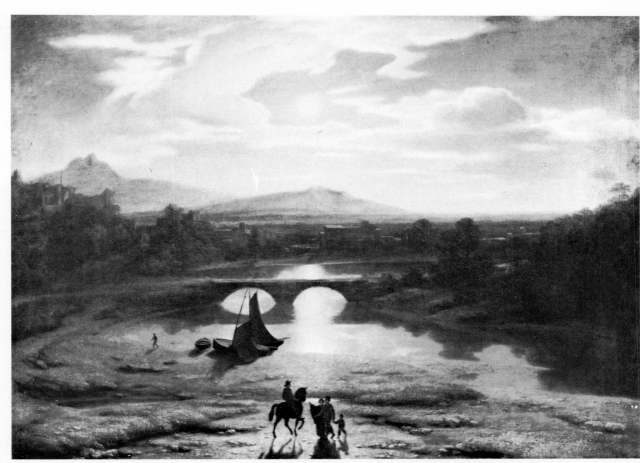

Moonlit Landscape, *1819,*
Washington Allston. 61 x 89 in., oil.
Courtesy, Museum of Fine Arts, Boston,
gift of Dr. William Sturgis.

ELIJAH IN THE DESERT, *1818,*
Washington Allston (1779-1843). 48¾ x 72½ in., casein on canvas.
Courtesy, Museum of Fine Arts, Boston.

Allston lived in London for eight years, surrounded by a coterie of famous and loving friends, Coleridge, poet William Wordsworth and his fellow American, author Washington Irving. Studies in London developed his academic technique, but from his admiration of the Venetian colorists, Veronese (1528-1588) and Titian (1477?-1576), he created his personal style of using underpaint and glazes to give a luminosity that penetrates even the moodiest of his canvases.

Allston finally grew homesick for America and in 1818 returned to Boston, where he became part of the enlightened circle of poets and writers of our blossoming romanticism under the leadership of Ralph Waldo Emerson. His paintings became less grandiose, more personal and pleased the eager art public, caught up as it was in the brilliance of the Romantic Movement. Critics and collectors at the time

ranked him at the peak of the history of American art, brief as it was, and there he remains for us.

He opened the way for those artists who have given us a very personal, serious — even grave and reverential — look into the inner workings of the human mind, men like Elihu Vedder (p. 116), John Quidor (p. 114), John LaFarge (p. 128) and Alfred Pinkham Ryder (p. 166). In the very practical-minded atmosphere of burgeoning America at the beginning of the nineteenth century, it took a daring, determined and highly gifted artist like Allston to venture out of that earth-bound world into one of unreality and visionary idealism. Allston's art genuinely rates the definition "classic" in a country which was struggling out of the pseudo-classicism, even archaicism, inherited from many Old World cultures.

THOMAS SULLY

LADY WITH A HARP: ELIZA RIDGELY, *1818,*
Thomas Sully (1783-1872). 58 x 94 in., oil.
National Gallery of Art, Washington, D.C.,
gift of Maude Monell Vetlesen.

General Andrew Jackson, *1845,*
Thomas Sully. 97-¼ x 61-½ in., oil.
The Corcoran Gallery of Art, Washington, D.C.

hints to his young admirers — "six sittings of two hours each is the time I require." A thorough professional, he made meticulous sketches from life then went on from memory. Just as meticulously, he recorded everything he did, what he was paid, where he went, how his portrait prices increased with his reputation. In Philadelphia he made between three and four thousand dollars a year, a wealthy income in those days.

He admitted his weaknesses, as he did when he asserted that, "no fault will be found with the artist — at least by the sitter — if he improves the appearance." A critic of Sully's portrait of Jackson noted, "Even craggy old Andrew Jackson, as pictured in Sully's portrait, looks like a gentle old ham powdered for the footlights and wigged for the role of Old Hickory."

Sully painted and sketched Jackson on various occasions when Andy was the hero of the Battle of New Orleans. The portrait was done about a month after Jackson's death, and perhaps that further explains the idealization. It is possible the dropped glove is symbolic of the defeat of the hero by death.

Sully's best portraits, however, are of females such as *Lady with a Harp: Eliza Ridgely,* perhaps because his idealization and ultra-refinement seem most appropriate in this context. In such graceful works Sully painted their demure femininity and the trappings of culture with a delicate but sure hand. His talents and interests are evident here in the care lavished on decorative forms in the carpet and harp, on the texture of satins and curls, and the dramatic contrast of glimmering white and muted darks. There is no pretense of portraying a musician, but instead, Sully has caught an image of the languid heroine from the romantic ideal that dominated the times. The women he painted look like young ingenues or theatrical grande dames, but no one can deny the beauty of his workmanship or the beauty of the subjects themselves. They seem to complement each other perfectly.

Sully had what all good portrait painters must have, a perfect "bedside manner." To sit for him was almost therapeutic, as good for the ego as a health spa is for an aching back. Sitters came to him with the sure knowledge that what they left behind of themselves on his canvas would flatter rather than disturb and would carry them into posterity as they wanted to be remembered.

Sully survived the industrial revolution, the Civil War and the expansion into the great West. His portraits reflect for us today, who live in a time of turmoil and change, the courtesy and grace which made civilization, in a large part, worth the effort. His technique, his whole approach to the portrait as an art form, is not in the least pretentious or pompous. It is an honest, even humble, expression of an ideal of personal behavior on the part of artist and sitter.

A career of almost seventy years and almost all of them successful: the foremost portrait painter of the period following the War of 1812 when Americans developed a rage for portraits; the heir to the title of Gilbert Stuart (p. 28); pupil of Benjamin West (pp. 23-27); helper and teacher of the young, including Samuel F. B. Morse (p. 68); "The American Lawrence" — a flattering title, for he admired the prodigious English portrait painter Sir Thomas Lawrence (1769-1830) above all others. Loved and admired by all, this was the career of Thomas Sully. His sitters included the young Queen Victoria, famous Americans such as Andrew Jackson, and most of the society masters and matrons of Philadelphia, New York, Richmond and Boston, such as Eliza Ridgely, subject of our painting.

Sully left behind him well over two thousand works of art. He had some success at landscapes and historical subjects, but his real talent was for portraits. Particularly enjoyable are the beautiful watercolor sketch pages showing the various poses of the society beauties he did so well. Sully came to this country in 1792, when he was nine, brought by his English parents who were actors, and there is always a touch of theatricality in his portraits. They are like small stage sets framing the star of the show, whoever the sitter happened to be.

He surely can be defined as the ideal artist to sit for. He recorded his requirements of the sitter in passing on some

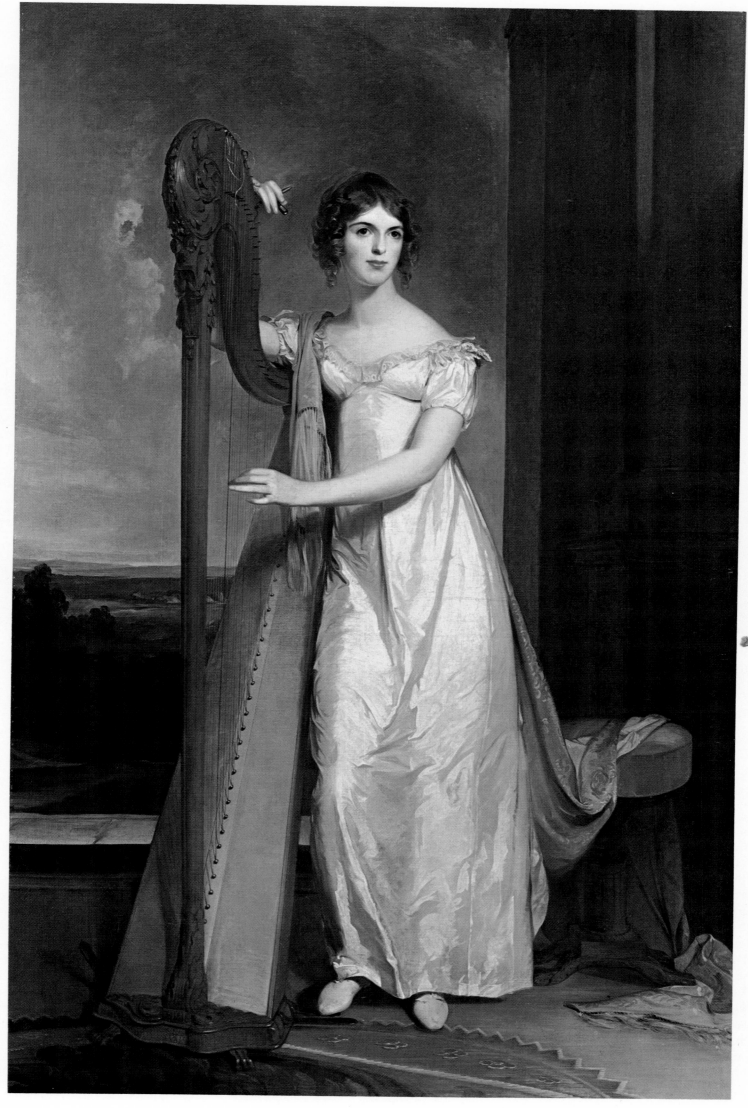

JOHN LEWIS KRIMMEL

A COUNTRY WEDDING, *ca. 1819,*
John Lewis Krimmel (1787-1821).
16¾ x 22½ in., oil. Courtesy,
Pennsylvania Academy of the Fine Arts,
Paul Beck Collection.

No one knows what John Lewis Krimmel would have become if he had lived longer than his thirty-four years. Probably not much more than his few surviving pictures tell us he was, a totally delightful if minor talent. Sometimes the great names, having found their high levels which critically satisfy us, become, if not a bore, then something taken for granted. The lesser masters, on the other hand, through discovery and less critical publicity, can be a pure joy. Somehow they belong to us with an intimacy that the masterpiece, being shared by everyone, cannot hope to inspire, however intentionally inspirational it may be. In the last decade of the nineteenth century, the minor Sienese painters of the late thirteenth and fourteenth centuries were reevaluated, and I would guess that the charming *oeuvre* of artists like Krimmel will enjoy the same experience in America's artistic history.

Krimmel was born in the same German town of Würtemberg as Emanuel Leutze (p. 96), whose parents

escaping political persecution brought Emanuel to this country at a tender age. Krimmel, on the other hand, arrived at twenty-three and came fully equipped, if not with technique, at least with an adult understanding of the sentimental art of his native land. It is possible he was trained there as a miniaturist, for he uses miniscule brushstrokes and fills his canvases with all the loving detail that the miniaturist lavishes on costume, eyelashes and hairdos. With this artistic equipment and a love for simple people doing everyday things, he became one of our first professional genre specialists in the second decade of the nineteenth century, paving the way for that delightful group, headed by William Sidney Mount (p. 106) and Eastman Johnson (p. 132), that was to come into its own several decades later. Art connoisseurs in Philadelphia, where Krimmel settled, tried to lead him into becoming an historical painter, but obviously he felt more at home in unpretentious subject matter. *A Country Wedding*, painted two years before his accidental death, is a culmination of his determination to paint what pleased him most.

Interior of an American Inn, ca. 1813,
John Lewis Krimmel. 16-7/8 x 22-½ in., oil.
The Toledo Museum of Art, gift of Florence Scott Libbey.

It is said that Krimmel moved from painting portraits to genre subjects by copying in oil a print of the Englishman David Wilke (1785-1841). In *A Country Wedding*, the English mood is clearly seen. Neither is it difficult to see similarities with the work of German painters of the same period, whose prints found popularity in America. The joy of the painting is its unabashed sentimentality and the delightful detail — the birds high up in their cage and the watchful cat on the same level; the mother of the bride having her little weep; and the old grandmother, late but welcome, puffed up with advice which she will give whether anyone wants it or not. The children could not care less that one of life's great moments is happening; they go right on with their world of playful make-believe.

Krimmel enjoyed success with his small output of simple scenes and he might have become more pretentious had success led him to attempt more grandiose stories. Fortunately, we can cherish his paintings as loving reports on the life he knew and be satisfied he did what he did with such honesty and devotion.

HENRY SARGENT

Boy on a Hobby Horse, *1817-18,*
Henry Sargent. 63 x 50-½ in., oil.
Courtesy, Museum of Fine Arts, Boston,
gift of Aimée Lamb in memory of Winthrop Sargent.

Genre painting is anecdotal; it tells of life's incidents. Today, genre subjects are caught primarily by the camera. The camera has been the great emancipator of art, but perhaps in its instant, often thoughtless, image-making of moments we would cherish, it has robbed us of those wonderful artists whose visual memory, trained hand, and sympathetic observation of daily events gave us so many unforgettable little masterpieces.

It is not that the camera in the hands of a master cannot be great art. It can and is, but the genre painter's problem is naturally quite different; he must maintain the moment, not just capture it. Perhaps in holding it all those hours, days, sometimes years that it takes him to put it on canvas, it is more digested and therefore satisfies us like a carefully prepared meal rather than a short order.

Henry Sargent was one of our first genre painters and he had an eye that today would have used the camera very professionally. He had great sensitivity to light and attention to detail. He understood architectonic composition — wherein form and space are of primary importance — far better than any of his contemporaries, borrowing it from his study of the Dutch and French masters. He had studied more formally with Benjamin West (pp. 23-27) in London and also studied with John Singleton Copley (pp. 16-22) there, but none of Copley's extraordinary realism in portraiture seems to have influenced Sargent's portraits. From West he cultivated a flair for historical and religious pictures, but it is in his few, much cherished genre works that his reputation survives.

The Dinner Party has the quality of a class photo. It is posed as self-consciously as these treasures of our childhood always are, though some of the guests did not obey and look in the right direction, and others are half-hidden behind a friend in surreptitious conversation. Sargent borrowed the composition from a painting by the French Neoclassicist, François Granet (1775-1849), called *The Capuchin Chapel*, showing friars at devotion. Sargent turned the chapel into his own dining room at 10 Franklin Place, Boston, where he was often host to a men's social club. Sargent himself is probably the man with his back to us at the end of the table, for then, in the true tradition of Dutch interiors and self-portraits, he can see himself in the mirror.

What is remarkable about this painting and its companion, *The Tea Party*, is the picture they give us of the period in which it was "taken." It is a joy to study every detail, the table settings, the mantelpiece, the light fixtures, the sideboard and the basket of wine beneath it and, of course, the company of good friends obviously having a hearty meal and conversation. It shows young Americans carrying on the cultural traditions of other lands and doing it very well. It is a happy song of praise and satisfaction that out of the wilderness they had hacked a civilized way of life. It is, finally, a picture of how we like to think about ourselves.

Sargent was alone in his enjoyment of this kind of homely subject, and it would be many years until William Sidney Mount (p. 106) came along to define it as a major part of our art. Sargent was an amateur in the best sense of the word, a lover of the arts, and to this he added what professional training he had to produce a few charming pictures. The good humor of the amateur approach, the lover's, shines through his limited techniques and tightly structured composition. The arts did not consume his life; Sargent had many outside interests in state and militia service, but art was very much a part of the man, a professionally trained amateur.

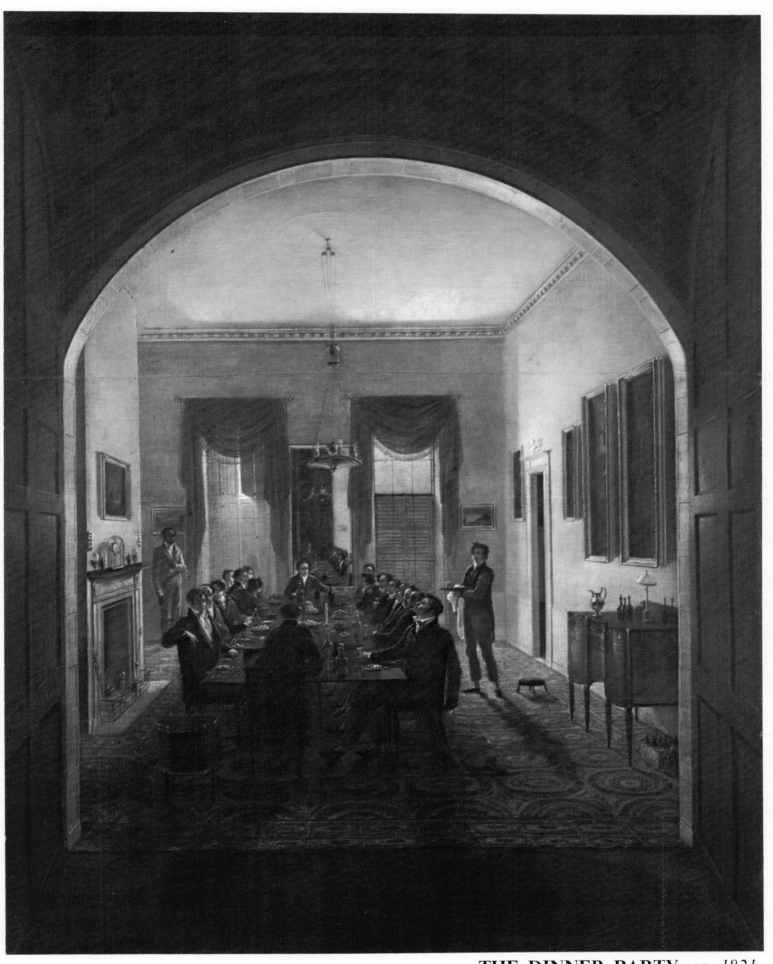

THE DINNER PARTY, *ca. 1821,*
Henry Sargent (1770-1845). 59½ x 48 in., oil.
Courtesy, Museum of Fine Arts, Boston, gift of Mrs. Horatio A. Lamb
in memory of Mr. & Mrs. Winthrop Sargent.

RAPHAELLE PEALE

Still Life, *n. d.*
James Peale (1749-1831). 18-3/8 x 26-9/16 in.,
oil on panel. Worcester Art Museum
Worcester, Massachusetts. James and his nephew
Raphaelle are credited with founding
still-life painting in America.

Raphaelle was the eldest son of Charles Willson Peale (pp. 33-39). He was born in 1774 when his father was thirty-three. He was by far the ablest of the Peale family of painters, but his tragic if lighthearted addiction to drink would indicate that perhaps he felt the crushing magnificence of his father's all-around genius. And yet, in his later years, Charles learned from his sons, Raphaelle and Rembrandt (1778-1860), and quite humbly accepted their advanced knowledge of art as far superior to his own. The elder Peale, instead of basking in his own success as an artist and hoping his children would pursue some more "honorable" profession, exposed all of them to everything he had learned in every field, especially art. He did not think himself worthy of art and hoped they would be, and we must remember that it is only in very recent times that the arts have been considered a calling worth pursuing.

Raphaelle is credited with being the co-founder of still-life painting in America, along with his uncle, James Peale (1749-1831). Ahead of his time and with accomplished technique and taste, he produced some of the most delightful deceptions in the entire field of this ever-fascinating area of art. Charles Coleman Sellers, writing about

Raphaelle, says, "Laughing in the face of tragedy and woe, striving toward perfect arrangement and illusion with an intuitive intensity, he will always be considered by many as the greatest of the Peales." And it was in still life that his greatest talent lay.

But he was almost as good a miniaturist as his uncle, James, much of whose career was given over to the popular art form. He brought great personality penetration to his larger portraits, too, but it is in this wonderful still-life composition we show here, *After the Bath*, that all his virtuosity is revealed. It was done two years before his death, in 1823, and the fable, true or false, that goes with it is as delightful as the picture itself. It was painted to shock his hot-tempered wife, Patty, who quite rightly nagged him to stop drinking and who perhaps aggravated it in the first place. Behind the sheet-towel is the illusion of a naked woman. The story goes that Patty was so infuriated that she clawed at the canvas to get at the hussy — much to the amusement and joy of her spouse. But for all its humor, as the writer Adam Elam says, it is "the most famous, and perhaps the most beautiful, *trompe l'oeil* in American art."

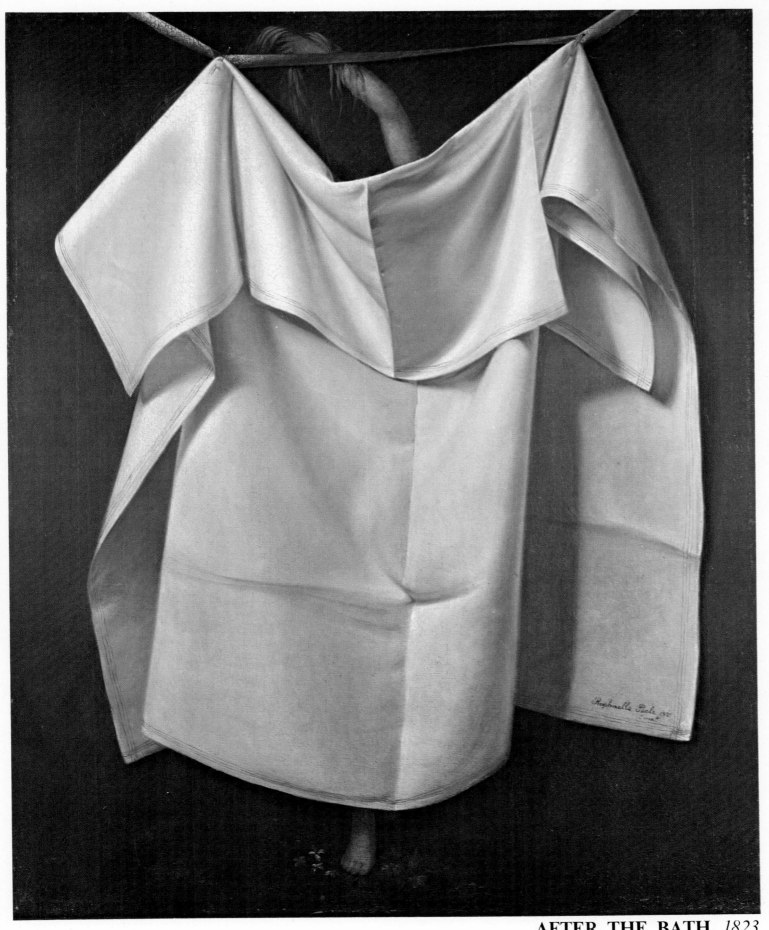

AFTER THE BATH, *1823,
Raphaelle Peale (1774-1825). 29 x 24 in., oil.
Nelson Gallery-Atkins Museum,
Kansas City, Missouri, Nelson Fund.*

Trompe l'oeil literally translated means "trick of the eye," but the Peales called them "deceptions," and Raphaelle obviously loved to indulge himself and his public with them. One of his pictures, called simply *A Deception,* is a card rack. It is done in pencil and india ink, and when you consider it was done as early as 1802, you can understand the true genius of this man. It is a form of art that comes right down to the present through a line of distinguished practitioners, William Harnett (p. 158), John Peto (p. 190) and to Aaron Bohrod (b. 1907) and many others today. Alan Gowans, art historian, states it quite succinctly when he says we still appreciate Raphaelle's work because it appeals "to a native admiration for technical dexterity, for 'plain' and 'honest' art."

JOHN JAMES AUDUBON

BARN OWLS, *183.*
John James Audubon (1785-1851
33¾ x 22¾ in., aquatin
Achenbach Foundation for Graphic Art
California Palace of the Legion of Hono

When fact and fiction merge in a man, a legend is born. John James Audubon shines out of our art history as a glowing legend, a beacon-star artist. Only the man has suffered in the years since he died in New York City in 1851. One suspects that is the way he wanted it, for he quite deliberately gave the legend a helping hand and obscured the man in hard words, passionate dedication to his art and a self-imposed life in the wilderness that abounded with birds and other wildlife, the source of his inspiration. Audubon pursued his mission with such zeal that he came to be one of the greatest figures in the world of art — a world abounding with greatness.

Audubon's attachment to his legend was perhaps his protective coloring to save him from the many predators that plague the artist. He fed the tales of his mysterious high-born French background, even acquiescing to the possibility he was the "Lost Dauphin." In truth, he was the illegitimate son of a French merchant and a Creole woman, born in Haiti in 1785. His father took him to France and lavished on him a good life and education. When the boy went beyond the pleasures of the hunt and began to make drawings of his quarry, the father sent him to the great Neoclassicist, Jacques Louis David (1748-1825), for instruction. He came to America at the age of nineteen, returned to France for a brief stay, then returned here where, according to art historian Edgar Richardson, "The rest of his life belonged to the American wilderness."

In Philadelphia he met and married Lucy Bakewell and set out for Kentucky where he intended to set himself up as a frontier merchant. The lure of the wilderness took him away from his business so much of the time that it was soon a failure. His passion to draw the teeming wildlife around him dominated his energies so completely that the family was forced to move south to Louisiana where Lucy supported them as a teacher. Here the great idea of his life, its purpose, was brought into focus, and he began his incomparable lifework of recording, first the birds of America, and then the quadrupeds. He covered the continent from Labrador to the upper Missouri to the Everglades, and the work poured from him until at last he was ready to present it to the world.

In 1824 he took his drawings and paintings to the scientific capital of America, Philadelphia, and there came up against the defeating fact that scientists and publishers, in their loyalty to Alexander Wilson, whose eight volumes, *American Ornithology,* were the accepted standard, refused him any consideration. At thirty-five, rejected and broke (he was thrown in debtor's prison and emerged with nothing but his clothes), he dived into the wilderness again in search of new specimens. Two years later, in 1826, he arrived in England where he finally sold his idea of *The Birds of America, from Original Drawings, with 435 Plates Showing 1,065 Figures* to a publisher. During the next ten years, with money he raised on subscriptions, Audubon traveled between America and England. Richardson sums up the energy output of these ten years as "one of the most fantastic instances of talent and energy in the history of American art."

Portrait of John James Audubon, the Naturalist, *1844,*
John Woodhouse Audubon. 44 x 60 in., oil.
Courtesy of the American
Museum of Natural History, New York.

One fascinating side of the man was his ability to adapt to his surroundings in his own way. In the wilderness he was the true sportsman-scientist, although he never lost his dramatic flair even there. In Kentucky he would dress in black satin breeches and silk stockings just to remind observers that his background was different from theirs. In London he let his hair grow long and created for his audience of British bird lovers the look of the frontiersman. He made up for his lack of scientific knowledge by creating a fantastic aviary of his own imagination, though these creatures were fortunately confined to his mind rather than set free on paper.

When you look at his birds, you cannot help but feel that without them we would have been robbed of one of the most dramatic and poetic visions of nature ever produced. *Barn Owls,* white-winged against the nighted sky, so far transcends the usual cute renderings of these legendary wise birds that we can read the story of all night creatures in the majesty of that composition. The superbly filled sky, in which the birds are not posed but are caught in an act of life, and the rolling river landscape below let us see what we would not have seen except through Audubon's eyes.

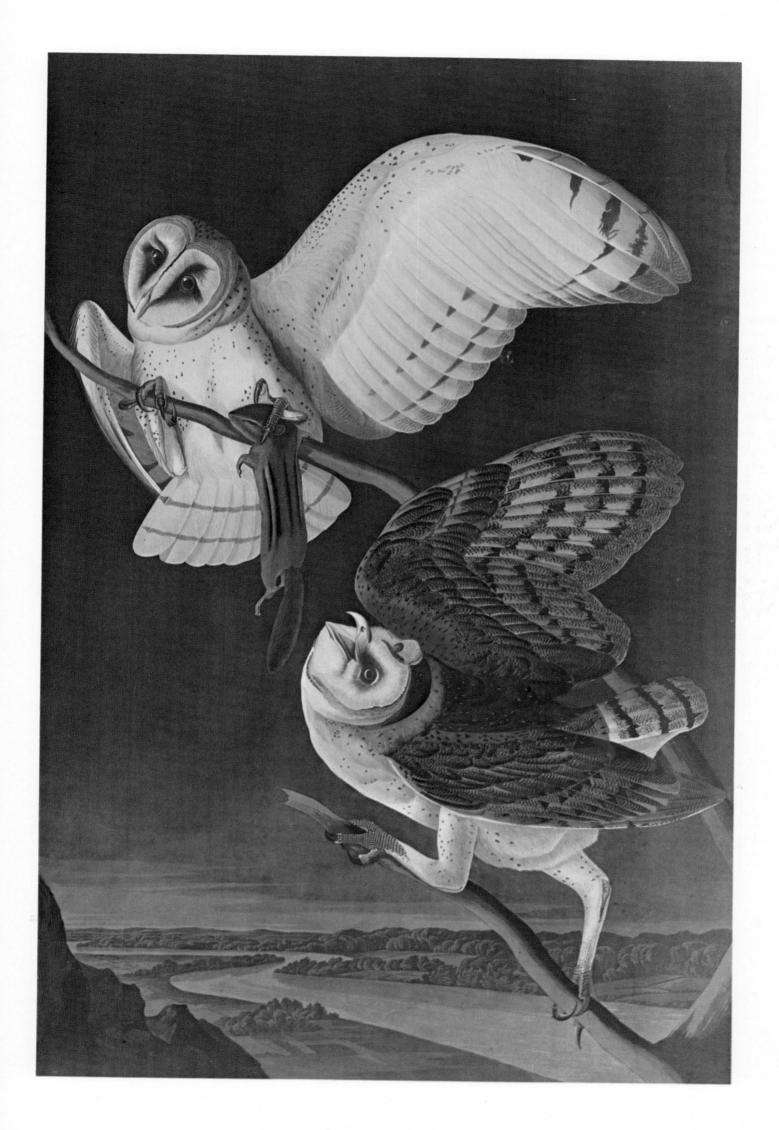

JOHN JAMES AUDUBON

A man with a mission may not be the most human of beings, but his contribution often justifies him. The members of Audubon's family did not have an easy time of it, and Lucy Audubon must have had extraordinary courage to back her husband's will to greatness and raise his family. His two sons, Victor and John, followed in his footsteps and were responsible, because of their father's failing eyesight, for carrying to completion the major part of his second great work, *The Viviparous Quadrupeds of North America*, published after Audubon's death in 1851. They were not the artists he was, but genius seldom comes down a family line undiluted.

One man matched Audubon, complemented his genius and indeed deserves a great deal of credit for the superb engravings made after his sketches and oils for *The Birds of America*, Audubon's masterwork. The English engraver Robert Havell, Jr. so completely captured the spirit of Audubon's originals that Audubon trusted Havell to make some of the backgrounds of his bird portraits. Later his son John was delegated this job.

Havell's contribution to the four-volume book was greater, for he translated the brilliance of Audubon's line and the delicacy of his color and design to the copper plate, losing very little on the way. He was able to capture the unique and innovative vision of Audubon, who set his birds flying free in their element of air or coursing through the seas and lakes. Together they broke the long tradition of static accuracy of previous ornithologists.

Audubon created works of art that have never been surpassed since. To do this he invented elaborate techniques such as wiring dead birds into the motion he wanted to reproduce. To catch the luminosity of the plumage he often worked long hours without food or rest, for he knew

it must be captured at its peak of lifelikeness, as feathers fade like all things in nature, once deprived of life. He knew many of his specimens, seen or shot, might not be found again for months or years, so the work had to be concentrated and brought to fulfillment immediately. Although he was not a great draftsman and a lesser painter, his passion to record "plain truths," as he called his observations of nature, overcame all obstacles and leaves us breathless with admiration for his magnificent achievement.

Benjamin Franklin felt the wild turkey should have been our national bird, but the eagle won out. Perhaps not all turkeys are as grand as this one by Audubon, which was the first plate in *The Birds of America*, but Audubon's monumental staging of the *Wild Turkey*, a true monarch of the forests and sky, gives us reinforcement for Franklin's belief. In a way, Franklin triumphed, for the turkey is the feast of our holidays and the one with which we thank God for our nation's bounty.

Perhaps of all the immigrant artists to this country, Audubon most vividly captured and was captured by its real wealth, its wildlife. In our day when so many of Audubon's family of birds are either extinct or on the endangered list, we realize that what he chose to preserve was indeed a natural resource as worthy of recording as the magnificent landscape. Men like Albert Bierstadt (p. 130) and Thomas Moran (p. 204), however superlatively they rendered that landscape, were doing it for an appreciative and acquisitive audience. Audubon had to sell his private passion for the wildlife of that landscape to a reluctant few. He succeeded with that audience, and later with all lovers of art, because his portraits of birds rose above what had previously been considered only an illustrative science to become great art.

Osprey and the Otter and the Salmon, 1844,
John James Audubon. 38 x 62 in., oil.
Arizona State University Art Collection, Tempe.

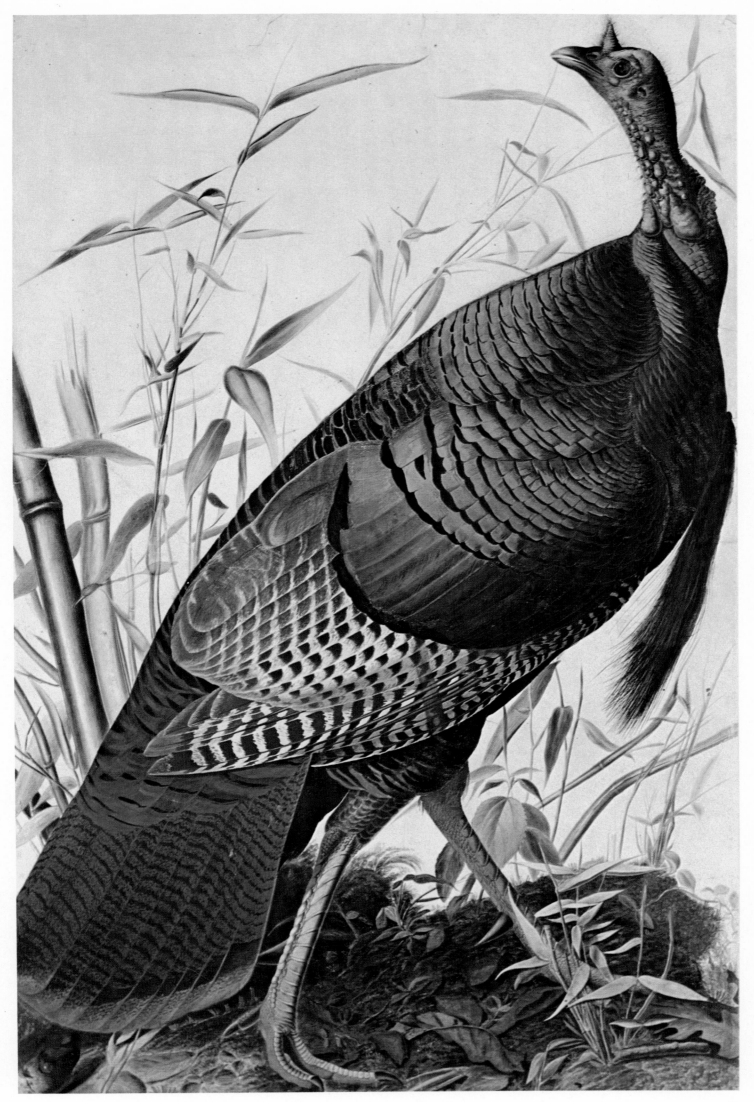

SAMUEL F. B. MORSE

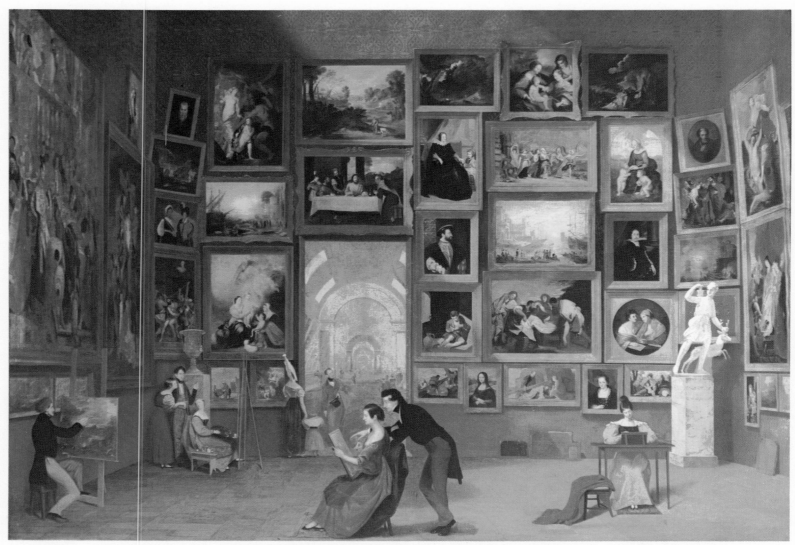

EXHIBITION GALLERY OF THE LOUVRE, *1832-33,*
Samuel F. B. Morse (1791-1872). 76 x 106½ in., oil.
Syracuse University Art Collection,
Syracuse, New York.

In our day when the arts and sciences are vying for private and even governmental priority, it hardly seems a paradox that a man named Samuel F. B. Morse was waging his personal war of preference over a hundred years ago. The year 1837 was critical for this artist-scientist. Since 1832, upon returning from Paris, he had been working on the two masterpieces of his life: a huge painting called the *Exhibition Gallery of the Louvre* and the experiments that led to his invention of the electric telegraph. To our minds, there is no question where his fame lies, but to this young man in his late thirties, art was his life and his great hope was to enlighten his countrymen to the cultural wonders of Europe through his painting of the Louvre. The hoped-for success of that painting never quite materialized, and discouragement over the loss of a commission to do a huge historical canvas for the Capitol in Washington made him determined to carry to its triumphant conclusion his work on the telegraph. Morse abandoned art altogether, and for many years after his death at ninety, his paintings were almost completely neglected and they became the curious sideline of a famous inventor.

A later biography of Morse suggests he was "the American Leonardo," but where da Vinci's all-encompassing curiosity married art and science so successfully that the two were never divorced for a single thought, Morse had to abandon the love of his youth to achieve the success of his maturity. He was perhaps one of the earliest victims of our age of specialization. He was forced to make the choice between dying the romantic death of a Renaissance man, jack-of-all-trades, or surviving with greatness as master of one field of endeavor.

Viewed from the apogee of today's tornadic accomplishments in science, we can see Morse, if not "an American Leonardo," at least as a true intellect in both the arts and sciences. We can admire his decision to leave the lesser talent for the greater, but we can still enjoy the great effort he spent on the lesser.

Although in his art Morse seemed to prefer grandiose subjects and he disliked portraiture, his romantic portrait of his daughter Susan, called *The Muse*, displays his subtler aesthetic talents. The *Exhibition Gallery of the Louvre* is a

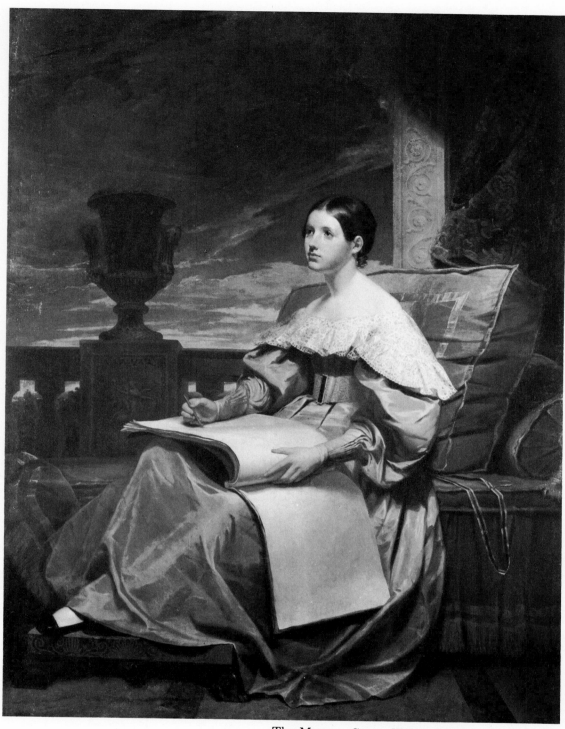

The Muse — Susan Walker Morse, ca. 1835-37,
Samuel F. B. Morse, 73-3/4 x 57-5/8 in., oil.
The Metropolitan Museum of Art, New York.

very real accomplishment, although perhaps more scientif-ic than artistic. It is a pictorial compilation of some famous art works in the Louvre, including such master-pieces as Titian's *The Entombment*, Raphael's *La Belle Jardiniere* and Leonardo's *Mona Lisa.* It shows as well as any painting in American art the unquenchable thirst of our artists and people for cultural achievement. The in-vention of the telegraph presages our equally great desire for predominance in the world of science and technology. Morse is a symbol of American success, even to this day, for the gap between the two cultures, between artistic and scientific prowess, is still there. We will become the great nation of our dreams only when that gap is finally closed and an American Leonardo finally appears.

THOMAS COLE

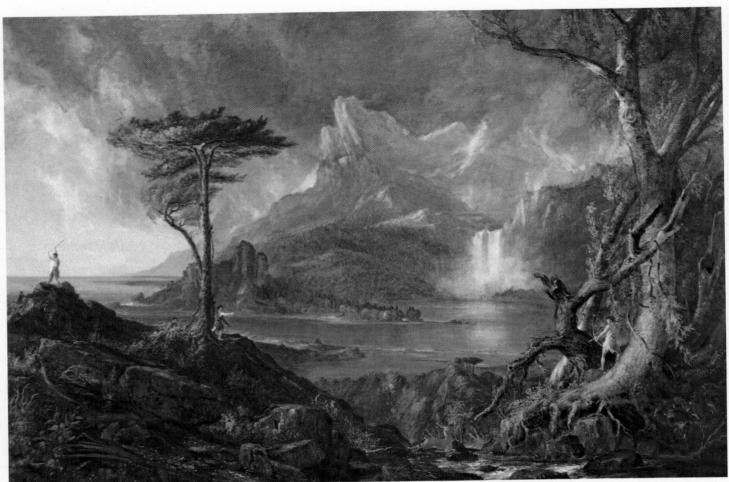

A WILD SCENE, *1831-32,*
Thomas Cole (1801-1848). 50½ x 76 in., oil.
The Baltimore Museum of Art.

American writers, such as Washington Irving and James Fenimore Cooper, saw and painted in words, not only the American dream, but its actual scenes before they came to the eye of its artists. It seems they were more inclined and willing to identify the new land as a separate entity with a life of its own apart from all foreign influences.

The early painters had been more concerned with portraying the men and women who were facing the wilderness and trying to make of it a counterpart of the civilizations from whence they sprung, or at least to model themselves on their foreign forefathers. The artists were also emulating European styles in painting. Perhaps it was due to a basic insecurity typical of a new nation's clinging to the best of the past while building a future that was better than either the past or present.

But there comes a time in the life of a people when insecurity decreases, and they can look at the reality of their present lives. And happily there always seems to be one man whom fate has determined to grasp the change in attitude of other men and to turn it into action for all. Such a man was Thomas Cole. He was, as Howard Merritt puts it, "In the entire history of painting in America. . .the most conspicuous example. . .of being the right man in the right place at the right time. . .we may legitimately see symbolized in Cole the emergent self-consciousness and self-confidence of the American artist."

Thomas Cole was an English immigrant to Philadelphia. But his art was born here, and he was the founder of our first completely native kind of art, the Hudson River School; yet he was not entirely prepared to accept the emerging program of that school as his own. There had been landscape artists before Cole — although not many — but it was the acceptance of his Catskill views by artists, such as Asher Brown Durand (p. 90) and John Trumbull (p. 30), and then by the art world that abruptly introduced a new and swiftly dominant theme into American art in 1825 and the years thereafter.

The Return, *1837*,
Thomas Cole. 39-3/4 x 63 in., oil.
The Corcoran Gallery of Art, Washington, D. C.

The Hudson River School, so named from the earliest scenes painted by Cole and Durand, turned the eyes of American artists and their public into the gorgeous, untamed American wilderness, a sight totally unfamiliar to European art, since that continent was thoroughly cultivated and tamed centuries before the art of painting discovered the landscape as subject. Cole and his followers, like the young Republic, were new under the sun.

Yet Cole's ambition was not content. He wanted to do large scale, historical allegory, carried through a series of paintings, as established in the very beginnings of modern painting by such early Renaissance giants as Giotto (1266-1337) and Masaccio (1401-1427?). In 1833 he got his chance. Luman Reed, a New York wholesale grocer and the first princely art patron in the United States, responded to Cole's prospectus and commissioned *The Course of Empire*, a series of five paintings on the theme.

Cole proposed — and painted — basically the same scene from slightly changing points of view as it progressed from wilderness through civilization to wilderness renewed, and he knew what he wanted: "The scene must be composed so as to be picturesque in its wild state, appropriate for cultivation, and the site of a seaport. There must be the sea, a bay, rocks, waterfalls, woods."

That is precisely the description of *A Wild Scene*, the first of the series. It called upon all of Cole's natural and developed gifts as a landscape artist, while at the same time setting the stage for the succeeding pictures: The third painting in the series, *The Consummation of Empire*, has the location all but covered with Graeco-Roman buildings; but by the last, *Desolation*, nature is returning, with vines covering columns and broken arches, and the distant mountain once again the dominant terrain feature. *The Course of Empire* was a remarkable and ambitious project for any artist, the more so for an American painter.

71

THOMAS COLE

The Oxbow, *1846,*
Thomas Cole, 51- ½ x 76 in., oil.
The Metropolitan Museum of Art, New York,
gift of Mrs. Russell Sage.

The Architect's Dream is surely one of the most roman-
tically and brilliantly conceived pictures of all time. It
ranks with Pieter Brueghel's *Tower of Babel* and Francisco
de Goya's *City on the Rock,* with Giovanni Piranesi's
Prisons and "Mad" John Martin's *Balthazar's Feast.* The
Metropolitan Museum describes it as "more than an
amusing period piece, it is an exciting study in gigan-
ticism," a reasonable definition of the American Dream.

The great series he did for Luman Reed, *The Course of
Empire* (p. 70), turned Cole's mind increasingly to archi-
tecture. The *Dream* was his purest venture in the field, for
foliage appears only as decorative borders and plantings.
The picture was commissioned by Ithiel Town, of Town
and Davis, America's first truly professional architectural
firm, creators of, among other buildings, the Wadsworth
Atheneum in Hartford, Connecticut, one of this country's
oldest museums. Town was not happy with the picture,
and Cole recorded his own irritation at the patron.

Cole warned his fellow artist, Asher B. Durand, to
"beware how you paint for the same patron." He goes on
to say that, "After painting him a picture as near as I could
accommodate my pictorial ideas to his voluminousness. . .a

picture of immense labor. . .he expects me to spend weeks
in pursuit of the uncertain shadow of his approbation."
Town expected another picture, a hodgepodge of "rich
and various landscape history, architecture of different
styles and ages, etc. . .or ancient or modern Athens?"
Somehow one feels closer to the idealist Cole when you
see him as just another indignant human being confronted
by an impossibly demanding employer.

Despite all this, the picture remains not only an elabo-
rate tour-de-force of architectural assemblage but actually
a kind of prophecy of the course of American public archi-
tecture for close to a century after this 1840 painting.

Harkening back to the convention of an earlier genera-
tion of history painters, Cole framed his vision with an
elaborately carved column of his own design, almost
completely hidden by a great double swag of billowing
drapery. This great curtain is drawn back to reveal the
central motif of the painting, the key to everything else —
and quite possibly the thing Town objected to most — the
figure of a reclining architect, draped himself over four
man-size volumes of plans and details, one hand holding a
large architectural design. The figure and its supporting

72

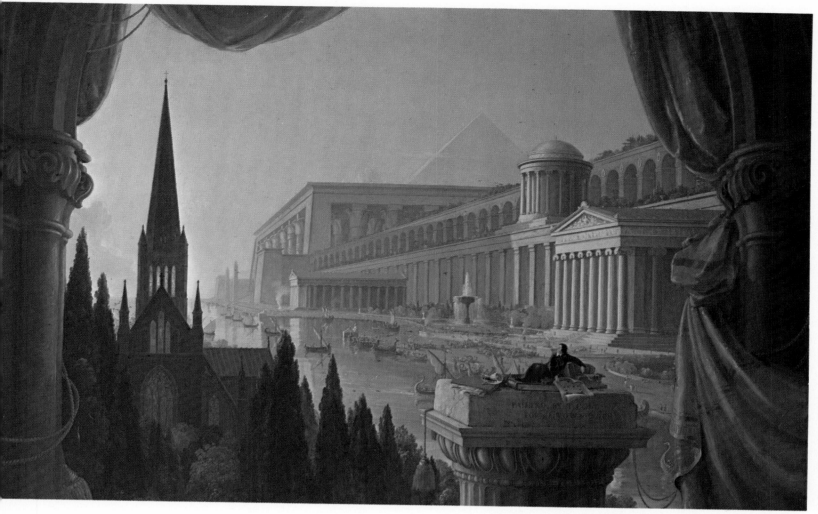

THE ARCHITECT'S DREAM, *1840,*
Thomas Cole (1801-1848). 54 x 84 in., oil.
The Toledo Museum of Art, gift of Florence Scott Libbey.

books are all supported by a large block of marble incised with the names of Cole and Town and the date.

All of this, however, column, marble block, giant tomes, is but prelude to the architect's dream: As he gazes out over one shoulder from his lofty perch, he sees an even loftier vision. Beneath him, not precisely defined, is a body of water bearing vaguely antique boats of a Phoenician-Roman design. Their harbor is a broad avenue in front of a huge temple with Ionic columns resembling the Parthenon in Athens. Beyond that are walls, a fountain, a Roman aquaduct, arches and, stretching up into and merging with the blue of the sky, there is the lofty outline of an Egyptian pyramid.

The overall vision is breathtaking in its sweep and scope and makes more than clear that, despite his importance as the discoverer of the American landscape, Cole was more than able to hold his own as a romantic visionary of history's glories. As things worked out, his past was also the nation's future. The nineteenth century saw all these styles proliferate across the land and as recently as the late 1930's.

So *The Architect's Dream*, like *A Wild Scene*, can be interpreted as a prophetic picture, the artist foreseeing

accurately, if only in broad general outline, the future. But is not he saying something more? Is not the artist saying to us that the rift between the past and present and the future is too great for the present to deal with, and that continuity, survival, sensibility are our only hope for survival, continuity and sensibility?

Is it possible Cole was a prophet of unparalleled insight? Was he saying, apart from our conjecture, that civilizations self-destruct? Was he anticipating the terror of modern man that progress from savage to civilized to savage, his struggle for survival, was at the heart of any nation's course of empire? Was his theme at the beginning the glorification of innocence and, at the end, its destruction the same hands — the forces of nature?

Cole wrote, "All nature here is new to art. . . .In looking over the uncultivated scene, the mind may travel far into futurity. . .on the gray crag shall rise the temple and the tower." This remark separates the two careers of Thomas Cole as nothing anyone else can explain or say: the pure, deeply observed landscapes and the equally pure, profoundly felt allegorical compositions.

GEORGE CATLIN

PIGEON'S EGG HEAD, *1832*, *George Catlin (1796-1872). 27¾ x 23 in., oil. Courtesy, National Collection of Fine Arts, Smithsonian Institution.*

We might never have known much about our native Americans as they were in their life before the white man had it not been for two remarkable artists. These two men were of such dissimilar backgrounds and temperaments it is difficult to realize they lived at the same time and that within the same few years they recorded an Indian way of life that was to disappear almost immediately. These two are, of course, George Catlin and Karl Bodmer (p. 80).

Catlin was an American, Bodmer a Swiss. Catlin was born in Pennsylvania in 1796 and knew the story of a bloody Indian raid near his home during the American Revolution. Survivors still told tales of those perilous times, and Catlin later wrote, "My young imagination closely traced the savage to his deep retreats and gazed upon him with dreadful horror, till pity pleaded and imagination worked a charm."

After an untrained and largely unpromising apprenticeship painting minatures and portraits, he resolved to do for the Indians what the great Charles Willson Peale had done for natural history in his Philadelphia museum (p. 38). Catlin had seen this collection and the Indian leaders who visited that city as early as 1824. He determined to found his own Museum of Indian Life, to visit them in their natural surroundings, to record their ways and to "snatch from hasty oblivion . . . a truly lofty and noble race."

Temperamentally Catlin was the ideal mixture of rugged eccentric, daredevil adventurer, romantic historian and prophet of the doom of a great people. He is an authentic American hero. In 1832, at the age of thirty-seven, he set out on the steamer *Yellowstone* up the Missouri River where he visited forty-eight tribes.

From the enormous output of work — over five hundred paintings in seven years — *Pigeon's Egg Head* deserves special note, for it shows us Catlin's interest in the individual character of an Indian.

Catlin met Pigeon's Egg Head on the *Yellowstone* and gives us a remarkable double portrait of the Indian before and after the white man's corruption. Catlin, who gained considerable fame for his writings such as *Letters and Notes on the Manners, Customs and Conditions of the North American Indians*, published in 1841, tells of the Indian's visit to Washington in 1831 and his return to his country shorn of his beautiful Indian dress and wearing a colonel's uniform. Pigeon's Egg Head, the son of an Assiniboin chief, was proselytizing for the whites, but he was accused of lying and was put to death by his own people. Even in the attitude of the figures, Catlin suggests the tragedy of this tale. The noble Indian dignified in his feathers looks straight at a world he understands and commands. The other is a caricature of what happens to those who betray their native tradition. The artificiality of the pose, the affectation of the stovepipe hat with a feather in it, the umbrella and the final insolence of the cigarette foretell the future Indian as a mock native American.

Overleaf, see pages 76-77

As an artist George Catlin was almost a primitive. His Indian scenes and portraits seem naive, yet one feels unmistakable realism in every report of what he saw. He was the first artist to open American eyes to the beauty of Indian life, Indian country, Indian people. Many of his contemporary critics, while admitting the validity of his subject matter, disparaged his techniques, but that great French critic, Charles Pierre Baudelaire, confounded the "rumor that he was a worthy man who could neither paint nor draw," adding, when he had seen Catlin's paintings in his Paris exhibition, "Mr. Catlin has rendered in a superior manner the proud and free character and noble expression of these good people.... As to the color, it has something of the mysterious that pleases me more than I can say."

With the painting *Bull Dance*, *Mandan O-Kee-Pa*, Catlin has brought to life a solemn, ritual function in a brilliant rendering of this picturesque ceremony.

The Mandans in whose villages Catlin spent the winter of 1832 were not a nomadic tribe. They did not go out in search of the buffalo, but performed elaborate ceremonial dances to bring the herds within their range. The Buffalo Dance, also recorded by Catlin, went on for months, until the animals appeared. The ceremony shown in *Mandan O-Kee-Pa* was very like the Buffalo Dance, but more elaborate and solemn. Witnessed by the entire village and repeated several times over a four-day period, the Bull Dance was performed by twelve men around a sacred altar, a large barrel-like structure in the center of the public area, called the "big canoe." Eight of the dancers wore buffalo skins and imitated the movements of the animal and each carried a rattle and a long, white staff. Between each pair of these eight was another dancer with a beautiful headdress and an apron of eagles' feathers. Two of these, called "the night," were painted black and were dotted with white "stars." Two were painted vermilion, called "the day," and were streaked with white "ghosts which the rays of the sun were chasing away."

The composition is extraordinary — the domed mud huts breasting against the prairie sky, the tall poles topped with spirit symbols, and the entire picture alive with figures dancing or watching the spectacle. Catlin makes us beholders of this activity with economical, almost shorthand notations of the figures and costumes. One is reminded of the great debt we owe Catlin, for a smallpox epidemic all but completely destroyed the Mandans a few years after his visit.

The artist left America in 1839 and took his paintings to many lands with missionary zeal to promote concern for the noble savage. Catlin was a real showman, creating a sensation wherever he appeared, usually in Indian costume, to display his paintings. The Europeans took to him immediately because he fulfilled their fascination with the romantic life of the noble savage, thus enabling them to escape into his pictures and away from mediocrity.

Unfortunately the Indians were doomed by white aggression as the West was won. They and the buffalo lost their world as the white man's fences crisscrossed their land patterning a new nation. But Catlin gave us many

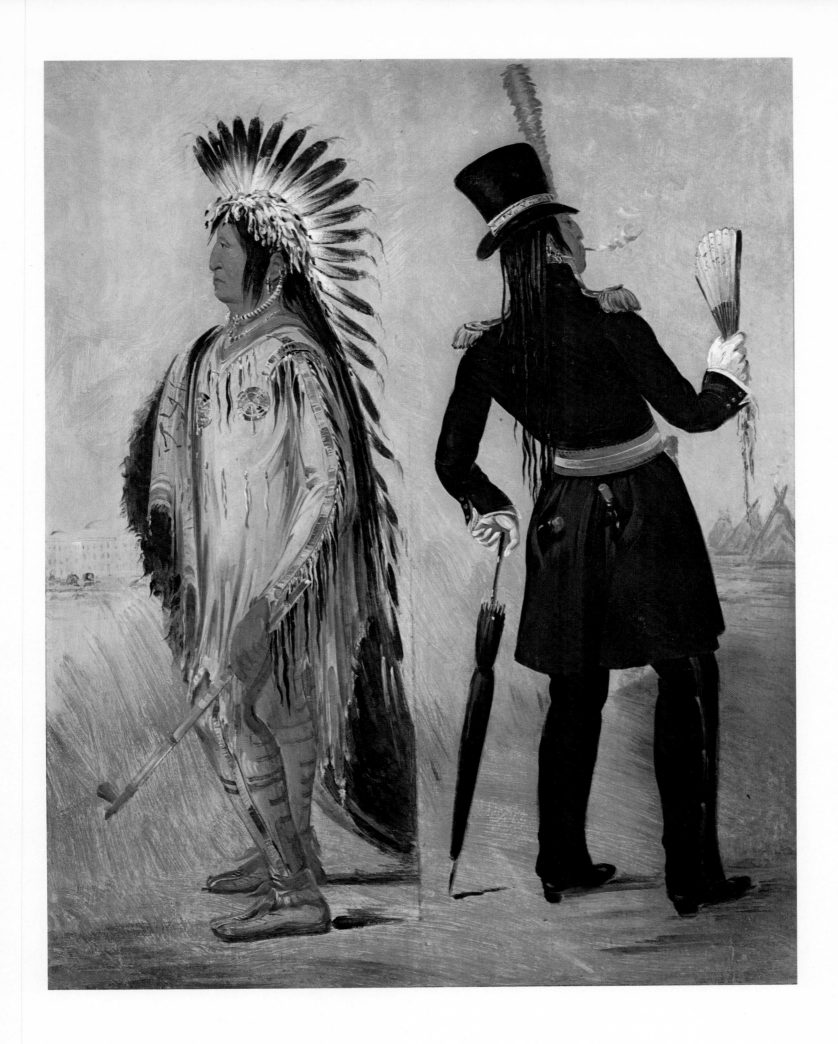

unforgettable memories of Indian grandeur, and his paintings keep alive a part of our history sadly lost forever.

Catlin tried to sell his collection to the nation, but in spite of Daniel Webster's support for the idea in the U.S. Senate, he failed. As it turned out, the Smithsonian Institution where they would have hung burned, and many of his rivals' — those by Charles Bird King (1785-1862), Seth Eastman (p. 86), and John Mix Stanley (1814-1872) — were destroyed. When the nation finally acquired the Catlin collection in 1879, it was almost intact and thus he was and remains the most important artist-reporter of Indian life.

THE BULL DANCE, MANDAN O-KEE-PA, *n.d.,*
George Catlin (1796-1872). 22⅝ x 27⅝ in., oil.
Courtesy, National Collection of Fine Arts,
Smithsonian Institution.

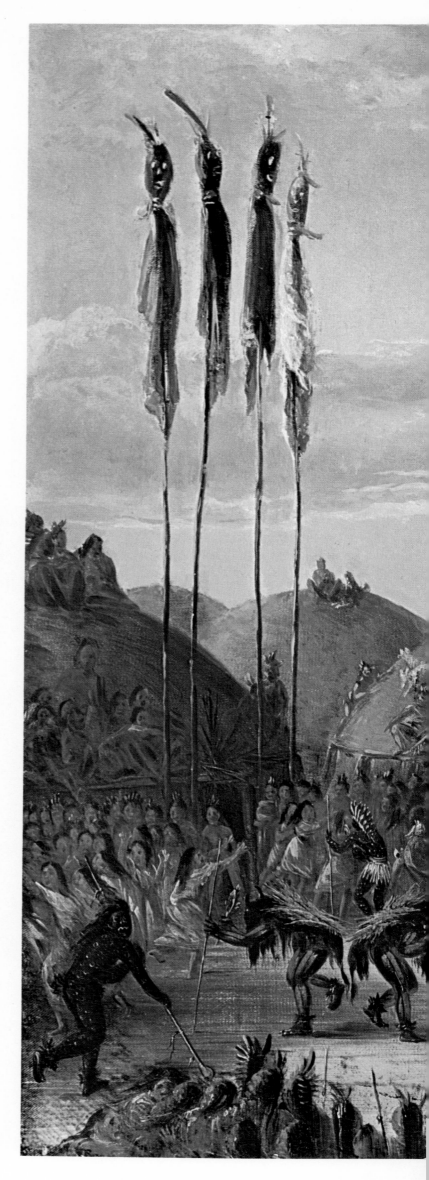

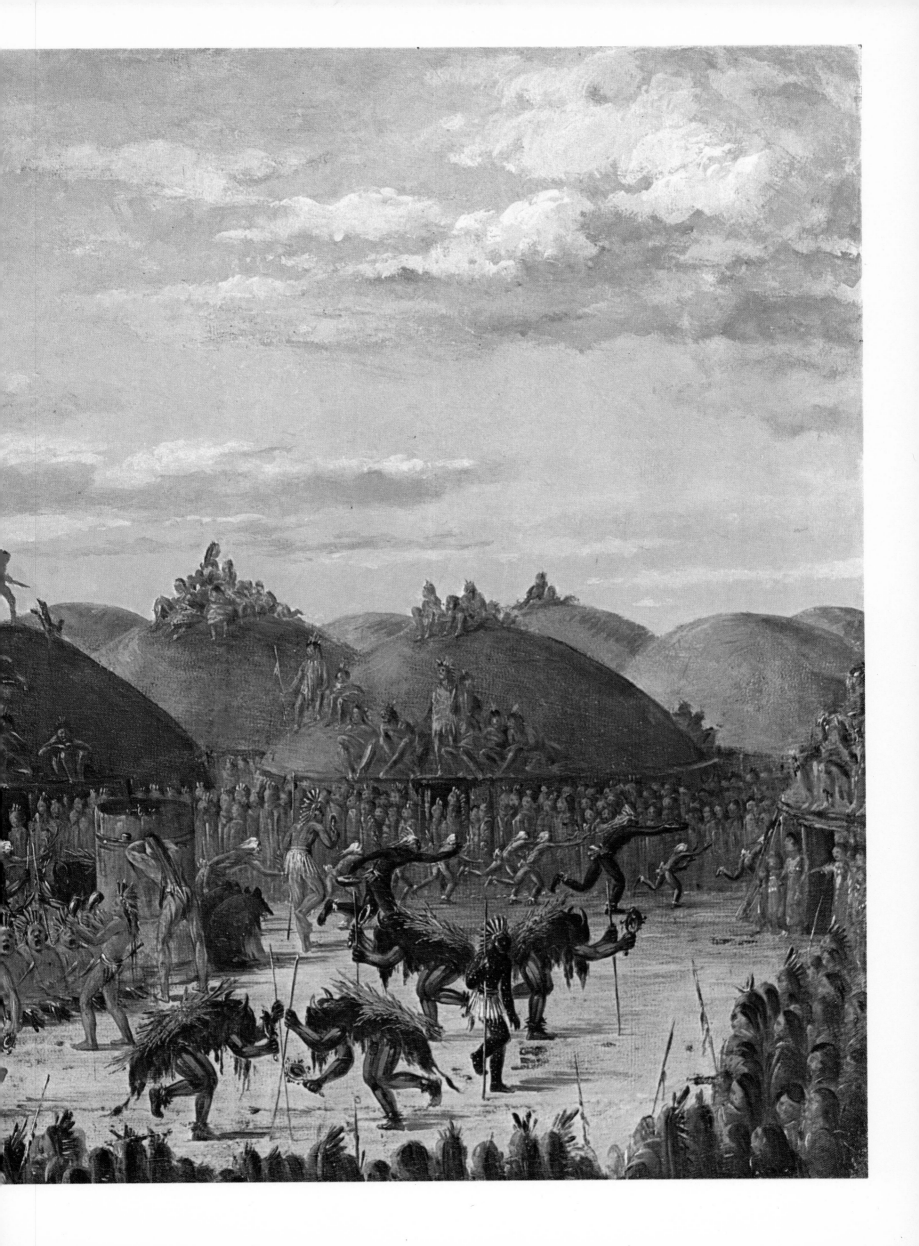

ALFRED JACOB MILLER

We have had at least two triumvirates among painters of the West — Remington (p. 196), Russell (p. 181) and Schreyvogel (p. 188), painting at the end of the last century and the beginning of the twentieth, and earlier, Karl Bodmer (p. 80), George Catlin (pp. 74-77) and Alfred Jacob Miller, the recorders of Indian and frontier life. Miller, like the others, spent only a short time in the West, and it was for him as for them the great adventure of his life. Like Bodmer, after leaving the West, he abandoned interest in the subject and became a respectable if dull painter elsewhere. But Miller's hour of glory equaled the others' and each has his own special appeal.

Catlin's missionary zeal saw him over his lack of technique, and he fascinates us with his reportorial immediacy. Bodmer was a true technician, a scientist, and the beautiful detail of his sketches gives us the thrill of truth. Miller's approach was an adventurous and joyous telling of a tale we cannot hear too often and, therefore, perhaps, the one that most completely satisfies the average viewer. James T. Flexner says, "His task was to record, for future transcription into large oils, a miraculous holiday."

He was born in Baltimore in 1810, and studied with Thomas Sully (p. 56) for two years, the same years Catlin and Bodmer were working among the Indians, 1831-32. His ensuing two year stay in Paris and Rome introduced him to the first flush of romanticism, especially as painted by Eugène Delacroix (1798-1863). The exoticism and dash of Delacroix's talent impressed Miller, and the emotion and color of the romantic artists crept into Miller's vision, too. Back in America, he moved to New Orleans where he met a nostalgic Scottish nobleman and veteran of the Napoleonic Wars, William Drummond Stewart. Stewart was reluctant to give up the glamor of his military life and sought to recapture it among the noble savages of America. He hired Miller, much in the same way Prince Maximilian had hired Bodmer, to accompany him on his last voyage to the West. Miller was twenty-seven and a fun-loving fellow used to the good life of the cities. No outdoorsman, he wrote home of the aggravations of the rough life, yet he knew he was sharing an exciting experience. Through the Scotsman he came to know many of the great trappers and Shoshoni chiefs of the frontier. Together they followed the fur traders out of the Rockies and back to civilization, witnessing and probably joining some of the festive rendezvous when the traders met to show their catch.

It is obvious from his many sketches and surprisingly free watercolors that he relished this unparalleled adventure. His scenes have a dash about them and his people a romance that is more lively than his fellow artists Catlin's and Bodmer's. They were intended to be mere preliminary sketches and thus escape the belabored feeling of his later oils. They represent a city man's reaction to the West and they also show an artist's sense of something unusual seen once and perhaps never to be seen again. Art school precepts fall to the side in favor of pure and sensuous vision. The arcadian quality of his genre scenes are frankly charming, and as Flexner says, "no more startling example exists of how overwhelmingly subject matter influences mid-nineteenth-century American paintings.... He brought to everything a young man's enthusiasm, that optimism which was in those pre-Civil War days characteristic of American art and life."

The Trapper's Bride records an actual event when a half-breed trapper bought an Indian girl from her father for six hundred dollars worth of trade goods. It is one of Miller's most popular subjects and one he reproduced many times in later years. It was done back east from one of the 166 watercolors he made during the 1837 trip.

Between Catlin, Bodmer and Miller we are privileged to see a time that will never be again, a time of the high romance and one we have lived off of ever since. As industrialization and speed of travel cut the world down to a place too small and far too unvaried, we look to these men to show us not only how life was different for them, but how through their art it can be different for us.

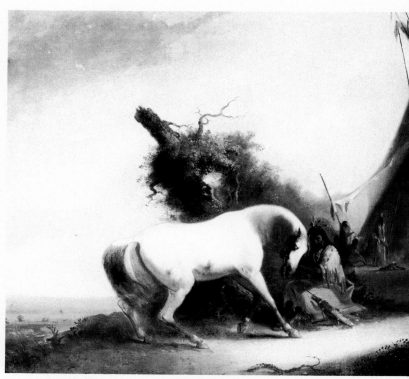

Shoshone Indian and Pet Horse, *ca. 1845,*
Alfred Jacob Miller. 20 x 26 in., oil.
The Peale Museum Collection, Baltimore.

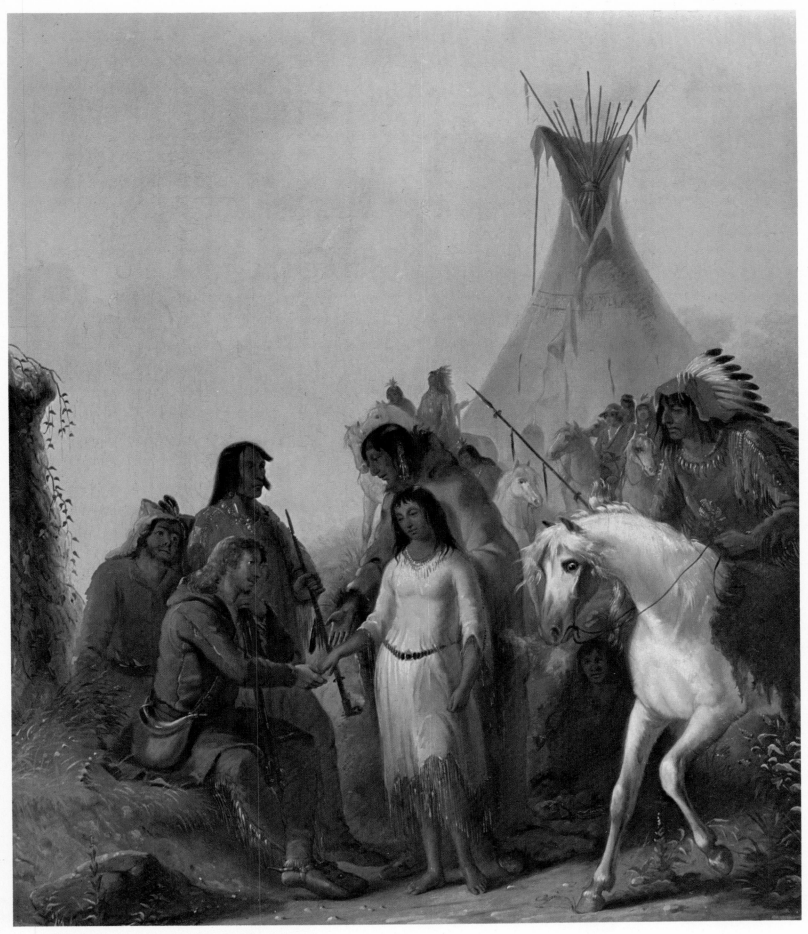

THE TRAPPER'S BRIDE, *1837,*
Alfred Jacob Miller (1810-1874). 25 x 30 in., oil.
Joslyn Art Museum, Omaha.

KARL BODMER

Karl Bodmer did not have the untamed personality of George Catlin (pp. 74-77), but the spirit of adventure was in him nonetheless. Imagine being given the opportunity to see the wild, wild West back in 1832. Just the trip across the Atlantic was a challenge. But for a budding young artist with a very civilized Swiss and Parisian upbringing and a great thirst to practice his already developed technical artistry in virtually unexplored country, it must have been a real adventure. In addition, he had been chosen to accompany one of the princely explorers of the age and to record the expedition — a high adventure indeed.

Bodmer and Prince Alexander Maximilian of Wied-Neuwied took off on their expedition on the same famous riverboat, the *Yellowstone*, almost exactly a year after George Catlin had sailed on its maiden voyage. They explored much the same country and even went further than the American, penetrating well into what is now Montana. Bernard de Voto in his book, *Across the Wide Missouri*, says of Maximilian's book, *Travels in the Interior of North America*, illustrated by Bodmer, that "a very great deal of American ethnology . . . rests solidly on it."

Young Bodmer was a far more talented artist than Catlin. He was a brilliant anatomical draftsman and his

approach to art and life was more sophisticated. He made his on-the-spot notes with the knowledge that they were to be translated into Maximilian's book in the form of engravings, therefore his color notes are true and give the hand-tinted engravings a biting reality and majesty. In his skilled observations, Bodmer may have missed some of Catlin's humanity, but it would be difficult to deny that Bodmer gave us more evocative pictures of Indians and Indian life.

Pehriska-Ruhpa, Moennitarri Warrior in the Costume of the Dog Danse is magnificent. Bodmer shows us the savage stereotype, and great love is labored on the ethnographically significant costume. But one does not feel the sympathy that Catlin felt for his sitters. After all, Catlin's approach was a deep-seated conviction of the humanity of the people, while Bodmer's was a scientific report. Catlin spent seven years among the Indians; Bodmer was in the West for two years.

After Maximilian's expedition ended in 1834, Bodmer returned to Europe to become a distinguished member of the Barbizon School. Basking in the gentle natural mood of the Barbizon painters was far removed from the harsh realities of life on the bleak but beautiful Western plains. One cannot help wondering if Bodmer ever longed to go back. Probably he did not, but despite his sophistication, perhaps there were times when he opened to his illustrations and let them conjure up for him the romantic nostalgia they represent for us today.

Fort MacKenzie, 28th August 1833, *1844,*
Karl Bodmer. 16 x 21-¼ in., colored lithograph.
Rare Books Division, New York Public Library.

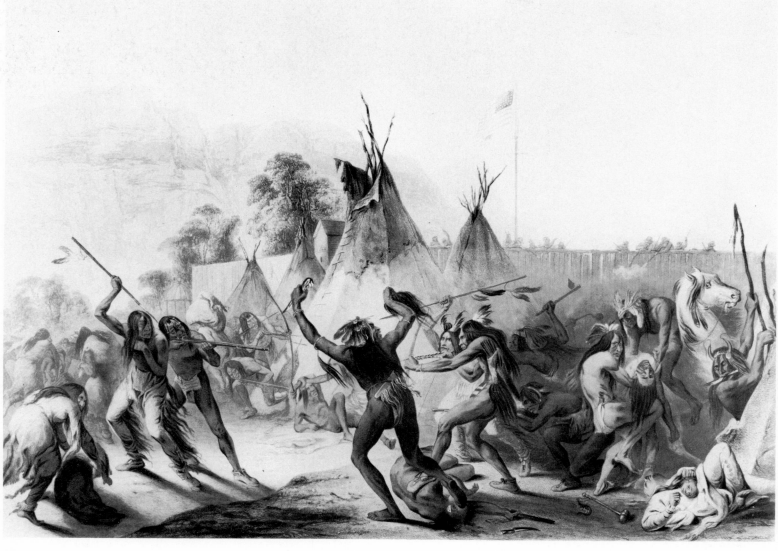

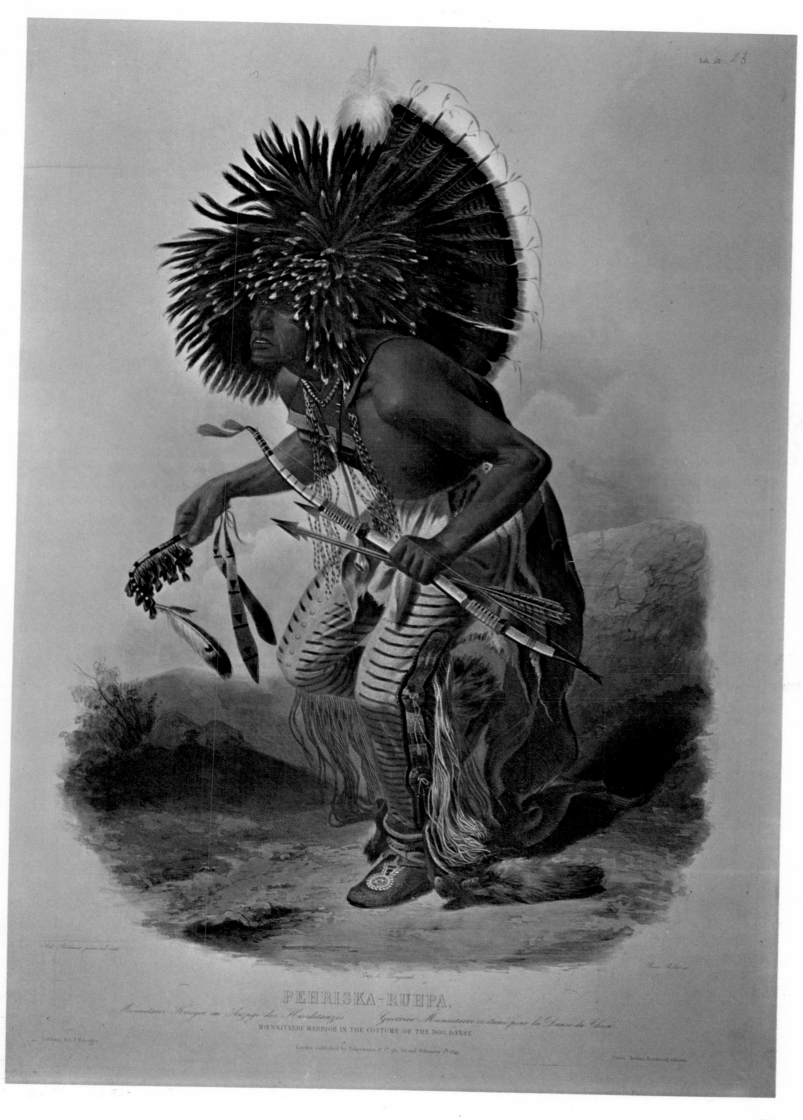

Tab. 23

PEHRISKA-RUHPA.

Moennitarri Krieger im Anzuge des Hundetanzes Guerrier Moennitarri costumé pour la Danse du Chien

MOENNITARRI WARRIOR IN THE COSTUME OF THE DOG DANSE

London, published by Ackermann & Co. 96, Strand, February 1st 1843

HENRY F. DARBY

The Reverend John Atwood and His Family is one of those rare paintings that is without any conceits or fancy whatsoever. It is so genuine a portrayal of exactly what the artist saw that the viewer feels he is an eyewitness to its creation rather than a mere observer of the finished product. There is no question about the truth of the statement made in this work by the artist, and as you come to know the people in the picture, the truth about them is quite evident, too. The biography of both artist and sitters is a peek into an area of American creativity and dedication to purpose we all too seldom are allowed to share.

Fortunately, when this picture entered the M. and M. Karolik collection in the Museum of Fine Arts in Boston, an unexpected amount of information came with it, though neither sitter nor painter were of world-shaking renown. Reverend Atwood was a Baptist minister born in New Hampshire in 1795 and educated in Maine. He settled in Concord, New Hampshire, where he served his church and was chaplain at the state prison. He also held the office of state treasurer. In 1850 he was nominated by the Democratic Party for Governor of New Hampshire, but the platform was pro-slavery so he refused to endorse it and was rejected. He returned to his original parish in New Boston where he became "a pillar of strength in church and community, supporting every worthy cause until his death in 1873."

His wife was Lydia Dodge, a member of his Baptist congregation, who married her pastor shortly after he was ordained as minister of the church. Her home was "a paradise for children," her own, her grandchildren and her friends'. She died at eighty "with natural force and faculties unabated." The children from left to right are Solomon Dodge, Mary Frances, behind them Ann Judson, Sarah Elisabeth, Lydia Dodge and Roger Williams. Sarah Elisabeth, the second oldest, lived until 1916. We know all this because the portrait hung in the family home for one hundred years, and its history was handed down by its final owners, the daughters of the youngest son of Reverend and Mrs. Atwood.

And we know more; of the two pictures on the rear wall, one is a "weeping willow" memorial picture, a type common in its day, inscribed with the names of two sons who died in infancy. The other is a mezzotint by the English engraver, James S. Lucas. We can see for ourselves the brown ornamental wallpaper, the stenciled floor that saved the cost of a rug, the flowers, the gold-framed mirror and, to modify my original remark, the picture's one conceit or purely fanciful item, the almost baroque fantasy of the reddish brown curtain that blows in from the window.

In all, we have a revealing picture of the life of a family which might never have been permitted us had it not been for our artist who lived in the family for a few months in

The Hollingsworth Family, 1840,
George Hollingsworth (1813-1882). 42 x 72 in., oil.
Courtesy, Museum of Fine Arts, Boston, Karolik Collection.
The painter Hollingsworth, a contemporary of Darby's also from Massachusetts, stands to the left behind his parents in this painting, formerly called New England Family Group.

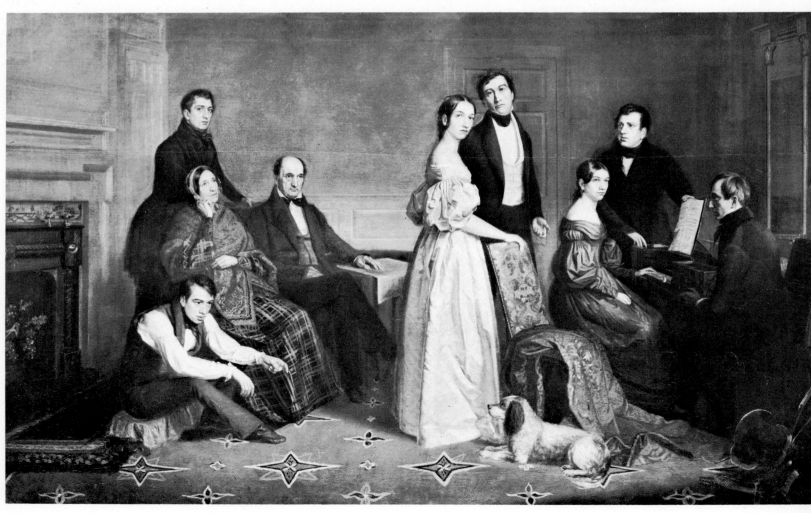

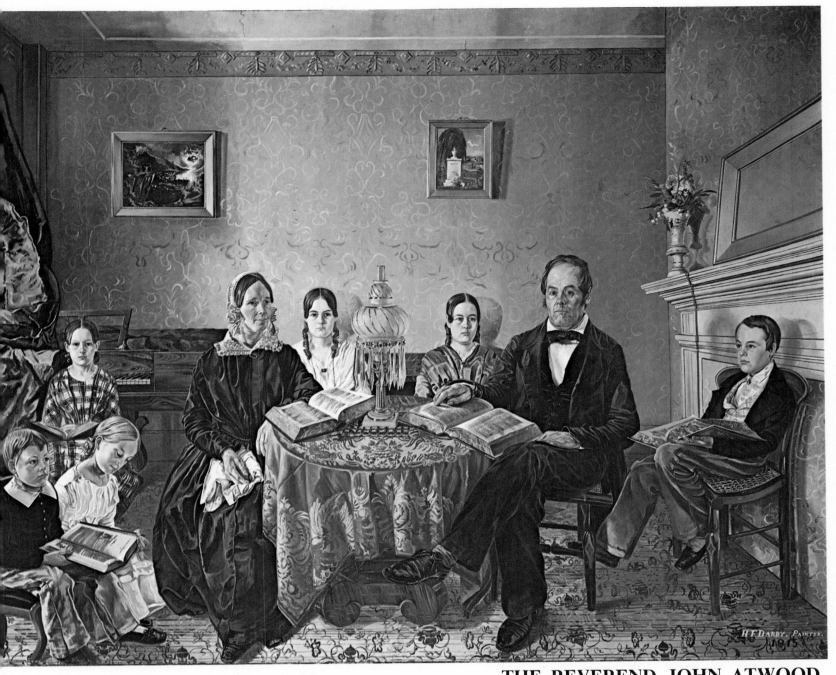

**THE REVEREND JOHN ATWOOD
AND HIS FAMILY,** *1845,*
Henry F. Darby (1829-1897). 72 x 96¼ in., oil.
Courtesy, Museum of Fine Arts, Boston.

the summer of 1845. Good solid, large families like this, especially of men of limited income like preachers, could hardly afford such a portrait, even if their sternness of character would tolerate such an image being taken. But luckily for us, the artist came to visit this friendly family and for the grand sum of fifty dollars painted "the father. . .sitting in the midst of his admiring wife and children, expounding the Bible." The artist, Henry F. Darby, was sixteen at the time.

At sixty-five Darby wrote a short biography for his only daughter. He tells of his background: "It would be difficult to find a spot where there was such destitution in aids to art as the place where I was born," North Adams, Massachusetts. He learned his artistry himself with occasional glimpses of accepted sytles from itinerant artists.

He tackled his first portraits at twelve and was so self-developed in his art by fourteen that he painted his first family group, his father's family. He was a true prodigy, and what would have happened to him and his art had his interest not dwindled, perhaps in pursuit of a better living, we cannot conjecture. At thirty-one after the death of his wife, he entered the ministry. He worked with the great photographer Mathew Brady, and perhaps the sudden popularity of photographed portraits rather than painted ones put him off. Perhaps his talent, having come to such charming fruition so early, just did not have the support needed to develop and last. But this in no way diminishes this masterpiece, for when we look at *Reverend John Atwood and His Family* we can be grateful to Henry Darby, age sixteen, for giving us a lasting friendship with some of the sturdier relatives of the family of man.

83

EDWARD HICKS

Edward Hicks is probably the most famous of the nineteenth-century primitive painters. He had a certain local fame in his own time — else why would he have done almost one hundred renditions of the same subject, his beloved *Peaceable Kingdom*? But his present prominence began as late as 1932 after he had been dead over eighty years. Only a modern interest in folk art brought him and others like him out of obscurity, released by the 1932 exhibition in the Museum of American Folk Art in New York. From that point, art historians began to piece his interesting life together until now we have a fairly clear idea not only of his art activities but of the rest of his life that comprises a story of an early nineteenth-century American artist that is quite different from that of others.

Hicks started his career as an artist by sign painting; he was much sought after, and it is said that every inn or tavern in Bucks County, Pennsylvania, of an established reputation sported one of his signs — a Declaration of Independence, or a George Washington on Horseback or his favorite subject, William Penn's Treaty with the Indians. By his own admission, painting was the only trade he knew, but even success could not keep him from deprecating it as not being man's real work. It was merely a useful craft. He thought it "an insignificant art which has never been of any substantial benefit to mankind." Being a Quaker minister, he regarded himself as craftsman rather than an artist, thus somewhat explaining his remark about art as "the inseparable companion of voluptuousness and pride," which, "has presaged the downfall of empires and kingdoms."

It was this personal conflict between art and religion that occupied much of his thinking. He was more famous

The Peaceable Kingdom, *1844,*
Edward Hicks. 17-½ x 23-½ in., oil.
Abby Aldrich Rockefeller Folk Art Collection,
Williamsburg, Virginia.

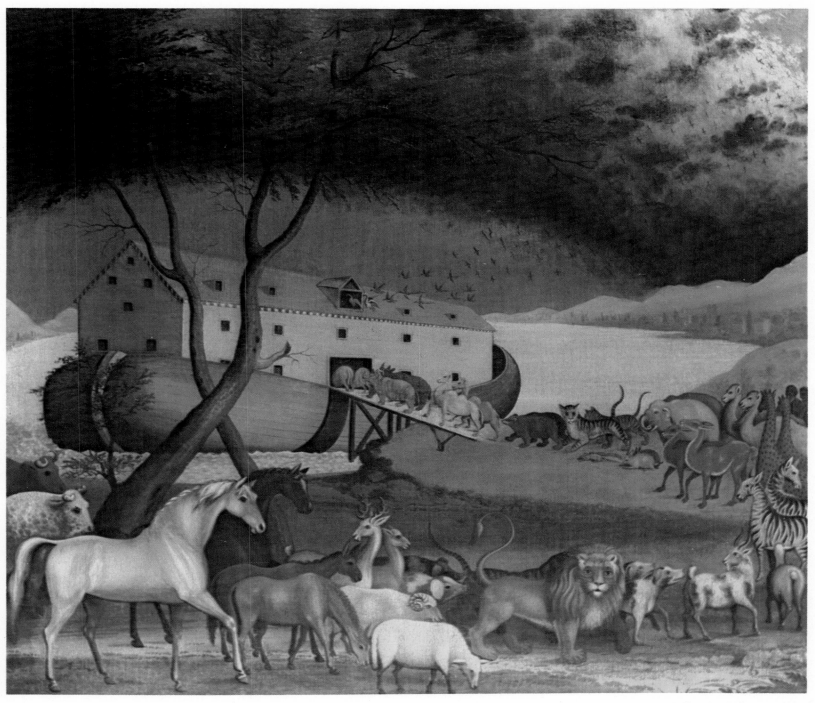

NOAH'S ARK, *1846,*
Edward Hicks (1780-1849). 26½ x 30½ in., oil.
Philadelphia Museum of Art, bequest of Lisa Norris Elkens.

in his time as a preacher than an artist and was enormously in demand for all church functions. Three thousand people attended his funeral when he died at the age of sixty-nine, but they were there to pay homage to the beloved man of God rather than the man of art. His deep religious convictions stemmed from his adoption by a Quaker family after his mother died and his father was left penniless following the Revolution. At the age of thirteen he was apprenticed to a coachmaker where he specialized in painting. Hicks went through a frivolous period, but with the moral admonitions of his parents always before him — "never act contrary to your conscientious feelings, never disobey the voice of eternal truth in your soul" — he gave himself over completely to the Quaker religion. He tried his hand at farming but went back to his craft as "the only business I understood and for which I had a capacity." Since he served the Quakers free, he had to make a living.

It was late in his life that he took to truly creative painting, and our charming *Noah's Ark* is from this time. It was based on an 1844 print by Nathaniel Currier of Currier and Ives fame. In his *memoirs* Hicks joked he was a smarter workman than Noah in that he could build the ark faster. The little American village in the background, the birds coming into the ark like modern airliners, the lion who is a fugitive from the *Peaceable Kingdom* and who is brought into relief by a striped creature behind him presumably his mate — each make a naive perfection. But best of all I love the Ark itself: It is so obviously a Pennsylvania barn built onto a wooden shoe. It is really no wonder at all that whenever a Hicks painting appears in an exhibition or museum it is the center of attraction. Such honesty is a rare thing in art. Hicks is an original and as such refutes criticism and evokes only pure joy from the casual observer or the expert.

SETH EASTMAN

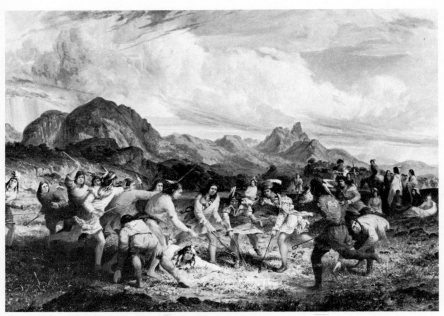

Lacrosse Playing Among the Sioux Indians, *1851,*
Seth Eastman. 28-¼ x 40-3/4 in., oil.
The Corcoran Gallery of Art, Washington, D. C.

Seth Eastman is representative of the kind of artists who collectively comprise a substantial part of American art — the dispassionate artist-reporters. His standing is between the charming, romantic view of Alfred Jacob Miller (p.78) and the spectacular show of George Catlin (pp. 74-77) on the one hand, and the factual but selective reporting of Karl Bodmer (p. 80) on the other. Eastman spent more time among the Indians than any other painter, a fact which certainly made his knowledge of them less romantic and more detailed. His paintings were not memories recalled in an Eastern studio, for he lived seven years with the Chippewa and Winnebago Indians at Fort Snelling, Minnesota, and his various military assignments took him into action against several tribes of Sioux, Chippewa, Winnebago, Commanche and Seminole Indians.

Eastman was first and foremost an army man, from his early years in the old Northwest Territory to his last years as Brigadier General and commissioned artist for the House Committees on Indian Affairs and Military Affairs. Yet he was dedicated nearly as long to his avocation — art.

His art instruction began apparently along with his military training at the U. S. Military Academy at West Point. Eastman was on the frontier in 1829, even before Catlin, and during his early army life was an Indian fighter. As he gained military promotions he also gained artistic skills, teaching drawing at West Point and exhibiting Hudson River-style landscapes regularly at the National Academy of Design. His paintings of Indians, for which we remember him, began during those seven years on assignment at Fort Snelling. There, his own and his wife's deep interest set him about recording what he knew of Indian life. Eastman depicted, with little or no intended drama, the daily work of hunting buffalo and fish, preparing skins, gathering wild rice, playing ball or checkers, burying the dead, courting a wife, breaking camp, practicing medicine and a score of other commonplace affairs. Interestingly, he made few paintings of actual war scenes and comparatively many of the non-violent and, particularly, medical procedures of Indian daily life.

Modern critics are at complete variance in their estimation of him. James T. Flexner can find nothing but contempt both for Eastman's feelings about the Indians and his portrayal of them. He says "his plates mingled bored reportage with polite genre and historical reconstructions to produce Indian pictures which can only be described as loutish."

Others are more kind; some are enthusiastic. John F. McDermott explains that, "The picturesque, the strange, the novel were not for him: his business was with the ordinary, the actual, the scenes and occurences of the daily world. . . . He became the most effective pictorial historian of the Indian in the nineteenth century." In two words here we can perhaps explain Flexner's objections: *business* and *pictorial*. Eastman was not the adventurer-idealist that Catlin was, nor did he claim to be. Nor was he a trained artist like Bodmer. His art schooling had been at the Military Academy as a topographical draftsman.

Eastman's feelings about the Indian people seemed to have changed during his life among them. In 1853, at the publication of his major work, *American Aboriginal Portfolio*, he wrote that the Indian braves were ruled by "ungoverned passions" and the squaws by "superstition and degradation." How the Indians could have been otherwise after their humiliation by the white man does not seem to temper his statements. But perhaps these were the feelings of an Indian fighter, who, when he turned artist, according to his wife, "spoke their language well They looked upon my husband as their friend, and talked with him freely on all subjects, whether of religion, customs or grievances." Eastman knew them as they were — cruel and proud, treacherous and impressive.

Mrs. Eastman may have been a softening influence on her husband. She was a knowledgeable writer about Indian life and very sympathetic to the people. Her work, *Dahcotah; Life and Legends of the Sioux around Fort Snelling*, completed before she left Minnesota in 1848, is said to have inspired Longfellow to write *Hiawatha*. From all this we are assured that Eastman had plenty of opportunities to study the Indians firsthand and the time to paint the ordinary truths about them. Certainly his paintings are not anti-Indian nor are they romanticized. As he continued in his recordings of Indian life, his wife wrote that it became "not a mere occupation; it became a passion with him."

Mrs. Eastman describes our painting, *Chippewa Indians Playing Checkers*, as "likenesses of two Chippeway Indians who were kept for a long time in the guard house at Fort Snelling. They passed their time playing cards, checkers, smoking." His technique has been criticized by some as being no better than Catlin's and just as static, and nowhere does he achieve Catlin's spiritedness. McDermott, however, finds him, "more faithful in his transcription and more natural in his presentation." He adds accuracy and knowledge to our picture of the Indians with his careful depictions of the commonplace aspect of their lives which offer viewers a healthy and truthful balance to the artists who emphasize the more sensational side. He is a worthy member of the small band of men with diverse interests and styles who have enabled us to have a remarkably well-documented and complete record of early nineteenth-century Indian life.

CHIPPEWA INDIANS PLAYING CHECKERS, *ca. 1848,*
Seth Eastman (1808-1875). 30 x 25 in., oil.
Collection of Mr. and Mrs. J. William Middendorf II, New York.

JUNIUS BRUTUS STEARNS

**THE MARRIAGE OF WASHINGTON
TO MARTHA CUSTIS,** *1849,
Junius Brutus Stearns (1810-1885). 40½ x 55 in., oil.
Virginia Museum of Fine Arts, Richmond,
gift of Edgar William and Bernice Chrysler Garbisch.*

There is something immensely endearing about the historical paintings of Junius Brutus Stearns. They are like witnessing ultrapretty puppet shows or going to a good wax museum. They are pure fun and you should not take them seriously for their historical accuracy. Just enjoy them and they fall into their proper place as popular pictures done at a time when history and a little culture were the most desirable menu Americans could ask for.

Stearns was not a major artist, and even in his day no one seems to have thought so. The historical tableau has had a long and brilliant history in art. Its practitioners include Raphael (1483-1520) and Rubens (1577-1640), Jacques Louis David (1748-1825) and Eugène Delacroix (1798-1863). The assumption of the historical tableaux is not that of the camera at all. Significantly, most examples were painted before the camera came into widespread use. The historical tableau assumes that great historical events ought to look like great historical events, solemn and grand, regardless of what they actually did look like. The best American practitioner was undoubtedly John Trumbull (p. 30) and in the middle of the nineteenth cen-

*Washington as a Captain in the French and Indian War, ca. 1849,
Junius Brutus Stearns. 37-½ x 54 in., oil.
Virginia Museum of Fine Arts, Richmond,
gift of Edgar William and Bernice Chrysler Garbisch.*

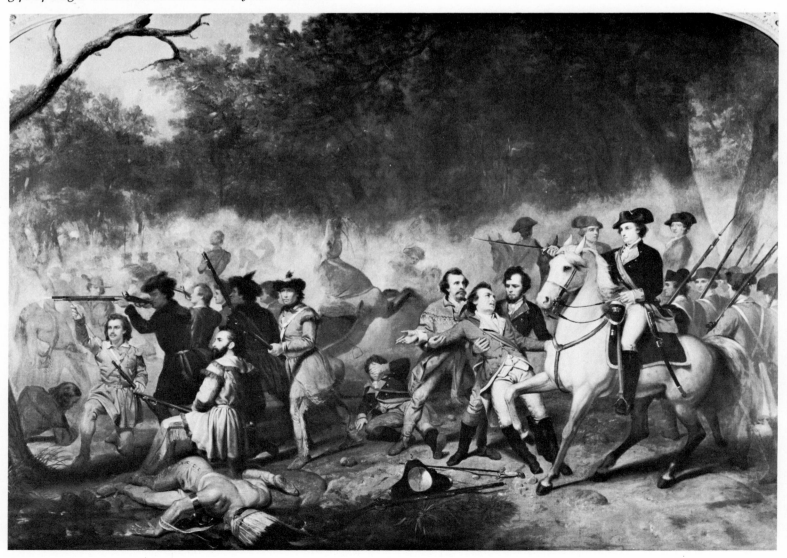

tury the best known American was a German, Emanuel Leutze (p. 96).

Working at the same time as Leutze and enjoying considerable popularity was Junius Brutus Stearns of New York. Although most recent books on American art history gloss over him or omit him, he does have a place just as those popular painters from whom Currier and Ives derived their prints. He satisfied a need for the romanticization and glorification of our then not-so-distant past.

By far his best known work was a series of four paintings on the life of George Washington, painted in 1849 and shortly engraved by Goupil and eagerly purchased by thousands of Americans. Along with Leutze's tableau of Washington crossing the Delaware and Parson Weems's fable of the cherry tree, the four pictures by Stearns are in great part responsible for the veneration for the Father of Our Country that Americans have felt ever since. Stearns's series shows Washington as a soldier, with Braddock in the French and Indian War, as a statesman, at the ratification of the Constitution, as a farmer, in the fields with his laborers, and as a citizen, getting married. The series satisfied the desire by Americans of the time to display in their homes their pride in their country through the nation's heroes, and, incidentally, pride in their artists.

Stearns undertook careful research to create these tableaux. The marriage picture was based on personal interviews with descendants of Martha Washington and the Custis family. G. W. P. Custis, Martha's grandson, was adopted by the Washingtons, and it was from him, interviewed in the Curtis-Lee mansion that now overlooks the grave of John F. Kennedy and the Lincoln Memorial from Arlington Cemetery, that Stearns got information that finally settled the question of where the wedding took place. Custis claimed it was in St. Peters Church, New Kent County, Virginia, and there Stearns placed it. The church to this day has the quaint title of "The First Church of the First First Lady."

Here we see the romantic young couple, handsome and shy, surrounded by friends and family including Martha's two children by another marriage. I do not know if it is intentional or not, but the older lady at the far right of the picture, perhaps Martha's mother, looks like the Gilbert Stuart portraits of Martha herself.

Whether it is a great painting or not, no one will ever again do these splendid romantic and idealized scenes, so, if for no other reason, we have Junius Brutus Stearns to thank for creating these charming interludes in our history and our art.

ASHER BROWN DURAND

Kindred Spirits is a definitive painting of the Hudson River School. The two men communing with each other and nature are the poet William Cullen Bryant (1794-1878) and the artist Thomas Cole (pp. 70-73). The painter is Asher Brown Durand, one of the key figures in that charming if somewhat enervating period to us of American art. But *Kindred Spirits* is inviting, and the more you know about it the more interesting it becomes, not only as a painting, but as a testament to a time when this country was in one of its most creative moods. It was painted as a gift to Bryant following the death of Cole at forty-nine. Bryant had delivered the oration at his funeral.

American men of letters, James Fennimore Cooper, Henry David Thoreau, Ralph Waldo Emerson, John Greenleaf Whittier, had opened the nation's eyes to the intense beauty of its wilderness. Bryant, in his poem "Thanatopis," published in 1817, had given painters the advice that fired them to an intense love affair with nature that was to deluge America with pure landscapes, perhaps more than any other single nation had produced in a similar short period of time of four or five decades. Even the British, always a people in tune with nature, never had such a concentration of artists in one period so set on recording every whim and mood of nature.

> "Go forth, under the open sky, and list
> To Nature's teachings, while from all around —
> Earth and her waters, and the depths of air —
> Comes a still voice."

This was Bryant's admonition quoted in Durand's "Letters on Landscape Painting," published in 1855, and it was taken quite literally by that single-purposed band of brothers who made up the Hudson River School. Later they were joined by the Rocky Mountain Painters and later still by hundreds of Saturday, Sunday and Monday painters of less talent but equal determination to record the many splendors of the American scene.

Durand is one of the sweetest of these artists. His early training as an engraver gives his pictures a certain crispness which is sugared over with a poetic light he borrowed from his one outside influence, Claude Lorrain (1600-1682). A trip to Europe's art centers in 1840, when he was forty-one and already a successful engraver of prints after other artists' works, left him "bewildered, wretched, and desolate." Only in Claude's romantic landscapes with their strange lighting effects did he find the answer to his fear, and the almost unanimous opinion in academic circles, that landscape painting was a mean art when compared to the great master works of the Renaissance portraitists. He returned with joy to America where he came under the stimulating influence of Thomas Cole, and Durand knew at once his artistic direction. Gradually, however, he threw off the influences of Claude and Cole who had frequently peopled their canvases with Neoclassical and Romantic Movement morality, and Durand went open-armed to embrace nature as the only worthy inspiration of art.

In his published "Letters on Landscape Painting" he echoes Cole's early advice that "in landscape there is a greater variety of objects, textures, phenomena, to imitate" than in man's image. Durand wrote, "There is no tint of color, nor phrase of light and dark, force or delicacy, gradation or contrast, or any charm that the most imaginative imagination ever employed, that is not seen in nature more beautiful and fitting than art has realized and ever can."

Dance of the Haymakers, *n. d.,*
Asher B. Durand. 36 x 55-½ in., oil.
Collection of Douglas B. Collins.

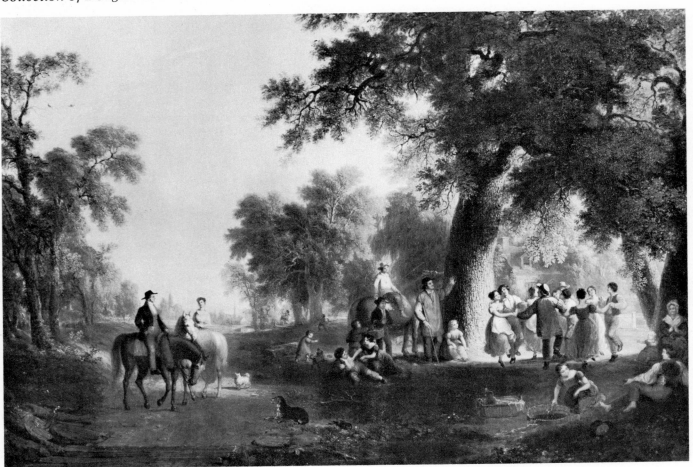

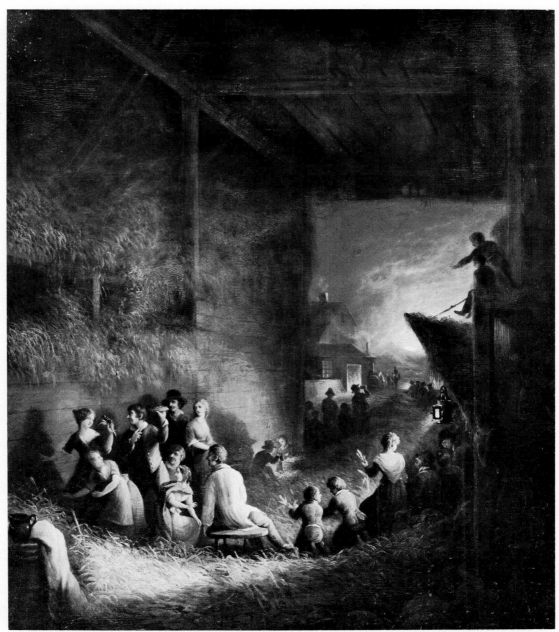

Corn Husking Frolic, *1828-29,*
Alvan Fisher (1792-1863). 27-3/4 x 24¼ in., oil on panel.
Courtesy, Museum of Fine Arts, Boston, Karolik Collection.
Fisher lived and worked near Boston much of his life and established
himself as a popular genre and landscape painter.

stadt (p. 128) and the like. The answer, of course, is the sketching trips these artists took to get back to nature, if only for a moment.

Pic Nick is a real labor of remembered loves, of friends and family, of good food and innocent fun. The lovers on the left have that idyllic something the Pre-Raphaelites in England loved to paint, and the setting of this little comedy is so luminous, leaf-framed and lucid you are hard put to question all the usual elements, such as technique, draftsmanship and composition. Like Henry Sargent's *The Dinner Party* (p. 60), it defies criticism with honesty.

I spent hours enjoying the original in Boston, "casting" the characters and their relationships to each other, for they are so lovingly interwoven in the day's sport that you remember your happy times by observing theirs. Even though it is from another period (and we wish it was ours), it is modern — a snapshot, a postcard that says not, "I wish you were here," but "Wish I was there." Many painters are self-conscious about this kind of innocent subject, but not

Thompson. They try to say more than should be said, and the viewer feels forced to find more than there is in it. We are grateful to the artist for his honesty.

A fascinating story of who was the artist of this painting came to light when *Pic Nick* was acquired by the Boston Museum of Fine Arts around 1950. The only attribution came from a torn label on the back with the first three letters of the artist's name, JER. Experts noticed the similarity with *Pic Nick near Mount Mansfield, Vermont* in the M. H. De Young Memorial Museum in San Francisco. The West Coast museum attributed their *Pic Nick* to Thompson, but Boston thought theirs the work of Jeremiah P. Hardy. Both artists worked in the same location and period, so the stimulating inquiry of the art historians began and they finally settled on Thompson. If they had decided on Hardy it would not have made any difference to us, except for the all-important fact that we now have had rescued for us, from the oblivion many American artists have suffered, another truly American master.

EMANUEL LEUTZE

One of the most patriotically popular paintings ever done in America was created by a man whose identity with this country was not the deepest rooted, to say the least. Born in Würtemberg, Germany, in 1816, Emanuel Leutze was brought here as a child by his father, a politically radical combmaker, who sought refuge from political persecution. His mother never did learn to write or read English; Emanuel could not write German.

An Indian genre painting done when he was in his early twenties caught the attention of an art patron who helped support a European trip where Leutze studied in Munich, Venice and Rome. But it was in Düsseldorf where he met his teacher, Karl Friedrich Lessing (1808-1880), and his bride, and there he settled down to live and work for the next twenty-four years. How completely German he became is revealed in a letter to his sister, "Can you picture me in a long painter's robe with a pipe reaching to the floor, a little cap on my head, long hair and a moustach?" — all the characteristics of a German artist. And indeed to this day Leutze's dual nationality has caused both nations to claim him as their own.

Washington Rallying the Troops at Monmouth, *1854, Emanuel Leutze. 156 x 261 in., oil. Collection of the University Art Museum, Berkeley, gift of Mrs. Mark Hopkins.*

Leutze brought great fame to Düsseldorf. His studio became a mecca for students from all over the world, especially America. Like Benjamin West (pp. 23-27), Leutze was generous with his time, friendship and encouragement. And again in the Benjamin West tradition, Leutze's great contribution to Düsseldorf and the art world in general was a modernization, a bringing up to date of the whole approach to historical painting. James T. Flexner says "he crossbred the high style of historical painting with genre," thus putting the heroes of the past into the shoes of the contemporary viewer.

Leutze went even further than just the democratization of the historical style; he was a political radical in life, championing a united Germany in 1848. He organized an artists' club called *Der Malkasten* ("the palette") which dominated the cultural life of Düsseldorf. His famous *Washington Crossing the Delaware* came about because the German Revolution of 1848 failed to bring that country together, and he needed an episode in another country's history, a turning point in a revolution that succeeded. He turned to his adopted country, for, once again like Benjamin West, he never forfeited his devotion to America.

Everyone knows that famous painting by heart — the Father of our Country like a ship's head stands in the small

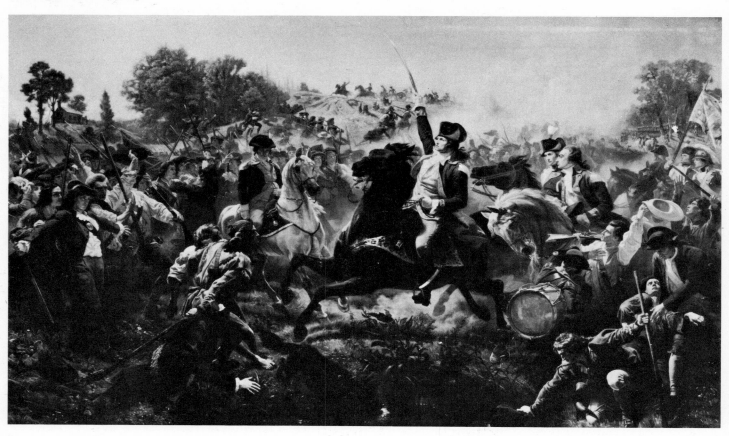

boat which leads his ragged troops across the icy river to surprise the Hessian troops. The first version remained in Germany, and it was the second that was one of the great attractions of the art world, drawing crowds wherever it was exhibited, including the U. S. Capitol, as was the tradition in those days before the movies, television and photography. The artist was the reporter, and his brush the sword of opinion.

But the fame of this painting was shared with another, *Washington Rallying the Troops at Monmouth.* This picture, painted in 1854, caused the same excitement when shown in Berlin that year. Washington here is again an aloof, godlike figure who appears in the midst of his despairing men and simply by his presence boosts their morale. This great canvas suffered, not the reversal of public taste, but the changing dictates of the art taste dictators. It was rolled up in 1911, stored away and forgot-ten until its rediscovery in 1966. Its condition was very bad, the paint cracked and the color faded, but after years of expert restoration, it is on view for all lovers of the heroic to enjoy at the University of California at Berkeley.

In spite of the highly dramatic aspects of the two pictures, one can see why Leutze received such recognition as a painter. There are passages of great painterly beauty in both. The figures are admirably posed and the facial expressions keenly observed and rendered. Thomas Worthington Whittredge (p. 134) and Eastman Johnson (p. 132) were both students in Leutze's studio and worked on the pictures as well as posed for several of the figures. These men who became famous in their own right did not continue in the epic tradition, but Leutze's influence cannot be overlooked in their work. Especially in Johnson do we see his training in the beautifully observed heads of his genre masterpieces.

WASHINGTON CROSSING THE DELAWARE, *1851,*
Emanuel Leutze (1816-1868). 149 x 225 in., oil.
The Metropolitan Museum of Art, gift of John S. Kennedy.

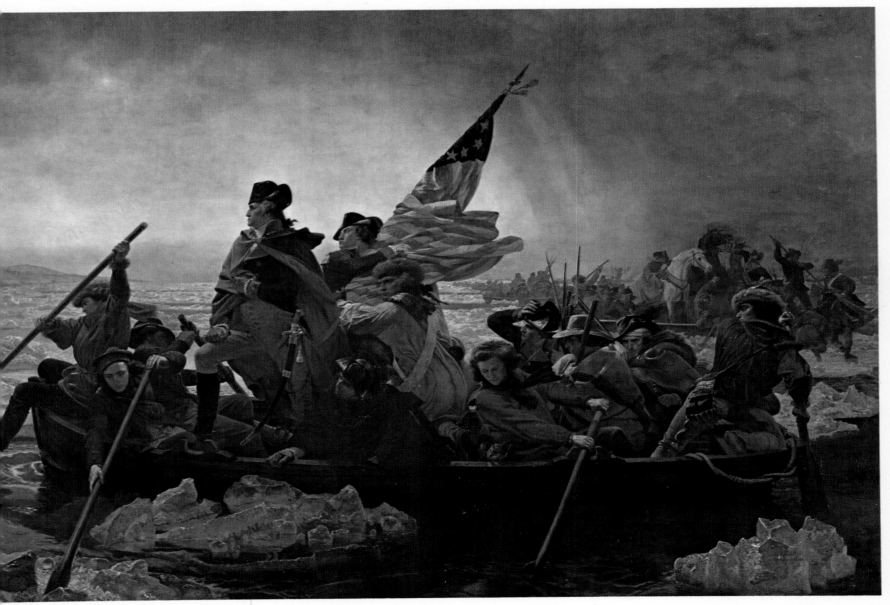

RICHARD CATON WOODVILLE

Politics in an Oyster House, *1848,*
Richard Caton Woodville.
16 x 13 in., oil.
The Walters Art Gallery,
Baltimore.

The two major art developments of nineteenth-century America were landscape and genre painting. The Hudson River School, the Rocky Mountain School, and the like filled American homes and galleries with reminders of our natural grandeur in the most impersonal way. Even though nature was all around, man required comment on its magnificence, but only rarely did the artist feel man added anything to the scene. Asher Brown Durand painted Thomas Cole and William Cullen Bryant in a Catskill setting and called it *Kindred Spirits* (p. 90), because these two were the poet and the painter of nature, friends of nature more than natural friends. This was a direct contrast to the genre paintings of William Sidney Mount (p. 106) and Richard Caton Woodville, of David Gilmour Blythe (p. 118) or George Caleb Bingham (p. 92), wherein nature, while not quite shut out of doors, plays a secondary role to the nature of man, man related to man and incidentally to his natural surroundings. The coziest of this delightful art sees man warmed in a man-made interior indulging in the happy pastimes of family and friends or, in the case of *Waiting for the Stage,* strangers. The viewer might almost wish it were his choice to take the bumpy

horse-drawn coach over terrible roads to somewhat crude communities, rather than wait for weather-bound planes in clinical airports with nothing to do. It is not mere nostalgia, for the good old days of Woodville's painting are beyond almost everyone's memory now. But I, for one, identify with its lack of hurry, its contemplative quiet, the tacit understanding of these three men that time is not rushing them anymore than the stage will rush them to an unwanted destination.

Richard Caton Woodville must have had such simple longings, for he reached into a simpler life than his own for his subject matter. Born of wealthy parents in Baltimore in 1825, he circumvented his parents' wish that he study medicine by drawing caricatures of his fellow students and teachers. In his sketching he became acquainted and enamored with the works of the Dutch genre painters in the Baltimore collection of Robert Gilmore, Jr.

Perhaps due to the familiar desire of young men to antagonize the establishment, especially if their family is a part of it, Woodville was enchanted by the Dutch genre masters' concern with common life. An early painting of

WAITING FOR THE STAGE, *1851,*
Richard Caton Woodville (1825-1855). 15 x 18½ in., oil.
The Corcoran Gallery of Art, Washington, D. C.

two vulgar habitués in a barroom so incensed his family that they consented to put up with his artistic inclinations only after he married into the proper social strata. With family money as well as consent, he sailed for Europe and took private lessons with Karl Ferdinand Sohn (1805-1867), an influential genre painter in Düsseldorf. But all he wanted from Sohn was technique, and he avoided the overly dramatic and super-sentimental subject matter dear to the Germans. Instead he preferred American scenes. He had come prepared with sketches to which he applied his new ability to organize tightly, sustain narrative and detail and to use interior lighting effectively. When he sent the paintings home, his success in America was almost immediate, and his work was sold and popularized by engravings after it.

When he died from an "overdose of morphia" at the age of thirty, the Baltimore newspaper wrote of his "aristocratic lineage. . .courtly manners. . .remarkable perceptive faculties. . .his acuteness of sight that the minutest details were visible to him at some distance. His sense of humor was refined and he expressed dramatic situations with rare power of composition." Later art historians like James T.

Flexner felt that, "Even if his reaction was American humor rather than Germanic sentiment, he was no closer to his theme [lower-class life] than the Düsseldorf painters were to Westphalian peasants." Flexner says of pictures like ours, "His best pictures express efforts to find things outside himself at which he could laugh."

I find myself somewhere in the middle of these two opinions. We must appreciate the fact that he found something to laugh at which he could also paint so well with the exquisite detail his acute sight enabled him to report. The humor of the dark glasses on the standing man reading *The Spy* is matched by the beauty of the little still life on the stove. His draftsmanship, rational but complex composition, plus his real interest for the overall story put Woodville high among American genre painters. He does not approach Mount's naturalness, but, as always with those who die young, we think of what was left unsaid.

Despite his personal distance from the life he portrayed, he exerted a strong artistic influence on painters who came later and who had a long enough life to further their talent in American genre painting.

99

GEORGE PETER ALEXANDER HEALY

G.P.A. Healy may be the perfect example of a portrait painter. This does not mean he was a great painter who could, among other things, produce a great portrait. Rather, he was a specialist who designed his own life to fit in with the lives of those he painted or, more honestly, who could afford to be portrayed by him. In his specialty he was very good, one of the best America has produced, yet it is difficult to define him as a typically American painter. He was, frankly, socially ambitious, a trait which, while not exactly foreign to the American make-up, led Healy to social heights at home and abroad which make him seem more European than most American artists.

Born in a poor section of Boston in 1813, Healy longed to move into high society and he decided at an early age to do just that. Actually, he decided to paint his way into his desired position and to live up to it in every way. As a teenager, he approached a reigning society matron and through flattery won a commission which he parlayed into a lucrative three years of society portraits. He earned enough money to go abroad. At twenty-one, Healy invaded Paris, there to come under the influence of the highborn painter Baron Antoine Jean Gros (1771-1835). Soon he was commissioned to paint the American ambassador to France, Lewis Cass, which in turn brought him to the attention of Louis Philippe, the "Citizen King" of France.

The ambassador's portrait still had something of the rough realism he had learned back in Boston, copying John Singleton Copley's (pp. 16-22) great portraits, so in future portraits Healy "gentled this condition" by adopting some of the fashionable flair of the Englishman Thomas Lawrence (1769-1830). Louis Philippe was pleased, and Healy moved from one head of state to another, becoming a painter-ambassador of good neighborliness, talent and charm. It was the French king who sent him back to the states to paint our presidents, living and dead, for their collections. Once home, he was in great demand.

Of course, his American sitters were flattered to be painted by a master who had been so highly accepted in Europe, and the fact that he was an American took any onus off his rather sophisticated European high-style technique. He made a fortune from his work and enjoyed a success here and abroad not paralleled in American art until John Singer Sargent (pp. 160-163).

Our portrait of Daniel Webster (1782-1852), magnificent American orator and statesman, was chosen because it does Healy great justice and, I should imagine, Webster, too. It is a good strong likeness of a strong man and shows Healy capable of what even some of the best portrait painters never learn — not to impose their own art affectations on their sitters. It could not be more direct and free from pseudo-sophistication. The portrait of Daniel Webster is highly competent and its simplicity makes it strangely sophisticated by today's standards.

Abraham Lincoln, *1860.*
G. P. A. Healy. 30-3/8 x 25-3/8 in., oil.
The Corcoran Gallery of Art, Washington, D. C.

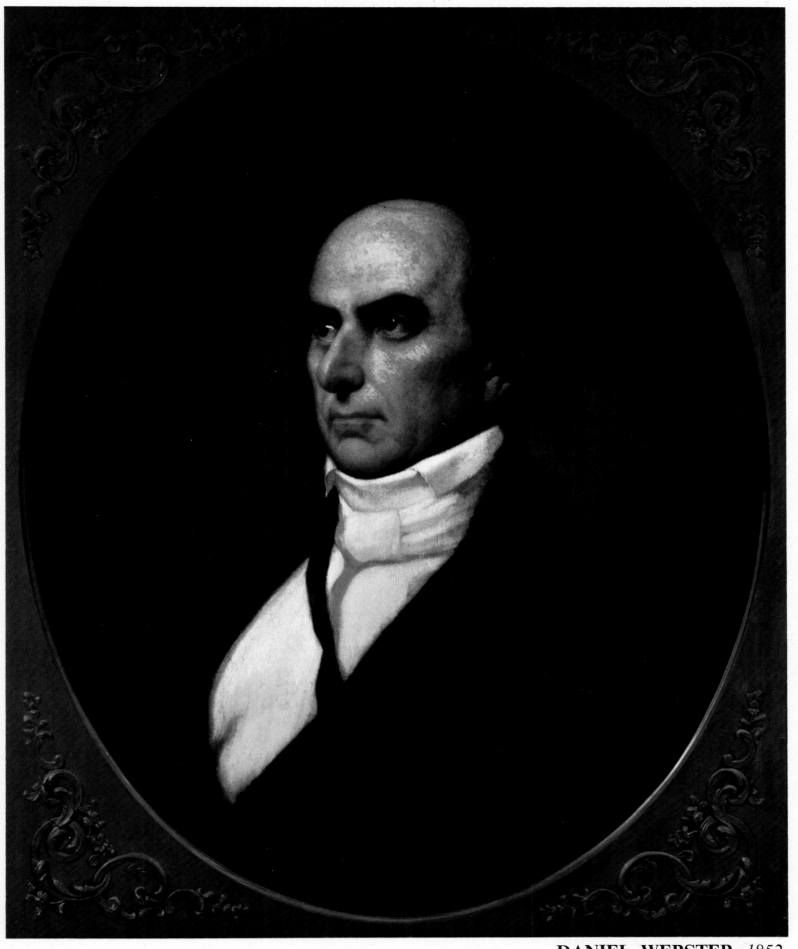

DANIEL WEBSTER, *1852,*
George Peter Alexander Healy (1813-1894). 30 x 25 in., oil.
Courtesy, Pennsylvania Academy of the Fine Arts,
Philadelphia, John F. Lewis Memorial Collection.

101

GEORGE HENRY DURRIE

THE WOOD SLED, *1854,*
George Henry Durrie (1820-1863). 18 x 24 in., oil.
Currier Gallery of Art, Manchester, New Hampshire.

Currier and Ives prints have become rare collectors' items because of their enormous contemporary popularity. It seems strange that anything so widely circulated and printed in such large editions could become rare. Yet for the same reason that children's books were used and often destroyed by the young, so adults used these prints, and when they no longer fitted in the scheme of their living, they were discarded and lost. Hence the rarity.

The publishers Nathaniel Currier and James Merritt Ives hired some rather poor artists to do the sketches from which they did their best lithographs. On occasion, however, they went into competition with other higher class lithographic firms who copied work of recognized masters. In these instances they hired some lesser-known but good painters, George Henry Durrie among them. Ten out of their thousands of prints and the top of their line were taken from his paintings.

Durrie started his career as a portrait painter in Connecticut and never moved far afield. He gave up portraits to do the rural scenes for which he is best known, largely

through the Currier and Ives prints. It was not until the 1920's, almost sixty years after his death, that his paintings were rediscovered and he became affectionately known as "the Whittier of American painting."

We know quite a bit about his life from a diary which survives. He was not at all curious about the art world which centered around Yale University in his native city of New Haven. One of his paintings which was exhibited at the National Academy and which he noted "Thomas Cole made favorable observations concerning it" brought little reaction from the countrified painter. He did not even make the half-day journey to see it and the work of national art leaders who shared the exhibition.

He was perfectly content to let his curiosity roam around the little world he knew and painted in Connecticut. His diary suggests he was enormously friendly, fascinated by the everyday life of his friends in their homes, woods and fields. He painted almost anything, including "pantry pictures" for his friends. Snow scenes were his specialty, I suppose, to keep the good people of

that rugged countryside constantly reminded in the good months that winter was not far away. Yet his pictures are pleasant in that they do not show only the inclement side of the weather. They promise that the wood being gathered, as in *The Wood Sled*, will burn brightly in the stove and hearth and that the pot will boil and the perfume of the good life will permeate the family atmosphere. Unlike the Hudson River painters, who did not want to jar their city customers with reminders of the cold outside and who seldom painted snow, Durrie was surrounded by it

and in winter lived with it and loved it — as is obvious in his cozy canvases.

James T. Flexner, who writes brilliantly on these lesser painters, says of Durrie, "His technique was an improbable combination of the naive with the knowing: his figures, for instance, look like colored paper cut-outs, but he was sophisticated at handling, particularly in his foregrounds, gradations of light." Durrie preached the virtues of winter and its special light with such tender, joyous zeal that his work becomes as comforting as the song "Jingle Bells" or the poem "Thanksgiving Day."

Clipper Ship "Nightingale," *1854,*
Charles Parsons (1821-1910). lithograph.
Anonymous Collection. Parsons was the outstanding
marine artist employed by the firm Currier and Ives.

ARTIST UNKNOWN

In 1971, the Whitney Museum of American Art in New York City put on the most absorbing show of wholly indigenous, American abstract art I have ever seen. The place was crowded with young and old, long haired and short, following around the high walls on which hung the king-sized works of art. Some were labeled *Duck's-Foot-in-the-Mud*, *Bear's Paw*, *Lemon Star*, *Kansas Trouble*, and some quite frankly were called *Crazy*. Almost any of these titles might be what people over the years have called abstract art, especially the last one. The show was, of course, of nineteenth-century American patchwork quilts.

It was a magnificent, awe-inspiring show. What artistry, design, craftsmanship, color sense, and just sheer beauty had gone into these useful, seemingly simple objects. Beside the visual splendor, one was over-awed by the fact that art is in everything that is well done.

Quilting was a family and neighborly affair. In the long winters around the glowing stove everyone used to come to the quilting bees to have fun and to work. I picture someone in command, the lady of the house most likely, for it would have been she who had collected the matching swatches of material from old clothes, drapes, anything she felt should be renewed, but not, most definitely not, thrown away.

The quilt began with the technique of cutting out paper shapes, which were carefully planned to make the required patchwork design. The overall pattern was charted on paper to fit the huge stretcher or frame on which the whole labor was later concentrated. The patches were then pieced together into blocks and these in turn were "set together" to make the top of the quilt. A muslin liner was taut on the stretcher, and it was onto this "back," with a great choice of quilting stitch designs — horizontal, spider web, diamond, ocean wave, pineapple, starfish and a score of others — which the wadding and top were quilted. Always, however, only one quilting pattern was used on each quilt.

Everyone got into the act and, from our delightful primitive picture, they all seem to be having a gay time of it. The date of our quilting party is from the third quarter of the nineteenth-century. The original composition was an engraved illustration in *Gleason's Pictorial*, but our unknown artist has taken great liberties and endowed each character with bits of his own humor. Perhaps the faces have been made to look like friends or relatives. The boy on the extreme right has to be the town jester if not the village idiot. The props, guns, painted chairs, and such have been added to give authenticity to the scene. Mary Black and Jean Lipman in their fine book, *American Folk Art*, have fun with the quilt in question, describing it as "one of the ugliest quilts ever to grace a dowry." If it is true that most of these parties were given in anticipation of a wedding, my guess is that the bride-to-be is the girl under the center window whose fiancé is bringing her a bowl of goodies. Stephen Collins Foster wrote a song, "The Quilting Party," which immortalized such gatherings:

In the sky the bright stars glittered,
 On the banks the pale moon shone,
And 'twas from Aunt Dinah's quilting party
 I was seeing Nellie home.

The picture's charm is in its utter naivety. The flat use of the color, the fact that the figures, character studies themselves, are almost laid on top of the room has undeniable appeal. Being a painted copy after an engraving, a practice used by some very talented painters of those days before reproduction, it would lose some of its charm if the artist had tried to be anything but that which he or she was capable of. The artist is one who enjoyed the little but good things in life and wanted to remember them within the limits of his or her own art talent.

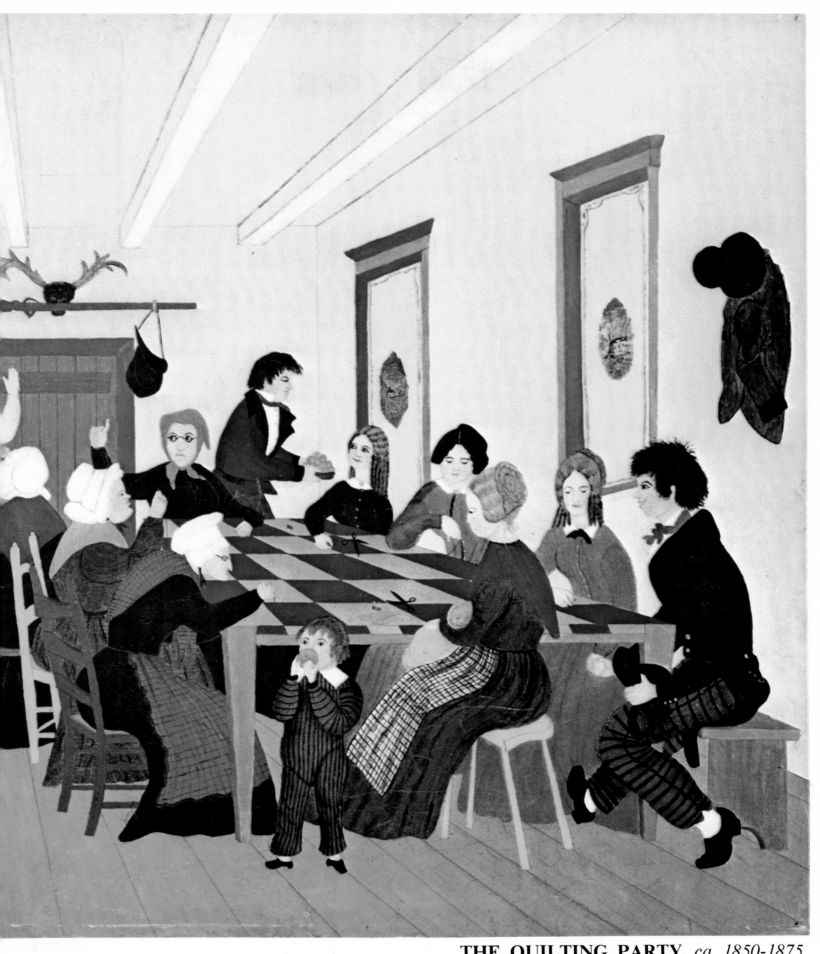

THE QUILTING PARTY, *ca. 1850-1875,*
Artist Unknown. 19⅜ x 26⅛ in.,
oil on composition board.
Abby Aldrich Rockefeller Folk Art Collection,
Williamsburg, Virginia.

WILLIAM SIDNEY MOUNT

William Sidney Mount is a pivotal figure in the history of American art, for Mount was the first accomplished native-born painter to base his career on and to make his livelihood from genre subjects. Not only did he refuse several offers to study in Europe, but he even gave up the big cities to make his art out of his simple life experience. Not that he did not have the chance to do as other artists of his time were doing — to make a living at portraiture, landscape or make a reputation in historical painting. In fact he tried his hand at these, but he was wise enough to know that these were not the kinds of painting that best suited his talents. What he knew and wanted to paint were people's daily activities. In depicting ordinary people in everyday tasks, Mount opened up the opportunity for others to do the same and to give American painting its highest definition. George Caleb Bingham (p. 92), David Blythe (p. 118), and Seth Eastman (p. 86) are a few of the men who followed his lead.

The eighteenth century was not a period of particular lightness of heart among our painters or their patrons. They were more interested in preserving their austere likenesses for posterity than their frivolous activities. But as it moved into the nineteenth century, the nation began to take more pride in itself as it was. The gap between the rich and the poor was filled by a middle class as the citizenry became less dependent on European ideas and more democratic in thought and taste at home. The middle class grew in size and self-confidence, and with it came an interest in man's work and play. The West was opening up and the epic qualities of the great American adventure were alive everywhere.

Mount did not follow George Catlin (pp. 74-77), Albert Bierstadt (p. 130) and others to the West; instead he retreated to Long Island, to the countryside where he had been born and brought up. He had put in his apprenticeship in the city as a sign painter, but his ambitions soon carried him beyond this and he took up portraiture, which he continued off and on throughout his life. But his heart was not attuned to the society who sat for him, and he turned to the simple folk with whom he shared his life — to their faces and their everyday activities. His contemporaries found in his comic, domestic, rustic scenes something new and wonderful. The dean of historical painters, Washington Allston (p. 54), praised him, and in the 1830's his fame as a genre painter spread. Beginning in 1834, Mount's work was reproduced in a highly successful series of lithographs that increased his renown and revenue. Because of his fame his life on Long Island did not cut him

Eel Spearing At Setauket, 1845,
William Sidney Mount. 29 x 36 in., oil.
New York State Historical Association, Cooperstown.

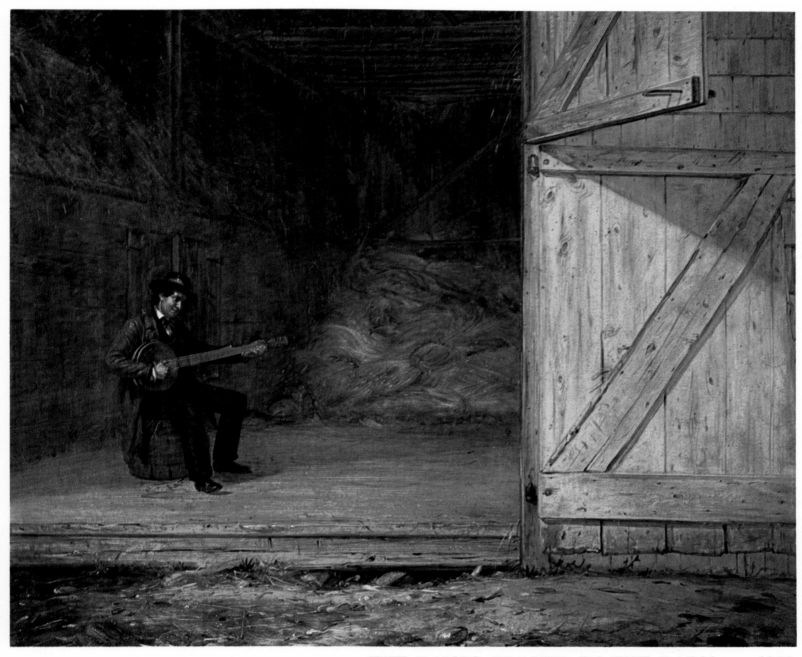

THE BANJO PLAYER IN THE BARN, *ca. 1855,*
William Sidney Mount (1807-1868). 25 x 30 in., oil.
Detroit Institute of Arts.

off from the mainstream of American art, and he counted among his friends many of the great names of his day. He was close to Thomas Cole (pp. 70-73) and honored the great man of the Catskills with one of his rare ventures from home.

His output was limited due to delicate health and his painstaking method of working. He said of his work methods, "I never paint a picture unless I feel in the right spirit." He also thought there were times when it was less important to paint than to think.

The Banjo Player in the Barn is Mount at his best. Mount was one of the first American artists to realize the paintable potential of the Negro. The banjo player, of whom he did a portrait, too, sits in a barn without an audience, just enjoying himself and his music. We can see in this uncomplicated composition evidence of Mount's admiration for Rembrandt. Here is Rembrandt's love of lights and darks on different surfaces. The spotlighting of the central figure, the care lavished on it and the quick, almost sketchy, surroundings remind us of the Dutch master's genius.

Mount was so obsessed with Rembrandt that he wrote a letter to himself from the long dead master. In it Rembrandt discusses his technique, which, of course, closely resembles Mount's. One revealing line of this letter sums up our painting, as "Rembrandt" writes, "I painted nature as I beheld it through a certain medium of my own creation." Even more closely does the following line of "Rembrandt's" apply to *The Banjo Player in the Barn*, "My models were placed in such a position, in the gloomy apartment, that, the light. . .served not only to illumine the principal figures. . .but, also, to illumine the apartment with a certain mysterious atmosphere, that served to detach these figures from the background in semirelief."

It is extraordinary how Mount's little life-dramas relate to us today. And they are dramas, not in the classical sense but in the modern. They are slices of life caught in an instant and, no matter how thin a slice they are, as revealing as Shakespeare's plays, which are one slice of life piled on another to make the feast which, in the case of Mount or any painter, can only be sufficiently relished by seeing all their work. In the case of Mount it is worth the effort.

107

CHARLES WIMAR

One of the major motivating forces in American painting we have not really explored enough is the spirit of adventure. Certainly any reader of this book or any other on the subject cannot help but be caught up in that spirit, for it is everywhere and ever present even in our time when art has finally "caught on" and rewards the artist — as it always has the viewer. A journey into any of the arts is an adventure because it is the realm of the spirit, but in our early days, adventure was often another kind, sometimes into the unknown. George Catlin (pp. 74-77), Karl Bodmer (p. 80), Thomas Moran (p. 204) and Albert Bierstadt (p. 131) actually journeyed to unexplored places to study little-known life and landscape. Others like Frederic Remington (p. 196) and Charles M. Russell (p. 181), especially the latter, lived the adventure and shared it with us. Some others took it secondhand and made it, if not the real thing, the next thing to it. N. C. Wyeth (p. 200), for example, gave us almost a more adventurous feeling than those who actually participated in the explorations.

Charles Wimar had both these traits in his experience, for he knew the American West and Indian life firsthand, going up the Mississippi with his teacher, Leon de Pomarede, a St. Louis painter and decorator, in 1849. He sketched and took photographic notes and opened a studio in his adopted city of St. Louis. But it was the realization of a long dreamed of trip back to his native Germany, which he left when he was fifteen, that brought his art to maturity. The famous art academy at Düsseldorf was his goal, and there he studied with Emanuel Leutze (p. 96). The academic training of that school appears in his paintings which are beautifully and dramatically drawn, but lack the free brushwork, as is typical of all painters who worked there.

He painted in Düsseldorf and sent back to the states some seventeen ambitious canvases on the Indian theme. Removed from the actuality, his visualizations became increasingly romanticized, and *The Attack on an Emigrant Train*, probably the last he painted there, is certainly a perfect finale to this period of his life. It is the first appearance in a painting of the fabled covered wagon and is a real thriller in every respect. Wimar was not above using other artists' work as inspiration. He often cribbed from Catlin's engravings, and the theme of our picture comes from an 1851 written account by the chronicler Gabriel Ferry called *Impressions de Voyages et Aventures dans le Mexique, La Haute Californie et les Regions de l'Or.* Wimar's work represents a caravan of gold diggers defending themselves against an Indian attack. It no doubt brought joy to the heart of any romantically minded American, and we know the Europeans adored it too.

Wimar died at thirty-four with his mission of chronicling the life of the American Indian incomplete, but his remaining pictures show promise that he might have given us an even more exciting or at least more dramatic overall story than those who did complete their task. He was the youngest of his breed of artist, and perhaps that explains why his storytelling is more illustrative of how today we think of the glorious adventure of the West. It may lack the blunt reality of Catlin's report or the ethnological accuracy of Bodmer's, but it is full-blooded and great fun to behold. Perry Rathbone, author of a book on Wimar, feels, "Wimar as a portrayer of Indian life deserves wider recognition and a permanent place in the development of romantic painting in this country."

THE ATTACK ON AN EMIGRANT TRAIN, *1856, Charles Wimar (1828-1862). 55¼ x 79 in., oil. University of Michigan Museum of Art, Ann Arbor.*

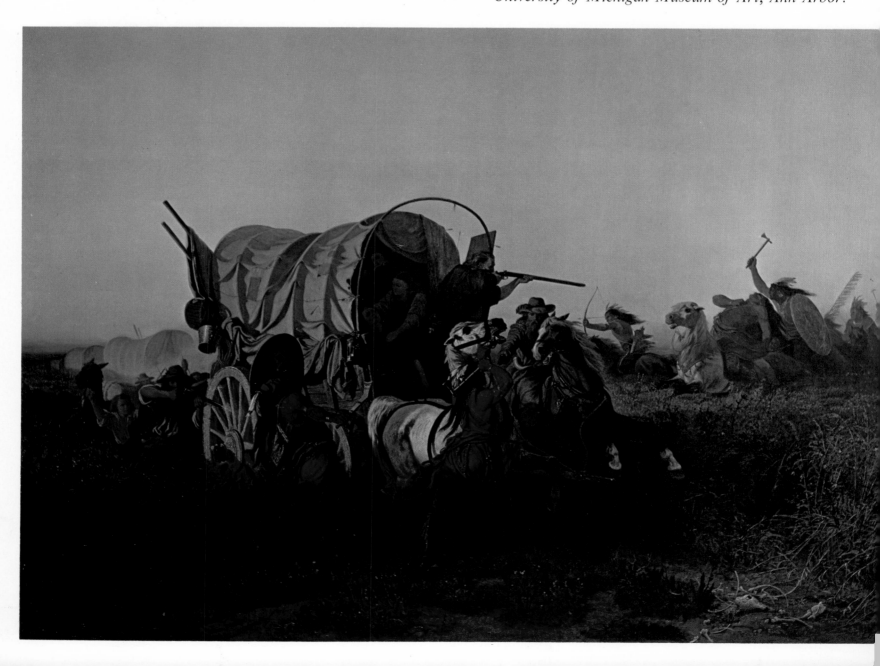

INDEPENDENCE (PORTRAIT OF SQUIRE JACK PORTER), *1858,*
Frank B. Mayer, (1827-1899). 12 x 16 in., oil on composition board.
Courtesy, National Collection of Fine Arts, Smithsonian Institution.

How would you like to get away from it all and retire to the country, put your weary feet up, smoke a pipe and be independent? *Independence* by Frank B. Mayer could be the poster to sell you all the above blessings. It is not a famous picture, and Mayer is not a great artist, but it represents something many books on art leave out, the competent little master who painted a marvelously satisfying little picture. *Independence* is only twelve by sixteen inches, but what acres of contentment it portrays.

Genre painting in the nineteenth century — and in most other centuries as well, including the seventeenth in Holland — was very much a local art. The landscape artists, who from 1824 to the end of the century were revealing to Americans the undreamt of glories of the American landscape from the Catskills to the Rockies, worked for a national audience, and the finest portraitists have always been in demand, without regard to geography.

But genre has been a local thing, and Frank B. Mayer was a genre artist of Maryland, especially of Baltimore, where he was born, and of Annapolis, where he died. He was a good painter admirably equipped to handle such a gentle subject as Squire Jack Porter, a prosperous farmer who owned Rose Meadow, a farm near Frostburg, a mountain town in western Maryland. Somehow, to a greater extent than in some more impressive genre paintings, the lack of social comment in *Independence*, the absolute inaction of this picture reveals what man essentially wants and strives for — peace. The pleasant impression of peace and contentment in this picture arises from very solid artistic virtues. The comfortable slouch of the Squire at ease

and at home is framed by and against the hard line of the stone and masonry wall of the farmhouse, the railings of the porch and its uprights.

Mayer had been working hard at art since he was a boy in Baltimore. He had told his successful lawyer father that he "must succeed" and in his teens was already earning his living in art. In 1851, following in the footsteps of his teacher, Alfred Jacob Miller (p. 78), he went to the Indian country of Minnesota for a historic treaty signing. In 1864, he went to Paris to study with the historical painter, Marc Gleyre (1808-1874), until the Paris siege of 1871 during the Franco-Prussian War. Between those two journeys, in 1858, he painted Squire Porter. After Mayer returned from France he settled down in Annapolis for the rest of his life.

Perhaps Mayer is overlooked by popularizing art historians because he had a very studious, normal and uneventful life. As for his art, it, too, was unspectacular though he did create two great historical paintings for the Maryland Statehouse. He was a tireless researcher and a collector of memorabilia.

But the appeal of this little masterpiece is comparable to those wonderful, inconspicuous pictures we come across in the off-gallery rooms of great museums — those little paintings done by minor Dutch masters with unpronounceable names you have never heard of. But suddenly after a glut of masterpieces, you find in them a tranquility of painterliness and purposelessness that is at once relaxing and exciting. You have been allowed to discover something for yourself that the guidebook has not told you you had to admire.

FREDERIC EDWIN CHURCH

In the middle of the last century, Frederic Edwin Church was so famous by the time he was in his late twenties that he was known as "the first landscape painter when landscape painting was the nation's first art."

Church was the only pupil of Thomas Cole (pp. 70-73), and together they make a fascinating contrast in an important chapter of our art. They shared the belief that nature by herself was not meaningful enough and therefore they threw the focus on carefully selected views of it, going beyond realism to idealization. But whereas Cole loved to add a further point of view — sometimes moral or sometimes historical — Church's approach was more scientific. Cole was still in the painterly tradition, whereas Church became almost photographic. Everything in Church's great paintings is a close-up, and indeed, when he exhibited his sensational *Heart of the Andes* in 1859, observers were supplied with tin tubes so that they could concentrate on each detail and thus create the illusion that they were on the spot, with Church looking for them at the world and at each part of it through binoculars.

Haying Near New Haven
(West Rock, New Haven), 1849,
Frederic Edwin Church. 27 x 40 in., oil.
New Britain Museum of American Art,
Connecticut, John Butler Talcott Fund.

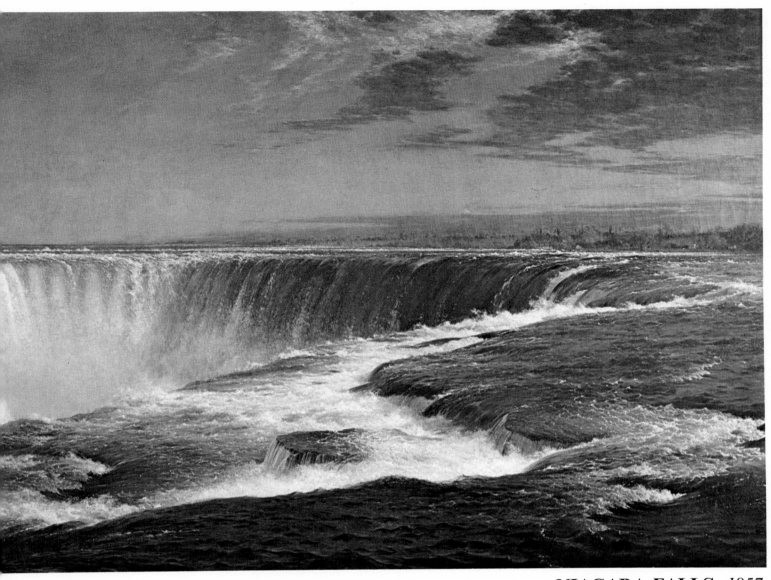

NIAGARA FALLS, *1857,*
Frederic Edwin Church (1826-1900). 42½ x 90½ in., oil.
The Corcoran Gallery of Art, Washington, D.C.

He was a real showman and often put his pictures in competition with other amusement attractions, charging admission and drawing huge crowds. One critic suggested he was the P. T. Barnum of painters. Another said that it was only natural that he was grandiose since he was indeed a contemporary of Richard Wagner, the German composer credited with reviving the concept of art as a gala production of and for the entire community.

West Rock, New Haven was painted at the time Church had finally freed himself from any influences of the Hudson River School and Thomas Cole. When it was first shown at the National Academy of Design in 1849, it heaped on Church's young shoulders such praise that his reputation was made. Church at the age of twenty-two "had taken his place, at a single leap, among the great masters of landscape." In it the young painter perfectly captured the nobility of the monumental title subject as well as the river, woods and flowing clouds that crown the rock.

But it was not until he had returned from his arduous trip to the Andes that he tackled the major scenic wonder of America, Niagara Falls. His teacher, Cole, had found it too overwhelming to paint, but nothing was too large a vision for the all-encompassing eye of Church. His *Niagara*

Falls is second only to seeing the real thing — as great a visual experience in art as in nature. When the work was exhibited in London, the eminent critic, John Ruskin, was impressed and at first glance thought the rainbow spanning the waters was a trick of refracted light through the gallery window.

Church did have some competition later in life when many great painters moved to the West to express the grandeur of America, especially Albert Bierstadt (p. 128). Bierstadt worked in the same studio on Tenth Street in New York, and for the art lover, a visit there with Church, Bierstadt and the others in residence must have been like a trip around the world. The visitor to the studio had his choice of a half-dozen styles of painting, and whichever artist the visitor favored, he would be able to enjoy some breathtaking views of natural wonders he could hardly hope to see firsthand. Even if he could, his eye could never compete with the artists, Cole, John Frederick Kensett (p. 122), Bierstadt, Asher Brown Durand (p. 90) or George Inness (p. 170). What a great debt we owe them today, for they recorded America "ideal and actual." They saw nature almost before the human eye encountered it — certainly before the common eye.

WILLIAM PAGE

"This is my opinion of myself. . .[I have] done more for art than any man (or woman) since Titian." Now before you look again at the name of William Page, stop to think of what Titian (ca. 1477-1576) did for art. Most critics rank this Renaissance master as one of the greatest artists of all time. But who was William Page? He was a gregarious loner in life and art. He moved in the highest cultural circles of Boston in the great days of the Transcendentalists, and his friends in Rome included the Brownings, Robert and Elizabeth Barrett. Robert Browning said of his work that, "No such. . .has been achieved in our time." Page was a loner in that he followed his own nose to find just the right scent he wanted from art. What he did search out for himself had respectable acceptance in his lifetime, but because he could not stop himself from technical experimentation, most of his pictures destroyed themselves — but only after he had declared them perfect. Page himself wrote, "Some have turned red, some black, some spotted, some slid off the canvas, and all gone as if by spontaneous combustion."

But it did not stop him in the least. He went right on endlessly working out his ideas, such as that colors attain their maximum resonance at the midpoint between light and dark, thus his palette was warm and deep as in his *Self-Portrait.* Even his wives, three of them, were so inundated by his ego that they slid out of the house. One wife, the third, survives in his famous picture, *Sophie Candace Stevens Page*, and stands before the Coliseum in Rome, a monument of a woman, bearing out another of his theories — that a portrait should be based upon sculpture rather than life. The companion to this is the colossal *Self-Portrait* where he stands before a piece of antique sculpture. It is a handsome painting which leaves us no doubt about the man who posed for it or painted it.

But for all his ego, Page ranks as the first experimental American painter. He did not do what so many artists in the past have done and still do — hit their style and stride, then ride them to exhaustion. He practiced his belief that the primary function of art was to find out more and more about art. He studied Titian, whom he admired so much that he tried to master his color, but unlike Washington Allston (p. 54) who also borrowed the Venetian master's palette and used it throughout his maturity, Page was not content to let it go at that. He went beyond, and, alas, he went too far. Page was an alchemist in paint, but though he came close to discovering the way to turn it into gold, he could not quite keep to the formula as Titian had done.

Portrait of Sophie Candace Stevens Page, *1860*,
William Page. 60-¼ x 36-¼ in., oil.
Detroit Institute of Arts.

EMBARKATION FROM COMMUNIPAW, *1861,*
John Quidor (1801-1881). 27 x 34¼ in., oil.
Detroit Institute of Arts.

America has a great number of "mysterious artists," for we have not systematically maintained the basic documents on many of them and we have wholly ignored as many more. Scholars and critics can come up with few explanations about their lives as artists and admit that there are great gaps even in the knowledge of their activities. Only in the past decade has there been a concentrated effort to clarify the facts of our artists' lives and to put their work into proper periods. Much of this important work is due to the efforts of the Archives of American Art in Washington, D. C.

John Quidor, according to his few biographers, still is baffling. We know he lived most of his life in New York City, and to date only forty-five paintings can be accredited to him of which thirty are known. What happened to the man and even worse to his work is basically tragic — Quidor lived and died in neglect. Until 1936, when the critic Alan Burroughs reappraised his work, he remained a forgotten man.

It seems extraordinary to us now that this solo performer — who followed no rules of painting, had no influences from the romanticist and heroic-minded art world of his time and had no followers — should not have been properly identified as one kind of genius. Washington Irving, author of "Rip Van Winkle" and "The Legend of Sleepy Hollow," and Quidor's main inspiration, has held an honored place in our literary pantheon since his own time. Certainly Quidor, who more than many painters captured a writer's mood to perfection and even gave it a pictorial independence, deserved the same.

During almost all of Quidor's creative life there was a definite distinction between acceptable artistic subject matter — such as landscapes, history painting, portraits and, to a lesser extent, more realistic genre pictures — and paintings inspired by storybooks. Since, Quidor's complicated designs precluded translation into engraved illustration, he and Washington Irving were never associated permanently in the public mind. Furthermore, Quidor paid

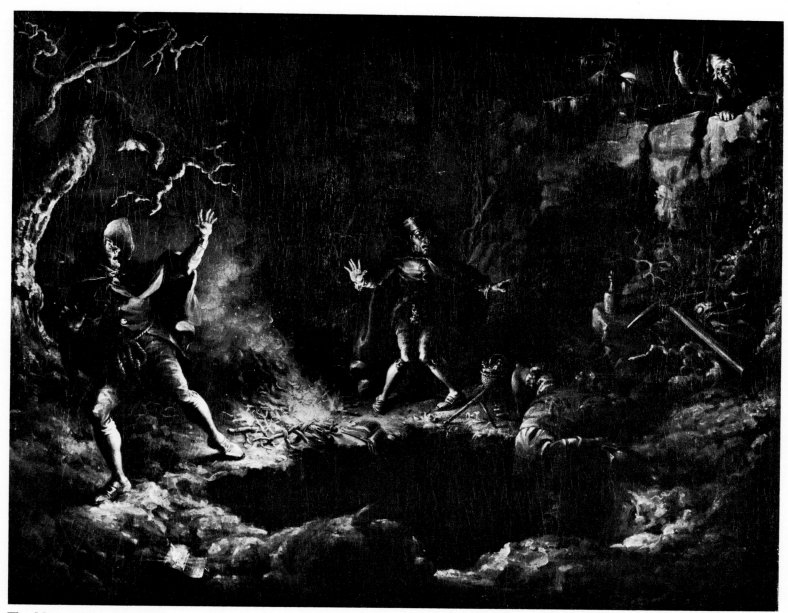

The Money Diggers, *1832,*
John Quidor. 16-3/4 x 21-½ in., oil.
Courtesy of the Brooklyn Museum,
gift of Mr. and Mrs. A. Bradley Martin.

no heed to usual social proprieties expected of an artist, antagonized the National Academy and did not care to train students in his style. Emotionally, Quidor was alien to his times; his world of unheroic characters was built of imagination, while the rest of the world preferred the art of grandeur.

Time plays with artists, and now we see Irving's great characters and stories almost more vividly through Quidor's eyes than through the author's. From 1828 to 1839 Quidor had years of fairly successful showing of his Irving and James Fennimore Cooper scenes. He abandoned these themes, however, after he painted *Rip Van Winkle at Nicholas Vedder's Tavern* in 1839. For six years he devoted himself to a series of seven enormous Biblical scenes, done in a heavy dramatic style alien to himself, apparently similar to Benjamin West's (pp. 23-27) religious scenes. These were lost, but when Quidor died at the age of eighty the brief obituary mentioned "he was famous for his Biblical topics."

Although the Washington Irving subjects are what have brought about his belated fame, especially the wonderfully mysterious and humorous *Ichabod Crane Pursued by the Headless Horseman,* our picture captures all his most en-

chanting qualities without relying on such familiar subject matter. Taken from Irving's *Diedrich Knickerbocker's A History of New York,* published in 1809, the scene is the *Embarkation from Communipaw.** The composition is charming in its frame of trees, and the lively procession of well-wishers seeing the comical-looking sage Van Kortlandt off on his journey compliment the tondoesque feeling of the picture's essentially circular composition. Even the patch of sky is circled by clouds. The whole picture has swing to it that identifies it as being the work of only one painter, Quidor. *Embarkation* was painted about 1861, near the end of his last brief creative period, after he abandoned his Biblical attempts. Quidor earns contemporary accolades as our first "romantic seer " and the first American to paint for his own enjoyment, art for art's sake of a very individual order. As the art historian James T. Flexner puts it, "He anticipated the immortal horselaugh of the early Mark Twain."

*Communipaw, a former Indian village on the "Jersey shore," according to Irving's book, was the first place the "Low Dutch" colonists settled in the New World. Van Kortlandt, known whimsically as "Oloffe the Dreamer," urged the settlers to leave Communipaw because he said St. Nicholas had appeared to him and given him this advice, and some of the men of the village decided to follow his suggestion. So one morning Van Kortlandt summoned his followers with a blast from a conch shell and they left in three small boats. They went up the East River and, after being caught in a whirlpool at a place they appropriately named Hell-Gate, they returned to their village.

ELIHU VEDDER

Elihu Vedder was not a prophet of blazing mystical truths. He was an honest man and talented artist who, with his fascination for the unknowable and while, perhaps at times on the brink of madness, managed to live and work quite successfully as painter of the fantastic, muralist and illustrator for eighty-six years. Vedder never totally succumbed to his visions. An affable *bon vivant* with a jolly if ironic sense of humor, Vedder had his cake and ate it too. He survived his propensities for the commonplace to produce work of great imaginative power and he survived the obsessions of his imagination to live with the pleasures of a life rich with common sense and fun.

Vedder survived despite some of the strange inclinations of his mind — a fact which makes him difficult to assess. Vedder's success lies in the fact that he did not find the contradictions of his life in any way strange or wrong. It seemed perfectly natural to him that summer sport on the Isle of Capri should delight him as much as the mysterious callings of his fantasy. He was, on the other hand, vulnerable to the crudities of critics of his black and white prints and those who variously damned him for being an "illustrator" (he did a series of more than fifty superb illustrations for an 1884 edition of the *Rubáiyát of Omar Khayyám*), for not being a "serious painter," and for inventing curious fantasies as a way of attracting attention and avoiding serious conviction, or for being an imaginative sensationalist who took advantage of his Victorian audience's desperate need for distraction by giving them pictures to tingle their spines, such as *The Lair of the Sea Serpent*.

But if no one else is sure what Vedder was about, Vedder himself suffered from no uncertainty. In his delightfully frank autobiography, *The Digressions of V*, Vedder wrote: "I am not a mystic, or very learned in occult matters. I have read much. . .and have thought much, and so it comes that I take short flights or wade out into the sea of mystery which surrounds us, but soon getting beyond my depth, return, I must confess with a sense of relief. . . ." Who can fault a man for not drowning? Vedder had the good sense to know his limitations. "Thus it comes that Blake [William Blake, English artist, poet and mystic] can wander with delight and retain his mental health in an atmosphere which would prove fatal to me, " he wrote. Vedder, unlike our modern "romantics" who are possessed by the alleged divinity of the extreme, never tried to be what he was not, nor did he go beyond that boundary of his visions from which he felt he could not return to the conventional world. Perhaps this is not the stuff of great men, but it is a quality which permits the possibility of living a long life greatly.

Vedder made no pretense — which is a singular triumph in a time when ordinary men like him, possessed with equal poetic faculties, were being deified in Paris for making a new, surrealistic, assault on the truth. Vedder's truth is disarmingly truthful. "It delights me to tamper and potter with the unknowable, and I have a strong tendency to see in things more than meets the eye. . . . There is another thing — the ease with which I can conjure up visions. This faculty if cultivated would soon enable me to see as realities most delightful things, but the reaction would be beyond my control and would inevitably follow and be sure to create images of horror indescribable. A few experiences have shown me that that way madness lies; and so, while I have rendered my Heaven somewhat tame, at least my Hell remains quite endurable."

The great lesson that Vedder has to teach us is that mystery is not reserved exclusively for madmen, saints or for those who are otherwise incapable of finding pleasure

The Lair of the Sea Serpent, *1864,*
Elihu Vedder. 21 x 36 in., oil.
Courtesy, Museum of Fine Arts, Boston,
bequest of Thomas G. Appleton.

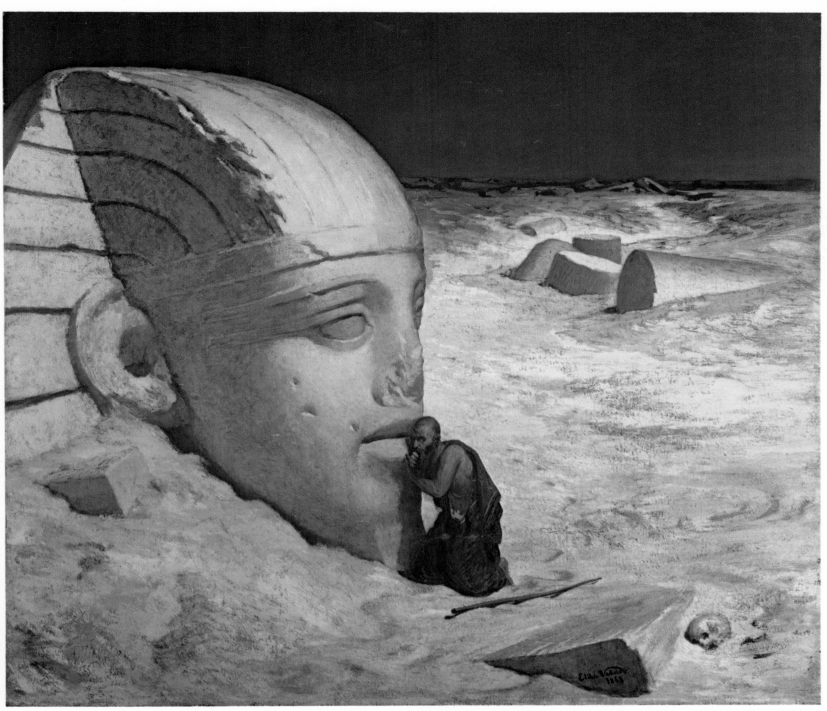

THE QUESTIONER OF THE SPHINX, *1863,*
Elihu Vedder (1836-1923). 36 x 41¾ in., oil.
Courtesy, Museum of Fine Arts, Boston, bequest of Mrs. Martin Brimmer.

in the ordinary beauties of an ordinary life.

Blake has said, "If the doors of perception are cleansed everything would appear to man as it is, infinite." Vedder chose to clean only a tiny portion of his door, but what he saw he reported as faithfully as possible. He was the illustrator of his own imagination, and if he felt that he had never "gotten over a faithful but fiddling little way of drawing," at least he was faithful to what he saw and in no way tried to falsify it in the glories of a style not his own.

Vedder's experience of Egypt, expressed in both his autobiography and in our painting, *The Questioner of the Sphinx*, gives evidence to the cornerstone of his character. Vedder was interested in preserving mystery, not in solving it. Of the artifacts he saw while visiting Egypt he wrote:

"It is their unwritten meaning, their poetic meaning, far more eloquent than words can express; and it sometimes seemed to me that this impression would only be dulled or lessened by a greater unveiling of their mysteries, and that to me, Isis unveiled would be Isis dead."

Vedder simply believed that some things not only could not, but should not, be known objectively — that the life of certain things is totally dependent on their insulation from factual understandings: A decidedly unpopular viewpoint in an age like ours when the moon itself has become merely the nineteenth green. One has no way of knowing what question the questioner put to the Sphinx. But it takes no imagination whatsoever to know what the answer is: "None of your business."

DAVID GILMOUR BLYTHE

In keeping with our country's early determination to force everything into a European mold, this gifted, imaginative and very American artist was called "The American Hogarth." William Hogarth's (1697-1764) style was original and indigenous to the British love for caricature. In our art Blythe is almost unique, but like Hogarth, he preferred the seamy side of life, and like him, too, he sold this preference with a veneer of humor. But there the similarity ends. Hogarth was a consummate painter and etcher, one of England's greatest, while Blythe was untutored, undisciplined and, even with today's reevaluation, a lesser performer in his profession.

Hogarth was genuinely concerned with the moral and social problems of his times, while we get the feeling that Blythe, a true Bohemian, painted what he saw, as he saw it, without any idea of causing any changes to occur. He never mounted Hogarth's lofty pulpit no matter how concerned he might have been with the human condition.

His personal life was poverty ridden, and much more in keeping with the familiar picture of the life of the suffering artist than was Hogarth's more conventional existence. Blythe painted for fun to amuse his drunken companions, and yet these jokes, seen from our vantage, point a finger to a much later direction in our art, the satiric social criticism of the 1930's and Ben Shahn (p. 296).

In the Pittsburgh Post Office, *1856-61, David Gilmour Blythe. 25 x 30 in., oil. Courtesy, Museum of Fine Arts, Boston, Karolik Collection.*

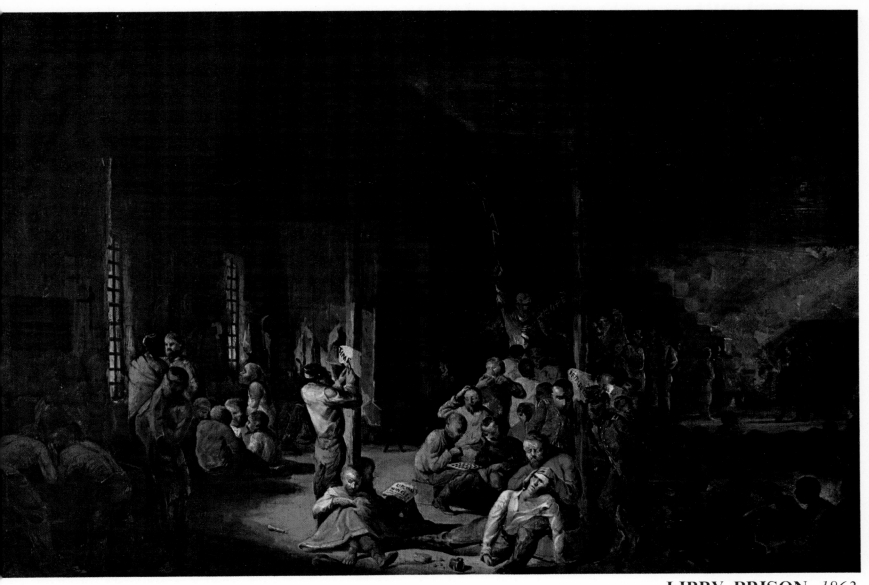

LIBBY PRISON, 1863,
David Gilmour Blythe (1815-1865). 24 x 36 in., oil.
Courtesy, Museum of Fine Arts,
Boston, Karolik Collection.

James T. Flexner in his brilliant book, *Nineteenth Century American Painting*, says if Blythe had had the advantages of Europe, he would have found a finer technical language, but Pittsburgh, "then as artistically backward as was possible in the civilized world. . .was his Rome and alcohol his Raphael." I would change Raphael to Daumier.

After his death from alcohol at fifty, his local fame died with him, but today we can see in him something of the prophet that is in all artists. America was changing, and while many of our painters were concerning themselves with socially wealthy patrons or escaping from creeping Eastern industrialization to bask in the unspoiled West, Blythe was painting the dark interiors and meanness of urban and petty village life around him, unconcerned with any art but his own, producing a valuable preview of the present day problems of our great cities. There is no romantic approach to his pictures; they appear somewhat rustic only because of their distance from us in time, but they are unflinchingly real and therefore of great value in examining the history of our country. *Libby Prison* is more bitter than some of his other works, such as *In the Pittsburgh Post Office*, but it provides insight into his technique, only lightly touched by social protest relative to Hogarth or Shahn. It is social comment simply told.

119

SANFORD ROBINSON GIFFORD

Villa Malta, Rome, 1879,
Sanford Robinson Gifford. 12-3/4 x 26-3/4 in., oil.
National Collection of Fine Arts,
Smithsonian Institution, William T. Evans Collection.

Of all the landscape painters America has produced, Sanford Robinson Gifford is perhaps the most ideal or at least the most idealistic. Born of well-to-do parents in Hudson, New York, his youthful yearning to be an artist had as a beacon the famous gothic-style house of Thomas Cole (pp. 70-73) across the river. Gifford was charged with emotion by Cole's romanticism, but his was not a desire to transplant Europe to America; rather he looked to the native landscape he hoped to paint as the be-all and end-all of an artist's visual need. He left school to set about seeing as much of this landscape as possible and, in studying the works by the masters of this category of art, to arrive at his own way of visualizing it.

In London he admired J. M. W. Turner (1755-1851) but could not subscribe to that great English master's dissolution of subject matter in light. J. B. C. Corot (1796-1875) he saw as sketchy, although the Barbizon School as a whole impressed him considerably. But their way was not his, and when you look at one of Gifford's immaculately clear and crisp landscapes you know why. He was concerned with "the light giving properties of the sky," which, according to James T. Flexner, he felt was "carried to the earth by atmosphere, imbued nature with sentiment, unity, and expression."

Gifford took many walking tours during his life to study landscape. On one he walked from Paris to Rome, on another he went on to Greece, Turkey and Syria. A great fisherman, he walked the east coast and Canada seeking "the king of the waters, the finest fish that ever swam." He made thousands of quick sketches wherever he went across western Europe, but he did not work from them in his studio. His memory served to put him, in the presence of an empty canvas, in touch with just the mood of nature he wanted to portray. Once the idea was roughly sketched in, he would go into training like an athlete. He would work ten or twelve hours at a time at a canvas; then there would be months of contemplation with additions. Finally he

would varnish the pictures many times so that he himself was creating the atmospheric mist with which he believed nature bathes all landscapes.

Gifford made another trip to the American West in the company of his friends, Thomas Worthington Whittredge (p. 134) and John Frederick Kensett (p. 122). But the Western landscape was not for them, and none of them could have turned out an Albert Bierstadt (p. 128) or a Thomas Moran (p. 204) landscape even if they had wanted to. Sanford Gifford was a gentle man, and his pictures are the product of his own serene and placid personality, not well suited to painting the rugged topography of the West.

Many of the first-generation Hudson River School artists fared better at the pen of subsequent critics than did the second generation to which Gifford belonged. There was criticism of his repetitious use of atmospheric light; others thought him artificial, since he worked away from nature. But not long ago a large showing of his work brought forth this modern criticism by Nicolai Cikovsky, Jr., who says of Gifford's work in comparison to that of his contemporaries, ". . .the things that he shared with his contemporaries knowingly or unknowingly became transformed by an artistic mentality and sensibility that, in its refinement, acute sensitivity, delicacy, subtlety — in short, in its aestheticism — had no parallel among them."

Kauterskill Falls, which has hung in the Metropolitan Museum of Art for many years, is one of his greatest works. It is a picture of such staggering depth that the viewer has almost to journey into it to discover the distance and all the wonders there. The falls itself is almost invisible but once seen becomes a destination for the eye and the imagination. As in many or really most of the Gifford paintings I have seen, the color is that of the suspended moment after sunset or before sunrise when the calm is suffused with pinks, golds and greys. The total effect is one of undiluted beauty.

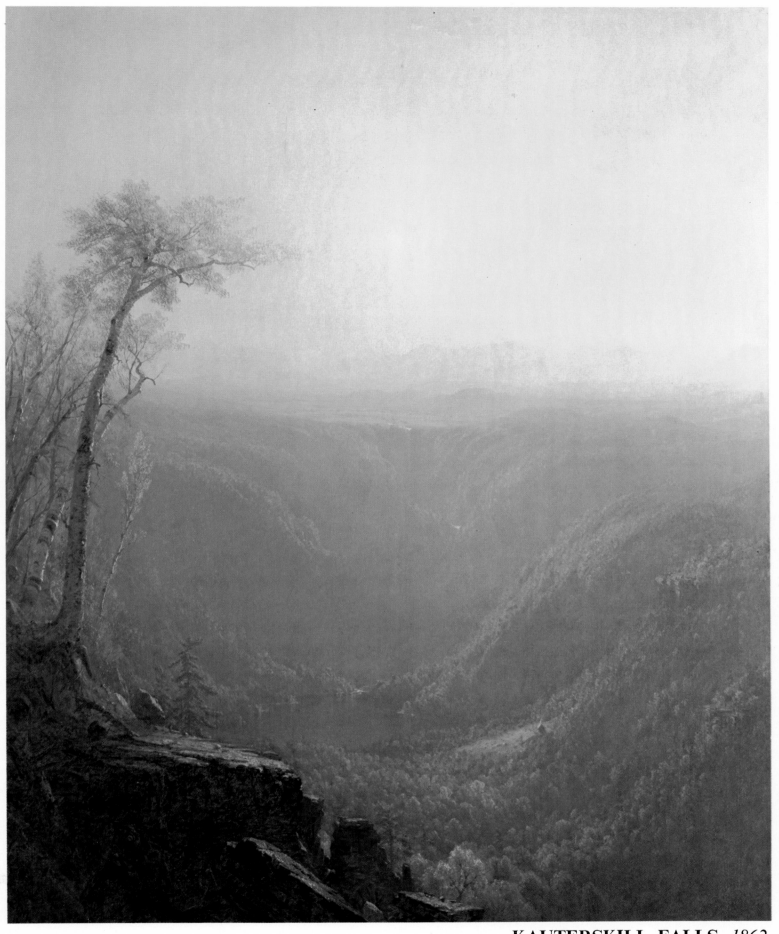

KAUTERSKILL FALLS, *1862,*
Sanford Robinson Gifford (1823-1880). 48 x 39⅞ in., oil.
The Metropolitan Museum of Art, New York,
bequest of Maria De Witt Jesup.

JOHN FREDERICK KENSETT

AN INLET OF LONG ISLAND SOUND, *ca. 1865,*
John Frederick Kensett (1816-1872). 14½ x 24 in., oil.
Los Angeles County Museum of Art,
gift of Colonel and Mrs. William Keighley.

John Frederick Kensett is one of our most enchanting and enchanted landscape painters. At a time when landscape painting was dominant, and thousands of beautiful ones were being turned out by very accomplished artists, Kensett's work was different. Essentially what makes that difference is his ability to portray superbly the great conflicting dramas of nature, violence and absolute peace. One could say nature at peace and war is ostensibly the aim of all landscapists, but few achieve the contrast of her moods with such simplicity of design and technique as Kensett. Once he established his style, he was completely consistent in this.

This style was born out of the knowledge he gained as apprentice to the engraver, Peter Maverick, the same man who hired the young Asher B. Durand (p. 90). This exacting craft shows through whatever atmosphere Kensett laid over his mature work. There is a precision, a clarity, that comes from this early training. Later, in 1840, when he and Durand were in their twenties, they went to Europe where they both came under the influence of English and American painters, especially the elderly American John Vanderlyn (p. 52), who advised Kensett to make copies in the Louvre. He then traveled to England where he wrote, "My real life commenced there, in the study of the stately woods of Windsor, and the famous beeches of Burnham, and the lovely and fascinating landscape that surrounds them." John Howat, a curator of American art at the Metropolitan Museum of Art, says that "in England [Kensett] discovered an attitude and a technique rather than a style." The style was developed during his stay in Rome and his wanderings in its beautiful Campagna.

But it was only when he returned home after eight years in Europe that Kensett set the style that made him, fortunately, distinctive from his contemporaries Durand, Sanford Gifford (p. 120) and Thomas Worthington Whittredge (p. 134). All his pictures have that rare quality of inner light we associate with the men of the Italian Renaissance and the Flemish masters like the elder Brueghel (1520-1569) and Jacob Patinir (1475/80-1524). They are haunted by light, whether it be the sinister light of a stormy day by the sea or the most idyllic glow of early morning sunlight. Clarity of light is his forte, an ability highly appreciated by critics and collectors.

Before he came into his particular and popular style, he often included genre scenes to "liven up his landscapes," but his mature works are almost devoid of humanity. The honesty of his lake and shore scenes is what intrigues modern viewers who are often bored with the sentimentality of other painters of this period. He had an abhorrence for "a bright sky and a hot sun" and yet he achieved a brightness that lets us see every nuance of the scene he was painting.

Though not as ambitious as some, *An Inlet of Long Island Sound* is a perfect example of his work. Its very directness attracts us: The wonderful way he leads us from the low grass foreground into the reedy middle distance and thence out to sea and almost to infinity. There is such peace here, the kind of view that makes the weary world walker stop to understand better the serene possibilities of the world we too seldom visit.

In contrast is the more dramatic view of *Conway Valley, New Hampshire.* The rough textures of the rocky foreground are used to contrast the pastoral valley and mountains again in the infinite distance. We see here why some critics were reminded of J. B. C. Corot (1796-1875), but, as James T. Flexner suggests, Kensett's silvery grey (for which both men were famous) had "less body and temperament, shone more virginally."

Conway Valley, New Hampshire, *n.d.,*
John Frederick Kensett.
32-3/4 x 48 in., oil.
Worcester Art Museum,
Worcester, Massachusetts.

MARTIN JOHNSON HEADE

STORM OVER NARRAGANSETT BAY, *1868,*
Martin Johnson Heade (1819-1904). 32⅛ x 54¾ in., oil.
Collection of Mr. and Mrs. Ernest T. Rosenfeld, New York.

By now, we should not be at all surprised to find that a little-known American artist who was "attacked" by an "all absorbing craze" for (of all things) hummingbirds, should also be an incipient Surrealist who painted sinister, supra-real pictures before the word "surreal" was even coined. The history of American art is filled with such unlikelihoods — so many of them in fact that one might say the word "unlikely" is descriptive of American art in general: Erastus Salisbury Field and his *Historical Monument* (p. 136); Morse and his telegraph (p. 68); Page and his vanishing paintings (p. 112). The life and work of

Orchids and Spray Orchids
with Hummingbirds, *1865,*
Martin Johnson Heade. 20 x 12 in., oil.
Courtesy, Museum of Fine Arts, Boston,
Karolik Collection.

Martin Johnson Heade perfectly exemplify this recurring phenomenon in our art.

At eighteen, Heade, a native of Bucks County, Pennsylvania, studied with Thomas Hicks, four years younger, a child prodigy thanks, perhaps, to his uncle, Edward Hicks (p. 84), and later a portrait painter of ability. Heade's father, a wealthy farmer, supported him for two years of study in Italy. Back home, although he gained acceptance among several of the leading landscape artists, especially his best friend, Frederic Edwin Church (p. 110), Heade proved a wanderer for most of his life. He was the first American to go to South America with the express purpose of recording scientifically its flora and fauna, an example followed to much great financial and popular success by Church. At one point, Heade became court painter to the emperor of Brazil, and the Amazon provided him with numerous opportunities to paint his obsessional image, the hummingbird, with or without a wild orchid as feeding station. Heade painted tropical flowers, exotic

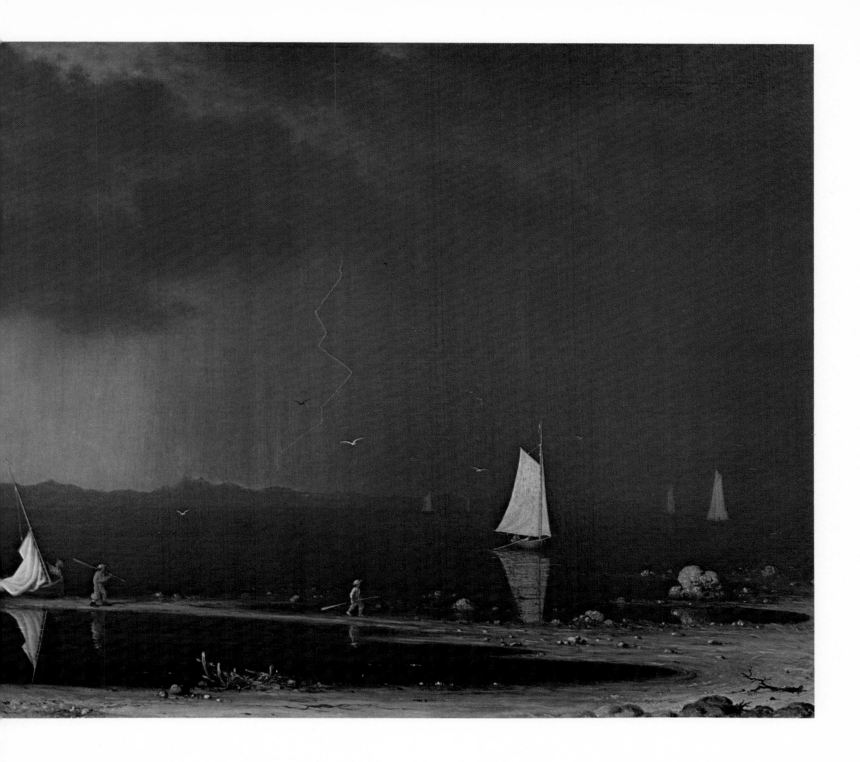

birds, portraits and moody landscapes. However, Heade had something else inside of him, and without his Surrealist temperament, he would have been just another competent professional artist of his time. As it was, he was largely forgotten after his death and only rediscovered after Surrealism has made its mark in our time.

The word "Surrealism" was coined in the 1880's by the French poet and critic, Guillaume Apollinaire. Heade painted *Storm Over Narragansett Bay* a good fifty years before the Surrealist Movement was born in Paris. The Surrealist clarity of the painting actually derived from the mid-century Luminism of which Heade was a leading practitioner. The Luminists were a kind of middle generation between the classic Hudson River School of Thomas Cole (pp. 70-73) and Asher Brown Durand (p. 90) and the American Impressionism of Childe Hassam (p. 202) and John Henry Twachtman (p. 174). Just as Church and Albert Bierstadt (p. 128) pushed beyond the geographical confines of the Hudson River area, so the Luminists

pushed beyond the straightforward, scenic views of the earlier landscapists, in whose work it was always two o'clock in the afternoon, to begin to study light itself, a subject most available in the changing lights of morning or evening. For Heade, the fascination lay not in a storm itself, but in the approach of one, with all the violent changes of the light that state implies. He did several canvases of that hour of awesome change. It was the intensity of his fascination and therefore of his observation that produced the prophetic Surrealist look of these works.

In works like *Storm*, although he was not concerned with the traditional Surrealistic concerns of pre-consciousness, he did do something ultra-real to nature. Because he was a nature lover, it seems natural that he would go nature one better and transform it, take it to its extremes, rather than opting for subject matter alien to his interests. For Heade, nature was the most real of all reality and, in this, one of his best paintings, he reveals her to us with such truth she becomes almost unreal.

JOHN FERGUSON WEIR

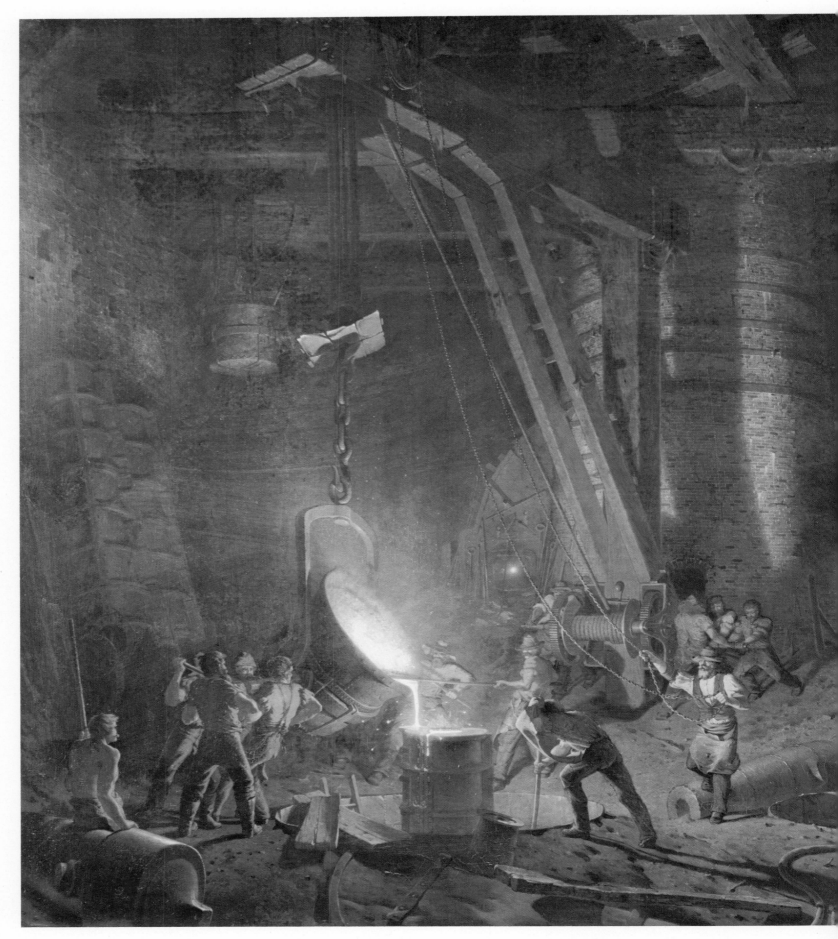

THE GUN FOUNDRY, *1886,*
John Ferguson Weir (1841-1926). 46½ x 62 in., oil.
Courtesy, Putnam County Historical Society, New York.

It is the fate of some artists to be born too soon or too late to fit the fickle moods of taste. Others have not been able to sustain their talent and have succumbed to the old saw that "those who can do, and those who can't teach." John Ferguson Weir in his later years suffered both these disasters and yet, by the time he was in his mid-twenties, was a full member of the National Academy and had painted the most important industrial picture of nineteenth-century America. It and several of his other works were far in advance of their time, but Weir was not able to keep in the vanguard. Time and taste rushed past him, and he became not even a great teacher, but ended up in the prosaic position of administrative director of the art school at Yale University. To his credit, as the first dean of this now distinguished art school, he developed it from nothing to a position of considerable importance.

Weir's beginnings were auspicious. His father, Robert W. Weir, was teacher of drawing at the West Point Military Academy and one of the elders of the Hudson River School. The boy literally inherited a place in this distinguished school of American landscapists, for under the tutelage of his father he was included in the explorations these artists made of the Hudson River Valley. By age twenty he had set himself up in the center of New York's art world in the Tenth Street Studios. He became an associate of the National Academy at twenty-three by painting landscapes.

A few years later this precocious young man set about an heroic task. The Civil War was at its height and the Parrott guns, which were the heaviest artillery then employed, were being cast in a huge foundry across the river from West Point. Weir's inborn interest in the American scene led him away from the hills and woods and into this unlikely inspiration for art, the foundry. His fellow artists, older and established ones like John Frederick Kensett (p. 122), Frederick Edwin Church (p. 110), and Thomas Worthington Whittredge (p. 134), encouraged his bold adventure. Even the great Asher Brown Durand (p. 90) made a trip to New Jersey to give him more encouragement.

Weir did many sketches of the foundry and the workers, "And one night," he wrote, "I spread my studies...on the walls and floors...I began to arrange the composition of the gun foundry in a large charcoal cartoon; cranes and rafters of the dusky place, with the foundry men all in busy action absorbed in their work; the interior lit up by the glow of a great cauldron of molten-iron swung by a heavy crane to be tipped while the ropy metal was poured into the moulding flask...which stood on end in a deep pit where a gun was to be cast. I worked on the cartoon through the night and by dawn had arranged the main features and effects."

Weir worked on the large canvas for two years, and though he has described the work for us in the words above, we feel perhaps even he did not realize its importance, for he did not follow up his great innovation of studying America's industrial pictorial possibilities. He went to Munich to study and there came in contact with that art center's dedication to the technique of the seventeenth-century Dutch painter, Frans Hals. The dashing techniques of the Munich artists were directly opposite the meticulous, almost photographic, Hudson River approach. The Munich School made no impression on Weir, but later it was to influence Robert Henri (p. 192), and from Henri stemmed that long line of American painters who accepted industrialization as part of the American landscape. Had Weir accepted this freedom and added it to his very avant-garde interest, he might have become one of the greatest of our painters. *The Gun Foundry* is an amazing picture for its time and its spells out the trance of machinery and industry long before other artists could bring themselves to see that way.

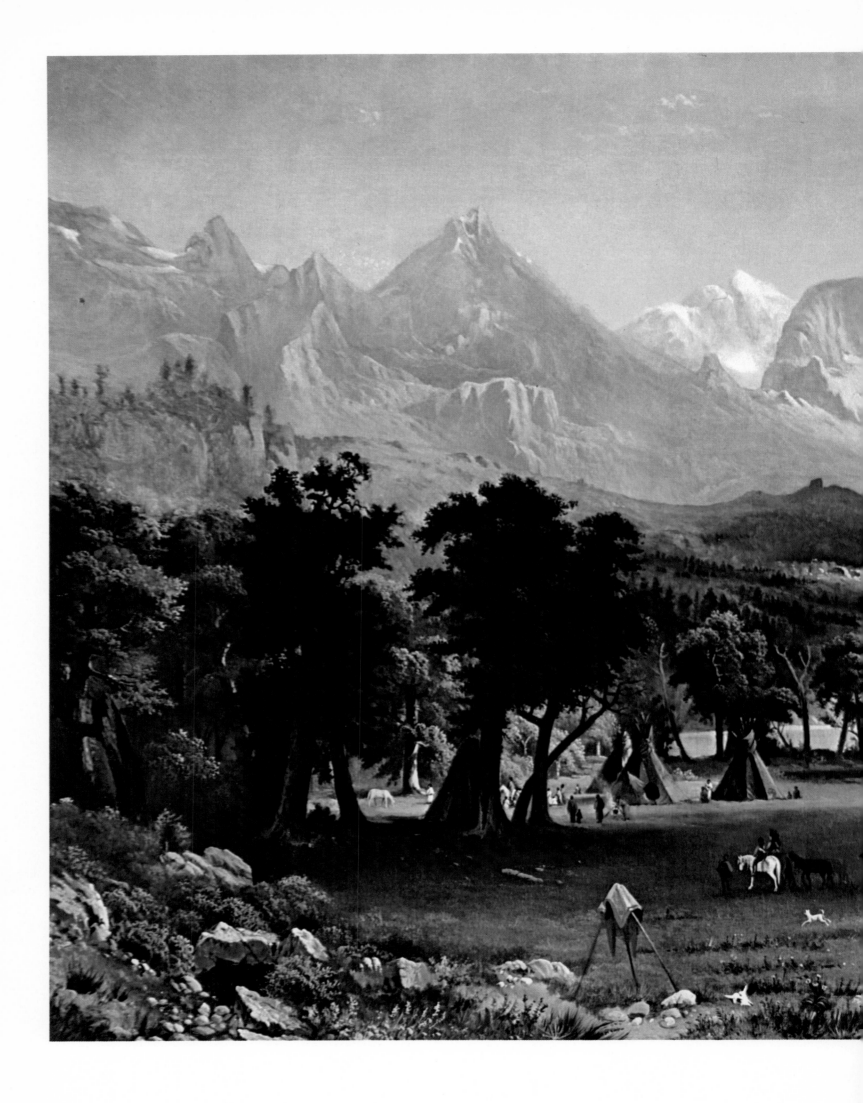

128

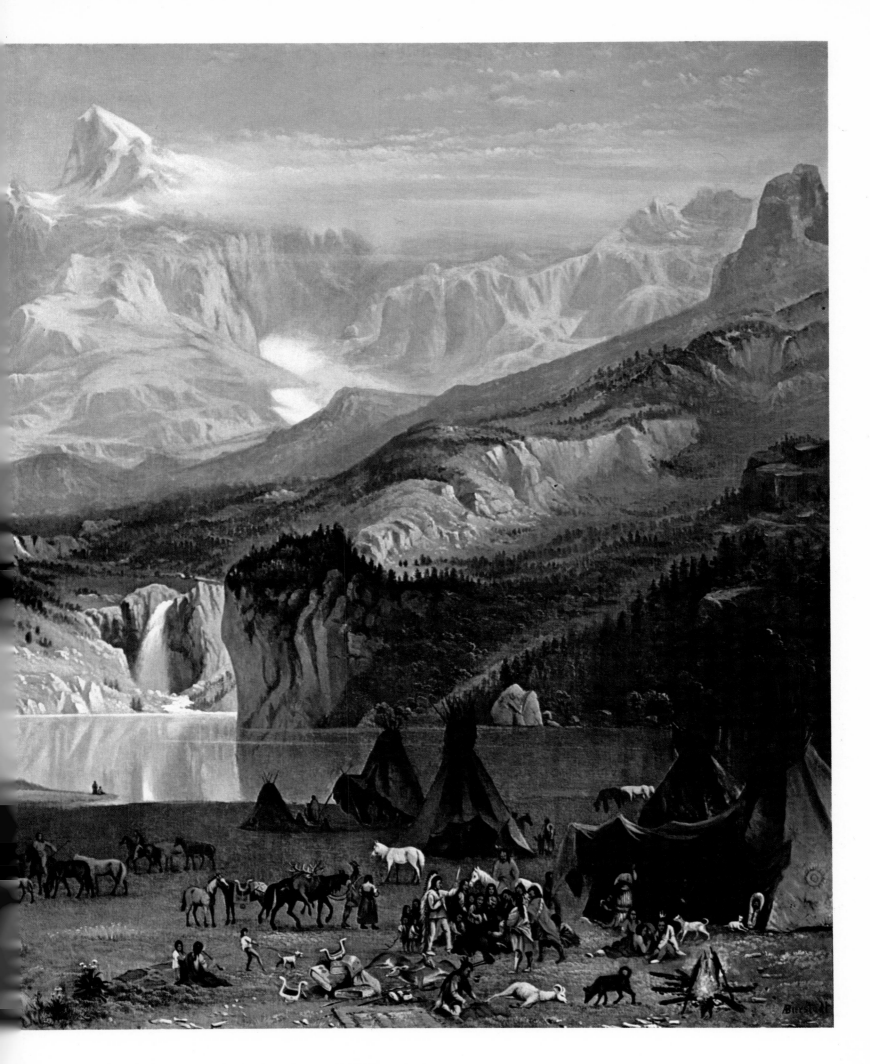

INDIAN ENCAMPMENT IN THE ROCKIES, *n.d.,*
Albert Bierstadt (1830-1902). 48 x 82 in., oil.
Whitney Gallery of Western Art, Cody, Wyoming.

ALBERT BIERSTADT

(Backleaf, see pages 128-129.)

If you stand in front of this colossal painting and are not impressed, perhaps you should see your doctor, priest or go on a long vacation. You are meant to be impressed by it, even as you are meant to feel you are standing on the scene itself. The chances are, however, you will see much more looking at the painting, for Albert Bierstadt was looking for you with the eyes of an artist at once overwhelmed by the grandeur of the scene and unjaded by the travel folder, postcard or television travelogue.

Bierstadt painted several similar versions of *Indian Encampment in the Rockies* in the early 1860's, and one of the largest of these was first shown to the public in New York City in 1863. It was sensational not only because of its great size, which brought the grandeur of the Rocky Mountains to the stone jungle of Manhattan, but because it was utterly foreign to most Americans. It was displayed with the best circuslike ballyhoo of the times — banners, headlines in the papers, with emphasis on the exotic — and it immediately established Bierstadt as a rival to Frederic Edwin Church (p. 110), the acknowledged master of grandiose art. As a point of departure, it had been Church's success with his showpiece *Niagara Falls* that encouraged Bierstadt to set off in 1858 with a government expedition to the fabled West to see if he could make the most of its picturesque quality.

Bierstadt was born in Germany near Düsseldorf in 1830 and came with his family to live in New Bedford, Massachusetts, when he was a baby. He returned to Düsseldorf, one of the art capitals of the Old World, and from there to Rome when he was twenty-three. He came home fully equipped to tackle the natural beauties of America four years later. In 1858, he joined Colonel Frederick Lander's party leaving from Troy, Missouri, to make preliminary survey sketches for a railroad route to the West Coast. He left the party to travel around the West on his own and returned a year later where he set up his studio in Irvington-on-the-Hudson. It may seem extraordinary that so many of our great Western painters worked out their compositions in the East, but we must remember they were not only portraying the beauties of the West and its life, but in no small measure fictionalizing it.

Bierstadt was not above intensifying the ruggedness of the landscapes he saw, sharpening the peaks, deepening the gorges, throwing over all the most dramatic effects of clouds, storms, light and shade. After all, very few viewers could check up on him, and, of course, tales of the West only made his wildest half-truths, or all-out fantasies, seem authentic. That he was a magnificent painter no one could question, and he deserved the honor of being called the founder of the Rocky Mountain School of American landscape painters. Though he studied art, his influences are not vital to his identification as a painter. He was largely self-taught, and his beautiful, spontaneous sketches show him to be a more sensitive artist than one would imagine from the huge finished masterpieces. He differed from the Hudson River School founded by Thomas Cole (pp. 70-73), in that he was not as concerned with the minutiae of nature as he was with the overall effect. One critic has suggested that the primary difference between the two schools is in the quality of man's relationship to nature. The contact is very personal for Hudson River painters. For Bierstadt, however, man, when and if he appears at all, is generalized to fit into the overall effect of nature in the raw.

Bierstadt's art went into eclipse with the opening of the West to tourism, but today we reappraise it not only for his awe-inspiring technical facility, but to see the unspoiled wilderness in Bierstadt's sensitive light so we can compare it with what remains of the wilderness today. Bierstadt's views of it, unhappily, are becoming memorials to it.

JOHN LAFARGE

WOMAN BATHING, NEWPORT, R.I., *n.d.,*
John LaFarge (1835-1910). 18 x 12¼ in., oil on panel,
Worcester Art Museum, Worcester, Massachusetts.

The elegant artist always carries a fascination for the public, and John LaFarge was elegant. He was an aristocrat by birth and by inclination. He went to study art in Europe, not necessarily to become an artist, but to let the arts make him a fuller man. When he worked with the great academician Jean Léon Gérôme (1824-1904), he made it a point to tell the master that his objective was not to do anymore than to improve his taste. Like the young English gentlemen of the early nineteenth century, what he sought on the continent was culture, and that was what he found.

Back in America, after meeting the great teacher and ardent interpreter of French art, William Morris Hunt (1824-1879), LaFarge at last succumbed to painting, and culture was his prime product. His murals for public buildings, especially churches, such as H. H. Richardson's Trinity Church in Boston, proved him to be a muralist in the great tradition. Although it may not be quite to the current taste, one cannot help but be impressed by the spiritual and artistic rightness of the great chancel painting in the Church of the Ascension in New York. It lacks the grandeur of a Piero della Francesca (1420?-1492) or the passion of a Michelangelo, but if you can throw yourself back into the artistic requirements of the time in which it was painted, just before the birth of our century, it seems absolutely correct. He stated his philosophy of art very succinctly: "Painting is, more than people think, a question of brains." And that perhaps sums up our criticism of him today: He is too brainy, an egghead in art, academically correct but without feeling. That is the thing that frequently arouses suspicion in the non-artist's heart: Too much intelligence.

LaFarge made a great contribution to our art nonetheless, for we needed this kind of cultural purity. American art, as I have said, is full of eccentrics, wild or tame individuals who often lost their taste in their idiosyncrasy. But LaFarge's work inspires confidence that we did, finally, come of dignified age. One modern critic sees in him the perfect definition of "an eccentric conformist."

LaFarge contributed much more, too, in his perfection of and innovations in the great art of stained glass. He created the opaline glass that revived the magnificence of the glass of the middle ages. He was an illustrator of note, wrote many fine essays on art and was on the committee that planned the Metropolitan Museum of Art.

One of LaFarge's most famous paintings is *The Wolf Charmer*, but I have chosen an exquisitely simple one that shows him at his classic best. Without a classic subject matter, with no religious implications, he creates in *Woman Bathing* a kind of perfection, a feeling of poise that lets us see the universality and timeliness of his taste. One can believe his biographer, Royal Cortissoz, when he wrote: "He founded no school. He was a tastemaker not an aesthetic innovator. . . . His work exerted a spiritual force. It refined taste and fostered imagination. It made powerfully for the establishment of a high ideal."

EASTMAN JOHNSON

The Drummer Boy, ca. 1866,
*Eastman Johnson. 26-½ x 21-½ in., oil.
The Fine Arts Gallery, San Diego.*

Eastman Johnson was one of our best genre painters. His scenes of everyday life in the city or the country are altogether endearing and convince us that this was the way things really were a century ago. His portraits, for which he was much more famous in his lifetime, seem rather heavy and dull to us today. Certainly his title of "The American Rembrandt," given to him in Holland of all places, is a clue to how little his contemporaries realized what we today hold to be Rembrandt's great contribution to art: the deep psychological insight into the characters of his sitters.

Johnson began his career as a portrait artist and ended that way, too, but for a golden quarter of a century, he roamed the country, or at least his favorite parts of the country, and left us a splendid record. He abandoned genre painting during the last twenty years of his life, much to the regret of his devoted public. His financial security, he felt, was in portraiture. Yet one feels from his writings and the early success of the genre work that it was much closer to his heart than he would admit, but he remained detached from it, using it almost as a holiday from his "serious" work as a portraitist. The year he died, *Scribner's Magazine* wrote in praise of this phase of his work, ". . . his conception of the rendering of the 'life of the

poor' of the 'tillers of the fields'. . . preaches no ugly gospel of discontent." In the light of today's social upheavals, this remark sounds like a slur on his character. Johnson himself deprecated the commonplace for perhaps another reason — to cover up for his obvious painterly joy in it. About his subjects he said, "Commonplaceness is the sum and substance of what one finds, go where one will."

A native of Maine, Johnson had a father in politics with powerful Washington connections and with an unusual discernment of talent. He apprenticed the boy at the age of fifteen to a Boston lithographer. At eighteen young Eastman was in business for himself, making portraits in crayon and pencil with such prominent sitters, thanks at first to his father, as Dolley Madison, John Quincy Adams and Henry Wadsworth Longfellow. Determined to perfect his talent, Johnson went to Düsseldorf, Germany, where he worked for two years in the studio of Emanuel Leutze (p. 96). In Holland he obviously learned much from the "little masters" of the seventeenth century, such as Pieter de Hooch and Jan Steen.

Through all the vicissitudes of taste, an artist's conception of his own work may not always be the most valid one. The public can be right, and their love of his senti-

132

THE SHELTER, *ca. 1870,*
Eastman Johnson (1824-1906). 23⅜ x 27 in., oil on board.
The Corcoran Gallery of Art, Washington, D. C.

mental pictures, like *My Old Kentucky Home,* originally titled *Negro Life in the South,* and *Wounded Drummer Boy,* has outlasted the taste of the Vanderbilts and Rockefellers who vied to be portrayed by him. Today's taste goes even farther, and we revere him for his charming sketches of his summer life in his native Maine, which exhibit an almost Impressionistic lightheartedness.

Johnson lived for eighty-two years. He outlived Thomas Sully (p. 56), saw Gilbert Stuart's (p. 28) star fade, even lived long enough to see the startling realism of the Ashcan School take over the art public's imagination. Not quite one of the giants of American art, he nevertheless left us some loving remembrances of a gentler way of life.

Outstanding in his impressive output were scenes from his native New England. He painted the harvest activities of cornhusking and cranberry picking on the island of Nantucket, where, for many years, he spent his summers. Perhaps the climax of his quarter century of recording with gentle affection the ways and days of America was an extended series of paintings on "sugaring off," the extracting of the sap from the maple trees in Vermont at the end of winter. *The Shelter,* also known as *The Truants,* is from that series painted just before Johnson gave up genre to concentrate for the last twenty years of his life on the portraiture which paid so well. It enjoys the same "your own backyard" philosophy that has the public appeal of a Mark Twain story. Johnson's contempt for the commonplace could not cover up his sensitivity to it, and he succeeds in making us feel if we have not been truants ourselves during sugaring off time, we wish we had.

133

THOMAS WORTHINGTON WHITTREDGE

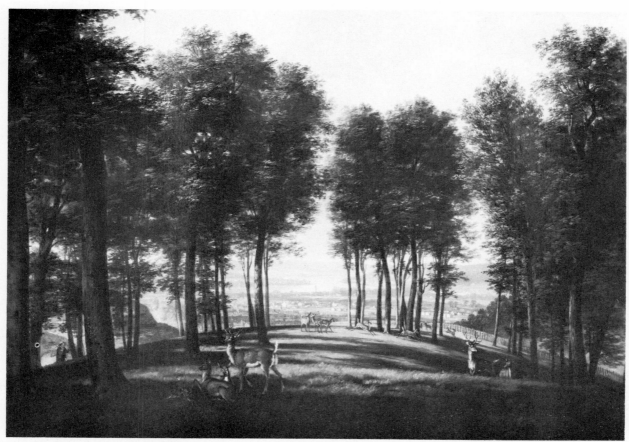

View of Cincinnati, *ca. 1850*,
Thomas Worthington Whittredge.
28-3/8 x 40-3/16 in., oil.
Worcester Art Museum,
Worcester, Massachusetts.

The spirit of Thomas Worthington Whittredge is aptly captured in these popular lines from the early 1900's, "America For Me":

> It's fine to see the old world, and travel
> up and down
> Among the famous palaces and cities of
> renown,
> To admire the crumbly castles and the
> statues of the kings,
> But now I think I've had enough of
> antiquated things
> So it's home again, and home again,
> America for me. . . .
> —Henry Van Dyke

Whittredge, like so many artists we have discussed, went to Europe and he came to hate it. He found no inspiration in London or Belgium. In France he searched out the Barbizon painters, who were preparing the way for Impressionism; however, he thought them "spirited but uninteresting." He stayed for four years in Düsseldorf and almost destroyed his talent by becoming a second-rate Germanic painter. In Italy he worried that the old masters did not mean as much to him as they should, and finally after what he considered ten wasted years, he came home in 1859. It was America for him all the way after that. In the New York Historical Society collection he found more excitement and a greater revelation than in all the European galleries. The traces of his European visit stayed with him, however, and to shake them off forever, Whittredge hid himself away from society in the Catskills.

But the ultimate break with his foreign style and the discovery of his own came after a trip in 1870 to the Colorado Rockies with John Frederick Kensett (p.122) and Sanford Robinson Gifford (p.120). None of the three were noticeably affected by the Rocky Mountain West, but as Whittredge returned east, the vast plains country took his fancy. The lack of clutter, the flatness reminded him of his native Ohio, and there was what he described in his autobiography as "an American freshness: vast and the appearance everywhere of innocent, primitive existence."

A Whittredge painting gives the sense that many Americans feel about the Midwest: It is the heartland of our country, friendly and welcoming. It is almost as familiar and comforting as home no matter where one is from. Even in his Eastern scenes, of which *A Home by the Sea-Side* is a fine example, there is a Midwestern feeling; the

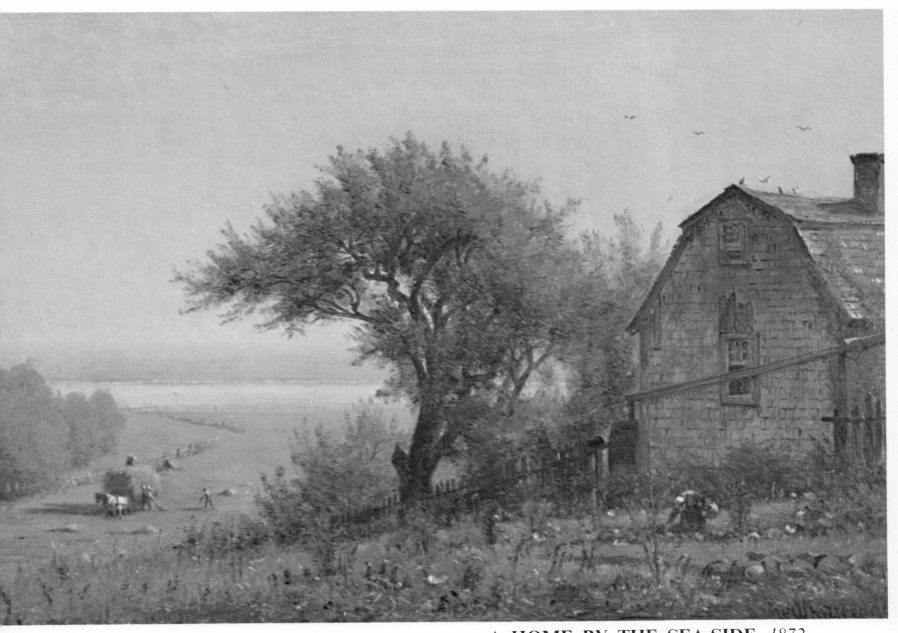

A HOME BY THE SEA-SIDE, *1872,*
Thomas Worthington Whittredge (1820-1910). 14½ x 25½ in., oil.
Los Angeles County Museum of Art,
The William Randolph Hearst Collection.

little house could just as well be on the banks of an Ohio lake. There is more mood in his landscapes than those of the Hudson River School painters. You have to stand back with the artist to enjoy this atmosphere, to become part of his romantic, realist vision. He sees the Eastern Seaboard as a place where people have lived long and made the land their own.

His appeal might be more understandable if we compare him to another American directly his opposite, William Merritt Chase (p. 156). To Chase, Europe was "the next best thing to heaven," and only there could he find aesthetic nourishment. Chase represents one of the two dominant themes in American art. His was the international America, a museum of world cultures, conglomerate of peoples and things. Whittredge's America is rural, self-sufficient, struggling to identify with itself and to create its own traditions. *A Home by the Sea-Side* shows America tending its own garden, content not to compete with Europe culturally, perhaps fortifying itself for the burdens of being a great nation in the future.

ERASTUS SALISBURY FIELD

The *Historical Monument of the American Republic* is thirteen feet long and nine feet high, the masterpiece of one of our most eccentric artists. It was painted to celebrate one hundred years of American freedom when the artist was sixty-seven years old. He did not regard it as just a visual curiosity, but a monument that should indeed be built. It is difficult to read this painting — and read is the right word — for the history of our country is written here in words and pictures within the picture. It is one of the extraordinary works of art produced in this country.

The question is, should we consider this painting as just a curiosity, an oddment, a white elephant in the world of art, as it were, or does it in some indescribable way enrich our lives simply by the fact that it exists, that a man created it?

Erastus Salisbury Field was largely self-taught. At nineteen, he studied for a brief three months with Samuel F. B. Morse (p. 68). He took up portrait painting and became a good, if naive, portrayer of the townsfolk of New England. He was defeated by the introduction of the camera into America, and so turned to the new art, learning it perhaps from his old teacher, Morse, and possibly from his neighbor, Mathew Brady. But Field failed as a photographer.

At the age of fifty-four, he settled in Sunderland, Massachusetts, where he eked out a meager existence as a farmer but continued to paint some portraits, the historical, Biblical and mythological subjects he had started to work on while still a photographer. Many paintings he gave away to friends. He died in 1900 at the age of ninety-five.

Garden of Eden, ca. 1860,
Erastus Salisbury Field. 35 x 41-½ in., oil.
Webb Gallery of American Art, Shelburne Museum,
Shelburne, Vermont.

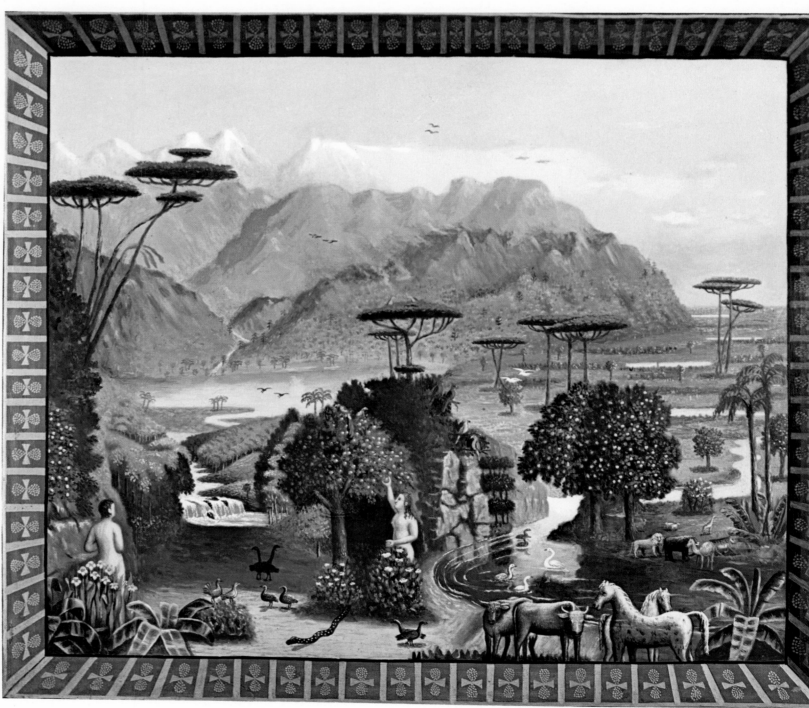

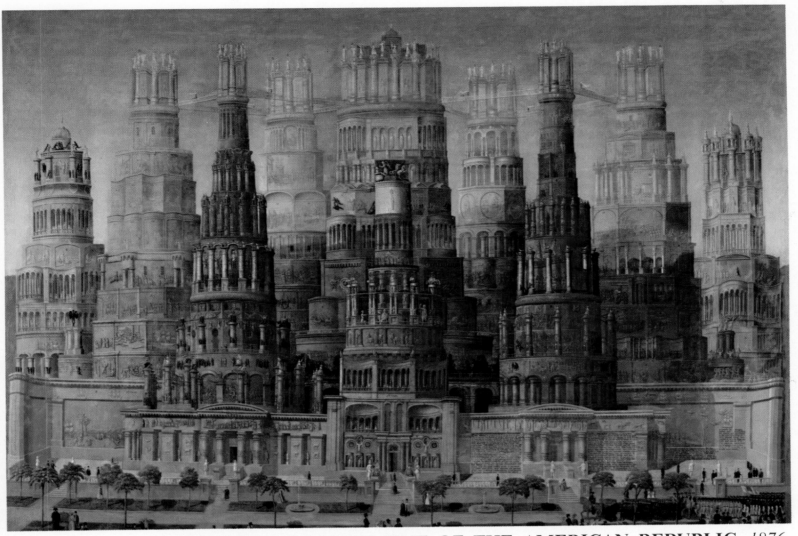

HISTORICAL MONUMENT OF THE AMERICAN REPUBLIC, *1876,*
Erastus Salisbury Field (1805-1900). 111 x 157 in., oil.
Museum of Fine Arts, Springfield, Massachusetts,
The Morgan Wesson Memorial Collection.

The Biblical and historical paintings were an escape from a monotonous life. Though our huge canvas was his last major work, one cannot consider it the creation of a senile, or even depleted, talent. It is the affirmation of a man still full of imaginative vigor. He gives the lie to those who see old age as a wasting away of creative powers, for indeed, not only did he give birth to this great pictorial idea in his advanced years, but bore with fortitude the long period of gestation. It took four years to complete the *Monument.* To read it you must throw yourself into it as you would a great book. American history is depicted in words, in objects such as an elevated railroad, in sculptured scenes of events from the settling of Jamestown in 1607, the Bill of Rights, the days of the steamboat, and in the dramatic architecture of the towers. All the national heroes of the day are represented. The *Monument* is a city populated by the mind of an artist past, so it holds in its very strangeness a clue to the future. Even New York with its topless towers does not fulfill the promised possibilities of future cities as does Field's monument.

In spite of his apparent artistic innocence, Field is an artist in a most sophisticated definition, with dedication to the highest ideal of art, pure creativity, untrammeled imagination, and by placing ideals above technique and commerce. All art is somewhat limited by the very nature of its unreality. When the imaginative spirit soars, as did his, he outstrips all limitations and becomes at once a heroic romantic and a romantic hero.

WINSLOW HOMER

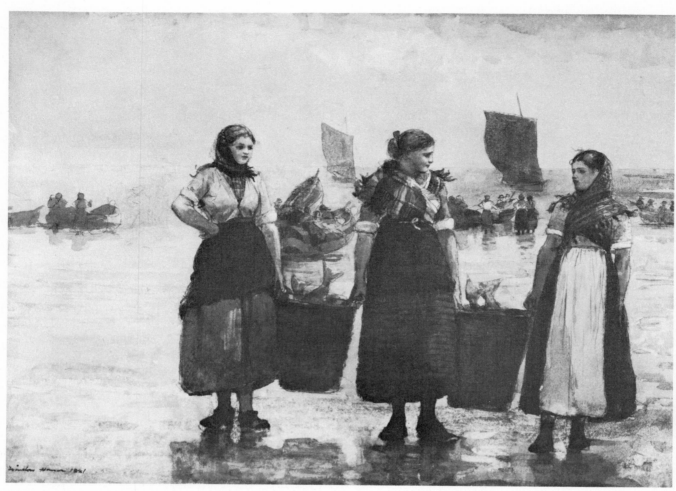

Fisherwomen, Tynemouth, England, *1881*,
Winslow Homer. 13-½ x 19-3/8 in., watercolor.
Honolulu Academy of Arts.

Few young men know when they are nineteen what they want to do with their lives, and among the fortunate few who do know, there are few who are convinced they want to be artists. But more important is that only a handful even of those persist in art throughout their lives and grow greater in it with each passing year. Winslow Homer matured very slowly, very methodically, with his goal always so far before him one wonders if he himself knew when he had reached it.

Born in 1836 of a wealthy family, at the age of nineteen he requested apprenticeship with a Boston lithographer. In the back of his mind was a desire that never left him to make visual reports of what was happening in his time. Photography was in its infancy and would come to a high point in America with Mathew Brady at the same time that Homer was making on-the-spot drawings for *Harper's Weekly,* for photography was not yet used in publications.

Homer was largely self-taught. Yet at the age of twenty-one he was hired by *Harper's* as an artist-correspondent, and he contributed regularly until 1875. When he was twenty-three he took a few classes at the Academy of

Design in New York and also worked with a painter, Frédéric Rondel, for a short time.

Perhaps it was the lack of formal training that made Homer such a spontaneous draftsman in his early period. Even the painstaking translation from original sketch to engraving on wood does not detract from the exuberance of his delightful social scenes or war themes. He loved action and was able to capture it with his pen.

At thirty-one Homer made his first trip to Europe, but he did not allow himself to be overawed by the wonders of the European art world. He saw the Louvre, of course, but nothing seemed to have a lasting effect on him except an amplification of his already established interest in Japanese prints and their unique use of design.

Still there are definite relationships in his work to what was going on in his time, for he was not a man completely apart from it. For instance, he shared the awareness with the painters of France, where he lived almost a year, of a new way of seeing in the open air, *en plein air*. The same thing happened fourteen years later when he lived in England on the North Sea.

138

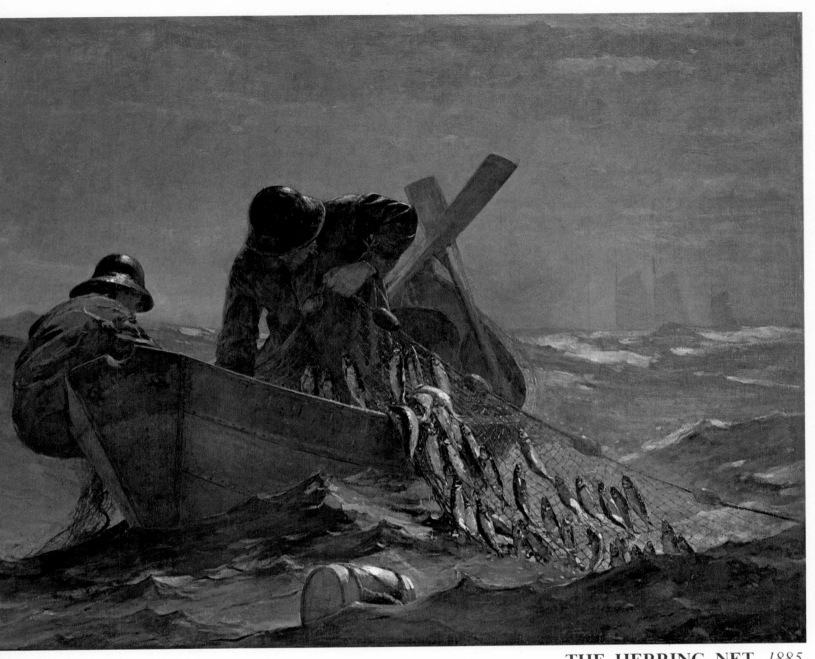

THE HERRING NET, *1885,*
Winslow Homer (1836-1910). 29½ x 47½ in., oil.
Courtesy, The Art Institute of Chicago,
Ryerson Collection.

In 1881 he made a second trip to Europe, this time in deep concern about his work and with a determination to get away from everything and everyone he had ever known. He chose to "hole up" in a remote English village on the North Sea called Tynemouth. Living completely alone, he let the simple, dramatic life of the people of the sea engulf him. He abandoned oils for the moment to work in watercolor which he had been struggling to perfect for many years and now he succeeded. He borrowed, for the first time in his life, from other artists who were, strangely, the antithesis of himself, Edward Coley Burne-Jones (1833-1898) and Edwin Henry Landseer (1802-1873). The figures of the "fishergirls," as he called the sturdy women of Cullercoats, were as near the idealizations of those two mannered artists as he ever came.

Up to this day, American painters have not been ashamed to declare the influences of their art. With Homer it is hard to discover any other than the influences of the truth of his own eye. He was, as Lloyd Goodrich says, " a man who had looked more at nature than at art."

In no instance was he seduced into a style foreign to him. He brought his own way of seeing with him, yet he was fully aware of the artistic and real life around him. The journey to the wild English North Sea Coast had given him an appreciation of the drama of the sea which he carried back to his final retirement in Maine. The English watercolor school was at its peak, but Homer's mastery of that difficult medium was again his own and seems to have taken nothing from the other. Without a doubt, however, it was here that a turning point of his career took place, for on his return home, he moved permanently to Prouts Neck, Maine, where he built a studio home overlooking the sea and spent the last twenty-six years of his life in the titanic struggle of art with nature that was to produce work that places him among the greatest artists not only in America but the world.

It was here that he simulated in his own way the dour life of the sea people he had come to admire so much as captured in his great sea portrait, *The Herring Net.* From this time on, the sea was the leading character in his art.

WINSLOW HOMER

Croquet Scene, *1866,*
Winslow Homer. 15-7/8 x 26-1/16 in., oil.
Courtesy, The Art Institute of Chicago.

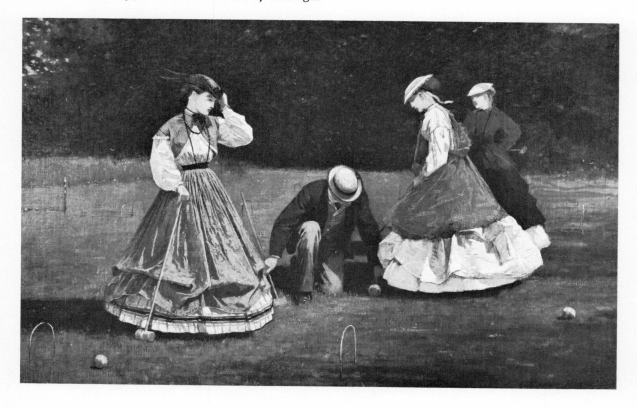

Winslow Homer offers a fascinating subject for character study. The key to his character is seriousness, but within this his tones range over great lightness and depth of heart. The recluse he became in later years was not brought on by hatred of people, for as a young man he had many friends, and, to quote one of them, "his share of love affairs." He remained a bachelor all his life, and one feels it was the seriousness of his artistic intent that drew him away from the sociability of his young manhood. He had to work it out, both life and art, for himself.

Homer's charming early works reflect the gaiety of American life at that time. A successful nation, prosperous and progressive, is reflected in Homer's portrayal of its fashionable side through its healthy, fun-loving young womanhood. His watercolors and illustrations for *Harper's Weekly* report this pleasant life, but for all their charm, his young women are not mere social butterflies; rather they are the abundantly healthy women who seem to be the rightful heirs to the hard-earned success of their pioneer forebears. For a bachelor it may seem strange that women and children are a dominant theme in his pictures, and it is equally unexpected that they are not the victims of sentimentalization either; they are part of nature and his love for it.

In the very early genre pictures, Homer threw himself full force into what some consider the golden age of America, that period before the Civil War, full of the healthy life of a robust young country, when William Sidney Mount (p. 106) and George Caleb Bingham (p. 92) were active. The former artist freed genre painting from the limitations of sentimentality to deal with the actual-

ities of American rural life. He celebrated the everyday occurrences of his self-styled Eden on Long Island, as Bingham did for frontier Missouri. Homer's world was the more fashionable one of the East, but all three artists were concerned with people and the good life they led.

Homer's Civil War works are in essence genre paintings, with soldiers and their environs as subject and place instead of the gay blades of city and resort society. Homer's battle scenes are not heroic, but rather they are evocative of the loneliness of the situation in which men unwantingly find themselves in wartime.

Although his frontline reports on the Civil War give us no great insight into the horrors of war, the fact and tragedy of Civil War cannot have failed to feed his inborn seriousness and make him look to those American qualities that would survive it.

The Civil War changed American life, and Homer's art changed with it. Though he continued in the woodblock medium to report on the war, he suddenly felt a need for a more profound art form to capture the seriousness of the conflict. At twenty-five with the help of Frédéric Rondel,

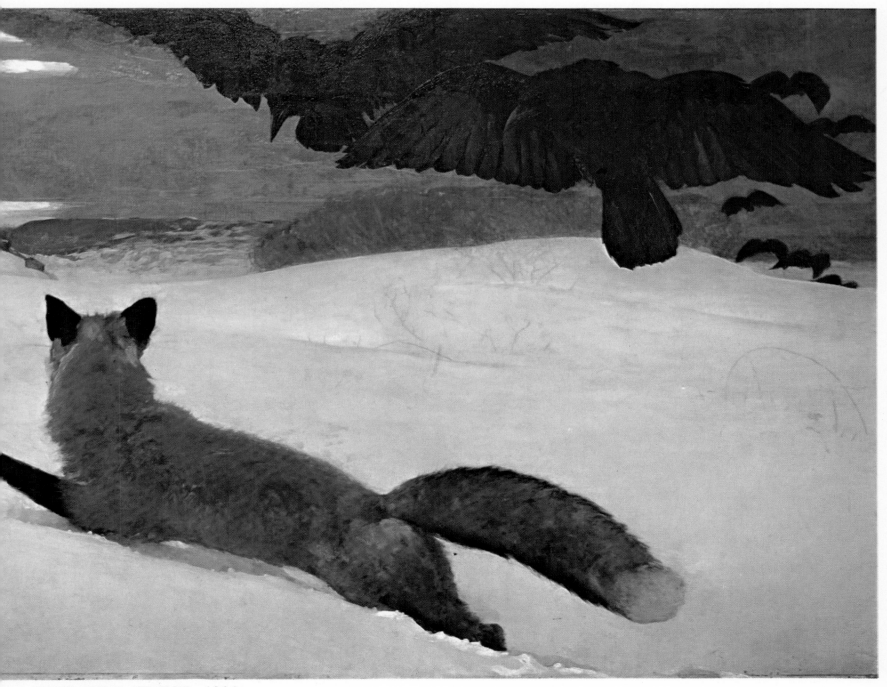

THE FOX HUNT, *1893,*
Winslow Homer (1836-1910). 38 x 68 in., oil.
Courtesy, Pennsylvania Academy of the Fine Arts, Philadelphia.

an obscure French artist, he quickly developed the technique for working in oil and was able to combine it with his well-established draftsmanship.

With the war over, Homer wanted to forget, so he returned to portraying the happy life, but this time in oil. Within a year he produced as sensitive and colorful a painting as the famous *Croquet Scene.*

His mastery of color is amazing for a man whose previous works had been primarily black and white drawings and engravings with only a few minor excursions into watercolor. He once said, "It's wonderful how much depends upon the relations of black and white — a black and white, if properly balanced, suggests color."

Later, when Homer turned to watercolor, he endowed that especially difficult medium with the same directness and achieved, after long years of labor, a foremost place among American watercolorists. To have made this transition from straightforward black and white to the most luminous and delicate use of color was quite remarkable.

He moved from this pleasant social scene, one feels, deliberately into the rugged country life of our land. Al-

ways a lover of the outdoors, a wanderer in our woodlands, a naturalist, a man who knew both the grim northern Atlantic off the coast of Maine and the gentler southern seas off Florida and the Bahamas, Homer must have felt that if he shunned these realistic aspects of American life he might lose touch with what this country is all about. It was its strength and its ruggedness to which he responded.

The Fox Hunt, the largest work Homer ever painted, is so beautiful one is apt to lose sight of the struggle portrayed, for *The Fox Hunt* is just that. The fox is not the hunter, it is the crows. In the deep winters of Maine, hungry birds would attack animals to get food. To paint this, Homer had friends shoot a fox and crows and then he froze them in position as models, but eventually went back to life studies to complete the painting when a local friend criticized the crows in his painting as unreal. He scattered corn in the snow and sat to watch them soar in for the food. The honesty of firsthand observation, that overwhelming fact of all his paintings, is so evident here that one can almost hear the cries of the crows and feel the cold snow as it sifts across the belly of the fox.

141

WINSLOW HOMER

Homer's love of the wilderness came late in life. Unlike the great landscape painters of the Hudson River School and those who depicted the Old West, he discovered the wilderness as a mature man in search of the solitude and solace of sport. With his eldest brother, Arthur, he explored Canada and the Adirondacks. Here he found the subject matter for many of his most beautiful watercolors. The lakes and streams — especially the rapids — were poetically realized, and, like all epic poetry, these realizations were reports of great virility and force. But it was the wilderness of the sea, which was his constant companion outside his studio window at Prouts Neck, Maine, that challenged him most, and here the great painting *Kissing the Moon* was painted.

The effect is as daring as anything in the history of art and is the ultimate achievement of a man to whom first-hand observation was the prerequisite of his art. The almost abstract treatment of the sea and sky, the mysterious and yet completely understandable placement of the men and their boat in the trough of a deep wave make it the arresting painting it certainly is. In *Kissing the Moon*, as in his famous and more conventional composition, *The Gulf Stream*, man tilts with nature for a place in her tournament of heroes.

If I have stressed the seriousness of Homer's art, it may, in the light of his joyous early work, seem an overemphasis. But Homer's seriousness as an artist must not be underestimated. With Thomas Eakins (pp. 144-151) and Albert Pinkham Ryder (p. 166), he remains preeminent among our artists. Each of them broke entirely with the dictates of taste, European and American, to develop a native art based on reality as opposed to the ideal. They are very different personalities, yet they have much in common, especially their independence of spirit in life and art.

Homer's retreat from the world may be called a facing up to nature, not as it might seem through sentiment, but rather as it is, the force of life that is always there for man to wage war against. The struggle for existence, man against the sea, man against death, replaces the earlier attitude of man and nature at one. Benign nature becomes the aggressor, and Homer took it also as an arena in which to battle out his artistic convictions. When Homer confronts us with nature — the sea, the animals, birds, man — we are assured that is the way it is. The serious game of life and death, he convinces us, is what humanity is all about. It is what his art is all about.

Winslow Homer "did for our painting what Walt Whitman did for our poetry — he made it native to our own earth and air," stated the distinguished critic, Lloyd Goodrich, and this idea is extremely pertinent to American art in general, for we tend to separate the arts here, to think of painting apart from music, poetry and architecture. But our artists have always intercommunicated, have been friends, have had profound influence on one another. Here as in other lands they have joined forces to give us the true picture of the age in which they lived.

In the last century the greatest literary force for other artists was Walt Whitman. He struck out with a bold voice to make known to all that this new nation would stand or fall on the strength of its people.

There is a majesty in both these men, loners in a new gregarious country, that sets them naturally apart from others. They shared a love for places of aloneness; they shared their sympathy for the masses and for men set against themselves by adversity or chance. The terrible chances of the Civil War they shared — Whitman as a sympathetic listener-nurse, Homer as a reporter in the field. They showered their attentive love upon the human form, celebrating the body as the masterpiece of nature.

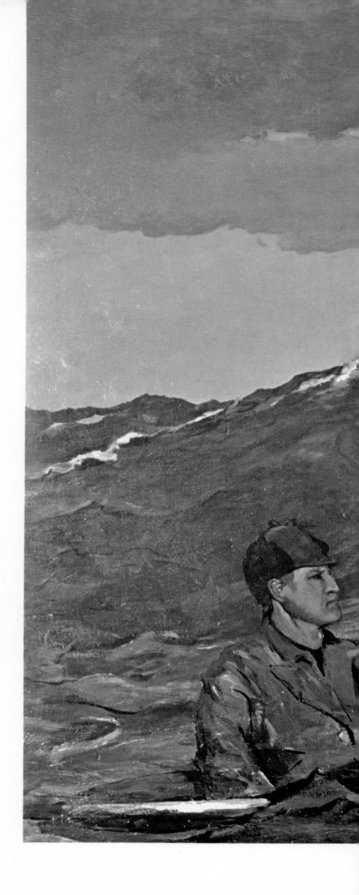

The profoundly serious works of Homer's maturity have become a national pride as have Whitman's epic poems. Both gave utterance in individual languages that were to become a major part of our cultural identity. Neither was deeply influenced by Europe. For each of the small band of cultural giants of the calibre of these two men and others, like Emerson, Thoreau, Thomas Eakins and Henry James, their art was self-discovery, and, at once a self-found and self-forced dedication to the ideals of universal truth. But these men retained in their universality unique identification with their native land. They are among the first Americans in art, as Jefferson and Franklin were among the first in statesmanship and public service. We owe them much for their retention and amplification of the original principals of the freedom-seeking men who founded our nation. That is the true appraisal of their worth to America.

142

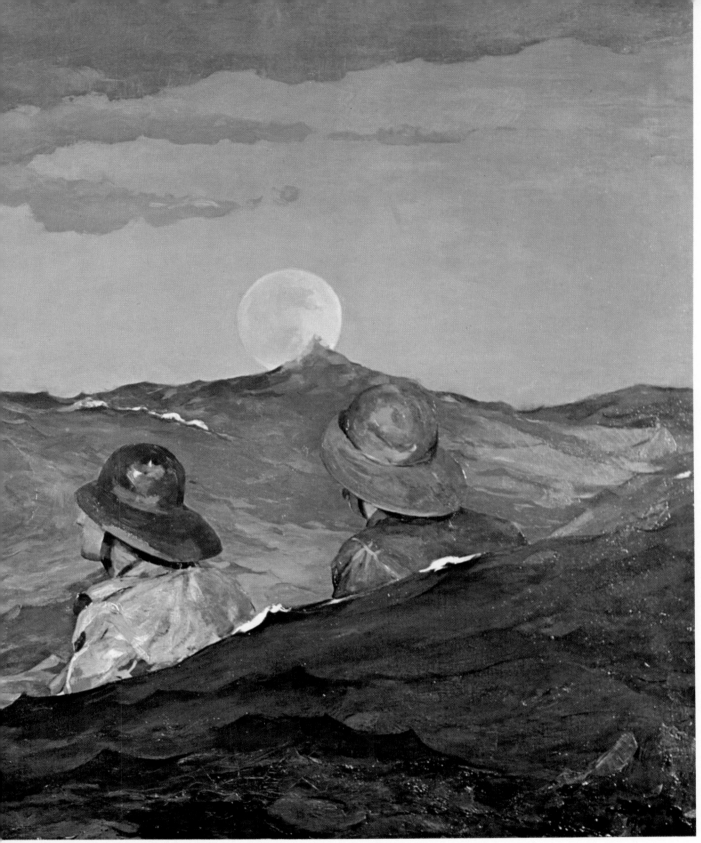

KISSING THE MOON, *1904,*
Winslow Homer (1836-1910). 30 x 40 in., oil.
Addison Gallery of American Art,
Phillips Academy,
Andover, Massachusetts.

The Gulf Stream, *1899,*
Winslow Homer. 28-1/8 x 49-1/8 in., oil.
The Metropolitan Museum of Art, New York,
Catherine Lorillard Wolfe Fund.

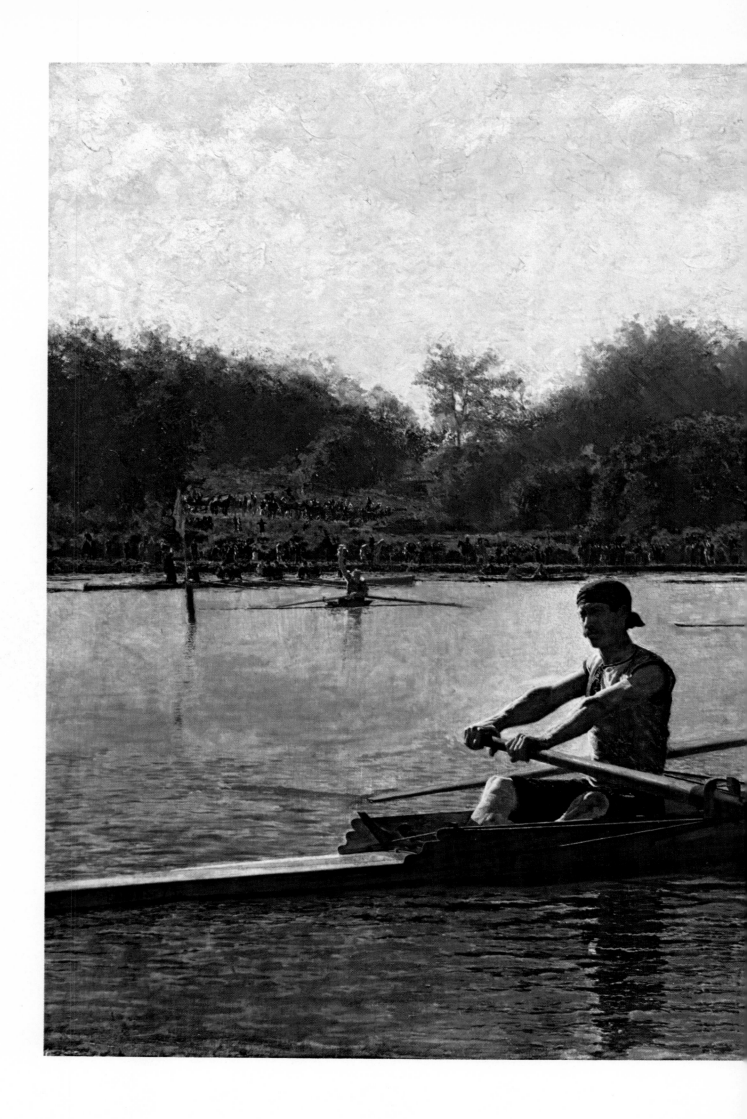

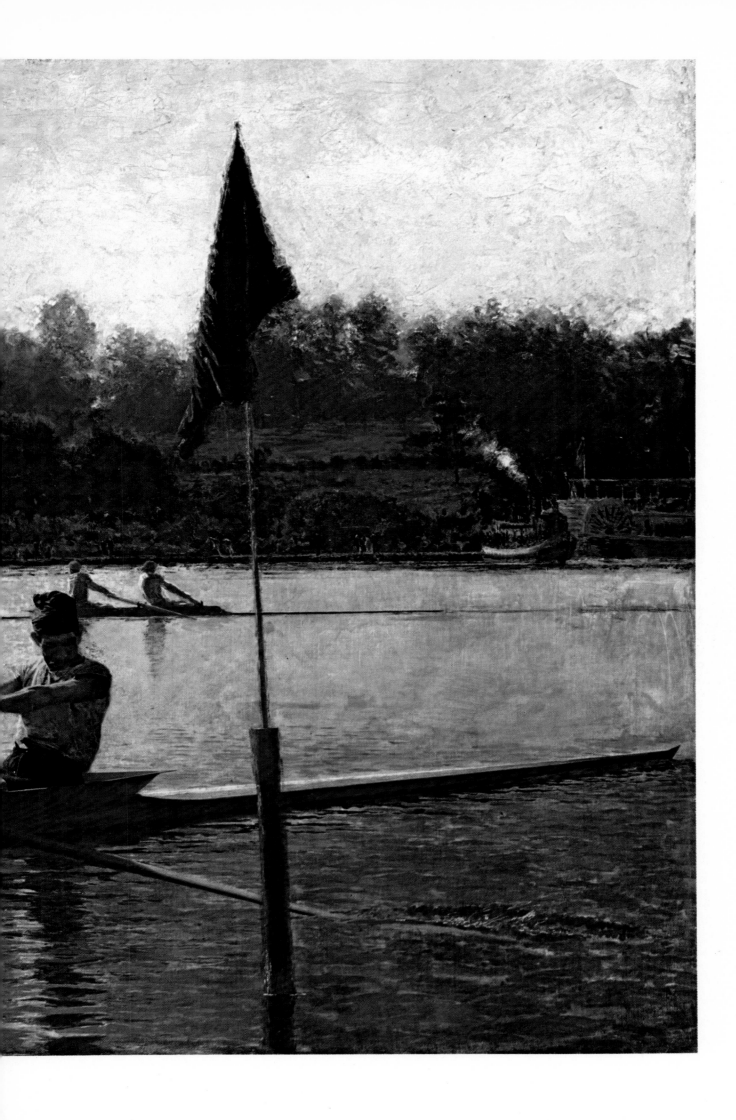

THOMAS EAKINS

THE BIGLIN BROTHERS TURNING THE STAKE, *1873,*
Thomas Eakins (1844-1916). 40¼ x 60¼ in., oil.
The Cleveland Museum of Art, Hinman B. Hurlbut Collection.
(Backleaf, see pages 144-145.)

Thomas Eakins is generally considered to be our greatest artist, but fame passed him by in his lifetime. He almost perfectly fits the popular definition of the great man, misunderstood in his lifetime, an irascible character, sensitive and yet contrary to the age he lived in. Everything about Eakins fits the picture, and for the right reasons, for he was a man absolutely true to himself. The man and his art are one, indissoluble, welded by genius.

His father, who was a profound influence in his life and who lived with him in the family home even after he was married, had enough money to help him along. But Eakins did not need much, and a good thing it was, too, for most of his paintings were done for family and friends and many were given away. The elder Eakins sent his twenty-two-year-old son to study in Europe where he enrolled in the École Des Beaux-Arts under the then popular artist and teacher Jean Léon Gérôme (1824-1904). He also studied with Leon Bonnat (1834-1923) a portraitist whose naturalistic style was to influence him greatly. He is said to have met the Impressionist Claude Monet (1840-1926) but never studied with him. It was Gérôme's insistence on drawing from the nude model that became the basis not only for Eakins's own painting but for his future teaching as well. Eakins remained grateful to him all his life.

The other great influences in his artistic life were the Spanish masters, Velásquez (1599-1660) and Jusepe de Ribera (1591-1652), whose works impressed him deeply when he saw them on a trip to Spain. In a letter home he declared that they changed his life. Having absorbed Gérôme's drawing lessons, he wrote again, "I am learning to make solid, heavy work. I can construct the human figure now as well as any of Gérôme's boys." After his

Spanish experience he wrote, "Oh, what a satisfaction it gave me to see the good Spanish work, so good, so strong, so reasonable, so free of every affectation." In these two statements he sums up his entire credo, and if there is a sentence to describe Eakins the man, it is "so good, so strong, so reasonable, so free of every affectation."

He returned to Philadelphia in 1870 and turned his training to produce a remarkable series of pictures concentrating on the outdoor amusements of men. *The Biglin Brothers Turning the Stake* was painted at this time. Eakins laid out the whole composition with mathematic precision, even the shadows. It is not quite as clinical a picture as the famous *Max Schmitt in a Single Scull* and it has more freedom and mood because of it. In this painting, done a couple years later than the *Max Schmitt*, we can see Eakins's wonderful use of light and shade beginning, as it does so profoundly in later work, to haunt the whole picture and give it an atmosphere that is uniquely his in American art. As in many of these early genre works, Eakins has included himself. He is firing the gun in the single scull in the left middle distance.

Here we see the beginning of the intense genius that was this solitary man from Philadelphia. Though the painting came out of, perhaps, the happiest period of his life, there is a brooding moodiness, a serious dedication, a lack of gaiety that seems to pervade all he did. It is as though he was aware of his isolation in the history of American art. The silence with which most of his figures are surrounded is present here, but there is the sense of expectation, too. The action will start as the gun held in his hand shatters the stillness and the report of his greatness will echo throughout all time.

THE GROSS CLINIC, *1875,*
Thomas Eakins (1844-1916). 96 x 78 in., oil.
Courtesy, Jefferson Medical College,
Thomas Jefferson University, Philadelphia.

During those first years back home, Eakins began to paint portraits of his family. The outdoor scenes are relaxing to look at compared to those dour, uncomplimentary likenesses. In portrait painting of that time such reality was unheard of and not very welcome. A portrait was a picture of someone who not only wanted it to be admired by others but to see it as flattering to himself. Anyone reticent about the shortcomings of his visage does not want them shown up to others. How Eakins's sisters who sat for him looked upon these gloomily penetrating studies I can find no record, but later several of his female subjects either walked out on him or were openly hostile to his clinical approach to their vulnerable psyches.

This near brutality in his portraiture certainly did not stem from Bonnat's teachings, which, while being true to nature, did not try to reveal every flaw. This was Thomas Eakins, a man who never stopped hating affectation, and there was not an ounce of it in his nature. From Gérôme's academic training, however, he took a cue that was typical of that time in art — to produce a major picture that would establish his reputation.

The result was one of the few genuine milestones in American art. He chose a typically unconventional, Eakinsian subject, a surgical operation in the clinic of the famous Dr. Samuel Gross. *The Gross Clinic* is the most extraordinary painting of nineteenth-century America. Though it seems almost romantic to us today with our preoccupation with technology, it was, to say the least, an apparent disaster that plagued Eakins for many years after it was first shown. Its reception has been likened to that given *Moby Dick*, and such Victorian disapproval is now considered "a classic illustration of the shipwreck of the imagination in nineteenth-century America." Critics and public alike reviled it. One critic was outraged that "society thinks it proper to hang in a room where ladies, young and old, young girls and boys and the little children are expected to be visitors. It is a picture that even strong men find it difficult to look at long, if they can look at all." It was rejected from the 1876 Philadelphia Centennial Exhibition Art Gallery and therefore hung among the medical displays!

All Eakins's humanity and his concern for the details of every aspect of humanity is exhibited in this portrait genre

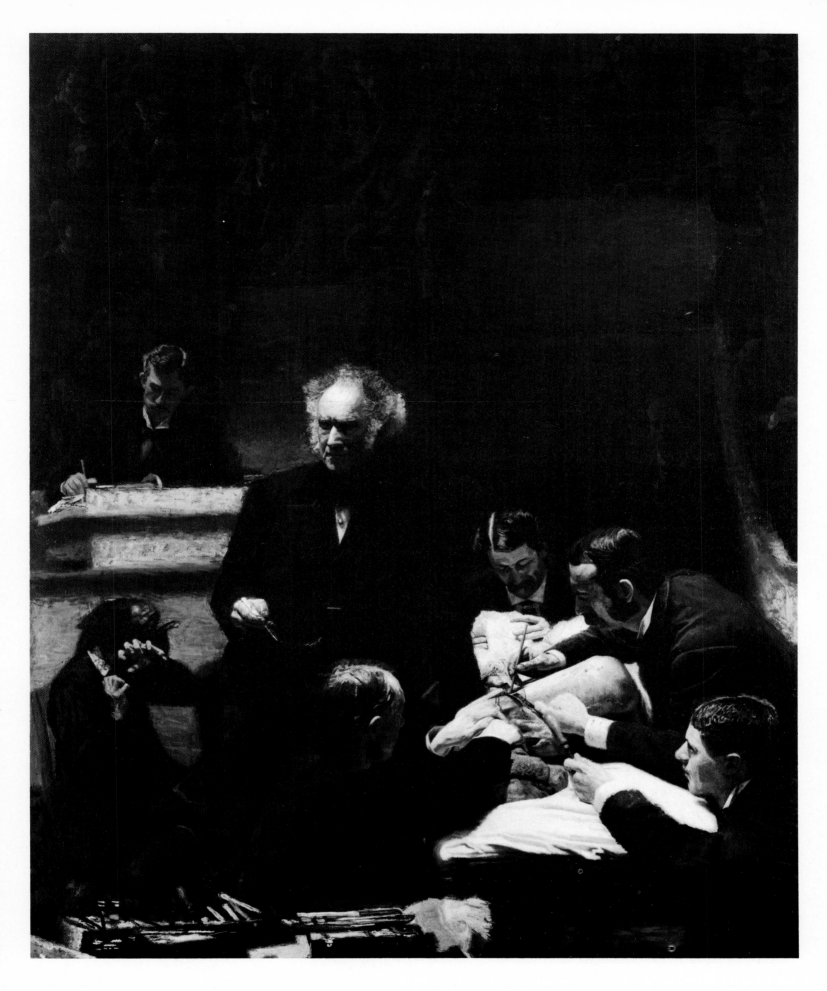

painting of one of the most celebrated medical men of his day. Dr. Gross was seventy when Eakins painted the clinic. He was as thorough a doctor as Eakins was an artist. Six years before the painting, Dr. Gross found himself lecturing "better, with greater enthusiasm. . .with more point and effect, with more ease and unction" than ever before. Eakins had studied anatomy, and we can see his debt to the seventeenth-century Dutch anatomy-lesson portraits, especially Rembrandt's *Anatomy Lesson of Dr. Tulp.* But

the black and silver coloring is his gift from the Spaniards. For once in an Eakins portrait there is idealization in the magnificent head of Dr. Gross. Eakins again included himself, sketching the scene in the front row at the far right.

Sylvan Schendler in his fine monograph on this painting says, "it is so important to American art because it raises realistic American subject matter to the level of myth with a broad and profound power and intelligence that had never been approached before."

147

THOMAS EAKINS

The Pathetic Song, *1881*,
Thomas Eakins. 45-¼ x 32-½ in., oil.
The Corcoran Gallery of Art, Washington, D. C.

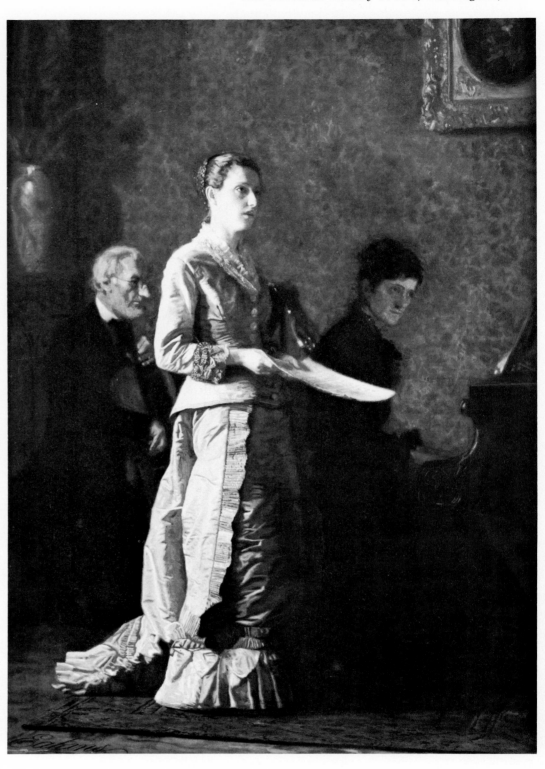

Eakins for all his singleness of purpose in art was a highly complex personality. There have come to light certain areas concerning his unconventional relationships with women that show he sometimes felt sexual stresses as much as the prudes who threw him out of his post as director of the Pennsylvania Academy of Art. Nineteenth-century morality was a burden to many artists who either acquiesced or who were felled in their revolution against it. Eakins was a part of the latter group. His insistence on study from the nude led him to the incident at the academy. One day, to make a point about the origin of a muscle to a women's art class, he took off the loin cloth from a male model. The storm of protest brought about his dismissal. Many of his students were shocked in a different way and rallied to his defense, but other charges were brought against him in his conduct with women students, and even his sister and her husband urged that he

be dismissed. Another time, a beautiful woman he persuaded to sit for him was poked in the stomach to improve her posture. Eakins suggested to other women sitters that they strip so he could paint them nude.

Oliver Larkin, the art historian, says of him, "It was the fate of Eakins to become an artistic surgeon in the age of quacks, a prober of symptoms with no tolerance for potent remedies." Later Eakins wrote, "My honors are misunderstanding, persecution, and neglect, enhanced because unsought." Although because of his personality, it can perhaps be said that, in a sense, he did little to avoid receiving these negative honors.

His friend Walt Whitman said of him, "Eakins does wear well, he is a good comrade. What are social graces. The parlor puts quite its own measure upon social gifts . . . Tom Eakins lacks them as . . . I would be said to lack

148

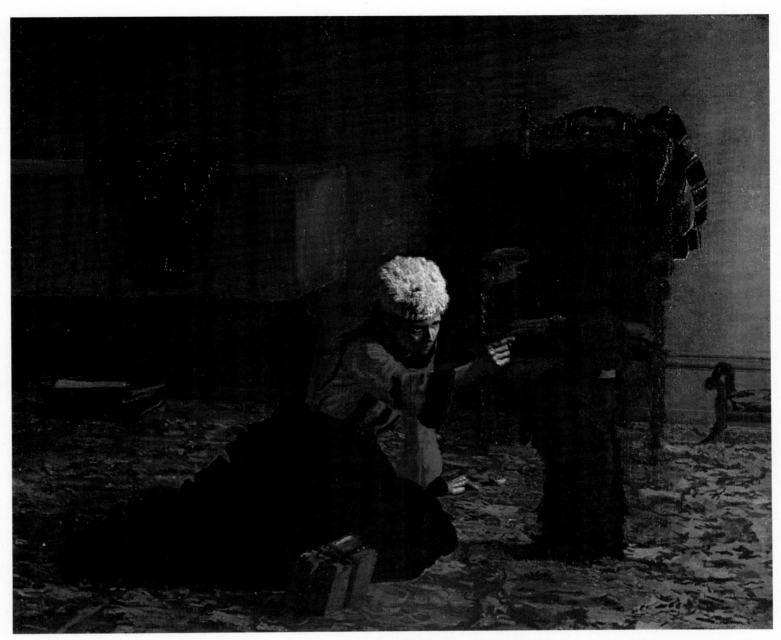

ELIZABETH CROWELL AND HER DOG, *1871,*
Thomas Eakins (1844-1916). 13¾ x 17 in., oil.
The Fine Arts Gallery, San Diego.

them. . . . He does not dismiss them but puts them in their proper place."

What Whitman said was true, but he also said, "I never knew but one artist, and that's Tom Eakins, who could resist temptation to see what they think rather than what is. . . .Eakins is not a painter, he is a force." Another commentator, Fairfield Porter, thinks this means that "Whitman understood the paradoxical nature of the content of his paintings. . . Eakins used art to express an American sense of life that was essentially anti-artistic."

Elizabeth Crowell and Her Dog illustrates this part of the Eakins personality. A tender little masterpiece, it was done before *The Biglin Brothers* and presages much of his later work. The subject is one of two sisters he painted. He preferred Elizabeth because she was, according to the art commentator Sylvan Schendler, "more woman than she is

a childlike creature of a civilization." There may have been some strange romantic attachment here, for he kept her portrait over his mantel for years. Yet he was engaged to her sister, Katherine, for many years, a love affair which ended with her death and his belated marriage to another woman at the age of forty.

I love this painting because it has that stillness that comes from nowhere and will be broken as soon as we turn our back on the moment he painted. The child-woman has clattered in from school, thrown her books on the floor and given her complete attention to her beloved dog. The concentration on this little lesson in dog etiquette is wonderful to contemplate. The hush of the dark room, the trembling stillness of the black dog, the soundless shaft of light that illuminates the serious face beneath the shaggy hat all go to make up the definition of a perfect, and profound, genre picture.

149

THOMAS EAKINS

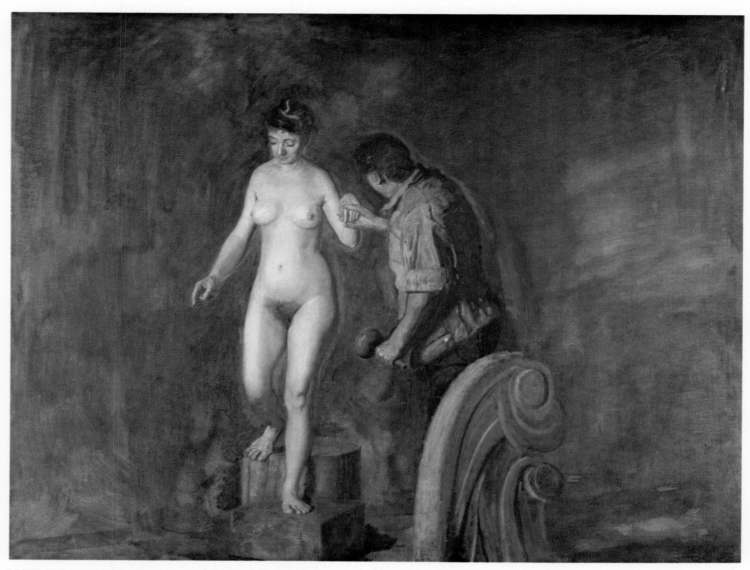

WILLIAM RUSH AND HIS MODEL, *1908,*
Thomas Eakins (1844-1916). 35¼ x 47¼ in., oil.
Honolulu Academy of Arts, gift of the friends of the academy.

William Rush and His Model comes from Eakins's most mature period. Between the first two, *The Biglin Brothers* (p. 144) and *The Gross Clinic* (p. 147), and reflecting the mood of *Elizabeth Crowell and Her Dog* (p. 148), came a parade of portraits that make up a gallery of American faces comparable only to that created by John Singleton Copley (pp. 16-22).

Eakins painted Rush's portrait and four other studio scenes of Rush, one of our earliest sculptors, at work. In this version, a young Philadelphia woman is posing nude for him. It is true that a woman posed for Rush's fountain figure, *Nymph of the Schuylkill,* but there is no substantiation that she posed for the draped statue in the nude. Eakins, of course, would have insisted on it. The event took place in 1809, before Eakins was born, but the problem of the artist and study from the nude was Eakins's lifelong concern and frustration. He identified with Rush and in this late version of the studio study he substituted himself for the sculptor, and, as Lloyd Goodrich puts it, is,

"handing the model down from the stand as if she were a queen." He goes on to say: "A strange and revealing obsession! His deep and healthy paganism, repressed by the prudery of his time and place, combined with his own strict realism, was expressing itself in this peculiarly roundabout manner. That this prevailing prudery had its effect even when he did paint the nude is suggested by the fact that almost all his nudes, both male and female, have their backs turned to us. But in this late . . . painting in which he himself appears as the sculptor, the model is for the first time turned fully toward us. In old age, he had finally freed himself from his self-imposed taboo."

One is reminded of Rembrandt to an extraordinary degree in this wonderful and mysterious picture, but it is all Eakins and very moving in its Pygmalion-like connotation: The artist in love with the model. Not Eakins in love with a woman, but with his ideal of art, the human body. This uncompromising man was a constant lover of life, though life treated him shabbily. He was a scientist-artist who told

150

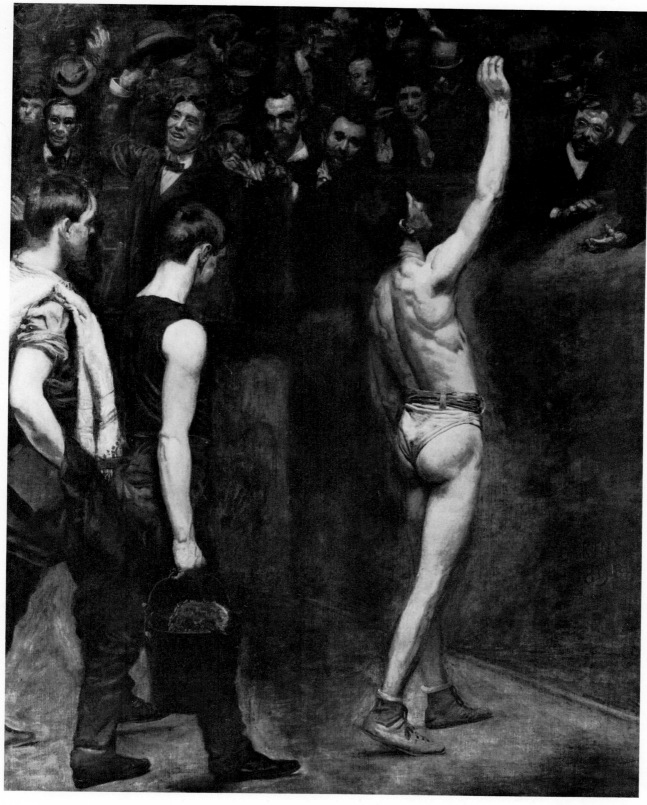

Salutat, *1898*,
Thomas Eakins. 49-½ x 39-½ in., oil.
Addison Gallery of American Art,
Andover, Massachusetts.
Phillips Academy,

his students of anatomy that, "One dissects simply to increase one's knowledge of how beautiful objects are put together." He practiced what he preached, dissecting the human, the American human nature, to lay bare its beauty. "If America is to produce great painters," he said, "and if young art students wish to assume a place in the history of the art of their country, their first desire should be to remain in America, to peer deeper into the heart of American life." For Eakins, art was the science of reality. Another scientist, a priest, Pierre Teilhard de Chardin (1881-1955), later said of his own explorations into the evolution of human life, "The least expected and most substantial result of my journey seems to me to be this: That I have progressed further in a zest for and appreciation of what actually happens, independent of its agreeable or disagreeable content." This was the journey of Thomas Eakins — he remained true to what actually was.

JAMES A. MCNEILL WHISTLER

The artist-personality has always drawn human curiosity as no other breed of man. The more famous the artist, the more we want to know about him. Sometimes the artist whets this desire by resorting to everything from complete withdrawal from the public to the most violent forms of exhibitionism. Artists are sometimes extroverts to the point of confusing their admirers utterly by creating a kind of cock and bull picture of themselves. Others are so completely honest about every whim of their complex personality that they become almost equally unbelievable. Quite honestly most of us are delighted to see them in whatever light they wish to be seen, for whether they like it or not, they become very personal public property.

One of the wittiest of the brotherhood was James Abbott McNeill Whistler. In his lifetime no artist attracted more attention — first, by castigating the public who adored him, and secondly, by creating of himself a "personality" that made him more than an artist. In short he was a *character.*

A small man, exquisite in speech, dress and manner, Whistler could be described as a fop, but his sharp wit would not allow such a deprecation. He was like a feisty little bantam cock and ruled the roost of whatever circle he moved in. He could take on all comers and did, from his fellow artist to the man in the street to the most revered critic.

London was his beat and he helped create that part of it called Chelsea, which to this day remains headquarters for artists. One could wish he was still around to pass a comment or two on the present generation, though he might still feel a little at home in the make-believe of their artistic posings. What he would not have tolerated is the high percentage of bad art which we see popularly accepted.

Whistler was a perfectionist whose sharpest jabs were directed toward the pretentious, the second rate, and an even larger group, those who did not agree with him that art should be personal and subjective and his dictate that a painting is an object made of paint — nothing more or less — not a story nor a moral nor a symbol. Yet he had many friends and admirers, although they could never be sure when they would fall into disfavor with him. When he wrote the story of his life he caustically entitled it *The Gentle Art of Making Enemies*, a book published in 1890.

He seemed to enjoy to the fullest the aura of hostility and even went so far as to provoke it. The most famous example of this was a libel suit he brought against the great critic John Ruskin. Ruskin had made a derogatory remark about Whistler's Impressionist approach to a picture; he accused the painter of "flinging a pot of paint in the public's face." After a lengthy and eagerly followed trial, Whistler was awarded one farthing as damages. This in no way upset Whistler, who considered it a triumph of justice. He proudly wore the farthing on his watch chain for the rest of his life.

Whistler's London was an exciting one. The Victorian mold was cracking, and some of the greatest poets and wits our language has produced — Dante Gabriel Rossetti, Algernon Charles Swinburn, Max Beerbohm and others — were emerging. Oscar Wilde was another, and of course Whistler could not resist taking a slap at this eccentric egocentric. They were competitive wits and exchanged retorts freely for many years.

People interested Whistler and he was a great portrait painter. He preferred, however, to think of them as subjects for his painting theories. His famous portrait of his mother was called *Arrangement in Grey and Black, Number One*. Our lovely child-portrait is of Miss Cicely Alexander but he called it *Harmony in Grey and Green*. Whistler used this musical terminology to emphasize that his art and science were making pictures, not telling a story. He was

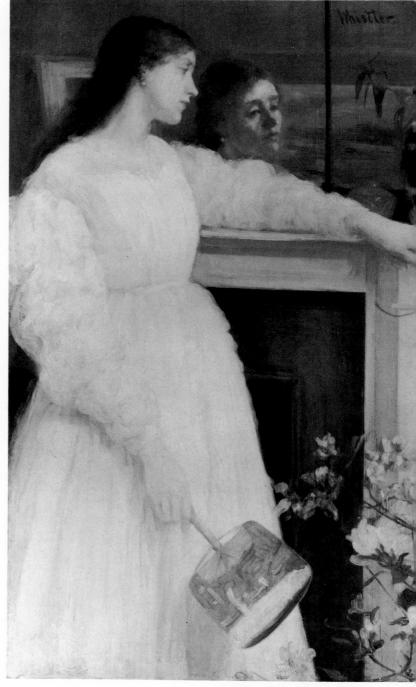

The Little White Girl:
Symphony in White, No. 2, *1864,
James A. McNeill Whistler. 30 x 20 in., oil.
Tate Gallery, London.*

impressed more than influenced by the Japanese and borrowed for the composition of *Miss Cicely Alexander* from their marvelous economy of line and space. He also acknowledged a great debt to the Spanish painter Velásquez (1599-1660) for the example set forth in use of rich dark and light design. It is such a beautiful painting that one can go along with Whistler's conceit and be in complete harmony with it.

Whistler is an Impressionist in the sense that he repeated and interwove color throughout his canvas but he certainly was independent from the movement. He was more influential on than influenced by Impressionism and indeed was a forerunner of the twentieth-century idea that pure paint, color and design have their own merit. He studied in Paris but was rejected there partly because of his flamboyant personality. Edgar Degas (1834-1917), master of the Impressionist circle, for instance, called him a "humbug." Whistler was his own man, and, once settled in Chelsea, created his own world of art.

152

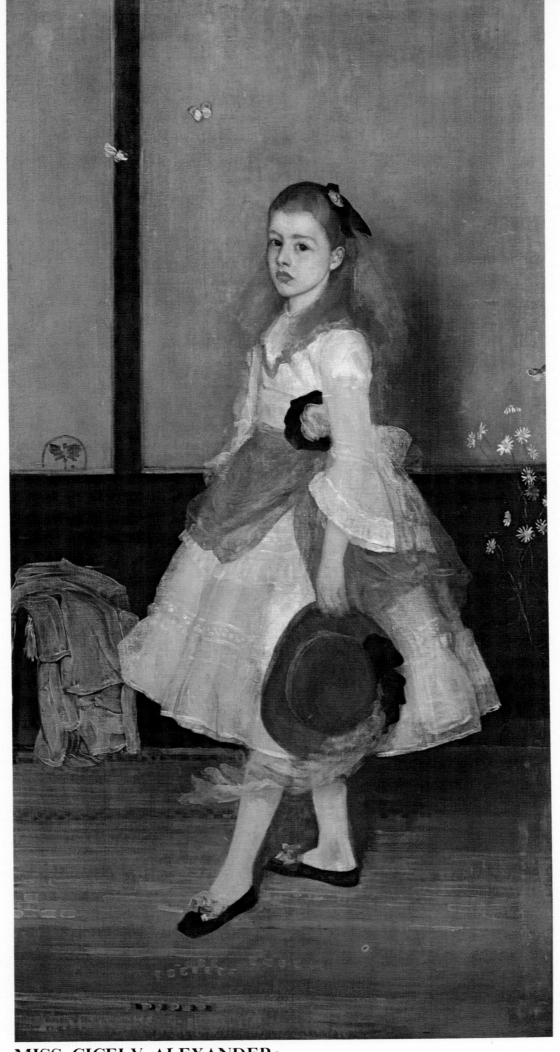

**MISS CICELY ALEXANDER:
HARMONY IN GREY AND GREEN**, *1872-74,
James A. McNeill Whistler (1834-1903),
74¾ x 38½ in., oil. Tate Gallery, London.*

JAMES A. MCNEILL WHISTLER

Confidences in the Garden, *1894,*
James A. McNeill Whistler.
8-3/8 x 6-3/8 in., lithograph.
Courtesy, The Art Institute of Chicago,
Charles Deering Collection.

Portraits, landscapes and etchings are the three fields of Whistler's painterly repertoire. We have seen his mastery of the portrait in the study of Miss Alexander. It is more than just a portrait: It is a picture, a human figure in a motif, a harmony of colors. That is why he gave his paintings musical names — arrangements, nocturnes, symphonies. His etchings and lithographs are among the most beautiful ever created. No painter of his period was more accomplished in these difficult media, and even here he remained highly individual. His masterful way of inking the plate with an almost painterly technique is unique.

In addition to these other accomplishments, portraits and the graphic arts, perhaps Whistler's greatest gift to us are his landscapes. They are landscapes in a very special sense, for the views he chose were not so much the product of nature but of man's use of it. He saw in the London factories, the warehouses, the boats on the rivers a special relationship between man and nature. Some of his wittiest remarks have to do with the artist's appreciation of this relationship and the average man's blindness to it. One evening at a stuffy party a friend suggested he and Whistler step out to look at the stars. Whistler refused on the grounds that there were too many stars and that they were so badly arranged.

He could wax poetic on the subject, too. In a famous speech called the "Ten O'Clock Lecture," he bemoaned the common man's "unlimited admiration, daily produced by

a very foolish sunset. Ah," he rhapsodized, "and when the evening mist clothes the riverside with poetry, as with a veil, and the poor buildings lose themselves in the dim sky, and the tall chimneys become campanili, and the warehouses are palaces in the night, and the whole city hangs in the heavens, and fairy-land is before us — then the wayfarer hastens home. . . . [They] cease to understand, as they have ceased to see, and Nature, who for once has sung in tune, sings her exquisite song to the artist alone." This statement is followed by a summation of his whole credo of art, that art is superior to Nature and belongs to the artist alone, "To him, her secrets are unfolded. . . . Through his brain is distilled the refined essence of that thought which began with the gods, and which they left him to carry out."

He believed that "Nature seldom succeeds in making a picture," and we can believe him when we look at what this man has done to make this incredibly beautiful lagoonscape truly poetic. Assuredly Venice is hard to make otherwise, but he adds that all-important factor — *who* is seeing it and how. Like the English artist J. M. W. Turner (1775-1851), he saw, as no other men have ever seen, the soul of Venice. The Venetian painters Canaletto (1697-1768), Carpaccio (1450-1425), Guardi (1712-93) saw it literally and lovely and lively for sure, but Turner and Whistler saw it as an ultimate composition of nuance and color.

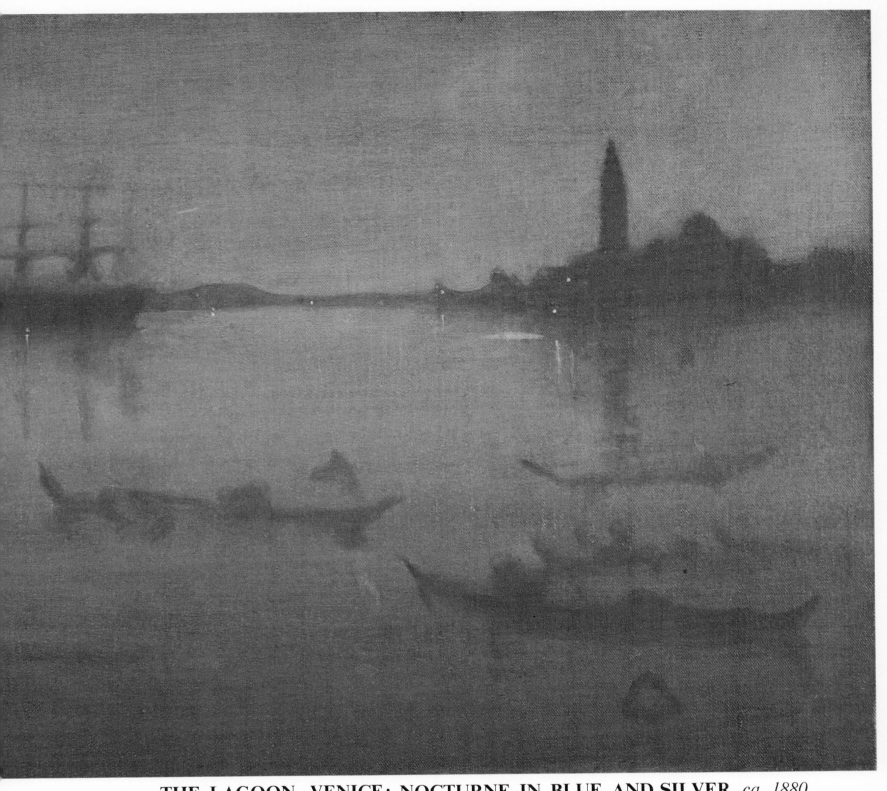

THE LAGOON, VENICE: NOCTURNE IN BLUE AND SILVER, *ca. 1880,*
James A. McNeill Whistler (1834-1903).
20 x 25¾ in., oil. Courtesy, Museum of Fine Arts, Boston,
Emily L. Ainsley Fund.

Green and Gold: The Great Sea, *n. d.,*
James A. McNeill Whistler.
5-3/8 x 9-¼ in., oil on wood panel.
Courtesy of the Smithsonian Institution,
Freer Gallery of Art, Washington, D.C.

155

WILLIAM MERRITT CHASE

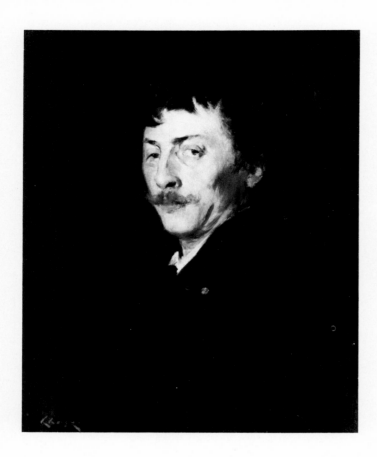

Pablo de Sarasate: Portrait of a Violinist,
1875, William Merritt Chase.
22-½ x 18-3/4 in., oil.
Los Angeles County Museum of Art,
bequest of Mary D. Keeler.

William Merritt Chase died in 1916, at the age of sixty-six. He had had a happy, full life in art, in marriage, in friends. Literally hundreds of young people came under the influence of his teaching and warm personality. He was successful and productive, with a fine humor and an ever-inquisitive mind. To his detriment is the verdict rendered by critics after his death, and by some while he was still alive, that his work had absolutely no depth whatsoever. One of them wrote, "it was perhaps a shortcoming of Chase's art that he insisted upon merely seeing his subject and not thinking about it. The appearance to him was every-thing, the reflection or thought about it nothing."

Chase's amazing facility with the brush, the banality of some of his subjects, the lightweight but charming attitude of his people and scenes may seem somewhat foreign to anyone who is acquainted with the intense seriousness of modern art. But we must not overlook the period in which he lived. The turn of the century was a time when com-paratively few of all the ills that were to plague us had become evident. The terrors of 1914 could hardly have begun to concern him two years before his death, or if they did, there is no display of it in his work. Perhaps the present renewal of interest in Chase's work is a sign of a broadening consciousness that allows for the validity of more optimistic attitudes, and even a yearning for a return to Chase's pre-1914 world and his gracious style of life.

Chase was a man who lived and breathed the atmos-phere of art. Forever curious about mankind's creativity, he was a passionate lover of all art. He haunted museums and was rhapsodic about the masters. He brought this enthusiasm to his own work and to his pupils'. He learned from the art of the past and inspired the art of his time. Beauty is in the eye of this beholder, and Chase surround-ed himself with it.

The son of an Indianapolis shoe store owner, Chase studied in New York, worked as a portraitist in St. Louis and then went to Munich for further study. Later he spent some time in Venice with fellow American artists Frank Duveneck (1848-1919) and John Henry Twachtman (p. 174), and it was perhaps while he was under the influence of this most serene city that he began to develop the "lightning of the palette" that distinguished Chase's work.

In the Studio is the story of his life in a picture. It was to this studio on Tenth Street in New York that fashion-able and artistic America flocked, not only to see the great artist at work, but to bask in the grandiose art atmosphere he created around himself. As Russell Lynes says, "Flam-boyance was a cultural condition of which Americans approved." This same critic classified Chase as "an upper-Bohemian wizard." The man and the place complemented each other as he crammed his studio full of those objects he loved and that had aroused his curiousity and admira-tion. The magazine, *The Art Journal*, in 1879, the year

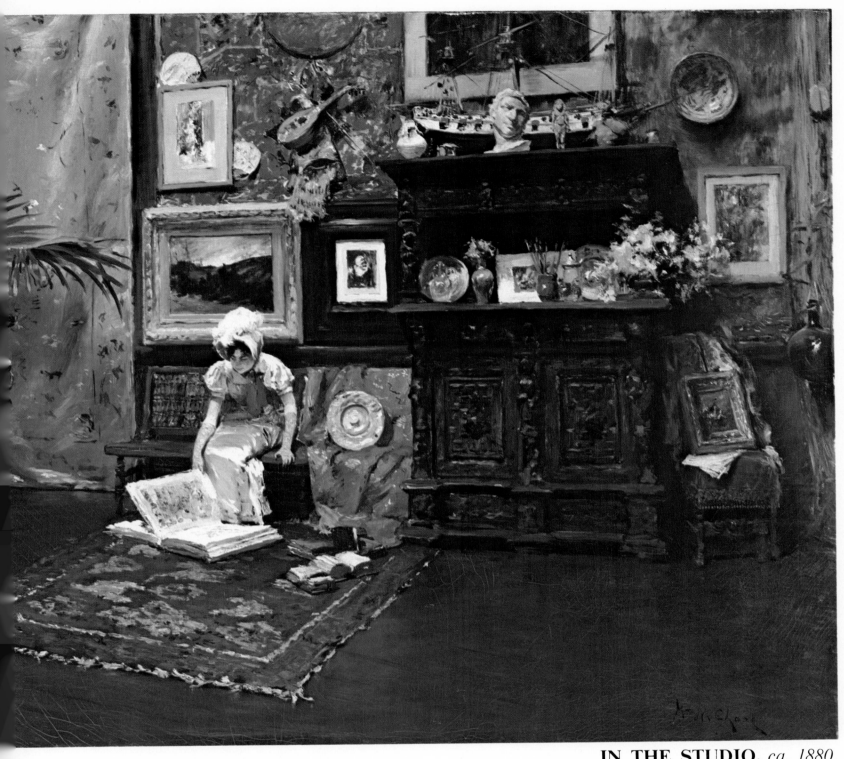

IN THE STUDIO, *ca. 1880,*
William Merritt Chase (1849-1916). 28½ x 40¼ in., oil.
Courtesy of the Brooklyn Museum,
gift of Mrs. C. H. DeSilver.

before this picture was painted, inventoried Chase's studio: "Quaint jars, Egyptian pots, paint brushes, strange little wooden carvings of saints, virgins, crucifixes and many other articles too varied to specify."

But it was the use Chase made of his curiosity that secures for him his formative role in the development of American art. He was both master of and subject to, his medium, curiosity. His ability to be catalyzed, to be inspired into making art out of his own visual experience, out of the unobvious, the neglected, strange or commonplace, makes him a fascinating artist. This disposition to be fascinated is an American as our terror of being bored. America is, by its nature, a repository of accumulated world knowledge and culture. Chase as an artist, teacher, student, collector and appreciator crystalized this American disposition and applied it intensely to his art.

WILLIAM MICHAEL HARNETT

The appeal of William Michael Harnett's paintings is so direct that it makes any probing into the reasons for his artistic statement irrelevant. The art historians and art psychologists have looked for deeper meanings in them than just pure enjoyment, but even their aesthetic obtuseness cannot eliminate the pleasure one feels in seeing his pleasant, meticulously observed, unquestioning, still-life arrangements of objects. When one reads that his work is "somewhere between Emersonian transcendentalism and di Chirico symbolism," I can only shake my head, mainly to clear away any lingering effects from this statement that disallows a simple, direct view of his work. Must one stop enjoying in order also to understand?

I have not found in Harnett's writings any recipes that tell me how to relish the feast he sets before us. He says that his approach to still life is not imitation but selection and suggestion. He found that grouping objects is not as difficult as selecting them, for his main purpose is to tell a story, in other words, to elicit nostalgia.

Nostalgia is the breath that has resuscitated Harnett and his work from oblivion. The tender selections of the not new but mellow objects with which he composes evoke memories for us as they did for him. He said that "new things do not paint well." He looks to their age for the story of their past usefulness, rather than to their definition as objects. A pipe is a pipe, but a Harnett pipe is a portrait of the man who smoked it.

Memento Mori, *1879,*
William Harnett. 24 x 32 in., oil.
The Cleveland Museum of Art,
Mr. and Mrs. William H. Marlatt Fund.

At first glance Harnett's objects may seem to be the things themselves rather than pictures, and such art is sometimes called *trompe l'oeil,* or "trick of the eye," painting. It is an ancient device in art but, for all the stories of the birds pecking at the grapes in an ancient Greek master's still life, one cannot really believe he or Harnett had anything in mind other than delight in the simulation of reality, a sense of artistic responsibility to observe and relate in their own preferential technique what they saw.

When his work began to sell he went to Munich in 1880, but his immaculate style was not appreciated in that famed art center, and so he went on to Paris where the fourth and final version of his masterpiece, *After the Hunt*, was exhibited in the official Salon of 1885. The picture was an immediate success with the public, if not with the critics. He sold the painting back in America, and for years it hung in a New York saloon.

Harnett had gone to Europe because he failed to get his share of critical acclaim at home, although he always enjoyed the patronage of the more humble American art collectors. Perhaps Harnett wanted to emulate the more successful painters in the modern manner in order to taste some of their success. Commendably, he realized that his style was his own and that he would be untrue to himself if he went along with the vogue. By this strength of character he established himself as one of the great individual artists in our history and gave us some of the most genuine and enjoyable paintings we have.

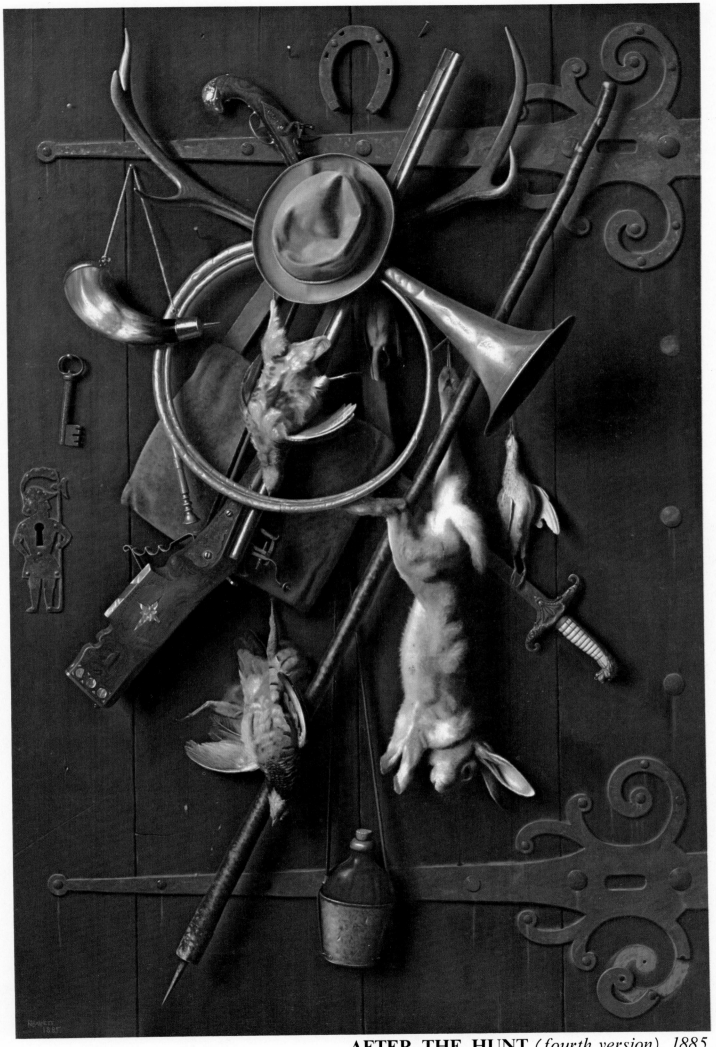

AFTER THE HUNT (*fourth version*), *1885,*
William Michael Harnett (1848-1892). 70½ x 47½ in., oil.
California Palace of the Legion of Honor, San Francisco.

JOHN SINGER SARGENT

Among the most famous expatriate American artists of the past century were James A. McNeill Whistler (pp. 152-155) and John Singer Sargent. Each was associated with European high society and gained notoriety; the former for purposefully affronting British public and critics alike for his rejection of subject matter as necessary for painting; the latter for an untypically realistic (for him) portrait of an affected French society beauty, Mme. Gautreau. But whereas Whistler, who apparently relished aesthetic conflicts, worked out his own style with influences mainly from French Impressionism and the art of the Orient, Sargent took his course from the more popular academic movements of his day as practiced by his teacher, Carolus-Duran (1838-1917). Whistler's flamboyant character — his witty, cutting lack of concern for patronage — belied his serious concern with the art of painting. Sargent, on the contrary, was more suited to be a businesslike artist who could cope with the foibles of his patrons and give them exactly what they wanted — technically perfect, recognizable, facilely executed portraits.

A more interesting comparison is between Sargent and Thomas Eakins (pp. 144-151). Eakins was born in 1844, twelve years before Sargent, and chose as his European teacher, Jean Gérôme (1824-1904). Both Jean Gérôme and Carolus-Duran were academicians but of quite different schools. Carolus-Duran denied the traditional French emphasis on outline and study from the nude and took the bravura approach of directly painting in oil on the canvas. The penetrating vision of Eakins, which stemmed from his disciplined training in precise statement, appeals to our taste today and is what we find lacking in Sargent.

Brilliant as he is, his concern seems disturbingly superficial compared to the profundity of Eakins. This may best be illustrated in their choice of subject matter — Sargent's sitters were of the *haut monde*; Eakins's were the everyday people of his everyday life. Even in their genre works, the one portrays the life of chic people and children in fashionable play or the exotic life of gypsies, while the other probes the more human level of the Sunday athlete, the amateur musician, the doctor practicing his profession.

Street in Venice, *1882,*
John Singer Sargent. 24 x 18 in., oil.
National Gallery of Art, Washington, D. C.

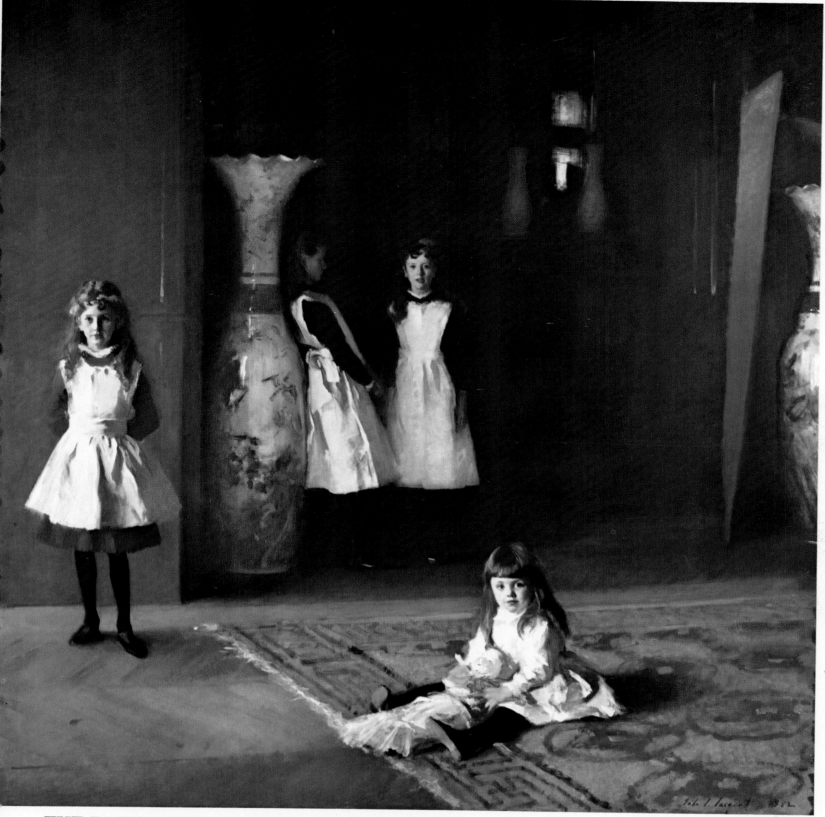

THE DAUGHTERS OF EDWARD DARLEY BOIT, *1882,*
John Singer Sargent (1856-1925). 87 x 87 in., oil.
Courtesy, Museum of Fine Arts, Boston, gift of
Mary Louise Boit, Florence D. Boit, Jane Hubbard Boit
and Julia Overing Boit, in memory of their father.

Only in the magnificent watercolors of both artists do we see Sargent approach Eakins's genius. In these watercolors, done all over the world on his travels, Sargent becomes as close to being personal in art as he ever did.

Sargent was twenty-six when he painted the four daughters of Edward Boit. The painting is superb in its feeling of spontaneous inspiration — its obvious brushstrokes, large blocks of clear color and off-center composition — almost like a snapshot. We can see in this brilliant achievement not only his admiration for the work of the seventeenth-century Spaniard Velásquez, but perhaps even justification for novelist Henry James's famous remark about the young artist, "it offers the slightly uncanny spectacle of a talent which on the threshold of its career has nothing more to learn.

It is his impersonality, his capitulation to art for art's sake rather than humanity's that puts us off, although we are impressed by his enormous virtuosity. We must judge him as an artist who sailed along with the fair winds of his time and shored up at the slightest sign of human storm.

JOHN SINGER SARGENT

Sargent has left us fascinating pictures of the artificial social world in which he lived and worked. His famous portrait of Isabella Stewart Gardner seems to sum up the Sargent biography as an artist and man. Mrs. Gardner was one of the most intriguing art patronesses of any period. This Boston beauty has left us a record of her life in art as personal as any in its history. Her museum home in Boston gives, as no other place I know of, a picture of a period and a personality that is complete. The period is America at its materialistic peak. The personality — womanhood burst out of centuries of protection and suppression into the matriarchal figure American women were becoming — symbolizes the advanced turn-of-the-century woman. Sargent was summoned to Boston to paint Isabella Gardner after Henry James had introduced them in Sargent's London studio. Sargent, whose training and life had been completely European, must have found the spirited Mrs. Gardner a new and frustrating experience, for he made eight unsuccessful attempts at her likeness before he finally hit upon a formula that would satisfy him and her. Happily, Mrs. Gardner's devotion to art was such that her patience survived his frustration and they became life-long friends. The portrait, if a monument to American woman-hood, is an idealization of the fact. But then, Mrs. Gardner was herself such a monument and Sargent was just the man to idealize her.

He was sincere in his effort to give up his successful but unsatisfying life as a fashionable portrait painter. But even on this he reneged to turn out some late portraits of the then richest man in the world, John D. Rockefeller.

In 1890, when he was chosen to do the murals for the Boston Public Library, Sargent came up against his spiritual shortcomings with a jolt. The models here had, in his words, "to symbolize the development of religious thought from Paganism through Judaism to Christianity." He simply was not up to it, and though he spent twenty-six years on the project, and contemporary critics considered it his "crown and glory," the murals now appear unimaginative and completely lacking in any spiritual force.

The Sargent that has lasted, however, is the portraitist. The Boit sisters are really exquisite, dear and brilliant reminders of a gentler age, while Mrs. Gardner will stand there forever as a reminder that beneath that gentleness was the will of iron that has made the American woman the most indomitable of her sex since Joan of Arc.

El Jaleo, *1882,*
John Singer Sargent. 94-½ x 137 in., oil.
Isabella Stewart Gardner Museum, Boston.

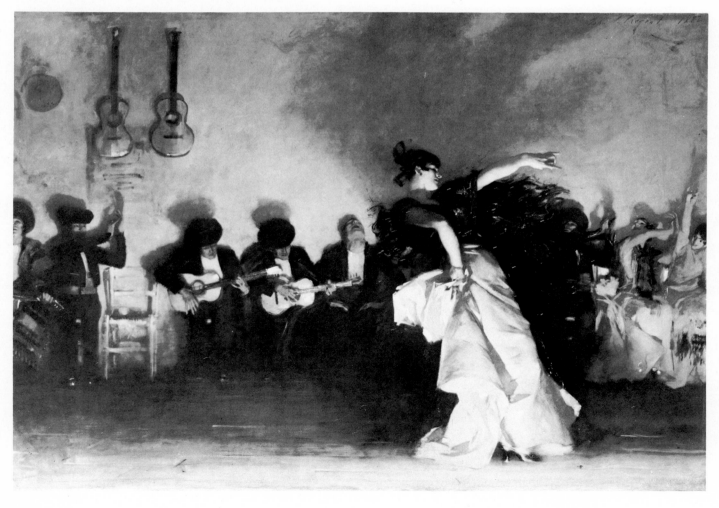

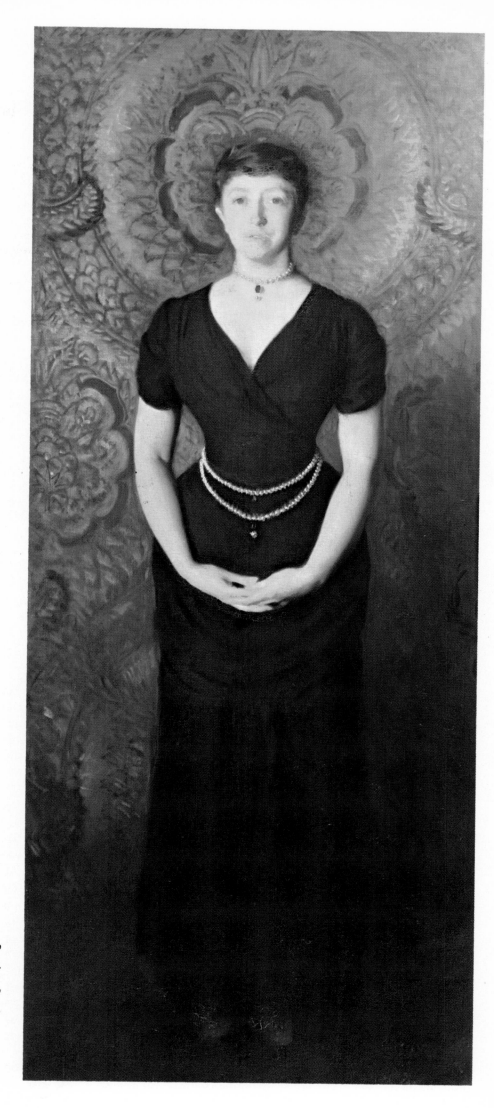

MRS. GARDNER, *1888,*
John Singer Sargent (1856-1925).
74¾ x 31½ in., oil. Courtesy,
Isabella Stewart Gardner Museum, Boston.

HOMER DODGE MARTIN

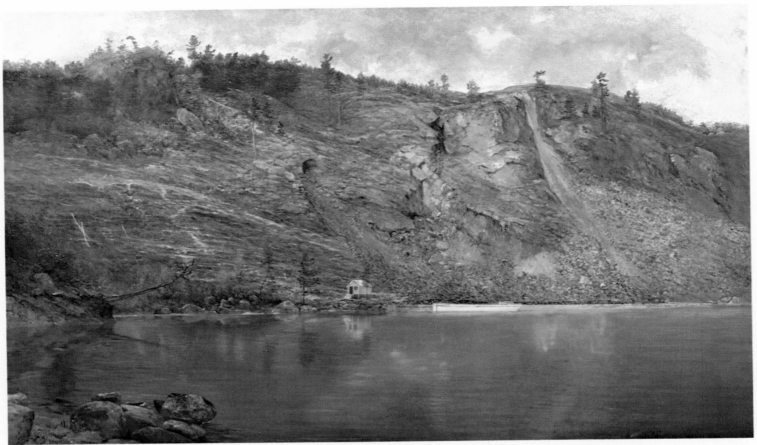

THE IRON MINE, PORT HENRY, N.Y., *n.d.,*
Homer Dodge Martin (1836-1897). 30 x 50 in., oil.
Courtesy, National Collection of Fine Arts,
Smithsonian Institution, Evans Collection.

"Martin's landscapes look as if no one but God and himself had ever seen the place." Thus wrote a contemporary critic of the work of one of America's most American painters and one of her best. His wife said of him, "There is an austerity, a remoteness, a certain savagery in even the sunniest and most peaceful of his landscapes, which are also in him." How directly opposite are those comments on his work to the known fact that Homer Dodge Martin was a witty, loquacious, even boisterous man, friend to many clubby intellectuals and yet on equally friendly terms with the reclusive Winslow Homer (pp. 138-143) and the contemplative Elihu Vedder (p. 116).

Whereas other American landscapists like Albert Bierstadt (p. 128) and Thomas Moran (p. 204) celebrated the grandeur of our wilderness, saying to themselves and their viewers, "Let's go look at the spectacular, let's revel in its unbelievable magnitude, let's go and be stunned into forgetting our jobs, the rent, our families and friends," Martin seems to scream, "I must escape from society. I've got to get away, I've got to go somewhere where 'we' doesn't exist and where I can confront nature as a greater ego than I am, the only ego deserving of recognition."

Martin struggled to paint. He was as un-Impressionistic as anyone could be, yet French Impressionism and especially its earlier manifestations, the Barbizon School, had their influence on him. He lived in Normandy for three years and studied all the French landscapists. But it is the early, sharply delineated J. B. C. Corot (1796-1875) we see in Martin, not the later fuzzy, soft-focus style that made Corot a fashionable popular master. Martin's pictures are hard and clear and direct. The agony he went through to paint from the bright-eyed beginning of his career to the near blindness of its brilliant end is reflected in everything he did. He endured long periods of artistic sterility, contrasted by violent activity. He did not just paint, he fought to get his pictures down on canvas.

He is, in his seriousness, typical of many American artists, perhaps even more typical in this respect than Homer, who always retained some jollity, some lightness of life, especially in his earlier sociable genre paintings. Martin's approach never betrayed his unrelieved seriousness, though it seems rather contradictory, considering Martin's happy married and social life and Homer's misanthropy.

The Iron Mine, Port Henry, N.Y. displays this seriousness. One has the feeling that the artist is standing on the other side of that body of water, taking long, deep breaths and deeper looks around him, grateful that the only sign of humanity is that apparently empty little house standing against the great, scarred cliff, man-forsaken. But is it? Perhaps the artist is fearful that someone will come out of the door and disturb the scene. And from the mine-pocked face of the cliff do we not get the message that man has destroyed something bleak but beautiful in his search for the material things, destroyed the soul of nature to feed the nature of man?

164

Harp of the Winds: A View on the Seine, *1895,*
Homer Dodge Martin. 28-3/4 x 40-3/4 in., oil.
The Metropolitan Museum of Art, New York,
gift of several gentlemen.

Autumn Landscape, *n. d.,*
Homer Dodge Martin. 19-1/2 x 35-3/4 in., oil.
Los Angeles County Museum of Art,
gift of Mr. and Mrs. William M. Harris.

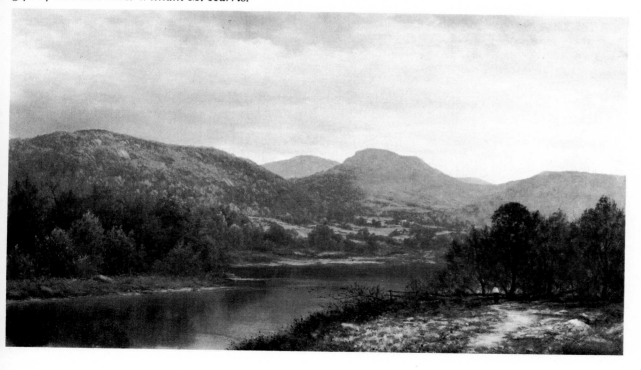

ALBERT PINKHAM RYDER

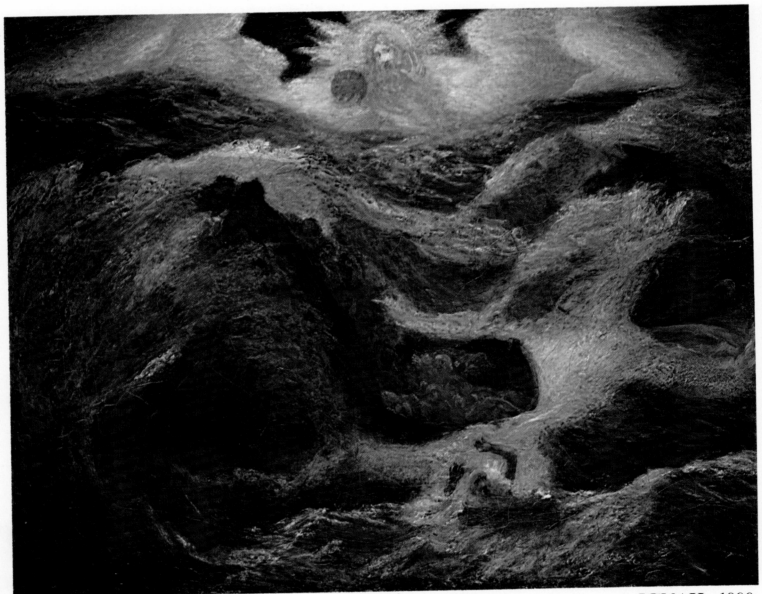

JONAH, *1890,*
Albert Pinkham Ryder (1847-1917). 26 ¼ x 33 ½ in., oil.
Courtesy, National Collection of Fine Arts, Smithsonian Institution.

Albert Pinkham Ryder is so close to filling the popular definition of the single-minded solitary artist that one has to untangle the romantic web he spun in life and almost clinically cut towards the truth of his art. At that, it is the nebulous truth of dreams which seem to the dreamer, at least, more real than the wide-awake world of more prosaic lives. A serene and almost childlike man, Ryder lived the major part of his working life in satisfied squalor in the middle of New York City. "I have two windows that look out upon an old garden whose great trees thrust their green-laden branches over the casement sills, filtering a network of light and shadow on the bare boards of my floor I would not exchange those two windows for a palace with less vision than this old garden with its whispering leafage." This was the only view he needed to reflect into himself, into his intense imagination, the only world he wanted and needed to see in order to produce the pictures in his mind.

And what strange and wonderful pictures they are, filled with the Wagnerian and romantic imagery of the second half of the last century, the escapism indulged in by all those super-sensitive souls floundering in the ever-advancing wave of the industrial revolution. Ryder retreated, not to the country, but into the heart of the city most affected by it. There he ignored it all. After a brief trip to Europe in his early forties where he augmented his romantic appetite — not so much on graphic art, one suspects, as on experience — he settled in New York and began to produce the little masterpieces which culminated in *Jonah*. Certainly his involvement with the sea as an element of drama stems from his Atlantic crossings.

In *Jonah* we can discover much about Albert Ryder. Here, lonely man battles against the elements of fear and rejection, watched over by God. Faith is the soil that keeps drawing him; it is the buoyancy that keeps him afloat. The great sea creature is a refuge from the unknown. It is as if Ryder understood completely this most improbable of Bible stories. Secure in his art, in the belly of his self-made whale-world, the painter could weather the storm of life and produce a miracle. By his own admission, painting was the prayer he offered up for his own salvation.

True mystics are perhaps even rarer in art than in religion. The Englishman William Blake (1757-1827), the Flemish Hieronymous Bosch (1480-1516), El Greco (1541?-1614) and the Frenchman Odilon Redon

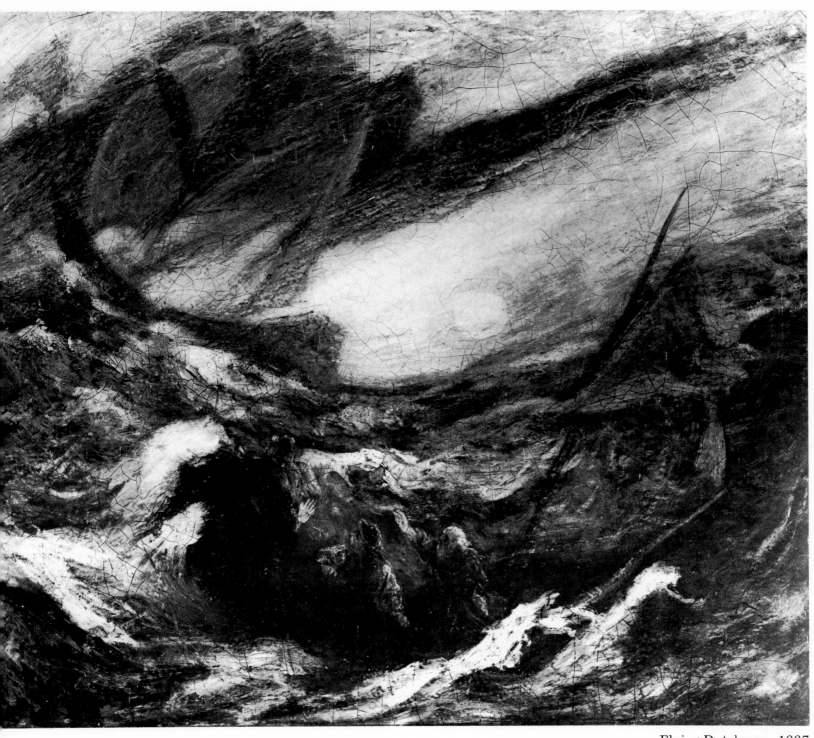

Flying Dutchman, 1887,
Albert Pinkham Ryder. 13-3/4 x 16-½ in., oil.
Courtesy, National Collection of Fine Arts,
Smithsonian Institution, gift of John Gellatly.

(1840-1916) were all mystical painters in various ways, recording their vision of reality behind the reality every man sees every day. Ryder concentrated so intently on his favorite images, the sea and the sky at night, that the viewer cannot escape the same hallucinatory image. Ryder, though perhaps not as great an artist as these other mystical painters, is because of his vision the one American who could be included in this rare company. But Ryder's greatest gift to American art is his life as a symbol to others. To survive in a complicated world, one must love a man like Ryder who did not abandon his spirit.

Almost saintlike, he was plagued with afflictions defeating to most artists. Weak eyes kept him from intense study of accepted art techniques. Perhaps it explains his sublimation of details and tendency to compensate with the broad effects of light and shade. Certainly his lack of study caused him to experiment with untested materials. Never a rapid painter, he was apt to load his little canvases with oils, candlewax, varnish and alcohol and over these undried surfaces he would glaze layer upon layer until each vision was polished to his own definition of perfection. Many of his pictures have deteriorated through the crackling of all these foreign materials until they look like ill-fitting jigsaw puzzles. *Jonah* fortunately did not suffer this fate and one must look to it and the few others in like condition to see properly how the others must have looked.

Still, in spite of his small output and the disaster that attacked so many of his canvases, Ryder remains a rare artist in every sense. Without his spirit, all art, especially ours, would be greatly impoverished. In him we see the artist's soul more than the artist or his work, and when that precious view is allowed us, we are privileged to get down to the very essence of civilization and those few men who stand as mileposts in its progress.

MARY CASSATT

THE BATH (*La Toilette*), ca. 189
*Mary Cassatt (1844-1926). 39½ x 26 in., o.
Courtesy, The Art Institute of Chicag.
Robert A. Waller Fun*

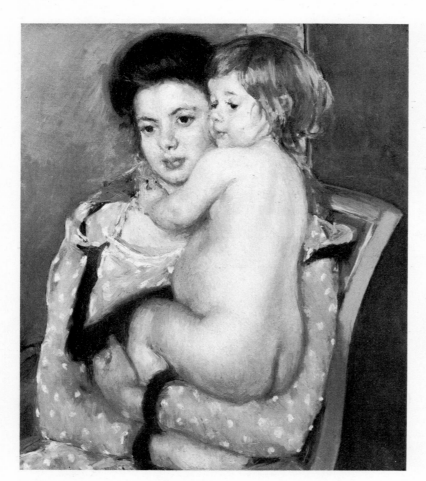

Reine Lefebvre Holding a Nude Baby, *1903,
Mary Cassatt. 27 x 24-½ in., oil.
Worcester Art Museum, Worcester, Massachusetts.*

The single American artist to be accepted into the small French Impressionist group of the 1870's and 80's was the austere woman from Philadelphia, Mary Cassatt. Although she was artistically in league with that elite group, her work could never be mistaken for that of anyone else, as sometimes is the case with the Impressionist style. Cassatt eagerly learned the best techniques of Impressionism — brilliant and luminous coloring — from the master, Edgar Degas (1834-1917), but her American forthrightness always sets her apart, particularly in her precise and bold draftsmanship.

Mary Cassatt was born of well-to-do parents in Allegheny City, Pennsylvania, in 1844. Her father was a man whose business acumen made it possible for him to live wherever he pleased and the family moved about Europe and back and forth to America so that the children became "international" almost without knowing it. After a short period of study at the Pennsylvania Academy of Art, Mary Cassatt made Paris her home and there she came under the influence of one of the great masters of modern art, Edgar Degas. She declared years later that "at last I could work with absolute independence...I had already recognized who were my true masters. I admired Monet, Courbet and Degas. I hated conventional art — I began to live." Still, in spite of these three typically French influences, as one biographer says, "There is a naturalism and directness in Mary Cassatt's vision which distinguishes her American sensibilities."

We must remember also that she was a woman, and an American woman in a period when many of them did not or could not ever say they could live in absolute independence, let alone work with it. Her life was protected in that she did not have to worry about money and she was surrounded by a devoted and understanding family. She remained single, lived a very proper, upper-crust social life

and was wholly married to her art. In her later years, she was dedicated to updating her friends' and family's taste in art. Largely due to her influence, the great patrons Mr. and Mrs. H. O. Havemeyer began collecting Impressionist and El Greco works. Their gift of that collection to New York's Metropolitan Museum of Art is said to have enriched its collections more than any other in its history. In summary, Mary Cassatt was a powerful force in the art of her country even though she was an expatriate. She brought to our rather provincial art taste an awareness of the great experiments going on in France which were to have such an effect on other American artists. Her own work retained an identifying American trait of individuality and strength which no American woman had ever achieved in art.

The Bath (La Toilette) is precisely Cassatt in both subject and style. Her long years of discipline in graphics, constructing color, line and pattern into a harmonious whole, and the lessons she learned from the old Japanese masters she studied, Utamaro (1753-1806) and Hokusai (1760-1849), are here merged. The composition is strong in simple lines and brilliant color. There is nothing extraneous or sweet. It is this that keeps her eternal theme of mother and child from degenerating into sentimental banality. Hers is a straightforward view of warm human sentiment, but with no hint of that cloying charm that might invade such subject matter. A Cassatt mother is often a plain woman and her children are not all adorable cherubs. In the best of her paintings and prints, the women and children are human beings helping one another to grow and mature, portrayed with integrity. Perhaps her single life style gave her the objectivity needed to avoid sentimentality. Her mature understanding of her own desires from art, and perhaps even her limitations in it, are what make her so appealing to every kind of art lover.

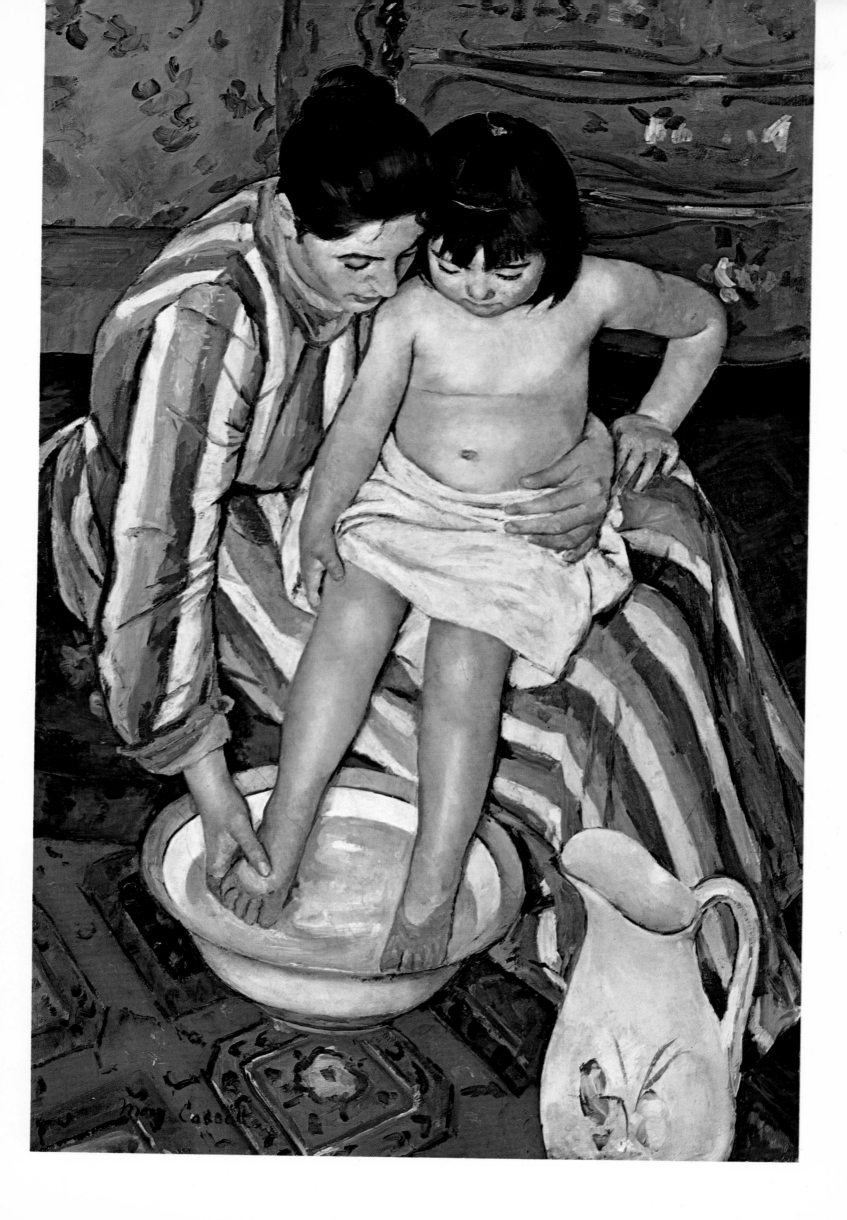

RALPH ALBERT BLAKELOCK

The most abused figure in American art is Ralph Albert Blakelock. A sensitive self-seeker in the arts, he hoped to make the beauty of our great wilderness part of our consciousness. Completely self-taught, he fell in love with the landscape of the Adirondacks and New Jersey, the nearest wilderness to his home, New York. He exhibited his first paintings at the National Academy in 1867 when he was twenty. Two years later he went west to paint, not the vast views of Thomas Moran (p. 204) and Albert Bierstadt (p. 128), but a very intimate picture of the primeval forest. What the others saw in the magnificence of the Yosemite or the Grand Canyon and the like, Blakelock saw in a tree, a pond, the varied light of day, dusk and moonlight. His pictures are sometimes hard to comprehend, as his technique was strange, and while giving a deep luminosity, time has dealt as badly with his work as it has with Albert Pinkham Ryder's (p. 166). Blakelock painted rapidly with varnish glazes and then laid more paint on top of that. If peaks built up he would scrape them off and then add more. James T. Flexner suggests that few of his works retain their final effect. Yet, he concludes, "soberly and deliberately contemplated, Blakelock's canvases still emit a tiny flash of that rarest of all fires, genius."

The tragedy of his life was the need to support himself and a large family by a new, personal art style which was not accepted because it was so different from the current fashion for landscape grandeur. He would make no concession to popular painting styles, and, being of a volatile temperament, inundated by anxiety for his family and the critical neglect of his work, his reason foundered at the age of forty-four. Still, there must have been a deep conviction within him, for he came back from confinement in a mental institution to create some of his finest paintings. But even though he found a few champions, he could

Hawley Valley, *1883,*
Ralph Albert Blakelock. 14-½ x 52-½ in., oil.
Museum of Art, Carnegie Institute, Pittsburgh.

not make life work for him and finally, eight years later, gave into the living death of dementia praecox, or schizophrenia.

Just before his first breakdown, *The Collector*, an art magazine, stated, "One word of encouragement is all that is required. . . . The artist has already fought his battle for existence to a victory with honor to himself. Who will earn the honor of aiding him to the fame which is his due?" But there was no one. He confronted one collector who offered him half his asking price, and when Blakelock would not accept it, he warned the artist it would be even less later. Blakelock finally had to take about a third of what he first asked, and shortly afterward he was found in the streets tearing up the money.

His revolt against the obdurate establishment was complete. Living in Harlem in a dingy flat with his large family, he had delusions of grandeur and dressed himself in the hippie fashion of today with beads and sashes of richly colored material. He grew long hair and a beard and, on the day his last child was born, his wife reluctantly had

him committed. He died at the age of seventy-two, having regained his sanity one month before.

Twilight was painted the year before his final breakdown and is one of his most poetic works. He wrote a poem which still adorns the frame of this picture.

TWILIGHT

What if the clouds one short dark night
 hide the blue sky until morn appears
When the bright sun that cheers soon again will rise
 to shine upon earth for endless years.

Certainly this is not a picture of a troubled mind unless it was one prophetic of man's desecration of nature. It is inspired rather by a stark lucidity that makes it hauntingly, even frighteningly, real. The final ironic epitaph to Blakelock's tragedy is the success of his work while he was confined in the asylum and after his death and the fact that his life and career were further obscured by many forgers capitalizing on his belated success.

JOHN HENRY TWACHTMAN

AZALEAS, *ca. 1898,*
John Henry Twachtman (1853-1902).
30 x 24 in., oil. Randolph-Macon
Woman's College, Lynchburg, Virginia,
gift of Mrs. Andrew C. Gleason.

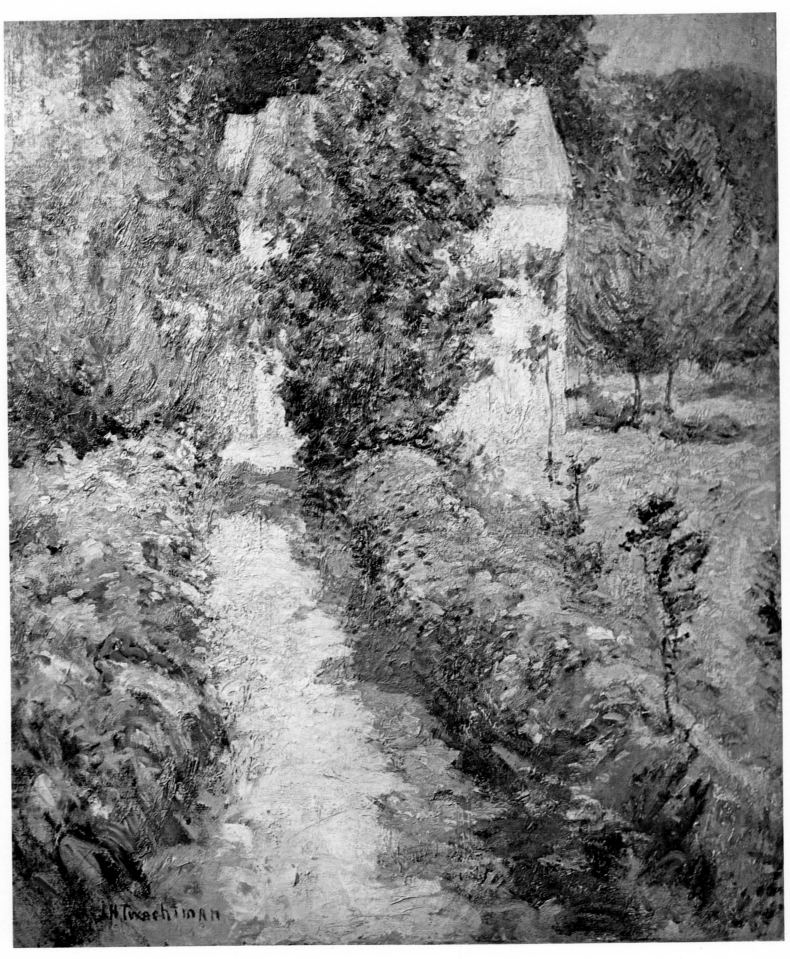

The White Bridge, n, d.,
John Henry Twachtman. 30-¼ x 30-¼ in., oil.
Minneapolis Institute of Arts,
Martin B. Koon Memorial Collection.

In addressing the Art Institute of Chicago's graduating class of 1893, John Henry Twachtman summed up the European domination of American art and the indifference of our collectors to our indigenous painters. He told his students, "You are studying art here now and someday some of you will become painters and a few of you will do distinguished work and then the American public will turn you down for second- and third-rate French painters."

What Twachtman was referring to, of course, is the obvious adoration of the American public for French academic painters who followed the line of Jean A. D. Ingres (1780-1867) with no feeling. Jean L. E. Meissonier (1815-1891), Jean L. Gérôme (1824-1904) and Adolphe W. Bouguereau (1825-1905) were the best known of these illustrators, but their imitators were legion; except for a handful of discriminating collectors, such as Duncan Phillips, they captured American collecting taste toward the end of the century.

Twachtman and his friends suffered under a double disadvantage with their countrymen in a position to buy their work. Not only were they Americans instead of the more prestigious Europeans, but, even worse, their European counterparts and predecessors were not the academics of hard, linear, story-telling pictures, but the Impressionists,

Auguste Renoir (1841-1919), Claude Monet (1840-1926), Camille Pissarro (1830-1903) and the rest, all of whom had trouble enough finding a French audience able to appreciate their new ways in paint.

Although there are superficial resemblances enough to justify the common name, there are great differences between French, American and even English Impressionism. All Impressionism came out of the practice of painting in the open air, as opposed to the artist confining himself to the studio. And both abandoned the "finish" of academic painting. The differences have to do with the national spirit of the painters. France, perhaps because of its long history, its struggles to be identified as an individual culture as far back as the Renaissance, and its final triumph in the nineteenth century, enjoys the lightheartedness of success. America, on the other hand, is still battering down the walls of outside interference and influence, and our artists wallow in the seriousness of this purpose and, even in as joyous an expression of art as Impressionism, lack the light touch.

Despite his feelings on the subject, Twachtman enjoyed great success in the galleries of New York and won many honors and prizes. He even shared an exhibition with the great Monet. But the American collectors paid him little attention.

Twachtman was a serious painter, very much involved with what was going on all over the world in his time. His personal involvement with men like James A. McNeill Whistler (pp. 152-155) and William Merritt Chase (p. 156) and his studies in Paris just as French Impressionism was hitting its stride in the 1870's quite naturally led him into Impressionism. Twachtman was never an innovator and never claimed to be; rather he sought out the best manner in which to make his own statement about his own art, his own vision. The study of light became his all-absorbing passion, but he reached his conclusions only after hard and serious consideration of what was right for him.

Azaleas was painted just before he gave himself over completely to the French ideal of Impressionism. It is a more American picture than some of his later works, which tend to blend into the French movement even while retaining their American seriousness. One sees here the influence of Chase more than of Whistler and, if it must be linked to a Frenchman's work, it is closer to Pissarro's than to Monet's or Renoir's. It is too literal to be confused with French. It is too American.

Even in his late work, when it became totally infused with Impressionist light, there is never the abandoned joy of the late Monets. It is studious, brilliant but never "loose" and free. The bravura light touch did not come to our art until Abstract Expressionism after World War II, which gave us, perhaps, our first true national art identity in the eyes of international art.

MAURICE PRENDERGAST

AFTERNOON, PINCIAN HILL, *1898*
Maurice Prendergast (1859-1924). 15⅛ x 10⅝ in.
watercolor. Honolulu Academy of Arts

Deep inside this wonderful artist was a security born of devotion to an ideal — art. Nothing else mattered. A weak constitution, deafness and long periods of neglect and poverty seemed only to fortify this gentle man to create some of the most beautiful works of art our country has produced. His deafness allowed him to shut out the clatter of the busy world and to bask in the study of art and literature. He had friends and admirers but he really needed only himself and the lifelong love of his brother Charles (1863-1948) to make a full life. Charles was an artist, too, but he rather sublimated himself, not only humbly but lovingly, to let his brother's slow growing genius mature and shine through. Maurice's first major recognition came when he was forty-one.

Born in St. Johns, Newfoundland, in 1859, he studied painting in Boston and earned his living by lettering show cards, while his brother made picture frames. Maurice sketched and painted all the time, learning what he knew to be his true trade, fine art. By 1886 he had saved a thousand dollars and took his first trip abroad. He studied at the Académie Julian and lived in Paris in his quiet way for four years. He absorbed the art of the museums and the new art of the Impressionists and he was able to learn much and, even more energetically, to unlearn the bad habits picked up in the formative searching years at home. He acquired a great admiration for the ancient cultures of Europe, the fabrics worn and softened by time, the mosaics, and above all an indelible picture of people on parade. Some critics say his admiration for the sixteenth-century Venetian, Carpaccio, the great master of pageantry, led to his love of pictures of people gathered in the common exercises of daily life, especially at play and recreation.

Prendergast was not overwhelmed by Impressionism as were other Americans in France at the time, such as Childe Hassam (p. 202) or John Henry Twachtman (p. 174). Rather he added it to his experience as an artist and used some of its methods and techniques, but only the ones he wanted and needed. His own mature art is closer to the Pointillism of Georges Seurat (1859-1891) and Paul Signac (1863-1935) than Impressionism in his use of small swaths of pure color side by side to give the overall luminosity that pervades all his paintings and watercolors. Alexander Eliot, in *Three Hundred Years of American Painting*, declares him to have been "one of the most timid revolutionaries in the whole history" of our art. He sums him up by saying, "Prendergast painted the world as a tapestry of nice people having fun amidst soft airs." Perhaps "diffident" or simply "quiet" would be more accurate words for his kind of revolution, for there was nothing timid in the way Prendergast developed his own method of seeing the world in paint.

A look at his works evokes pure joy. There is nothing harsh about what they say or how they look. They seem to whisper to us that the world and its inhabitants are really lovely to look at, and he looks for us to see it just so: lovely, full of love. What a contrast his gentle art must have seemed in that first, all-important showing of The Eight. Robert Henri (p. 192) and George Luks (p. 222) took their inspiration from the seventeenth-century Dutch painter, Frans Hals; Everett Shinn (p. 198) from Edgar Degas (1834-1917), William Glackens (p. 186) from Claude Monet (1840-1926) and Pierre Auguste Renoir (1841-1919). But Prendergast is closer to Seurat and Paul Cézanne (1839-1906). His building up of form through the

Eight Bathers, *ca. 1916-18,*
Maurice Prendergast. 28-¼ x 24 in., oil.
Courtesy, Museum of Fine Arts, Boston.

use of individual and perceptible strokes of paint closely relates to Cézanne's work, whose Post-Impressionism was perfected a decade or so earlier than Prendergast's at every stage. Actually he belongs to no school but his own, the school of self-searching through constant learning about everything and everyone else. Furthermore, the revolution of The Eight was more one of subject matter, slices of American life that had not been depicted before in art, while Prendergast's was a true artistic revolution, one of method, of style, of a way of seeing.

Afternoon, Pincian Hill depicts the Romans strolling away the happiest part of their day in this glorious park. This painting tells us how easily the different areas of the world fit into Prendergast's requirements for happy subject matter. There really is no specific place, for these same people might be found where he painted them in Boston or Central Park. What concerned the artist was togetherness with the surroundings. One writer summed up his work by saying that, "The subject of his painting is always a secure and innocent joy."

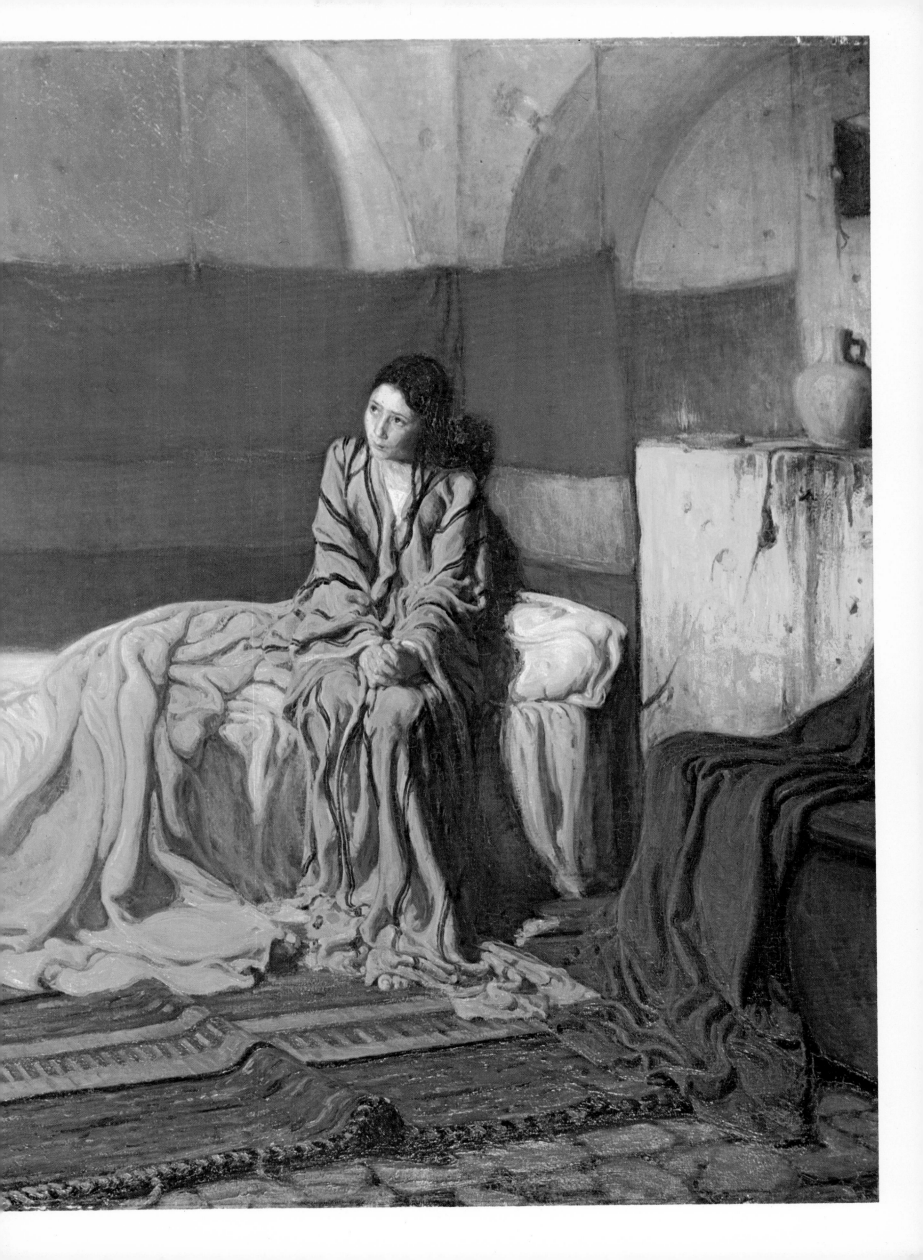

HENRY OSSAWA TANNER

THE ANNUNCIATION, *1898,*
Henry Ossawa Tanner (1859-1937).
57 x 71¼ in., oil. Philadelphia Museum of Art.
(Backleaf, see pages 178-179.)

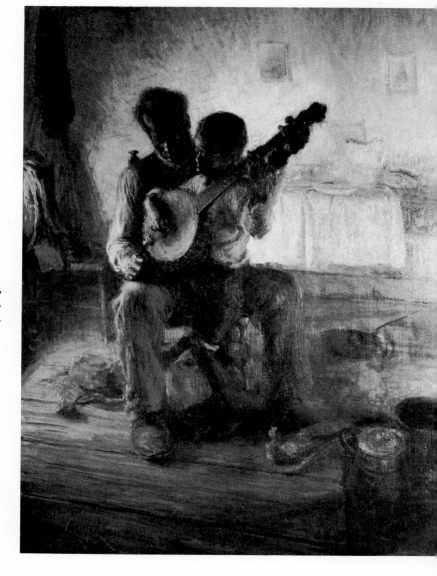

The Banjo Lesson, *ca. 1893,*
Henry Ossawa Tanner. 48 x 35 in., oil.
Courtesy, Hampton Institute, Hampton, Virginia.

No story of our nation's art is more touching or more American than that of Henry Ossawa Tanner, our first and perhaps still greatest black artist. Unfortunately, the story involves all the white man's prejudices that plague black people and have kept them from contributing their enormous inherent artistic power to our art force. But Tanner found a receptive European audience, and we can only hope other black artists will not have to desert their country to achieve a similar acceptance.

Tanner's father was a bishop of the African Methodist Episcopal Church who brought up his son in Philadelphia and educated him in an all-black school. At the age of twelve he knew he wanted to be an artist. He aspired to fill the artistic gap proclaimed by an art magazine, the need for a great marine painter. In his teens he had difficulties finding a teacher who would work with blacks. He wrote, "But with whom should I study? No man or boy to whom this country is a land of Equal Chances can realize the heartache this question caused me. . . .The question was not, would the desired teacher have a boy who knew nothing and had little money, but would he have *me.*"

He finally found someone who would have *him,* and that was a man who was himself misunderstood, but who was not only a great teacher, but perhaps our greatest master, Thomas Eakins (pp. 144-151). All his life Tanner remembered and followed Eakins's admonishment when he was having difficulty with a painting. "What have you been doing? Get at it, get it better, or get it worse. No middle ground of compromise." From Eakins he learned to depict convincingly the structure and weight of the human body and how to do this in two dimensions. He also learned the importance of using light to reveal character and the true nature of things.

For all Tanner's efforts and obvious talent, however, a one-man exhibition in this thirtieth year proved a financial disaster. He determined to try his luck abroad, and sailed for Europe in 1891. Tanner was not a man who longed for a European veneer of art training: He had to leave home.

Without in any way deviating from his original art intentions, he remained an academic traditional realist to the end, despite the fact that the great movements of modern art, Impressionism, Cubism, Surrealism were winning victories all around him. He achieved enormous success in Europe, winning prizes, selling his work to French museums and finally receiving the title of chevalier of the Legion of Honor in 1923.

Tanner, however, was never an expatriate. He remained an American and a Negro all his life, although he rarely returned to his home, and he died in France in 1937.

The Annunciation was painted in 1898 and marks his progress in his chosen field of religious painting, coming as it does after his well-known *Lazarus* and *Daniel.* The model is Tanner's wife, Jessie, a woman who was his devoted companion and model throughout his life. They met when he first went abroad and fell in love; her warmth and spontaneity were a contrast to his own gentle reserve.

Though Tanner's art is not as well known today as it was in his lifetime, having suffered from the same malady as other American art of his period — our love for every whim of European art — *The Annunciation* still remains a great public favorite in the Philadelphia Museum. In this picture Mary is not a humbled, thunderstruck receptacle of divinity, nor is she the hallowed, glowing mother of mothers. She is a mortal listening, somewhat quizzically, to a spirit who is telling her of an astounding design. She is considering it and exercising human choice and reason. She will agree to bear the divine child, but it is her human understanding that gives this Annunciation its strength, appeal and its spirituality.

180

CHARLES M. RUSSELL

LEWIS AND CLARK ON THE LOWER COLUMBIA, *1905,*
Charles M. Russell (1864-1926). 18½ x 23½ in., watercolor.
Amon Carter Museum of Western Art, Fort Worth.
(Overleaf, see pages 182-183.)

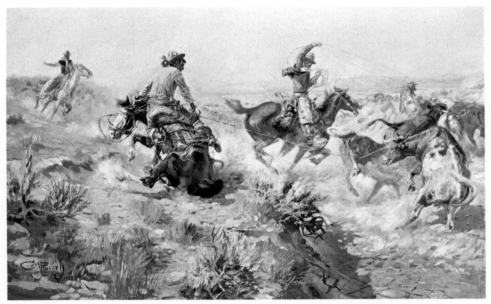

Jerked Down, *1907,*
Charles M. Russell. 36 x 22 in., oil.
Gilcrease Institute of American History and Art, Tulsa.

Charles M. Russell was born in St. Louis, Missouri, in 1864, three years after Frederic Remington's birth in Canton, New York. Remington (p. 196) was an Easterner with a romantic's love for the West and a deep desire to report its changing life style, but Russell not only lived all over the West, but he lived its life completely — hunting, riding and wrangling. There was no other life for him, and even his marriage at thirty-two and his eventual settling down in Great Falls, Montana, did not entirely change his ways. He merely transferred the active life into paint and clay but never lost sight of it as living experience. The saloons he frequented served as galleries to display his work, and his art dealers were bartender friends. His other friends were all those rugged men who like himself loved the West — Teddy Roosevelt, Tom Mix, Will Rogers — and they in turn loved him and his art.

He was completely self-taught. From his boyhood, drawing or modeling in clay was as natural as playing ball, eating and sleeping; but according to Mrs. Russell, "He did not like the new, so started to record the old in ink, paint, and clay." He turned out a prodigious number of "records" during his lifetime but, though few of them remained long in his studio before going into private collections, he did not achieve fame in the accepted sense of a New York showing until 1911 at the age of forty-seven. From that show Russell and his paintings traveled in fame around the states and to Canada and Europe.

Most of Russell's paintings have as their subject matter the life he knew so well, such as *When Horseflesh Comes High,* but on occasion he tackled the more ambitious but similarly adventurous scenes of history. *Lewis and Clark on the Lower Columbia* was a story that quite naturally intrigued him, and so he recorded it in his best fashion. His great gift for storytelling is here combined with his brilliant eye for detail. His draftsmanship is impeccable and he

brings to life the story of Sacajawea, the "bird woman," who at seventeen joined the expedition as interpreter. She is talking in sign language to the Chinook Indians. The canoes bear the famous crew, including York, the black man who so intrigued the Indians, and Lewis and Clark. The former stands at the prow, the latter wears a cocked hat. Sacajawea is bargaining for the otterskin cape mentioned in the journals and worn here by the chief.

Most Americans share Russell's delight in our stern and adventurous beginnings. The paintings evoke nostalgia for the days that appeal for their ruggedness, but there is another side, a gentler side to this extremely robust artist's nature, and it is beautifully revealed in his small animal bronzes. They are comparable to those of the great French *animaliers* who thrived during the Romantic Movement of the nineteenth century. Russell's animal bronzes betray the tender and deeply sensitive vision of a man whose wife wrote of his eyes that, "they seemed to see everything, but with an expression of honesty and understanding." This is quite a contrast to the accepted image we have of the square-jawed, deep-set-eyed man whose visage was accepted by the tough, action-tried men of the working West as one of their own.

J. Frank Dobie, in the Gilcrease Institute's 1960 catalogue on Russell, says of this rare artist, "He not only knew the West, he felt it. Few men of action have had the temperament and skills to aesthetically communicate, much less re-create, the world of action in which they lived.

181

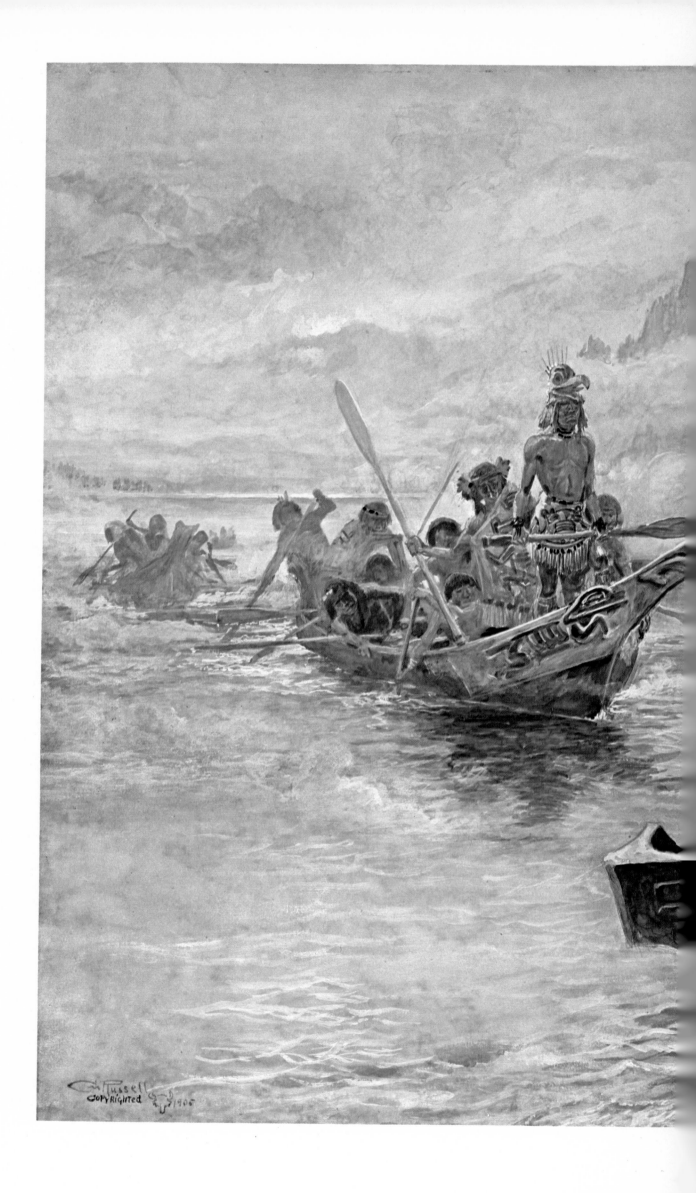

182

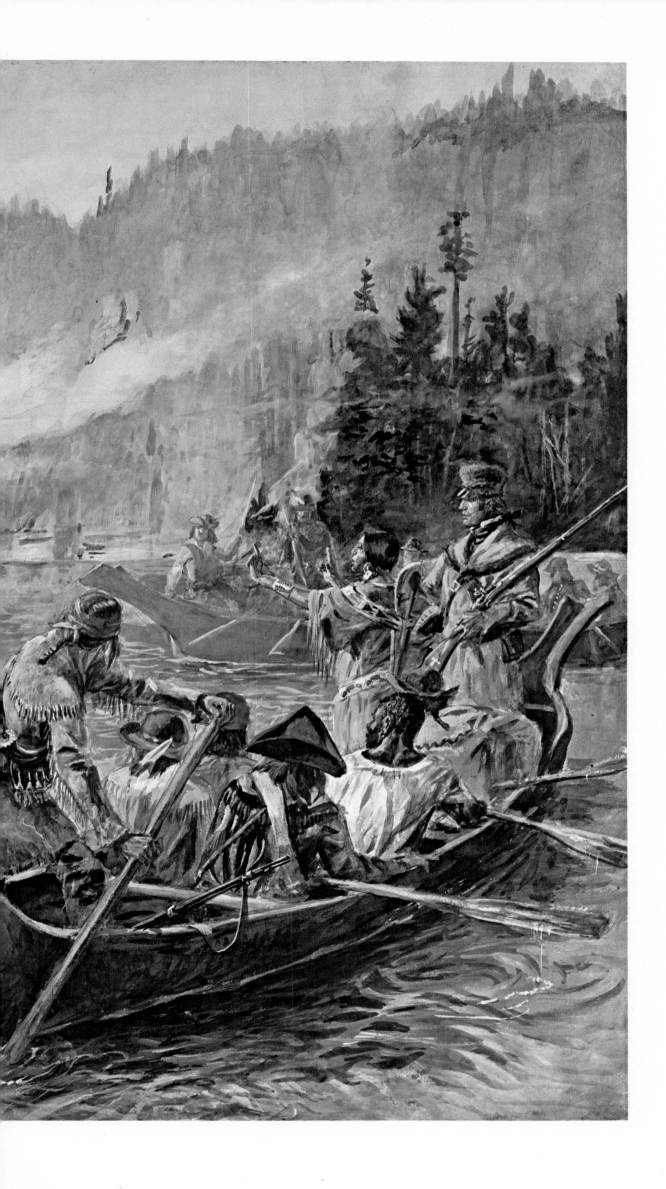

ERNEST LAWSON

BROKEN FENCE, SPRING FLOOD, *n.d.,*
Ernest Lawson (1873-1939). 30 x 24 in., oil.
Courtesy, Pennsylvania Academy of the Fine Arts, Philadelphia.

So many of our American artists were strong personalities in search of themselves in art; some were rebels; many intended to break with the past, to find new paths to different ways of seeing. A very few, such as Ernest Lawson, were contented with their talent and reverential towards art as the fact of their lives. One American artist who knew Lawson, Guy Pène du Bois (1884-1958), said that of all artists anywhere, Lawson was the first to come to mind when one thinks of pure landscape painting. Lawson was, of all our landscapists, the most content to deal with his limited interests in art and dedicate himself fully to his own vision of the world around him, not as it should be, but as it was. Du Bois explained that Lawson's art is "pure because it is not tortured into symbolic shapes by the ruthless requirements of a philosophical or scientific doctrine." Lawson's firsthand examination of nature is directly opposed to the practices of other artists in his time who approached nature with a preconceived idea.

Our present attitudes, in which we approach nature with little humanity, perhaps explain why Lawson has been the last of our Impressionists to come to full recognition. The great French experiment, Impressionism, which tortured so many of our painters until they were able to make it their own, Lawson absorbed on contact. He was not seduced into the haze with which others filmed their subject matter to the detriment of form. He was the only one of the famous Eight who painted only landscape. The life of the city to which the others were so given did not appeal to him. He took to the parks and especially the unspoiled beauties of nature found at the end of Manhattan Island called Spitting Devil or Spuyten Duyvil. There he painted the peace of nature and its beauty under cultivation.

His personality matched his paintings. "Social, easy, happy, smiling" are the only words du Bois used to describe him. Contemporary critics like James Huneker, the great art dandy of his day, waxed poetic about his serene canvases — "a palette of crushed jewels" in Huneker's words. Frederick Newlin Price in an essay on Lawson almost loses the modern reader by overpoeticizing him, but in explaining the technique he comes to the point: "Technically, Lawson puts on paint quite fully, no vague tracery but solid building of the medium. . . there is weight to his canvas, no superficial stains, no areas that time may fade. Time mellows and enriches them like the grand masterpieces of old time."

When you come upon a Lawson in a collection of American painting, two things strike you: the feeling of permanence and the absolute stillness. *Broken Fence, Spring Flood* does not suggest flood as torrents of wild water nor a broken fence as vandalism or neglect. It is rather a statement of what naturally happens to man's work and how nature works of itself for man, not against him. The waters will recede and the woods will be alive with violets and verdure. The fence may or may not be mended, for no one but our painter may ever walk this way.

Winter, Central Park, N. Y., *1920,*
Ernest Lawson. 20 x 24 in., oil.
Arizona State University Art Collection, Tempe.

185

WILLIAM GLACKENS

If there is a way to help people understand the avant-garde movements in art, perhaps one of the best would be to try to explain why most people understand and are attracted to the work of men like Pierre Auguste Renoir (1841-1919) and William Glackens. Both these greatly talented men were simply reporting the utter joy of life, and it is important to know that they were not fabricating but actually reporting what they saw, the way they saw it.

Too often we intellectualize or moralize and are thrown off by the reported joy of life these two artists extolled. We try too often to find a message of drama and tragedy in a work of art. It may be that we identify with ourselves this way, preferring to see life as tragic or burdensome at best. To love Glackens and Renoir you must give yourself over to the holiday spirit. Both artists simply convey to us the feeling that to miss life's fun is the deadliest sin, even more deadly than to enjoy the sensuous beauty of a woman's body or a loving couple, full of food and fun in the flooding light of a lovely day.

Glackens was yet another member of the famous Eight. Their fame rests on the needed awareness they brought to America that the unemotional or heroic approach to art is not enough. Emotions are what make us, and to deny them is to miss half the pleasure of living, even if everyone's definition of it is different. The Eight were all robust individuals who were not afraid to tackle every side of life's drama. But whereas John Sloan (p. 194) and George Luks (p. 222) of The Eight were concerned with its more ordinary aspects, Glackens concentrated on the glamorous world, not of the rich, but of the joyous. Leslie Katz in an effulgent article about him makes a wry statement, "His paintings may be said to be haunted, as we say the paintings of Edward Munch or Oskar Kokoshka are haunted, by national qualities as well as personal ones. The fact is,

paradox that it may be, that the paintings of Glackens are haunted by the spectre of happiness, obsessed with the contemplation of joy."

Katz sums up his style as being "deceptively deadpan." I like that statement because it puts into the vernacular the point of view of so many of our modern reporters. It is such an American trait and gives a clue to American humor from Mark Twain to James Thurber. Glackens was a reporter, an illustrator, born in a time before photography had taken over completely. Like Winslow Homer (pp. 138-143) and many others in this country, his training was that of a visual reporter. I have always felt that all art, even the most abstract, would not be so misunderstood or approached so uncomfortably if one could admit that this is basically the purpose of art — to report life in every aspect — each artist to his own taste.

Glackens's world of joy is something we all need to look at, if only to reassure ourselves there is something good to look at at all. Ugliness is always near us, but we need to see the possibility of beauty, and that, too, is the artist's function. *Hammerstein's Roof Garden* is a place of practiced joy. The entertainer is the practitioner of happiness. The spectator comes to be amused, excited, calmed down from the stresses of daily life. Glackens captures all this with the dash and verve of an eyewitness. John Sloan said Glackens could draw anything, and that is the quality we find here: an immediate drawing in paint of an instantaneous performance. We see his debt to Édouard Manet (1832-1883) in the solidity of the ringmaster and his love of Renoir in the color and swirling forms. But the picture is Glackens's and it is very definitely an expression of American art.

In the Luxembourg Gardens, *1906,*
William Glackens. 23-3/4 x 32 in., oil.
The Corcoran Gallery of Art, Washington, D.C.

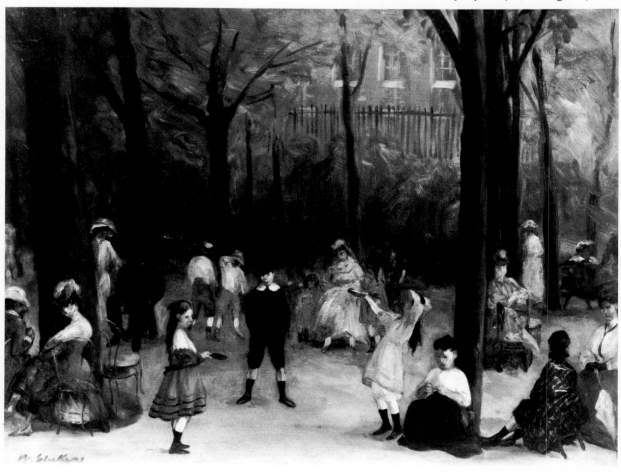

186

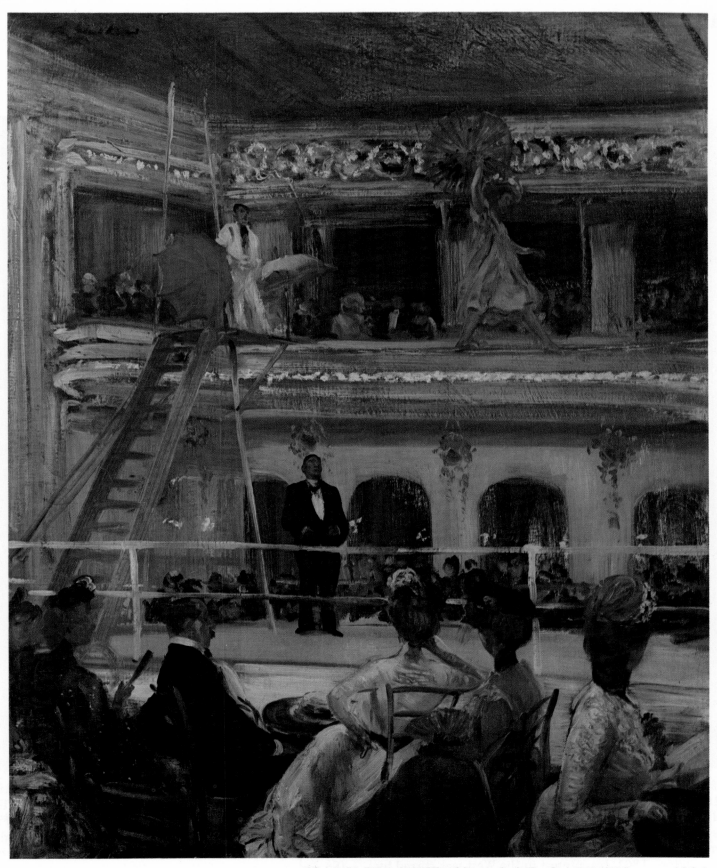

HAMMERSTEIN'S ROOF GARDEN, *ca. 1901,*
William Glackens (1870-1938). 30 x 25 in., oil.
Collection Whitney Museum of American Art, New York.

JOHN FREDERICK PETO

LIGHTS OF OTHER DAYS, *1906,*
John Frederick Peto (1854-1907). 30½ x 45¼ in., oil.
Courtesy, The Art Institute of Chicago,
Goodman Fund Collection.

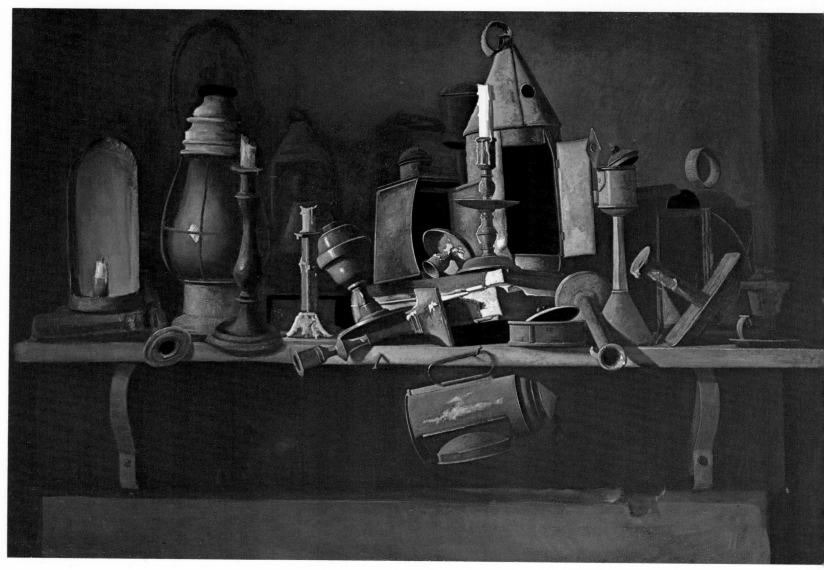

Many an artist's work has become lost in the fame of another. It has taken scholars years to unravel the identity of many paintings. The results have sometimes been rewarding in that they have revealed comparable talent buried under another's fame. Every master has had some pupil who became so embued with his genius that he could not release his own true self. That, unfortunately, is where unscrupulous people take advantage of the situation, and the signature of the pupil disappears under that of the master's. This sometimes results in tragedy for the artist and confusion for the collector or critic.

Many of the finest works "by" William Michael Harnett (p. 158) were done by John Frederick Peto. Art critic and historian Alfred Frankenstein wrote a brilliant investigatory book, called *After the Hunt*, of the Peto mystery for an exhibition of his work and concluded by saying, "If the Harnett canon has been somewhat impoverished by the removal of the Peto forgeries, American art as a whole has been greatly enriched by the addition of a new and exceedingly interesting master." "Forgeries" does not imply that Peto signed Harnett's name to his canvases, but rather that

his isolation from the art world in the little town of Island Heights, New Jersey, and the paucity of information on his artistic or private life made it easy for dealers to deceive the many eager collectors of Harnett's work in Philadelphia and elsewhere. Besides, Peto continually deferred to his friend Harnett's preeminence in the art of still-life painting. The influence the two men had on one another was one of admiration if not actually teacher and pupil.

Frankenstein's account reads like a detective novel, and indeed discovering the life and work of this obscured man almost required fingerprint experts. Peto had many odd habits for identifying his pictures, such as writing his many addresses on the back, and he took much of Harnett's iconography and made it his own. The card rack, the mug, pipe, and newspaper, the ink bottle, quill, letter and roll of bills, the stack of books all were common subjects for both men and, according to art catalogues of the period, to other artists too. This kind of homely still life was popular, and Harnett reaped fame and fortune from it while Peto eked out a meager existence selling to saloons, offices and scattered expositions.

Old Reminiscences, *1900,*
John Frederick Peto. 30 x 25 in., oil.
The Phillips Collection, Washington, D. C.

Adding to the confusion, the two men often used the same titles. *Lights of Other Days*, as far as I can ascertain, was Peto's title alone and, being one of the major clues to identification of his other work, we should note Lloyd Goodrich on Peto's peculiarities: "The placement of the objects in space is likely to be somewhat ambiguous . . . you always know where a thing is when Harnett paints it . . . it relates to other things." *Lights of Other Days* is a fascinating conglomerate, and I find it more exciting than some of the meticulously composed Harnetts. Both men loved "banal" subjects, but we know from Harnett that he was careful in his later years to choose more elegant antiques, while it appears Peto threw things together as they

might have been by anyone other than an artist. It is this quality of "the found object," the worn out, used up, dog-eared items that appeals to us today, devoted as we are to those artists who create something, if not beautiful, then intriguing from the dumpheaps of our civilization. Peto has taken objects — rusty, disjointed and bent — that we have used to light our way out of the darkness and, by shedding his own light on them, made a magical work of art. Critics have tried to find deep psychological reasons for the objects in the works of Peto as they have in Harnett's, but I concur with Frankenstein when he defines the appeal as "the fantasticality of the commonplace and the pathos of the discarded."

ROBERT HENRI

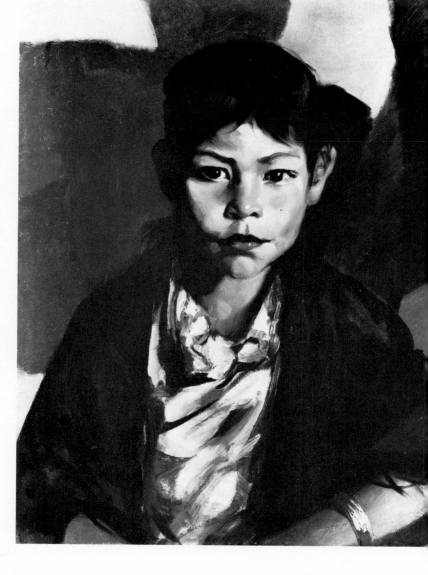

Pepita of Santa Fe, *1918,*
Robert Henri. 24 x 20 in., oil.
Los Angeles County Museum of Art,
Harrison Collection.

It has long plagued artists that many fine talents have had to teach to make a living. Only a few have succeeded in maintaining their creative output at a high level while passing on their knowledge to others. Robert Henri was such a man. He was a forceful teacher who brought, from his own student explorations and his experience of life, much of what became the first wave of twentieth-century painting in America.

His first teacher, Thomas Anshutz (1851-1912), had inherited from his teacher, the great Thomas Eakins (pp. 144-151), the headship of the Pennsylvania Academy of Fine Arts, so that Henri felt, once removed, the power of Eakins's patient realism and passed it on to the hundreds of students he taught himself. But it was while studying in Paris that he awakened to the new movements in art. He learned more from the psychological profundity of Rembrandt's portraits, the spontaneousness of Frans Hals's (1580-1666) technique and the social implications of Francisco de Goya's (1746-1828) art than from the tight, inhibiting technique and sensuous softness of his academic teachers at the École des Beaux-Arts. In those Dutch and Spanish masters, Henri found the inspiration that made him closer in his approach to painting to the more recent generation of Édouard Manet (1832-1883) and Gustave Courbet (1819-1877) and shaped his own art on his return to America, where he sought and found, as he said, "deep roots, stretching far down into the soil of the nation, gathering sustenance from the conditions in the soil of the nation and in its growth."

In his native land and his fellow Americans, Henri found much to comment on and made his own major contribu-

tion in a series of portraits he called "my people." Bypassing the rich society supporters of the arts, Henri showed the faces and feelings of Americans of all national origins.

Dutch Soldier is a brilliant example of his concern for plain people. Farmers, gypsies, American Indians, Mexican-Americans, show people and street people, soldiers and clowns all intrigued him and formed a gallery of portraits filled with human insight. Henri was one of the first American artists to become involved in the common scene.

He inspired his many students with his own curiosity about life, guiding them not by forcing his technique upon them, but by teaching them to see for themselves the world and its people in relation to world art.

With his students John Sloan (p. 194), George Luks (p. 222), William Glackens (p. 186), and Everett Shinn (p. 198), a group augmented by Maurice Prendergast (p. 176), Arthur B. Davies (p. 212), and Ernest Lawson (p. 184), Henri formed The Eight, or, as they were facetiously nicknamed, the Ashcan School, which defied the procedures of recognition administered by the National Academy and revealed a whole new world of painting subjects on the sidewalks of New York. While suffering some of the derision normally heaped upon those who oppose any establishment, this group eventually became accepted as one of the most vigorous forces in our national art. This vigor stemmed in a great degree from Henri's own and came to its fullest bloom in the work of his star pupil and friend, George Bellows (p. 208).

192

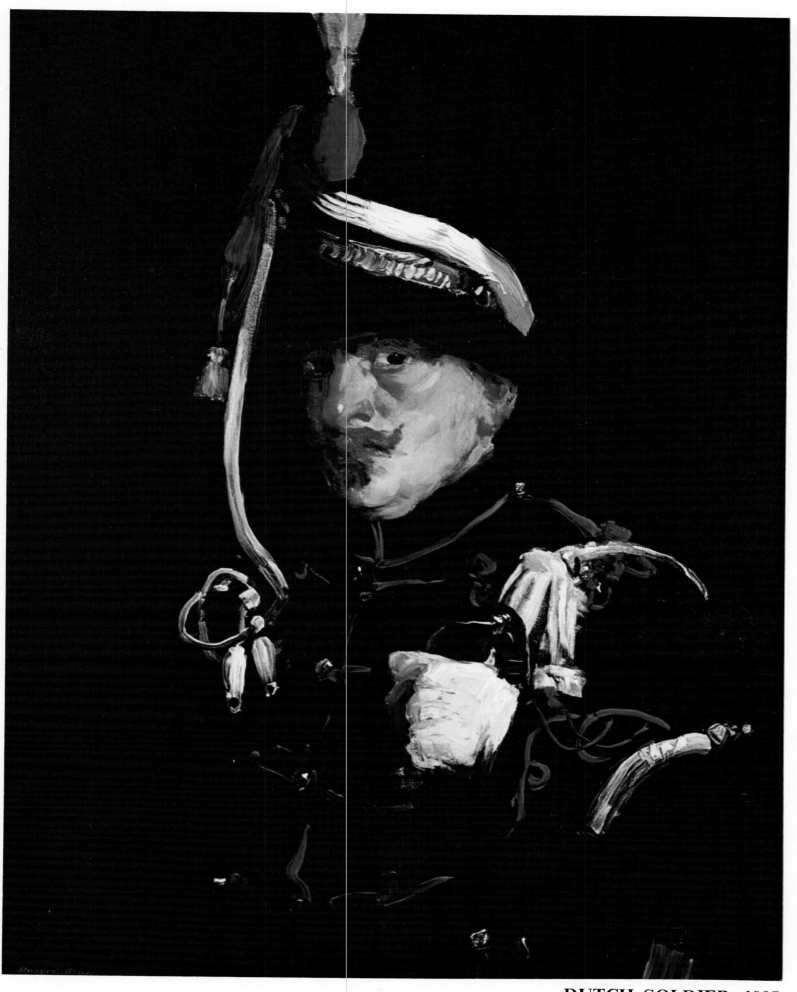

DUTCH SOLDIER, *1907,*
Robert Henri (1865-1929). 32⅝ x 26⅛ in., oil.
Collection of Munson-Williams-Proctor Institute, Utica, New York.

JOHN SLOAN

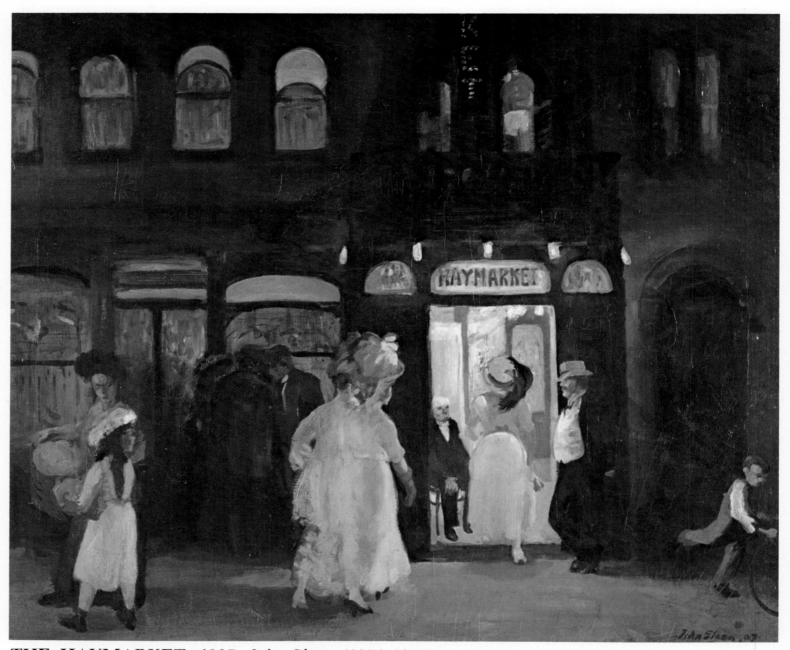

THE HAYMARKET, *1907, John Sloan (1871-1951).*
26 x 31⅞ in. oil. Courtesy of the Brooklyn Museum,
gift of Mrs. Harry Payne Whitney.

"The importance of life is the primary motive of art" was the key that Robert Henri gave to his pupils and artist friends. For most of them it opened their lives onto the broad vistas which were to free American art from the academic prison which threatened to stultify it altogether. Before the turn of the past century, few artists had looked to the American urban scene for inspiration or subject matter. For even New York, the American dream city, was an untapped well of visual wealth. When at last its charms, and sinister aspects as well, were discovered by our painters, one of the most exciting periods of American art began. No one made a greater contribution to this than John Sloan, the most influential and exuberant of the group of early twentieth-century artists called The Eight or the Ashcan School.

Sloan became a painter rather late in life, in his forties, but once he did he gave us some of the most joyous pictures of our city life we may ever see. Joyous is the word for Sloan's art, for even when he makes some of his more profound social comments, his paintings are always filled more with life's happiness than sorrow. His long years as a newspaper illustrator-reporter had given him an intimate familiarity with a broad range of urban experiences that helped him immensely when he finally turned to painting. Other positive results of his newspaper days included the contacts and friendships he made which lasted his lifetime and enriched it beyond measure.

We are more aware of the coteries of artists that produced the rich periods of European art than we are of our own, but certainly the group of widely accomplished men and women that formed around Sloan was one of the most fortuitous and productive in the history of art in any country. Not only was Sloan one of The Eight with William Glackens (p. 186), George Luks (p. 222), Everett Shinn (p. 198), Robert Henri (p. 192), Maurice Prendergast (p. 176), Ernest Lawson (p. 184) and Arthur B. Davies (p. 212), but The Eight shared an enthusiasm for life with men of letters, the theater and the sports world. They missed nothing of the excitement that was the vital force in our country's growth at the turn of the century.

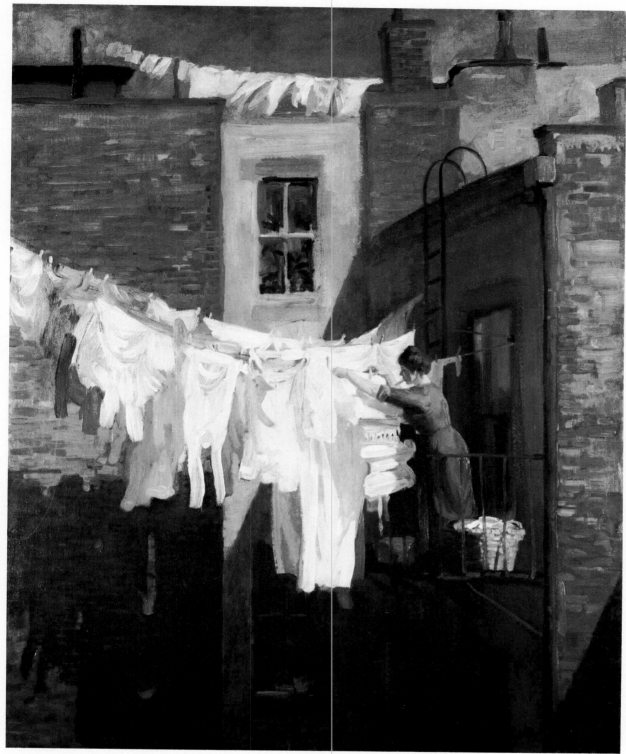

Woman's Work, *ca. 1911,*
John Sloan. 31-5/8 x 25-3/4 in., oil.
The Cleveland Museum of Art,
gift of Amelia Elizabeth White.

The dominant quality in Sloan's work is "wit," a quality he claimed to have inherited from his Scotch-Irish mother. In almost every painting or etching there is an underlying good humor. *The Haymarket* is a slice-of-life painting typical of him. His love of the common side of life is evident in the flossy elegance of the ladies, aware that the front-door guardian is ogling them, and in the washer-woman and her dressy little girl looking enviously at the "ladies." In his fine autobiography, *Gist of Art,* he describes the scene, "This old dance hall on Sixth Avenue, famous through infamy, was a well-known hangout for the underworld. Ladies whose dress and deportment were satisfactory to the doorman were admitted free. Gents paid."

Sloan is a realist reporter of the life he lived and loved. His technique was based on schooling with Thomas Anshutz (1851-1912), who was Thomas Eakins's (pp.

144-151) number one pupil. From Henri he derived all the benefits that great teacher garnered from his admiration of Francisco de Goya (1746-1828), Velásquez (1599-1660) and Édouard Manet (1832-1883). His training in the newspaper field and his affinity to illustrators like his English contemporary Walter Crane gave him a decorative quality that is evident in all his paintings.

At the end of his career he moved west to Santa Fe and found a new subject matter, the countryside and the small town, and a new style. Almost ugly, the figures of this period are strongly expressionistic with harsh drawing and color crosshatching. Whether or not we like them as well as his happier, earlier work, we must admire this man who was not afraid to change and whose whole life effort was dedicated to art and whose various modes of living, in New York and Santa Fe, are so brilliantly reflected in it.

FREDERIC REMINGTON

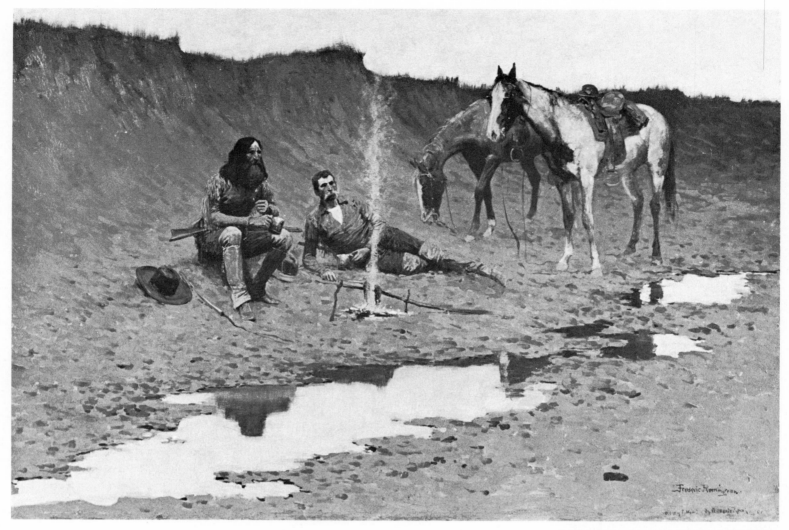

A New year on the Cimarron, 1903,
Frederic Remington. 27 x 40 in., oil.
Museum of Fine Arts, Houston, The Hogg Brothers Collection.

At the height of his career, Frederic Remington had won the acclaim of three of the most knowledgeable spokesmen of the American West. "As long as there are such pictures and books as his, Americans will remember the heritage of the dim frontier," said the popular Western author Zane Grey. Teddy Roosevelt was no less admiring: "He is, of course, one of the most typical artists we ever had. . .the soldier, the cowboy and rancher, the Indian, the horse and the cattle of the plains, will live in his pictures and bronzes. . .for all times." Owen Wister, author of the Western classic, *The Virginian*, topped them both when he declared, "Remington is not merely an artist, he is a national treasure."

Although Remington lived only for forty-eight years, he achieved great success and created over 2,700 drawings and paintings in addition to twenty-four sculptures. He was not a Westerner and, except for two years when he owned a sheep ranch in Kansas, he never settled in the West on a permanent basis. Remington attended Yale for two years, where he was a considerable athlete, and attended art classes, but the lure of the West came to him early while reading the papers of George Catlin and the works of historian Francis Parkman. Trips to Montana, Kansas, Oklahoma, Arizona and New Mexico in the 1880's gave him the impetus he needed to dedicate the rest of his life to recording the vanishing history of the Old West. He brought to New York many crude but powerful drawings

from these wanderings and did others from memory. Success did not come easily, but he was persistent, and when he sold some sketches to *Harper's Weekly*, and Teddy Roosevelt selected Remington to illustrate his great book, *Ranch Life and The Hunting Trail*, his reputation began to grow.

Remington made many more trips to the West but about 1892 he established a studio in New Rochelle, New York. He made pen and ink sketches while traveling, then executed the more exacting watercolors and oil paintings in his Eastern studio. Until 1900 most of these were in black and white monochrome because they were intended to be copied or reproduced, although he sometimes added color. Not until the turn of the century did Remington aspire to heights beyond that of an illustrator, and his detailed realism gradually changed into a form of colorful semi-Impressionism, probably somewhat under the influence of his friend, Childe Hassam (p. 202).

He was a convivial man who had the knack of getting to know all the kinds of people he wanted to tell about in his art. He was an accomplished writer, but at the peak of his success, interviewers were hard put to get his story, for he preferred to let his work speak for him.

What strikes us today is Remington's sense of drama of the times and the people he took for his subject matter. *Stampeded by Lightning* is one of my favorite works by Remington. Everything about it expresses his personal vi-

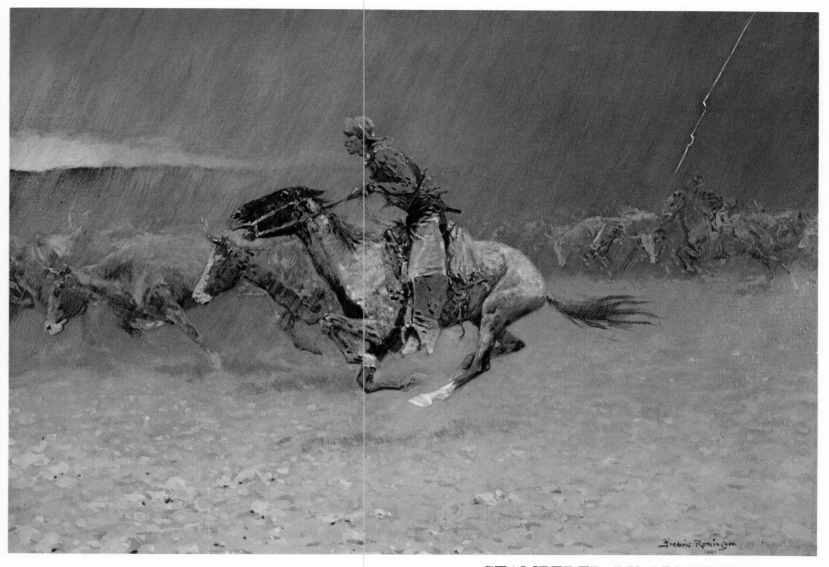

STAMPEDED BY LIGHTNING, *1908,*
Frederic Remington (1861-1909). 27 x 40 in., oil.
Gilcrease Institute of American History and Art, Tulsa.

sion of the Old West: the incredible action, the monochromatic color, the cowboy who is not only heading off a stampede but running for his life. The Texas longhorn cattle have been spooked by a sudden, violent lightning thunderstorm. Nothing haunted the cowboy's heart with more urgent fear, for, should anything happen to his horse during the stampede, he was a goner.

This is Remington at his best, although it is hard to find a dull painting by him; even the most placid subjects spring to life in his hands. The bronze sculptures, illustrations and sketches, as well as the paintings, seem to represent the moment before action, and you feel the drama rising in your throat as you look at them. He is a magnificent storyteller and we owe him a great debt, for the tales are about a long ago that thrills us still, when men and women had to be self-reliant. They take the Old West out of the realm of the cliché and make it fresh, for Remington restricts his scenario to action and suspense, and to see his paintings and bronzes and sketches at the Gilcrease Institute in Tulsa, the Amon Carter Museum in Forth Worth, the Remington Art Memorial in Ogdensburg, New York, or the Buffalo Bill Museum in Cody, Wyoming, offers more excitement than any Western movie. Remington's paintings are as American as the buffalo and as glamorous as an Indian war bonnet.

EVERETT SHINN

The dreadful glut of ineptly painted and sentimentally conceived clown pictures in today's art supermarket belies the profound and exciting introduction of this genre of painting, not too many years ago, by several very fine artists. Two of these we have included here: Walt Kuhn (p. 248) and Everett Shinn. They found in the theater, circus and the night club, not banality, but the wonderful world of those very human people whose lives are not their pleasure alone but the pleasure of others. If beneath the makeup they found poignancy, it was no less a discovery than that of their fellow artists like John Sloan (p. 194), George Luks (p. 222) and George Bellows (p. 208), who saw in the workingman the essential loneliness of modern life. Kuhn and Shinn did not overlook the glamor and glitter, but neither did they miss the art beneath the artificiality.

Kuhn's great clowns and acrobats pay monumental homage to one profession all people secretly long to be a part of. Kuhn with his flat, frontal approach to the figure gave us a look at the performer's essential dignity.

Shinn, on the other hand, gives us a more ephemeral picture of the entertainer caught in action with his real self showing through the make-believe. Both pictorial approaches to those whose profession it is to please comprise, of course, only a part of the whole. Neither defines the entire personality, but they are more than the empty mask presented by today's clown painters pandering to the worst taste.

Shinn was one of The Eight and like many of them started as an illustrator. Whereas some of the others, in their concern for "real life," borrowed techniques established by Robert Henri (p. 192), Shinn seems to have always had a lighter touch, more French than Spanish or Dutch. It is the great Frenchman, Edgar Degas (1834-1917), to whom he seems closest. But Shinn's drawing, when compared to that master draftsman's, almost falls to pieces. What holds him together as an artist and sells his work to us is this very lack of profundity. There is a gaiety about all his theater pictures in particular that captures the here-today-gone-tomorrow aspect of show business. He shares this quality with Henri Toulouse-Lautrec (1864-1901). In *Dancer in White* Shinn uses Degas's device of the orchestra and audience in the foreground and the abstracted scenery of the background to spotlight the dancer. There is a painful little look I detect

Fifth Avenue and 34th Street, 1905,
Everett Shinn. 20 x 30 in., pastel.
Courtesy, M. Knoedler & Co., Inc., New York.

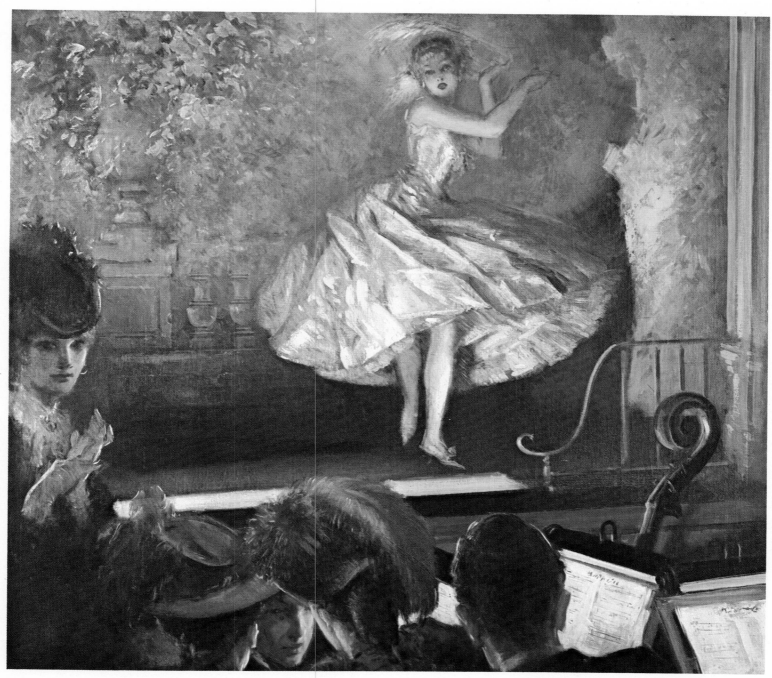

DANCER IN WHITE, *1910,*
Everett Shinn (1876-1953). 35 x 39 in., oil.
Butler Institute of American Art, Youngstown, Ohio.

in her eyes, and why not? The rude lady on the left is not watching her performance. This picture has the reality of a scene in an unreal world.

Perhaps Shinn's talent can best be defined as decorative. Some of his loveliest pictures were done for the Plaza Hotel facing New York's Central Park. In the bar are several large canvases of the same scenes you see out the window. They are dark and drenched with the mystery of the big city. He had a knack for catching the paintable qualities of many places and he had the talent to communicate his affection for them in just the right way.

As a man he was happily gregarious. He tried his hand at arts other than illustration, decoration and easel painting. He wrote many plays, and some were quite successful. He loved to act, and it is that quality of the performer you feel in his work. He wants to get his act across.

NEWELL CONVERS WYETH

We have discussed several families in American art, the Hesseliuses and the incredible Peales, and now we come to one of the most talented of the group, the Wyeths. A third generation has already begun, and from the quality of work of the latest I would say we may expect several more.

The patriarch of the family was Newell Convers Wyeth, known to every youth of my generation, at least, as N. C. Wyeth, illustrator of books by Jules Verne, Robert Louis Stevenson and others. The Wyeth family has a long American background, for N. C. Wyeth's paternal ancestors were old Massachusetts stock. However, his mother was first-generation American, of Swiss background, and the artists in the family were her relatives. Wyeth credited them with his passion for art from childhood. He started drawing animals, horses in particular, and the animation with which he learned to endow these creatures carried over into his human figures. His imagination, too, was hard at work and his head was filled with illustrations of the period by Frederic Remington (p. 196), George Catlin (pp. 74-77) and all those others that children loved then and still do. It was Wyeth's picture of a cowboy that attracted the attention of the Curtis Publishing Company, and soon he had a *Saturday Evening Post* cover to his credit.

At this time his greatest mentor stepped in and put the brakes on the ebullient N. C. Wyeth. This was Howard Pyle (1852-1911), one of the greatest illustrators America has ever produced, fondly remembered for his spirited illustrations for such children's books like *The Merry Adventures of Robin Hood* and *The Story of King Arthur and His Knights*. Because of his early interest in Wyeth and as his first real teacher, Pyle convinced the young man to give up his momentary success in order to study art. Wyeth, somewhat dampened in spirit, agreed. He soon was a member of Pyle's school of art and his success was not curtailed for long. Yet the cowboys and Indians were still playing in his head, and he realized he had to see these imaginary creatures so, again at Pyle's insistence, he went to see them firsthand.

Wyeth left for a Colorado ranch and, because he was an excellent horseman, he joined in the active life of the West with joy. The experience was, of course, fully digested, and immediately drawings and paintings were finding their way back into Eastern magazines. *Scribner's Magazine* published an illustrated article about sheepherding, and his reputation was made. Soon he was on his way to his ultimate goal of becoming America's favorite illustrator.

In 1911 Scribner's published *Treasure Island* with Wyeth's illustrations, and there followed a long string of bestselling illustrated classics. Wyeth was happily married with a growing family, all of whom were pressed into service to dress up and pose for the characters in his exciting story pictures. The paintings from which the color illustrations were taken became richer and more beautiful with each book. Although he may have regretted being primarily known as an illustrator, he carefully studied those who had become masters in this art. He believed quite rightly that the narrative element in painting had a long and distinguished history: Honoré Daumier (1808-1879), Albrecht Dürer (1471-1528), Eugène Delacroix (1798-1863), William Blake (1757-1827) all told a story in their work, but few told it better than N. C. Wyeth. Along with Pyle

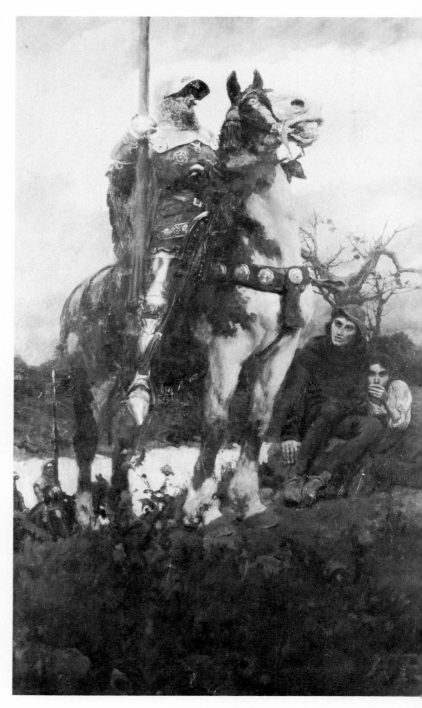

The Coming of Lancaster, *1908,*
Howard Pyle (1853-1911). 35-½ x 23-¼ in., oil.
Courtesy, the Delaware Art Museum, Wilmington.
Pyle was the beloved teacher of the widely
popular school of illustration centered in the
Brandywine area of Pennsylvania at the turn
of the last century.

and Remington, he was among the outstanding artists in historic illustration during its golden age. To him, art was life work, and the artist did what was at hand. As Giotto (ca. 1276-1337) illustrated church walls, Wyeth illustrated books or did murals for banks or public buildings. He was convinced that artists should be judged for their talent and not critically departmentalized by what branch of their profession they succeeded in.

One More Step, Mr. Hands from *Treasure Island* gives a wonderful insight into his conviction. It is an illustration, but it is also a painting of great artistry — draftsmanship, color, composition — and it tells its story in no uncertain terms. No one can ask more of the illustrator-artist.

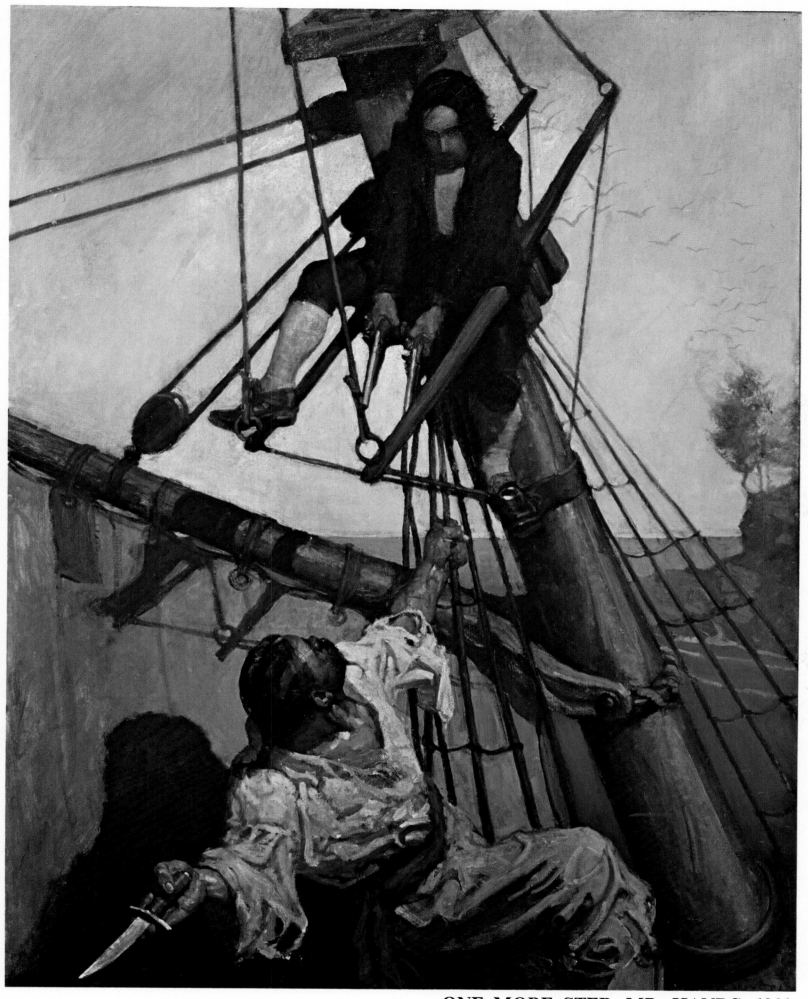

ONE MORE STEP, MR. HANDS, *1911,*
Newell Convers Wyeth (1882-1945). 47 x 38 in., oil.
New Britain Museum of American Art, Connecticut,
Harriet Russell Stanley Fund.

201

CHILDE HASSAM

American taste in the arts is fickle. One sure way to follow it is in the marketplace, the auction rooms and galleries. This is not to speak simply as a collector who bemoans not having taken advantage of the art market and picked up an out-of-fashion master when he was down in price. The important point about American artists in particular is that we tend to barter their reputation on the scale of commerce and fashion.

Childe Hassam is a case in point. He was one of our first true Impressionists. He arrived in Paris in 1886 and, under the influence of the great French artists of his period, he produced his first major Impressionist work a year later. He adopted Claude Monet's (1840-1926) method of laying paint on the canvas in adjoining strokes of pure color so that the mix of color to some extent took place in the eye of the beholder rather than on the canvas. But he was essentially a painter of the American scene in the spirit of French Impressionism, rather than an expatriate copyist. His reputation was well established early in his career both here and in Europe, but in spite of his obvious mastery of

the Impressionist technique, he felt, even in his lifetime, the onus of being American. Pierre Auguste Renoir (1841-1919), Camille Pissarro (1830-1903), even Alfred Sisley (1839-1899), an Englishman living in France, became the rage of American collectors, while our Impressionists ran a poor second with museums as well as collectors. Even today, men like Hassam have had to suffer from our affectation that anything from Europe must be better.

Hassam is a first-rate master by any country's aesthetic standards. Perhaps his work does not have the welcome lightness of heart that Renoir's has, but there is something solidly honest about his pictures that even the best Frenchman rarely achieves. Hassam was from Puritan stock and he had a Puritan point of view, but this does not in any way diminish the brilliance of his achievement as an artist. Americans must come to see this about their painters: The very fact of their Americanism, their ability to retain it and perfect it in the face of public European preference, has made our art unique and as valid a statement about our way of life as any nation has produced.

Boston Common at Twilight, *1885-86,*
Childe Hassam. 42 x 60 in., oil.
Courtesy, Museum of Fine Arts, Boston.

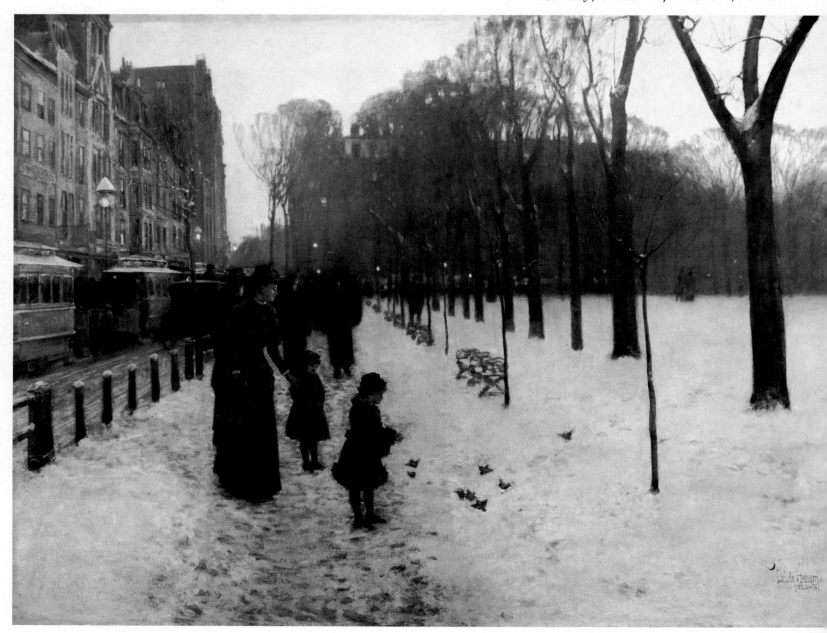

202

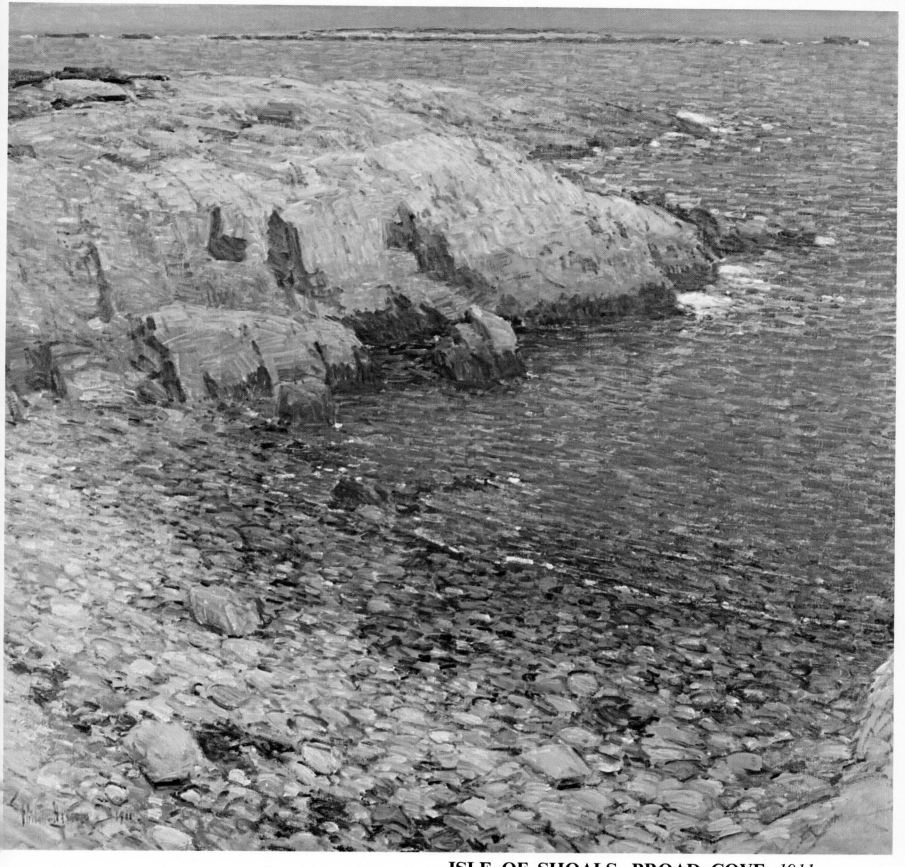

ISLE OF SHOALS, BROAD COVE, *1911,*
Childe Hassam (1859-1935). 36 x 34½ in., oil.
Honolulu Academy of Arts, gift of Mrs. Robert P. Griffing, Jr.
and Miss Renee Halbedl.

It is not in Hassam's case a matter of neglect, for he has always had his admirers and he never fell into complete neglect, but the day would be welcome when a top quality Hassam would fetch the price of a Monet. As long as money proclaims an artist's fame as it does today (and always has), let us put value where it is due. Childe Hassam is our major Impressionist, and that school is not an exclusively foreign product. Hassam was every brushstroke an American painter, the high point in our land of an international way of seeing.

Boston Common and *Isle of Shoals, Broad Cove* are contrasting pictures, technically and in mood, thus illus-

trating perfectly the transition Hassam made so completely from a very literal style into Impressionism. The Impressionists literally opened the skies for him to let the sunlight in, and he flooded his mature work with a luminosity never seen in this country before. But, although the technique of *plein-air* painting (painting in the open air with the subject in front of the artist) was French, the vision is native to him. Hassam saw through new eyes, perhaps, but he saw in his own way and introduced American Impressionism to the world.

THOMAS MORAN

Thomas Moran made his living doing what is universally considered impossible — expressing a reaction that is beyond expression. Imagine seeing the Grand Canyon or the Yellowstone for the first time — with no post cards to prepare you, with no preconceptions — virgin, utterly without warning, astonishing. One's reaction would be staggering, inarticulate wonder. If you were a sensitive immigrant from England, a painter whose chief occupation, up to that point, had been painting scenes from the literary works of wonderlust romantics like Shelley, the experience of America's heroic magnitude would have made an indelible impression. So it was with Thomas Moran, one of the first painters to trek into America's unimaginable wilderness — the fantasy world that would become our national parks.

In 1871, at age thirty-four, Moran accompanied the expedition of the American geologist, Ferdinand Vanderveer Hayden, into the country of the Yellowstone. Hayden's was one of the first scientific explorations of that region that has now become a national shrine. Two years later, Moran was the official artist on one of Major John Wesley Powell's legendary adventures up the Grand Canyon. Moran was never the same after these encounters with the magnificent. He spent the remainder of his eighty-nine years making sure the American public would know of its natural treasures, and he succeeded. Largely because of his early paintings of Yellowstone country, President Grant, in March 1872, signed a bill that made the Yellowstone area a national park, the first such park in the world. Moran conveyed to Americans, few of whom had seen or even heard of our natural wonders, this nation's gigantic geographic proportions. America was big enough and bold enough to domesticate the Grand Canyon and proud enough, too, to pay it homage as a metaphor for our national greatness. Moran painted the landscapes of no less than eight of our national parks and monuments — Yellowstone, Yosemite, Zion, the Grand Canyon, the Grand Tetons (where Mount Moran is named after him), the Mount of the Holy Cross (near Denver), Devils Tower and the Petrified Forest. In Major Powell's words, "His pictures not only told the truth . . . they displayed the beauty of the truth."

Other artists had confronted the majesty of America's Western landscape; all despaired of expressing their wonderment. Frederic Remington (p.196), a great admirer of Moran, commented on a painting depicting the Golden Gate Pass of the Grand Canyon, "[It is] one of those marvelous vistas of mountain scenery utterly beyond the pen or brush of man. Paint cannot touch it, and words are wasted. . . . Mr. Moran made a famous stagger at this pass in his painting; and great as is the painting, when I contemplate the pass itself I marvel at the courage of the man who dared the deed."

Moran was the painter of awesomeness, the artist of the ineffable. Naturally, some critics would accuse him of lapsing into romantic idealization and, of all things, of topographical inaccuracies. But the Yellowstone, Yosemite and the Grand Canyon are in themselves idealizations, bigger than life and beautiful beyond imagination. Moran had the audacity to attempt to show, within the discipline of art, his unashamed exuberance. Perhaps, without his audacity, Americans would not have had these shrines of wonderment and awe preserved for them.

None of the many wonders he had seen so impressed Moran as the Grand Canyon. Throughout his life, from his

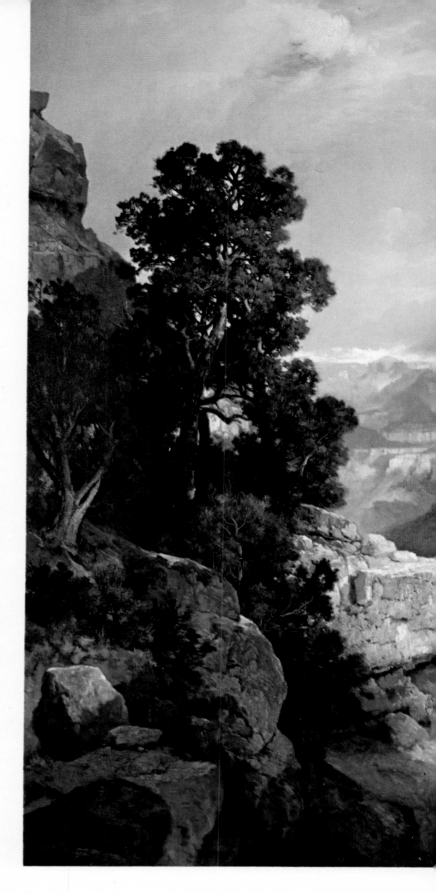

first contact with it, he painted it from every angle. The painting at the Gilcrease Institute of American History and Art in Tulsa is one of the best. One can hardly say he has seen Moran's work without a visit to the Gilcrease, for it contains hundreds of his sketches, drawings and paintings. One can see the many marvels he saw and also appreciate the brilliance of his technique. It is an experience second only to a visit to the Tate Gallery in London with its incredible collection of works by Moran's master, J.M.W. Turner (1775-1851). Moran is not as romantic as the Englishman, but then Turner might have had less to romanticize had he seen the unbelievable grandeur of the American West.

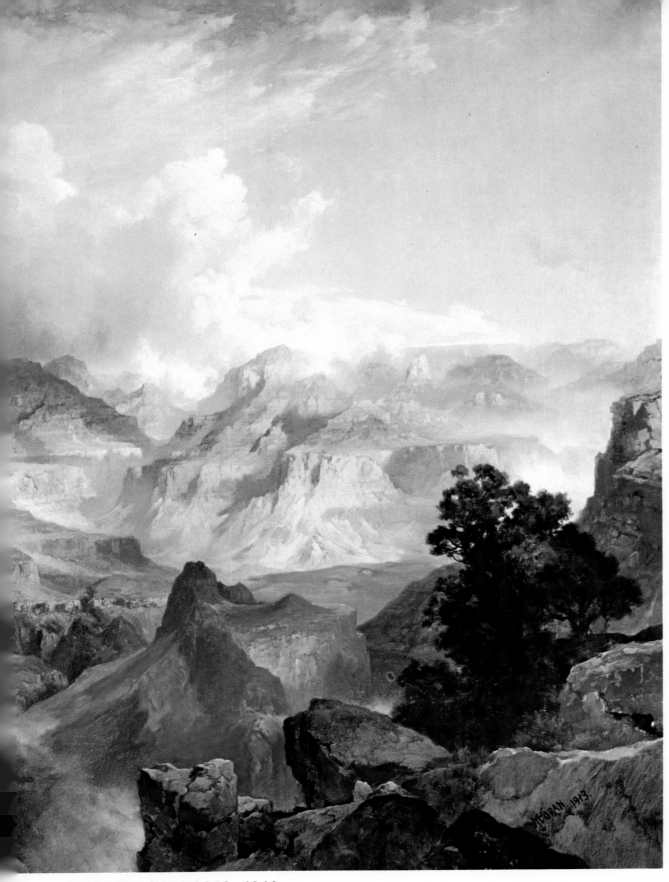

GRAND CANYON, *1913,*
Thomas Moran (1836-1926). 30 x 40 in., oil.
Gilcrease Institute of American History and Art, Tulsa.

JOSEPH STELLA

BATTLE OF LIGHT, CONEY ISLAND, *1913,*
Joseph Stella (1880-1946). 75¾ x 84 in., oil.
Yale University Art Gallery,
gift of Collection Société Anonyme.

Three American painters who have much in common and who have made special contributions to our art are Jackson Pollock (p. 268), Mark Tobey (p. 254) and Joseph Stella. In the work of each of these three, the spaciousness is obvious and the lack of restraint never means abandon as much as it connotes an exercise of the imagination in action. Stella's work shows both Pollock's freedom and Tobey's lyrical but controlled action with possibly more explosive violence than either, but he is never at a loss to control the explosion or harness the violence.

All three artists are expressions of the tumult and upheaval of the twentieth-century American city. Stella, painting a generation earlier than Pollock and Tobey and perhaps bringing to the theme his native Italian clarity and objectivity, saw the new lights of the new city as a revelation, as something to be exclaimed over, but also grasped intellectually and artistically.

Stella had originally come to America in his mid-twenties. After art studies and the successful beginnings of a career in illustration, he returned to his native land in time to see the beginnings of Italian Futurism, a variation of Cubism based upon multiple images. Filled with enthusiasm for this Italian development, Stella returned to New York and he exhibited at the Armory Show of 1913.

He began to absorb our vital culture and was especially attracted by "the drama of our great industries." It dawned upon him that the future the Futurists were envisioning in Italy was actually coming into existence in America and nowhere more extremely than in the gaudy wonderland that was Coney Island as electrical lighting came into general and spectacular use.

Our version of *Battle of Light, Coney Island* is literally an electrifying picture. Few paintings have ever boasted of such movement, of so much seen in action, and yet it gives off the same kind of peace one breathes in after giant fireworks have noisily ascended, exploded, then in silence showered the night with gaudy short-lived stars.

Stella next became absorbed in his famous series of the Brooklyn Bridge, then a marvel of modern engineering, which have a static kind of energy and which vindicated the wrath heaped upon him by critics and academicians for the bravery of his *Battle of Light.* Still he had powerful champions in 1914.

The effect Stella made on his sensitive, literate contemporaries was dramatically recorded in a 1914 issue of the highly respected *Century* magazine devoted to "This Transitional Age in Art." At a time when color printing processes were still relatively primitive and extremely expensive, *The Century*, reproducing works by Paul Cézanne (1839-1906) and Picasso in black and white, gave one picture alone the honor and substantial effort of full color reproduction: Stella's *Battle of Light, Coney Island,* with the following caption: "This painting, which in all probability is the last word in modernism, is a daring interpretation of the artist's impression of the dazzling light, the noise, the confusion, and ceaseless motion of Coney Island. It represents an attempt to express the brilliance and the dynamic energy of modern life so evident in America. . . . Had he merely represented the physical appearance of the American fiesta, he believes that he could not have given the rhythm of the scene, which transforms the chaos of the night, the lights, the strange buildings and the surging crowd into the order, the design and the color of art."

Although the appreciation of Stella's art grew slowly, nothing has been written since that so well expresses what Stella meant to modern American art than that contemporary comment.

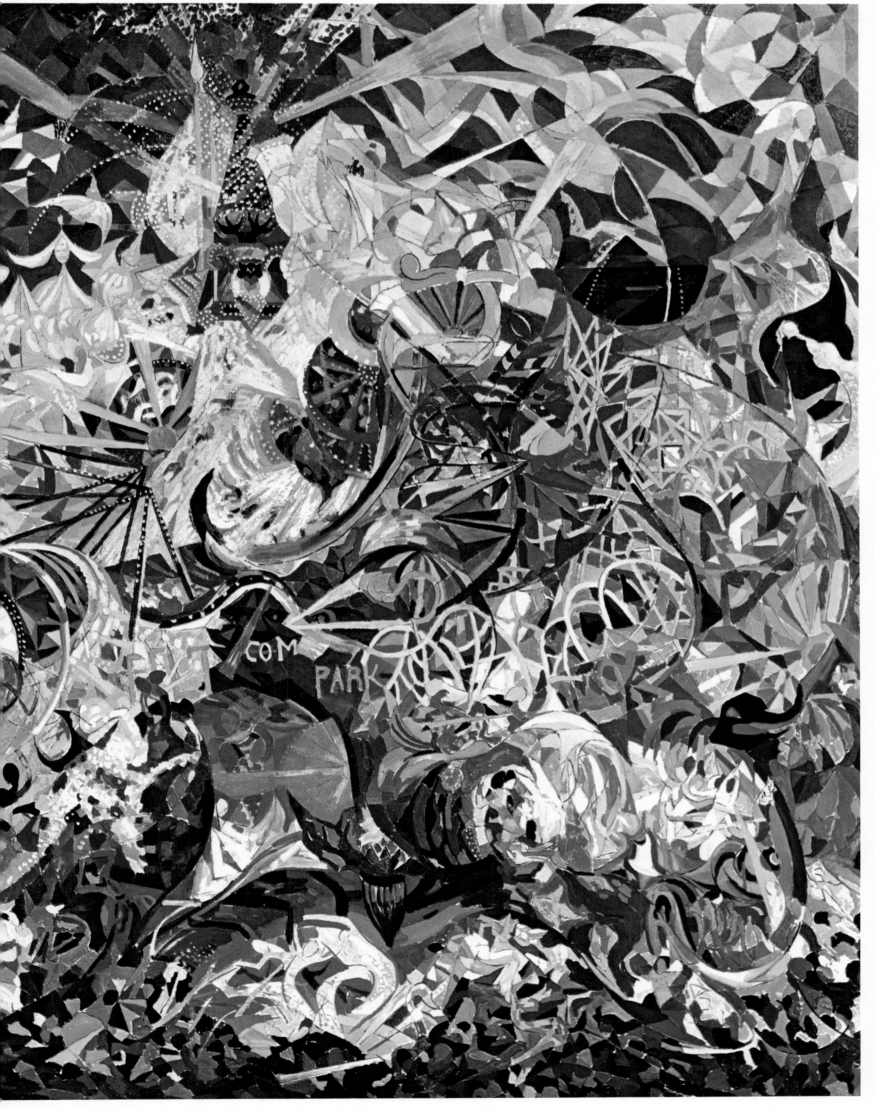

GEORGE BELLOWS

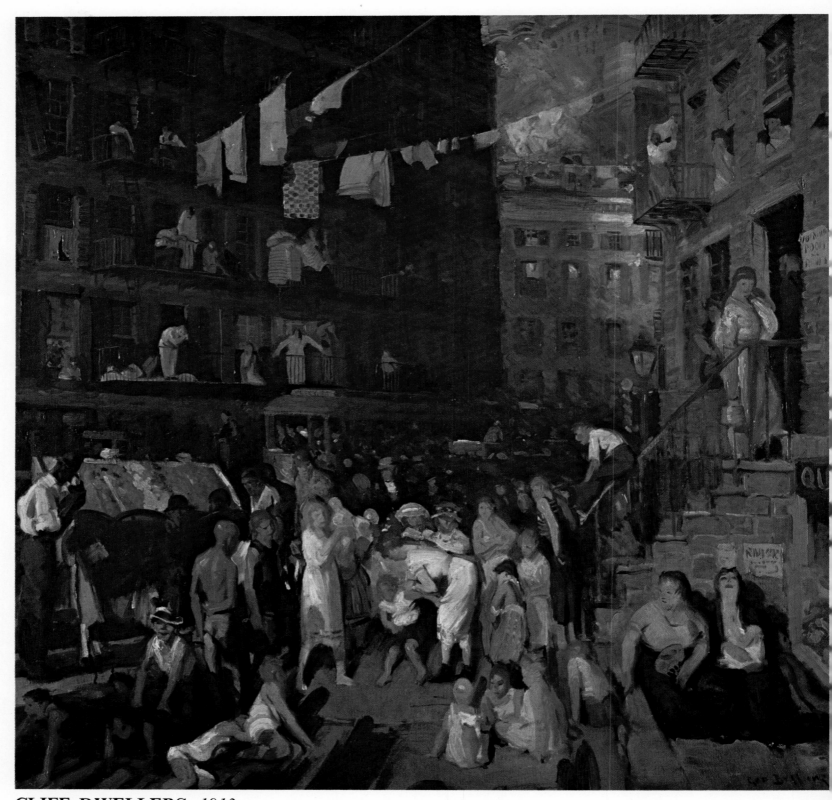

CLIFF DWELLERS, *1913,*
George Bellows (1882-1925). 39½ x 41½ in., oil.
Los Angeles County Museum of Art.

Looking at George Bellows's powerful sports paintings or his animated scenes of adults and children at play, one might think him a bit of an American caricature. Our national predilection for the outdoor life and sports in general has tended to allow the world to think we have little time for the arts. Sports and business are the world's definition of the United States. But here in one man, perhaps more than any other American painter, we have a joyous and gifted combination of art and the rewards of physical well-being. Bellows was an outstanding athlete in professional baseball and basketball, a follower of the physically

active life, as American as apple pie, but an artist of great sensitivity who seemed to command his brush or pencil with the same disciplined energy as he did his body.

He was well aware that his country was universally defined as uncultured and he struck out at those who criticized its emerging artists.

An unsent letter to one critic declares emphatically that, "What the world needs is art. . .art in social, economical relations, in religion, in government. We have a vast deal of science, of flying machines, singing, talking, moving, breathing, tasting, smelling, feeling machines but a great emptiness of imagination, a great barrenness of beauty."

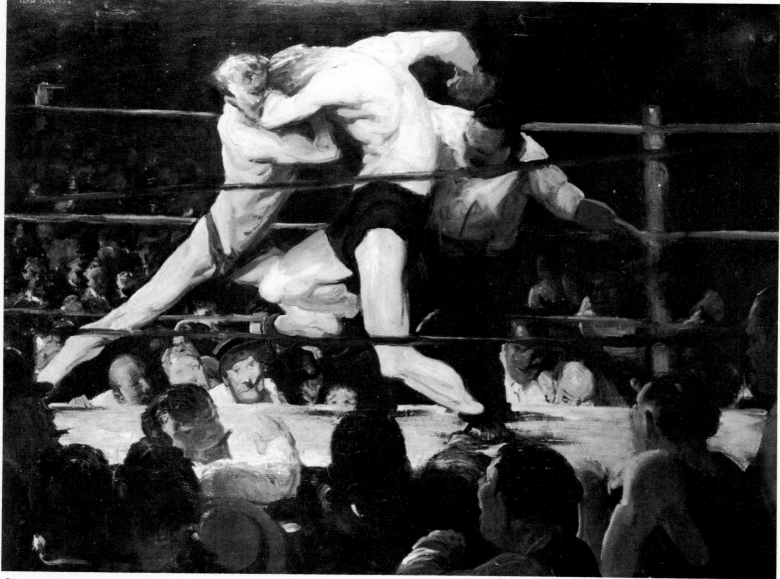

Stag at Sharkey's, 1909,
George Bellows. 36-¼ x 48-¼ in., oil.
The Cleveland Museum of Art, Hinman B. Hurlbut Collection.

Bellows felt that our artists were great and were making headway against our material mindedness. His work was a mighty force in awakening American eyes to the power of art to comment on American life. This belief was his inheritance from his teacher and life-long friend, Robert Henri (p. 192), whose insistence on the value of the American scene and people as art subject matter was a major contribution to an important aspect of modern American art. Bellows, who lacked the idiosyncracies of many artists, was well portrayed by another close friend, the painter, Eugene Speicher (1883-1962), in a tribute written after Bellows's untimely death at forty-three: "He was a robust, healthy American type with an amazing zest for life. He was uninhibited, clearheaded and forceful — a man without meanness."

Though we have come to accept the virility of Bellows's work as part of our life and art language, *Stag at Sharkey's* shocked art lovers when first exhibited in 1909, while making him something of a celebrity. By the very openness of his nature, his normalcy, he overcame all obstacles to its acceptance, and he stands today as one of the most revered of all American artists. Bellows belongs to the 1920's and 1930's, a period that saw the fulfillment of the promise of American art — with pungent realism ranging from the social commentary of Ben Shahn (p. 296) to Edward Hopper (pp. 218-221) and Regionalists such as Grant Wood (p. 228) and the beginning of abstraction. While he admired and defended his contemporary artists from all

lands, like Winslow Homer, Bellows remained deeply rooted in his own background.

The Cliff Dwellers, while not as personal a statement as the famous *Stag at Sharkey's*, is representative of Bellows. It ties him in with The Eight — especially with John Sloan (p. 194), who liked to portray the realities of city life. But he was not one of that group, for he went his own way equaling, if not surpassing, most of them. Bellows transcends his master, Robert Henri, especially in his brilliant series of portraits. Without resorting to Henri's shorthand techniques, Bellows still conveys technical flair, and there is a calm profoundity to his portraits of old people and children that gives them a more enduring charm and sense of reality. Henry McBride, the great critic of the early twentieth century, couples Bellows with Eakins. He said of one of Bellows's portraits, "It has the Eakins intensity and monumentality that springs. . .from the implacable Americanism characteristic of both men. . . ."

In *The Cliff Dwellers*, this "implacable Americanism" is prophetic of the plight of overpopulation. Where do our children play? In the pollution of our rivers, in the debris of our destitute cities? Though Bellows's joy in life is evident in the body action of the people who are unaware of their momentary joy, he is reporting a fact, and one that becomes alarming in the light of today's problems. Joy becomes more temporary than it is or should be, lost in his prophecy.

JOHN MARIN

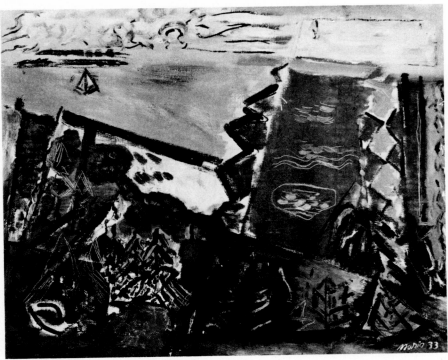

Composition--Cape Split, Maine, *1933,*
John Marin. 22 x 28 in., oil.
Santa Barbara Museum of Art,
Preston Morton Collection.

There probably lurks in the art layman's mind the suspicion that any visual artist who needs verbal volumes to explain his work must somehow have failed to make us see what he saw. Such a breed of art-explainers that came into being with modern art often lose their readers in obscurities that are even more baffling than the art they are attempting to explain. Furthermore, the modern artist himself has come to talk endlessly about his art in hyperboles until all of us who wish to understand modern art are lost in a forest of all trees but no vistas.

But there have been some uncommon artists who speak their verbal language as effectively as they paint their visual language. We speak of a painter's language because there is no other way to express it, unless perhaps we substitute the word, "vision." But speaking of the *language* of art is more understandable to those who would shy from the word *vision.* There are few visionaries who speak to us directly, intelligently. John Marin does and he left behind him virtually a dictionary for defining and clarifying the meanings of the art of our century.

Marin is one of the most important modern American artists. He was able to introduce several generations of Americans to the art of their time in a way few others could do because he spoke clearly, though still somewhat abstractly, in the uncomplicated manner of a man very close to nature. And it was nature that drew from him most poetic utterances of sunsets, sea, rocks and of the nature of man, of himself. Like most of us he had a dual nature but, unlike most of us, he admitted it. Both sides of him appeal to us, for he declares himself with such honesty that we recognize our own lack of it and admire his.

"I am part of a small, large world," Marin said. In that powerful, simple statement he defines his art and his life. He was tempted by the big world, saw what he wanted of it, Europe and America, but retired from it to a small one he could examine more intimately. In New Jersey, where he was born and lived all his life, and in Maine, where in the summers he went and lost his heart completely to its rugged beauty, he found enough to carry him productively into his eighties.

Marin's greatest success was in his mastery of the difficult medium of watercolor. He treats the white paper as a world he must populate and plant but never entirely obscure. It is the solidity of that colorless world, the white sheet, that gives even the rocks he plucks from it, or the trees he grows on it, or even the firmament he hangs above it an integrity which the least initiated viewer can understand. His masterful etchings have the same believability.

Marin was very much aware of this and never completely abandoned these techniques even when he painted in oil. If there was frustration in his long, happy life, it was the public's resistance to his oils. His fame still rests on the watercolors, but increasingly critics are helping to push aside the veils that keep us from complete enjoyment of the oils. The painter-critic Frederick Wight, summing up Marin's artistic life, wrote that it "rose in three waves, his etchings, his watercolors and his oils — and it is not certain that the third wave is not the greatest. . . .There is a fourth wave too, of communication, writing and speaking; the man who could see and paint could also tell and write. . . ."

A humble, salty and completely dedicated man, Marin wrote of his art, "I guess a picture is good when it don't irritate the eye. Poetry, imagination, intellect, temperament, oh, they come in on a later train." Sometimes, confronted with the wind churning up the waves and piling up storm clouds, Marin would stand before the scene and paint with both hands. He explained to a visitor, "It's like golf: the fewer strokes I can take, the better the picture."

This wonderful picture in watercolor, *Deer Isle — Marine Fantasy*, is a Marin fantasy in which he sees and paints and tells us the provocative truth of nature, that it is never static, that it is made up of, and makes up, the big-small world in which we live. Marin wrote, ". . .the elemental big forms — Sky, Sea, Mountain, Plain — have everything. But to express these, you have to love these, to be a part of these in sympathy. One doesn't get far without this love, this love to enfold too the relatively little things that grow on the mountain's back. Which if you don't recognize, you don't recognize the mountain."

All his writings and his paintings are intensely human, but there is, as well, always something godlike in his admonishment that his eye is on the sparrow.

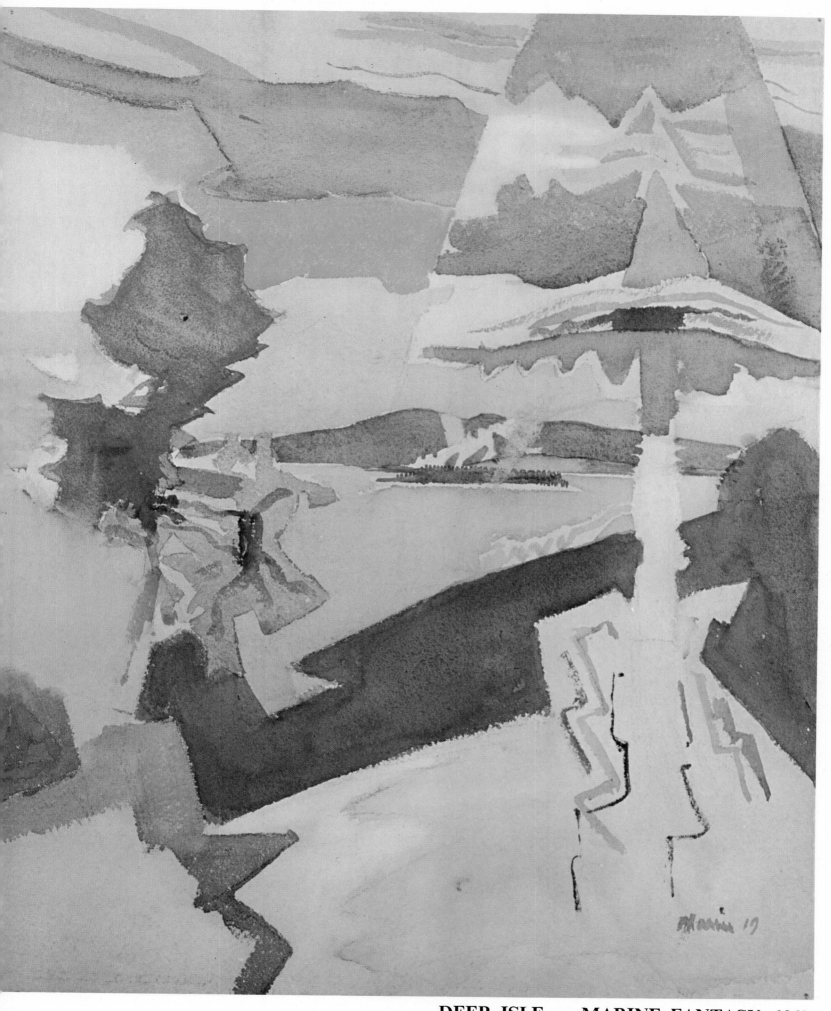

DEER ISLE — MARINE FANTASY, *1917,*
John Marin (1870-1953). 19¼ x 16 in., watercolor.
Honolulu Academy of Arts.

ARTHUR B. DAVIES

Sometimes what an artist recognizes in other artists is more important than what he does himself; but that can be responsible, too, for others outside the arts neglecting or overlooking his real talent and contribution. Arthur B. Davies is, more than any other American artist, responsible for the introduction of "Modern Art" as we know it into this country. With Walt Kuhn (p. 248), he put together the famous New York Armory Show in 1913 for which he gave up a year of his jealously guarded painter's life to travel to many countries and visit many artists, gathering their work for this all-important exhibition. That single show changed the artistic outlook of Americans more than any other event of our century. It was Davies, too, who selected eight American painters for a show at the Macbeth Gallery in New York. The eight were Robert Henri (p. 192), George Luks (p. 222), William Glackens (p. 186), Everett Shinn (p. 198), John Sloan (p. 194), Maurice Prendergast (p. 176), Ernest Lawson (p. 184) and Davies himself. While not of world importance, this was a show of great impact in this country and a landmark in our art.

Strangely enough, although Davies's own work was included in the Armory Show, he was outside what we might call the mainstream of the rest of it, for here were being shown for the first time in America such highly abstract artists as Georges Braque (1882-1963), Pablo Picasso, the Fauves and sculptors like Constantin Brancusi. One did not find in the hard intellectuality of these men the lyricism of Davies. Perhaps only in the murals of Puvis de Chavannes (1824-1898) or the dreamlike scenes of Odilon Redon (1840-1916) could we find such gentle mystery.

Mother of Dawn, *1909,*
Arthur B. Davies. 18 x 30 in., oil.
Arizona State University Art Collection, Tempe.

But Davies was always sympathetic to other artists' work although he borrowed little from any except perhaps the late fifteenth-century Italian pastoral masters like Giorgione and Piero di Cosimo. Still he is very much in the tradition of individualistic American painters such as Elihu Vedder (p. 116), Albert Pinkham Ryder (p. 166) and John LaFarge (p. 128). Royal Cortissoz, the distinguished critic, considered his "a contribution of pure genius, singular and enchanting . . . he brought something into the world that was personal, new-minted."

What he brought into our American world with the Armory Show came close to eclipsing his own place in our art. American taste for modern art has always divided itself between preference for the sweet beauty of Impressionism and the tough vitality of the more experimental Post-Impressionists, Cubists and Surrealists. Davies lies somewhere in the middle and therefore has gone through a period of neglect. He is now enjoying the benefits of a new look by critics and patrons who are finding in his ambrosial paintings another view of our immediate art past.

His background was very American. Born in upstate New York, he later studied at the Chicago Academy of Design and the Art Students League in New York. While he traveled in Europe and Mexico and, naturally, absorbed those cultures, his main influence and preferences were native to his land but especially to himself. There is some closeness in the design aspects of his canvases to the Art Nouveau movement and to the designer William C. Tiffany, but he is an original, and seeing a Davies painting imparts an immediate, personal identification with it.

Heliodora is a lovely example, classical and poetic. The figure Heliodora comes from Greek tragedy; the name was also given to his daughter's doll which was saved from a studio fire and inspired the artist to record the incident. Davies had planned to use it as a design for a tapestry, and it is evident that the simplicity of the patterning would have worked very well in that medium.

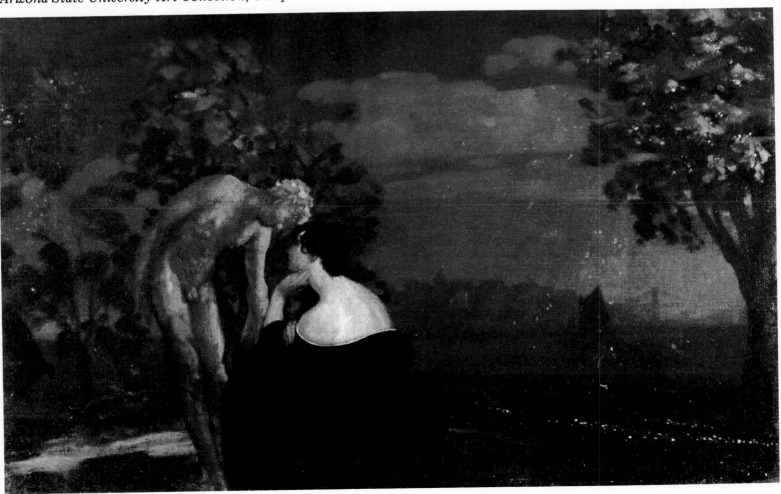

212

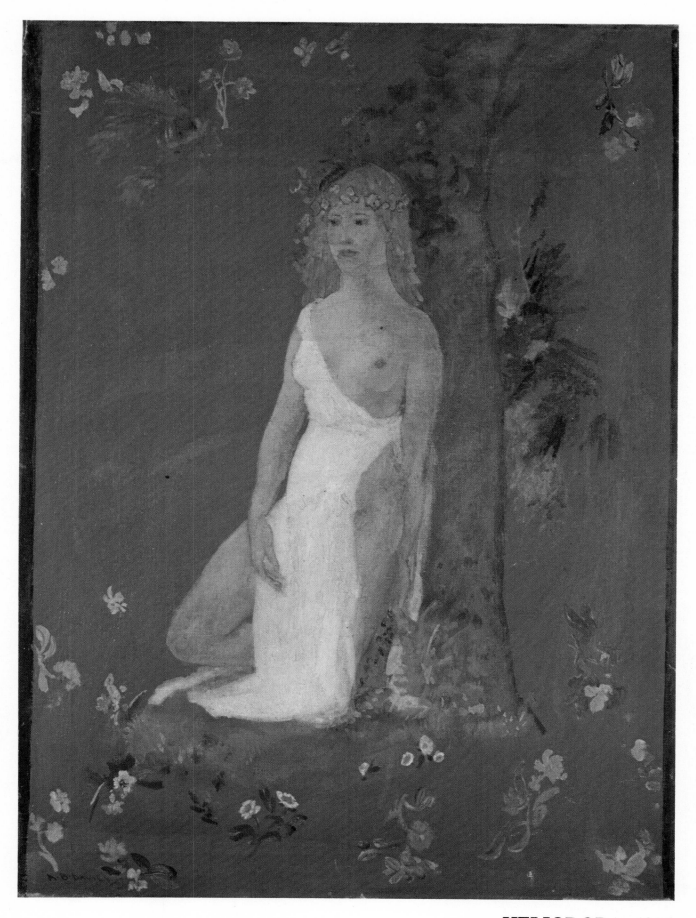

HELIODORA, *1926,*
Arthur B. Davies (1862-1928). 24 x 18¼ in., oil.
Courtesy, Museum of Fine Arts, Boston,
Charles Henry Hayden Fund.

CHARLES DEMUTH

TOMATOES, PEPPERS AND ZINNIAS, *ca. 1927,*
Charles Demuth (1883-1935). 18 x 11¾ in., watercolor.
Courtesy, The Newark Museum,
Arthur F. Egner Memorial Fund.

A few years ago when I was lecturing in Lancaster, Pennsylvania, I witnessed a most distressing sight. The citizens of that town were berating themselves because they had been too late with too little concern for a great artist who had lived and died in their midst. On the very night I was there, a New York auction room was selling the wonderful watercolors of Charles Demuth at very high prices. The Lancastrians were those who years earlier could have bought his work from him at a fraction of the auction price and had not.

It was not that Demuth needed the money or the acclaim. His family was well to do and entirely in sympathy with his artistic longings. In New York, he had shown in famous galleries. The great critic Henry McBride praised him, and Alfred Stieglitz, the great photographer and art collector, made him part of his famous "stable" at An American Place. Fellow artists like Georgia O'Keeffe (p. 216), Marsden Hartley (p. 236), Arthur Dove (p. 252) and John Marin (p. 210) called him their intimate friend and admired his work as he did theirs. The poet William Carlos Williams and the playwright Eugene O'Neill were in his circle. What those good people of Lancaster resented most was what they had missed by not knowing him and being at least a small part of his exciting creative life.

But Demuth, even though much of his finest work was produced in Lancaster, had turned his back on small town America and even New York. Like Marin and Max Weber (1818-1961), he sought out the more sympathetic art climate of Paris. There, at twenty-one, he came under the influence of Georges Braque (1881-1963), Henri Matisse (1869-1934), the Fauves and especially Paul Cézanne (1839-1906). He was one of the very first American artists to be influenced by Cubism. "John Marin and I drew our inspiration from the same source, French Modernism," Demuth said, "He brought his up in buckets and spilt much along the way. I dipped mine out with a teaspoon, but never spilled a drop."

He painted simple things: fruit, flowers and vaudeville life. He was a brilliant illustrator, as evident in his sketches and watercolors for the 1918 editions of Henry James's *Turn of the Screw*, Emile Zola's *Nana* and Frank Wedekind's *Pandora's Box* and several other works. He loved and mastered the delicate medium of watercolor and may be said to have excelled in it more than oils. Yet he did some stunning compositions of old and new architecture in oils and gouache. Great tenderness and finesse are apparent in everything he did, and he is one of the few artists that everyone seems to agree was a true aesthete. His elegant and witty nature shines through all his truly beautiful pictures, and yet there is more — a profoundly sensitive and artistic nature not without a sense of irony.

Tomatoes, Peppers and Zinnias has an undeniable sense of familiarity with nature, and the picture is composed with that same austere economy found in Cézanne's greatest still-life paintings. Demuth and Cézanne, an unbeatable duet of master craftsmen, both endowed with the divine gift of presenting nature in the abstract, but as real as nature herself.

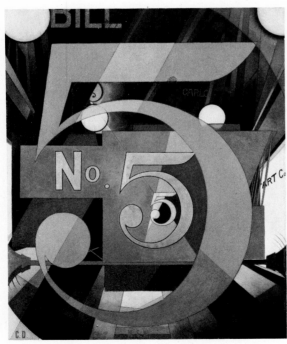

I Saw the Figure 5 in Gold, 1928,
Charles Demuth. 36 x 29-3/4 in., oil on board.
The Metropolitan Museum of Art, New York,
Alfred Stieglitz Collection.

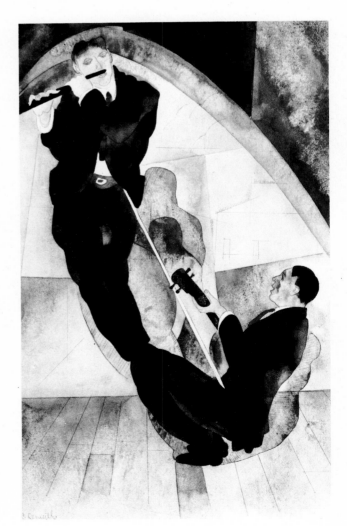

Vaudeville Musicians, *1917,*
Charles Demuth. 13 x 8 in., watercolor.
Collection, The Museum of Modern Art,
Abby Aldrich Rockefeller Fund.

214

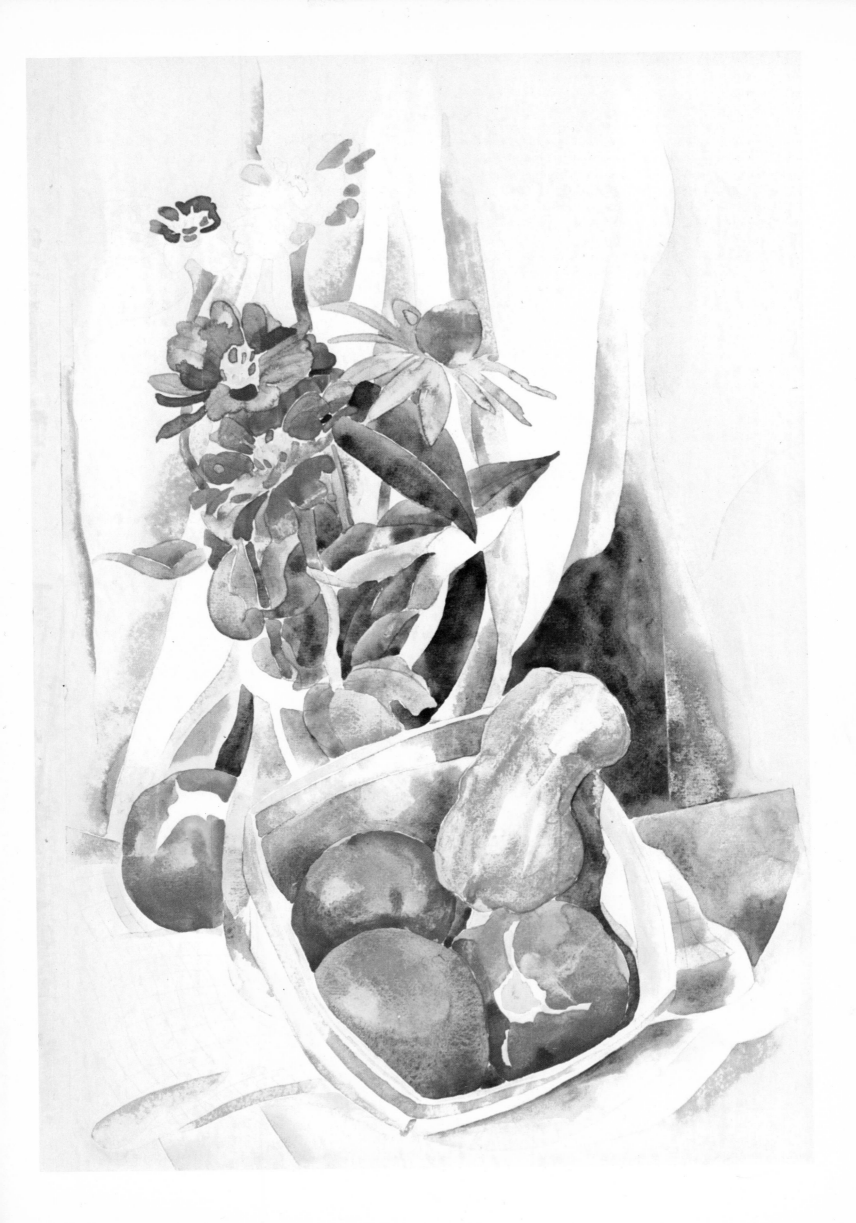

GEORGIA O'KEEFFE

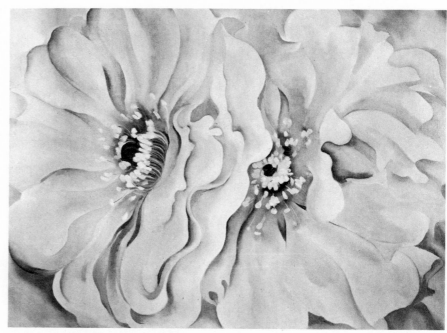

Yellow Cactus Flowers, *1929,*
Georgia O'Keeffe 29-3/4 x 41-½ in., oil.
Fort Worth Art Center, gift of the William E. Scott Foundation.

Americans have been made aware of the individuality of our art by two artists more than by any others — Andrew Wyeth (p. 274) and Georgia O'Keeffe. Reproductions of their work have been sold to millions, proof they have the common ear (or eye) though they speak with uncommon tongues. Georgia O'Keeffe almost single-handedly brought recognition and acceptance to the American woman in art. Mary Cassatt(p.168), some may say, came first and did more, but her art stems from French Impressionism rather than an innovative expression of our own. O'Keeffe is entirely American, from her inventive technique and compositional mastery to her choice of subject matter in city and spacious landscapes from New York to New Mexico.

There is a monumental calm about her work that helps quiet the anxiety and quiet desperation many of us feel. To look at her pictures is to understand the possibility of eternity and the actuality of a great plan, for there is no trace of the accidental in anything she does. O'Keeffe does not attempt to bring order out of chaos, for chaos does not have a place in her orderly world. Nor does she sense chaos around her. Much has been written in praise of this great woman in recent years, and one senses that during the remainder of her life she will continue with calm determination to live as fully as she has in the past. In her maturity, her art, although obviously full-bloomed, will continue to grow and leave our nation as enriched by her art as we are in her presence.

O'Keeffe is a born artist with an impressive, if cursory, background study with some fine teachers, among them the ubiquitous William Merritt Chase (p. 156). Her long life has been spent "doing her own thing" in life and art, and one can only envy her achievement in both. Art and life can be a oneness, if made to function together. For her, there have been no distractions from her art. It is a vivid reflection of the even drama of her deliberate life style. She has lived for it, and it becomes her.

Daniel Catton Rich, writing about forty years of her art, said, "She objectifies, rather than condenses nature. . .but it is on her power to eliminate that O'Keeffe's art really rests." There is a consistent quality of penetration in all her work, for when I am looking through her eyes to the heart of a flower, I see things I have never seen there before. It is because she has pushed aside everything superfluous about that flower to give me its essence. When I am confronted by the great *Black Cross, New Mexico* forcing its arms above and outside the canvas, I can see the bleak New Mexican hills breasting into an endless distance, because she wants me to see it that way, her way, and it becomes my way, too.

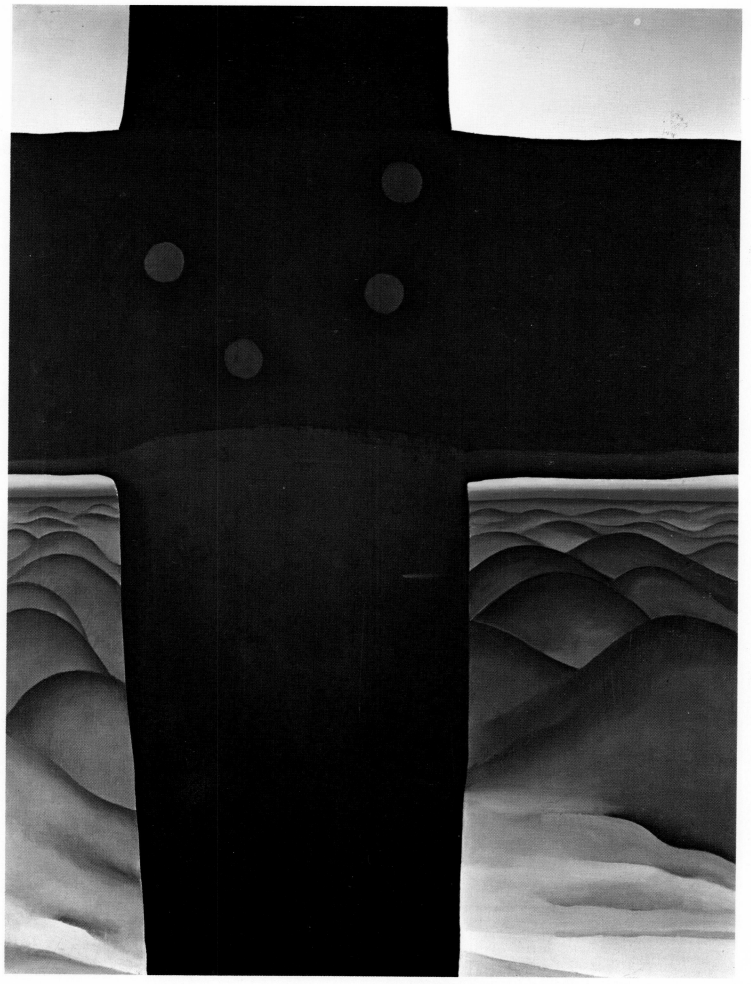

BLACK CROSS, NEW MEXICO, *1929,*
Georgia O'Keeffe (b. 1887). 39 x 30 1/16 in., oil.
Courtesy, The Art Institute of Chicago.

217

EDWARD HOPPER

With art in our time moving in so many different directions, we can, with the work of Edward Hopper, safely anchor ourselves in the great American tradition. There is a timelessness about his paintings that gives a sense of purpose and permanence too often missing in modern art. He records the everyday scenes, and sometimes yesterday's, with an art approach at once traditional and modern, so that the viewer understands the artist's meaning exactly and is still allowed his own interpretation of it.

A recent article by Paul Richard of *The Washington Post* sums it up in a headline, "The Art of Edward Hopper: Ecstatic View of Common Things." He expands his comments by comparing Hopper's quietness with Eakins's clarity and the "sublime enormous landscapes of our nineteenth-century Romantics. . .and those space-dissolving Pollocks. . . ." Richard finds in all these diversified artists "a memory of ecstasy, a hint of something holy."

When he died at eighty-five in 1967, Hopper had outlasted all the whims of modern art and left a body of very personal work containing a consistency that is startling. His early training with Robert Henri (p. 192) and his short periods of study in Paris (1906-1910) seem only to have caused him to become increasingly his own man and artist. Nothing of that decade — neither Fauvism nor the impact of Cézanne (1839-1906) — deeply influenced him. Cubism, which was flourishing in Paris then, he ignored, though many critics have tried to find it in his simplicity and angularity. Some have labeled the slice-of-life subject matter of many of his finest paintings as a kind of Social Realism stemming from Henri and the Ashcan group. Yet there is a vast difference between Hopper's scenes and any of The Eight. His people may be lonely, lost in a moment of life, but they do not protest against that moment; they endure it with stoic calm or simply live it out for the moment in which he captures them.

The Bootleggers is completely Hopper in its subtle mood and color. The graying Victorian house, a city house, sits as a symbol of the past on the seashore. A solitary man waits in the cold for the arrival of the bootleggers, another clue to an American past. But all seem timeless in Hopper's story, in fact, isolated. Hopper was very aware of what he called a "chaos of ugliness." In

Pennsylvania Coal Town, *1947,*
Edward Hopper, 32 x 40 in., oil.
Butler Institute of American Art, Youngstown, Ohio.

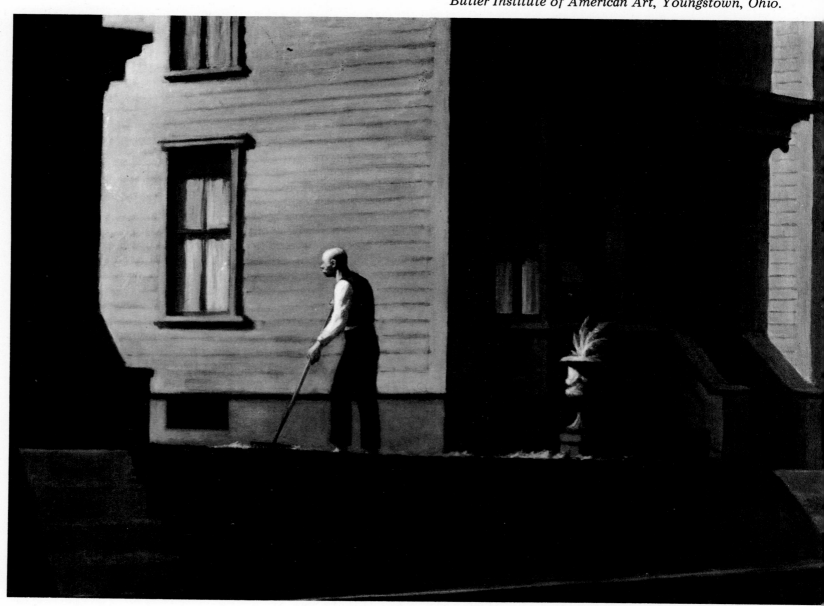

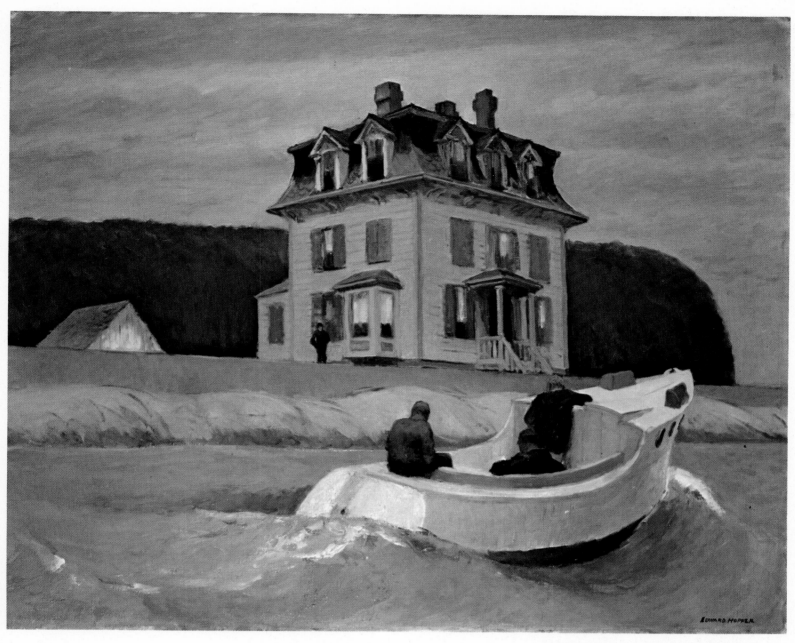

THE BOOTLEGGERS, *1925,*
Edward Hopper (1882-1967). 31 x 38 in., oil.
Currier Gallery of Art, Manchester, New Hampshire.

commenting on the other American artist, Charles Burch-
field (p. 266), Hopper also described his own painting,
"Our native architecture with its hideous beauty. . .these
appear again and again, as they should in any honest de-
lineation of the American scene." But out of that chaos of
ugliness what beauty he evokes, an ability he shares with
the painter Burchfield whom he admired so much. They
have left us such a true picture of our country. Writing
about Burchfield, Hopper made another statement equally
applicable to himself, "His work is most decidedly found-
ed, not on art, but on life, and the life that he knows
and loves best."

Hopper's career was slow in starting. He exhibited in the
famous Armory Show of 1913 and there sold his first
canvas, but six years elapsed before he sold another, this
time to the Brooklyn Museum. In twenty-three years as an
artist he sold only these two while he supported himself as
a commercial artist. In 1924 a show of his watercolors was
a success, and for the remainder of his life he carried out
his mission of creating his views of American life, painstak-
ingly, slowly, always at a high level of artistic perfection.

EDWARD HOPPER

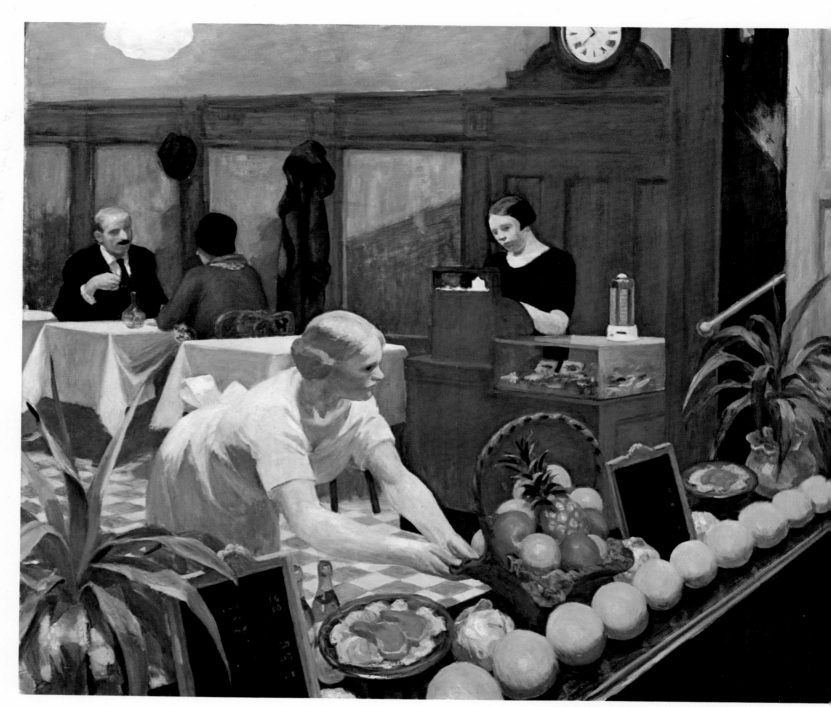

TABLES FOR LADIES, *1930,*
Edward Hopper (1882-1967). 48¼ x 60¼ in., oil.
The Metropolitan Museum of Art, New York.

Tables for Ladies was painted in 1930, five years after *The Bootleggers.* It is equally typical of his work and perhaps even more expressive of his very particular genius for realism. His conviction that "a nation's art is greatest when it most reflects the character of its people" could not be more evident than in this hauntingly poignant portrayal of an aspect of American life we all know. It is not the people who have personality here but the place. The anonymity of the little restaurant creates a sanctuarylike atmosphere, and the anonymity of the people in it makes it the sad little place of refuge it is.

It is realism at its best, for Hopper gives the impression of technical precision, rather than the actual thing. His brush stroke is loose but sure, with none of the prettiness or technical flamboyance of the French Impressionists. Hopper was very vocal on that subject, saying much which I have reiterated in this book. Writing in

1933, he said, "The domination of France in the plastic arts has been almost complete for the last thirty years or more in this country. If an apprenticeship to a master has been necessary, I can only think we have served it. Any further relation of such a character can only mean humiliation to us."

It is this honest Americanism about him that has made him one of the most universally loved of our artists. He, like Thomas Eakins and Winslow Homer, is aloof from everything but always aware. His perception is unmatched, and he has the ability to make us see his way, too. What he sees is so direct and the way he sees it is so logical that his intent and his achievement are timeless and universal.

We can find in his paintings unsuspected technical brilliance, always purposely hidden so as not to intrude on the overall effect he wants to create. *Tables for Ladies* is filled

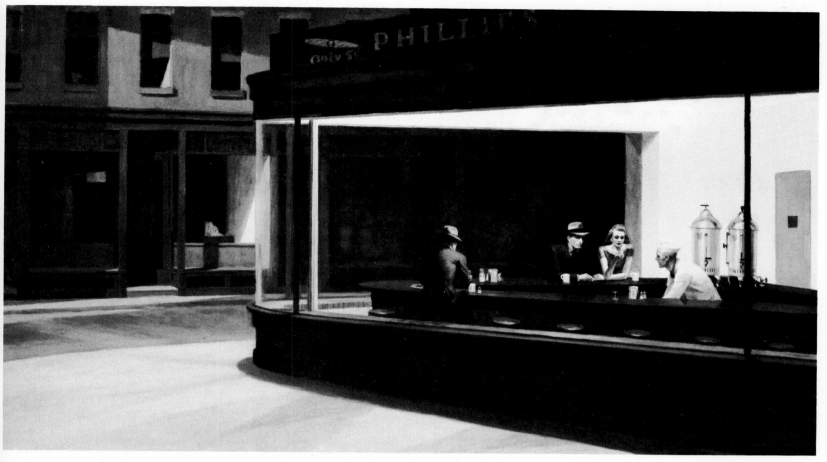

Nighthawks, 1942,
Edward Hopper. 33-3/16 x 60-1/8 in., oil.
Courtesy, The Art Institute of Chicago,
Friends of American Art Collection.

with small wonders of painting. The still life of the cigar case, the pattern of the floor, the suggestion of looking through a window, the beautifully realized procession of fruits behind that invisible glass, the crispness of those plants all have to be sought out, for Hopper's simplicity is deceptive and perhaps consciously so.

One thing that is always fascinating in a Hopper scene is the very real feeling you get of what is going on outside of the picture. In *The Bootleggers* you somehow know where the boat has come from. *Tables for Ladies* leads us into its quiet from a crowded street. In the Chicago Art Institute's *Nighthawks* you look through the empty night into a sparsely peopled coffee shop and out beyond into the empty streets that belong to no one, only the night. Paul

Richard of *The Washington Post* says of *Nighthawks*, "The picture's beauty is so modest and direct, so intimately sensual, that it makes the viewer sense not just death, but the possibility of joy."

This kind of literary tribute brings to mind the writers of Hopper's youth who were doing much the same kind of picture in words that he was in paint. Theodore Dreiser, Sinclair Lewis, Thomas Wolfe and William Faulkner were each dealing with the great American tragedy of alienation from the technological, urban world we have come to live in. If Hopper is "the most American of American painters," it is because he recognized and can portray the lonely drama that has evolved from the American dream to become the American nightmare.

GEORGE LUKS

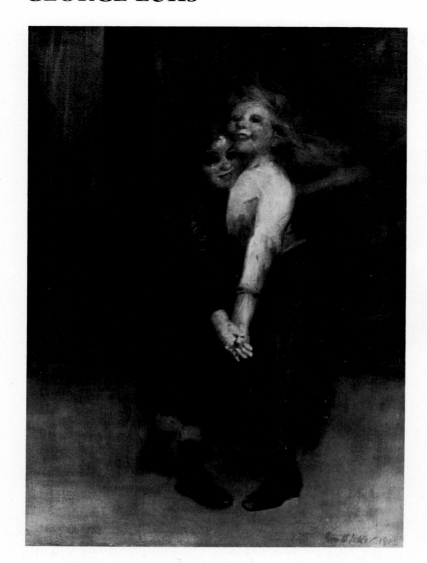

The Spielers, *1905,*
George Luks. 36 x 25 in., oil.
Addison Gallery of American Art, Phillips Academy,
Andover, Massachusetts.

Of all the illustrious Eight, George Luks is the one who best fits the popular definition of the Bohemian artist. His friends called him "Lusty Luks," and in the spirit of that nickname he did not find his inspiration in Claude Monet (1840-1926), Pierre Auguste Renoir (1841-1919) or the Spaniards, but in the equally lusty Dutchman, Frans Hals (1581-1666). Like William Glackens (p. 186), John Sloan (p. 194) and Everett Shinn (p. 198), he was an illustrator in Philadelphia and came under the all-important influence of Robert Henri (p. 192) who persuaded all of these men to abandon illustration and turn their brilliant draftsmanship into paint, watercolors and pastels. They took to it with gusto, and while each had his own character, George Luks was the most memorable character of them all.

He counted among his close friends many of the most colorful literary figures of that period before World War I, during and after it. A critic and collector, Homer Saint-Gaudens, capsulized his character: "He lacked patience. He lacked restraint. He thrived on the ribald. There was nothing delicate about his personal or artistic stomach. He boasted, with reason, of his prize-ring prowess. He drank his share of liquor. . . . He threw paint around with a muscular gusto, that at times produced answers of startling effectiveness, witness his portrait of Mrs. Gamely."

About himself he had no doubts, of his talent or his love of life. He was opinionated, admitted it, and ran headlong into those who did not think as he did. He lived to excess and paid the price of eventual obscurity, but he never lacked defenders of his erratic behavior and his uneven artistic output. The good things he produced make you forget the mediocre, and even they never lack excitement. He died alone under the Sixth Avenue elevated in New York City, but shortly before his death he defended his way of life when some compassionate friend tried to seek him out. He told a reporter this friend had asked him "whether I would live my life over if given the choice. Well! Well! Here we are in the veil of tears, eh? Alas, though I roast for it, I will be guilty of no hypocrisy. My answer to life is yes."

Mrs. Gamely was painted three years before his death. Saint-Gaudens points to the brilliance Luks could bring out of the chaos of his life, and here it is. One can read years of positive life in the old lady. The twinkle is there and a wonderful contentment even in the bare surroundings that is all life has left her. You feel that rooster will never stew in the pot. It is to be a companion, not a meal.

There is much of Frans Hals in this portrait. Both men being primarily concerned with the character of their sitters, with the lighter side of their lives, both developed a quick method of getting the light moment down on canvas. "Draw a man so that you show what he is," was his motto and Hals's too.

I believe that George Luks, more than any of his confreres, was far ahead of his time. It could be that Luks himself felt the others around him, for all their innovative daring, were not really getting on with life, that they were vital when their experiment with life began, but that age, success, and acceptance of their own talents prevented them from keeping pace with it. Luks never let go. His answer to art may not have been complete, but to life he said — yes! To much of his art we can also say "yes."

222

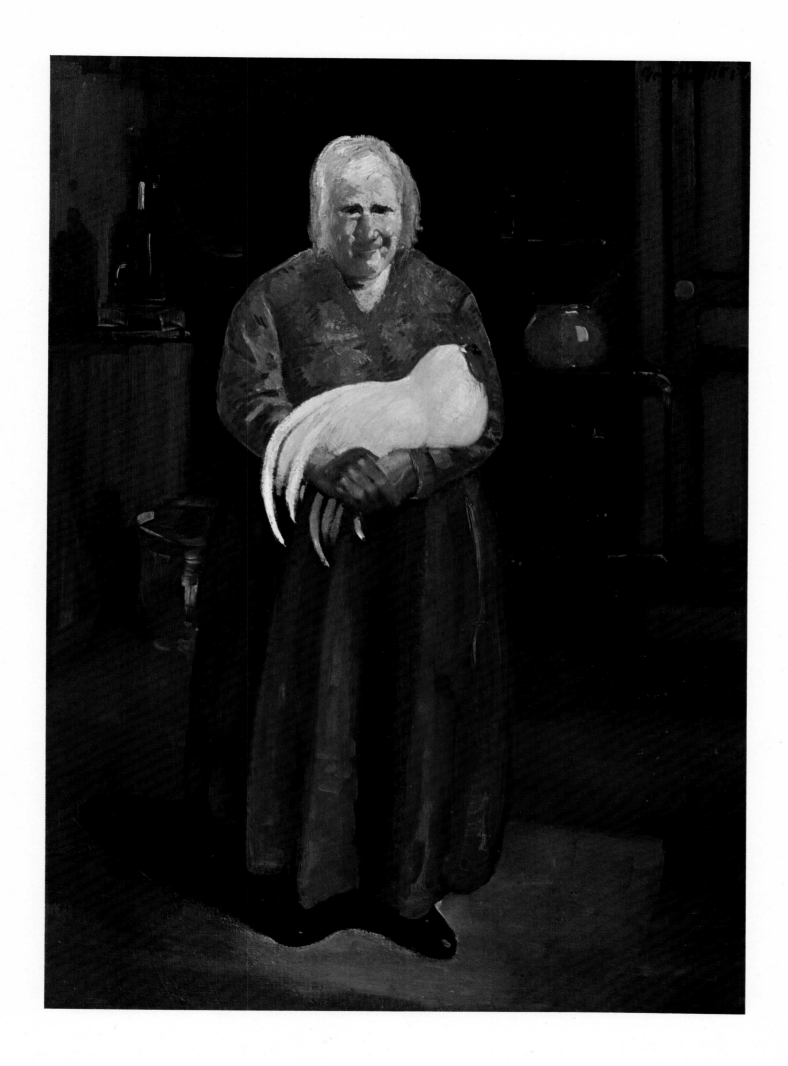

STUART DAVIS

Stuart Davis came into his own at an opportune time in American art development. By the 1920's, our artists were beginning to feel they had paid off their debt to Europe and were now able to make a freer use of both European and American visions. Davis was a leader among them, for early in his career he decided to become a *modern* artist. He would be one to make new use of the individual expressions of Cubism, the Fauves' wild colors, and the older examples of Paul Gauguin (1848-1903) and Vincent van Gogh (1853-1890) and apply these manners to American life of the time. To this end, he was convinced that the American artist "has need for the impersonal dynamics of New York City." He set about his ambition with the same disciplined orderliness that characterizes his paintings.

When he spoke of New York City, Davis included all the impersonal dynamics of modern life which are so blaringly concentrated there. The symbolic minutiae of time fascinated him, for he felt they told our story better than anything else. "I often use words in my pictures because they are part of an urban subject matter." This statement could be broadened to include cigarette packages, signs, taxicabs, kitchen utensils — all the trivial but vital symbols of our time. They have had tremendous subconscious impact on us, and Davis gave them consciousness in art.

Though he credited the 1913 Armory Show as having a great influence on him, Davis was totally imbued only with that which applied to the American scene. He prided himself that he saw American life, its tempo and temperament, in a new way, and indeed he did. His achievement is that his vision of American life seeped back into it and enriched our visual concept of ourselves. We see ourselves in his art, and his view of America inspired all artists, especially those who worked with the symbolic minutiae of everyday life, the commercial artists. It has been suggested that, since so much more has been borrowed from Davis than he ever took from others, we may have to reevaluate him in an

Gloucester Wharf, *1926-35,*
Stuart Davis. 16-¼ x 19-3/4 in., gouache on cardboard.
Milwaukee Art Center Collection.

GARAGE LIGHTS, *1931,*
Stuart Davis (1894-1964). 32 x 42 in., oil.
Memorial Art Gallery, University of Rochester,
Marion Stratton Gould Fund.

historic light. He was imitated so often that his work is at present in danger of being lumped with the clichés which were his subject sources.

Davis's background was art. His father was art director of the *Philadelphia Press* for which John Sloan (p. 194), William Glackens (p. 186), Everett Shinn (p. 198) and George Luks (p. 222) worked. The same guiding hand of Robert Henri (p. 192) that led these men into the fine arts also helped him. Henri's admonition to look at the life around them made Davis a realist, and even his most abstract work, after he had broken from the Henri tradition, he insisted was "realist."

Of all the debts he owed to the Armory Show artists, the greatest was to Fernand Léger (1881-1955). Davis described the Frenchman as "the most American painter painting today." Obviously the two had much in common, for Léger saw in modern French life all the same signs

Davis saw in the American. Davis said that "some of the things that have made me want to paint . . . are the brilliant colors of gasoline stations, chain store fronts . . . fast travel by train, auto, and airplane . . . the landscape and boats of Gloucester" He felt that an artist driving a car, riding a plane — in other words living in this time — "doesn't feel the same way about form and space as one who has not." He was, in short, a completely modern visual communicator.

Garage Lights was painted in 1931. Perhaps in the light of the great popularity of his later work, this early painting gives us a glimpse of everything we have said about his art philosophy and how it evolved from this early realization of his own style. It took him a long time to arrive at it, but here it is full blown. His painting is both illustrative and yet is a unique, sensuous object. Davis would later abstract and simplify, but he would never lose the crispness and clarity of this wonderfully decorative work of art.

LYONEL FEININGER

All great artists have a language of their own. Some speak only in the vernacular of their time, some speak to the future, and some few create a new tongue that other artists understand but can only whisper. Even the public, who often feel left out of these artistic vocalizations, sometimes seem to grasp the new language sooner or later and listen to the artist with joy and understanding. Such a painter, etcher and watercolorist was Lyonel Feininger.

He was born in New York in 1871, moved to Germany with his musician parents at age sixteen and lived there until 1939. When he finally came home, his reputation was firmly established in Europe, but our critics rejected him. It took several years for Americans to accept him, but now he is an internationally recognized master.

That short biography leaves out very pertinent facts about Feininger's place in American art. Can we really consider him part of the American scene? He was, as were many twentieth-century artists, influenced by the Cubism of Georges Braque (1881-1963) and Picasso. From them he learned to reveal the geometry of everything. But of longer lasting importance were his connections with the German art movement between the world wars loosely called Expressionism and with the famous Bauhaus school of design (closed by the Nazis in 1932) and his membership in the Blue Rider group which included other non-Germans such as Paul Klee (1879-1940) and Vasili Kandinsky (1866-1944). None of this sounds very American, but oddly enough, his European associates always referred to him as "the American." To them and to Feininger himself, his identity was with his native land.

Indeed, his youthful sixteen years in America were full of influences and inspirations that never left him. His love of Bach, whose art is "incomparably terse," came from his parents; an early trip to the Metropolitan Museum opened

Gaberndorf II, *1924,*
Lyonel Feininger.
39-1/8 x 30-½ in., oil.
Nelson Gallery-Atkins Museum,
Kansas City, Missouri,
gift of the Friends of Art.

his eyes to the romantic and mysterious mood of the Gothic, which pervades his many architectonic studies; the lifelong fascination with sailing ships, bridges, trains and all things mechanical were carry-overs from his childhood in New York. Then there was a short period of producing that very American commodity, the comic strip, for American newspapers. He sent his drawings from Germany, but the humor was American. People who met him while he lived in Germany were amazed to find him relentlessly American in speech and devotion. He was an American artist, and one of the first rank.

What is appealing about Feininger is the absolute precision of everything he does. His art, like Bach's, is terse. There is no waste, no elaboration. He has been described as classically abstract, but like Bach and unlike the impersonal chill of some Cubist works, he conveys warm overtones. This is, perhaps, due to his romantic subject matter, but I like to think that is due more to our American good humor, a kind of naive open-mindedness that his years with the functionalist Bauhaus group could not quite erase.

Typically, in his work he divides the very air itself into crystalline planes stabilized around a central object, as in the many churches and buildings he painted, or around a group of objects, as in many of his sailing boat pictures. *The Motor Boat* is a superb example. Here Feininger humorously contrasts the romantic subject matter of the ships of nostalgic vintage with the focal point of the painting, the darting little motorboat in the foreground. Moreover, the contrast is made entirely in pictorial terms, rather than narrative or anecdotal ones. The differences in size, in weight, in the felt movement of the vessels are the differences that make the point of humorous contrast. It is a picture that well exemplifies the individuality of Feininger's artistic language.

THE MOTOR BOAT, *1931,*
Lyonel Feininger (1871-1956). 17¾ x 30½ in., oil.
The Cleveland Museum of Art, gift of Julia Feininger.

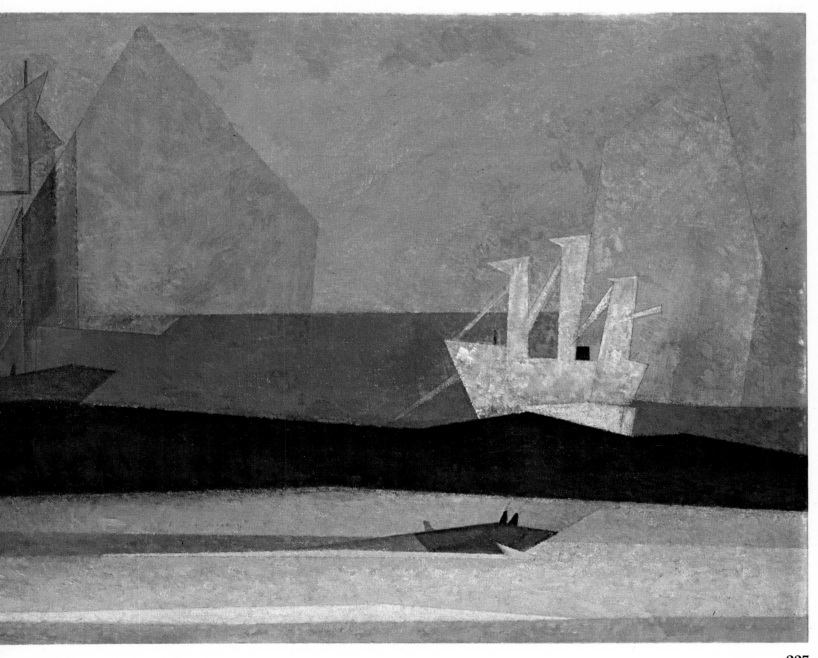

GRANT WOOD

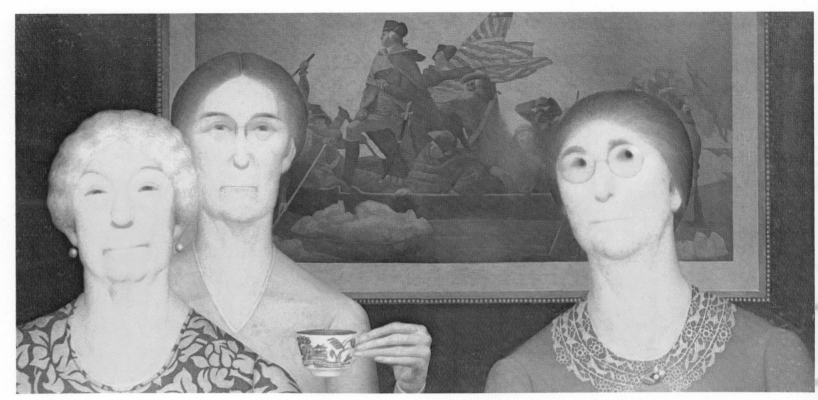

DAUGHTERS OF REVOLUTION, *1932,*
Grant Wood (1891-1942). 20 x 40 in., oil.
Courtesy, Cincinnati Art Museum and
Associated American Artists, Inc., New York.

A few of the true landmarks of popular American art are John Gutzon Borglum's (1867-1941) monumental sculpted heads of the Presidents on Mount Rushmore, James Earle Fraser's (1876-1953) *The End of the Trail*, and Grant Wood's *Daughters of Revolution*. Some might argue that Wood's *American Gothic* was more popular, but *Daughters* is my favorite for subject and execution. I first saw it in Edward G. Robinson's fabulous collection of French nineteenth-century paintings, and it stuck out like that other American expression, a sore thumb. Nothing could be further removed than it was from the Renoirs, Cézannes and such, nor was any other picture so obvious as to its national origin.

Wood, along with Thomas Hart Benton (p. 256) and John Steuart Curry (p. 234), was one of the prime figures in the Regionalist movement that thrived during the 1930's. The movement encompassed neither a unified style nor a single point of view, but simply included art that grew from local or national experiences. But Wood has turned out to be the most popular of the Regionalists. His was almost Pop Art before there was such a thing, and certainly his is popular art, if the reproduction and caricature of his work is a measure of its popularity.

His present acceptance was long in coming, and his first real achievement came only after years of living in poverty in Iowa and taking many jibes and much criticism. That achievement was *American Gothic* which he painted when he was thirty-eight. It won an award at a Chicago Art Institute show in 1930. Twelve years later Wood was dead of cancer. But he survived his early struggles and lived long enough to produce a kind of art that was to him pure

American — narrative as a comic strip, as flat as a Midwest accent, but unmistakably his own.

Earlier, Grant Wood, like so many other Americans, had to travel to Paris to arrive soundly back where he came from. He rebelled against "the sleazy artifices of Impressionism" to "realize that all the really good ideas I've ever had came to me when I was milking a cow. So I went back to Iowa."

If there are influences outside the American scene in his work, they stem from his admiration of the naivety of the primitive painters both here and abroad and his technique, which was that of the old masters, tight draftmanship and painstakingly wrought layers of transparent oil glazes over tempera underpainting. However, the naivety shows in the stiffness of the figures, the decorative, almost cut-out qualities of the landscape, trees and buildings. They are like illustrations of the simplest stories, with all the charm such pictures have. The portraits are as studied and stunning as those of the German and Flemish primitives he saw and admired so much during a second European trip, one to Germany in 1928. They, too, have the storybook quality, telling tales of people.

Wood may not be the most profound or important American painter, but because his work is unmistakably his he proves a point about our art that is important to remember. Our best artists are most often fiercely individual, and each one who achieves to a superlative degree his particular individual mode of expression gives us one vital part of the true and highly complex accomplishment that is American art.

228

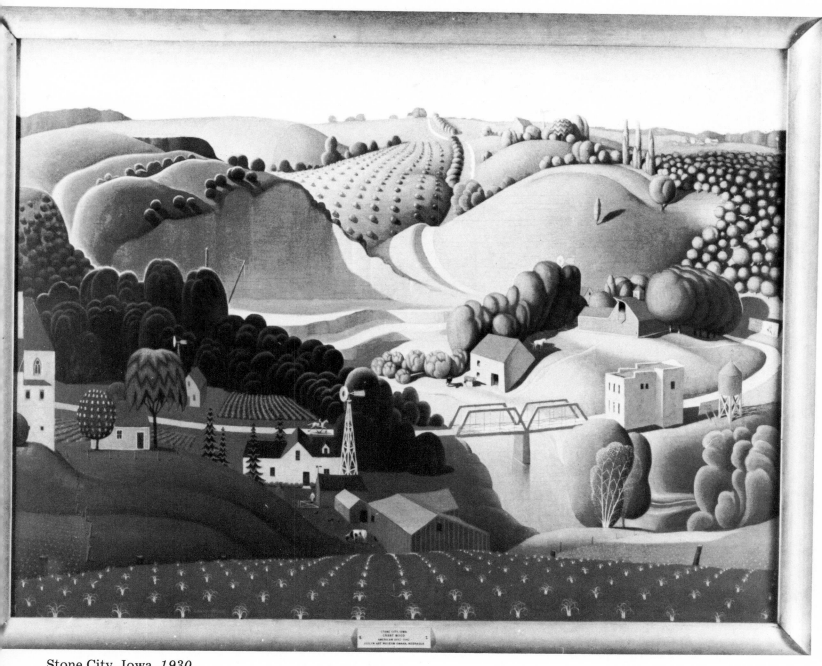

Stone City, Iowa, *1930,*
Grant Wood. 30-¼ x 40 in., oil on wood panel.
Joslyn Art Museum, Omaha.

EDWIN DICKINSON

The Fossil Hunters , *1926-28,*
Edwin Dickinson. 96-½ x 73-3/4 in., oil.
Collection Whitney Museum of American Art,
New York.

There has always been something fascinating about the self-portrait. If we can accept the oldest philosophical dictum "know thyself," we should see in the painter who paints himself at least an attempt to achieve self-revelation. Rembrandt, who is the Everyman of art, created the ultimate success in this personal undertaking of self-portraiture. In this book, we have seen Ivan Albright (p. 300) looking at himself and in a miraculous way showing us at the same time the nature of his physiognomy and the nature of his work.

Edwin Dickinson loves self-portraits and he goes further when he incorporates himself into the story of his pictures as a character. In one painting named for the bloody Civil War battle at Shiloh, he is the dead soldier. He achieved this by holding a mirror between his legs and reflecting his face from below, then, with one eye closed, he painted what he saw.

Dickinson's interest in the self-portrait is entirely appropriate because he is one of the most personal artists we have produced. To see one of his paintings is to become a part of him and the world he has created for himself and all who would enter it. It is an inviting world, recognizable in its detailed reality, but at the same time it is one of great imagination and mystery. It is a mystery created by Dickinson to give the viewer the feeling that all of us are alone in a world of things we only half understand.

Woodland Scene is a remarkable achievement and an ideal introduction to the work of this remarkable artist. It required nearly five years and four hundred sittings. It went through many stages and changes; even its size varied twice. It is one of those magical pictures that must be examined and studied, explored as one does a new and unfamiliar place. The central figure was modeled on an elderly Portuguese woman in Dickinson's beloved Provincetown, Massachusetts. She is unsexed by her age and by the night which she inhabits. She has often been thought to be a man with a beard, but the neckline of her coat is just that, not a beard. On first view she seems alone, but the woods are alive with the remains of things, a weathered wall, an abandoned plowshare, a cartwheel. The

230

WOODLAND SCENE, *1929-35,*
Edwin Dickinson (b. 1891). 71⅜ x 68½ in., oil.
Herbert F. Johnson Museum of Art,
Cornell University, gift of Esther Hoyt Sawyer.

light that illumines comes from a ghostly figure that blazes in the right background. Is it her lost youth or the ultimate illumination of death waiting to rejuvenate her? And who is that sensuous floating figure? Is she the embodiment of the human need for companionship that we all admit but seldom satisfy?

Dickinson does not explain any of the imagery. He combines the real and the unreal without the labored symbolism of the Surrealists. He paints, and paints superbly, the dream of life that is at once real, ephemeral, and ethereal. His adept draftsmanship, his consummate ability to compose even the most complicated forms and subject matter make him not only one of the most important American artists and one of the most individual, but a man who has helped to bring American art to a place of distinction in the art of the world.

231

JOHN KANE

Self-Portrait, *1929,*
John Kane. 36-1/8 x 27-1/8 in., oil on composition board.
Collection, The Museum of Modern Art,
New York, Abby Aldrich Rockefeller Fund.

A phenomenon of modern art appreciation has been the "discovery" of the primitive painters, men and women whose personalities outside the arts were as interesting as in them. These artists have been true loners without formal training who continued to support themselves by other labor and thus have remained independent from the main art movements of their day. Henri Rousseau (1844-1910), *Le Douanier* ("the customs inspector"), and John Kane are two fine examples. Like other primitive or folk artists, such as Edward Hicks (p. 84) and Horace Pippin (p. 258), John Kane approached painting, not in reaction to schools and expressions, but in an energetic search for his own ability to simply paint a picture.

John Kane was always a workman. He enjoyed using his strong body, and nothing seemed to break his spirit. This, of course, was what sustained him and eventually inspired him to become a full time artist at an age of over sixty. The simplicity of his statements about his art when the art world finally came knocking at his door are completely disarming. Like other truly naive and simple souls, he spoke almost in Biblical truths. "I think a painting has a right to be as exact as a joist or a mold. . .I only know I paint the way I see life, honestly; the way God made it." Once asked why he painted Pittsburgh, one of the least prepossessing cities, he answered, "Why shouldn't I? I helped build Pittsburgh's mills and homes; I paved its streets, made its steel, and painted its houses. It is my city; why shouldn't I paint it?"

After immigrating from Scotland to America, his early years were spent in heavy labor in Southern mines and factories. He took up his childhood love of drawing again and moved to Pittsburgh to be with his family. At thirty-one he lost his leg in an accident. He took it as a fact "that life wasn't all for good times," but even this did not daunt his spirit. He continued his physical activities on a wooden leg, dancing jigs and boxing and even climbing ladders. He became a house painter, and paint became his life. He took up hand coloring photographs and also tried rough landscapes on sides of freight cars — only to paint them out within hours. "Beauty of whatever kind I wanted to draw, but I did not learn to paint for a long time afterwards." Often he would go to draw in the cemetery near Pittsburgh called Calvary where "the scene of beauty would take hold of me and I was forced to put it down in a little sketch." Of painting he said, "I study it all out. I puzzle and figure and work. . . .By and by it comes to me. . . .Sometimes we can add something beautiful to a scene, or take away something that seems unreasonable." *Panther Hollow, Pittsburgh* also indicates how he maneuvered landmarks — the railroad, buildings, even the cows — in his own design of nature.

Nine Mile Run Seen from Calvary, *ca. 1929,*
John Kane. 23½ x 23½ in., oil.
Museum of Art, Carnegie Institute, Pittsburgh.

PANTHER HOLLOW, PITTSBURGH, *ca. 1933-34,*
John Kane (1860-1934). 27¾ x 34 in., oil.
Museum of Art, Carnegie Institute, Pittsburgh.

In 1925 he took a decisive step in art and life; he personally submitted a painting to the Carnegie Institute's International Exhibition. It was a copy of an old master, and Homer Saint-Gaudens, the director, explained to the weathered, old, peg-legged painter that only originals were accepted. When he got home, Kane set about working on an original which he submitted the next year only to be rejected once more. But the director found out more about the artist and his unusual background, and the third year the six-man jury accepted *Scene from the Scottish Highlands.* One of them bought the painting for fifty dollars and John Kane was officially launched on a career, this time as picture painter, not house painter.

Fame came rapidly after that, and though his work was collected by artists and connoisseurs, he never made a lot of money, just enough to keep on painting. He remained humble and grateful and accepted acclaim with classic stoicism. "I have lived too long the life of the poor to attach undue importance to the honors of the art world, or to

any honors that come from man and not from God." His *Self-Portrait,* done when he was sixty-nine, conveys this unaffected attitude well. Here are sophisticated composition and sharp observation in balance.

Panther Hollow, Pittsburgh is a remarkably beautiful picture and one that attracts the eye and the imagination. You can sense the artist's delight at being able at long last to see all this beauty and to be able to capture every detail of it, down to the cobblestone road and railroad ties. It is not a childish piece of work, yet it is compelling in its straightforward comprehension of industrial Pittsburgh. Kane said it better than anyone could, "Truth is love in thought. Beauty is love in expression. Art and painting are both of these." The truth is what shines down from those concrete clouds on those embroidered trees and cutout houses. There is no confusion about techniques. It is a simple statement of honesty. The art commentator Lloyd Goodrich suggests Kane's epitaph could be his own words, "The job is done as well as I can do it."

JOHN STEUART CURRY

Always concerned with nature, the American artist approaches it with a total respect seldom found in other lands except perhaps in the Orient. Man plays his part, too, in the natural drama but is, more often than not, the loser. The so-called Regionalist painters from the Midwest have been eyewitnesses to nature in some of her most ferocious moods, and the traditional respect amounts almost to reverence. John Steuart Curry and Thomas Hart Benton (p. 256) are nearly Biblical in their admission that nature still has the upper hand and, if nothing else will define her angry moods, we can blame them on the wrath of God.

Curry is the more melodramatic of these two Regionalists, covering up weaker technique with stories of violence: A hog killing a rattle snake, or, in our picture, *The Mississippi*, an even more deadly serpent swallowing life and property. The one thing that can never be doubted in a Curry picture story is the sincerity of the artist. He is not working from hearsay but from personal knowledge of the facts.

Born in Kansas in 1897, he spent his youth on his father's farm. Even though his parents were sympathetic to his artistic leanings, there still was the farm work to keep up with, chores starting at 4 a.m. and not ending until night. But he could not keep from drawing. Young Curry did not fall into bed like the rest but continued his self-searching to find out why art to him was the greatest purpose, greater even than his love of the good earth. Somehow he seemed to sense that, hard as farm life was, an artist's life in the American climate at that time would be harder. He was right. Curry starved to make a go of it.

He was an indifferent student in school, but his teachers realized there was something else in the boy, and his parents knew this, too. He determined to go to Kansas City to the Art Institute when he was nineteen, but his awkward ways made him the butt of many jokes and he quit to work on a section gang for the railroad. That fall he spruced himself up and made it to the Art Institute of Chicago where he managed to stay two years by doing

Baptism in Kansas, *1928,*
John Steuart Curry, 40 x 50 in., oil.
Collection Whitney Museum of American Art,
New York.

THE MISSISSIPPI, *1935,*
John Steuart Curry (1897-1946). 36 x 47½ in.,
tempera on canvas. Courtesy,
The Saint Louis Art Museum.

every kind of work. He learned enough to begin to identify himself as an artist, not a farm boy, but he knew that his subject would always be the soil he had left. "My whole life was made up of sensations," he said. "I used to go out in the garden and pull tomato vines to pieces so that I could smell them. I used to go out in to the pasture to the mudholes where the doves had gathered so that I could see them fly up against the sky. . . . I loved the smell of wet dust." There is the key to his character, to his ambition, to his art. He was concerned with the drama of the earth, and that is the key to the appreciation of his art — drama.

The Mississippi is a truly bold story. Anyone who has lived along the great river has known its anger. Many have been smitten by its injustices. It seems to be partial to the poor as it takes them from their shacks that dot its banks. Curry's telling may seem overly dramatic, but one must remember that it comes from a period when the plight of the black Americans was just beginning to receive notice. They were finding a voice. The magnificent spirituals were finding their way into the American musical vocabulary. *Porgy and Bess* (1935) and *The Green Pastures* (1930), were to become classic theater, and the public was becoming more aware of black America. Curry, Benton, Grant Wood (p. 228) turned back from brief encounters in other fields of art to cultivate their own land. They are an important moment in our art history and one that has its value in our cultural identificaton.

MARSDEN HARTLEY

In order to understand and enjoy Marsden Hartley some effort is required from the viewer. Although we must admire him for his aesthetic qualities, enjoyment is the high purpose of art, and that is not easy to derive from his works. There is something almost brutally unrelenting about his stern landscapes and even sterner portraits. Even our *Sea Dove*, which comes as close to being pretty, lovely and appealing as anything you will find from him, is stark. A dead bird stripped of even the softness of its featherskin lies rigid in a nimbus of equally stark design.

The nimbus is important. It surrounds the fact of the dead bird with reverence, for such a nimbus is the conventional sign of holiness. In another picture of his, *The Fishermen's Last Supper*, done in 1940/41, Portuguese-American sea-farers are ranged around the table in an order roughly based on Leonardo da Vinci's famous painting. Over the heads of some are painted golden flashes of light — the men who were drowned in the next day's fishing.

Northern Seascape, Off the Banks, *1936/37,*
Marsden Hartley. 18-3/16 x 24 in., oil on cardboard.
Milwaukee Art Center Collection,
bequest of Max E. Friedmann.

In both pictures, the nimbus is a primitive device: It has not been used with a straight face, as it were, by a sophisticated artist in almost three hundred years. Yet Hartley was a very sophisticated artist, an intellectual but not a poseur, utterly guileless in the directness of his statements. He said, bluntly, "I have no interest in the subject matter of a picture, not the slightest. A picture has but one meaning — Is it well done, or isn't it? — and if it is, it is sure to be a good picture, whether the spectator likes it or not." Hartley paints good pictures.

Throughout his writings and in records of conversations, he aligns himself with intellectual painters like Paul Cézanne (1839-1906) or romantic loners like Albert Pinkham Ryder (p. 166) and William Blake (1757-1827). He also admires Pierre Auguste Renoir (1841-1919), an opposite in many ways, by saying, "He painted with all his manhood, and is it not evident."

But it was Ryder who "shook the rafters" of his being. On seeing his first Ryder, he "felt as if I had read a page of the Bible." These two men have much in common, including a reverence for the sea. But Ryder and Hartley did

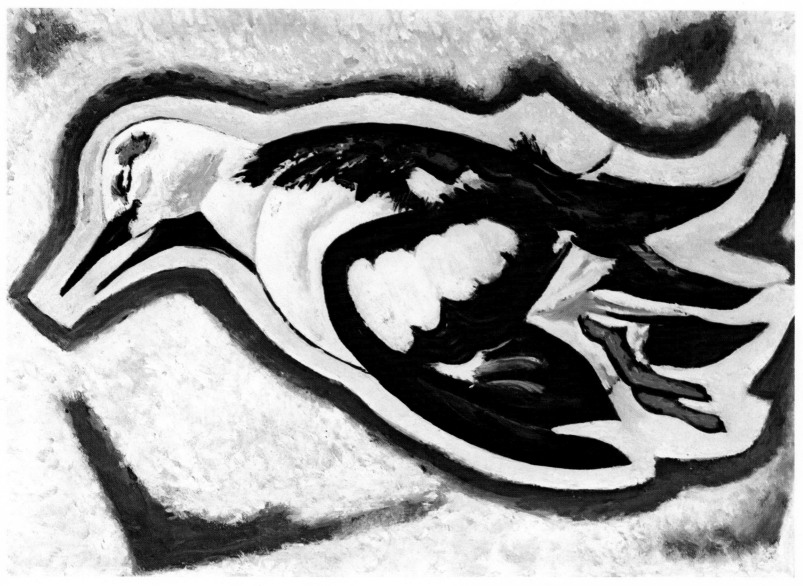

PORTRAIT OF A SEA-DOVE, *1935,*
Marsden Hartley (1877-1943). 9¾ x 13¾ in.,
oil on composition board. Courtesy, The Art Institute of Chicago,
Alfred Stieglitz Collection.

not go to the sea for inspiration; the sea came to them, was in them. There is a great solemnity in both their works, especially when they think seaward. Their sea pictures are deep, turbulent, mysterious, yet calm and moody. They are not pretty swells, curling in a moonstream, but massive passages of poetry, of music. Ryder converted Hartley "to the field of imagination to which I was born;" he threw him "back into the body and being of my own country," and the body and being of America is in every one of Hartley's canvases.

While experiments of all kinds were pouring in from all over the world inundating the American artist, many were attracted to them, but too often watering them down to banality. Hartley was not affected by these experiments and new styles, except that he did find something useful in the vision and techniques of German Expressionism. An example is seen in his *Portrait of a German Officer,* painted in 1914, during a visit to Germany. A more lasting effect of German Expressionism is the thick black line

with which he outlines the subjects of his pictures, such as *Northern Seascape, Off the Banks,* perfectly expressing Hartley's own intensity. Basically, however, he remained an American individualist and a serious and brilliantly successful one. After his travels, it was in his native Maine that Hartley found his true artistic calling in the life along the rocky coast.

Again, we come up against that streak of seriousness that identifies our art. It is not that we have neglected altogether the light side of life, but rather have concentrated on the harder aspects of growing up as a nation. The niche we carved out of the wilderness was a serious undertaking by people determined to be free from their oppressive native backgrounds, politically and spiritually. It is a strange fact that the toughest traits we had to deliver ourselves of were, and to some extent still are, the cultural ones. When an artist surfaces as uniquely the product of our culture we have to take notice of him and give him his special due as an American artist.

PETER HURD

THE NEW MILL, *1935,*
Peter Hurd (b. 1904). 21½ x 17½ in., oil on gesso.
Courtesy, Pennsylvania Academy of the Fine Arts, Philadelphia,
gift of Mrs. Thomas E. Drake.

238

Nito Herrera in Springtime, *1960,*
Peter Hurd. 17½ x 22-3/4 in.,
egg tempera on board.
Courtesy of the Denver Art Museum,
gift of Mrs. Alexander L. Barbour.

The Old West was superbly memorialized by artists like Frederic Remington (p. 196) and Charles M. Russell (p. 181) just before it passed into the limbo of legend. But legend, of course, lives after those artists, in song, story, movies and television and, of course, the West still exists, as alive as ever. No machine can round up cattle; for that matter, no machine can repair and keep in running order the other machines that have lightened the rancher's burden somewhat. Man is still around in the West, and it is still that very special man who has always made the West exciting. He moves in much the same scenery and, oftener than not, on the same old dependable beasts or old work-machines. For anyone who knows New Mexico, Arizona, Colorado, Texas, Utah and Nevada, a special kind of thrill is to be found there that no other life affords.

Happily, there are painters who are not memorializing this way of life, but perpetuating it in the belief that it will never die. Their art is gentler, less dramatic, more every-day, than that of Remington and Russell, but it conveys no less powerfully the feeling that the West, while some-what tamed, has lost none of its virility or vitality. Of these latter-day Western artists, none is more successful at his task than Peter Hurd, and none has achieved more widespread and enduring recognition. For most Americans, he is *the* Western artist of today.

As artist and as person, Peter Hurd is a product of the West, although his father was a Bostonian who wanted his son to be an Army officer. Hurd attained an appointment to West Point but realized that drawing was more impor-tant to him than soldiering. He withdrew from the Point, briefly attended Haverford College, then enrolled at the Pennsylvania Academy and achieved his real goal as an art student. This was, simply, to get N. C. Wyeth (p. 200), whose illustrations for children's classics had enlivened and inspired Hurd's boyhood as it had many others, to teach him art.

The older Wyeth was a strong influence and a good one, but he himself recognized the dangers to students of his being too great an influence, and all his children and Hurd were individualists who could not be entirely dominated. As author Paul Horgan, a friend of the family, puts it, "Influences change; intensities to be true must always be born within the artist, not acquired from without." We have told of the life of art and the art of life enjoyed by this closely knit family, and young Hurd learned from all the painting Wyeths because it was that kind of family. He soon became part of it by marrying N. C.'s daughter, Andrew's sister, Henriette (p. 240), and the two have been artists of the Southwest ever since. But in addition to N. C. Wyeth, Peter Hurd very consciously studied and learned from Jan Vermeer (1632-1675), John Constable (1776-1837), J. M. W. Turner (1775-1851), Winslow Homer (pp. 138-143) and Albert Pinkham Ryder (p. 166), and from them and from Wyeth he developed his own style. Again Horgan states it well: "To select the terms for his effect upon the world became merely another manifes-tation of style; and style is of course the attribute without which neither art nor artist can exist."

We see the style he evolved in *The New Mill.* Hurd is a realist, but he infuses drama into the most common activi-ties. One difference between Hurd and his great predeces-sors, Remington and Russell, is that they looked for, found and painted the rare peak moments of action in the Old West: Cowboys on a spree after payday, gunfights at the corral and Indians hunting. Both, significantly, came West from a more staid way of life and were enchanted by such movement when the West seemed truly wild. In con-trast, Hurd grew up in the West and has always known it as home. Therefore, as a realist, he paints the more familiar life of everyday. Above all, his paintings convey the unique sense of the country, the endless miles of the dry plains, the austere majesty of the mountains under the sun and the measureless sky.

In *The New Mill*, Hurd subtly creates drama through the tensions of a construction project; the wires holding the mill in place; the men measuring the balance with poised eye and hand; and the great sky above, whose whim it will be to give the blades their life to bring the water from the arid earth. It is a gentle picture of man vying with nature, but the essential conflict is there. The technique perfectly complements the whole; nothing is overpowering. In this sense it matches the modern theater's concern, not with the great events of great people, but the ordinary, the prosaic, the moment in life, not the momentous.

239

HENRIETTE WYETH HURD

Portrait of My Father, *n. d.,*
Henriette Wyeth Hurd.
47-¼ x 53 in., oil.
Roswell Museum Collection,
Roswell, New Mexico,
gift of Mrs. N. C. Wyeth.

We have had some distinguished women artists in America and doubtless will see more in the future as changing circumstances make all careers more open to women. The list of women who have enriched our heritage includes Mary Cassatt (p. 168), Cecilia Beaux (1863-1942), Helen Frankenthaler (p. 288), Georgia O'Keeffe (p. 216), Isabel Bishop (p. 280), Loren MacIver (p. 276) and Henriette Wyeth Hurd. Of them all, only the latter came to art through the deepest and best marked channel, her family. I am sure the fame of her father and brother have created for her a dangerous course through which to navigate in order to find her own artistic identity and recognition. But for this immensely talented woman's work there is a devoted public. For that public, Henriette Wyeth is very decidedly an individual personality, totally on her own, her style easily distinguished from those of her father N. C. Wyeth (p. 200), her brother Andrew (p. 274), her husband Peter Hurd (p. 238), her nephew Jamie Wyeth (b. 1946) and any other related talents yet to bloom in this amazing American art family.

That family was headed by Newell Convers Wyeth, the dean of American illustrators. From what we read of their life, it was family first and art for all. Though they were in no way forced into art, if any child showed a glimmer of light in that direction, it was fanned into flame by the family's artistic environment.

None of the Wyeth family has ever been afraid of hard work and that is what each child got under the direction of their father, whom the noted writer Paul Horgan called "the greatest natural teacher I've ever known." Henriette Wyeth, like her younger brother and sister, Andrew and Carolyn, learned at home under her father's instruction, but she was precocious and she soon felt the need to find her own way in art. She studied briefly with Richard Andrew in Boston and later enrolled at the Pennsylvania Academy of Fine Arts when she was sixteen. Her diligence brought her to her own style, and before she was twenty, she was exhibiting in national shows such as the Pennsylvania Academy Annual. Her still lifes are beautiful and technically perfect. She is the least illustrative of the Wyeths and one of the most imaginative; she does not tell stories but allows the canvas to tell its own.

Henriette is also an accomplished portrait painter, taking endless pains not only to catch a likeness but to make a work of art. Her portrait of her father is doubly a work of art: the portrait itself of the painter sitting with his back to his work, holding his glasses in hand as if in mid-conversation, thoughtfully, quietly intense; and the picture of the picture on the easel, in which the light, interestingly and as a kind of warrant for the artistic reality, comes from the opposite direction to that which illuminates the painter. The portrait can also be considered a

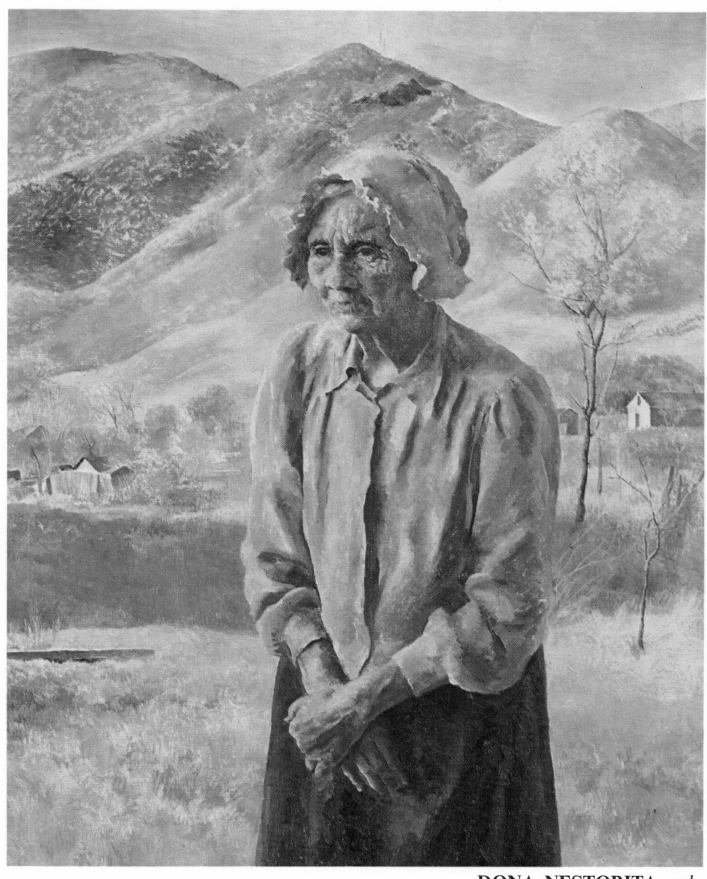

DONA NESTORITA, *n.d.,*
Henriette Wyeth Hurd (b. 1907). 46 x 37 in., oil.
Roswell Museum and Art Center, New Mexico,
gift of Mr. and Mrs. Donald Winston.

statement of artistic independence: Henriette here places herself apart from her father and his work by being able to regard both, to capture both on her own canvas, in her own terms.

Dona Nestorita is a long biography of a long life, a fact which gives this painting much of its dramatic appeal. The resignation to old age, apparent in the slope of the shoulders, is belied in the sharp eyes and determined mouth. Dona Nestorita seems a quiet individual but also a shrewd

one. Remarkably appropriate to the spare yet delicate style of Henriette Wyeth, the subject will live forever for us.

Whether out of pure coincidence or through complete consciousness on the part of the painter, the name "Nestorita" is an affectionate, feminine diminutive form of the name of the oldest and wisest counsellor among Homer's Greeks. The portrait completely embodies the idea.

241

CHARLES SHEELER

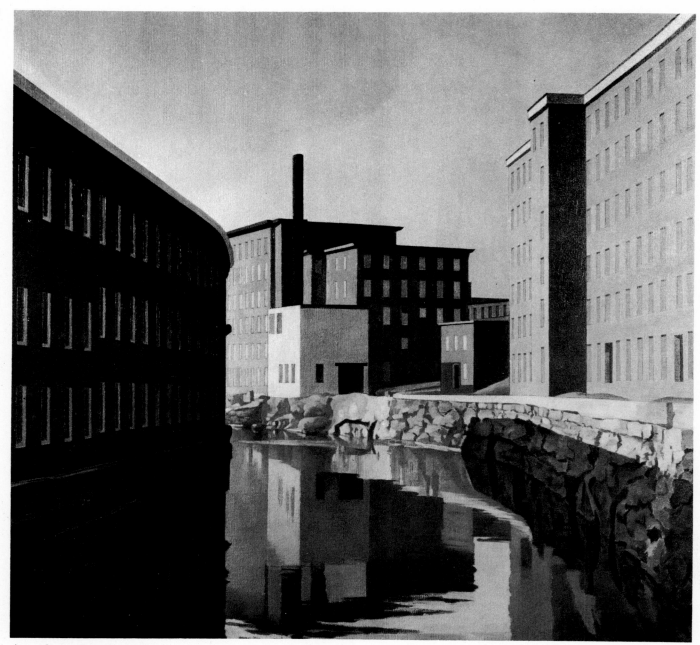

Amoskeag Canal, *1948*,
Charles Sheeler. 21-½ x 23 in., oil.
Currier Gallery of Art,
Manchester, New Hampshire.

"Art is self-inventory, that's all there is to it." Charles Sheeler's remark is as revealing and terse a statement as any artist is ever likely to make. His work emphatically illustrates what he meant, for his pictures are as precise as that statement. Sheeler was the product of this age of specialization, and his speciality was its speciality, the machine. Industry, its forms and its force, is the subject matter that caught and held the attention of this man who used the discipline of Cubism — which he first met at the famous Armory Show in 1913 that was revelatory to many American artists of the new European styles of art — to bring into focus the major landscape of our time.

Sheeler was a photographer before he turned to paint, and the great visual invention never had a greater exponent — once he left it. His intention as a painter was to create realism comparable to the camera's. Sheeler explained it thus, "The great realist offers a final enhancement — a plus. We get his vision of the facts as well as the facts. . . that final sense which I feel in a great painting — is like radium, extracted from a mass of pitchblende."

The pitchblende is what most of us take as the view of industrial construction; nothing to inspire, something to be accepted but overlooked. *City Interior*, despite the hard edge machines and the impersonal architecture which houses them, in spite of all the unheard clank and noise, is a tender, loving picture. Like Charles Demuth (p. 214), who also painted the industrial environment, Sheeler combined a geometric, Cubist style with generic American literalness. But Sheeler, unlike Demuth, did not delete human intimacy or warmth from his cityscapes. *City Interior* is as fresh as a well-conceived landscape; it has a natural pungency; it is poetic. It has that same feeling one gets walking through any great city before it is awake.

Sheeler's teacher, William Merritt Chase (p. 156), was a man far removed from him in every aspect of his art. Yet

242

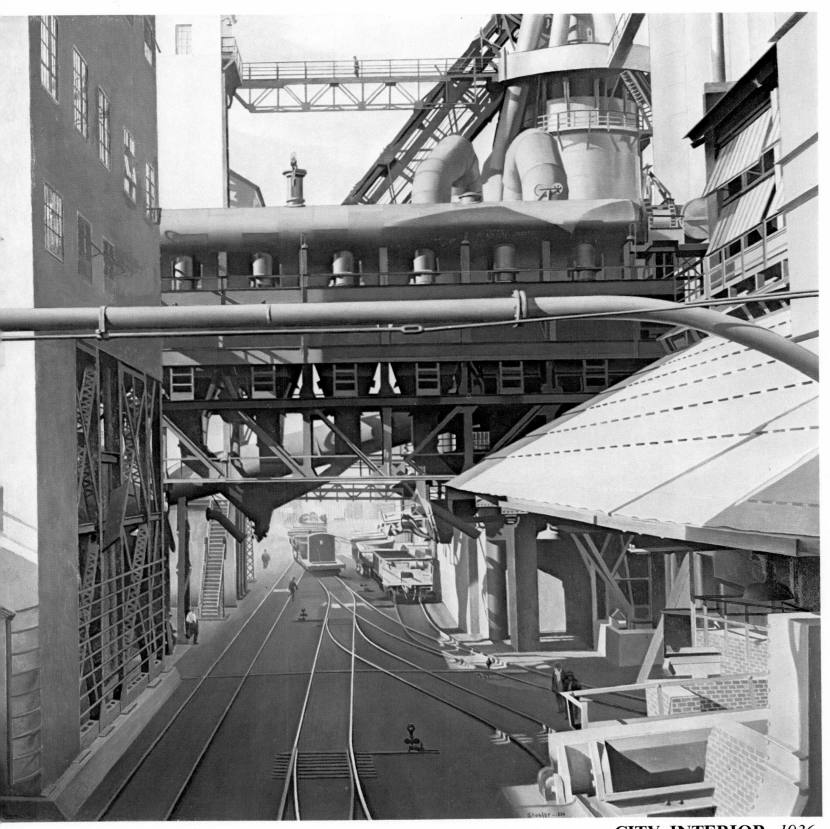

CITY INTERIOR, *1936,*
Charles Sheeler (1883-1965). 22⅛ x 27 in.,
paint on fiberboard. Worcester Art Museum,
Worcester, Massachusetts.

there are strange kinships in art that go deeper than style and subject matter. Both these artists had a passion for curious accumulations. Like Chase, Sheeler had no qualms about putting together a conglomeration of things and many experiences to make a picture. *City Interior* was based on photographs taken at the Ford Motor Company's River Rouge manufacturing plant ten years before he undertook the canvas. The camera may have taken the photos but it was Sheeler's inner eye that put them together, finally producing what might be called a mechanically perfect picture. Sheeler never regarded painting and photography as competitive arts but rather saw "painting being the result of a composite image and the photograph being the result of a single image."

REGINALD MARSH

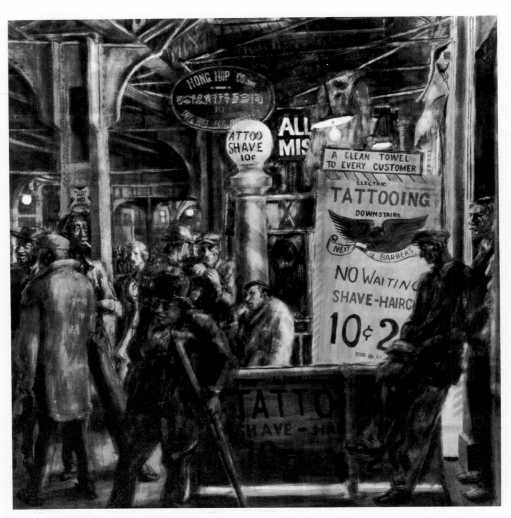

Tatoo and Haircut, *1932,*
Reginald Marsh. 46-½ x 47-7/8 in.,egg tempera.
Courtesy, The Art Institute of Chicago,
gift of Mr. and Mrs. Earle Ludgin.

The American city! Variously described as a concrete jungle, Babylon Revisited, or just plain Hell. It has been the subject of much of the art of our time in novels, on the stage and screen and in painting. The American urban nightmare has produced some frightening dreams and terrifying realities, and few artists have seemed forthright enough to tell it as it is. Those few "bold" ones are usually highly sensitive people who end their pretense of being tough in some form of self-destruction. If not all actually suicides, many of them have been swallowed whole by the violence which they may have been artistically equipped to handle, although ill-equipped to live in.

One of the few who got right down to the guts of the matter was Reginald Marsh. He did not tackle the city with close-ups of the single characters playing out the intense drama of urban life, but gave us a panorama that takes us beyond any phony nostalgia for the good old days to show it as it was when he painted it in the 1930's: bitter, disillusioned, sad.

Marsh does not waste his time trying to make us see the Depression years as part of our folk heritage. His is not the Frankie and Johnny, Bonnie and Clyde approach. He paints the city scene as a world unto itself, a man's world of toil, desperate pleasure, and, when women do come into it, it is often with a look of determination to get out. Even the floosies and burlesque queens seem to be transient in a male world. Titles like *Tatoo and Haircut, End of the 14th* *Street Crosstown Line* and *High Yaller* give clues to what he saw on his endless sketching rounds of New York.

All his life Marsh fought against the sensitivity he had within him and the elegance of his background and education. He graduated from Yale and worked for the most down to earth of all New York newspapers, the New York *Daily News,* for three years and drew for several top magazines, including the newly founded *New Yorker.* Throughout this period he studied with many of the most distinguished artist-teachers of his time — John Sloan (p. 194), George Luks (p. 222) and especially Kenneth Hayes Miller (1878-1952). Miller was one of those rare creatures who managed to keep his own career moving while exerting enormous influence on his many students. His relationship with Marsh was special, however, and Marsh never did a painting he did not show him.

Monday Night at the Metropolitan, although it depicts the upper crust of society rather than his usual down-and-outers, is one of Marsh's most successful paintings. It is a social document, but lighthearted. To look at it closely is to have a ticket to the grand cultural past that went with the Met's destruction. The orchestra and two box tiers are superbly populated with a delightful cross section of our society. You can almost tell how much each group's seats cost. And the expressions on some of the faces are a documentation of human reaction to mass culture. Only Marsh could have managed this with such irony, wit and masterful technique.

244

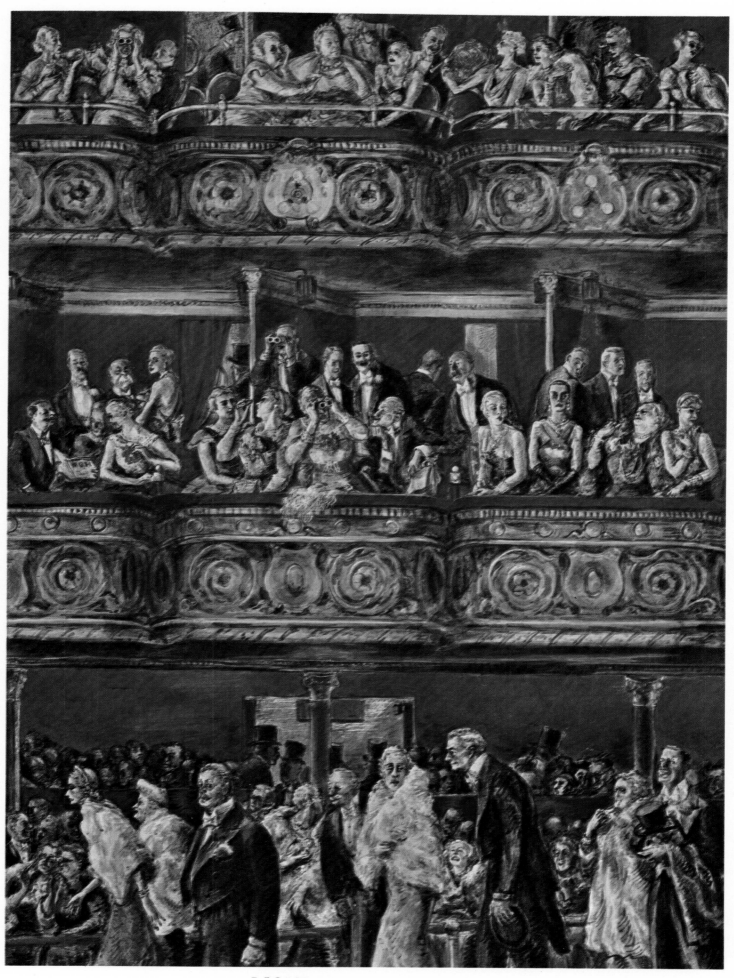

MONDAY NIGHT AT THE METROPOLITAN, *1936,*
Reginald Marsh (1898-1954). 40 x 30 in., oil.
University of Arizona Art Gallery, Tucson.

ARSHILE GORKY

During his lifetime and over the few years since his sad death by suicide, other artists and some critics have found in Arshile Gorky's work and in his life the synthesis of modern American art, although it was not until after his death that he was generally recognized as one of our foremost artists. Still this artist, born in Turkish Armenia, is difficult to align clearly with any one culture, Middle Eastern or American. So much of his aesthetic and intellectual acuity shows through, however much he attempted to shield himself and his work with his self-created personality of the neglected Bohemian peasant. Yet it is difficult not to be taken in by both, for Gorky is a very personal artist, even for many who do not like modern art, and he was a very personable human being to all who knew him or have heard his story. What might appear as arrogance is revealed by his longtime friend and dealer, Julian Levy, as "devotion to a self-appointed mission. Art was a religion for Gorky, and in a museum God was in his temple and Gorky was his prophet." Levy's beautiful tribute to this "very camouflaged man" tells of the artist's choice of the name Gorky, meaning "the bitter one." He deliberately

Tracking Down Guiltless Doves, *n.d.,*
Arshile Gorky. 11-½ x 15-½ in., oil.
San Francisco Museum of Art, gift of Robert Howard.

created a "climate of unhappiness" around himself and lived the part he wished to play in that climate as a gardener tending the art of his time.

The most beloved flower in that garden was Picasso. He tended every leaf and bud of the master's work until the final bloom belonged as much to him as it did to the original plant. Gorky's early paintings, especially a sensitive portrait of the artist and his mother, almost look like early Picasso paintings. Later Gorky emulated the master's Cubist works. But in the work for which Gorky is best remembered and revered, although Picasso is always present, his work is not. It is all Gorky. The mature Gorky left behind his former idol in the creation of his own idol, which he quite properly worshipped as himself.

Perhaps this sounds pretentious, but one needs many clues to find the full meaning of Gorky as a man and as an artist. He went through as many periods in his art as he did moods in his life, and there is a kind of passion about his art that reflects into his life, even to the final tragic moments of his disillusionment with art and life and passion in suicide. Everything, in the light of his suicide, seems to point to this final act. There is an obvious kinship with Van Gogh, especially in the last, frantic years of painting.

Enigmatic Combat may say more than any person can about Gorky. His life was just that, an enigmatic battle. We see it here in this 1936 painting when he was at war to win his own identity over the influences he deliberately chose as opponents. Picasso and others were the friendly enemies

ENIGMATIC COMBAT, *ca. 1936,*
Arshile Gorky (1905-1948). 35¾ x 48 in., oil.
San Francisco Museum of Art,
gift of Jeanne Reynal.

who, by drawing him into battle, taught him to make war in his own fashion. The Spaniard Joan Miró (b. 1893) painted unidentifiable but suggestive figures, sometimes called "biomorphs," that served as a point of departure for some of Gorky's distinctive later works.

Earlier I said I found it difficult to identify him as an American artist, yet his fight for his own style is analogous with the American War of Independence. Both are struggles to be free from foreign influences. He, with other immigrants or first-generation Americans like Willem de Kooning (p. 262), Hans Hofmann (p. 260), Mark Rothko (p. 292), William Baziotes (b. 1912) and Adolph Gottlieb (b. 1903), did triumph and bring about what many held to be the first truly American style of painting, Abstract Expressionism. Gorky in particular was an important precursor of and instructor to this influential and creative post-World War II movement. He provided a bridge from what had been done to what would be done. A journey through his career gives visual documentation to his conflicts and his position among American art personalities.

WALT KUHN

TRIO, *1937*
Walt Kuhn (1880-1949). 72 x 50 in., oil
Collection of the Colorado Springs Fine Arts Center
gift of the El Pomar Foundation

If ever there should be a plaque put on a site commemorating an historic event, it should grace the place of the Sixty-Ninth Regiment Armory in New York City. February 17, 1913 was the date an event took place which has been known ever since as the Armory Show. Its participants, some three hundred of them, were a regiment of artists, half in number of the six hundred in the Crimea, but their act was every bit as heroic, and the results of their battle far more tangible and lasting. It brought about an art revolution in America that, instead of freeing us from any single part of the world, tied us to all of it.

America as a nation was not quite a century and a half old, and though made up of people from all nations, was isolated from the Old World not only geographically but ideologically. Our intent was stressed in our industrial economic bent; our arts were struggling for a purpose that would be equally electrifying. Once again it was "the old countries" that came to our rescue, but this time it was as a league of nations, not just one or another, and the universal trumpet of art was to be the shout heard around the world — from the world, this time including America. The Armory Show was the first great gathering of modern art.

Two of the organizers of this historic moment were Arthur B. Davies (p. 212) and Walt Kuhn. They were worlds apart as people and artists, but they were both devoted to an ideal that, on a certain level, admits to no differences — art. Davies was a highly sensitive man, almost a recluse, whose art was poetic, romantic and gentle. Kuhn was an extrovert, outspoken, but an artist who had not quite found himself as such at the time of the great show. Davies's background was one of formal learning and training; Kuhn, on the other hand, had to form a style which would fit him from his jack-of-all-trades ability to do almost anything in the arts.

Kuhn was an intensely American man, proud of his German-Spanish-Irish background, but, as he dubbed himself, a "yankee doodle boy." He had trained himself thoroughly in art history of all eras, but it was the contacts he made in search of Armory Show participants that gave him the inspirations that led to his final vital and highly individual style.

Paul Cézanne (1839-1906) was a big discovery in his life. This most important of modern art innovators had a tremendous impact on him, as did Georges Rouault (1871-1958) and the whole Post-Impressionist movement, the Fauves, the German Expressionists, everything that made the Armory Show the turning point for all American artists. Everyone was busy, after this jolt from Europe, discovering how they could use it to move beyond the jaded traditions of American art of that time. From beginnings as a competent Impressionist, Kuhn's style leaned toward the bright, dramatic effects of Expressionism, but it was not until he was nearly fifty that he hit his stride with his quixotic figures and had his first big one-man show. Very few of his paintings survived from the interim period; he simply destroyed what did not satisfy him.

By 1929 he had arrived at a style which in the next few years was to produce some of our most exciting paintings. Let us call it the Kuhn style, for it is inimitable in its pure, even blunt, statement — a quality that grew from his struggle against his impulse to be merely graceful or pleasant. In 1929 he painted *White Clown,* and this very direct approach to subject matter was to serve him until he died at sixty-nine in 1949.

The aristocratic *Trio* is Kuhn at his best. The straightforward pose and the flat background make you feel the acrobats are going to step out of the picture to perform. Kuhn often had others set up his still-life compositions so that he could approach them in surprise. The story behind *Trio* is

The Young Clown, *1945,*
Walt Kuhn. 10 x 8 in., oil.
Arizona State University Art Collection, Tempe.

that the three acrobats, who had posed for him singly, suddenly asked him what pose he wanted the three of them to take. In panic he asked them how they themselves wanted to pose, and with the customary "hup," the center figure, Mario, brought them into performance position.

Kuhn knew circus and vaudeville life from childhood. He loved the glaring but crowd-pleasing bad taste of stage colors. If it seemed beyond reality to some, it was very real to Kuhn. In each of the famous paintings of clowns he catches this quality of theater: a world within a world. These are his best-known pictures, and one cannot help but feel that in them the long trial to which he put his talent finally paid off. Along with the startling paintings of Marsden Hartley (p. 236), Kuhn has produced some of the strongest works in American art.

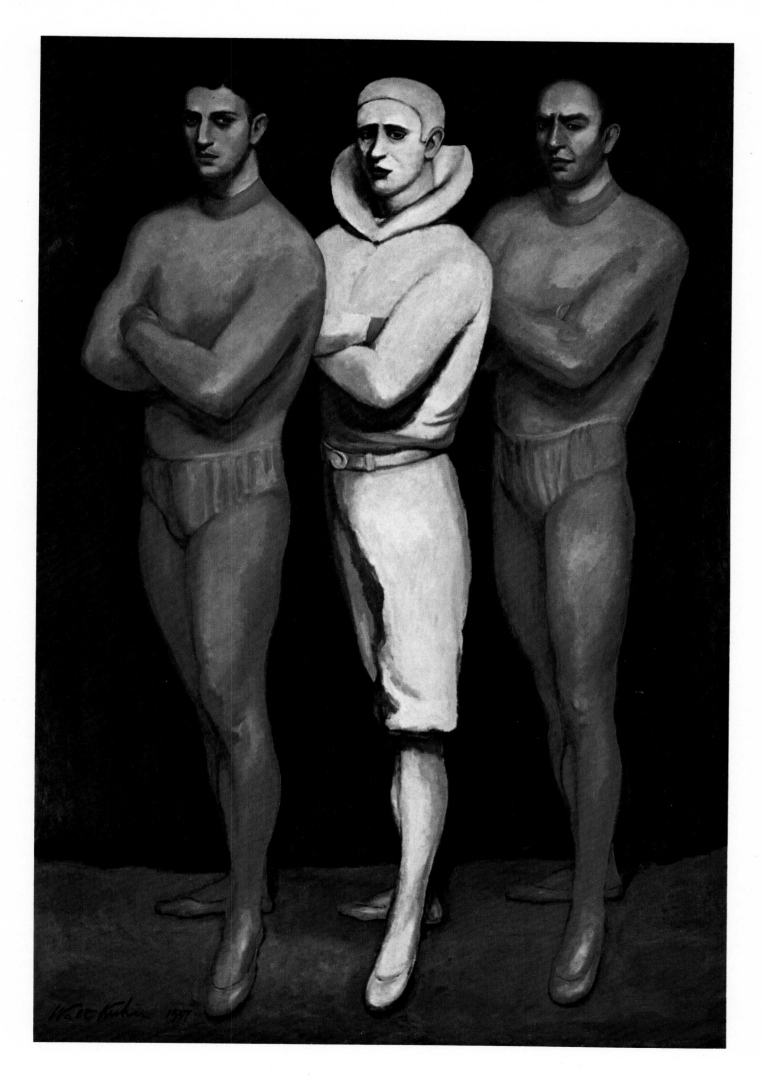

MORRIS GRAVES

Flight of Plover, *1955*,
Morris Graves. 36 x 48 in., oil on composition board.
Collection Whitney Museum of American Art, New York,
gift of Mr. and Mrs. Roy R. Neuberger.

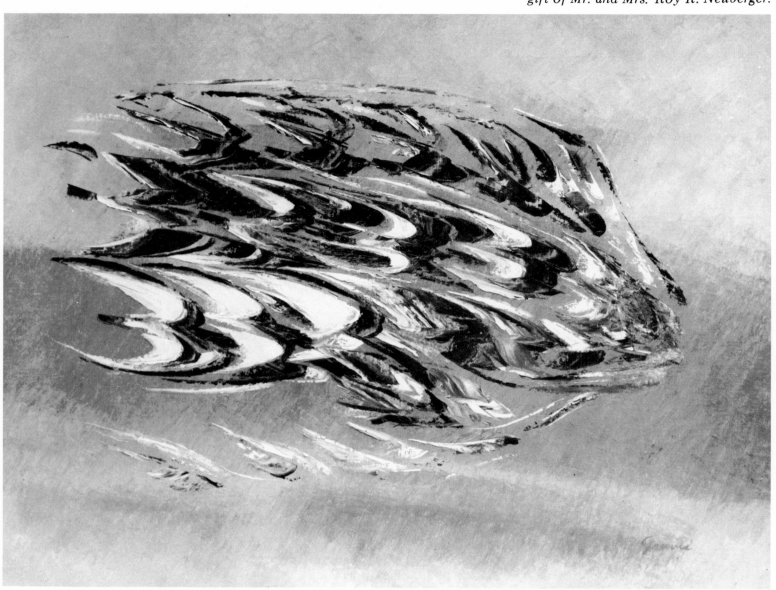

When I saw Morris Graves's *Blind Bird* and the other wonderful creatures of his world of the inner eye at the Museum of Modern Art in the early 1940's, I realized at once that I was meeting a very special artist. While the history of art has afforded us many unique talents from Hieronymous Bosch (ca. 1450-1516) to Paul Klee (1879-1940), there have been few who were so divorced from humanity's world that they became a part of nature itself. Graves joins William Blake (1757-1827), English artist, poet and mystic, as another who created a world of his own out of this world. Each is unique by any definition.

But beyond that, and hence uniquely unique, Graves's watercolors and gouaches, crafted with the most natural of lines, are capable of divorcing us from our own troubled humanity and allow us to do so the more we let ourselves enter Graves's vision. It is not difficult, for Graves takes us back to a purity of seeing, the same purity with which we once saw the simplest things — a bird, a tree, a snake. With Graves's clear patterns in our inner eyes, we can follow his flight as, whether soaring and resting, he contemplates other parts of nature, as in *Flight of Plover*. Graves shows us the way into the earth, or how to be upon it or above it, as simply as though we had, in fact, discovered those most surprising natural secrets ourselves.

One of the supreme functions of the artist is to assist or even force us to escape our own limited vision through and into his. Graves painted a picture some little time after those first ones at the Museum of Modern Art called *A Time of Change*. Through it, I began to wonder about one of nature's greatest mysteries, the death of wild things. Where do they go, those billions of creatures through the ages? They change from life to death, simply, seasonally.

If the world of Graves seems limited because it does not include humanity, one must admit it is as large as nature herself, excluding us only in our unnaturalness, in the complexities heaped upon us by our human nature. His influences are from nature directly or from those men only who were directly concerned with it: the poets and priests of the Orient, the Zen Buddhists, the early artists in bronze, the sculptors of Chartres. With Mark Tobey (p. 254), almost a generation older than him, Graves, who was born in Fox Valley, Oregon, co-inherited the Oriental art language, the calligraphy, which together they changed from black to white writing to paint. Graves takes refuge in the same spiritual places, in contemplation. In his own words, Graves paints "to rest from the phenomena of the external world . . . and to make notations of its essence with which to verify the inner eye."

With Tobey, Kenneth Callahan (b. 1906) and Guy Anderson (b. 1906), he makes up the Pacific School of our Northwest, who, in varying degrees, all came under the influence of the Orient. But Graves alone, or at least most effectively, avoids the human vitality of that exciting part of our country in order to explore everything else about it, the everythings of nature. The poet and the painter mingle and marry in Graves to visualize the strong ties of man and nature which are too often undone in the human struggle.

Blind Bird is a masterpiece from a period beginning about 1939 when Graves, who works in series, did several particularly evocative depictions of birds. The subtle tonalities of gouache have been applied to the thinnest of mulberry (Japan) paper and help to convey Graves's belief that the bird is a symbol of solitude and the environment of solitude.

BLIND BIRD, *1940,*
Morris Graves (b. 1910).
30⅛ x 27 in., gouache on mulberry paper.
Collection, The Museum of Modern Art, New York.

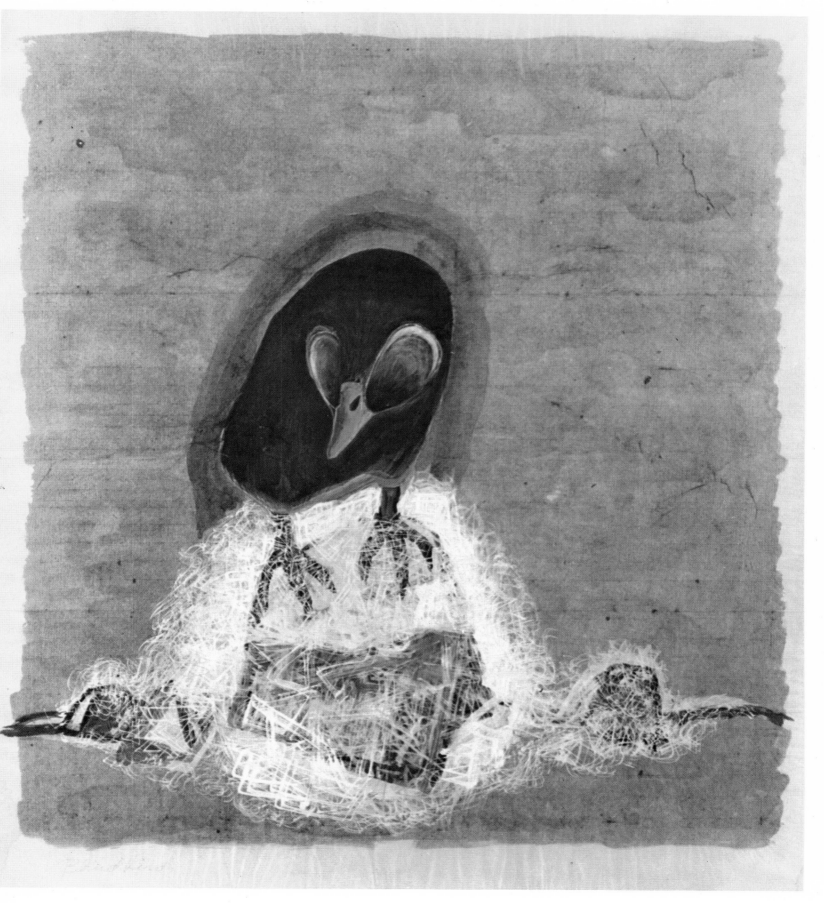

ARTHUR G. DOVE

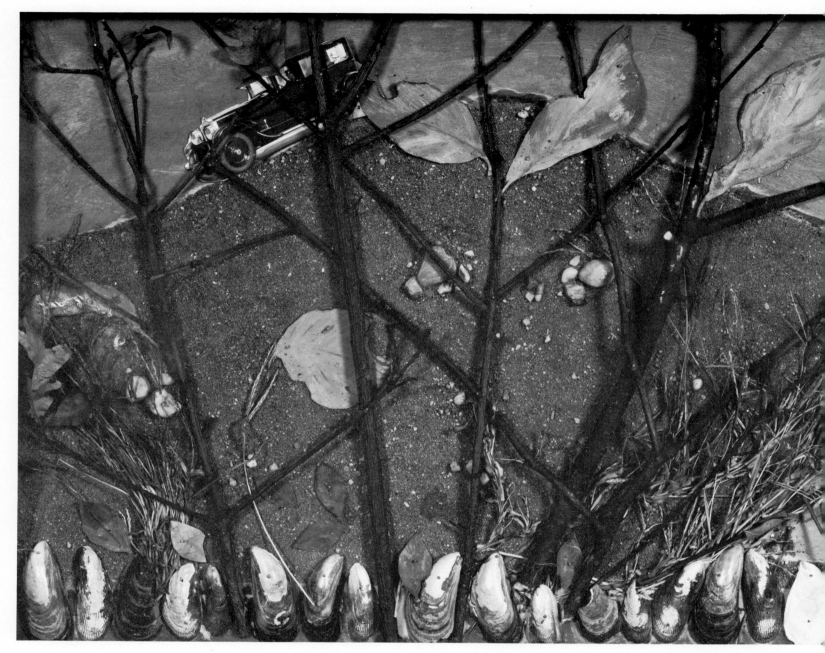

Long Island, *1925*,
Arthur G. Dove. 15 x 20-3/4 in., collage on painted panel.
Courtesy, Museum of Fine Arts, Boston.

There are some artists who must absent themselves from the world to find their own private one. The obvious does not attract them, nor do the works of man. Only nature can fulfill their need to be at one with life and with themselves. Sometimes these strangers to life, as most of us know it, are extremely articulate about what they want both in their art and in their limited conversation with the outside world. Arthur Dove wrote from his secluded Connecticut farm home: "I should like to enjoy life by choosing all its highest instances, to give back in my means of expression all that it gives to me, to give in form and color the reaction that plastic objects and sensations of light from within and without have reflected from my inner consciousness. Theories have been outgrown, the means is disappearing, the reality of the sensation alone remains. It is that in its essence which I wish to set down. It should be a delightful adventure."

How very few of us, artists or not, can state our intentions in life so succinctly. And even fewer can live up to those

intentions. Arthur Dove succeeded and his life was "a delightful adventure," and for us, so also his art. His work is serene, simple, communicating to us what we so desperately need: contact with nature uncluttered by man's havoc on it. The light in his paintings comes from within and makes the color supplicant to the form. Line, form, light all complement each other. The appeal is a kind of uncomplicated sensuality. It is as direct as poetry or music are; it flows through us as an elemental vision. In a poem accompanying a 1925 exhibition at Alfred Stieglitz's (1864-1946) famous Intimate Gallery, he says, "We have not yet made shoes that fit like sand/Nor clothes that fit like water/Nor thoughts that fit like air. . . ." But his beautiful paintings seem to take care of these discrepancies in our frightened natures.

The Brothers #1 seems to justify his statement that "Perhaps that is the way the world began — with no one looking on," and perhaps it could be explained by his need to find proof of the brotherhood of man. In its perfection of line, form and color, there is a definition of how man

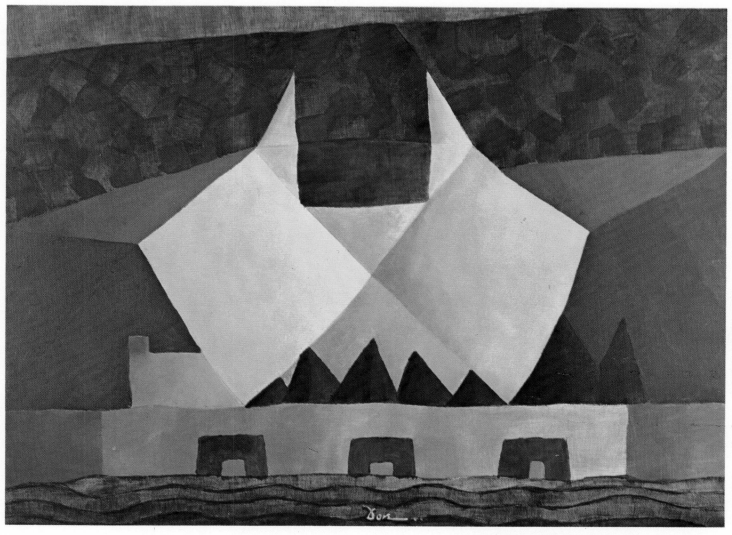

THE BROTHERS #1, *1941,*
Arthur G. Dove (1880-1946). 20 x 28 in., oil.
Honolulu Academy of Arts, gift of the Friends of the Academy.

should live with himself and his fellow man. It is as pure as a sonnet and as systematically and logically constructed, coming to its conclusion with an almost religious or at least a moral fervor, dispassionate and yet fulfilling.

Arthur Dove is one of the very few American artists who is in no way eclectic. Instead, he was uncompromising in his aim to find an independent inspiration for painting. In expressing himself through symbols abstracted from nature, he is entirely unmatched. He was a vanguard artist in the same sense that Paul Klee (1879-1940) the Swiss-German painter was, and yet neither man had direct influence on other artists except that they were both recognizably great in what they had to say to all artists — that the inner spirit is the ultimate source of all inspiration.

MARK TOBEY

As a milestone in the history of American and world art, Mark Tobey's work is leagues ahead of our present understanding. Though he is very responsive to the human figure and especially to the theme of man, nature and God, Tobey is most famous for his experimental form of painting, the non-figurative, unmistakable "white writing." Tobey responded with this new kind of painting because we are surrounded with wires, tracks, neon lights, jet patterns in the sky, the linear abstracts of modern life. William Seits in his monograph on Tobey says, "He has made line the symbol of spiritual illumination, human communication and migration. . .movement between levels of consciousness." He speaks of his "linear multiplicity," and there is no clearer explanation of those marvelous and mysterious "white writing" paintings of Tobey's mature period. They are a maze of contemporary life patterns.

There is no question about Tobey's debt to the Oriental influences and his choice of the Pacific Northwest as the place to receive this inspiration and to translate it into his particular Western idiom. In the proud isolation of that beautiful land, Tobey created a world that will become more and more familiar to us as we fully appreciate the peculiar beauty of modern life. Sometimes the "linear multiplicity" becomes so intense in this paintings that Tobey's world seems obscured as in a fog, but his intent is the same as the Japanese master artists who used fog to obscure some parts of nature to enhance others.

Tobey was born in Wisconsin and was educated in Chicago and New York. His youthful wish was to become a portraitist or sculptor, but this he found increasingly difficult "because we do not believe in man." Tobey moved to Seattle in 1922 to teach at Cornish School where he first came into contact with Oriental brushwork. Later he went to Shanghai and Japan to study their Eastern techniques of calligraphy. Now living in Switzerland, he has been greatly honored in his life, winning the ultimate accolades of first place at the Venice Biennale in 1948 and the Carnegie International in 1961.

Forms Follow Man is definitive of Tobey's attitude toward art. The forms of the title are evident in every stroke. Man is almost totally obscured and seems to have

Dragonade, *1957,*
Mark Tobey. 24-3/8 x 34-1/8 in.,sumi (ink) on paper.
Milwaukee Art Center, gift of Mrs. Edward R.Wehr.

FORMS FOLLOW MAN, *1941,*
Mark Tobey (b. 1890). 13⅝ x 19⅝ in.,
gouache on cardboard. Seattle Art Museum,
Eugene Fuller Memorial Collection.

run out of the picture while the fury of the forms which he has created still pursue him. Look very closely at the rush of line-forms — swoops, dots, shadowy strokes, slashes, zig-zags, swirls — and you can feel how forms follow after man.

Tobey's influence on modern painting has truly been great. His ability of seeming to allow the viewer free flight into fancy presages Jackson Pollock (p. 268) and other Action Painters. But where Pollock's passion gives his works a chance to live their own life with their own passions and temperament, Tobey is the careful director of what mental flight pattern he wants in the viewer's response. His lines move us into masses, mazes, nets or even molded figures. The line, plain and simple, has always

symbolized movement. Tobey has given it meaning also as the movement of human communication and illumination.

We have come to learn that there are many passions transmitted through art. In modern times we seem to be given the choice between the intellectual passion conveyed by abstract art or the almost physical passion of the Action Painters and the Abstract Expressionists. Tobey is of the former order, and order is the rule in his painting. There is complete logic behind every stroke of his highly inventive brush, and he gives us the same precise pleasure that we get from great music. According to Tobey, his art came about through the analysis of the chief movements in modern art, especially Cubism. His is a profound synthesis of all that is modern in art.

THOMAS HART BENTON

Thomas Hart Benton, the man, has caused so much controversy during his long life that critics have sometimes been hard pressed to do him justice as an artist. They have been one of his prime targets along with dealers, collectors and others on the periphery of the arts. Many have thought him insensitive to the many moods of modern art and the many manipulators and translators of it, but Benton's forthrightness has had its point even if time has made it seem as if he never made it.

But whatever his altercations with the art world, it cannot forget his creative talent. It was a talent that came equipped with a personality to fit it, and the one without the other might not have survived. Benton came into American art at a time we have much discussed here when our taste was unresolved. American art taste was so eclectic it could get no further than the docks of New York where it had landed from Europe.

Ballad of the Jealous Lover of Lone Green Valley, 1934, Thomas Hart Benton. 52-½ x 41-1/4 in., oil on masonite. Museum of Art, University of Kansas, Lawrence.

Benton had taken the European route, but he was different from most American artists who had gone before. Tom Benton was a Midwesterner. In different times he would have stayed in America as did George Caleb Bingham (p. 92) or George Catlin (pp. 74-77), but when he was in his formative years, an American artist was supposed to go to Europe to get what he needed to develop artistically. But Benton was a realist from Missouri and the fantasy world of Paris left him cold. There was nothing there for Benton but the museums, and there he found at least a language he could understand: the works of El Greco (1541?-1620) and Tintoretto (1518-1594). not the artistic revolutionaries such as Picasso or Henri Matisse (1869-1954), who were throwing the old world of art on the mat and watching it take the count.

His stories, the ones he knew and loved and wanted to paint, were not the kind that had been told so often that it was almost impossible to give them fresh artistic expression. His stories were the new old stories of the land

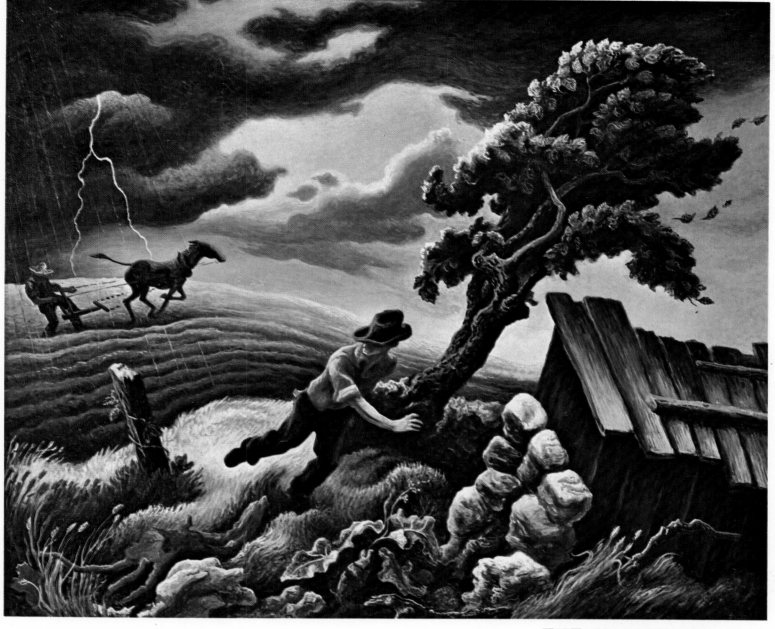

THE HAILSTORM, *1941,*
Thomas Hart Benton (b. 1889). 33 x 40 in.,
tempera on gesso panel. Joslyn Art Museum, Omaha.

where he lived, the tales of home, of Missouri and its people and their lives.

Benton's newly discovered Americanism hit America just as the people were ready for it. The Depression sent the nation into a desperate search for the real America, and at just that moment Benton arrived in national notice with a vividly American art, variously called Regionalism or The American Scene. He and his followers celebrated the common people in the back country of America. Benton also became the pioneer of a mural revival, pointing the way to the flowering of that all but lost art during the government art projects of the New Deal and perhaps to the super-size paintings of later decades as well.

The fluid quality in Benton's work, the quality that relates him to Tintoretto and El Greco, comes from a highly personal device he invented for himself, only to find that the Spaniard and perhaps the Venetian as well had used it centuries before. Benton did not merely make sketches or studies for a picture. For years he fashioned a small sort of stage set for each painting, with the figures made of clay, softened in the hand and drawn out into their proportions. That drawn-out look gives his figures and their settings a dynamic tension, an air of expectancy or foreboding and makes his realism a shade more convincing than life itself.

The Hailstorm to a Midwesterner is as literal a story as it is legendary. When the skies open up out there, as Benton had seen them, all hell breaks loose, crops are ruined, the threat is death to everything. It is Biblical in its implications, it is God's wrath; it is as familiar as the sacred words read in the parlor every night. Benton's affinity with Tintoretto and El Greco has as much to do with their preoccupation with similar dreadful events — storms over Toledo, Spain, or the Sea of Galilee — with man the puny victim of a greater power, as it does with their baroque approach to the themes portrayed. Man quivers before the vengeance of God and nature like a flame. He is distorted but recognizable in his anguish. The three great Regionalists, Benton and John Steuart Curry (p. 234) and Grant Wood (p. 228), went to the old masters, not the new, in order to create a manner of their own.

257

HORACE PIPPIN

The Holy Mountain, I, *1944,*
Horace Pippin. 36 x 30 in., oil.
Collection of the Encyclopaedia Britannica, Chicago,©William Benton.

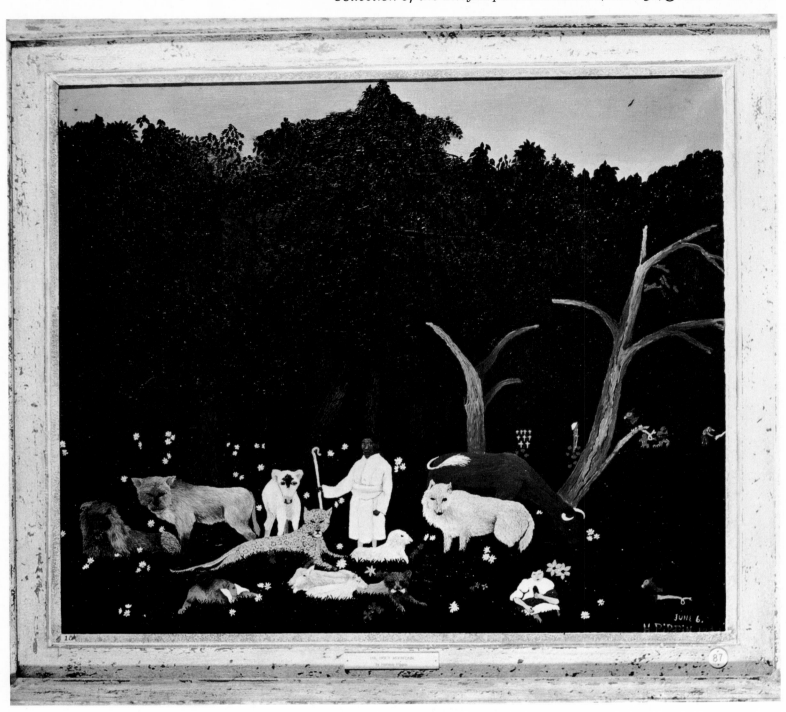

Horace Pippin is one of the most intriguing black American artists and, unfortunately, one of the few this country has produced. Perhaps we will see more now, for the interest in their creativity is high and the public in recent years has finally been introduced to their African cultural background which was, sadly, ignored during the centuries since blacks were first brought to the New World. The struggle that black artists continually have to undergo in order to survive this country is a lamentable comment on the generally accepted notion that art knows no racial boundaries — only talent.

Only a few black artists have succeeded in white America, such as the sculptor Richmond Barthe (b. 1901) and the painter Jacob Lawrence (b. 1917). Horace Pippin's popularity during his lifetime — his work was ranked with Henri Rousseau's, the noted French primitive artist — and his lasting reputation have depended on several things. He was a highly gifted primitive painter who had the capacity to grow artistically into a kind of sophistication that belied the charm and directness that is typical of the best primitive painters. He did not venture into subject matter beyond what he knew firsthand, either visually or emotionally. His style is free from any apparent influences, and he endowed each canvas with the color, design and technique he felt right for them. His comments about this are as direct as his painting, "Pictures just come to my mind and I tell my heart to go ahead."

What an uncompromising message from head to heart that was for a poor boy born in 1888 in West Chester, Pennsylvania. What courageous instruction that mind gave the right arm which, paralyzed from a World War I bullet, had to be guided by his good one. Pippin had to make pictures and nothing could stop him. But it took time, and not until 1937, at the Chester County (Pennsylvania) Art Association exhibition, did he begin to win recognition.

His subjects are so immediately a part of him you cannot imagine anyone else attempting them. One favorite is *The Holy Mountain*, which is very close in spirit to Edward

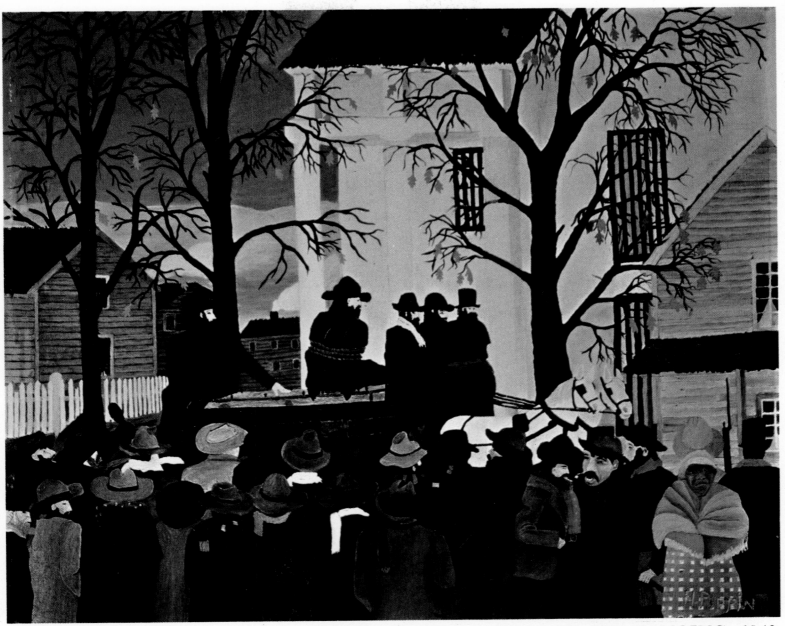

JOHN BROWN GOING TO HIS HANGING, *1942,*
Horace Pippin (1888-1946). 24 x 30 in., oil. Courtesy,
Pennsylvania Academy of the Fine Arts, Philadelphia.

Hicks's famous series of the *Peaceable Kingdom,* painted years before and obviously unknown to Pippin.

But for the sheer drama, forthrightness and inner conviction nothing touches *John Brown Going to His Hanging.* He told his friends how deeply he felt about this picture in a tender and moving letter. He felt it echoed Brown's own words when, bound to his own coffin, he approached the place of execution saying, "This is a beautiful country. I never had the pleasure of seeing it before." Pippin said his mother had witnessed the scene as a little girl, but one can credit only the artist for the visual impact the picture produces. The subtle use of color, almost a lack of color, the intricate patterning of the trees against the buildings and sky, the static somberness of the crowd, the old lady on the right who turns her back on the drama of man's inhumanity to man make it a lasting memory, one not easily forgotten. It is one of those paintings that is just right, and Pippin indeed makes us feel his head directed his heart to paint it.

HANS HOFMANN

FANTASIA, 19[...]
Hans Hofmann (1880-196[...]
51½ x 36⅝ in., oil, duco, casein on plywoo[...]
Collection of the University Art Museum, Berkele[...]
gift of the art[...]

Frederick Wight, in an article on Hans Hofmann, gives as splendid a clue to the enjoyment of his art as he does toward a realization of the man. "Hans Hofmann, at seventy-six, is a spectacle of health and exuberance, a man of a compelling physical amplitude. Rubens might have brushed him in; visibly he is a product of the baroque spirit." Such a statement fits a man like Arthur Rubenstein, too, when he walks out on the stage to play: The piano is singing his song. He looks at the keyboard and only sees the music which is already there. I have never seen a Hofmann canvas that did not have this kind of inevitability. Like Michelangelo in reverse, who looked at a block of marble and took away what he did not need, Hofmann looks at the empty canvas and fulfills the necessity he senses there.

Hofmann was born in Bavaria, was sent to Paris to study art and there met up with Henri Matisse (1869-1934), Georges Braque (1882-1963), Robert Delaunay (1885-1941), Picasso and Juan Gris (1887-1927). Matisse, who was in the Fauve movement at that time (a style notable for vivid colors in marked contrast to one another), was an important influence on the young man, as was Delaunay. Matisse's color is still evident, the raw strong color of the Fauves. As Wight suggests, however, the "Wild Beasts," or Fauves, were being tamed by the extraordinary discipline of the Cubists as exemplified by Braque and Picasso and Hofmann. The Fauves "became absorbed in Cubism." From this, Hofmann derived a style that, while clearly of both movements, was also close to German Expressionism with its heavy definitive lines. But Hofmann emphasized color, always color.

He became one of the most powerful teachers in America, and his own art changed radically. The object disappeared slowly and finally altogether. In an interview with Wight, he stated, "That was my whole influence on my students. . . . The object should not take the importance. There are bigger things to be seen in nature than the object." That is what he means when he speaks of his cosmology, what Wight describes as "the metaphysical world of his own creations. . .a way of seeing the Universe." But though Hofmann ignores the object, he says that in teaching: ". . .I discipline my students from nature. In the beginning with the figure — the model. . . . A very important thing. I say to my students, you must give with the least the most, not with the most the least. A thousand leaves are still not a tree, a thousand flowers not a bouquet. Greater you should go, simpler you should go. But simplicity should mean pureness, not poorness."

When Hofmann takes an object from nature to deobjectify it, he says, "I paint it very quickly. . . . Those from the imagination take longer." But perhaps another statement of his helps explain more precisely his art approach to us: "A picture must be made, dictated, through the inherent laws of the surface. I invented what I call 'push and pull,' force and counter-force." Charmingly he adds, "I have been very modest about it, but they really are great discoveries."

There is much conjecture as to who owes what to whom, Hofmann to Abstract Expressionism or vice versa. It does not really matter, for both forces are of their time.

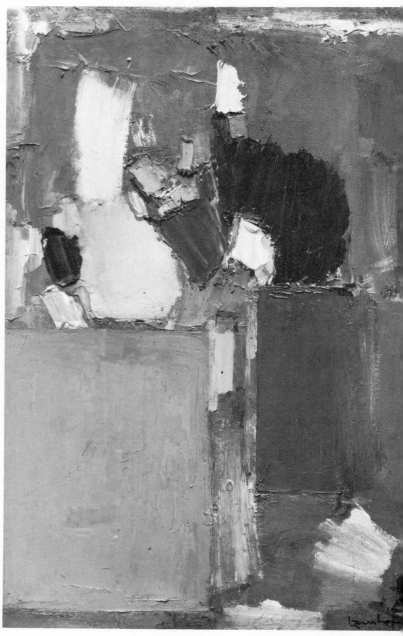

Ruby Gold, *1959,*
Hans Hofmann. 55 x 40 in., oil.
Memorial Art Gallery of the University of Rochester,
Marion Stratton Gould Fund.

No artist involved in the late 1940's and 50's could escape the time, a period of violence and almost complete revolution against the past. Wight's remark about Hofmann being "brushed in by Rubens. . .a baroque spirit," is a clue, uncluttered by metaphysical double talk. If you can throw yourself into the viewing mood needed to appreciate the passionate statement of the baroque — of Giovanni Bernini (1598-1680), Giovanni Battista Tiepolo (1696-1770) and Rubens (1577-1640) — you can enjoy *Fantasia*. The title tells us that this picture comes from somewhere deep inside the imagination of the man who made it. It is full of vitality, his vitality, it has the music of fantasia. It is a sensual experience.

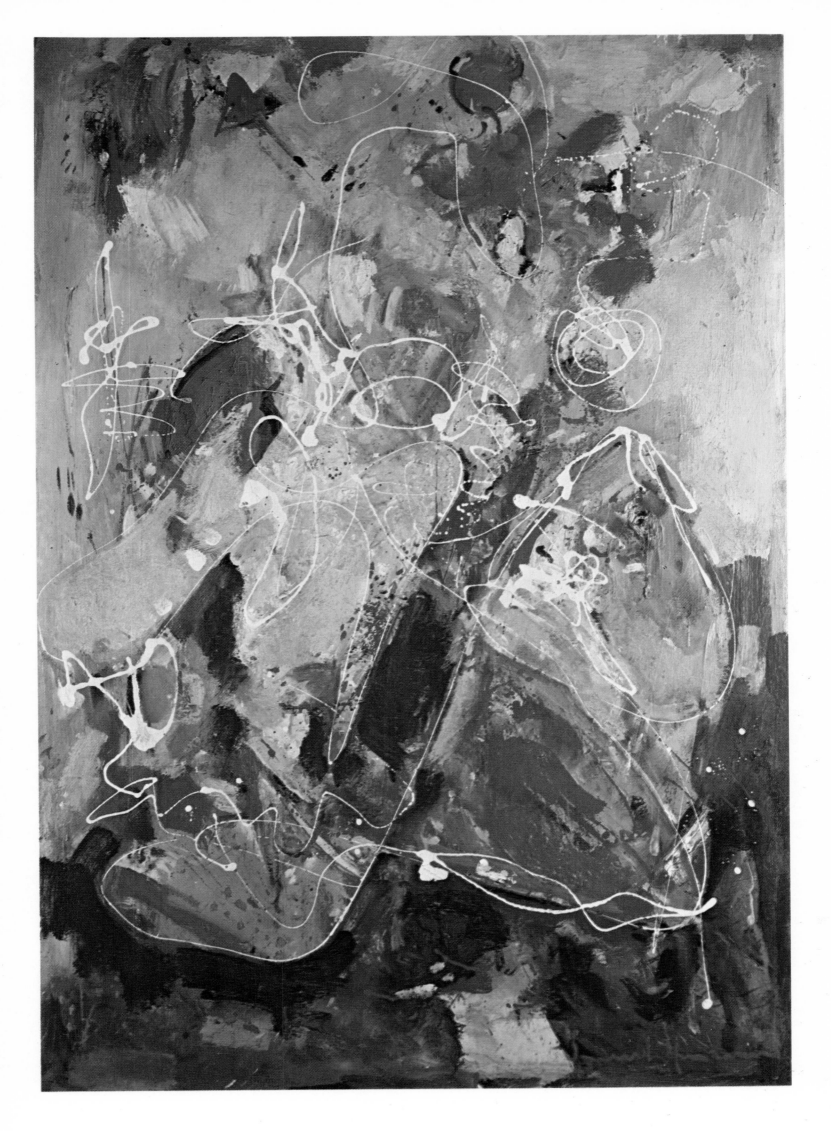

WILLEM DE KOONING

THE MARSHES, *ca. 1945*
Willem de Kooning (b. 1904). 32 x 23⅞ in.
charcoal and oil on composition board
Collection of the University Art Museum, Berkeley

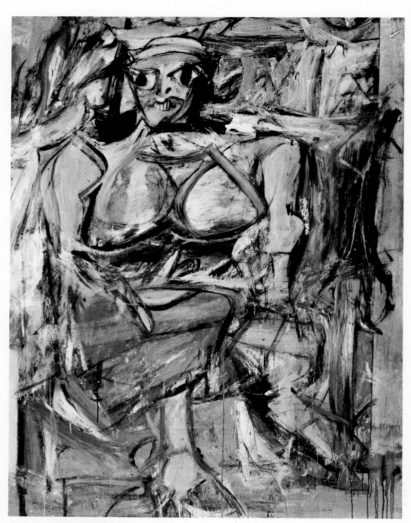

Woman I, *1950-52,*
Willem de Kooning. 75-7/8 x 58 in., oil with charcoal.
Collection, The Museum of Modern Art, New York.

In every age there have always been two kinds of artists: those who work within the existing tradition, with what has gone before, and those who, sensitive to changes in the society and all fields of contemporary activity, create a new art in tune with those changes. This latter group of artists often lead us into a new age of art and thinking, into a new tradition.

Willem de Kooning is decidely the latter kind of artist, the creator of a new tradition.

Human nature is always more comfortable with what it already knows than with something new, strange and foreign. Most people therefore find it difficult to keep up with the changing fashions in art. Avant-garde artists and especially their small bands of admirers, champions and dealers do not help matters: Their defensiveness can become a kind of snobbery that puts the public off even more than the new work itself. When they come close to an understanding, often another art movement is underway, and, once again, the public finds itself left behind.

Because America is a magnet for advanced ideas in all fields, our country has imported and produced many of the most advanced ideas in art. Being the polyglot nation we are, many of our inspirations still come from Europe and Asia, but they are so quickly assimilated and digested that they soon seem wholly American. In the past thirty years, the international reputation of our art has reached an all-time high, and many of the artists responsible for this change are primarily such first generation or newly naturalized Americans as Arshile Gorky (p. 246), Mark Rothko (p. 292), Adolph Gottlieb (b. 1903) and Hans Hofmann (p. 260). They represent a short but potent period in our relatively brief art history. One of the giants of the group is the brilliant, still controversial, but now firmly established leader of American art, the Dutch-born de Kooning.

De Kooning came to America from his native Rotterdam after a thorough traditional art training and some years of practice in commercial art. In New Jersey he began as a house painter, became a free-lance commercial artist in New York and worked as a mural assistant to the French painter, Fernand Léger (1881-1955). In one way or another, virtually all of these experiences may be traced in his mature work, including the broad brushstrokes of the house painter.

Through all the various jobs he took and handled competently to earn a living, de Kooning continually practiced his own painting, though for many years its only audience consisted of himself and his artist friends, most notably Arshile Gorky, with whom he shared a studio for some years. These two giants mutually influenced and benefitted each other, and, in turn, their influence spread to other painters. De Kooning is an outgoing man who is not bitter about his early lack of acceptance. His devotees and followers now are legion.

The culmination of de Kooning's search for his identification in the modern art movement was a huge canvas titled *Woman I.* It became, after its purchase by the Museum of Modern Art in New York City, the most widely publicized and reproduced work of art of modern times. It was painted in 1952, entered the museum's collection shortly after, and, in spite of its familiarity, still holds the public in awe and amazement.

De Kooning is such a pivotal figure in modern art, and he always will be in the mainstream of wonder at what art is all about. His associates in the arts are like the cast list of the great art drama of our time, musicians, poets, painters, architects, philosophers.

It is close to impossible to describe his painting. Everything depends on its impact on you, the viewer. However, if you must have a definition of his work, these words by the critic Thomas B. Hess may help: "One is reminded of. . . the temptation to which medieval monks were susceptible, an obsession that comes from a profound and sustained concentration on recurring forms and ideas. . . ."

Much of the impact of any of de Kooning's work is that we feel the artist, almost before our eyes, is struggling to discover what it is he wants to express and the best means of its expression, that each painting is a work in progress. *The Marshes* was painted in 1945, but in the forms we can see *Woman*, those forms that led to the famous *Woman I* in 1952, the "recurring forms and ideas." He used black and white enamels from his house painter's kit, some colors straight from the tube and a swift, whiplash line. The pigment was often thickly applied, built up to be even thicker, and then polished down to achieve unusual effects, combining the effects of bas-relief and collage.

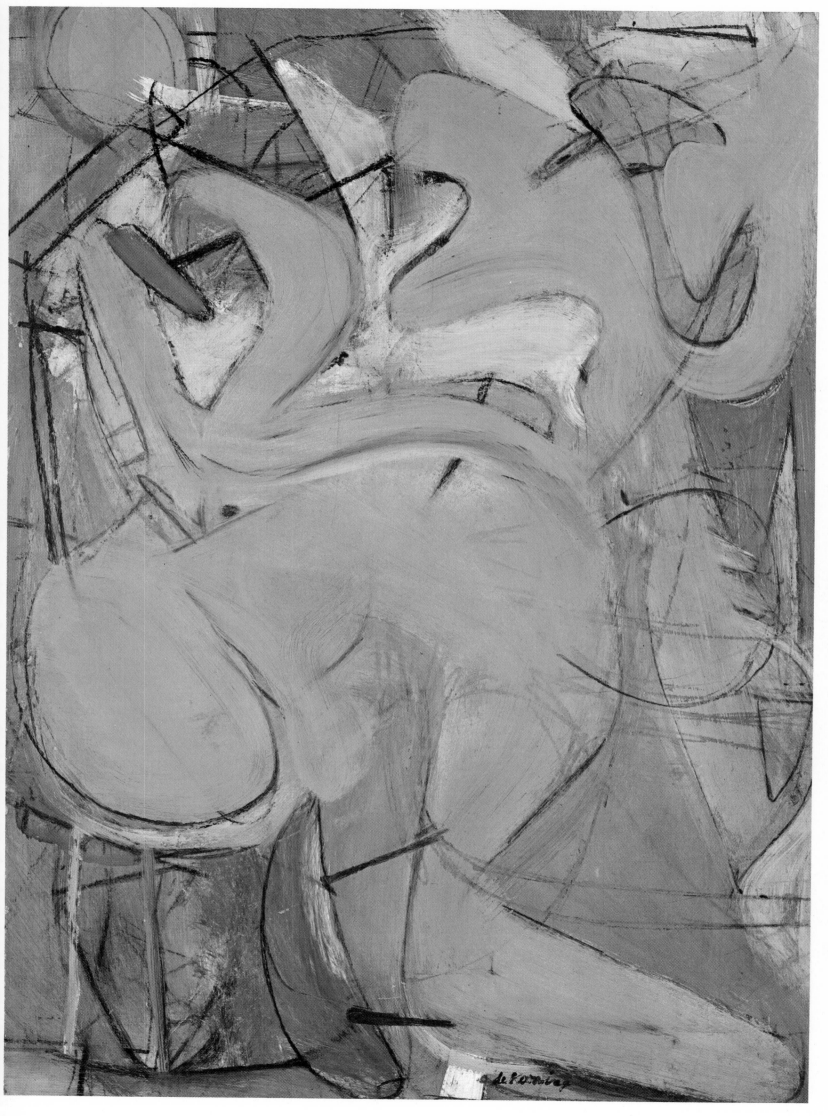

263

YASUO KUNIYOSHI

Deliverance, *1947,*
Yasuo Kuniyoshi. 16-½ x 13-½ in., oil.
Collection Whitney Museum of American Art,
New York.

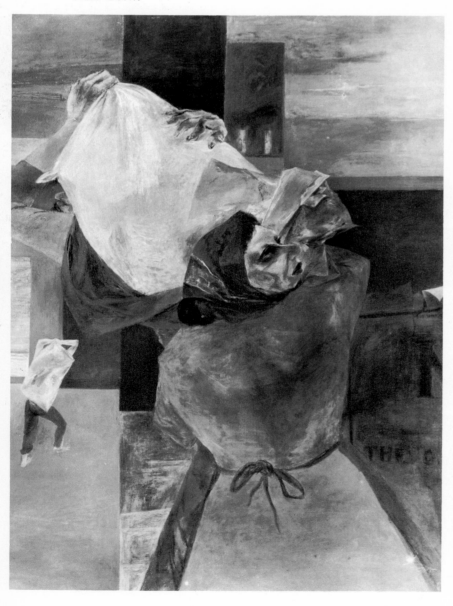

The innate good taste of Oriental art has had vast influence on world art ever since painters like James McNeill Whistler (pp. 152-155) and Mary Cassatt (p. 168) in Europe, and Winslow Homer (pp. 138-143), Mark Tobey (p. 254), Morris Graves (p. 250) and many others here came in contact with it. Several of our finest museums (Boston, Kansas City and Seattle) have major collections of Oriental art, and at least two Japanese Americans have achieved worldwide recognition, the sculptor Isamu Noguchi (b. 1904) and the painter Yasuo Kuniyoshi. In both men the Kipling admonition is put to the lie: East and West have met. What is more, they have blended into a style that is at once unique and enormously appealing.

Kuniyoshi left Japan to see America in 1906. He was seventeen and alone. He settled in Seattle, a city always in touch with the Orient, and he worked in the production of textiles, an art form in which his native land has always excelled. He earned enough money to repay his father for the trip, and feeling America to be his artistic home even in that short a time, he determined to become part of its then blooming art adventure. He went to New York where he was a fellow student of Stuart Davis (p. 224) at the National Academy studying under the great teacher Kenneth Hayes Miller (1878-1952).

His earliest exhibitions were scenes of Maine whose rockbound coast has much in common with parts of Japan. Oriental fantasy and their special use of perspective gave these works a genuine feeling of modernism, and, blending with his academic training, he began to show the sophisticated, fanciful style which was to be his trademark.

Women and children became favorite subjects in the later years, but when World War II was declared, social comment and satire crept in and made him a real force in the questioning art of that unsettled period of our history. And there is no doubt that Kuniyoshi was an American. "My art training and education have come from American schools and American soil. I am just as much an American in my approach and thinking as the next fellow." But because of his birth he was suspect and denied citizenship. His friends, most of the important artists of the 1920's and 1930's, rallied to his support. Perhaps the sadness, which he admitted inhabits his pictures, resulted from this feeling of exclusion, and though he denied any Oriental influence in them, it is definitely there.

A trip to Europe brought him further contact with world art, but he still retained much from the Orient — a delicacy of touch, the clear, vivid color of Japanese prints, and especially a hard-edge feeling that stems directly from the woodblocks of Utamaro, the seventeenth-century Japanese artist. *Look, It Flies!* shows these influences, a mastery of luminous color and precise form, and the subject matter — the love of simple toys — is unquestionably an Oriental inheritance. Yet it is a modern Western work and proves Kuniyoshi one of the most charming and sophisticated painters we have produced.

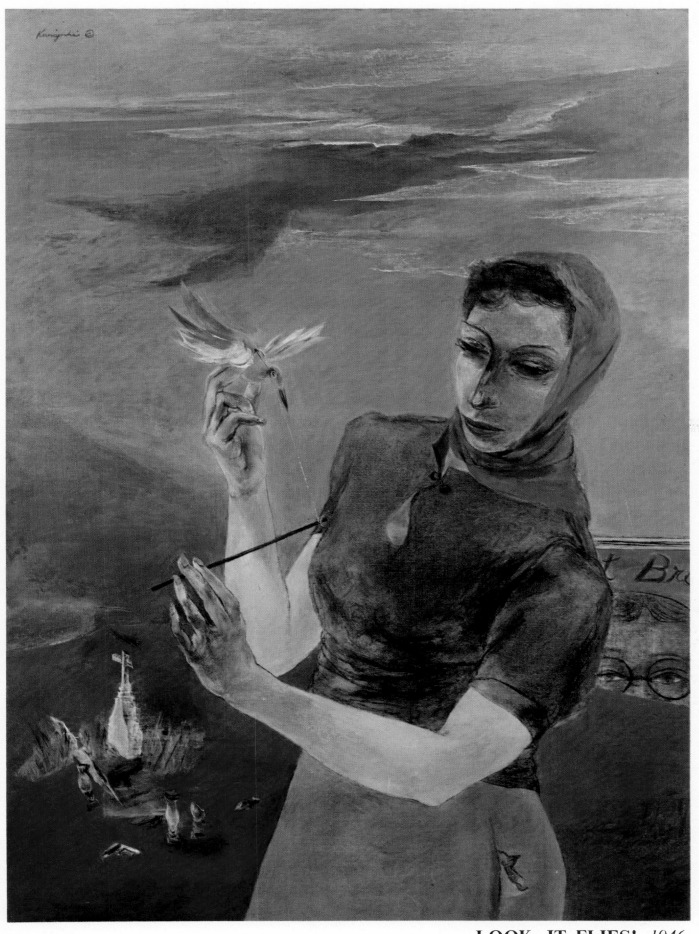

LOOK, IT FLIES!, *1946,*
Yasuo Kuniyoshi (1893-1953). 39¾ x 30⅜ in., oil.
The Hirshhorn Museum and Sculpture Garden,
Smithsonian Institution.

CHARLES BURCHFIELD

There is a great melancholy that lies over all of Charles Burchfield's pictures, whether they be his early watercolors of industrial scenes, the even earlier fantasies of his young manhood, or those last monuments to melancholy that have brought him lasting fame as one of our most spiritual painters. He once wrote to his dealer, Frank Rehn, that, "God is *in* his creation but separate from it." That is the feeling his later paintings seem to share with the artist: Burchfield is *in* them but standing some distance away so that he can be a spectator of life and particularly of nature.

This romantic melancholia ran throughout his life. He was a shy, inarticulate man working in a wallpaper factory but turning out pictures that conjured up the lost innocence of his youth. Not until he was forty-two, married, with five children, did he give up his factory job to paint full time. But while working at a job he hated, he turned out the factory and city scenes which gained him a national reputation as one of our best regional artists. Still he longed for a purity of soul he felt he had lost when he had strayed from nature. In truth, he never did abandon nature, investing even the most powerful of his industrial pictures with a natural environment of their own. The great buildings no longer seem man-made intrusions on nature but complementary to it, as if they had always been there and belonged.

Lavender and Old Lace, *1939/47,*
Charles Burchfield. 36-3/4 x 52-½ in., watercolor.
New Britain Museum of American Art.
Connecticut, Charles F. Smith Fund.

AN APRIL MOOD, *1946-55,*
Charles Burchfield (1893-1967). 49 x 54 in., watercolor.
Collection Whitney Museum of American Art, New York,
gift of Mr. and Mrs. Lawrence A. Fleischman.

An April Mood is one of the finest works from when he was in the middle of the final mood of his art. Now nature itself takes on a personality that is almost human, just as the factories, bridges and railroad yards of the earlier stage became the works of nature. Burchfield described this bleak April landscape as expressive of the anger of God — a Good Friday mood; it does not stretch the imagination too far to visualize the tragic scene of the crucifixion taking place here. The three trees wait with their heavy burden, and the grief-stricken spectators look on from the distance at the side. The wrath of God weeps from the sky, and all seems to be lost. But there is also promise of order coming out of chaos in the furrowed field that waits only for a touch of sun once again to produce the sustenance of life.

This picture, which seems so spontaneous, took nine years of spasmodic concentration to complete. Burchfield would leave it for months at a time, then return to labor more on the bitter mood he wanted. This process of seeking and finding the exact mood for each picture is what makes one able to share in its rightness. Nothing is left to chance; it is precisely the way Burchfield meant it to be and for you to see it. Technically he is a very mature artist, but his craft is sublimated to the effect he wanted to achieve, an effect that had to emerge from him in order to be felt by the viewer. The mystery we are made to feel comes less from his strange style than from our awe that anything so intensely private can be even partially revealed to us.

JACKSON POLLOCK

GALAXY, 19..
Jackson Pollock (1912-1956). 43½ x 34 i..
oil and aluminum pai..
Joslyn Art Museum, Oma..

Guardians of the Secret, *1943,*
Jackson Pollock. 48-3/4 x 75 in., oil.
San Francisco Museum of Art,
Albert M. Bender Bequest Fund.

Abstract art, by the very definition of the word abstract, means it is up to the beholder to see what he wants to see. The artist presents you with his emotions, and it is up to you to say if they appeal to you or not. Abstract art is no more abstract than the definition of love. One man's love is another's hate. Love, beauty, truth, honor are all abstract nouns, but we accept them as such and so we must accept the emotional art of Jackson Pollock. In a brilliant short documentary film made on him, Pollock explained that his purpose in the "controlled accidents" he let drip or slide from his brush were done "because a painting has a life of its own. I let it live."

Do not be misled into thinking that Jackson Pollock was a disorderly opportunist who took advantage of the violent, disassociated world of his time and played tricks of equally disordered violence on his public. He was an extremely well-schooled painter who saw his time in the perspective of horrendous upheaval and reported it with no more or less realism than what he saw around him. He was witness to an age of cataclysm and his paintings are apocalyptic — they are the revelation of the age in which we live.

Born in Wyoming, Pollock, like his father, was an itinerant, always on the move before he finally settled down in New York. He battled with poverty and with drink and with an even tougher opponent for an artist, critical neglect. The patronage of the collector and dealer Peggy Guggenheim not only supported Pollock when he was finding his own way in art, but introduced him to one of his two basic influences, the refugee European Surrealists whom Miss Guggenheim had helped to escape from Hitler's conquered France.

But before he came under the influence of the Surrealists, Pollock was the student of Thomas Hart Benton (p. 256), the fiery advocate of Americanism and individualism in art. That unlikely combination is the key to Pollock's highly original, ground-breaking manner of painting, one which has influenced, directly or indirectly, almost all younger American painters and one which made him, in my opinion at least, the greatest American painter of the twentieth century since John Marin.

From the Surrealists, besides the stimulation of an intellectual atmosphere always open to any possibility, Pollock learned to have faith in the subconscious as a source of art and, specifically as a means of opening the subconscious, he learned the Surrealist technique, borrowed from early twentieth-century spiritualism, of "automatic writing." For Surrealists it meant, in poetry, the chance juxtaposition of words or phrases; in painting it meant either the chance juxtaposition of images or the creation of surface accidents which might suggest images, as they are sometimes suggested by cloud formations.

Communication is perhaps the most crucial word of our time. Lack of it has caused much of our unhappiness, much of our violence. The visual language of the Action Painters such as Pollock, which came into art in the 1940's and 50's, was needed, for what was left of "the ideal" after World War I was almost totally destroyed by World War II. The atomic bomb shook the whole world, if not as lethally, at least as forcefully as it did Hiroshima. Suddenly there was a tangible threat to every man's existence, and the artist, historically among the first to answer a call to action against threats, went into action. He saw the writing on the wall quite literally and answered it with his own. From the Orientals Pollock acquired the habit of painting on a limp canvas on the floor. Thus he was able to walk around it, "get acquainted" with it, even get into it. He dripped liquid paint upon the canvas, in lines and splashes and great, swinging arcs. He has been accused of being accidental in his method of work; this, too, is Oriental, but the accident must be controlled. He denied the accidental, calling his approach direct. He also called upon the subconscious to make his attack on the canvas, feeling that each work of art has its own life and the painter was in a sense the medium that called it into being.

If you need an explanation for *Galaxy,* look to the stars. Today, when we can accept without batting an eye the impertinence of man on the moon, why should it be difficult to open our eyes to man when he explores the further away realms of his imagination? Perhaps that is what Pollock is trying to tell us — that no matter how far man reaches physically into the unknown, he can reach much further in his dreams, his aspirations, his spirit.

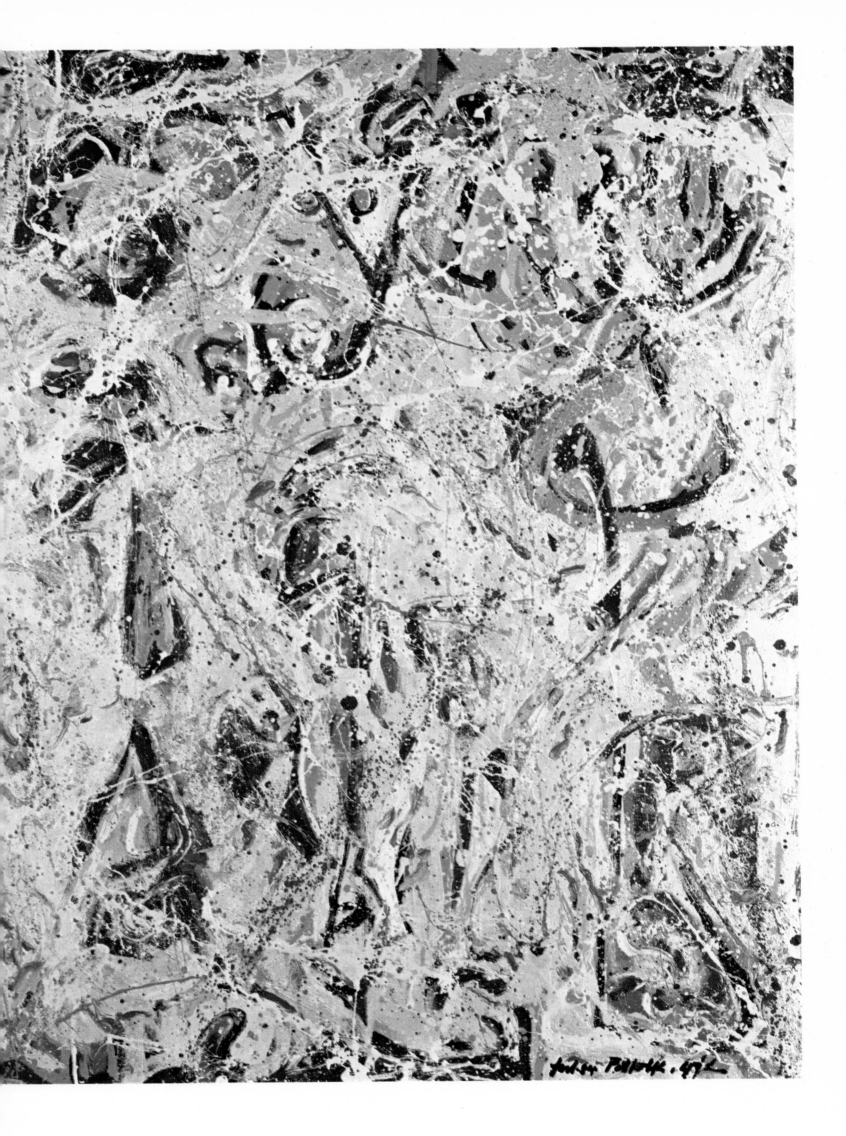

269

PHILIP EVERGOOD

It is astonishing how many of our artists owe Europe such a great debt, not only for the influences on their art, but their lives, their philosophy. Art is universal, but I believe in the concept of national art, for I am convinced that art defines a people more precisely than anything else.

One of the greatest difficulties American artists have had is retaining their national identity or, if once lost abroad, returning to it. Sometimes in studying an artist's life, one is surprised in this regard. For instance, I would have guessed that Philip Evergood is one of the very few American painters who has not been touched by European influence. He seems to be a man primarily concerned with America and her people and their problems. His technique combines the cartoonist's tough line with a storyteller's sense of fantasy, both traditional in American art.

He was completely involved with the WPA when I first saw his work. He was a painter of the social scene, but always with a great sense of beauty even if the subject were grim, sad and depressingly real. The sense of a picture was always there, and a handsome one at that. During the 1930's, the great problems of America were coming to the surface — hunger, unemployment, police brutality directed against unions — and Evergood, in the American tradition, became politically involved with them. But his work never became mere social propaganda.

The New Lazarus, 1927-54,
Philip Evergood. 48 x 83-¼ in.,
oil on composition board.
Collection Whitney Museum of American Art,
New York, gift of Joseph H. Hirshhorn.

What I find surprising is that his background is not restricted to the American scene, far from it. Born in New York of gifted parents, he was a boy genius at eight, playing the piano in concert. His father, an Australian artist who worked in New York, sent his son to England to attend Eton and Cambridge. Feeling unfitted for the academic life of these schools, he moved to the famous Slade School of Art in London. Perhaps it was this upper-crust education that gave him the proper shocked perspective when he returned to America at the beginning of the Depression. It may be this same cultural awareness that never lets him become so involved in social problems that he forgets to paint a fine picture.

Her World is a perfect case in point. There is no question that the theme is the problem of black segregation or, at that time, the isolation of blacks. The child is fenced into her world and fenced out of any other. But tears do not dribble from big sad eyes; rather she looks outside her world, as any adolescent does, to what is on the other side of the fence. Her face may reflect more earnestness than children with more advantages might display, but this enhances rather than distracts from the handsomeness of the picture as a work of art. Evergood is above all a fine painter, and, of course, because of that he can say anything and make you see.

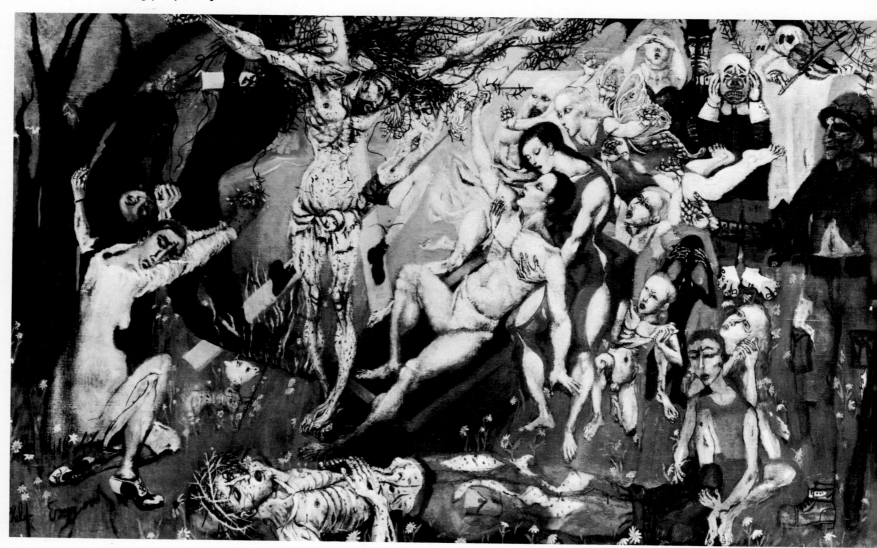

270

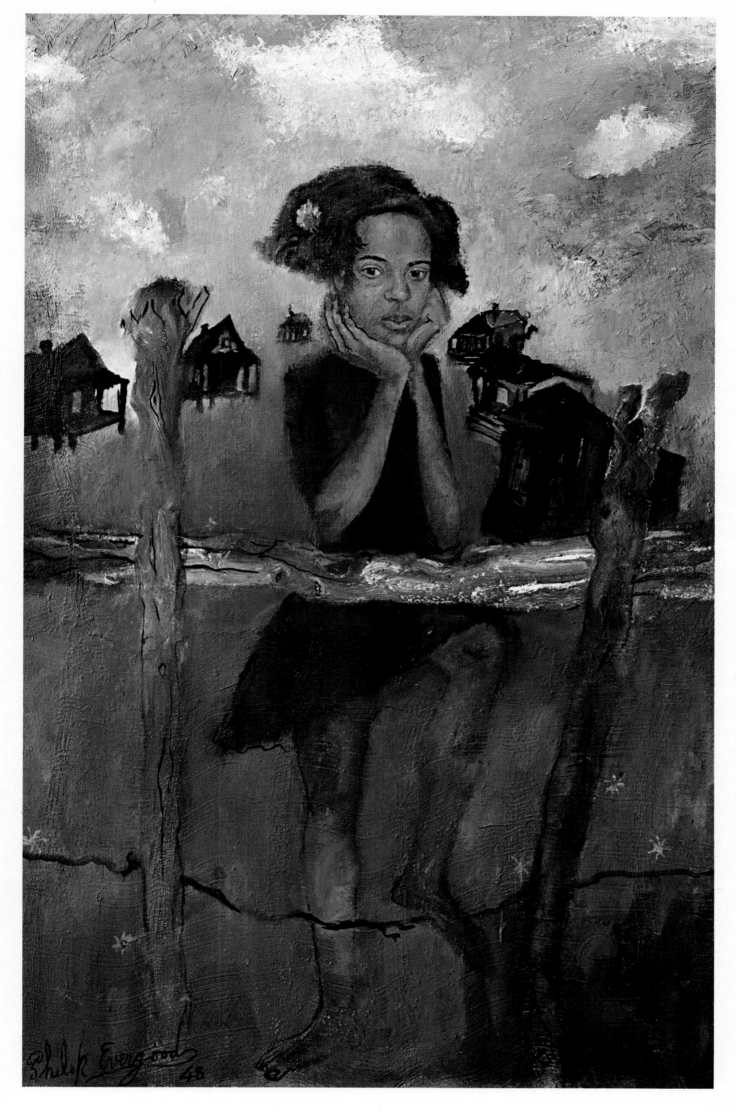

PETER BLUME

Peter Blume is an unreal realist, an antisocial commentator. He is a cartoonist with grim humor, a draftsman with steel. Above all, he is a collector of fragmentary ideas and disparate objects which, carefully arranged and painted with meticulous care and a high finish, make for an ideological solidity, a story. To read the story, you have to learn his visual language, and it is not an easy one, for he speaks of things many of us would like to forget and frequently have forgotten.

Although he has fashioned a personal imagery and style, he is not outside his period of American art. He is in the wake of Surrealism and in the vanguard of social protest. Indeed, he is very much of his time.

Blume is, by his own admission, a story-teller. He considers this "one of the primary functions of the plastic arts." But his stories are not romances; they are reports. In *The Rock*, he tells the jigsaw story of a world blown apart by war, trying to make something out of the fragments. It is a hard, tough picture of an agonizing passage from destruction to construction. In another "report," Blume's *South of Scranton* details a journey from Scranton, Pennsylvania, to Charleston, South Carolina. All the real events are there and more — the landscape of waste, the machinery, the harbor, even the energetic sailors and ship that happened to be there when Blume was. His strange realism in this picture was considered "insane" by the critic Homer Saint-Gaudens, but others found in it the makings of an award winner — the Carnegie International Award in 1934.

Like a surprising number of outstanding twentieth-century American painters, Blume was an immigrant from the Baltic Sea area of the old Russian Empire. He came to America at the age of five. There is much bitterness somewhere in him, and there is also something very Slavic. He seems to be making a joke drawn in tears. The comedy is the human comedy, and to quote Edgar Allen Poe, the hero is "the Conqueror Worm." Man may rebuild, but it will all be destroyed again.

He is not an artist one goes to in order to escape or even to love. You go to his work to be made to think, and if you do not want to think about it, you will not stay for long. He is American in his seriousness, and he has a kind of Rube Goldberg approach to social philosophy — Goldberg's machinations, but deadly serious. The people in his paintings are grimly humanistic in their efforts, but the natural elements are reverential, almost holy.

Technically, he compares to Salvador Dali (b. 1904), but whereas Dali is a showman, Blume is an exhibitionist. Dali made protests of the Spanish Civil War, but one feels he was involved in it only momentarily. Blume never forgets, and he does not want us to forget either. But we do, and therefore his pictorial reminders nudge our memory rather than bring it back to life.

A great social commentator like Francisco de Goya (1746-1828) startles us with the horrors of war, or the frivolities of human nature, but his art is so sublime, we are morally stimulated to be better. Blume conveys no such uplifting feeling, but he is apt to make us wish we were not as bad as we are, although we doubt we can really do much about it.

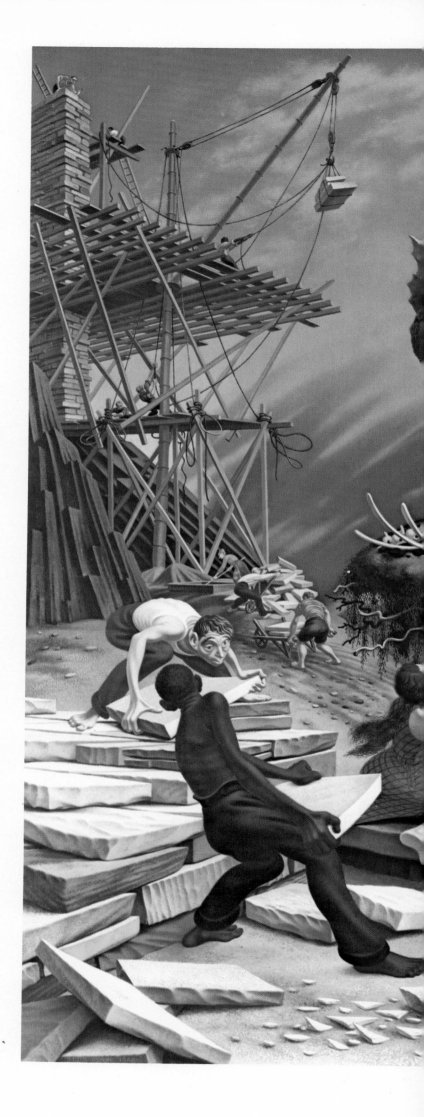

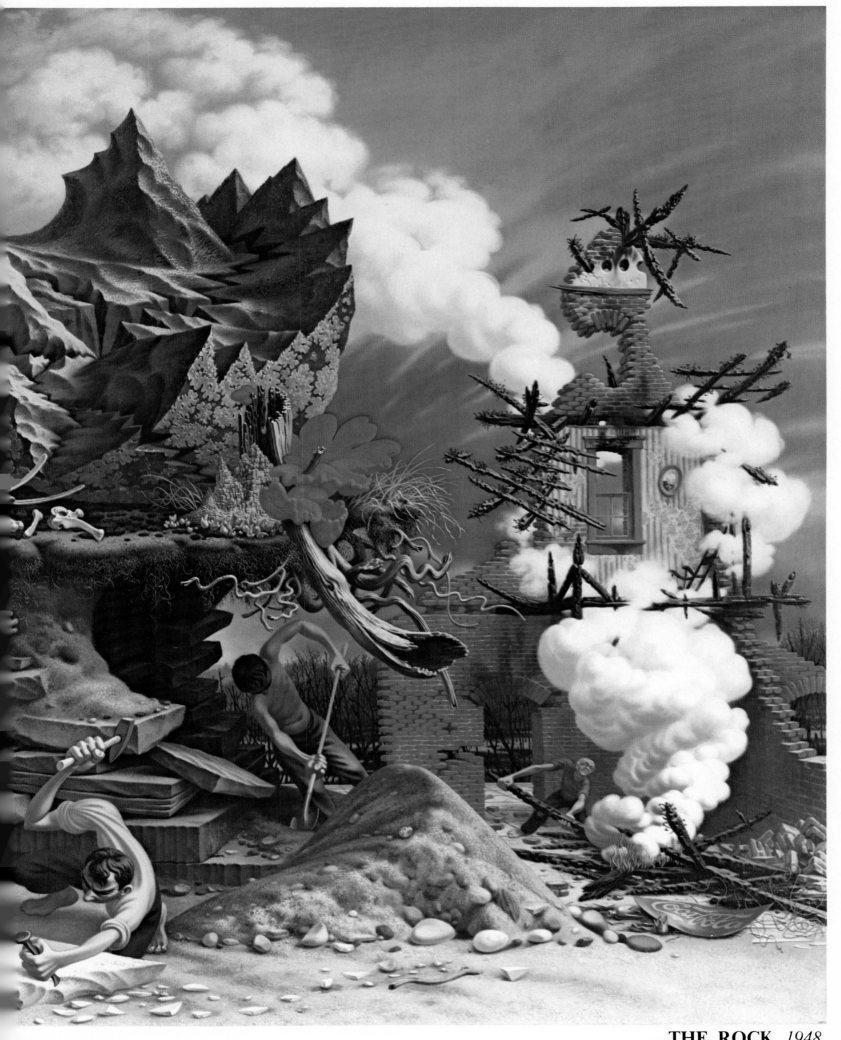

THE ROCK, *1948,*
Peter Blume (b. 1906). 58 x 74 in., oil.
Courtesy, The Art Institute of Chicago, gift of Edgar Kaufmann, Jr.

ANDREW WYETH

The year was 1937, the place, 57th Street, New York. A gallery was giving a first showing to the son of the great American illustrator, N.C. Wyeth (p.200). The young man had just turned twenty, and many of the watercolors being shown were painted in his late teens. I was doing my first Broadway play, *Victoria Regina*, with Helen Hayes, and it was a hit. I had money in my pocket and I was in love with art. I had started to collect young American artists' work and master prints. Here was an exhibition full of pictures that had everything for me — a young American who painted like a master. I bought one for fifty dollars. The artist's name was Andrew Wyeth.

It does not matter that I can no longer afford a Wyeth — he's now the most highly priced and prized American painter — for I have the world of Wyeth all around me. No other contemporary artist, except Pablo Picasso, has been reproduced so often. Wyeths in television settings, Wyeths in motels, Wyeth books, Wyeth postcards, Wyeths everywhere. Thank goodness he is as good a painter as he is.

Why is it we do not tire of his work? Because his art story is a simple one, and his art is simply a labor of love — exquisite craftsmanship, carefully thought-out compositions, a penetrating good sense about people and enchanting subject matter. The major miracle of his work is that he enchants us without resorting to sentiment. He catches that "decisive moment" of observation of a scene or a person that matches the magic of the camera in the hands of a great photographer. In addition, Wyeth's hands add the art of a great painter — spirit, craft, humanity.

If Wyeth appears to come close to sentimentality, it is the fault of his audience, not his. They are accustomed to finding sentimentality in works displaying the real world

The Capstan, *1963,*
James Wyeth (b. 1946). 21 x 17 in., watercolor.
Courtesy of the William A. Farnsworth Library
and Art Museum, Rockland, Maine.

The Country, *1965,*
Andrew Wyeth. 40-5/8 x 35-3/8 in., tempera on panel.
Virginia Museum of Fine Arts, Richmond,
gift of the Alfred I. duPont Fund.

THE CLOISTERS, *1949,*
Andrew Wyeth (b. 1917). 31½ x 40½ in., oil on board.
Courtesy, The Art Institute of Chicago,
gift of Mrs. Joseph Regenstein.

so accurately in every detail and capturing the moods of people and places. He avoids sentimentality with a care for his subject matter that only a very profound lover of life could master. His art is very human, and the simplest of men can understand it. It fills a great need in our disordered, noisy world: the need for silence, for simple good taste, and for beauty. He reminds us of the life and "love we seem to lose with our losts saints," to quote Elizabeth Barrett Browning. His pictures are pure and necessary.

Some may wonder why I did not select the famous *Christina's World* as the color reproduction to represent this popular painter. I wanted to show what I consider to be Wyeth's major contributions, the absolute maximum he can achieve with the minimum show of effort. He once said his aim was "not to exhibit craft, but rather to submerge it." In *The Cloisters*, the interior of one of a group of abandoned religious buildings in Pennsylvania, he does just this. This is no exhibition of technique of any one kind, rather a simple whole where painterly knowledge adds up to a complete pictorial experience.

His art is the culmination of several of the art areas we have explored in this book, the ultrarealism of our national outlook and the serious sensitivity of our artists in their struggle to identify us as a cultural nation. In particular, Wyeth feels great admiration for his precursors in realism, Thomas Eakins (pp. 144-151), Winslow Homer (pp. 138-143) and Edward Hopper (pp. 218-221). And certainly much of his father's training and his brother-in-law Peter Hurd's (p. 238) technique of dry-brush painting have assisted in producing the mastery that Andrew Wyeth commands. Yet, his dignity and control are all his own.

This member of a great American art family has also given us the next generation in his son, Jamie. Already he has become deeply absorbed, not only with working out his inherited technical skill, but with the study of his own and his subject's personality. This was first popularly witnessed in the much publicized portrait of the late John F. Kennedy and is also evident in smaller pencil sketches of other members of that family. The clear image — both technically and intellectually — for which the Wyeth family group of painters is recognized appears also in *The Capstan.* It will be fascinating to see how this immensely talented young man will come into his own expression — greatly, I would predict.

275

LOREN MACIVER

LES BAUX, *1952,*
Loren MacIver (b. 1909). 47¾ x 40 in., oil.
Courtesy, The Art Institute of Chicago,
gift of the Claire and Albert Arenberg Fund.

In the very first rank of painters, American or international, is Loren MacIver. She is one of the most inventive artists of our time. What sets her apart is her love of everyday simple things and her incredible ability to turn them into magical wonder-worlds of light and darkness. But one must not think of her as naive, for each canvas is sophisticated (that much abused word) in the sense of being philosophical. She glides down the path that divides abstraction from pictorial reality and, like all fine artists, comes out with a language all her own that will admit to no definite direction. In stating her mind, she unearths a vision. MacIver is a revelatory artist.

When looking at her paintings you can almost guess that she has always made art, for there is no self-consciousness about her work, as there is none with children. She is an innocent. She is self-taught, and as far back as she can remember, she painted. No matter how hard you look for influences, they just are not there. She proves the point which all parents suspect is true, but do little or nothing about — that the natural creative act if nurtured and allowed to grow, not even necessarily cultivated, can survive. While in secondary school she painted in the spare time that her education permitted. She never went through the stage of trying to conform to what was admired pictorially at school. Intuition is a most perishable human commodity, but hers was not destroyed, because she would not allow it. "Perhaps," she says, "it is because I. . .intended to be a painter. I just liked to paint."

MacIver's approach to each picture fits the problem at hand. In the catalogue for the "Fourteen Americans" show at the Museum of Modern Art in 1946 she wrote: "Quite simple things can lead to discovery. This is what I would like to do with a painting: starting with simple things, to lead the eye by various manipulations of color, objects and tensions toward a transformation and a reward. . . ." She uses various manipulations and symbols or abstractions, until she succeeds in leading our eye to the picture and then, by color, into it. Often she paints over a dark background so that the colors flash like candles in the night. *Red Votive Lights* in the Museum of Modern Art is just such a picture. She saw in it "symbols of constancy."

Les Baux is not a thing but a place. It is a village in the middle of France from which, in medieval times, poetry poured forth, the poetry of minstrels who, like Homer in his time, sealed the legends of the middle ages in song and story. Deep in its caves cut into the bauxite rock, MacIver felt night, even in the hot afternoon daylight. She sensed poetry still shining forth from the darkness. It may seem completely abstract, but if you have ever visited the depths of a cave where nature over the centuries has created her own crystalline light, you know this work is completely real. It needed only the light of a lamp, in this case the artist's imagination, to set the darkness blazing.

Red Votive Lights, *1943,*
Loren MacIver. 20 x 25-5/8 in., oil on wood.
Collection, The Museum of Modern Art, New York,
James Thrall Soby Fund.

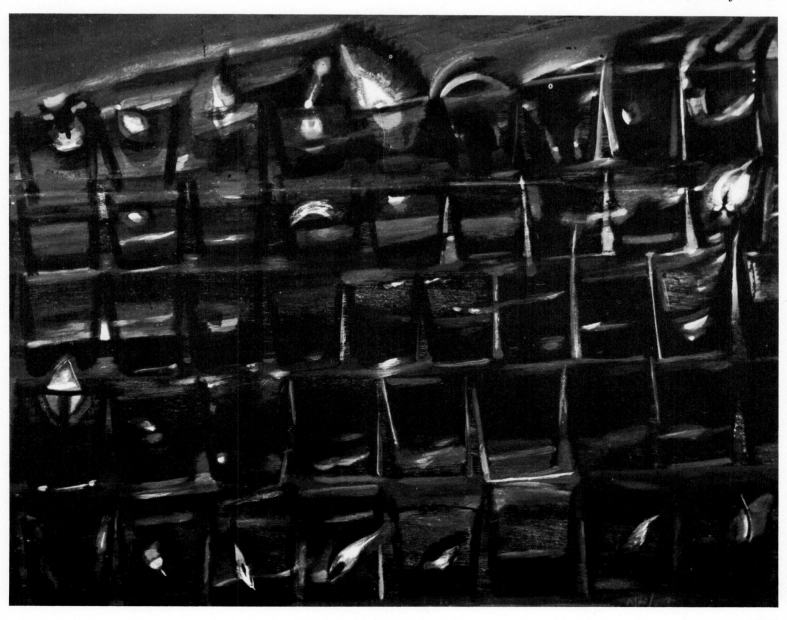

JACK LEVINE

The so-called painters of social commentary and criticism have one great trap to avoid — boredom. Not necessarily their own but the boredom of their audience, for more often than not, the kind of viewers they attract are as aware of the social problems attacked as the painters are. So these artists should be equipped to make their point brilliantly, and the works of only a few survive the age in which they were done. In the past two centuries we can name very few — Honoré Daumier (1808-1879), William Hogarth (1697-1764), and, in his graphics, Francisco de Goya (1746-1828) in Europe — and fewer here.

Jack Levine is among these few because, first, he is a marvelous painter, and secondly, because no matter how fierce his comment, he is always wittily wise. Levine's professed admiration for Daumier would seem obvious, but it is to Rembrandt that his devotion is highest. He says, "The Rembrandt thing is not adulative. . .It gives me a direction in which to continue. It takes me closest to the subject, the human drama." It is to the human drama that he addresses himself, not just to that which is inhuman in our society. "Not to break with Rembrandt. . .but to bring the great tradition, and whatever is great about it, up to date."

Levine was only fifteen when the Great Depression hit the land. He was brought up in Boston's South End where "It was rough but it wasn't rough on me. . .no objection to it. Life was interesting." And that is what you always feel about his pictures; they are interesting for him *and* for us. The Depression was miserable but it was interesting. It was a time of conflict, the essence of the human drama. It brought out the best in some, the worst in others. Levine does not always concern himself with the worst, or, if he does, he manages to find some good in it.

For example, in *Gangster Funeral* he depicts mobsters, but they do not sneer or snarl or even look particularly tough. The drama is created by the hypocrisy of their act

Medicine Show I, *1955,*
Jack Levine. 50-½ x 55 in., oil.
Courtesy, Pennsylvania Academy of the Fine Arts, Philadelphia.

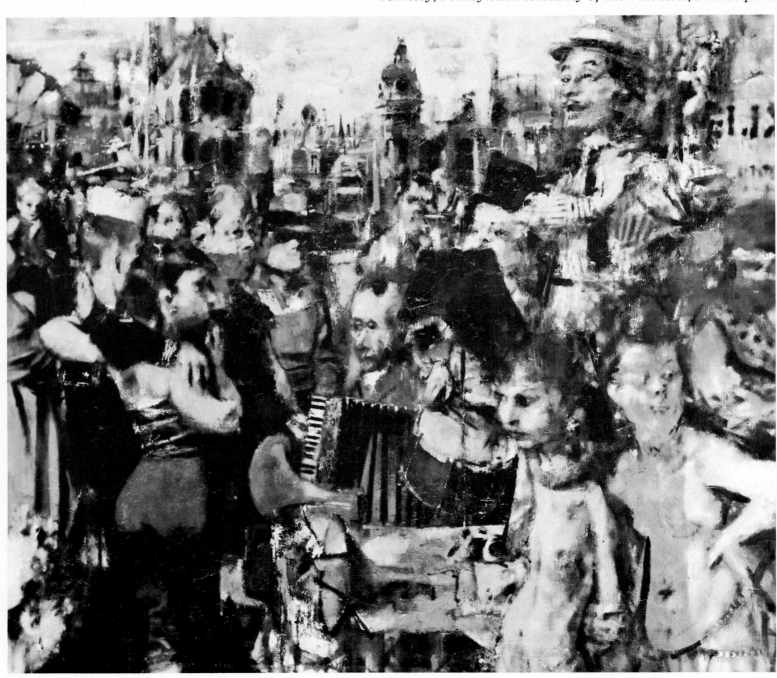

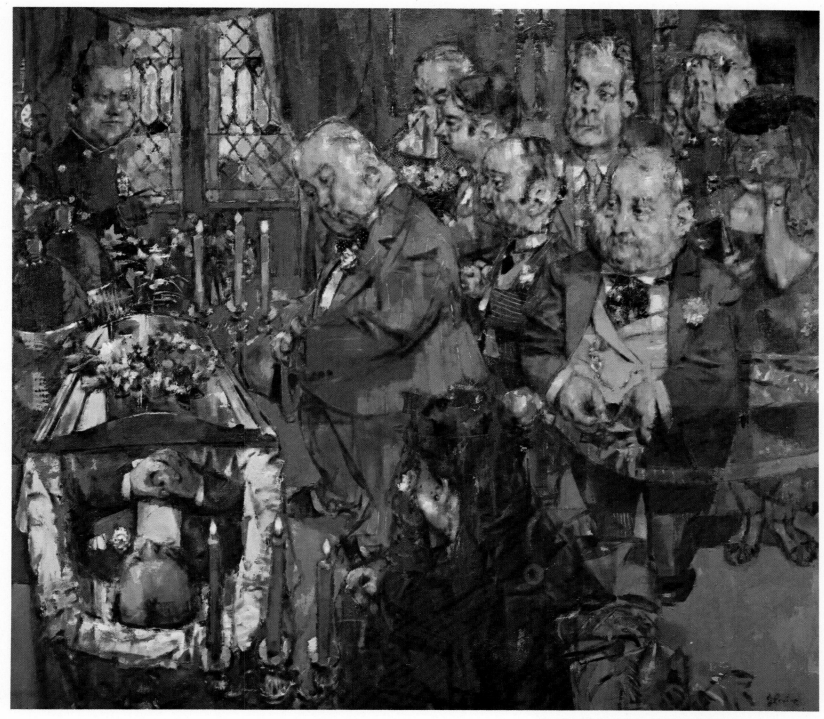

GANGSTER FUNERAL, *1952-53,*
Jack Levine (b. 1915). 63 x 72 in., oil.
Collection Whitney Museum of American Art, New York.

of grief, not the tragedy of death. It might not even be an
act; perhaps the dead fellow might have been a friend
whom they felt had to be killed, and they are entitled to
remember their friendship. Very human that, and few of
us are not guilty. This picture might be described as the
death of the twentieth-century folk hero.

Levine said that all considerations of modernity or con-
temporaneity fill him with horror and that "dehumaniza-
tion seems to be the keynote of every field of modern
endeavor." When he speaks like this he is pledging alle-
giance to the tradition of humanity in art, to the art of
painting and to the translation of that art into any lan-
guage the artist chooses to speak. *Gangster Funeral* is a
masterpiece because it is humanity artistically expressed
rather than simply a great message. As with Rembrandt,
the message lies buried beneath the many layers of his
artistic genius.

279

ISABEL BISHOP

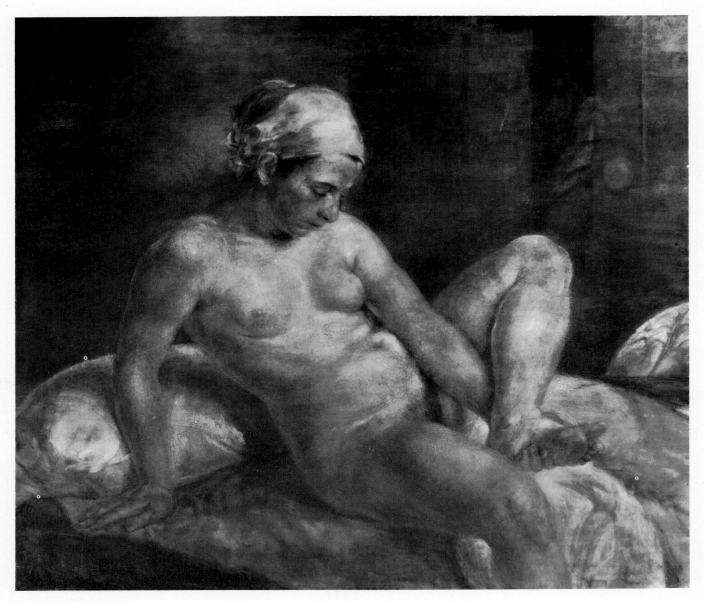

Nude, *1934*,
Isabel Bishop. 33 x 40 in., oil on composition board.
Collection Whitney Museum of American Art, New York.

America has produced her share of good women painters, until recently a rare occurrence. Some, like Doris Lee (b. 1905) and Peggy Bacon (b. 1895), have viewed society from a lightly satiric or humorous point of view, much like that of some of our best women writers, notably Dorothy Parker and Anita Loos. Humor is always rare in painting, whether by men or women, and most of our women artists, like most men artists, have been straightforwardly serious in their approach. The best known names are those of Mary Cassatt (p. 168), Georgia O'Keeffe (p. 216) and Loren MacIver (p. 276). One who fits their pattern equally well and also relates to the concerns of the twentieth century is Isabel Bishop.

She is not as innovative as O'Keeffe and MacIver, nor does she have the international acceptance Cassatt commands, but just as Cassatt gives by far the best, most honest and convincing view of the private lives of nineteenth-century women of the upper middle class, so Isabel Bishop is just about alone in portraying the realities of the twentieth-century, big city, working woman.

Her portrait of the working woman is perhaps the truest to life of any artist dealing in this popular genre. It is in the middle between Reginald Marsh's (p. 244) satire of everyday urban life and Paul Cadmus's cruelty. The working woman is depicted by Bishop as she is, hardworking and dedicated to the recognition of her sex.

What most distinguishes her pictures from those of other urban realists is the sense of movement she conveys, even in her most static subjects. Her working women are always on the way somewhere, pausing, perhaps to chat, but on the move. In *Snack Bar*, quite incidentally, Bishop records the pathetic gastronomical reality of American business life. A hamburger or a ready-made sandwich is all we have time for; a cup of gossip and a pickle are all we require for taste divertissement.

Technically, Isabel Bishop is immaculate. Underglazes creating an almost palpable personal atmosphere that suffuses the entire picture with city light, the drawing is firm and well established. The stories she tells are not the depressing ones of social turmoil or bitterness, nor do they fit into the sometimes banal category of "slices of life." They are always honest, seemingly effortless and pleasing. In her etchings, she reveals an old master quality of absolute sureness, and her drawings have a briskness that points up her involvement in the action inherent in the lives of her subjects.

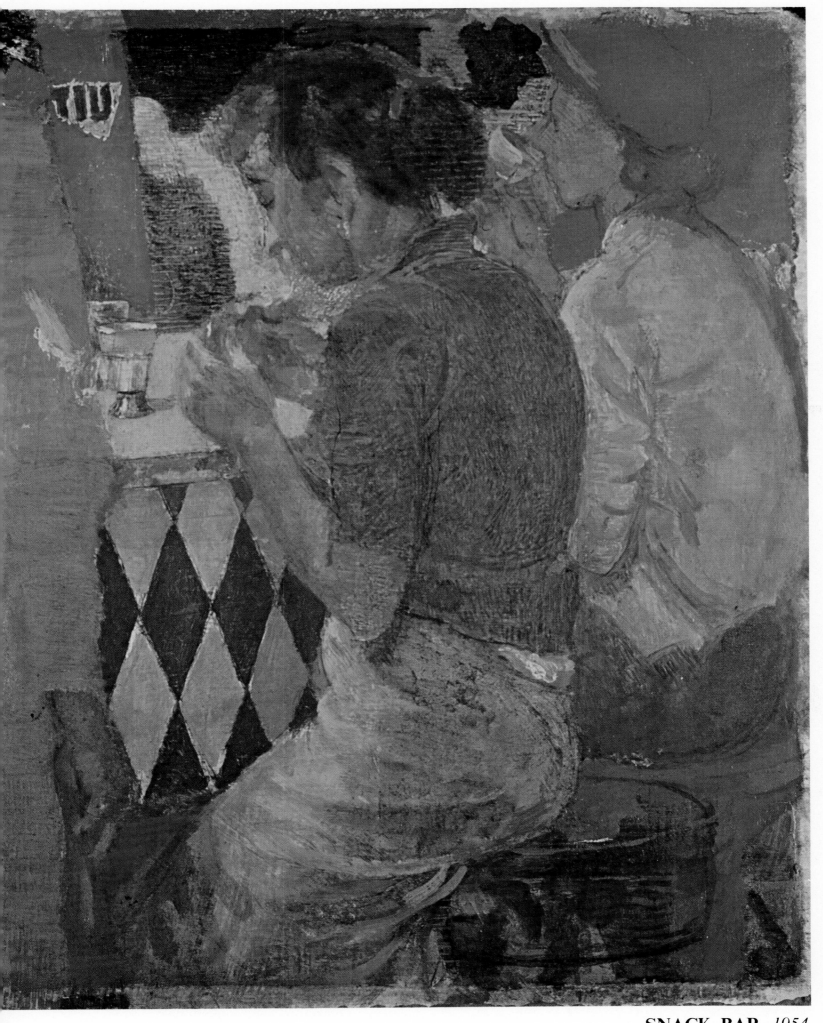

SNACK BAR, *1954,*
Isabel Bishop (b. 1902). 13½ x 11⅛ in., oil on masonite.
The Columbus Gallery of Fine Arts, Columbus, Ohio, Howald Fund.

LARRY RIVERS

WASHINGTON CROSSING THE DELAWARE, *1953,*
Larry Rivers (b. 1923). 83⅝ x 111⅝ in., oil.
Collection, The Museum of Modern Art, New York.

Larry Rivers is one of the most versatile and interesting artists of our time. He draws and paints like an angel. His sense of humor is contagious. Although he may not seem to be the most serious of our modern painters, he is one of the most delightful.

A true "personality" of the art world, Rivers almost matches Salvador Dali (b. 1904) in his eccentricities and unconventional way of life. A native New Yorker who studied music at the prestigious Juilliard School of Music in 1944-1945, he is a first-rate jazz musician and one of the few of his rank in the arts who has not locked himself away in an ivory tower.

Rivers was attracted, early in his musical career, to the work and the personalities of the New York painters who were creating the Abstract Expressionist movement. He began painting and studying with the chief teacher of the movement, Hans Hofmann (p. 260), as well as at New York University.

But although his friends have been mostly either jazz musicians or Abstract Expressionists, Rivers, in his own work, has never been totally identifiable with that dominant movement of the 1950's. Although he has been cate-gorized as an important forerunner of Pop Art, a popular movement in the 1960's, he is elusive and difficult to label, which is apparently the way he likes it. He is an action painter, a super-realist and abstractionist — he is all of these, but above all, he is a showman and a revolutionary.

Amazingly, whatever he turns his hand to is never second-rate. A large retrospective exhibition of his drawings at the august Art Institute of Chicago amply demonstrated Rivers's mastery of his craft, even to his many critics. Anyone who avoids the recognizable categories of modern art does so at some risk to his reputation; yet much modern art stems from that classic innovator, Pablo Picasso, who has lived at least nine artistic lives. Perhaps Rivers will, too.

As a figurative painter, Rivers has always painted whatever was on hand. Thus, he came to paint certain images already existing in the public mind, such as several versions of *The Last Confederate Veteran,* apparently based on a *Life* magazine photograph, and *Washington Crossing the Delaware.* This early masterpiece, painted in 1953, although reviled by his fellow artists, has survived to be recognized as a harbinger of Pop Art. Some have claimed

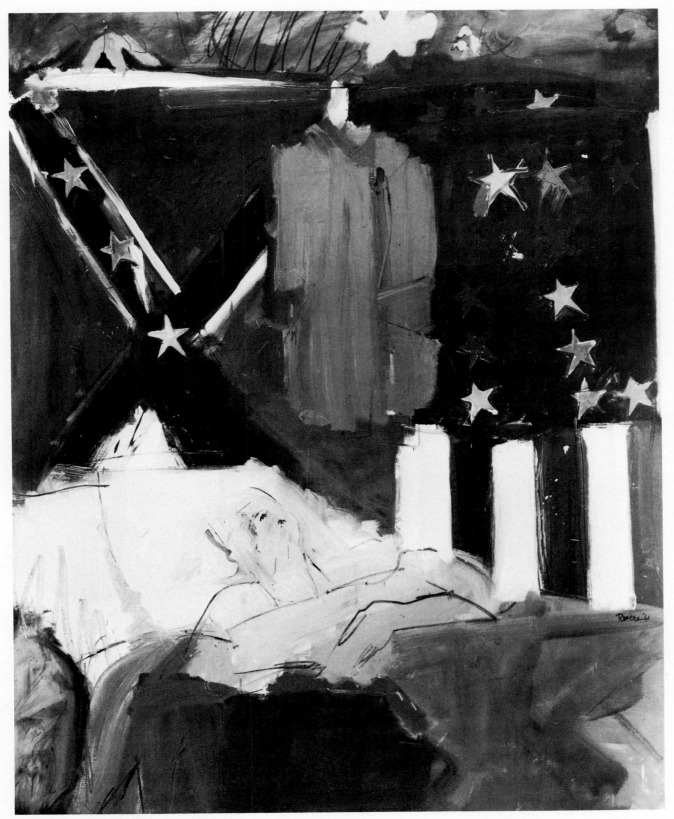

The Last Civil War Veteran, *1961,*
Larry Rivers. 82-½ x 64-½ in., oil.
Collection of Martha Jackson, New York.

that it was based on Emanuel Leutze's famous picture (p. 96), but it has little or nothing essential to do with it. In the first place there is no similarity in pose or content. As close an association as there may be is that both pictures were quite frankly painted for their public appeal. Leutze may have been a hundred years closer to the actual event than Rivers, but both pictures are equally contrived as far as reality is concerned.

Once again the innumerable drawings for this picture prove the seriousness of his intent, and in fact, his completed paintings at their most typical look like pages from some gigantic sketchbook, the preparations an artist makes for a painting rather than the completed painting itself.

There will be an unfinished version of the central motif, a few details of it, isolated and scattered about the canvas, some extraneous bits of drawing, perhaps, and, almost always, some passages of runny or dribbled paint. His work is work in progress and that is a great deal of its charm.

Fortunately, time has taken whatever onus may have been heaped upon him and thrown it back into the faces of his critics. A statement he made some years back is revealingly honest, "In order to paint I must look at something and I must think that in some way it is about the thing I'm looking at. I think what I chose to look at is based primarily on, 'what out there will allow me to use what's in my bag of tricks.'" Not many artists will admit so much, and Rivers's "bag of tricks" is a pretty formidable one that may just rank him among the great magicians of art.

ROBERT MOTHERWELL

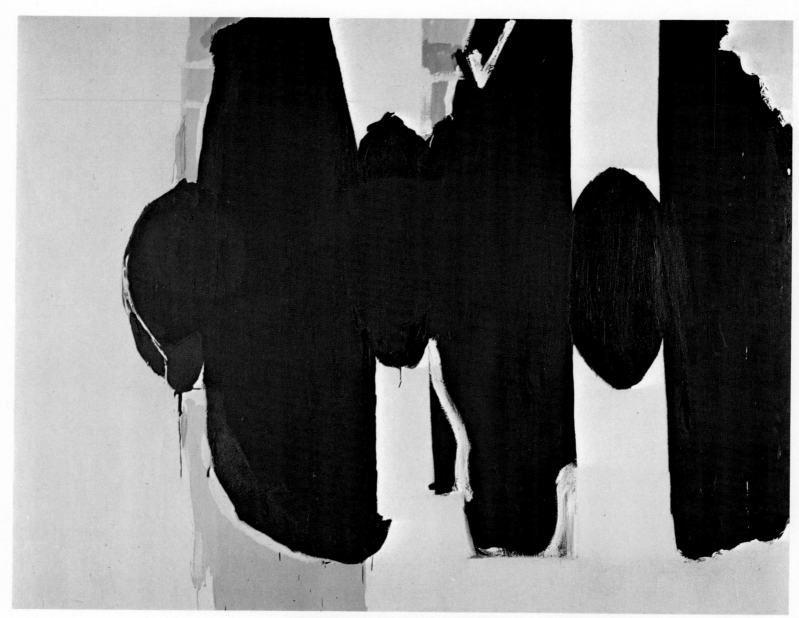

ELEGY TO THE SPANISH REPUBLIC, LVIII, *1957-60,*
Robert Motherwell (b. 1915). 84 x 110 in., oil.
Rose Art Museum, Brandeis University, Waltham, Massachusetts,
gift of Julian J. and Joachim Jean Aberbach.

Very few artists, ancient or modern, could write their thoughts on art and life as well as they could paint, cast or carve them. Vincent van Gogh's (1853-1890) gift of tongue was comparable to his bounty as a painter; Leonardo da Vinci had much to tell the world with his pen as well as his crayon or brush. For most artists, however, it is beyond them to explain their vision in words. One modern American artist, however, Robert Motherwell, has written much about his art and others' with startling intellectuality. Erudite and appreciative of the work of other artists, he is able to voice opinions about his own that, while not necessary for enjoyment by the viewer, do throw new light on it for the layman who faces the eternal problem of understanding anything new in art.

A scholar and student of philosophy before he became a painter, Motherwell has lectured and written on such diverse artists as Eugène Delacroix (1798-1863), Piet Mondrian (1872-1944) and Hans Arp (1887-1966). His friends include practically every great modern American artist. He was the editor of the famous magazine *VVV,*

devoted to "imaginative works of universal interest, whether they be in poetry, the plastic arts, anthropology, psychology, sociology, the evolution of science, comparative religion, or in what may simply be called the field of the wonderful," according to its prospectus.

Through his teacher and friend, art historian Meyer Shapiro, Motherwell met the refugee artists who arrived in New York in the early 1940's. It was during this period that Motherwell came to the belief that the painter should try to make his mind and his technique as innocent as those of an uninstructed child. This idea, originally taught by Paul Klee (1879-1940), has given Motherwell's art simplicity and purity of the kind that may be found in children's art. His devotion to Shapiro gave him his wide range of wonder, but it is his incurably inquisitive mind that has enabled him to continue in the role as intellectual artist without peer in America.

Motherwell linked himself with a group that called themselves the Irascibles: Theodoros Stamos (b. 1922), Max Ernst (b. 1891), Jackson Pollock (p. 268), Barnett

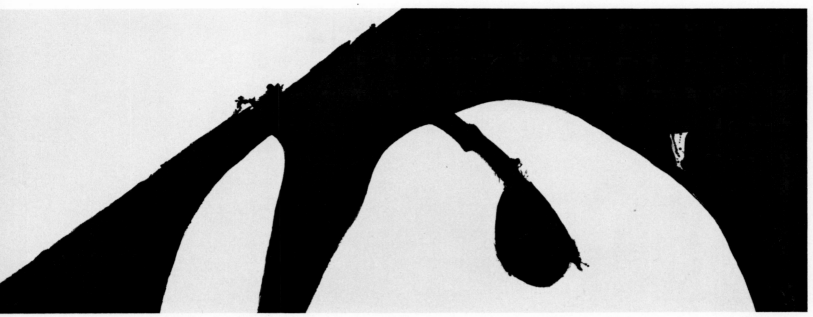

Africa, 1965,
Robert Motherwell. 80 x 225 in., acrylic.
The Baltimore Museum of Art.

Newman (1905-1970), James Brooks (b. 1906), Mark Rothko (p. 292), Richard Pousette-Dart (b. 1916), William Baziotes (1912-1963), Willem de Kooning (p. 262), Adolph Gottlieb (b. 1903), Ad Reinhardt (1913-1967), Maurice Sterne (1878-1957), Clyfford Still (b. 1904), Bradley Walker Tomlin (1899-1953). Indirectly he summed up this powerhouse of American abstract art when he stated, "The present vitality of American art is connected with the unparalleled depth of our democracy.

On the subject of his own writing, which was always in great demand by art publications, he said, "My writing does not compare, in depth or originality, with my painting. But most people are more at home with writing. Painting," he went on to say, "is a totally active art." About the art business he said, "I much prefer trading to selling, but not everyone who has something I need is an art-lover."

On his inspirations he wrote, "When one is asked what painters one admires, one realizes one likes all great ones. Who are more significant are those who invariably excite one to paint oneself; in my case Rembrandt's drawings, Goya, Matisse and Picasso. . . . Caution," he feels, "is the enemy of art, and everyone is more cautious than he thinks he is." On a personal note he confessed, "Art is less important than life, but what a poor life without it." And about art and life he said, "One does have to 'understand' wholly to feel pleasure . . . we rush towards death. Moments of joy make existence bearable: who ignores joy is immoral . . . an artist *cares*, that is what can be trusted."

Motherwell himself said about those who try to explain abstract art, "Those whose profession it is to do the explaining are more often than not mistaken . . . one has to

understand the fury of Picasso's famous statement of 1935, 'Everyone wants to understand art. Why not try to understand the song of a bird? One loves the night flowers, everything around one, without trying to understand them. While the painting everyone must understand. If only they would realize that an artist works above all from necessity'."

One of Motherwell's great determining influences was a lecture he heard in 1937 on the Spanish Civil War given by André Malraux, a novelist who fought in that war. For Motherwell as for many Americans, the Spanish Republic became an heroic enterprise, a cause comparable to the liberation of Greece for Byron's generation a century before. Although the conquest of the Republic by General Franco with the aid of the Nazi air force has long since been surpassed by greater military-political horrors in Europe, Asia and Africa, Motherwell has remained faithful to that original cause of his generation. It has provided the direct inspiration for the main work of his artistic life, the long series of abstract paintings called *Elegy to the Spanish Republic*. *Elegy to the Spanish Republic, LVIII* is the fifty-eighth painting of that title from Motherwell's easel and there were others on that general theme before he began using that title. In this version, as in most of the others, the dominant colors are the stark black and white of mourning.

An elegy is a poem of mourning, of lamentation for that which has perished from the earth. In these paintings Motherwell has expressed, over and over again, with a childlike fixation, his continuing grief for that original lost cause, one which, to many sensitive people of about his age, was the first of a train of disasters.

285

RICHARD DIEBENKORN

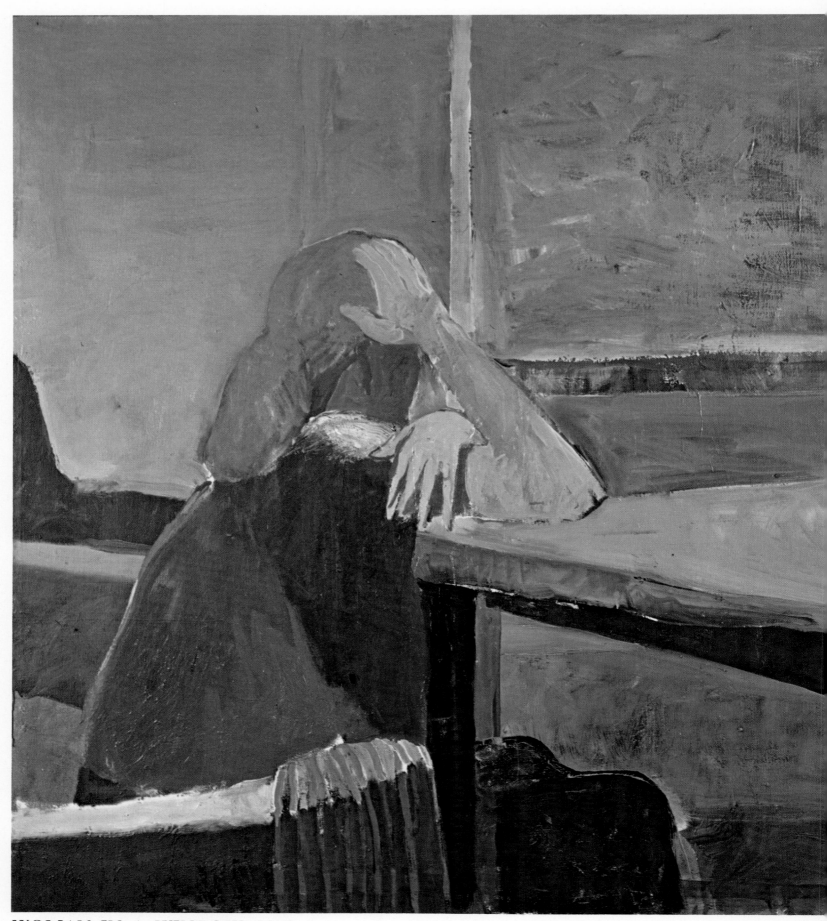

WOMAN IN A WINDOW, *1957,*
Richard Diebenkorn (b. 1922). 59 x 56 in., oil.
Albright-Knox Art Gallery, Buffalo,
gift of Seymour H. Knox.

The artist's problem today is one of disturbing confusion. Ideas are hourly shot at him like intercontinental missiles. The sensitive man may choose to abstract himself from these bombardments, or he may go along with each new blast. Or, he may catch them in his intellectual radar net and file them into memory for further use when he needs power from outside, if and when his own runs down.

The blows dealt by modern communication are powerful, swift, visual, oral, literate and often deadly. Only a few artists like Henri Matisse (1869-1954) and Picasso have had an intellect capable of solving the problem. These survivors are giants. A plethora of change in style and purpose particularly apparent in Picasso has similarly inundated

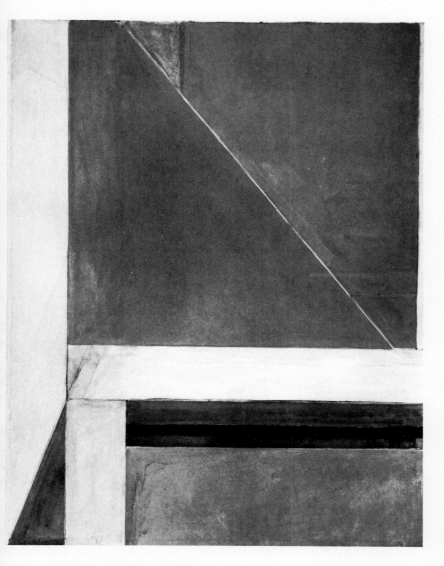

Ocean Park #29, *1970,*
Richard Diebenkorn. 100 x 81 in., oil.
Marlborough Gallery, Inc., New York.

Richard Diebenkorn, perhaps the most celebrated living artist from the West Coast. Yet with Matisse as his guide, his constant reference point, he has withstood all to become one of our most self-possessed painters. The pictures of Matisse, and of Pierre Bonnard (1867-1947), as Diebenkorn saw them in the Phillips Gallery in Washington, D. C., while he was in the service, come back to him even today as he works on his own paintings, according to the artist.

Early in his amazing career, during the 1950's, before he was "the most important West Coast artist," I had the fortune to become acquainted with his work. Then, for the most part, his style was abstract and he had already gained enthusiastic support for his strong canvases of explosive, emotive abstractions, although there is something figurative identifiable in even the most abstract Diebenkorn, something like beauty, excitement, majesty.

In the face of this acceptance, Diebenkorn restlessly began to change towards obvious figurative painting, a move which left many of his friends and critics skeptical when so many of his contemporaries were turning to the McLuhanesque view of man distanced from emotion — the beginnings of Pop Art and Hard-Edge painting.

Upon the first exhibition of these works, which immediately preceed *Woman in a Window*, Diebenkorn faced accusations of hesitancy, indecision, a willingness to leave unresolved problems apparent on his canvases, and of "avoiding the painter's prime problem to make an illusion on canvas that is a reality in itself." Clearly, Diebenkorn had a battle within himself. But such figurative works began to be understood, and soon one writer conjectured that these then-latest figurative paintings were Diebenkorn's ultimate expression. Yet there was always the evidence that abstraction was by no means past.

Woman in a Window is strong in humanism and shows little need for the explosive emotions of the former works. However, in dealing with human encounters, such as this woman's, the abstraction remains in the complex geometry of the composition, with the figures overlaid. The art commentator Gerald Nordland has described the picture's appeal aptly: "The balance between emptiness and incident, weight and absence is ingenious, but the real impact of the picture derives from the felt quality of the figure's reverie and the timeless need of humans to look through windows toward the sea." Here Diebenkorn found that subject matter — the common images he found near him in his studio — could bring feelings as strong as he had previously evoked in his canvases of sheer, abstracted color, space and proportion.

At this moment a new Diebenkorn is being born, the child of both the first and second Diebenkorn, as *Ocean Park #29* might indicate. Diebenkorn always knew there was the possibility of returning to abstraction, and he has. This can only be expected when today's artists must reflect today's confusions, its torturous overload of information about many things we really need not know. Diebenkorn is very much of our time. Controversy has attended his rise to fame, and what he has brought out of it is an intensely individual creative style. He says that each painting is an autobiography. In a time when many artists are lost, he has found himself. He is a born painter who, despite the overt changes in styles or form, continues in a rich flow, renewed by those very bombardments of modern communication.

HELEN FRANKENTHALER

There is in Helen Frankenthaler's work something that is very personal, something so gentle, so truly womanly that she will probably dislike my saying it. But such is my reaction to those huge, light-filled, nature-textured canvases that can cheer any gallery or room.

My first exposure to other than a single canvas here and there was a huge show in London's Whitehall Gallery down in Cheapside. It is not exactly the brightest section of that great city, but the experience of seeing twenty or more Frankenthalers was bright. These pictures came upon me suddenly like a kind of wonderful promise fulfilled. I was in nature and yet outside of it looking in. I thought of a very different woman artist, Georgia O'Keeffe (p. 216), and I remembered how many years before she, too, had helped me accept the miracle of nature as a source of art and yet one from which art must be abstracted. Frankenthaler's distance of abstraction from nature is, of course, greater than O'Keeffe's. However, whatever the distance, or more properly, the degree of the artist's detachment, when natural things are abstracted we become enchanted with their promised reality.

Frankenthaler began to form her own style in the late 1940's mostly from her study of Arshile Gorky (p. 246) and Jackson Pollock (p. 268), two of the most influential of the founding fathers of Abstract Expressionism. In spite of some adverse popular opinions about Action Painting in general, I have always been impressed with the ability of the masters of that craft to bring off even their most explosive efforts with grace and taste. Frankenthaler shares this quality with them, but without the violence. Rather,

the strong impact of her work is engendered by the art of love which can outreach stars.

The principal, original stylistic contribution of Frankenthaler to Abstract Expressionism was based on a technical innovation. She began "staining" her canvases instead of painting on them. Traditionally, and in most modern work as well, the canvas is "primed" with a first coat, often of white, which the painter then uses as a ground for his work. Frankenthaler painted directly on the canvas, and the canvas sucked in the color, the color becoming part of the canvas rather than merely being supported by it. The most visible result of this technique are the feathery edges, very delicate, of her colored shapes.

Round Trip, with its color forms that seem to float in space, represents her in the midst of growing toward her present personality. It leads us as viewers, as it led her, out of experiment and out of the influences then so strong within her. It clues us in to her painterliness, her draftsmanship and her quite superb sense of composition.

Abstract art is the most difficult to reproduce, and Frankenthaler's abstracts are especially so. For those viewers puzzled by abstract art, I would prescribe several hours at an exhibition of her paintings, because when you see them before you, you are as amazed by what she does not paint as by what she does. I know of no other artist who allows the canvas to do so much work. Like Albrecht Dürer's (1471 - 1528) touch in his remarkable late watercolors, she seems to know how to evoke her work from the material without over-burdening it with paint. The result is something that is absolutely real and precisely as abstract as those sacred words we call the abstract ones — beauty, love and truth.

Sun Frame, *1966,*
Helen Frankenthaler. 44 x 104 in., acrylic.
Honolulu Academy of Arts, Margaret Emerson Fund.

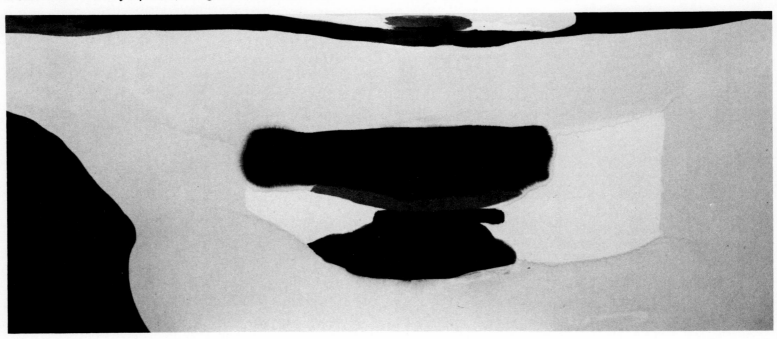

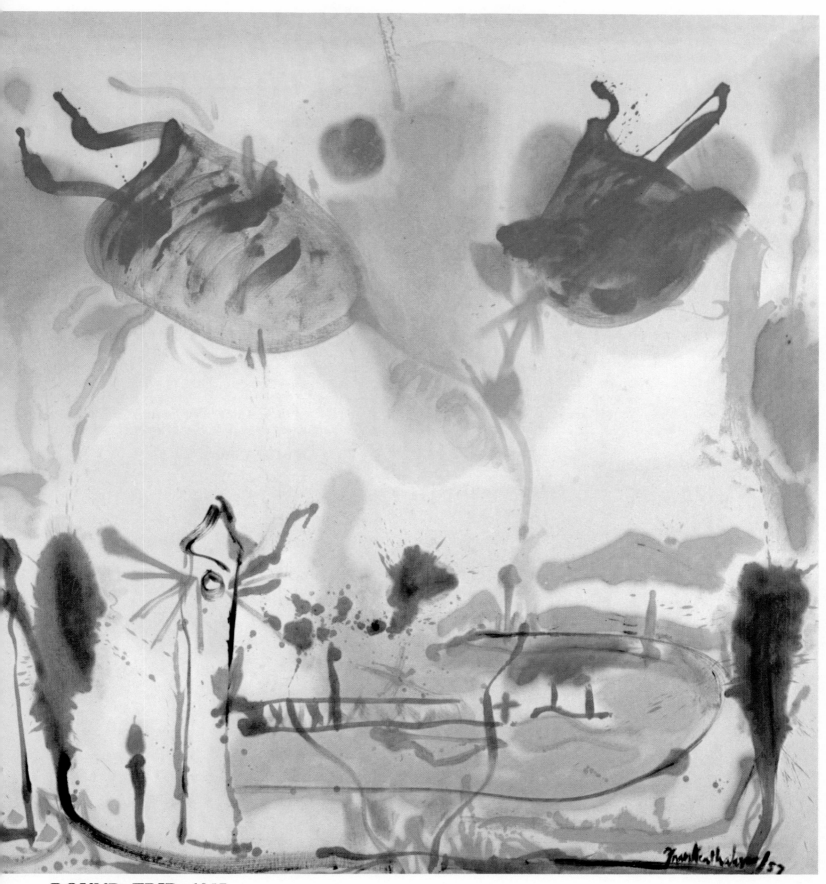

ROUND TRIP, *1957,*
Helen Frankenthaler (b. 1928). 70¼ x 70¼ in., oil.
Albright-Knox Art Gallery, Buffalo,
gift of James I. Merrill.

MILTON AVERY

Communication has always existed between artists regardless of time. One generation can speak to another over the ages, for art, man's spiritual voice, is eternal. Milton Avery was a listener, a silent man who said, "Why talk when you can paint?" He absorbed complicated visual patterns from the past and simplified them for us to see more easily. Other artists watched him and simplified even more.

An artist of the past who spoke for the silent Avery as well as himself was Albert Pinkham Ryder (p. 166). His *Paragraphs From The Studio of a Recluse* told the unborn Avery, "It is the first vision that counts, the artist has only to remain true to this dream and it will possess his work in such a manner that it will resemble the work of no other man — for no two visions are alike. . . .His eyes must see naught but the vision beyond. He must await the season of fruitage without haste, without wordly ambitions, without vexation of spirit."

To look at an Avery painting is to have your vision unvexed, to be put at your ease, experience the beauty of simplicity. Avery has achieved that which was also Vincent van Gogh's ambition, "To say something comforting as music is comforting. . .to paint things with that something of the eternal which the halo used to symbolize and which we seek to give by the actual radiance and vibrations of our coloring."

Avery's training in art was minimal. He was self-taught and self-disciplined. Adelyn Breeskin, a curator of contemporary art, says, "He was always loyal to his own sensibilities, unswerving, never tempted by changing fads or isms. He preserved a certain innocence which was maintained in spite of experience which brought with it a rare kind of sophistication — a sophistication evidenced in his art rather than in himself." He was a master of color and it was this that brought him close to such divergent talents as Mark Rothko (p. 292) and Adolph Gottlieb (b. 1903): color and his intense simplification of subject matter almost, but never altogether, to the point of abstraction. Gottlieb and Rothko completely lost the subject, but it is always present in Avery's paintings. And the subject was always something with which he was completely at home: his home, his family, the sea, nature.

Tangerine Moon and Wine Dark Sea is what the artist saw and what he wants us to see. He does not presume we

Spring Orchard, 1959,
Milton Avery. 50 x 60 in., oil. Courtesy,
National Collection of Fine Arts, Smithsonian Institution.

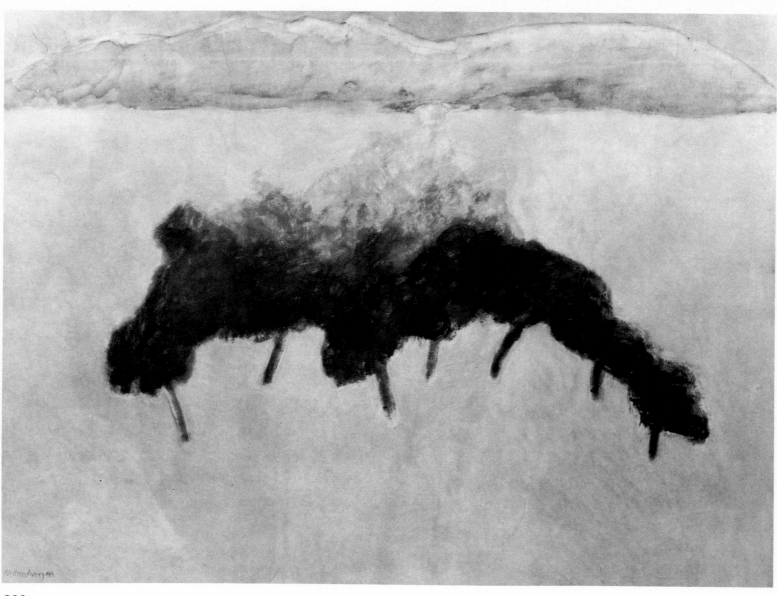

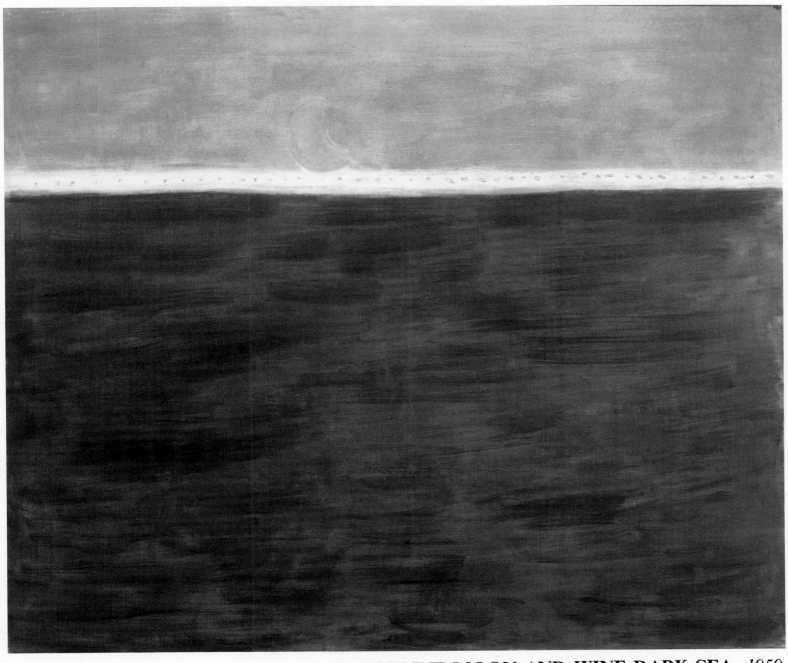

TANGERINE MOON AND WINE DARK SEA, *1959,*
Milton Avery (1893-1965). 60 x 72 in., oil.
Collection of Mr. and Mrs. David Lloyd Kreeger,
Washington, D. C.

are blind to beauty but rather intensifies it for us by his talent as a colorist. During his life critics heaped praise on him and at his death artists spoke of their gratitude for his inspiration. Clement Greenberg, the eminent critic, wrote, "There is the sublime lightness of Avery's hand on the one side, and the morality of his eyes on the other: the exact loyalty of these eyes to what they experience." James R. Mellow wrote three years after Avery's death in 1965: "Avery created one of the most remarkable oeuvres in American art. That his work held firmly to recognizable subject matter, to certain aspects of the American scene, when American art was developing its own authoritative forms of abstraction, is part of its uniqueness."

Mark Rothko, in praising his friend, tied Avery's work into our experience of seeing it most closely, "Avery is first a great poet. His is the poetry of sheer loveliness, of sheer beauty. Thanks to him this kind of poetry has been able to survive in our time."

MARK ROTHKO

When a man's life runs out — he dies. When an artist's life goes dry — he has the right to die. For the creation of art is the most ephemeral of all our senses and the least used, and when used, it is the rarest of all human experiences. Mark Rothko's creative life ran out recently, and he, as too few of us should do or have the courage to do, ran out on it — he committed suicide — not as a coward, but as a true hero of modern art.

In our time when art has almost abstracted itself completely from life and its latest trends (Minimal Art and such seem to many to negate all recognition of what has gone before), Rothko kept in constant touch with beauty, and beauty for most of us is a prime function of art. Much that is ugly and violent in contemporary art can be justified by the ugly and violent times in which we live. The artist has always been the visual reporter of his age. Rothko, however, has seen through ugliness to the promise we all so desperately need, the promise of serenity, the chance to restore our mental equilibrium through the contemplation of beauty in art. The great artist allows us this "surcease from sorrow" even when he is dealing most directly with sorrow itself.

Rothko's contribution to Abstract Expressionism as it arose in New York in the late 1940's was an image of peace and serenity completely at variance with what most people think that movement was. The great abstractionists, by their innate taste, even when they seek to disturb, can soothe the troubled heart. But when a man such as Rothko dedicates himself to peace of mind in beauty, in simplicity, in the negation of the superfluities that give us concern for our survival or at least for our peace of mind, then we must praise and respect his genius for what it is — generosity of the spirit.

One cannot help but find peace in a Rothko painting, and if Rothko did not find it for himself, we must still feel for him the same gratitude that we feel for the prophets of art who laid down their lives for us. Peter Selz, a fervent champion of Rothko's art, likens his paintings to "annunciations." Rothko, writing in the mid-1940's, explains that, "The unfriendliness of society to his activities is difficult for the artist to accept. Yet this very hostility can act as a lever for true liberation because the sense of community and of security depend on the familiar. Free of them, transcendental experiences become possible." Selz amplifies this conjecturing by saying that, "In Renaissance painting man was the measure of space, in Rothko's painting, space, i.e., the picture, is the measure of man."

One must not contemplate Rothko's work with preconceived ideas of what art is or should be. Nothing like it ever before was put on canvas. It has in common with nature a sense of the eternally unexpected, the forever new. The profound observer of nature will recognize in Rothko what most men miss, having blinded themselves to the appreciation of nature's ever changing moods.

Born in Latvia and brought here at ten by his Russian parents, Rothko began studying art in his early twenties, entering the Art Students League where he learned something of Cubism and Surrealism. In 1948, with three other artists, he founded an art school which rapidly developed into a discussion group which met regularly in Greenwich Village. Called "The Club," this forum was immensely influential on most of the artists who became the leading Abstract Expressionists and on younger ones as well.

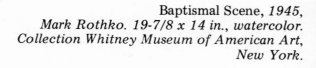

Baptismal Scene, 1945,
Mark Rothko. 19-7/8 x 14 in., watercolor.
Collection Whitney Museum of American Art,
New York.

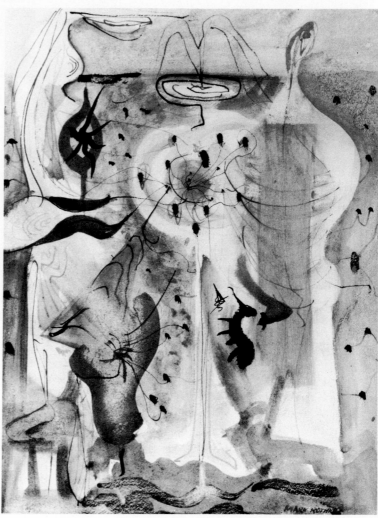

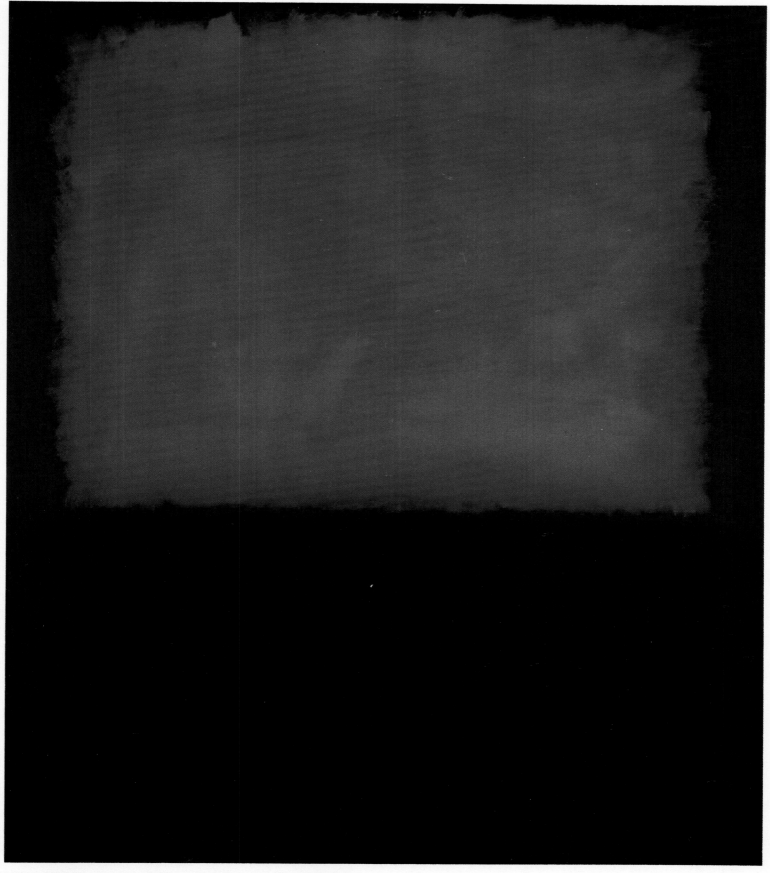

NUMBER 207 (RED OVER DARK BLUE ON DARK GRAY), *1961,*
Mark Rothko (1903-1970).
92¾ x 81⅛ in., oil. Collection of
the University Art Museum, Berkeley.

Beginning in 1950, Rothko's figures vanished entirely in the colored mist that had long characterized his work. His culminating works are those found in the Rothko Chapel in Houston, Texas, completed in 1970, shortly before he died, and those immediately preceding them, such as *Number 207,* created in 1961 just before he began work on the chapel. Few modern artists have been given the opportunity to create a "place" with their work which has been dedicated to religion and human development. Dominique de Menil, the chapel's donor, says, "The colors in the Rothko paintings are those of blood and wine...the paintings are close, very close, even warm and comforting. Only a mighty artist can capture in his work the infinity of God and his closeness to man."

To understand the works of Rothko's last decade, the artist and the viewer must meet together in solitude, spirit to spirit. There must be acceptance from both sides to arrive at an appreciaton and understanding. To miss the experience of Rothko's work is to miss much of the aim of modern life, its philosophy and its art.

OSCAR HOWE

An honest book on American art cannot be done without including the fascinating art of the American Indian. We have looked at George Catlin (pp. 74-77), Karl Bodmer (p. 80) and the others and have seen their report on what the undefeated Indian represented in the arts of design, dance and craft. We have seen Indian portraits done by Charles Wimar (p. 108) and Gilbert Stuart (p. 28). We know that Catlin and Bodmer transmitted their own fascination with American Indian culture to Europe, and it is a sad fact that the greatest interest in it is still outside the land that once was theirs. The Europeans see in Indian art what we have come to see in the art of Africa, the islands of the South Pacific and Mexico: The great sophistication of people who communicated in visual arts as readily as we do with our many dialects and languages.

So must we not consider native American Indian art today? Has the great European invasion of North America, which all but destroyed their culture, in any way been mitigated by an unquenchable desire in the Indian to make the arts again part of his life, today as it was in the past? I have examined this possibility over many years and have included two evidences of the affirmative, Oscar Howe and Fritz Scholder (p. 304), teacher and pupil. Their approaches to art are as separate as Cubism and Pop Art, but they have both retained their Indianness in exciting ways.

Oscar Howe, the teacher, is a full-blooded Sioux. He is the great-grandson of hereditary chiefs and noted orators of the Yanktonai Dakota Sioux. The Sioux have a long history of art and craft, which, in Indian art, are one. They were and are vital and adventuresome people; as Howe explains, "For well over the past two hundred and fifty years. . .their creative impulse has never faltered." The Sioux are great and ancient artists of storytelling, and Oscar Howe speaks today for the Sioux with his hands and eyes. He is withdrawn in company but wonderfully ebullient with anyone sympathetic to his art. Most important is

*Buffalo Calf Woman, 1967,
Oscar Howe. 27 x 21 in., casein on matboard.
Courtesy, U. S. Department of the Interior,
Indian Arts and Crafts Board.*

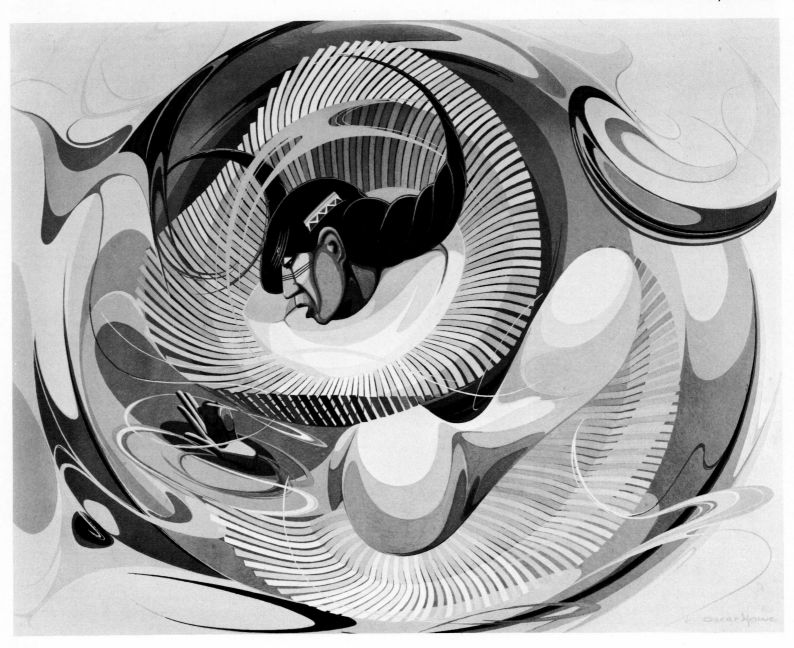

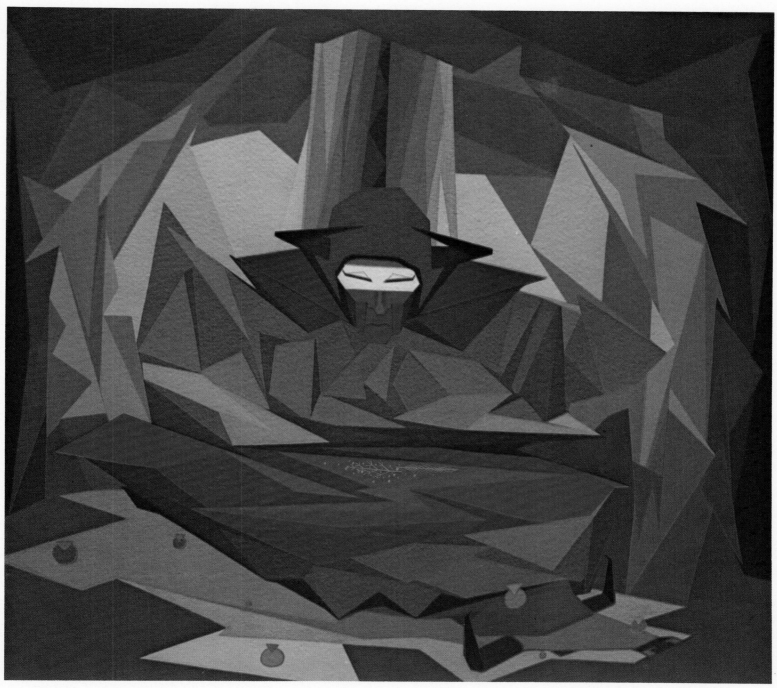

MEDICINE MAN, *1962,*
Oscar Howe (b. 1915). 20½ x 22½ in.,
casein on illustration board.
Courtesy, U.S. Department of the Interior,
Indian Arts and Crafts Board.

his ability to preserve the long storytelling tradition of his people in a modern idiom which, we might say, almost cuts it to a short story.

Howe does not fill his canvases with the complicated compositions of earlier Sioux artists, whose teepee decorations, and especially their buffalo hide paintings and ledger-book winter counts, are marvels of storytelling. Rather, he has simplified and focused on the leading character of an event. With *Medicine Man*, he has surrounded the dramatis personae with befitting mystery in the most abstract, almost Cubist, manner. The colors are brilliant, but the mood is somber because of the concentration of the medicine man on the precise, little curative still life before him.

Howe made contact with modern art as practiced by the white man in Europe and America, first as a soldier in World War II, and then at the Santa Fe Indian Art School

under the tutelage of an inspiring woman, Dorothy Dunn Kramer. Her belief in him tells the basic story of the triumph of an artist over the devastation of the plains people. But the late René D'Harnoncourt, director of the Museum of Modern Art, expressed it when he said that "a capable, creative artist with a strong native background can become erudite in the techniques and philosophies of the art schools and come through at last, with his original art strengthened, not harmed, by his experience."

Howe has interwoven the traditional nature colors, symbols and linear movements of Sioux art with "modern" techniques to create paintings that are in unity with the Museum of Modern Art's collection. Yet Howe's own ancestors would immediately recognize these works as part of the old Sioux tradition of "the painting of the truth," that is, the visual objective translated from the verbal idea.

BEN SHAHN

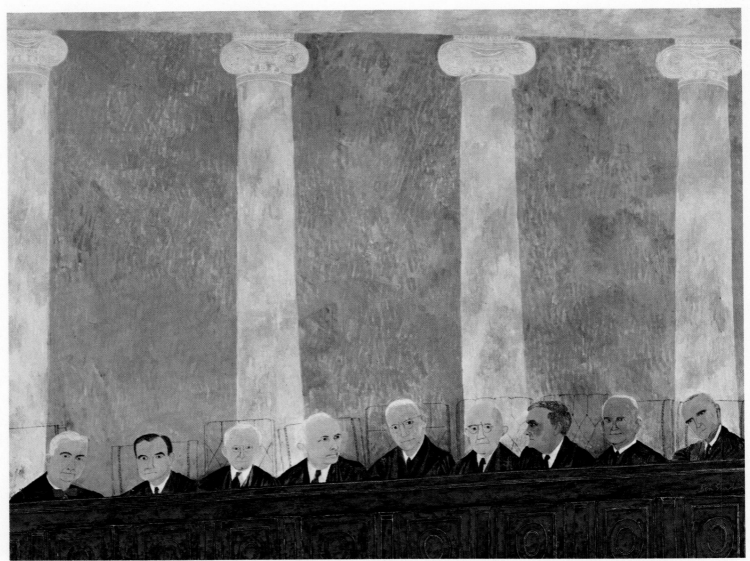

INTEGRATION, SUPREME COURT, *1963,*
Ben Shahn (1898-1969). 36 x 48 in., tempera on panel.
Courtesy, Des Moines Art Center,
James D. Edmondson Collection.

Any artist who has much to say about the human condition, especially as it is conditioned by political beliefs, is bound to be controversial. Some few manage by the sheer force of their beliefs to withstand public and private pressures against them and retain their artistic reputations and political convictions. A few hit the public imagination with such an impact on both fronts that they become popular. Lithuanian-born Ben Shahn is one of the rare ones who survived such popularity and remained true to himself on all scores. In 1952 when fame had come to him after many rebuffs he said, "I'm sadly dulled to fame, too, now that it has come at last, because during all those years of obscurity I protected myself with the philosophy that a headful of thoughts and a roomful of paintings were the important things in life even if the public never found out about either. I still think so."

The years of obscurity were long but they were partly self-imposed. After being apprenticed to a lithographer while still a boy he stayed in the trade of commercial lithography until he was thirty-two. He said he would rather work regularly than earn just enough by teaching painting in order to paint himself a few months in the summer. During this time, during the late 1920's, Shahn lived with and was encouraged by the brilliant photographer, Walker Evans (b. 1903), who is one of the most famous photo artists of the Depression. Certainly they must have reinforced each other in their sensitive perception of the commonplace.

It was not until 1931-32 that he found a subject in which he could believe entirely. His self-proclaimed like for stories and people and life-long hatred of injustice found its mark in the Sacco-Vanzetti case. He did a series of twenty-three small gouache paintings and two large panels on the subject. They make up one of the most biting comments against social injustice ever done in this century. Shahn's technique of flat surfaces and strangely stunted figures with blank, almost cartoonlike faces make this stirring story palatable to even the casual viewer. Not only did they appeal to liberals who deplored the trial, but to the layman who, in a period when abstract art was all the rage, could read these pictures and get the message.

From here Shahn began a career that was to make him the most famous social satirist of his time. There were lean times during the Depression, but he and his talented wife,

296

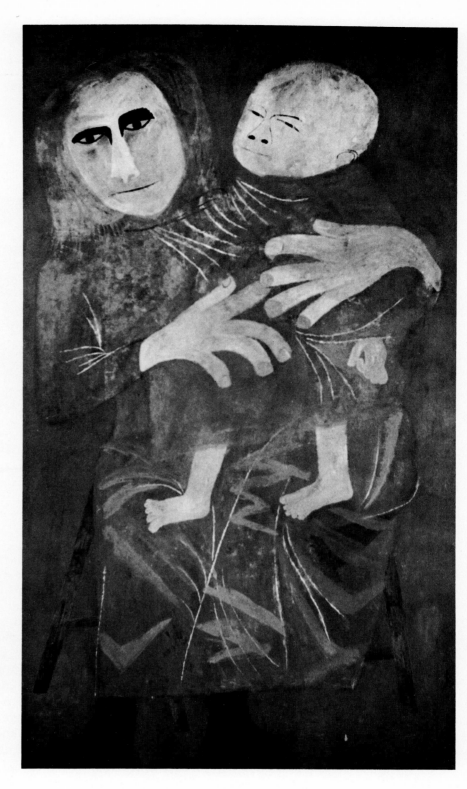

Lullaby, *1950,*
Ben Shahn. 52 x 30-3/4 in., tempera.
Santa Barbara Museum of Art,
gift of Wright Ludington.

Bernarda Bryson, worked for the W P A , and later came several rewarding mural commissions for a federal housing development, post offices, the Federal Security Building in Washington, D.C., and others. Meanwhile he was building up a following among his fellow artists and some collectors. By 1939 he was ready for a one-man show at the well-known Julien Levy Gallery in New York City. Though he continued in his social comment, he also did some charming non-satirical pictures, of children particularily, which have won him a large and devoted audience. *Lullaby* is one of these and has the same telling detail on the faces that we find in his bitterer, political paintings.

Shahn has not been without his critics, too, and many who have grown used to his political philosophy have felt his art suffered because of it. Others deplored the fact that after the late 1930's he altered his social themes. In his eloquent book, *The Shape of Content,* published in 1957, Shahn explained: "Theories had melted before such experience. My own painting then had turned from what is called 'social realism' into a sort of personal realism. I

found the qualities of people a constant pleasure. . . .There were the poor who were rich in spirit, and the rich who were also sometimes rich in spirit. . . ." Selden Rodman in his *Portrait of the Artist as an American,* which contributes much to unravel this complex personality, quotes Shahn as saying: "I don't really care that much about art. I'm interested in life, and only in art in so far as it enables me to express what I feel about life."

Integration, Supreme Court was painted in 1963 and was one of the few thematic pictures of that period of Shahn's life. It tells its own story, a double one perhaps, that while that august body of men had made the great decision, there was no integration in the body itself. As a Shahn painting it is a good example of Shahn's absolute simplification of detail, the concentration on subject matter, the caricaturelike portraits and the rather limited palette. It is perhaps paradoxical that an artist with such forceful things to proclaim to the world should express them in such a tasteful whisper.

RICO LEBRUN

FIGURE IN THE FLOOD, *196̶3̶*
Rico Lebrun (1900-1964). 96 x 48 in., casein on boarḏ
Courtesy, National Collection of Fine Artṣ
Smithsonian Institution, gift oᶠ
S. C. Johnson and Son, Inc̶

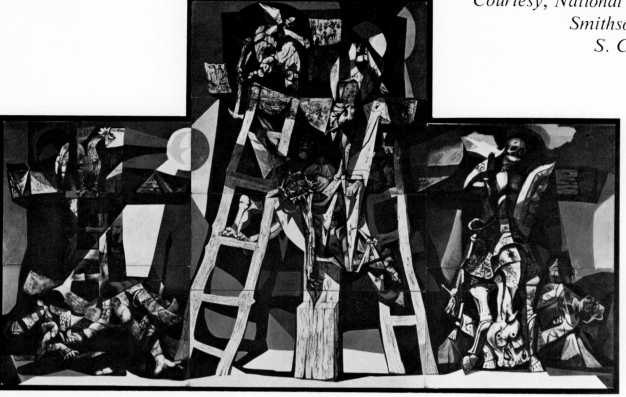

Crucifixion Triptych, 1950,
Rico Lebrun. 16 x 26 ft., duco on upson board.
Courtesy, Syracuse University Art Collection.

Rico Lebrun in another age would have been recognized immediately as a master of the first order. Since his death in 1964, his prolific output of high caliber work has been undergoing careful reappraisal, and he will come to be considered, I believe, one of the most fascinating eclectic artists of our time. With Lebrun, eclecticism was a natural thing, for he was a profound student of contemporary art and deeply appreciative, not only of his own Italian heritage, but his inheritance from the great art of all time.

There has been no more forceful and passionate draftsman in American art. His own special magic is in every line he put on paper. America has not produced greater drawings than this man achieved, and they present a welcome joy to the art lover who looks to a master's use of pen and pencil as proof of his ability. Lebrun's early drawings are so accomplished they tend to put one off and put him into a category of cleverness. It is the same awe-inspiring facility that draws us to Salvador Dali (b. 1904) and makes us wonder if he can live up to it. But whereas Dali has become lighter in spirit, Lebrun became more profound. He was deeply concerned with the human condition. Some artists who matured during the World War II era treated the disturbing passions that led to the war and were aroused by it — often summarized by the phrase "man's inhumanity to man" — with satire and almost cartoonlike comment. Lebrun was working inside himself to bring his vision of the human condition into view for those bold enough to admit and behold it. Lebrun expressed his vision in the eternal subject matter of the Crucifixion and those all too human abberations that led to God's punishment by the Flood.

Figure in the Flood is not so much a writhing human lost in the Almighty's wrath as it is a human being dissolved and defeated by life in the flood of abuse which man heaps on his fellow man. The viewer's temptation is to reject it, as one rejects the thought of death or damnation as a personal possibility. It has that same grandness of concept that makes those last dark works by Francisco de Goya (1746-1828) almost more than we can bear to look at and which can be understood only in the context of his whole work.

Lebrun had no fear of looking at modern life and separating its little light from the predominating dark, but it was the dark side that not only concerned him but appealed to him. In his company one felt great compassion, great hope, but one was never far from the great truth known by the greatest number of mankind — the knowledge of despair.

He wrote as he painted, in bright day colors muted by the promise of the eternal night. The promise is one of surcease from sorrow, for nothing fulfills it here but the hope of something better — if only a single act of kindness on the part of one man for another. In a letter to a friend, Lebrun wrote a description of his own mood and the mood he hoped to evoke from those who saw his work: "I and they will die in the open air with blue shadows and membranes wrapping up internal organs finer than silk with nets of rubies and gold of bile. They are bodies made to speak aloud and in a low voice to God about the glories and miseries of a woman's womb and a man's belly. They have a tremendous hunger to reveal themselves as they are in a dream and not as they appear in life."

Lebrun was a man of the baroque mood of the eighteenth century transplanted into a period that lacked any gaiety except on the surface. His mission was to dig beneath the surface and acquaint us with despair. Perhaps we must be further removed than he from this despair for us to possess the hope which his work so forcefully reminds us should be our prime living concern.

299

IVAN ALBRIGHT

That Which I Should Have Done I Did Not Do, *1931/41,*
Ivan Albright. 97 x 36 in., oil.
Courtesy, The Art Institute of Chicago.

Some of the most cruel, most tender, beautiful, terrifying, disturbing, tranquil works of art have been created by one man, Ivan Albright. All these seeming unrelated attributes are in each of his paintings. The great unique French artist, Jean Dubuffet (b. 1901), said it superbly. On seeing Albright's painting of a door at the Art Institute of Chicago, he concluded it was ". . . worth going to the ends of the earth to see. . . . Never have paintings had such strong powers of *revelation*. . . . Abolished here totally are what were our canons of beauty. . . . Must these paintings be burned?" he asks; "Yes, without any doubt, if fear of mental adventure prevails . . . [but] if we opt for navigation in the great deeps . . . let us salute this very great artist [as] the *aile pilote* of new seas."

Albright is the super-realist of our time. Not poetic like Wyeth (p. 274), nor clinical like Hyman Bloom — yet more poetic and clinical than both. He does not go beyond realism as the Surrealists do to prove a poetic point; he goes into the very bottom of it for proof of reality itself. He is never photographic, for he sees several times what the camera sees only once, and at every level of observation all at once. You do not look at an Albright, you look *into* it. You are likely to see all art within it, if your mind is able. Albright's paintings are like music; the moods evoked come in a torrent and go in a flood.

He has been called "the master of the macabre." There is no unreality in his work, and by his own admission, he says, "The body is our tomb. Shake the dust from our souls and maybe there lies the answer, for without this planetary body. . .we might be men." In that sense he is macabre, but what of the beauty of the dust, the identification of each pore of the body's covering with life — real life, not idealized? His art is not macabre but *lively* in the extreme.

And there is humor, the least macabre of attributes. What a revelation, this *Self-Portrait in Georgia!* How he revels in his own deterioration, sees in himself all men aging, yet hopefully becoming more and more aware of themselves. All his art is brought to play in this portrait of himself. The incredible technique that counts everything in the roll call of a face, a room, and gives each thing, animate or inanimate, a personality.

His background, present and future, is art. His father learned from Thomas Eakins (pp. 144-151) and then taught his son. The whole family drew constantly. His maternal grandfather was a surgeon, a student of the intricate machinery of the human body. Albright himself was employed in a hospital during World War I to do watercolors of soldiers' wounds. He never stopped searching for the human hurt to find beauty in it and to find the possibility of healing as well.

He may seem to be out of the mainstream of modern art, but in the background of this *Self-Portrait* we see his interest in the bold shorthand approach to conveying the visual experience. And he masters it, using it to throw the proper focus on the unrelieved reality of that ravaged face.

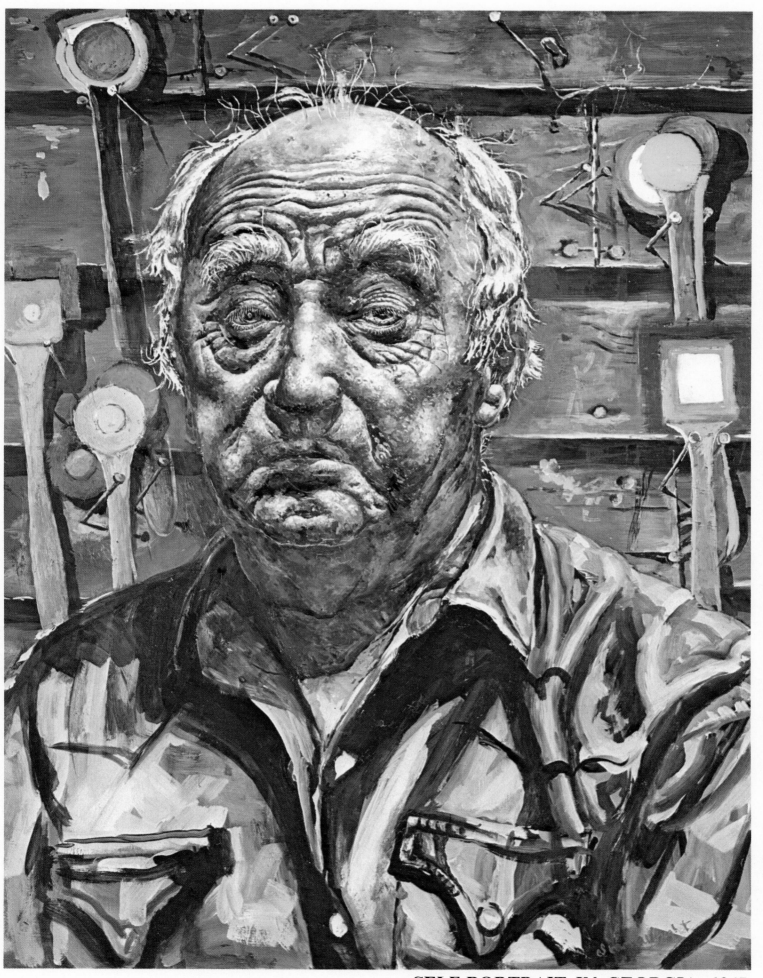

SELF-PORTRAIT IN GEORGIA, *1967,*
Ivan Albright (b. 1897). 20 x 16 in., oil.
Butler Institute of American Art, Youngstown, Ohio.

JASPER JOHNS

One of the main difficulties most people have in accepting Pop Art is their inability to accept things that are a part of their everyday life as objects of art, even if they are reevaluated and interpreted by an artist. In other lands, everyday activities and objects are considered part of man's art pattern. In Japan (where Jasper Johns is not only accepted but considered a great master), even the most ordinary foods are displayed as works of high art. The Pop artist celebrates the ordinary in precisely this manner, but in our society, oriented to monetary values, we look for the beautiful or even the interesting only in things of great expense.

One of the biggest storms that has blown over the public has been Pop Art. Having weathered Cubism and Abstract Expressionism, suddenly in the 1950's a new wind came up that bowled us over. That we have now almost come to accept Pop Art proves once again that the art viewer, even if belatedly, has as much stamina as the art producer.

Writers on art have found it difficult enough to explain all the earlier movements of modern art only to be confronted with the task of elucidating on Pop Art with the same old vocabulary. Personally, I find that, brilliant as they often are, they miss an essential point in the consideration of many phases of modern art — enjoyment,

Map, *1961*,
Jasper Johns. 78 x 123-1/8 in., oil.
Collection, The Museum of Modern Art, New York.

302

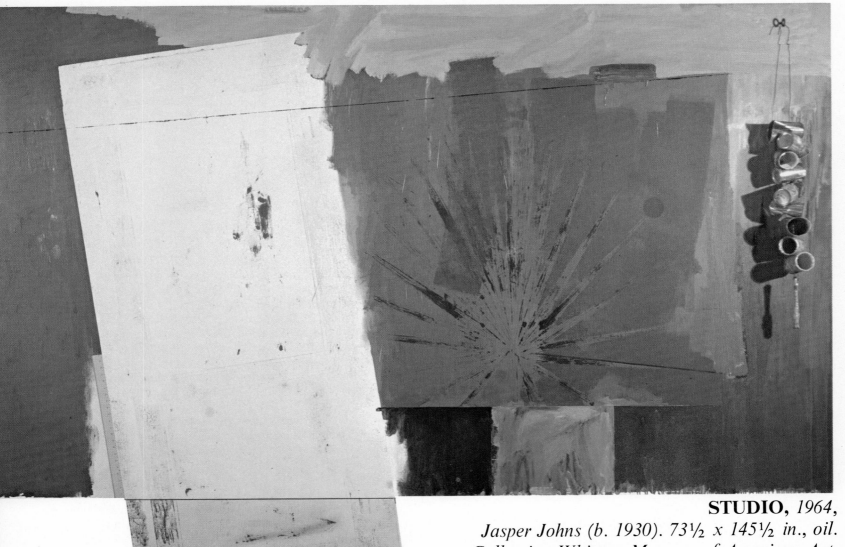

STUDIO, *1964,*
Jasper Johns (b. 1930). 73½ x 145½ in., oil.
Collection Whitney Museum of American Art,
gift of friends of the museum.

fun, the pure sensation, the feel of love that someone is saying something many of us wish we could but, in the seriousness of life, have forgotten how to say. Real humor is one of the rarest elements in art and in life, but we reject it for lacking the high seriousness which we think has a priority as we struggle through life. This is especially true of America, the last great nation to escape from the false and frustrating moralities of the nineteenth century.

Every modern art movement has given me pleasure because each one seems to fit, as the artists have meant it to, the moods and questions of the time in which it had been created.

A man with a serious sense of humor and a master's control of comedy is Jasper Johns. He has said, "At every point in nature there is something to see. . . .My work contains similar possibilities for the changing focus of the eye." Alan R. Solomon, writing of his work stated, "It is an art which grows out of an involvement in the process of painting, and not by indirection out of literary attitudes. . . ." This is evident in Johns's use of letters, numbers, sentences and words, as in the painting *Map*. Here and in *Studio*, Johns takes simple and common objects out of their ordinary context. The conventional has become unpredictable. Johns had done this with his earlier and famous *Three Flags* of 1958 (three consecutively smaller American flags painted one upon the other), but he seems to be growing towards a more ambiguous use of forms in these later paintings. The same whimsical juxtaposition of things continues, but one feels that *Studio* is highly intuitive. It has the makings of the ordinary studio — a painting, a door, several three dimensional cans — yet it may not be. Regardless of whatever objects he uses, there is a feeling of tremendous energy conveyed by his involvement in the process of painting, as the critic Alan Solomon says, and that energy is spent on the canvas. The viewer becomes involved in the process, too.

Johns is a serious humorist, and there is nothing trifling about his pictures. They are too beautiful to be funny, and to assign them the qualities of wit and humor is the highest compliment. The humor of Jasper Johns has the same profundity as the playfulness of Picasso.

FRITZ SCHOLDER

AMERICAN INDIAN, *1970,*
Fritz Scholder (b. 1937). 60 x 42 in., oil.
Courtesy, U. S. Department of the Interior,
Indian Arts and Crafts Board.

Wotawe ("medicine bundle"),
19th century, belonged to Sitting Bull,
Hankpapa Sioux. 25 x 33 in.,
painted muslin. Courtesy,
U. S. Department of the Interior,
Indian Arts and Crafts Board,
Sioux Indian Museum, Rapid City,
South Dakota. The contents of the
bundle are shown, and the rawhide
container is to the left. The central
form is a dream figure of an elk.
The four shapes in the corners
represent dragonflies,
messengers who contact spirits.

According to an Indian friend of mine, the current interest in the art of his people is the white man's last stand in the battle with his guilt. Suffice it to say we have not treated our Indian brothers with much compassion. Even their wonderfully creative spirit we have relegated to the crafts category. We have condemned Indians to mediocrity in which we would feel happier if they would remain. It is discomforting now to find a people demanding our attention we would rather ignore.

One who commands such attention is the brilliant young Indian artist, Fritz Scholder. Unlike the artists of the past who looked at the Indian clinically, as did Karl Bodmer (p. 80), or with the almost crude sympathy of George Catlin (pp. 74-77), or from a dispassionate distance as in the case of Frederic Remington (p. 196) or Charles Schreyvogel (p. 188), Scholder is involved firsthand with the need to identify with his own heritage. He works from the Indian's image of the Indian, not the European's or the white American's.

The new Indian art movement is one of the most exhilarating today. Exploring their poetic, pictorial and legendary past, they are establishing the appreciation of true native art in this country. They are taking this great tradition and putting it into the searching context of modern times when people are becoming, or had best become, concerned with their neglected fellow man. Indian artists are expanding their tradition and, for the first time in modern history, creating new ones. Fritz Scholder is making a legend of his people as they are today.

He studied with the fine Sioux artist, Oscar Howe (p. 294), who brought back the inspiration of Cubism after a brief stay in Europe. Cubism fitted perfectly in the geometric puzzle of traditional Indian designs and symbols, and Howe put it to brilliant use to produce a modern Indian art form in which he perfected an extremely individual and highly appreciated style. Scholder then worked with the technically inspired Pop artist Wayne Thiebaud (b. 1920) and perhaps here began perfecting his ability to use color. Scholder was part of the Rockefeller Southwest Indian Art Project from 1961 through 1963 which pre-

figured the new movement in Indian Art. Then he became an instructor at the Institute of American Art in Santa Fe. Here he found young Indians from over eighty different tribes struggling to re-identify with their origins, to salvage something of their proud history and bring dignity to their present condition. They were caught up in the Pop Art whim but, as Scholder says, not doing it well. The philosophy of Pop Art lent itself to Indian subjects. It presents things as they are in narrow focus.

Scholder felt that, while teaching his pupils to paint better, he "really wanted to do good paintings on the subject [themes being treated by Pop Indian Art]. It had never been painted well before. It had never been painted honestly before and nobody, certainly, had painted the Indian the way he is today . . . people really don't like Indians — not Indians the way the majority of them are, poor, outside the social value system, sometimes derelicts. People like their romanticized conception of the Indian, noble and handsome and inscrutably embodying wisdom and patience. But the Indian of today is in transition. He is a paradox to society and himself." And with this intent he started on his great Indian series.

Oddly enough, in painting the Indian as he is and avoiding the cliché of the noble warrior, Scholder has created out of him a noble and handsome work of art. The force of his art, its power and excitement, is not dependent on some mystically inherent virtues of his theme. He is the force of his art. He is first and foremost an excellent painter gifted with perhaps the greatest talent any artist can possess — the instinct to surprise. Not only does he anticipate the unexpected, but he makes it understandable.

The simply titled *American Indian* is a monument to the cliché and a put down of the stereotype we have perpetuated. Any one who has seen a staged Indian pow-wow in a national park can recognize in this great portrait something of the descent from greatness our native people have had to endure. Robert Ewing of the Museum of New Mexico puts Scholder and his art "somewhere between red power and Hiawatha."

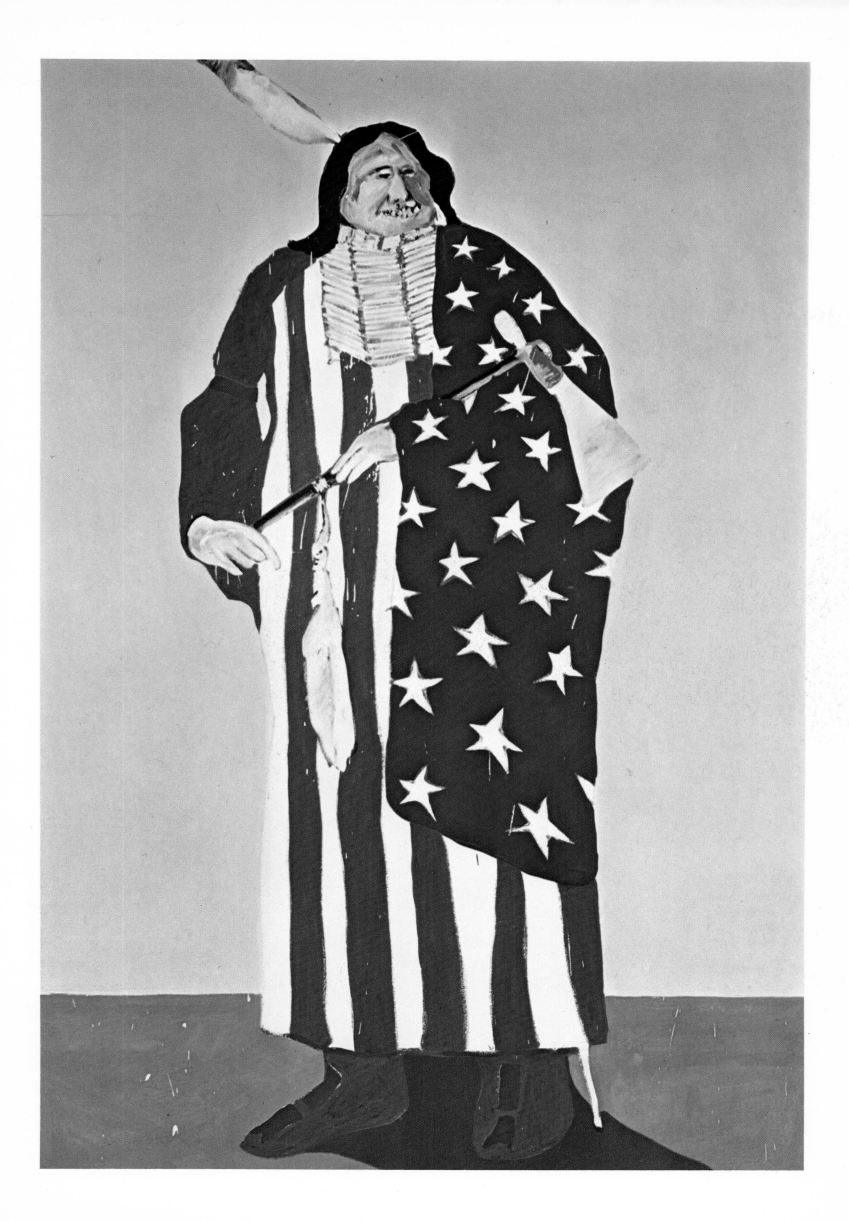

FRANZ KLINE

There is no American painter's work that is more difficult to explain than Franz Kline's. If its strength and congruence with the time in which it was created do not strike you, nothing the critics can say will help. The paintings are a force, a charge. They have voltage and they are incandescent clues to the art of bold power that was given birth in America in the 1950's. They reflect the post-World War II period as no other music, poetry or painting can do. Only the mother of the arts, architecture, and the sculpture of America's David Smith (b. 1906) seem to have taken so vital a direction.

Kline's paintings are unfinished architecture, that is, the scaffolding, the huge skeleton, the process of building, rather than the complete structure. But make no mistake, for they are not lacking in anything essential. They are complete statements as powerful as a scream and just as arresting. They almost frighten with their power.

Kline was born in Wilkes-Barre, Pennsylvania, and his step-father was in charge of a railroad roundhouse. The majesty of the giant locomotives fascinated the boy, and many of his late works bear titles from these early impressions, *Cardinal* and *Chief*, two famous trains. He moved to New York, and the enormity of that city naturally hit his imagination, too. His early paintings during

Requiem, 1958,
Franz Kline. 101-½ x 75 in., oil.
Albright-Knox Art Gallery, Buffalo,
gift of Seymour H. Knox.

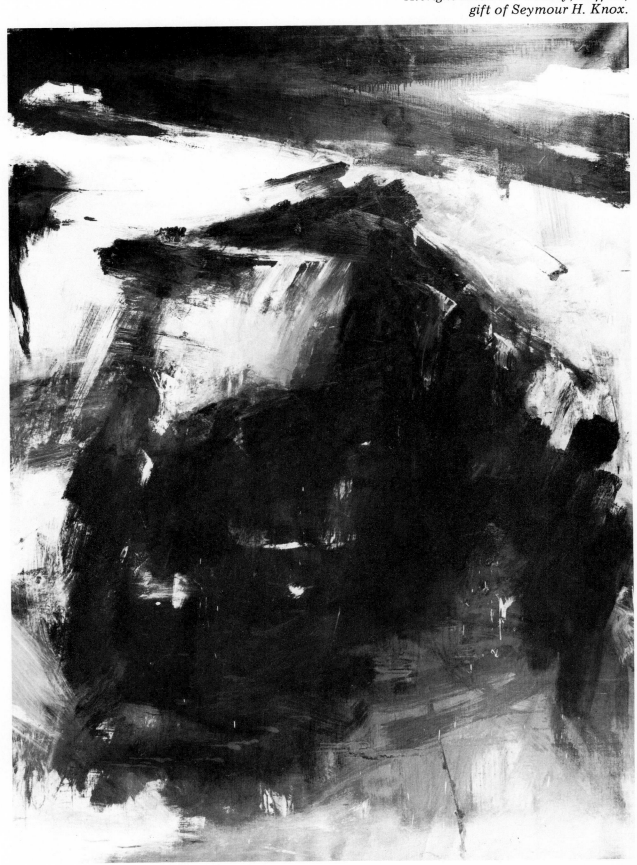

the 1940's had much the same sensitivity to the New York scene as John Sloan's (p. 194) had decades before. Kline also loved the paintings of Albert Pinkham Ryder (p. 166) and the Frenchman, Honoré Daumier (1808-1879), and said of them, "The final test of a painting, theirs, mine, and other is: Does the painter's emotion come across?" Some painters, far removed from his style, have answered this question, but those from whom he received the deepest affirmative were, quite naturally, Spain's Francisco de Goya (1746-1828) and Velásquez (1599-1660), as well as Rembrandt.

These three were master painters in the techniques of manipulating light and shade. The great shadowy depths of Rembrandt and Goya may have been what led Kline to his final powerful expressions in black and white. In an interview for an art magazine, he explained, "It wasn't a question of deciding to do a black and white painting. I think there was a time when the original forms that finally came out in black and white were in color, say, and then as time went on I painted them out and made them black and white. And then when they got that way, I just liked them, you know."

Kline was part of a whole movement in art abstraction in which each artist was desperately seeking his individual means of breaking with the clichés of art. *Caboose* was painted the year before Kline's death in 1962. It is the quintessence of his work, simplified to the most dramatic terms. It is, indeed, the end of the train of this art movement which he shared with Willem de Kooning (p. 262) and Jackson Pollock (p. 268) and others. He was the ultimate in Abstract Expressionism. The Japanese, who understood him at once as related to their own love of calligraphy, felt in Kline a marriage of writing and painting, and the artist Sabro Hasegawa paid this tribute to him, "Here are daring, strong, straight lines and their sorrows and solitudes." John Gordon, curator of the Whitney Museum of American Art writes, "He must be considered one of the great pioneers of this extraordinary development in the story of American painting. His canvases, large and well constructed, are symbols of our culture, full of its strength and loneliness." Kline himself described his purpose simply as the "intention . . . to create definite positive shapes with the whites as well as the black."

CABOOSE, *1961,*
Franz Kline (1910-1962). 79¾ x 107 in., oil.
Estate of Franz Kline,
courtesy, Marlborough Gallery, New York.

BIOGRAPHICAL INDEX

By Frank Getlein
and the Editors of Country Beautiful

ALBERS, JOSEF (b. 1888), p. 308, geometric abstractionist. Born in Germany, he emigrated to the U. S. in 1933 after thirteen years of association with the Bauhaus School. Albers, along with Hans Hofmann, who also came to the U. S. in the 1930's, has been one of the two great teachers of modern American painters. His career has included sixteen years at Black Mountain College, North Carolina, and a decade as head of Yale University's Art Department. He said of his teaching, "I believe that art as such cannot be taught, but a lot can be done to open eyes and minds to meaningful form." His treatise, *Interaction of Color,* demonstrates hundreds of ways in which a color changes its character in juxtaposition to a neighboring color. In his paintings, Albers worked with a geometrical motif of squares within squares, usually restricting himself to not more than four colors.

Homage to the Square: It Seems, 1963.
Josef Albers . 40 x 40 in., oil.
The Philadelphia Museum of Art.

ALBRIGHT, IVAN (b. 1897), pp. 300-301, Chicago Surrealist who has created his vision not out of the juxtaposition of incongruous objects so much as by the juxtaposition of separated times in a single texture, surface of form. His portraits and still-life arrangements seem to decay before the eyes of the observer, so closely painted are they. His major works have taken him fifteen years or more to produce and usually bear long, poetic, melancholy titles. An American original with neither obvious antecedents nor admitted followers, Albright studied art in Paris, Philadelphia and Chicago after youthful efforts in architecture. A medical draftsman in World War I, he may have taken his morbid intensity from that experience more than from his formal studies.

ALLSTON, WASHINGTON (1779–1843), pp. 54-55, landscape and allegorical painter once regarded as America's foremost artist. A native of South Carolina, Allston graduated from Harvard College, studied with Benjamin West in London, went on to Paris and some years later to Italy. He was a friend of the English poet Samuel Taylor Coleridge, whose portrait he painted and whose romantic, poetic doctrines

certainly influenced Allston's best work, the romantic landscapes. The last quarter century of his life was largely wasted in futile effort to complete large *Belshazzar's Feast* in the grand manner.

AUDUBON, JOHN JAMES (1785–1851), pp. 64-67, first scientific painter of America's birds and animals, especially noted for the former. Born in Haiti, brought up in France, he came to America at twenty, then returned to France for brief study with J. L. David, Neoclassicist painter of the French Revolution and Empire. Something of David's hard, fixed line may be seen in Audubon's birds, but the American was mostly self-taught. From 1827 to 1838, he published *Birds of America* in England, where he enjoyed a professional and a personal vogue as a man from the wilderness. His devotion to American wildlife is perpetuated in the societies that bear his name.

AVERY, MILTON (1893–1965), pp. 290-291, quiet, lyrical painter of people and seaside scenes highly abstracted but always recognizable. A native of Altmar, New York, Avery studied briefly in Hartford, Connecticut, but was chiefly self-taught, finding his distinctive style early and refining it over decades. Suppressing detail, Avery saw nature as large, simplified color areas, the colors often of great delicacy and subtle relationships one to another. Long a stranger to financial success, Avery was able to pursue his art by the earnings of his wife, Sally, in fashion art. His simplifying influence, with its concentration on color, may be seen in the work of Mark Rothko and others of the New York School, but his influence is most directly seen in the paintings of his daughter, March.

BADGER, JOSEPH (1708–1765), p. 46, colonial portrait painter who worked in and around Boston. Badger typified the best of the pre-Revolutionary artists: completely without adequate training for what he hoped to do, he nevertheless persisted and brought to his rather stiff work an intensity of vision that made up for other lacks. His most enduring claim to fame is as the teacher of John Singleton Copley.

Sita and Sarita, 1893-94,
Cecilia Beaux . 37½ x 25½ in.,
oil. The Corcoran Gallery of Art.

BEAUX, CECILIA (1863–1942), p. 308, academic portrait painter. Born in Philadelphia, she studied at the Pennsylvania Academy and in Paris under Adolphe William Bouguereau and others. Popular as a painter of women and children, she won numerous awards. Her diary is a valuable source book for art conditions in Paris and America over a long period.

BELLOWS, GEORGE (1882–1925), pp. 208-209, the youngest and in some pictures the most vigorous member of the Ashcan School. Born in Columbus, Ohio, Bellows starred on the university baseball team there and later, in New York, became perhaps the only major artist to support himself while studying by playing professional baseball and basketball. As the favorite pupil of Robert Henri, leader of the Ashcan painters, Bellows absorbed his thick direct approach to paint, especially evident in his great fight pictures, such as *Stag at Sharkey's* and *Both Members of this Club.* For portraits, often of his family, and for landscapes of the Hudson, he perfected a quieter, less flamboyant style. The youngest member of the National Academy, he also helped organize the Armory Show Show of 1913.

BENTON, THOMAS HART (b. 1889), pp. 256-257, muralist and the most vociferous leader of the movement among American artists of the 1930's and '40's to celebrate American rural life, variously known as Regionalism and The American Scene. Decended from a politically prominent Missouri family, Benton was in Paris before World War I, "in and out," as he has said, "of a dozen -isms." Following the war, which he spent in the Norfolk, Virginia, Navy Yard, he passed a decade or so drifting around the country and gradually realizing that this was his subject. His paintings of Missouri frontier life include the murals in the Harry S. Truman Library at Independence. He was the influential teacher of Jackson Pollock.

BIERSTADT, ALBERT (1830–1902), pp. 128-130, the most grandiose of American landscape painters. A native of the Düsseldorf region in Germany, he was raised in New Bedford, Massachusetts, then returned to Düsseldorf for artistic training. From the Düsseldorf style, he absorbed a mastery of textures and a somewhat melodramatic taste, both perfectly suited to his career. In 1858 he joined an army map-making expedition from St. Louis to the Pacific. His paintings from this expedition, actually executed on his return to New York, caused an immediate sensation and launched Bierstadt into three decades of all but unparalleled prosperity as an American artist. Today his smaller sketches are more highly regarded than the enormous views of the Rockies and Yellowstone which made his fortune.

BINGHAM, GEORGE CALEB (1811–1879), pp. 92-93, painted both the mystery of the frontier and the raucousness of its society. A native Virginian, he was taken as a child to the Missouri Territory, the life of which made a lasting impression on his art. He studied in St. Louis, Philadelphia and Düsseldorf, Germany, one of the first Americans to attend that school which was to influence later nineteenth-century American painting so strongly. A captain of volunteers in the Civil War, he gave up painting entirely to concentrate on politics. But his great, enduring American images include election days scenes and the quiet drift of fur traders on the Missouri River.

A Sleighing Party, *1841*,
Thomas Birch. 19 x 29 in., oil.
The Currier Gallery of Art.

BIRCH, THOMAS (1779–1851), p.309, son of
an English topographical engraver who brought
him to America at fifteen as his apprentice. At
twenty-one he collaborated with father, Wil-
liam, on engraving series, "Views of Philadel-
phia." His marine paintings of naval engagements
in the War of 1812 were popular, but his less
romantic, more accurately observed landscapes
were a more solid contribution to our art.

BISHOP, ISABEL (b. 1902), pp. 280–281, a
woman painter of working women, Isabel
Bishop anticipated the Women's Liberation
movement by decades. Born in Cincinnati, she
studied in Detroit and at the Art Students
League in New York under Reginald Marsh and
Kenneth Hayes Miller. She early discovered her
own subjects on the streets of New York and
early perfected her highly personal technique, a
rare combination of a firm line and a genera-
lized, hazy atmosphere, often glinting with the
palest of gold. The effect is sometimes that of
office or counter girls, at lunch, in conversation,
or undressing at home, depicted in tapestry.

BLAKELOCK, RALPH (1847–1919), pp.
172-173, romantic painter of the West. Born in
New York City, Blakelock studied medicine
briefly, then switched to art at the Cooper
Union. In his early twenties he set out for the
West and returned, after three years, with
sketchbooks full of the material for his paint-
ings. His West was quiet, mysterious and evoca-
tive—and a complete failure with an art market
accustomed to the spectacular vistas of Fred-
eric Church and Albert Bierstadt. Driven mad
by his inability to support his nine children,
Blakelock spent the last twenty years of his life
in an asylum, where he regained sanity and
freedom one month before his death.

South of Scranton, 1931,
Peter Blume. 56 x 66 in., oil.
The Metropolitan Museum of Art,
New York, George A. Hearn Fund.

BLUME, PETER (b. 1906), pp. 272-273, highly
individual painter of assembled images often
thought of as a Surrealist social critic. Born in
Russia, Blume was brought to New York at the
age of five, studied at the Educational Alliance,
the Art Students League and the Beaux-Arts
Institute. Immensely talented, he began earning
a living through his painting at the age of eigh-
teen at a time when many American artists
never did. His *South of Scranton* an assemblage
of things seen on a motor trip from Pennsyl-
vania to Charleston, South Carolina, won the
top prize at the Carnegie International Exhibi-
tion of 1934, while *The Eternal City*, 1934-37,
with its green head of Mussolini as a threatening
jack-in-the-box among Rome's ruins is a lasting
image of Fascism.

BLYTHE, DAVID GILMOUR (1815–1865),
pp. 118-119, a genre painter of great humorous
insight. Blythe was born near Pittsburgh when
the city was still much closer to the fort of the
crucial battle of the French-Indian Wars than
to the industrial giant it has been so long. After
a stint in the Navy, Blythe settled down in Pitts-
burgh and kept himself in whisky by painting
comic scenes of everday life and sometimes
quite penetrating sketches of the sufferings of
the new class of industrial workers.

BODMER, KARL (1809–1893), pp. 80-81,
scientific draftsman born in Switzerland,
trained in Paris, worked in America only
1833-1834 as illustrator for botanist Prince
Maximilian of Wied-Neuwied. On his return to
Paris he translated his watercolor drawings into
superb engravings of Indian life beyond the
white man's frontier as seen by a cooly scienti-
fic observer.

Fur Traders Descending the Missouri, *1845,*
George Caleb Bingham. 29 x 36-1/2 in., oil.
The Metropolitan Museum of Art,
Morris K. Jessup Fund.

BURCHFIELD, CHARLES (1893–1967), pp.
266-267, with John Marin, the outstanding
twentieth-century American watercolorist and
nature painter. Born in Ohio, he studied at the
Cleveland School of Art, but spent most of his
life in Buffalo. Though from age twenty until
his death, Burchfield's life saw American art in
one turmoil, revolt or overriding fashion after
another, the painter ignored them all, perfect-
ing an individual view of the provincial Ameri-
can townscape and, in full maturity, a pulsing,
mystical identification with a life-force in na-
ture. This at times seems to radiate in waves
from his flowers, sun, trees, even rocks.

CASSATT, MARY (1844–1926), pp. 168-169,
Impressionist painter of mothers and children
and women at leisure. Born in Pittsburgh,
Cassatt studied briefly at the Pennsylvania Acad-
emy but spent most of her life in Paris, where
she was a protégée of Degas, who said, "At last,
a woman who can draw." To Impressionism
and to late nineteenth- and early twentieth-
century art in general Cassatt introduced wom-
en as private people, not merely attractive

forms or portrait subjects. Although she never
married, her pictures of mothers with their
babies and young children are the most effec-
tive since Raphael's and more real. Cassatt,
from a wealthy Pennsylvania family, was also
responsible for several of the great collections
of older European art now in American muse-
ums, advising visiting friends on their purchases.

CATLIN, GEORGE (1796–1872), pp. 74-77,
artist-explorer and the most famous painter of
American Indians. A native of Pennsylvania, he
lived as a child in the then frontier region of
that state, along the New York border, where
he made friends with Indian residents. Later, in
Philadelphia, where he started as a lawyer, then
switched to painting at the Pennsylvania Acad-
emy, he was deeply impressed by an Indian
delegation en route to Washington. He had
found his theme. In the 1830's, he traveled
west with military expeditions and then alone
and copiously documented the life of the
Comanches, Mandans and forty-six other tribes.
Back east and in Europe, he exhibited his paint-
ings with little success, in later life sought sub-
jects from Alaska to South America, with
equally distressing results. After his death, how-
ever, some five hundred of his Indian paintings
were accepted by the Smithsonian Institution.

CHANDLER, WINTHROP (1747–1790), p.
40, Connecticut portrait painter whose strong
feeling for composition and obvious sympathy
with his subjects, some of them relatives, re-
deemed his pictures from the extreme concen-
tration of details of drapery and his tendency
to frame sitters in a grand manner at variance
with their hard, country characters.

CHASE, WILLIAM MERRITT (1849–1916),
pp. 156-157, figure, portrait and still-life paint-
er. Born in Indiana, the young Chase moved
rapidly from instruction from an Indianapolis
portrait artist to the National Academy classes
in New York to Munich for six years and
Venice for one. He returned to New York with
a personal blend of Munich dash and Venetian
light. His Tenth Street studio was a meeting
place for artists and people of fashion and, in
the numerous paintings he did of it, a veritable
prop shop for the painter's trade of exotic
backgrounds and costumes. At least as impor-
tant as a teacher and as an artist, Chase advised
his students to give a picture all the time it re-
quired: "Take two hours if you need it."

CHURCH, FREDERIC E. (1826–1900), pp.
110-111, the most spectacular of the nine-
teenth-century American landscape artists. Son
of a well-to-do Connecticut family, Church
studied for three years with Thomas Cole,
founder of the Hudson River School of land-
scape painting. The student soon took that
school far beyond the river, creating one of the
great views of Niagara Falls and immense pan-
oramas of the Andes and the Arctic. His curious
and splendiferous Moorish-Victorian castle
home "Olana," overlooking the Hudson, is a
national monument.

COLE, THOMAS (1801–1848), pp. 70-73, the
first widely acknowledged American landscape
painter and thus father of the dominant nine-
teenth-century painting. Born in Lancashire,
Cole came to America with his family, followed
his dream of the wilderness up the Hudson and
achieved instant success when three of his Hud-
son River landscapes were highly praised by
John Trumbull, painter of the Revolution. Cole
also employed his feeling for landscape with
allegorical series, especially *The Voyage of*

Life and *The Course of Empire* , but his Hudson River scenes remain his most enduring claim to fame.

COPLEY, JOHN SINGLETON (1738–1815), pp. 16-22, the most accomplished of all the pre-Revolutionary painters. Stepson of a popular Boston engraver, Peter Pelham, who died when the boy was thirteen, Copley immediately set himself up as a professional portraitist and in a very few years, through talent and determined self-teaching, brought colonial portraiture to new heights through his utter mastery of textures and forms and his interest in psychology. He painted a particularly fine portrait of Paul Revere ten years before the famous ride. Praised by Sir Joshua Reynolds, Copley emigrated to England on the eve of the Revolution and never returned to America. His English portraits showed an increasing mastery of studio tricks and a steady decline of the vigor and freshness of his American work.

CURRY, JOHN STEUART (1897–1946), pp. 234-235, painter and muralist. A native of Kansas, Curry began his career as an illustrator for popular magazines, and found himself as a painter of the Midwest during the Regionalist movement of the 1930's, along with Thomas Hart Benton and Grant Wood. At the University of Wisconsin he was probably the country's first artist-in-residence. Work resembles Benton's in theatrical poses and dramatic moments.

DARBY, HENRY F. (1829-1897), pp. 82-83. Born in North Adams, Massachusetts, Darby was a self-taught portraitist and working in oils by the time he was thirteen, three years before painting *The Rev. John Atwood and His Family*. In 1847, he went to teach at South Carolina Female College, Barhamville, but soon returned north to work in New York, painting portraits of Henry Clay, John C. Calhoun and others, exhibited at the National Academy of Design. His grief at the loss of his wife in 1859 caused him to abandon art, and about 1860, after being ordained an Episcopalian minister, he lived in Oxford, England, for five years, returning in 1865 to become rector of St. John's in Whitesboro, New York, He resigned four years later and lived in Fishkill, New York, until his death.

DAVIES, ARTHUR B. (1862–1928), pp. 212-213, painter of dreamlike landscapes with graceful nudes. Davies was an unlikely leader of the revolt of the Ashcan School ; his subjects and his style were worlds removed from the vigorously painted scenes of daily life of Sloan and Luks. He believed deeply in artistic independence and was one of the ringleaders of the Armory Show of 1913 that introduced modernism to America.

DAVIS, STUART (1894–1964), pp. 224-225, leading abstract painter of the mid-twentieth century. Davis, a prodigy, was also the son of a Newark newspaper editor who employed Robert Henri and John Sloan and others of the Ashcan School. Taught by Henri, Davis appeared in the Armory Show while still in his late teens. Jazz, neon signs and the invigorating clash of city life inspired his hard-edged, bright colored abstractions.

DEAS, CHARLES (1818–1867), p. 310, painter of scientific observation along the frontier and of genre scenes. Deas made his name during the 1840's in St. Louis with highly melodramatic pictures of the perils of frontier life. In the

early 1850's, Deas went mad and passed his remaining fourteen years in an asylum.

The Death Struggle, *1845,*
Charles Deas (1818-1867). 30 x 25 in., oil.
Webb Gallery of American Art,
Shelburne Museum, Shelburne, Vermont.

DE KOONING, WILLEM (b. 1904), pp. 262-263, one of the leaders–with Jackson Pollock–of the Abstract Expressionist movement in the 1940's and 1950's. Born in Rotterdam, he was apprenticed at twelve to a firm of commerical artists and decorators. Studied art in night classes, came to United States in early twenties. After commercial art, house painting, WPA, and a job as mural assistant to Fernand Léger, he developed his own style, basically a method of improvising in paint rather as a musician does in sound, while teaching at Black Mountain College, North Carolina and Yale. His influence upon younger painters, both by example and by teaching, has been incalculable.

DEMUTH, CHARLES (1883–1935), pp. 214-215, abstract painter of industrial forms. Born in Lancaster, Pennsylvania, Demuth went to Paris at twenty-one, returned there for four years of study just before World War I. With Charles Sheeler and several other artists, tagged by art historians as "the Immaculates" or "the Precisionists," Demuth applied Cubist doctrines to the stark purity of form of American industrial architecture.

DICKINSON, EDWIN (b. 1891), pp. 230-231, romantic abstract painter. Born in Seneca Falls, New York, Dickinson studied with William Merritt Chase and at Pratt Institute, Brooklyn, and the Art Students League, New York City. His range includes formally complex structures and spontaneous expressions. Influential as a teacher, he taught many years at the League and Cooper Union Art School.

DIEBENKORN, RICHARD (b. 1922), pp. 286-287, leader of the "San Francisco Bay Area Painting," or "California Figurative" art, in the 1950's and after. Broad, thickly painted color areas, with harsh light and deep shadow characterize his figures and landscapes.

DOVE, ARTHUR (1880–1946), pp. 252-253, the first completely abstract modern painter. Born in Geneva, New York, he first studied art at the age of six, became an illustrator, went to Paris in 1907, returned to New York to join the group of modern painters exhibited by Alfred Stieglitz. By 1910 Dove was making total ab-

stractions based on his emotional responses to nature. He was also perhaps the first American artist to employ collage, making a portrait of his grandmother out of a fragment of her needlepoint work, a page of her Bible, some pressed flowers arranged on a weathered shingle.

DURAND, ASHER BROWN (1796–1886), pp. 90-91, engraver and painter of the Hudson River School. Born on a New Jersey farm, Durand delighted his relatives as a boy by hammering pennies into flat disks, engraving them and making prints from them, an extraordinarily sophisticated process for a child to teach himself. Apprenticed to New York engraver Peter Maverick, he soon outdistanced his teacher and made his fortune with his engraving of John Trumbull's painting of the signing of the Delcaration of Independence. At forty, Durand turned to painting and, inspired by Cole, created Hudson River landscapes of greater purity than the master's.

DURRIE, GEORGE HENRY (1820–1863), pp. 102-103, the best of the large stable of artists who worked for the colored print house of Currier & Ives. A native of Connecticut, he began as a portrait artist, switched to landscape with the burgeoning popularity of the Hudson River School, but developed his own specialty, winter, a theme almost never touched by the Hudson River artists.

EARL, RALPH (1751–1801), pp. 44-45, the best of the Connecticut School of portrait artists. Earl fought in the Revolution, then studied in England for six years, but always retained a certain provincial awkwardness that complements the rugged Yankee honesty of his portraits of rural Connecticut townspeople.

Max Schmitt in a Single Scull, *1871,*
Thomas Eakins. 32-¼ x 46-¼ in., oil.
The Metropolitan Museum of Art,
New York, gift of George D. Pratt.

EAKINS, THOMAS (1844–1916), pp. 144-151, realist painter and, in the generally accepted view, the greatest artist America has produced. Born in Philadelphia, Eakins spent most of his life there except for study in Paris as a young man and a trip to Spain, where Velásquez deeply influenced him. Like the Spanish master and like Rembrandt, another influence, Eakins developed the ability to paint absolutely what he saw before him and, through that, to paint the very soul of his subject. Most of his subjects were people he knew, academics, clerics, musicians and relatives. He painted some notable sports pictures and two group portraits of anatomical clinics as homage to Rembrandt. Eakins also experimented with photography as a device to record humans and horses in motion. A long-time teacher at the Pennsylvania Academy, his tradition of plain-

spoken, deeply seen realism has remained a central one in American art.

EASTMAN, SETH (1808–1875), pp. 86-87, painter of American Indian life. Native of Maine and graduate of West Point, Eastman soldiered with the First Infantry in the frontier territories of Wisconsin and Minnesota, later in Texas, sketching, drawing and painting the Indians at work and play. Recalled to Washington, he produced almost 300 illustrations for H.R. Schoolcraft's monumental, many-voluminous study of the condition of the Indians.

EVERGOOD, PHILIP (b. 1901), pp. 270-271, painter of social protest and a personal, dreamy, semi-Surrealism. Born in New York, Evergood was sent to England by his father, an Australian-born painter. At Eton and Cambridge, Evergood excelled at sports but not at studies, quit the university to enroll at Slade School of Art, London. He later studied in New York with George Luks. Savagely or subtly, Evergood mocks popular American verities and also creates haunting, private visions of isolated individuals.

FEININGER, LYONEL (1871–1956), pp. 226-227, American expatriate artist. Born in New York, Feininger went to his parents' Germany to study music in 1887, stayed on to study art, joined the Bauhaus and developed a personal Cubism of crystalline planes extended from buildings and boats to divide the entire surface of his delicately colored abstractions. He returned to America in 1936.

FEKE, ROBERT (1705–ca. 1750), pp. 10-11, the best of the colonial portraitists of the first half of the eighteenth century. Worked in Boston, Newport, Rhode Island and Philadelphia and may have studied in Europe. Apparently painted only during the decade of the 1740's, but his work in that brief period outclassed his contemporaries, adding dignity and grace to somewhat naive compositional approach he shared with them.

FIELD, ERASTUS SALISBURY (1805–1900), pp. 136-137, primitive painter. Born in Leverett, Massachusetts, Field was apparently self-taught, despite vague claims to a brief period in the studio of Samuel F. B. Morse. Portraitist and Biblical illustrator, his fame rests on a single picture, celebrating the U. S. Centennial, *Historical Monument of the American Republic*, 1876, a fantastic array of imaginary architecture decorated with sculptures and reliefs of American history.

FISHER, ALVIN (1792–1863), p. 95, Boston painter typical of the strictly local artists who flourished in many cities in the mid-nineteenth century. Starting as a painter of prize cattle for their owners, Fisher switched to landscapes with the rise of the Hudson River School, but never progressed beyond pale imitations of European romanticized scenery.

FRANKENTHALER, HELEN (b. 1928), pp. 288-289, second-generation Abstract Expressionist. Born in New York, Frankenthaler was educated at Bennington College, Vermont, subject to avant-garde art teaching. She married Robert Motherwell, the chief artist-theorist of Abstract Expressionism. Frankenthaler developed her personal version of that school by staining unsized canvas with paint, a method and vision which greatly influenced Color Field Painting of such painters as Kenneth Nolan and Morris Louis.

GIFFORD, SANFORD ROBINSON (1823–1880), pp. 120-121, Hudson River painter. In the 1850's, Gifford spent some time in London and was greatly influenced by the J. M. W. Turner landscapes and seascapes he saw there. Thereafter he developed a manner based on a single dominant color from the sky playing over the whole picture.

GLACKENS, WILLIAM (1870–1938), pp. 186-187, member of the Ashcan School, despite his generally more elegant subjects. After a visit to Paris, Glackens lightened his palette and adopted a breezier touch. He was the principal advisor-agent to Albert Barnes in assembling that superb collection of French Impressionist paintings and he was a prime mover in the Armory Show.

GORKY, ARSHILE (1904–1948), pp. 246-247, abstract Surrealist and precursor of Abstract Expressionism. Born in Armenia, he came to America in 1920, studied at the Rhode Island School of Design, later at the Grand Central School of Art, New York City; he was also a WPA artist. His early work somewhat resembles early Picasso, but Gorky's chief development came on meeting, around 1944, the refugee Surrealists in New York. He painted "biomorphs" that recalled Joan Miró's and used a method of association in painting halfway between Surrealist automatic writing and Abstract Expressionist spontaneity. Cancer and an automobile accident that paralyzed his painting hand preceded his suicide.

GRAVES, MORRIS (b. 1910), pp. 250-251, draftsman and painter, member of the Pacific Northwest group of artists. Born in Fox Valley, Oregon, he journeyed to the Far East and later settled in Seattle, where he was influenced by Mark Tobey. A believer in Zen Buddhism, Graves is the most obsessed painter of birds since Audubon. For some years, he has lived in Ireland.

GREENWOOD, JOHN (1727–1792), pp. 12-13, Boston portrait artist and the inventor of American genre paintings in a single canvas. Greenwood was briefly the teacher of John Singleton Copley, but his true fame springs from one picture, *Sea Captains Carousing in Surinam*, which portrays and lists their names on the back, a score of drunken Yankee seafarers in the Dutch port.

HARNETT, WILLIAM MICHAEL (1848–1892), pp. 158-159, the best and best-known of the nineteenth-century sharp-focus realists, or "fool-the-eye" painters. Born in Ireland, brought to Philadelphia as an infant, Harnett studied at the Pennsylvania Academy, became an engraver on silver and began painting in 1875, bringing to art the same close attention engraving required. His "bachelor still lifes"–pipes, beer mugs, cards and invitations– were popular from the first. His *After the Hunt* is probably the most ambitious work in the field.

HARTLEY, MARSDEN (1877–1943), pp. 236-237, early abstractionist. Born in Maine, Hartley spent years traveling to Europe and elsewhere and seemed as mobile in style as in voyaging. He tried Cubism and became perhaps the first American to be sympathetically aware of German Expressionism. His best pictures are powerful, simple paintings of Maine scenes and people painted with vibrant color and strong black lines.

HASSAM, CHILDE (1859–1935), pp. 202-203, American Impressionist and leader of The Ten in the 1890's. Born in Boston, Hassam went to work for a publisher, became an illustrator for magazines and books. In 1886 went to Paris to study, where he saw the Impressionists, adapted their style to his own and won a medal in the 1889 Paris Exposition, another at Munich. At home, his attractive paintings won him an audience, purchasers and honors.

HATHAWAY, RUFUS (1770?–1822), pp. 40-41, painter and physician. Born in Freetown, Massachusetts, Hathaway apparently had little formal training but was painting portraits by 1790. In 1795 he fell in love with the daughter of a merchant who persuaded his son-in-law-to-be to give up painting and become a doctor. Although certainly a primitive, he was capable of penetrating character studies.

HEADE, MARTIN JOHNSON (1819–1904), pp. 124-125, landscape painter, member of Luminist group interested in light and atmospheric conditions. Born in Pennsylvania and active in New Jersey, Heade also traveled extensively in New England and in South America, in search of inspiring subjects. His landscapes are seen in early morning, twilight or beneath an approaching storm; they share with his flower and bird pictures a strange sense of hallucination.

HEALY, GEORGE PETER ALEXANDER (1813–1894), pp. 100-101, immensely successful portraitist. Born in Boston, son of an Irish sea captain, Healy early showed talent, earning enough through portraits to study in Paris under Baron Gros. Commissioned by Louis-Philippe, the "bourgeois king," to paint his portrait, Healy so pleased the king that he sent the painter back to America to record the likenesses of leaders here. Besides Lincoln, Tyler, J. Q. Adams, Webster, Clay and Jackson, Healy's subjects included Liszt, Pius IX, Louisa May Alcott and Henry Wadsworth Longfellow.

HENRI, ROBERT (1865–1929), pp. 192-193, realist painter and founder of the Ashcan School. Son of a famous Western gambler, Henri was born in Cincinnati, studied at the Pennsylvania Academy and in Paris. Returning to the Academy as a teacher, he recruited artist-journalists John Sloan, William Glackens, George Luks and Everett Shinn as aspirant fine artists. As a group they worked for papers in Newark and New York where they staged the first art revolution of the new century, the exhibit of The Eight in 1908, featuring pictures of street and tenement life, as against landscapes and sanitized peasants. More influential as a teacher than as a painter, Henri's students included three generations of Americans.

HESSELIUS, GUSTAVUS (1682–1775), p. 15, colonial portrait artist. A native of Sweden, Hesselius practiced in Philadelphia, where he helped to establish the American portrait as a study of a single personality. He also painted classical allegories. His picture of Lapowinsa, a century before Catlin, may be the first portrait of an Indian.

HESSELIUS, JOHN (1728–1778), pp. 14-15, son of Gustavus Hesselius and trained by his father to practice portraiture in Philadelphia. He is best known for his portrait of Charles Calvert as a boy, accompanied by a black slave also in aristocratic dress. He was also the first teacher of Charles Willson Peale.

HICKS, EDWARD (1780–1849), pp. 84-85, primitive painter, Hicks was born and raised in Bucks County, Pennsylvania. He began as a carriage and sign painter, never progressed far beyond the limited mastery needed for those trades. But as a part-time Quaker preacher, he expressed his simple love of God and the Bible in many versions of *The Peaceable Kingdom* and of Penn's treaty with the Indians.

HOFMANN, HANS (1880–1966), pp. 260-261, painter and very influential teacher of Abstract Expressionism. A native of Germany, he founded an art school in Munich, taught in the United States and moved here in early 1930's. He taught at Berkeley, Art Students League, Cape Cod and at his own school in New York. His own paintings are colorful and decorative. His teachings – such as "push-pull," or positive and negative space, or the tracks in the work of the act of painting–can be found exemplified in some of the most traditional pictures, but Hofmann's interpretation urged them to exist in and for themselves in paintings.

HOLLINGSWORTH, GEORGE (1813-1882), p. 82, portrait and landscape painter trained for the profession in Boston and Italy. Hollingsworth worked and lived in the Boston area where he was the first and chief instructor of drawing at the Lowell Institute from 1851 to 1879. His canvas of *The Hollingsworth Family,* done when he was about twenty-seven, is a candid and somewhat awkwardly posed family portrait.

HOMER, WINSLOW (1836–1910), pp. 138-143, painter of landscapes, seascapes, and everyday life. Homer is equal to or second only to Thomas Eakins as a giant of American art. Born in Boston, he passed his childhood there and in Maine. Early apprenticed to a lithographer, he became an artist-journalist and covered the Civil War for *Harper's Weekly,* which transformed his drawings into wood engravings. A war painting, exhibited at the National Academy, gave Homer an instant reputation. After the war he perfected his art in the best genre paintings the country has seen, including remembered scenes from country schools and beach groups in New Jersey. A recluse in Maine for his last thirty years, Homer took extended trips to the Adirondacks, the Canadian woods and Caribbean, during which he established watercolor as a medium for major works, as Constable had done in England. In his oils, the feeling of high ground or the sheer weight of the sea has never been more convincingly expressed.

HOPPER, EDWARD (1882–1967), pp. 218-221, realist painter of city streets and interiors, watercolorist of seaside houses and activities. The monumental patience of Hopper's career is reflected in his oils of humble, rundown city streets or sad rooms inhabited by single people alone in the city. Born in Nyack, New York, he studied commercial illustration, with which he supported himself for years, and painting under Robert Henri and Kenneth Hayes Miller. Hopper sold his first painting in the Armory Show, 1913. Ten years later he sold his second, a watercolor of a Cape Cod house. In the meantime, he had made himself a master of etching, printing and selling the same kind of themes that later distinguished his oils.

HOWE, OSCAR (b. 1915), pp. 294-295, most distinquished of contemporary Indian painters. A full-blooded Sioux, he was born on Crow Creek Reservation in South Dakota and studied painting at U.S. Indian School, Santa Fe, New Mexico. Majoring in fine arts, he graduated from Dakota Wesleyan University, Mitchell, South Dakota, in 1952, and earned a Masters from the University of Oklahoma in 1954. In 1957 he became professor of fine arts and artist in residence at University of South Dakota, Vermillion. He has exhibited widely and in 1960 was named Artist Laureate of South Dakota and Fellow of the International Institute of Art and Letters, Geneva, Switzerland, the same year. He has stated that, "It is my greatest hope that my paintings may serve to bring the best things of Indian culture into the modern way of life."

HURD, PETER (b. 1904), pp. 238-239, regionalist painter of the Southwest, especially New Mexico. After West Point, he studied at the Pennsylvania Academy and with the great illustrator, N. C. Wyeth, whose daughter he married. Hurd seemed a natural to paint the official portrait of Lyndon B. Johnson, but that President pronounced the work "the worst painting I've ever seen."

INNESS, GEORGE (1825–1894) pp. 170-171, after a brief career as a teen-age grocer in Newark, New Jersey, in a small store established by his father, Inness studied art in earnest and achieved wide recognition at twenty-one. Various sponsors underwrote a series of trips to Europe, which experience contributed to making him the most sensitive painter of more or less domestic landscapes, with a strong hint of the spirit if not the technique of Impressionism, in the later nineteenth century.

JOHNS, JASPER (b. 1930), pp. 302-303, one of the two founders of Pop Art in America, the first reaction against Abstract Expressionism. A native of South Carolina, Johns painted literal reproductions of targets, the American flag and other popular images, including the Arabic numerals as stenciled. He is the creator of such objects as beer bottles cast in bronze and is a very fine lithographer.

JOHNSON, EASTMAN (1824–1906), pp. 132-133, superior genre painter of the late nineteenth century. Born in Maine, Johnson showed early talent for portraiture, studied in Düsseldorf, then in the Low Countries, where he absorbed the compositional restraint of the Dutch "little masters," whose example helped him avoid the depths of sentimentality of genre painting in his time.

KANE, JOHN (1860–1934), pp. 232-233, primitive painter of Pittsburgh area. Born in Scotland of Irish parents, he came to America as a child, worked as laborer in various jobs until he lost a leg beneath a locomotive. Then, as painter of railway cars, he took to painting scenes on them in his mornings, painting them over in the afternoon. Simple, straightforward and strong, his art had no subtlety, but the intensity of his love of life.

KENSETT, JOHN FREDERICK (1818–1872), pp. 122-123, landscape artist and Luminist. Born in Cheshire, Connecticut, he started out as an engraver, switched to painting under the influence of Asher Brown Durand, who led him and two other students on a European tour. After seven years abroad, Kensett returned to travel in America to paint what he saw and liked, generally soft and pleasant landscapes.

KLINE, FRANZ (1910–1962), pp. 306-307, Abstract Expressionist leader. Born in Wilkes-Barre, Pennsylvania, Kline supported himself selling comic drawings and decorating saloons, until the late 1940's. His mature style consisted of powerful thick black lines roughly painted on a white ground, images sometimes apparently projected from scratch pad scribbles. Late in his career he experimented with color, but the stark black and white, suggestive of girders or bridges, remains his signature.

KNATHS, KARL (1891–1971), p. 312, American modern painter. Born in Eau Claire, Wisconsin, studied at the Chicago Art Institute. Settled in Provincetown, Cape Cod, in 1919, painted there the rest of his life, developing a kind of personal Cubism based on form relationships and complex color harmonies.

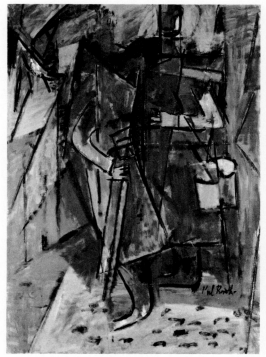

Clam Digger, *1960,*
Karl Knaths.
45-3/4 x 36 in., oil.
Honolulu Academy of Arts.

KRIMMEL, JOHN LEWIS (1789–1821), pp. 58-59, America's first professional genre painter. Born in Germany, where he may have been trained as a miniature painter, in Philadelphia Krimmel painted scenes of everyday life, often jammed with figures and details. Enjoying wide popularity for his work before his early death by drowning, Krimmel resisted efforts to lure him into history painting.

KUHN, WALT (1880–1949), pp. 248-249, realist painter. Born in Brooklyn, Kuhn began his career as a newspaper cartoonist in San Francisco, later studied in France and Germany. Kuhn was one of the major devisers of the Armory Show of 1913, serving as executive secretary. His strong still lifes of rugged, country fruit and flowers and his deeply melancholy clowns and acrobats completely ignored the most obvious lessons of the Armory Show, but extended American realism for another generation.

KUNIYOSHI, YASUO (1893–1953), pp. 264-265, figurative painter. Born in Japan, Kuniyoshi came to America as an adolescent, studied at the National Academy and with Robert Henri and Kenneth Hayes Miller. He painted with great delicacy – thought by many to be Oriental in origin – and with humor and grace. He considered himself and his work strictly American and is truly more related to a gentle Surrealism than to traditional Japanese painting.

LAFARGE, JOHN (1835–1910), pp. 130-131, painter, muralist and stained-glass designer. Born in New York City, LaFarge studied in Paris and in the Newport, Rhode Island, studio of William Morris Hunt. LaFarge's turning point came during a long tour of the Orient, which opened his eyes and his palette to a new world of tropical color.

LANE, FITZ HUGH (1804–1865), p. 313, foremost marine painter of his period. Christened Nathaniel Rogers Lane by his parents, he was crippled from childhood, probably by polio. Starting as a commercial lithographer, Lane was largely self-taught as a painter, but created some of the most sensitive harbor scenes in art, especially of Maine and his native Gloucester, Massachusetts.

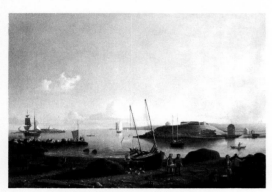

View of Gloucester Harbor, *1848,*
Fitz Hugh Lane. 27 x 41 in., oil.
The Virginia Museum of Fine Arts.

LAWSON, ERNEST (1873–1939), pp. 184-185), American Impressionist and member of The Eight. Lawson was born in Halifax, Nova Scotia, and lived in Mexico City before arriving in New York in 1891. He studied at Art Students League under J. Alden Weir and especially John Twachtman. He was a friend of William Glackens who introduced him to other members of the Ashcan School. Although passionately Impressionist in manner, Lawson painted city scenes in jewel-like tones.

LEBRUN, (FREDERICO) RICO (1900–1964), pp. 298-299, American Expressionist of great power. Lebrun was born in Naples, Italy, served in Italian army in World War I, then became stained-glass artist. He was brought to America in 1924 by Pittsburgh Plate Glass Company and worked in New York as fashion and advertising artist and on WPA mural projects. He settled in California in 1938 and had long influence there. His *Crucifixion,* 1950, is among the strongest religious paintings of the century.

LEUTZE, EMANUEL (1816–1868), pp. 96-97, German-American painter of historical tableaux and of considerable influence on American taste. Born in Germany, he was brought to Philadelphia as a child, but as a young man returned to Düsseldorf, where he spent most of his active life. His *Washington Crossing the Delaware* remains a basic American image, though it was actually painted for German patriots after the 1848 risings.

LEVINE, JACK (b.1915), pp. 278-279, American Expressionist and social protest painter. Born in Boston in immigrant poverty, Levine studied drawing in a settlement house, was instructed in art history and subsidized by Harvard professor Denham Ross. Exquisite draftsman and beautiful painter, he combines the virtuosity of Rubens with the savage attack of Goya and Daumier.

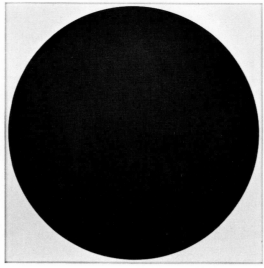

O Red, *1962,*
Alexander Liberman.
82-¼ x 82-¼ in., acrylic.
University Art Museum, Berkeley.

LIBERMAN, ALEXANDER (b. 1912), p.313, one of the originators of Hard-Edge or Minimal Art; sculptor, photographer, film maker and art editor. Born of artistic Russian parents, Liberman left Russia with his family in the early 1920's for London and eventually Paris. His formal art training began there when he was seventeen, although his earlier sketches show the influence of Soviet Constructivism, with its severe and formal organization of mass, volume and space. He studied painting and architecture in Paris and worked as magazine art editor, book designer, film maker, movie critic and painter of Cubist, realist and Pointillist works. Moving to America in 1941 to edit and direct for Condé Nast Publications, Liberman continued painting, began sculpting and since has written many essays on art and artists. In his long career, he has also worked in the style of Geometric Abstraction, though his present painting has become involved with the flow and spatter of paint, while his sculptures have become increasingly larger.

LUKS, GEORGE (1867–1933), pp. 222-223, member of The Eight. Born in Williamsport, Pennsylvania, Luks studied in Düsseldorf, Munich, Paris and London before settling in Philadelphia in the early 1890's where he became a newspaper artist and joined Robert Henri, John Sloan, William Glackens and Everett Shinn in painting city life. People of the street were Luks's forte, especially unusual ones.

MACIVER, LOREN (b. 1909), pp. 276-277, lyrical painter of dreamlike, misty images of places and objects. Largely self-taught, MacIver married the poet Lloyd Frankenberg and lives in Greenwich Village and Montparnasse, finding subjects in both places.

MAENTEL, JACOB (?–?), pp. 50-51, portraitist who worked exclusively in watercolors. He painted full-length portraits of Pennsylvania-German farmers and their families. Despite the paintings' small sizes, his subjects' stiff poses, and their unnaturally tiny feet and narrow bodies, Maentel's portraits in profile depicted his subjects as individuals and usually in accurate likenesses, set against charming Pennsylvania landscapes or house interiors. Most of this work dates from 1810 to the mid-1820's when he began to paint his subjects full face, which he did for the remainder of his career.

MARIN, JOHN (1870–1953), pp. 210-211, early modernist painter. Marin was creating small semi-abstractions by 1905, few of which survive. Born in Rutherford, New Jersey, he began taking sketching trips in his twenties, studied at the Pennsylvania Academy and the Art Students League. From 1905 to 1909 he painted and etched in Europe. Back in New York he joined the modernist group associated with Alfred Stieglitz, the photographer and art dealer. America's greatest watercolor painter since Homer, Marin transferred into his oils something of the spontaneity that marked his watercolors. In both media he conveyed a powerful sense of energy and movement in nature and in the city. New York City and the Maine coast furnished most of his subjects.

MARSH, REGINALD (1898–1954), pp. 244-245, painter of city life, especially of the Bowery during the Depression. Born in France of American parents, Marsh studied at Yale and the Art Students League, as well as with John Sloan and George Luks. Illustrator for *Vanity Fair, Harper's Bazaar* and the *Daily News.* He painted important murals for the New Deal's projects in the New York Customs House. His work conveys a powerful sense of the crush of the city; his style derives from his study of the old masters and from his great gifts in drawing.

MARTIN, HOMER D. (1836–1897), pp. 164-165, landscape painter. Martin began as a continuator of the Hudson River School, became a Luminist, although rather more muted and melancholy than most others, and ended, during and after a decade in France, as a tranquil, glowing pre-Impressionist.

MAYER, FRANK B. (1827–1899),p. 109, portrait and Indian painter, born in Baltimore, where he studied with Alfred Jacob Miller. Mayer also studied in Paris with Marc Gleyre and Gustave Brion and worked chiefly in Baltimore and Annapolis.

MILLER, ALFRED JACOB (1810–1874), pp. 78-79, portrait artist and Indian painter. Born in Baltimore, where he studied with Thomas Sully, he also studied in Paris at the Beaux-Arts. In 1837 he was hired to accompany a trading expedition to Oregon, making sketches for murals in the Scotch ancestral home of the leader, Captain William Stewart. The sketches gave Miller a freedom not found in his finished oils and comprise a fresh, lively watercolor record of Indian life before the conquest by the Europeans.

M'KAY, (1791), pp. 42-43, is the signature of an otherwise unknown painter of the early Republic. He worked in or around Worcester in central Massachusetts, where two portraits in the American Antiquarian Society so signed are strongly superior to most anonymous portraiture of the period.

MORAN, THOMAS (1837–1926),pp. 204-205, landscape painter and engraver. Born in Lancashire, England, Moran studied in France and Germany, made his first trip into the American West in 1871 with a railroad expedition. His large-scale views of natural wonders at Yosemite and Yellowstone were immensely popular and many of his favorite areas have since been made national parks.

MORSE, SAMUEL F. B. (1791–1872), pp. 68-69, romantic historical and portrait painter. Born in New Haven, he attended Yale and studied with Benjamin West in London. He practiced

portraiture in Boston, New Hampshire, Charleston, South Carolina, and New York, where his commissioned portrait of the aging Lafayette was very popular in engraved form. Morse helped found and was first president of the National Academy of Design. He was an early experimenter in photography but is best known as the inventor of the telegraph.

MOTHERWELL, ROBERT (b. 1915), pp. 284-285, Abstract Expressionist painter. Born in Aberdeen, Washington, he studied art in Los Angeles and San Francisco, graduated from Stanford and Harvard. Deeply influenced while in Mexico by Matta Echaurren, the Chilean Surrealist. Married to Abstract Expressionist Helen Frankenthaler, Motherwell is the leading theorist of his movement.

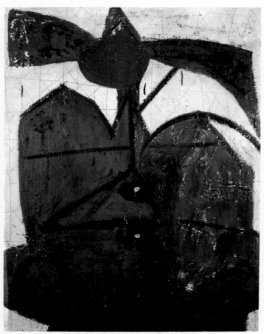

Emperor of China, 1947,
Robert Motherwell. 48 x 36 in., oil.
Chrysler Art Museum of Norfolk.

MOUNT, WILLIAM SIDNEY (1807–1868), pp. 106-107, portrait painter and outstanding genre painter. Born in Setauket, Long Island, he spent most of his life there except for early studies with his brother as a sign painter and at the National Academy, both in New York, where he also painted portraits from 1829 to 1836. His direct, honest, sometimes humorous visual reporting of ordinary life has left a very attractive record of vanished ways.

O'KEEFFE, GEORGIA (b. 1887), pp. 216-217, early modernist painter. Born in Sun Prairie, Wisconsin, she studied with William Merritt Chase and Arthur Wesley Dow. She began seriously painting in 1916 and became, with John Marin, one of the two "stars" of the modernist gallery of Alfred Stieglitz, the great photographer whom she married in 1924. Her "abstractions" are mostly extreme close-ups of, for example, the blooms of flowers, or schematized views of modern urban buildings. She has lived many years in New Mexico, where the light and the landscape both have shaped her work.

OTIS, BASS (1784–1861), pp. 48-49, Philadelphia portrait artist. Otis began as a scythe maker, turned artist and at one time was in partnership with John Wesley Jarvis, a prolific portraitist. In 1819 Otis made the first lithograph in America, *The Mill.*

PAGE, WILLIAM (1811–1885), pp. 112-113, portrait artist and painter of scriptural and mythological scenes. After preparing for a law career, Page studied with Morse and was elected to both the American Academy and the National Academy in his mid-twenties. His technical experiments led to many of his paintings turning completely black and others were lost. His few surviving works show him as the continuator of the romantic melancholy of Washington Allston.

PARSONS, CHARLES (1821-1910), p. 102, artist for Currier & Ives who specialized in marine scenes. Born in England, he came to America at age nine with his parents. He was apprenticed at age twelve to George Endicott of Endicott & Company of New York City and two years later he began working in the firm's lithographing department. Eventually he was given control of Endicott & Company's art department at a time when Currier & Ives was farming out work to this firm. Parsons became head of the art department of Harper & Brothers in 1863 and remained in this capacity until he retired in 1892. Throughout these years Parsons was a close friend of Nathaniel Currier and James Ives and their families and executed many originals for their firm. Currier & Ives frequently went to Parsons for help and advice and for finding talented young artists.

PEALE, CHARLES WILLSON (1741–1827), pp. 33-39, painter, scientist and museum founder. Born in rural Maryland, he studied with Benjamin West in London, then became portraitist in Baltimore and Georgetown, now part of Washington, D.C. He served in Continental Army, later painted Washington and other national heroes. He engaged in scientific excavations, founded Peale's Museum in Independence Hall, Philadelphia, and taught five of his seventeen children to be artists.

PEALE, JAMES (1749–1831), p. 62, brother of Charles Willson Peale, whose profitable business of painting miniature portraits on ivory he took over when Charles moved on to more ambitious projects. With his more talented nephew, Raphaelle, James was virtually the founder of still-life painting in America.

PEALE, RAPHAELLE (1774–1825), pp. 62-63, a still-life painter of extraordinary talent, Raphaelle Peale was the son of Charles Willson, nephew of James. Besides his glowing, luminous still-life arrangements of flowers and fruits, Raphaelle perfected illusionist still-life painting, *trompe l'oeil,* or "fool-the-eye" pictures which seem to be reality itself.

PEALE, REMBRANDT (1778–1860), p. 33, another talented son of Charles Willson. Rembrandt Peale's most ambitious project, like his father's museum, merged art and show business. His enormous painting, *The Court of Death,* was a moral allegory which Rembrandt toured with, exhibiting it accompanied by music and readings. He abandoned art for commerce, moving to Baltimore to open a gas works and a museum.

PEALE, SARAH MIRIAM (1800–1885), p. 38, youngest daughter of James Peale. Throughout the 1820's, she had a studio in her cousin Rembrandt's Baltimore museum, where she painted still lifes, but most of her work was portraiture. Her move to St. Louis in 1847 brought the family's influence into the Midwest.

PETO, JOHN FREDERICK (1854–1907), pp. 190-191, *trompe l'oeil* still-life painter, second only to William Michael Harnett in that specialty in America. Born in Philadelphia, Peto studied at the Pennsylvania Academy and became friendly with Harnett. Never a success as a painter, Peto moved to New Jersey and became a professional cornet player. His paintings were long confused with Harnett's and indeed forged as Harnett's by unscrupulous dealers.

PIPPIN, HORACE (1888–1946), pp. 258-259, Negro primitive painter of sparkling vision. Odd job man and junk dealer, Pippin was wounded in World War I and, unable to work, began painting straightforward, untutored pictures mostly of an imagined past.

POLLOCK, JACKSON (1912–1956), pp. 268-269, the best known of the Abstract Expressionist painters. Born in Cody, Wyoming, Pollock lived in Los Angeles, studied at the Art Students League under Thomas Hart Benton and was a painter on the WPA projects. He exhibited at Peggy Guggenheim's gallery and came under the influence of European Surrealists she helped rescue from Hitler's France. He developed his own highly original style of abstract painting by dripping paint onto canvas lying loosely on the studio floor. After his early death in an automobile accident, Pollock attained the status of a martyred saint among admirers of Abstract Expressionism.

PRENDERGAST, MAURICE (1859–1924), pp. 176-177, member of The Eight, but not related to their common subjects and style except in being rejected by the Academy and the critics of the day. Born in Boston, Prendergast traveled and worked in Europe and developed an original tapestrylike and dreamlike manner of painting scenes of leisure in the open air.

PYLE, HOWARD (1853-1911), p. 200, illustrator and author. Privately educated, he was early introduced to the work of such English illustrators as John Tenniel. After his brief art study in Philadelphia and the Art Students League in New York, an illustration of his was accepted by *Scribner's.* He eventually contributed his imaginative illustrations to many magazines and to books such as *A Modern Aladdin* (1891). Pyle used a woodcut technique for medieval tales and became known for the accuracy of his historical illustrations, particularly those depicting colonial history. He taught at Drexel Institute, Philadelphia.

QUIDOR, JOHN (1801–1881), pp. 114-115, painter-illustrator. He began his professional life painting pictures on fire engines, but soon turned to the folklore of the old New York-Dutch country in and around his native Tappan Zee. Many of his paintings are illustrations of the Dutch stories of Washington Irving, who lived near Tappan Zee. His exaggerated faces and figures and his heightened lighting give his work a Gothic intensity.

REMINGTON, FREDERIC (1861–1909), pp. 196-197, painter and sculptor of the West. Born in Canton, New York, Remington studied at Yale and the Art Students League. Going to the West for his health, he began drawing cowboys and Indians and became a popular illustrator for *Harper's* and other magazines. He covered the Spanish-American War for William Randolph Hearst and prided himself on his knowledge of the horse and of the many Indian tribes.

RIVERS, LARRY (b. 1923), pp. 282-283, jazz musician who became a close friend of the Abstract Expressionists and began painting himself in a style related to theirs but with a use of images that led him to be consid-

ered a forerunner of Pop Art. Born in New York City, where he studied at the Julliard School of Music, Rivers has lived and worked in or near the city most of his life.

ROTHKO, MARK (1903–1970), pp. 292-293, leading member of the Abstract Expressionist group. Born in Dvinsk, Russia, he was brought to America as a child. Studied at Yale and the Art Students League. He worked on the WPA art project, developed through Surrealist biological shapes into large, glowing color areas.

RUSSELL, CHARLES M. (1864–1926), pp. 181-183, with Remington one of the two most famous Western painter–sculptors. Born in St. Louis, Russell ran away as a boy and became a cowboy apprentice in Montana, where he began, completely self-taught, to draw and paint his comrades, the cattle and the Indians. Enormously popular during his lifetime and since.

RYDER, ALBERT PINKHAM (1847–1917), pp. 166-167, mystical, visionary painter of Biblical, literary themes and of the sea. Born in the sea-faring town of New Bedford, Massachusetts, Ryder studied at the National Academy, but was essentially self-taught for better and worse: Due to his lack of knowledge of paint chemistry, many of his pictures deteriorated rapidly, but his solitary vision remained pure and personal.

SARGENT, HENRY (1770–1845), pp. 60-61, early but only occasional painter of genre subjects. Born in Boston, Sargent painted two interiors of social occasions, numerous portraits and several large religious pictures to be exhibited on tour. Not successful, he devoted most of his energies to other pursuits.

SARGENT, JOHN SINGER (1856–1925), pp. 160-163, fashionable portrait artist in France, England and America. Born in Florence of American parents into the expatriate life of leisured Americans abroad, Sargent studied there at the Accademia, later in Paris with Carolus-Duran. He developed his own dashing, lively style based in part on Velásquez. Sargent is generally considered shallow, but some portraits are brilliant as are pictures he painted because he was struck with the scene.

SCHOLDER, FRITZ (b. 1937) pp. 304-305, contemporary American Indian painter of American Indian subjects. Born in Breckenridge, Minnesota, Scholder studied with Indian painter Oscar Howe, and with Pop artist Wayne Thiebaud. His work relates to that of both of his teachers but resembles neither. Winner of numerous prizes in competitions, Scholder paints the contemporary Indian as the depressed, undeveloped victim of American civilization. His broad, crude brushstrokes convey the inarticulateness and the roughness of the Indian's state.

SCHREYVOGEL, CHARLES (1861–1912), pp. 188-189, Western painter. Born in New York City, Schreyvogel studied in Munich, returned to America and went West for reasons of health. Specialized in the fights between the cavalry and the Indians, did bronze sculpture as well as oil paintings of large size.

SHAHN, BEN (1898–1969), pp. 296–297, painter of social comment and photographer. Born in Russian Lithuania, Shahn was brought to New York as a child, studied at City College, New York University and the Art Students League. His paintings of the trial of Sacco and Vanzetti introduced him as social painter of

great power. Acting as photographer for the Farm Security Administration during the Depression, he compiled a kind of folk alphabet of home-made lettering which he used regularly in paintings. He was assistant to the Mexican muralist Diego Rivera in Rockefeller Center. In later years he did a memorable series on nuclear explosions in the Pacific and in the last years of his life he designed posters advocating peace in Vietnam and the election of Eugene McCarthy as President.

SHEELER, CHARLES (1883–1965), pp. 242-243, "Immaculatist" painter of contemporary industrial shapes and earlier, craftmade American shapes in a personal Cubism of great clarity of line and plane. Born in Philadelphia, Sheeler studied at the Pennsylvania Academy, later became a professional photographer. His pictures in both media were among the first to reveal the purity of industrial architecture in this century.

SHINN, EVERETT (1876–1953), pp. 198-199, member of The Eight. The youngest of the group, Shinn was born in New Jersey, studied at the Pennsylvania Academy and joined the Henri-Sloan circle. An admirer of Degas, Shinn painted light and cheerful scenes of the theater and of Paris.

SLOAN, JOHN (1871–1951), pp. 194-195, member of The Eight, the best known of the group and the painter of the most enduring achievement. Born in Philadelphia, he educated himself as a commercial and later newspaper illustrator before turning to painting under Robert Henri's influence. Following his teacher to New York, Sloan became one of the great painters of that city, a successful rebel against the art establishment and himself a teacher of many younger artists.

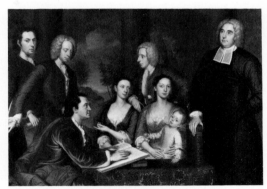

The Bermuda Group (Dean George Berkeley and His Family), *ca. 1729, John Smibert . 69-½ x 93 in., oil. Yale University Art Gallery, gift of Isaac Lothrop.*

SMIBERT, JOHN (1688–1751), p. 315, colonial portrait painter. Born in Edinburgh, he had studied in Florence and practiced in London. Joining Bishop Berkeley on a voyage to found a university in Bermuda, the bishop and the artist instead landed at Newport, Rhode Island. In Boston in 1730, Smibert exhibited his portraits and old master copies and in the next twenty years became the founder of New England portraiture, as well as a picture framer and art supplies dealer.

SMITH, CAPTAIN THOMAS (active ca. 1650–1680), p. 8, the earliest American painter whose name is known. Captain Smith came to the mainland colonies from Bermuda and painted a portrait of a clergyman for Harvard College and a self-portrait with a background of a sea battle off a fortified coastal battery.

STEARNS, JUNIUS B. (1810–1885), pp. 88-89, painter of historical tableaux. Very popular in his lifetime, especially through the sale of engravings of his series of paintings on Washington's life, Stearns is now almost forgotten. A New Yorker, he researched his principal subject in Virginia.

STELLA, JOSEPH (1877–1946), pp. 206-207, early modernist painter. Born in Italy, Stella came to New York at twenty-one, studied at the Art Students League and with William Merritt Chase. After working as an illustrator he visited Italy, absorbed Cubism and Futurism and, on his return to New York, applied the principles of both to the growing city of skyscrapers and brilliant lights.

The Bridge, *fifth panel, 1922, Joseph Stella. 54 x 88-¼ in., gouache. Collection of the Newark Museum, Felix Fuld Bequest.*

STUART, GILBERT (1755–1828), pp. 28-29, best known portrait painter of the early Republic. Born in Rhode Island, he studied in Newport, then traveled to Edinburgh and down to London where he studied with Benjamin West, returning to America in 1792. Working in New York, Philadelphia and the new capital, Washington, he spent most of the rest of his life in Boston, painting increasingly superficial portraits and many copies of his own pictures of Washington, especially the third one, commissioned by Martha Washington and long familiar as the face on the one dollar bill.

SULLY, THOMAS (1783–1872), pp. 56-57, portrait artist. Born in England, Sully was brought to Charleston, South Carolina, as a boy and was painting miniatures with his brother in Richmond and Norfolk in his late teens. He studied with John Trumbull in New York, Benjamin West in London. Settling in Philadelphia, he painted almost three thousand works, including a commissioned portrait of the young Queen Victoria.

TANNER, HENRY OSSAWA (1859–1937), pp. 178-180, leading American Negro artist of the nineteenth century. Born in Pittsburgh, son of a bishop of the African Methodist Episcopal

Church, Tanner studied at the Pennsylvania Academy under Thomas Eakins. After indifferent success in genre, he moved to Paris, studied with Benjamin Constant, visited Palestine and spent the rest of his life as a French artist who had been born in America, exhibiting in the Salon and winning small prizes.

THOMPSON, JEROME B. (1814–1886), pp. 94-95, genre painter. Thompson's specialty was the landscape with figures, particularly picnic scenes painted with an eye for character and a quality of quiet good cheer.

TOBEY, MARK (b. 1890), pp. 254-255, leading painter of the Pacific Northwest school of the mid-twentieth century. Born in Centerville, Wisconsin, Tobey worked as an illustrator in Chicago, a portraitist in New York, before settling in Seattle in 1923, where he has been ever since. His "white writing" prefigured Pollock and "field painting"; his attitudes provided a bridge for American artists to Oriental thought.

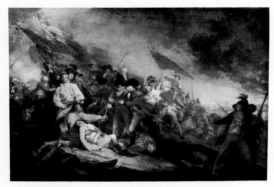

The Battle of Bunker's Hill, *1786,*
John Trumbull. 25 x 34 in., oil.
Yale University Art Gallery.

TRUMBULL, JOHN (1756–1843), pp. 30-32, the leading historical painter of the Revolution. Son of the Governor of Connecticut who was an ardent patriot, Trumbull, after early studies with John Singleton Copley, joined the Continental Army, was Washington's aide-de-camp, but resigned over a delay in his promotion to colonel at twenty. He studied with Benjamin West in England, J. L. David in Paris, where he witnessed the French Revolution. Back home he painted his great scenes of the War of Independence and became a powerful figure in early art organizations.

TWACHTMAN, JOHN HENRY (1853–1902), pp. 174-175, an American Impressionist and member of The Ten Americans. Born in Cincinnati, Twachtman studied with his father, then with Frank Duveneck of that city, later in Munich, Florence, Venice and Paris, where he worked out an Impressionist manner of his own. His European works were lost at sea, but Twachtman settled in Connecticut, painting misty landscapes in which the details were sometimes lost in the atmosphere.

VANDERLYN, JOHN (1775–1852), pp. 52-53, romantic painter. Son of a Dutch artist in Kingston, New York, Vanderlyn studied with his father, and briefly with Stuart in Philadelphia. Subsidized by Aaron Burr, he went to Paris at twenty-one, stayed abroad most of the next two decades. Back in New York he exhibited a huge panoramic view of Versailles, but it was not a success. His *Ariadne* was considered the finest American nude.

VEDDER, ELIHU (1836–1923), pp. 116-117, painter of strange images not so much dreamlike but as if from quiet nightmares. Born in New

York City, he studied in Paris for five years, returned home for the Civil War, eaking out a living at the lowest end of commercial art. In 1867 he settled in Rome, living there for the last fifty-six years of his long life, roaming the hills and beaches of central Italy, returning to America only for mural commissions, including one in the Library of Congress.

The Philosopher, *1867,*
Elihu Vedder. 14-3/4 x 20-3/4 in., oil.
Collection of the Newark Museum.

WEBER, MAX (1881–1961), p. 316, one of the first "primitives" and most eclectic of the modern art movement, who painted under the influences of Paul Cézanne, Henri Matisse, Henri Rousseau, Fauvism and Cubism as early as 1908. An immigrant from Russia of a family with strong Jewish heritage, Weber began his professional and highly varied art training at Brooklyn's Pratt Institute, where he was guided by his exposure to Oriental, American Indian and Paul Gauguin's art and his teacher Arthur Dow's precept that painting is the expression of an idea, "not merely an assemblage of objects truthfully represented." Upon his return to America in 1908 after three years in Paris, Weber's contact with the great photographer and modern art collector Alfred Stieglitz and his study of African and Mayan art began to formulate his personal credo, though his styles have varied radically over the years. Weber felt that "the expression of an experience should give rise to still another experience. . . . To fill eternity with the ripest and the sanest expression of our consciousness is the essence as well as the purpose of life."

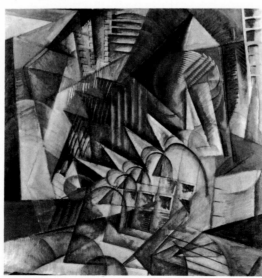

Rush Hour, *1915,*
Max Weber 36-¼ x30-¼ in., oil.
National Gallery of Art, Washington, D.C.

WEIR, JOHN FERGUSON (1841–1926), pp. 126-127, landscape painter and very early artist of industry. Son of Robert Weir, of the Hudson River School, John grew up in the tradition and the locale, was elected to the Academy at

twenty-three. Simultaneously, he painted his large canvas of the casting of Civil War guns. Later Dean of Yale Art School.

WEST, BENJAMIN (1738–1820), pp. 23-27, history painter and "father of American painting." Born in Springfield, Pennsylvania, West began as a portrait artist, showing such talent that some Philadelphia merchants financed a trip to Italy, where he studied three years under Raphael Mengs, who was Goya's teacher. Then West went to London where he spent the rest of his life as a friend of George III, a daring and innovative history painter, a founder of the Royal Academy and its second president, and, above all, a friend with an open studio door to dozens of American artists who came and studied under him.

WHISTLER, JAMES A. McN. (1834–1903), pp. 152-155, expatriate painter, etcher. Born in Lowell, Massachusetts, Whistler lived in Russia while his father built the Moscow-St. Petersburg railroad, returned to America to enter West Point, flunked out, arrived in Paris by twenty-one. He developed his own style from Gustave Courbet, Velásquez and Japanese prints. An early Bohemian in Paris and London, Whistler survives as a wit and as aesthetician as well as a delicate painter and etcher of riverside scenes.

WHITTREDGE, THOMAS WORTHINGTON (1820–1910), pp. 134-135, landscape artist and Luminist. Born on a pioneer farm in southern Ohio, he perfected an early style in landscape in Cincinnati, where there was an art colony. Studied ten years in Brussels, Paris, Düsseldorf and Rome and made sketching trips, but found his true inspiration only on return to the American landscape, which he painted from the New England beaches to the Western prairies.

WIMAR, CHARLES (1828–1862), p. 108, Western artist. Born in Germany and thoroughly trained at Düsseldorf, Wimar brought that school's predilection for theatrical detail to his spectacular scenes of the Rocky Mountains and of Indian life.

WOOD, GRANT (1892–1942), pp. 228-229, leading Regionalist of the 1930's. Born in Cedar Rapids, Iowa, Wood found his subjects there after a try at French Impressionism in Paris and the revelation of homely faces in early Flemish-German art. Of the three leading Regionalists, only Wood had a strong sense of satire, as in *Daughters of Revolution* and his famous picture, *American Gothic.*

WOODVILLE, RICHARD CATON (1825–1855), pp. 98-99, genre painter. Born in Baltimore, son of a wealthy merchant, Woodville studied Dutch genre paintings in a local collection and was one of the first Americans to study in Düsseldorf. Deserting his wife, he went to Paris with a woman artist and there committed suicide, ending a career that, on the evidence of his few pictures, might have been the dominant one in American genre.

WYETH, ANDREW (b. 1917), pp. 274-275, realist painter. Born in Chadds Ford, Pennsylvania, son of the famous illustrator, N. C. Wyeth, Andrew was a sickly boy and at an early age was permitted to abandon formal schooling in favor of reading at home and study with his father. His pictorial subjects are taken mostly from the depressed rural life around Chadds Ford and the family's summer home in Maine.

He is also one of the great American masters of watercolor, using the dry-brush technique to paint close-ups of field flowers and grasses.

WYETH, HENRIETTE (b. 1907), pp. 240-241, latter day Western artist and portraitist. Daughter of N.C. and older sister of Andrew, Henriette was born in Chadds Ford, studied with her father. Married a fellow student of N.C.'s, Peter Hurd, and moved with him to New Mexico, where she has painted the people and places ever since.

WYETH, JAMES (b. 1946), p. 274, realist and portrait artist. Grandson of N.C. Wyeth, son of Andrew, James showed talent at an early age and was encouraged to develop it. Besides por-traits, he paints elaborate still lifes and subtle puzzle pictures.

WYETH, N. C. (1882–1945), pp. 200-201, great American illustrator. Born in Massachu-setts, where his family had settled in 1645, Wyeth studied drafting in Boston and illustra-tion at various schools in the area. In 1902 he was accepted by the illustrator Howard Pyle for his art school in Wilmington, Delaware, Pyle and Wyeth becoming the pillars of the Brandy-wine School of illustration, named for the river in the neighborhood. Best known for his illus-trations for the works of Robert Louis Steven-son, Wyeth was also the founder of what has become a dynasty of American artists.

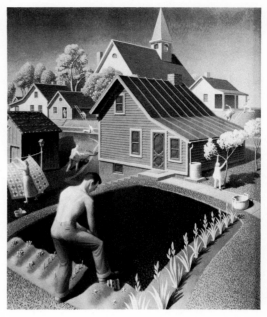

Spring in Town, *1941,*
Grant Wood. 26 x 24-1/2 in., oil.
Sheldon Swope Art Gallery, Terre Haute.

GLOSSARY

ABSTRACT EXPRESSIONISM, term invented by Robert Coates, art critic of *The New Yorker,* to describe the dominant form of New York painting in the 1950's; enormously influential in U.S. and throughout the world. It derived from Surrealism, with, usually, no representational content yet strong emotional implications. Wil-lem de Kooning, Jackson Pollock, Robert Motherwell, Mark Rothko, Franz Kline, Hans Hofmann and Adolph Gottlieb were among the chief practitioners.

ACADEMY, has two proper meanings: the American Academy, headed by painter John Trumbull in early years of the Republic; and the National Academy of Design, whose first presi-dent was Samuel F. B. Morse. Trumbull's group was artists and patrons, with the latter tending to dominate. Morse's organization was made up of artists only, tending eventually to be conservative. The third American meaning is simply any group that presumes to dictate the only acceptable way to paint, as "the Academy of the Museum of Modern Art and *Art News* magazine."

ACRYLIC, a new synthetic paint medium intro-duced after World War II, claimed by its manu-facturers to be as enduring as the older ones and much easier to work with, being able to act as either oil or watercolor and having the prop-erty of fast drying.

ARMORY SHOW, large exhibition of modern art in Europe and America assembled by Walt Kuhn, Arthur B. Davies, William Glackens and other artists, in the 69th Regiment Armory in New York City in 1913. The show later played Boston and Chicago, occasioned violent attacks by critics and public officials but introduced America to Cubism, Fauvism and other new European manners.

ART STUDENTS LEAGUE (NYC), student or-ganized and operated school of studio instruc-tion. It was founded in 1875 by students of the National Academy of Design when the Academy closed its school for lack of funds. Beginning with William Merritt Chase and Frederic Edwin Church, distinguished American artists have always taught at the League. In the 1890's the League also established a summer school in rural Woodstock, New York, which became an art center.

ASHCAN SCHOOL, originally a derisive term, like many accepted names for art movements, ap-plied specifically to the exhibition of The Eight at the Macbeth Gallery, New York City, in 1908. It meant that the painters were painting street scenes instead of idealized peasants and land-scapes. More broadly, the name is applied to all such painting, was originally coined in 1916 by Art Young, a Socialist cartoonist, who scorned such pictures lacking propaganda content.

BARBIZON SCHOOL, group of French land-scape painters who began working in the open air instead of, as traditional, in the studio, in and near the village of Barbizon, thirty miles from Paris. J. B. C. Corot, Diaz de la Pena, Théo-dore Rousseau and Charles Daubigny formed the nucleus of the School. It was popular in Ameri-ca and influenced our painting through George Inness and William Morris Hunt.

BAUHAUS, German school of art and design cre-ated in 1915 by architect Walter Gropius under the patronage of the Grand Duke of Saxe-Weimarm, dedicated to the reunion of fine arts and applied arts, especially design for industrial production. *Bau* is German for "construction." The faculty included Paul Klee, Wassily Kandin-sky, Lyonel Feininger. The ideas of the school were enormously influential in modern design and architecture in U.S., where many members moved after Hitler persecuted "degenerate art."

BLUE RIDER GROUP, second group of German Expressionists, following The Bridge Group, founded about 1911-1912, practiced distortion for emotional expression: Wassily Kandinsky, Franz Marc, Paul Klee, August Macke, Heinrich Campendonk, Lyonel Feininger, Alexei von Jawlensky and Alfred Kubin.

CUBISM, first great twentieth-century art revo-lution, founded in Paris in 1907 by Georges Braque and Pablo Picasso, the latter's *Les Demoiselles d'Avignon* being the first major Cubist painting. Based on Paul Cézanne's belief that nature was composed of cubes, cylinders and cones, the Cubist painters did exactly that in viewing the world (analytical Cubism) and in composing pictures (synthetic Cubism). They also viewed objects from several points of view in single paintings. Fernand Léger, Juan Gris,

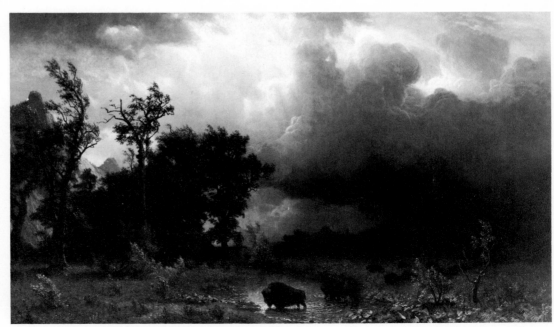

Buffalo Trail - - The Impending Storm, *1869,*
Albert Bierstadt. 29-½ x 49-½ in., oil.
The Corcoran Gallery of Art, gift of Mr. and Mrs. Lansdell K. Christie.

Albert Gleizes and Jean Metzinger and hundreds of others practiced Cubism in various ways through the end of World War II.

DE STIJL, short-lived Dutch modern movement named for a new journal of the arts, *The Style* magazine. Austerely geometric and equally applicable to architecture and design as to painting. Included in the movement were Piet Mondrian, Theo van Doesburg, Georges Vantongerloo.

DÜSSELDORF SCHOOL, very popular nineteenth-century painting manner practiced and taught in that German city and featuring a grandiloquent historicism. Emanuel Leutze and many American students studied in Düsseldorf.

EIGHT, THE (See *Ashcan School*)

FAUVES is French for "wild beasts" and was applied to the painters in one room of the Salon d'Automne in Paris in 1905 by the critic Louis Vauxcelles, who also coined the name Cubism. He referred especially to the violent color contrasts of Henri Matisse, Georges Rouault, André Derain, Georges Braque, Pierre Albert Marquet, Maurice Vlaminck and others.

FEDERAL ARTS PROJECTS of the New Deal during the 1930's were based on the make-work strategy of the Works Progress Administration and on the belief that artists, too, were Americans out of work and entitled to support. There was direct support of money and materials, with the government owning a percentage of the work produced. There were classes in art centers for all ages. And there was the Fine Arts Section of the Treasury Department, engaged in procuring murals and sculpture for the many new Federal buildings being constructed. "The Project," as artists called the phenomenon, not only helped American art survive the Depression, but gave artists a new confidence and relationship to the whole community.

FLEXNER, JAMES THOMAS, long established commentator on American art. His important works include *First Flowers of Our Wilderness, The Light of Distant Skies, That Wilder Image, America's Old Masters, Nineteenth Century American Painting* and books on John Singleton Copley, Gilbert Stuart and Winslow Homer. Educated at Harvard College, he has contributed to magazines and newspapers and is a lecturer on American art and civilization.

GENRE is painting of scenes of everyday life, often humorous or anecdotal with a special danger of sentimentality. William Sidney Mount is generally considered America's foremost genre painter.

GERMAN EXPRESSIONISM constitutes the major German art movement between 1900 and the coming of Hitler, who suppressed it as "degenerate." It is actually the Nordic, modern and tragic phase of Romanticism, with distortion of color and line for strength of composition and immediate emotional appeal. Emile Nolde, Karl Schmidt-Rottluff, Ernst Kirchner, Franz Marc, Paul Klee, and others were part of this movement.

GOTHIC, of course, was never used by the builders of Gothic cathedrals. The word was invented by Giorgio Vasari, Renaissance painter and the first art historian, to mean, roughly, non-Italian, or barbarian, art. Early nineteenth-century romanticism changed the meaning by rediscovering the merits of Gothic style. As in the Gothic novel, the Gothic painting of, e. g., John Quidor, is scary, ghost-ridden and full of chills and thrills.

GOODRICH, LLOYD, former director and now Advisory Director of the Whitney Museum of American Art. His well-known books on American art include monographs on Winslow Homer, Thomas Eakins, Albert Pinkham Ryder, John Sloan, Max Weber, Edward Hopper, Yasuo Kuniyoshi, Edwin Dickinson and the books *Pioneers of Modern Art in America* and *American Art of Our Century.*

GOUACHE, a medium of painting consisting of opaque watercolors applied to paper; white is produced by pigment rather than the paper, as in regular, translucent watercolor, and a slight texture can be obtained with bristle brushes.

HARD-EDGE ART, a sub-variety of post-Abstract Expressionist advanced American painting, consisting of few, bright, simple color areas sharply or hard-edgedly defined from one another. Ancestors include Henri Matisse and Josef Albers; leading practitioners are Ellsworth Kelly, Frank Stella, Kenneth Noland, though other categories have been made for some of these.

HISTORICAL PAINTING, traditionally, the highest form of painting from the earliest Renaissance through the mid-nineteenth century. The term embraced Biblical personages and events and classical mythology as well as more formally recorded history. The painters include almost everyone from Giotto to Delacroix and such Americans as Charles Willson Peale, John Trumbull, Benjamin West, Gilbert Stuart, John Singleton Copley and the last of them, Emanuel Leutze.

HUDSON RIVER SCHOOL, America's first native manner of painting, concentrating on the landscapes of the Catskills and New England. Begun by Thomas Cole and Asher Brown Durand, followed by hundreds. The original landscape impulse was modified in two directions: the sometimes grandiose exoticism of Frederic Edwin Church and Albert Bierstadt, and the Luminist, atmospheric interests of Martin Johnson Heade and George Inness. Throughout the nineteenth century the Hudson River School was the center of a "Golden Age" of art appreciation of American painters by the American public, never equalled before or since.

IMPRESSIONISM, AMERICAN, a local adaption of the aesthetically powerful French movement twenty to thirty years later. The American variety was more an Impressionism of mood induced by or expressed in atmosphere than the pseudo-scientific study of atmospherics in the Impressionism of Claude Monet and Camille Pissarro. In one sense, Mary Cassatt was the only real American Impressionist, living in Paris, accepted by and exhibiting with the original members of the group. In another sense the leading local exemplars were John Henry Twachtman, William Merritt Chase, Childe Hassam and Ernest Lawson.

LUMINISM, the principal pre-Impressionist development in American landscape painting, characterized by a shift from concentration on the features of landscape itself to those of the time of day or the conditions of the atmosphere in which the landscape was viewed. In Martin Johnson Heade, Luminism produced almost Surreal views of hallucinatory power. Others were John Frederick Kensett, Thomas Worthington Whittredge, the early George Inness and Sanford Robinson Gifford.

MEDIUM, in art, has two related meanings. Paint, like bronze or marble, or like verse or music, is the medium through which the artist expresses his vision or concept. More technically, oil, like water, wax or acrylic, is the medium which holds the colored pigment in solution and makes painting possible.

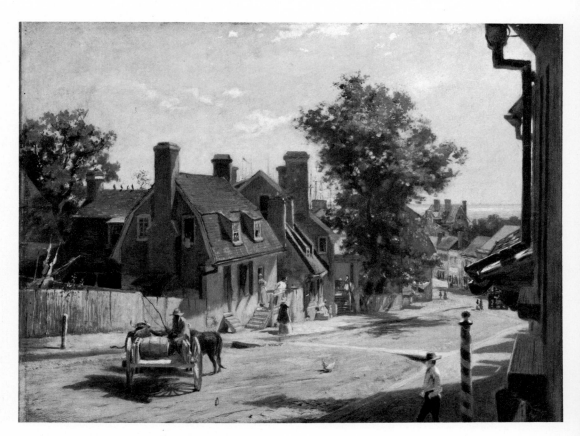

Francis Street, Annapolis, *1876,*
Frank B. Mayer. 15-3/4 x 20-½ in., oil.
The Metropolitan Museum of Art, New York, Rogers Fund.

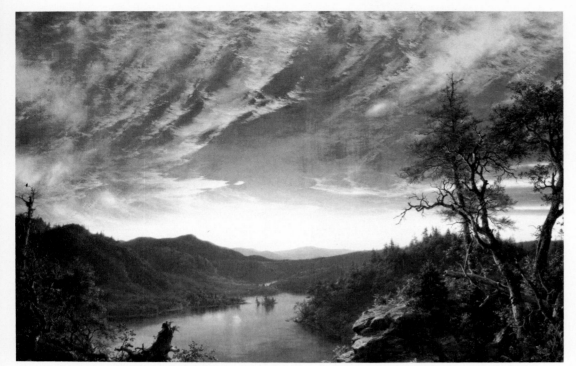

Twilight in the Wilderness, *1860,*
Frederic Edwin Church. 40 x 64 in., oil.
The Cleveland Museum of Art,
Mr. and Mrs. William H. Marlatt Fund.

MINIMAL ART, one of the post-Abstract Expressionist, as well as post-Op, post-Pop, developments the 1960's. Derived from Josef Albers and others, Minimal Art is precise, often geometrical, in shape, simple, often primary, in color. It seeks to do very little and usually succeeds.

MUNICH SCHOOL, or Munich Style, a robust, zesty manner of painting, derived ultimately from seventeenth-century Dutch artist, Frans Hals, dominant in that Bavarian city after the 1848 uprising and the abdication of King Ludwig. Dominated by the excellent German painter, Wilhelm Liebl, the Munich style was briefly but deeply influential on Americans who studied there, featuring rich dark colors and thick paint dashingly applied. A Cincinnati painter, Frank Duveneck, was the most Munich-like of Americans, but the style survived in some of John Singer Sargent's work and even in one sense, in the thick paint and free strokes of Abstract Expressionism.

MURALS/FRESCO PAINTING is first a place, the wall, and second a manner of application. "Fresco" is Italian for fresh and refers not to style but to the plaster, freshly put on the wall and painted on when still wet, causing the color to become part of the plaster. Murals can also be painted on canvas which is then glued to the wall or mounted on closely fitted wood framework.

NEOCLASSICISM, a revival of Graeco-Roman architecture and, in painting, a certain severity and strength of line. In America, the architecture was more important and influential than the painting, which, however, included John Singleton Copley, Gilbert Stuart, Benjamin West, John Trumbull and Charles Willson Peale.

OP ART, an ingenious post-Abstract Expressionist manner in English and American art, derived partly from Josef Albers, partly from visual tricks and games. The Op is for "optical" and refers to illusionary, sometimes vertiginous, visual effects often making it hard for the viewer to sort out the colors and shapes.

PAINTERLY, characterized by qualities of color, stroke or texture, as is distinctive to the art of painting; as opposed to the arts of drawing, sculpture or the limner approach of American colonial and primitive painters (who used paint but were not "painterly"); especially, the rendering of forms and images in terms of the paint's color and tone, rather than of contour and line.

PATROON PAINTERS, six or so artists, active in the first third of the eighteenth-century painting the "patroons," or Dutch landowners in the lower Hudson River Valley. The painters' names are lost and they are named for their subjects and patrons, the De Peysters, Schuylers, Gansevoort and Van Cortlandt families.

POP ART, the dominant successor to Abstract Expressionsim as avant-garde American art in the late 1950's and 1960's, also one form of a wider return to figurative painting that took place simultaneously. The name refers to popular images, such as those of comic strips, neon signs, advertisements and window displays faithfully copied by the artists. Pop artists include Roy Lichtenstein, Andy Warhol, Claes Oldenburg, Robert Indiana and James Rosenquist.

PRIMITIVE, OR NAIVE, PAINTERS, uninstructed or self-taught painters usually far removed from any connection at all with the art world. They commonly paint their surroundings, their remembered childhood or their imaginings of historical events in a technically simple manner of drawing outlines and filling them in with color. Grandma Moses, Horace Pippin and John Kane are the best known of twentieth-century Americans. "Primitive" is also used to designate the very early, still half-Byzantine painters of the early Renaissance and artists of industrially undeveloped cultures in Africa, pre-Columbian America and the South Seas.

REGIONALISM, a movement of the late 1920's and 1930's to seek artistic inspiration in rural, Midwestern America. Especially in the pronouncements of the leading Regionalist, Thomas Hart Benton, and the leading critical advocate of the movement, Thomas Craven, it often appeared anti-European and anti-New York, but Regionalism responded to part of the New Deal patriotic revival and certainly aroused art

Jawbone and Fungus, *1933,*
Georgia O'Keeffe. 17 x 20 in., oil.
Memorial Art Gallery of the University of Rochester,
Marion Stratton Gould Fund.

interest in many parts of the country. Besides Benton, John Steuart Curry and Grant Wood were the chief artists.

RICHARDSON, E. P., , director of the Henry Francis du Pont Winterthur Museum, director of the Archives of American Art, editor of *The Art Quarterly* and former director of the Detroit Institute of Art. Among his books on American art are *Painting in America: The Story of 450 Years, The Way of Western Art, American Romantic Painting,* and *Washington Allston, A Study of the Romantic in America.*

ROMANTICISM (EUROPEAN), a general mood which grew up in the wake of the French Revolution and expressed itself in art, literature, music and architecture, in the latter reviving interest in medieval structures, in all the arts shifting emphasis from classical concern with balance, order and serenity to imagination, personality and individual sensibility.

SCHOOL, in art, has two meanings; one, obviously, a place of formal instruction or studio criticism of work in progress, an art school; the other, a group of artists with a common point of view or a shared manner of painting, often named for a place, as the Barbizon School, the Munich School, or, sometimes derisively, a presumed characteristic, as the Ashcan School, the Brown Gravy School.

STIEGLITZ, ALFRED, photographer, dealer, collector and impresario par excellence, credited with first bringing modernism to American art just past the turn of the twentieth century. Trained in engineering at the Berlin Polytechnic Institute, his imagination turned to the new field of photography, wherein he soon gained a reputation when he came to New York. Founded *Camera Work* magazine and in 1905 opened the first of his many avant-garde galleries (Photo-Secession, 291, Intimate Gallery, An American Place). Supported and stimulated the Americans Marin, Maurer, Hartley, O'Keeffe, Dove, Weber, Nadelman, Steichen, MacDonald-Wright; also displayed the Europeans Picasso, Matisse, Rousseau, Rodin, Picabia and Brancusi, plus children's drawings and African sculpture, many for their first American showings.

Portrait of Frank Wadsworth, *n. d.,*
William Merritt Chase. 20 x 16 in., oil.
Los Angeles County Museum of Art,
Mr. and Mrs. Wm. P. Harrison Collection.

STILL LIFE, the lowest of the orders of painting in the classical, academic hierarchy, which placed history painting first and relegated still life to the status of useful exercise for amateurs and students. There have, however, been great masters in still-life painting, Caravaggio and Zurbaran, Chardin and numerous Dutch masters among them. In America, still life begins with the Peales of Philadelphia and Baltimore and includes such varied contemporaries as Georgia O'Keeffe, Ivan Albright and Claes Oldenburg. The attraction of conventional still life is that the composition can be created with the objects themselves, then painted. The challenge is to transcend values beyond the subject matter.

SOCIAL CRITICISM (REALISM) came into American art during the Depression and grew out of the New Deal art projects because of the social concern of many artists. Subjects included victims of social injustice and views of slum and factory conditions; painters included Ben Shahn, Jack Levine, George Biddle and Philip Evergood among others.

SURREALISM, one of the most important and enduring of twentieth-century art movements. It can be seen as a new Romanticism related to the new Classicism of Cubism. Surrealism called upon the world of dreams and other elements of Freudian psychology as a source for artistic vision and even technique. Some Surrealists, such as Salvador Dali and Rene Magritte, painted dream images in academic manners; others sought accidental images in blottings, pourings and other methods. The common note is the Romantic vision of a secret world beneath the world of appearances. Surrealism provided a method of painting and a predilection for the artist's unconscious that are important features of American Abstract Expressionism.

TEMPERA DRY BRUSH, a medium for color. The tempera technique dissolves the color in an emulsion of casein or pure egg yolk. It is very ancient, was practiced by the Egyptians and the Greeks. It is often used as a priming, a first coat and base, for oil paintings; tempera itself, when varnished, greatly resembles a thin oil painting. The dry-brush technique, which is also used with watercolor, gets a spare, lean effect. Among recent American painters, Andrew Wyeth has made extensive use of tempera.

TEN AMERICANS SHOW, an exhibition of New York and Boston painters in 1895 which summed up the strength of American Impressionism. Included were Thomas Dewing, Edmund Tarbell, Frank W. Benson, Joseph De Camp, J. Alden Weir, John Henry Twachtman, Willard Metcalf, E. E. Simmons, Childe Hassam and Robert Reid. William Merritt Chase joined the group in 1902, following Twachtman's death.

TENTH STREET STUDIOS, a spacious and fashionable studio building in New York City in the later part of the nineteenth century and early twentieth century. It helped center artistic life in and around Greenwich Village. Studios were occupied by many of the later landscape artists and the Impressionists, including Frederic Edwin Church among the former and William Merritt Chase among the latter. Studios served as sales galleries and social halls as well as places of work.

W P A ARTS PROJECTS (see *Federal Arts Projects*).